Stratford-upon-Avon

The Biography

NICHOLAS FOGG

AMBERLEY

For my friend, Chris Towner, on his retirement.
'I wish no other Herald'

First published 2014

Amberley Publishing
The Hill, Stroud
Gloucestershire, GL5 4EP

www.amberley-books.com

British Library Cataloguing in Publication Data.
A catalogue record for this book is available from the British Library.

ISBN 978 1 4456 3787 7 (paperback)
ISBN 978 1 4456 3799 0 (ebook)

Typesetting and Origination by Amberley Publishing.
Printed in the UK.

CONTENTS

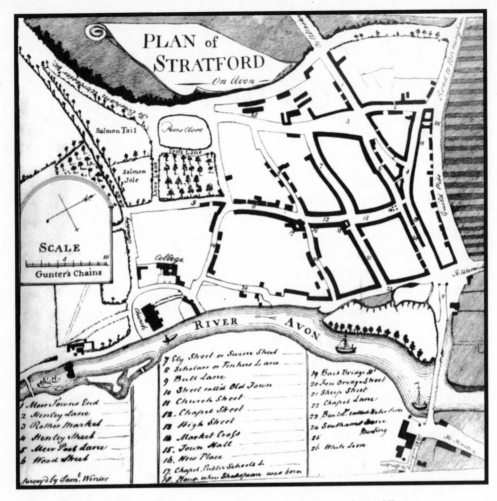

Plan of Stratford, 1759. The street pattern is unchanged since the Middle Ages.

Introduction

It is realised increasingly that local history represents a fascinating, invaluable and often neglected resource for the study of our past. It represents the life of the nation in microcosm and we can find something of ourselves and our origins there. Yet the writing of it is fraught with difficulties. The inevitable unevenness of the records means that in some areas there is a welter of information, in others a sparsity. In the early centuries of this story, two facts, separated by a hundred years, may form the basis of a judgement. The unexpected discovery of a third may change the picture. There is far more information from Shakespeare's time, enabling a fuller picture of town life and personalities. Does one give greater editorial weight to this era than the more sparsely recorded ones that precede and follow it? The answer must be 'yes', for the more personalities and communities can be brought to life, the more effective the history becomes. The records that the Stratfordians left behind them were not generally for posterity, but for themselves and their immediate use. Thus, we deal with a partial picture. The activities of the lawbreaker, those with a grievance and the sexually indiscreet are far more likely to find a way into the records than those of the law-abiding, the content and the continent. It would be a mistake to judge the general health of the population from the casebooks of John Hall. Yet, although the glass may be misty, frequently we have no other. The distorted glimpse may be our only means of discovering anything at all, particularly about those whom the Victorians called 'the submerged one tenth', whose impact on the records is often only through court proceedings. An occasional chance discovery can illuminate. The finding of a report on the apprentice pauper boys of Measham (*Chapter 10*) eradicated the idea that, given the circumstances of the time, they were probably more fortunate than most. Such illumination cannot always be found, and often a statement from the records must stand alone without inclusion of the vital detail that stands behind it.

This book, like all others of its genre, is thus a book of chance. What has not survived or been discovered could have confirmed or changed the picture. It is also, of course, dominated by the articulate. Our view of Stratford and the Stratfordians during Garrick's Jubilee in 1759 comes almost entirely from witty and fastidious London scribes. It is a picture which undoubtedly differs from the one that the Stratfordians would have given, but, seen in the context of the whole, it is additionally valuable because it makes us realise how the people of our town appeared from a sophisticated, urban perspective. William Shakespeare, who had a foot in both camps, appears not to have been averse to mocking (for literary purposes) the rural qualities of his townsfolk.

As I explain in the bibliography, to list all the sources would be a task made excessive by the limits of time and space. I will gladly answer any specific or general queries through the

publishers. I have kept original spelling wherever possible. Where it has been modernised it is sometimes for the sake of clarity, and sometimes because it comes from a secondary source.

In acknowledging my debt to a large number of people, I am conscious that there are those who will be left out, but whose help is nonetheless appreciated. The research facilities of the Shakespeare Birthplace Trust possess exemplary staff that must be the envy of all such similar bodies. I would particularly mention in this context, the help given to me by Dr Robert Bearman and Mairi Macdonald. The Trust's director, the late Levi Fox, kindly gave me permission to reproduce illustrative material that is reproduced here. Edward Sturge drew the map of Shakespeare's Stratford.

I'm grateful to Nicola Gale of Amberley Publishing for her expertise, enthusiasm and encouragement. Others who have contributed, sometimes inadvertently, include the late Dennis Flower, Dr Richard Ough, Dr Judith Champ, David Crawford, Ernest Thorp, Dr Tom Axworthy, the late Peter Pearce, Dr Wilhelm Vossenkuhl, Graham Downie, Dr Sylvia Morris, Chris Towner, Willie and Emily Wilson, Michael Payne and Preston Witts. The continued interest of friends too numerous to mention has sustained my own, especially that of my wife, Edwina, who has endured patiently the vagaries of the manuscript and has always made constructive and encouraging comments.

I

'A Proper Little Mercat Town'

Stratford, a proper little Mercat towne, beholden for all the beauty that it hath to two men there bred and broughte up; namely John de Stratford, Archbishop of Canterbury, who built the church, and Sir Hugh Clopton, maier of London, who over Avon made a stone bridge...

William Camden, *c*. 1530

The Origins of Stratford

Stratford is not an old town by English standards. No extensive settlement existed there until the Middle Ages. Few traces of Neolithic man have been discovered beyond a little crude pottery, implements of bone and some burnt flints. In Roman times, the area was bypassed 6 miles to the west by Icknield Street, and the Fosse Way, a similar distance to the south. The very name of the place implies that the Anglo Saxon invaders of the sixth century found a minor Roman road linked to a river crossing, probably connecting the small garrison town of Alcester with the extensive ironworks across the Avon. At nearby Tiddington, a Roman–British settlement flourished beyond the collapse of the Empire, demonstrating that the first English did not drive the Britons before them in an Armageddon of the Dark Ages, but settled alongside them in a process of mutual absorption. Words of Celtic origin were common in the almost-forgotten local dialect. Nearby Shottery derives its name from some 'Scot' who lived by its brook. At Welcombe curious earthworks of obscure origin may betoken resistance to an invader, but the site would not be efficacious for military purposes.

The Anglian tribe which settled in South Warwickshire were the Hwiccas, in time to be absorbed into the Saxon kingdom of Mercia. A diocese of the Hwiccas, with Bosel as its bishop, was established at Worcester by the year 680. Like his successor, Oftor, Bosel had been a monk at Whitby Abbey in Northumbria. 'Having devoted himself to reading and applying the scriptures', Bede tells us that Oftor, 'to win perfection', visited Rome. On his return, he spent a long time in the province of the Hwiccas, 'preaching the word of faith and setting an example of holy life to all who met and heard him'. It was probably during this mission that a monastery was founded at Stratford. The first extant reference to it occurs when Egwin, Bishop of the Hwiccas from 693–717, exchanged a religious house at Fladbury for one held by the King of Mercia at *Aet-Stratford*: 'the Isle of the Ford'. Presumably, this was on the site of the church of the Most Holy and Undivided Trinity on the higher ground above the Avon and its river marshes. The ford that gave the place its name was probably nearby, rather than at the later road bridge further upstream.

The monks must have come south with Bosel or Oftor, and it is one of these bishops that was the likely founder of Stratford. They were treading a land still largely heathen and kindling a light for future generations of English. The monastery was well sited and the little community thrived. The potential for a watermill on the Avon below the church was seen and developed. Early in the eighth century, the King of Mercia granted more lands around Shottery to the bishopric, and in 781, Offa, the greatest of the Mercian kings, confirmed the right of the Bishops of Worcester to 'Stretforde', an estate of 30 hides (over 3,500 acres), whose boundaries stretched to Billesley and Milcote. Another Mercian King, Bertulf, reconfirmed these privileges at a Witangemoot held on Christmas Day 845. The land was described as sufficient to support twenty families and was free 'from all human servitude, all secular tributes and taxes'. The last recorded charter of this monastery was in 872. When, why and by whom it was dissolved is unknown. Most probably, it was destroyed by Danish raiders. In 1015, every religious house in Warwickshire except Polesworth was burnt down.

The Norman Conquest, elsewhere a watershed of history, passed quietly at Stratford. Wulfstan, the Saxon Bishop of Worcester, acknowledged the Conqueror's claims and retained his see. The Domesday survey of 1086 revealed that Stratford was smaller but wealthier than in Saxon times; some fourteen hides supported twenty-one villeins, a priest and seven cottagers – a population of around 200. The tenants paid rents totalling 100s a year and had the use of thirty ploughs, of which three belonged to the bishop. The annual cash income from the watermill, where the villagers were obliged to grind their corn, was ten shillings, but many tenants paid in kind. Each year, 1,000 eels were sent to the bishop's kitchens from his Stratford manor, from which the annual profit was a handsome £25.

A comprehensive feudal system with every man in his place and a place for every man developed in the manors around Stratford. In 1228, Robert de Clopton founded a long-lasting dynasty when he obtained the manor from which he took his name Peter de Montfort. The Bishop's estates were held by knights, who in their turn were overlords of the tenant farmers. One such tenant, Simon, was living 'bi-the-broke' in Shottery (perhaps on the later site of Anne Hathaway's Cottage) in 1252. Every year on St Martin's Day, he paid 'wattselver' for the militia and tolls on 'each horse born to him, should it be sold within the manor, 1*d*… and for a pig over the year, 1*d*, and of less age 1s 2*d*, but it may not be a sucking pig'. Simon's lord, Thomas de Bissopdene (Bishopton), was aware of the dangers of putrefying meat, for he forbade his tenants to sell pork during the summer without permission. Simon helped brew 'Fulpthale' during the winter, but if he brewed for sale he paid a silver penny. Within the manor, there was a lock-up for vagrants and other offenders, where Simon took his turn at guard or from where he escorted prisoners charged with more serious offences to Warwick. He had to obtain his lord's permission for his son to leave the farm or for his daughter to marry. He worked one day a week for the lord, and in the spring brought one of his labourers to assist him. If he harvested his corn before his lord, he owed service with one or two men 'until all be gathered in'. Even death did not end his obligations, for the lord was then entitled to his best animal.

Simon's duties were the norm for the other tenants. Felice Palmeres held his land for 8s yearly 'as the aforesaid Simon'. Fanty, the fisherman, perhaps farming eels in Shottery brook, paid 'as Simon Bythebroke' for his quarter virgate.

The society of Simon and his neighbours was one of duties, rights and labour, in which the people tilled the earth that sustained them; an unchanging world with every character fixed in place like figures in a Book of Hours. Yet in one respect, life was dynamic in this corner of Warwickshire, for at the end of the twelfth century a new town came into being. With its grid of wide, regular streets, Stratford has the air of a planned town, in contrast to the cramped thoroughfares of most medieval settlements. It was perhaps the building of a wooden bridge that led those responsible for diocesan finances to see the potential of the river crossing linking the rich pastures of Arden with the uplands of Cotswold and Feldon, whose wool production was developing and whose barley would provide Stratford with its biggest industry of malting. In 1196, Richard I granted the right to a market every Thursday 'in perpetuity', for which the citizens paid their Bishop 16s annually. Soon afterwards, the Bishop of Worcester, John de Coutance, issued the borough's first charter. The new town's planned character is revealed by the uniform size of its tenements: three perches wide and 12 perches long, each one rented for 12d a year. Significantly, the burgesses were to hold their property 'by hereditary right freely and quietly', in contrast to the constraints placed upon the feudal tenants who still inhabited the old settlement around the church.

An Episcopal survey of the Stratford manor undertaken in 1251 reveals that the new town thrived. The occupations of the inhabitants included tanners, turners, mercers, whitesmiths, locksmiths, tailors, carpenters, skinners, coopers, dyers, potters, wheelwrights, ironworkers, fullers, bakers, weavers, barbers, shoemakers, butchers, salters, piebakers, chapmen, millers, fishermen, parchment-makers, curriers, cardmakers and tylers. The 'uly', or oil-makers, gave their name to what is now Ely Street, whose alternative name was Swine Street. Other commodities were sold in 'Sheep' Street, 'Wood' Street, 'Corne strete' (now Chapel Street), 'Butchers Row' (the passage through 'Middelrewe' in Bridge Street) and the great 'Rother' or cattle market. A pillory, where offenders could be pelted with the humiliating refuse of such streets, was established in 1309. The trade and prosperity of Stratford attracted immigrants from the surrounding area. Among those living in the town in 1314 were John de Lapworth, John de Kynton, Hugo de Compton and Thomas de Clifford.

Fairs were a great stimulus to trade. In 1214, a fair was granted on the eve, day and morrow of 29 October, the patronal feast of Holy Trinity. Other fairs were later granted on St Augustine's Day, Ascension Day and for the Feast of the Exaltation of the Holy Cross on 23 December, the patronal festival of the guild of that name.

The Guilds of Stratford

When, in 1389, the wardens of the Guild of the Holy Cross responded to a royal writ, stating that the 'source of the Guild was from the time whereunto the memory of man reacheth not'. Certainly it existed in 1270 when the Bishop granted a charter to build a considerable complex in the town. The document implies that it was already in being, but there is no mention of the Stratford guilds in the episcopal survey of 1251, so this venture was the first time any of them acquired property.

The guilds had a duel function. Their members acted as guardians of those altars in Holy Trinity to which their guild had a special devotion. They were also a corporate body

of Christian laity intended to protect mortal bodies and sanctify immortal souls, so they developed charitable and liturgical functions. In the second half of the thirteenth century, there were at least three guilds in existence and perhaps others that have left no trace.

The smallest was the Guild of St John the Baptist. In 1344, William de Gorschawe gave the rental of 8*d* from a messuage in Rother Street, to the Proctors of 'the Guild of St John the Baptist and St John the Evangelist in the Church of Stratford'. The dual title signifies perhaps an earlier amalgamation. It merged in the Mary Guild as 'The Brethren of the Blessed Mary and the Blessed John'. This guild possessed a hall next to the church gate, called St Mary's House. Most of the north aisle at Holy Trinity formed the chapel of Our Lady under its guardianship. The inventories demonstrate the devotion of its brethren. Robert de Walleys endowed an annual rent charge of 12*d* to its altar; Richard Hylgar gave 4*d* yearly to maintain the altar light, the rental from 'a stall where flesh is sold'; a messuage in Henley Street was given to the work of the 'Blessed Mary' by Alice, widow of Walter Marescall. In 1313, the north aisle was reconstructed. The Primate of Ireland granted a forty-day indulgence to those who visited the altar or contributed to its beautification. 'Item', reads a later inventory, 'a blew cloth to oure Ladye in tyme of Lenton', when the statue would have been covered. Richard Warner gave 36*d* from the rental of a tenement 'in the street in which pigs are sold (Swine Street), 12*d* for the celebration of our Lady the Blessed Virgin, 12*d* to keep a wax light before her altar and 12*d* for a lamp'.

By the mid-thirteenth century, the Guild of the Holy Cross was a powerful religious community under a lay warden, Robert Hatton. The charter granted in 1270 by Godfrey Giffard, Bishop of Worcester, is worth quoting extensively for its charm and insights into the character of the Guild:

> Whenever a pious request is earnestly made it is right that a gracious assent should be granted. It is therefore that our beloved children in Christ, Master Robert de Stratford [and] the brothers and sisters of the Holy Cross have humbly besought us that they might build a certain hospice, in the village of Stratford-upon-Avon, in honour of our Lord Jesus and the Holy Cross, and also to erect an oratory and a chapel there with bells, in order that divine service may be celebrated for the souls of their ancestors and all the faithful departed, and for the maintenance of all those serving in the same chapel, the needy brothers and sisters of the same fraternity, and of the poor of the same town and also of needy priests who have been promoted without a certain title by the Bishop of Worcester for the present.

The guild was to pay the bishop a token rent of a gallon of ale from every brewing, three cakes from every baking and 'certain rents in the same village, under the sign of the Holy Cross'. The hospice was to be 'immediately, in full right, subject to us and our successors'.

On the houses of the hospice and its tenants, a cross was to be erected and bells hung. A monastic community lived in the hospice under the Augustinian rule. Such luxuries as linen garments were forbidden, 'except for drawers, or for the sick and infirm' and then only at the master's discretion. Their tunics were of russet 'as it comes from the fleece', with over-tunics furred in black-and-white sheepskin. Over this, the brothers wore a cloak embroidered with a black cross surmounted by a white mitre. When riding out, they wore a russet cloak bearing the same emblems. The order's nine lay brothers dressed in the same

way, except for a scapular who wore the emblem in the centre, instead of on the cloak. No one was allowed to eat, drink or go out of the hospice unless he was wearing his habit. The members of the order ate together in the refectory and slept in the communal dormitory. It was forbidden for the brethren to eat or drink in Stratford without the Master's permission. The sick and infirm were tended to in the infirmary.

Novitiates took vows of chastity and obedience. At his investiture, the ordinand lay on his face before the altar in the chapel, while the majestic hymn 'Veni Creator Spiritus' was sung, followed by the verse 'Confirma hoc Deus quod operatus in nobis' and the response 'Omnipotens sempiterne Deus qui facis'.

Each member of the guild paid 4d yearly. If a poor townsman, or a passing stranger without means, died, the guild provided the dignity of a requiem, with four candles, a winding sheet and a hearse cloth. When a member died, the fraternity were summoned, a third at a time, to watch and pray by the body. To ensure the emergence of its members amongst the church triumphant, the Guild employed two chantry priests in its chapel.

The guild acquired considerable property in Stratford. In 1353/54, it leased tenements with a total rental of £20 3s 5d. Times were hard that year, possibly through a slump in the wool trade. An unpleasantly long list of persons owed rent. A note of incentive appears in a bonus of 2d given to a roofer 'to get him to work better'.

It was probably after the promulgation of the Statute of Winchester in 1285 that the first structures of local government were formulated in Stratford. The Bishop's steward presided over a Leet court of twelve citizens of substance which advised him on the annual election of a bailiff, constables and other officials. A schoolmaster is first mentioned in 1295, when among those ordained deacon by Bishop Giffard were William Grenefield, rector of the church at Stratford and Richard, rector of the school. Grenefield was an eminent lawyer who later became Archbishop of York. The growing importance of Stratford in the early fourteenth century is demonstrated by the fact that he was one of three former rectors to become Lord Chancellor of England. The others were the brothers John and Robert Hatton, who were probably sons of Robert Hatton, who was Warden of the Guild of the Holy Cross. Like him, they bore the suffix 'de Stratford'. Their seal punned on the family name, showing a figure with his hat on.

The Brothers Hatton de Stratford

John de Stratford was the first recorded Stratfordian to attend university, graduating from Merton College, Oxford, as a doctor of canon and civil law before 1311. Around this time, he became Rector of Stratford, but did not devote his entire energies to its spiritual welfare, holding plural benefices and regularly giving legal advice in Parliament. In 1319, he became Archdeacon of Lincoln and his brother Robert, also an eminent lawyer, was installed as Rector of Stratford in his place. John de Stratford was a diplomat at the Papal's Roman Curia before becoming Bishop of Winchester. His role was as much political as spiritual. His part in the abdication of Edward II in 1326 is depicted in Marlowe's play of that name. Edward III made him Chancellor in 1330 and he was principal advisor to the King for the next ten years, playing an ambiguous but moderating role in the French Wars as virtual ruler

of England during the King's campaigns. In 1333, he rose to England's highest spiritual dignity as Archbishop of Canterbury. His brother's star also rose. In 1331, he became Chancellor of the Exchequer and, later, Chancellor of Oxford University. In 1337, he became Chancellor of England and was consecrated as Bishop of Chichester by his brother. A third member of the family, Ralph Hatton de Stratford, became Bishop of London in 1340.

John de Stratford's primacy, like that of Thomas Becket, brought him into conflict with the King, who was attempting to increase his power. When de Stratford was threatened with the same fate as his illustrious predecessor, he defended Magna Carta from the sanctuary of a Kentish monastery. After a jury of peers acquitted him of all charges against him, he returned to the royal favour before his death in 1348. He was buried in his own cathedral, next to the shrine of St Thomas, where his effigy remains.

The de Stratfords were great benefactors of their native place. Robert's contribution was soundly practical. In 1332, he raised a toll on agricultural commodities to pave Henley Street, Greenhill Street and Old Town. John de Stratford devoted his philanthropy to Holy Trinity. He erected a wooden bell tower, widened the north aisle and built the south aisle. There he established a chantry, endowed by the nearby manor of Ingon and dedicated to his special saint, Thomas Becket, 'for the praise of God and for the soul's health of myself, Robert my brother and for the souls of Robert and Elizabeth, my father and mother, and for the good health of my lord, King Edward and that of my successors.'

In 1337, John de Stratford sought to appropriate the patronage of Holy Trinity from Simon de Montacute, Bishop of Worcester. A local layman, John Lacey, wrote a deposition in his support which revealed that the rector, like many of his predecessors, was mainly non-resident and that only two chaplains served the church. If it were appropriated, the number of resident ministers would be increased to eight.

John de Stratford gave the endowment of the church to the chantry he had founded. The office of warden, or *custos*, was a powerful one and he and the sub-warden were appointed for life, while the other priests were elected or dismissed at his discretion. The appropriation exempted the parish of Holy Trinity from much of the normal jurisdiction of the bishop and gave it tenuous spiritual jurisdiction over the Guild of the Holy Cross. Two years out of three, the warden could exercise many of the prerogatives of the bishop, including the prosecution of offenders against canon law in his own court. In 1353, Ralph de Stratford built a college for the chantry clergy near the church. The creation of the peculiar brought anomalies and friction between the ecclesiastic and civil jurisdictions that would endure for centuries.

Until the mid-eighteenth century, the seal of the Stratford peculiar bore the effigy and arms of John de Stratford. The archbishop is represented as standing in an attitude of benediction, beneath a canopied tabernacle with this legend in a reeded border: *s'peculiar jurisdicois de Stratford sup. abana.*

Guild and the Church

The growing power of the Guild is demonstrated by a complaint registered in 1377 by Thomas, Earl of Warwick, in which forty-six Stratfordians and others led a considerable body of archers to

invade the Earl's manor at Fulready, breaking down fences and pillaging houses. They assaulted 'his men, bondmen and tenants, whose lives they so threatened that they could not attend to his business … not daring to remain there any longer'. The cause of this aggression is unknown, but it must have been serious, for the list includes some of the most prominent brethren of Stratford.

By 1397, the Mary Guild had been absorbed into its richer neighbour, the Guild of the Holy Cross. Its guild house became a schoolroom and the schoolmaster lived there rent-free. In 1403, the combined guild was reformed and incorporated as the 'fraternity and Gild of the Holy Cross at Stratforde-on-Avone and St John the Baptist'. The officials consisted of a Master, eight aldermen and two proctors, elected annually. Sexual equality prevailed, the sisters voting together with the brothers. The proctors recorded fines for admission and the frequent legacies. They saw that repairs to Guild property were carried out and arranged the great feast. Their accounts illuminate contemporary manners and customs. Benefactors and their gifts are noted each year, with the communal principle prevailing that each should contribute according to his abilities. In 1408/09, Simon Groves, a carpenter, was admitted and excused the £53 4*d* he owed the Guild in return for building two bays at the eastern end of the kitchen. Other beneficiaries show the range of the membership and the diversity of the gifts. Henry and Margaret Lyttleton of Handy gave two quarters of lime, and Lady Joanna Clopton, a canopy. In the year 1440, John Wydbury, Rector of Stretton, gave six quarters of barley, valued at 16*s*; John Bultys, a pair of vestments and William Pyers a hogshead of red wine. In 1454, Henry Newport of Daventry was admitted with his wife, Joanna. He was a fishmonger who gave a *lavetre* [lavebo] with four cocks, 'for the use of the chaplains to wash at'.

Perhaps the most useful addition to the fraternity was John Prynce, the Earl of Warwick's master cook, who was admitted with his wife in 1416. He paid no fees, 'on condition that he shall be always assiduous at the annual Communions of the Guild, to give council and assistance, if so previously required, annually during his life.'

Prynce lived at a time when there was little distinction between the secular and ecclesiastical uses of the word 'feast'. On principal feast days, the Guild chaplains met the master and aldermen at the great white cross that stood before the Chapel and solemnly processed to Holy Trinity, splendid in their copes and liveries, bearing the Guild crosses and banners and feasting on their return. At Easter, the great Guild feast was conducted so that 'brotherly love shall be upheld among them and evil speaking driven out and peace and love upheld.' At other seasons, the Guild would hold 'lovedays' to resolve disputes between the townspeople.

Each brother and sister brought a great leather drinking vessel to the feast, which was filled with ale to be given to the poor. Before eating and drinking they prayed that 'God, the Blessed Virgin and the much-to-be venerated Cross, in whose honour we have come together, will keep us from all ills and sins'. The tables were spread with 'napery' and groaned under the weight of a huge repast and minstrels performed. In 1416, payments were made for wheat, malt, beer for the cook (probably John Prynce), 7 calves, 16 pigs, boars' heads, 4 lambs, 7 sheep, lard, 209 pullets, 2 geese, 12 capons, butter, milk, cream, vinegar, honey, salt, 1,900 eggs, three gallons of wine, fuel, pepper, saffron, ginger and mace. These Breughelian feasts were accompanied by music and dancing on the rush-strewn floor. After 1421/22, the Guild year dated from the Feast of St Thomas the Martyr and the feast was held on that day, another mark of special devotion to the saint of Canterbury.

It was not only feasts that the Guild observed. Both brothers and sisters received a penitential hood as part of their liveries, and wore it to process to church of Good Friday and other days of fasting and penitence.

The coveted status of 'collegiate' was conferred on Holy Trinity by Henry V in the Agincourt year of 1415. The church incorporated a college of priests which educated scholars. After 1423, the warden assumed the title of dean. Wills, testaments and accounts give more information about the appearance of the church. As was traditional, a crucifix surmounted the rood beam. Three aumbry lights using seven gallons of oil each year burnt before the reserved sacrament. In 1465, William Bulle bequeathed two candelabra to 'serve' at the altar of St Thomas – one before the statue of St Dominic, the other before the *Pieta*.

In the 1420s, the reformed Guild began to build a grander chapel, paying an eminent lawyer, Sir Thomas Burdet, for services *pro ratificatione*. Early in 1427, John Harris, one of the chaplains, and William Bedley, a prominent Guild member, rode to Wedyngton to speak to the Bishop, presumably about the consecration. A schoolhouse was provided in the reconstruction at a cost of £9 7s 11½d. Thus, the origins of Stratford's ancient grammar school may be dated, and this John Harris was its first schoolmaster. 'On this side St Hilary', the Bishop was in Stratford, perhaps to view the new buildings. Later that year, the chapel was elaborately and splendidly consecrated by the suffragan. Three ells of linen were used in the ceremonial cleansing of the altars prior to benediction. Scores of candles were lit and the air was thick and sweet with incense, as the Bishop anointed twenty-four points around the building, marked by red-and-white crosses.

The increasing autonomy of the Guild was causing concern at Holy Trinity. In 1428, a citation was served on behalf of the Primate on the four chaplains (including John Harris) and three lay members of the Guild to answer complaints from Richard Praty, the warden of the Church. A three-man Episcopal commission investigated the matter. The Guild judiciously gave a dinner in their honour and sent Master John Foton to Rome with their charter. The Church authorities were active too, for the Bishop's judgement reaffirmed that 'the rule of St Augustine and the ordinances laid down by Godfrey, formerly Bishop of Worcester shall be observed by all concerned … under a pain of a fine of 20s from the master … half of which shall be spent on alms, half on the cathedral church of Worcester.'

Other letters' patents indicate the matters in dispute. Hay from the hospice grounds was eligible for tithes. The chaplains of the Guild were forbidden to conduct burial services or administer the sacrament, 'except the blessed bread and water to the sick in the said house'. All members of the Guild were to attend mass and vespers at Holy Trinity on the four principle feast days, when the Guild chaplains, 'wearing their correct surplices' (clearly another point of contention), would sing in the choir. To underline 'the superiority of the said Church', the hospice was to pay it an annual tribute of 4s. The Guild appealed to the Pope, and Master Thomas Hanwell was delegated to seek an audience. A Bull, now lost, which presumably confirmed the previous decision, was issued in 1432.

This division of function ensured that the Guild no longer developed as a semi-monastic foundation, but as a lay body that expressed impressively the medieval ideal of community. The transformation was reflected in the changing functions of the buildings. The *frater* became a hall, the *dorter* an upper hall, and the livery a costume for formal occasions. By 1480, the

fellowship of the Guild included many of the local gentry and merchants and bankers from a wide area and some of the greatest in the land.

Stratford's development under the benign patronage of the Bishops of Worcester cocooned it from many of the troubles of the age, although they encroached to the very boundaries of the parish. In Henry IV's reign, a royal commission investigated reports that

> certain evildoers, scheming to hinder the King's lieges, merchants and others, going by roads and highways between the town of Bermyngham and Stratford and the town of Alcestre, to the markets of Coleshull, Bermyngham, Walshule and Dudley ... assembled in divers convecticles and veiling their faces with masks, with garments turned in the manner of torturers and carrying machines called "gladmeres" and other instruments, lay in ambush and assaulted the King's lieges going to and from the markets and put them and their horses to flight, so that the women and children riding on the horses with sacks filled with corn, fell off and some died and some were injured and cut the sacks and scattered corn along the roads.

Yet, so far as the little town was concerned, the French Wars might never have been, and the inhabitants were shielded from the Wars of the Roses, although complete isolation could not be afforded from events so close, particularly when one of the main protagonists was Richard Neville, the 'Kingmaker', Earl of Warwick. In 1450–52, the Guild served wine in the house of Agnes Chalcomb for Anne, Countess of Warwick, and two years later spent £3 8*d* on wine when 'the Earl rode by this way towards Wales'. Later, the Kingmaker sent two deer 'to gladden the brethren and sisters ... on the Feast of the Dedication of the Church'.

Stratford's fortune in being aloof from the lawlessness of the times is demonstrated by the sad affair of Ankarette Twyno. This friend of the Queen was seized in Somerset and brought to Warwick by soldiers of the Duke of Clarence, who was seeking revenge for the Queen's opposition to his projected marriage into the ducal House of Burgundy. Ankarette's family and their servants were lodged in Stratford during her trial. She was executed on a charge of poisoning Clarence's wife, Isabella. The justices who condemned her asked her forgiveness 'in consideration of the imagination of the said Duke and his might'.

The Guild roll reads like the *dramatis personae* from Shakespeare's Wars of the Roses, and its elders possessed the instincts necessary for survival in troubled times. After the Kingmaker's defeat and death in 1471, King Edward VI and his Army passed through Stratford, the first recorded visit to the town by a reigning English monarch. In 1477, the fraternity judiciously elected to its number, Neville's effective successor at Warwick, his son-in-law and the King's brother, George, Duke of Clarence, with his wife and two children.

In the following year, 'false, fleeting, perjured Clarence' was executed for treason, a few weeks after Thomas Burdet from Arrow was executed for being his necromancer. The Warwick inheritance passed into the hands of King Edward IV, so, in 1479, the Master of the Guild rode to Shrewsbury to confer membership on Edward, Prince of Wales (the ill-fated future prince in the Tower); Anthony, Earl Rivers, the Queen's brother, and the Bishop of Worcester. It is probable that the nine-year old Prince presented the Guild with its earliest-known, and still surviving, mace on that occasion. It bears the Royal Arms surrounded by the Prince of Wales' feathers.

Contemporary troubles did not divert the Guild's growth to prosperity. Most of its buildings were reconstructed between 1468 and 1480. A notable endowment came from a wealthy priest of the Guild, Thomas Jolyffe, who in 1482 gave his property in Stratford and Dodwell to provide an annual salary of £10 for a priest 'to teach grammar freely to all the scholars coming to the school, taking nothing of the scholars for their teaching.'

Stratford's prime benefactor in this era was Sir Hugh Clopton, who made a great fortune as a London mercer and became Lord mayor in 1492. In Stratford, he built the great house known as New Place, probably the town's first brick building, marking the start of the start of a long transformation from wattle and daub. He bequeathed five marks each as dowries to twenty poor maidens of 'good name and fame dwelling in Stratford', £100 to the town's poor householders and £50 to rebuild the cross aisle at Holy Trinity, as well as endowments to the hospitals of London and six exhibitions for poor scholars at Oxford and Cambridge.

Sir Hugh's greatest gift to Stratford was the 'great and sumptuous bridge upon the Avon', a wonder with fourteen arches – over 400 yards long with its causeway. Lelend, the antiquary, noted its benefits. 'Before the time of Sir Hugh Clopton there was but a poor bridge of timber and no causeway to come up to it, whereby many poor folks either refused to come to Stratford when the river was up, or coming thither stood in jeopardy of life.' In 1444, John Rawlyns, 'Hermit' of the chapel of the 'Blessed Marie Magdalen' at the far end of the bridge had been admitted to the Guild.

The maintenance of the bridge was the task of the bridge wardens, who organised the annual pageant of St George and the dragon on Ascension Day, which wound its way through the streets and was accompanied by a great tasting of ale. Monies raised from the occasion went to the maintenance of the altar of St George in Holy Trinity, and the profit from candles burnt there went towards the upkeep of the bridge.

Sir Hugh started to rebuild the Guild Chapel and left instructions for its completion:

> Whereas of late I have bargayned with oon Dowland and diverse other masons … I will that the saide Masons sufficiently and ably doo and fynysshe the same with good and true Workmanshipp … making the said werkis as wele of length and brede and hight such as by the advise of mine executors and other diverse of the substantialist and honest men of the same parish shall or canne be thought moost convenient and necessary … and in like wyse the covering of the rofying of the same chapel with glaising, and all other fornyssments thereunto necessary to it, to be paide by my saide executors as the werkis aforesaid goeth fourth.

The 'other fornysshments' included wall paintings which paid tribute to the patrons of the triumvirate of institutions that ran Stratford. On the ceiling were scenes from St Helena's discovery of the Holy Cross; on the walls were pictures of the martyrdom of St Thomas Becket, the meeting of King Solomon and the Queen of Sheba, the discovery of the True Cross, the passion and death of Christ and St George and the Dragon. Above the chancel was a great painting of the Last Judgement. Its graphic, gaping devils dragging lost souls to perdition, contrasted with the blessed ascending to glory. It must have brought fascinated terror to children, and served as an unneeded *memento mori* to the sick and infirm who chiefly used the chapel.

Substantial improvements were also taking place at Holy Trinity, wrought by two notable deans. Thomas Balsall rebuilt the choir as the exquisite structure which still survives. The work reveals two master craftsmen of very different character. Neither was familiar with contemporary trends in his craft. One created a delicate tracery throughout the choir, but in the Early English style of two centuries before, which he might have seen in the great cathedrals. The earthy creations of the other demonstrate the continuity of a peasant culture within the medieval *ecclesia*. He carved the fantastical and bizarre misericords on the choir stalls. The twenty-six carvings contain such folk memories of the Crusades, as a Saracen's head and a sphinx with a rider. An ostrich swallows a horseshoe; a mermaid combs her hair at a hand mirror and the explicit sexual image of *Luxuria* or lechery, as a naked woman rides a stag. Domestic discord is provided by a wife who seizes her husband's beard while pummelling him with a frying pan. Oddest of all is the depiction of two rampant bears, flanked by a chained ape, which provides a urine sample for another ape to examine.

On the roof of the stalls, the master paid due heed to the sacred but retained his basic flavour, creating the kind of effect that St Bernard of Clairvaux described as 'uncouth images of angels and cherubs in profusion'.

It was the collegiate dean, Ralph Collingwood, who assigned lands in Stratford, Drayton and Binton for the maintenance of four choristers and left strict ordinances for their conduct. They were to attend matins and vespers daily, which were sung according to the *Ordinale Sarum*. On entering the church they were to kneel and say a *Pater Noster* and an *Ave*. They were to sit quietly and say their offices distinctly. They were forbidden to go into town or to fetch beer from the buttery. At dinner and supper they waited at table and read the Bible 'or some other authentic book'. Afterwards, one of the clerics gave them singing lessons at the organ. Their bedroom (later the charnel house) adjoined the sanctum of the church, and the boys shared two beds to which they retired at eight in winter and nine in summer. Before undressing, they were instructed to say a *De Profundis* loudly, with the prayers and orizons of the faithful, before exclaiming 'God, have mercy on the soul of Ralph Collingwood, our founder, and Master Thomas Balsall, a special benefactor to the same.'

Catholicism flourished in Stratford until the Reformation. Human failings were placed within a perspective in which worship was cared for and the sacraments made a living reality. Education was encouraged and charity extended far beyond the town. Yet, for most, faith brought demands rather than material rewards and it was the influence of the age that kept the fear of God before their eyes.

2

'...a Body Corporate and Politic'

The inhabitants of the borough of Stratford ... have humbly prayed us that we would accord them our favour and abundant grace for the amelioration of the said borough and the government thereof ... and that we would deign to make, reduce and incorporate them in a body corporate and politic.

Charter of King Edward VI, 1553

The Reformation at Stratford

The forces that produced the Reformation sent ripples towards Stratford. The growth of national consciousness and the secular power of princes were breaking down Catholic universalism. Sheep farming was encroaching onto the Midland plains, destroying labour-intensive farming systems and causing a drift from the land. 'In this shire ... sheep turn cannibals', lamented a visitor to Warwickshire, 'eating up men, houses and towns, their pastures make such depopulation.' But there was another viewpoint:

...it is pleaded for these enclosers that they make the houses the fewer in the country and the more in the kingdom. How come building in great towns every day to increase..., but that the poor are generally maintained by clothing, the staple trade of the nations?

This economic revolution strongly influenced life in Stratford, where the wool trade was of increasing importance.

It would be incautious to interpret too much from occurrences in Stratford before the Reformation, which, in a different chronology, would not assume such significance. Yet they are made noteworthy by their proximity to momentous change. They had no doctrinal causation, but reveal a growth of individualism and the questioning of authority. Certainly, they demonstrate an unwholesome increase in factionalism, alien to the spirit of brotherly love intended to pervade the Guild.

John Eylis, a former master of the Guild, was appointed as the bishop's deputy steward in 1509. His conduct aroused the opposition of three men of substance in the town, Richard Bentley, a smith by trade, who had been admitted with his wife, Margery, as long before as 1471 and two former proctors, Thomas Thomasyn and John Staffordshire. Their behaviour led to a complaint from Silvestro Gigli, Bishop of Worcester, to the King. A jury had been sworn in for the annual election of two constables and a bailiff, 'as all weys hath be used there

tyme out of mynde', with Elys presiding. It appears to have been a stormy affair, and William
Cottoun was elected bailiff. He too was a prominent member of the Guild. Admitted in 1492,
he was a Proctor on 1499 and an Alderman between 1502 and 1508. No sooner was it over
than Thomas Thomasyn, who 'of his own presumptious mynde wold be baily there for this
yere', gathered with Bentley, Staffordshire and 12 other men and

> with Bills, clubbys, stavys and swords came riotously to the courthouse, threatened to kill Elys and
> kepying the said court and with assautes & exclamacons riotously kept the said deputie styward
> & xij men tille hit was passed x of the clocke in the nyght, to the grete disturbans of your peas
> and in contempt of your highnes & of your lawes to the perillous example of mysdoers enless
> they may have due punysion [punishment] therefore. In consideration where of, that it will pleas
> your highnes to directe youre honorable letters of pryve seale to the said Thomas Thomasyn,
> Richard Bentley and John Staffordshire to appere before your highnes and your most honourable
> Counsaill at your palous at Westminster... there to answere to thes premises and to be punished
> for their said riotte and contemptes.

The defendants replied that from 'tyme out of mynde', the bailiff had been chosen by twelve
of 'the most substanciall and honest persones', but Eylis selected the jury from 'the senglest
[silliest] and simplest persons... and some of them were but mennys servants and left the
substanciall men out of the same jurie. And after the said jurie was sworn they kuld not agree
upon oon of the Bayliffes and they so beying not agreed the John Eylis proclaymed Bayliffes
and Constables at large in the sayd Town such as hym pleased'. It would appear that the
King and his councillors found for the gerrymanders rather than the riotous legalists, for
John Eylis continued as an alderman until 1520, but none of the defendants held office again.

Although the Reformation swept much away, its effects were less profound in South
Warwickshire than elsewhere. There is little evidence of local zeal for change, although Hugh
Latimer, soon to become the Protestant Bishop of Worcester, was arrested at Hampton Lucy
while the King was still the Pope's *Fidelis Defensor*. This learned and austere man, who was
to be burnt at the stake in the reign of Queen Mary, preached at Holy Trinity in 1537 and
referred subsequently to the area around Stratford as the 'blind end' of his diocese.

If judgement were to be made on the scant evidence available from this one small town,
the conclusion that avarice, rather than doctrine, was the prime motive for the Reformation
would be irresistible. In 1535, following the King's defection from Rome, his commissioners
seized plate from Holy Trinity. Before the end of the reign, 260 ounces of silver and gold had
been appropriated. In 1542, the lordship of Stratford passed from its creator, the Bishopric of
Worcester, when a new bishop, Nicholas Heath, described merely as the King's 'delegate', was
obliged to surrender his manor of Stratford to John Dudley, Earl of Warwick, in exchange for
lands in Worcestershire.

The Guilds and the College survived the reign of Henry VIII. In 1535, the College had
an annual income of £128 9s 11d and was occupied by the warden, five priests and four
choristers. A glimpse of this little community emerges in the presentation of 20 June 1544
by Anthony Barker, provost of the college, asking leave to appoint a *subcustos*. A number of
people testified for the candidate Master Giles Coventrie. On 27 December 1546 he appointed

another *subcustos*, Edward Alcock, after Coventrie resigned. This was the last free-recorded act of a college warden. In the following year, the first of the reign of Edward VI, all colleges and chantries were suppressed. Alcock did well from his brief tenure, gaining a gratuity of £6 13s 4d. All images in the churches of the diocese were ordered to be destroyed. Thus perished the remaining treasures of Holy Trinity, the cultural heritage of the Middle Ages, the gifts of the centuries, of the pious and the place-seeker, together with the communal vision that produced them.

The collegians at Holy Trinity took steps to preserve at least a small part of their Catholic heritage. It had been ordered that stone altars, symbolic of the sacrifice of the Mass rather than the new dispensation of a memorial meal, should be destroyed. They buried the altar piece from the chapel of St Thomas of Canterbury under the floorboards of the south aisle. It was not found until 1892, when it was restored to its position.

There were those in the town who, through conviction or expediency, understood the movement of the times. Thomas Bentley, physician to 'the late Kynge of famous memory Henry VIII', leased New Place in 1545. His will made in 1548 demonstrates the new formulae of secular and ecclesiastical power: 'Edward the syxte by the grace of God of England, France and Irelande Kynge, defender of the faith and in earth of the Church of England and also of Irelande supreme hedd.'

The changes made less impact on the Stratfordians than might be supposed. For the next two centuries, changes in the state religion were frequent. Most citizens learned to accommodate them, the exceptions considered fanatics or saints according to point of view.

Within a few years, Catholicism was briefly restored under Mary and Roger Dyos, who had been a priest at the College, was restored as vicar. The Stratfordians disported themselves again in the great pageant of St George that had been suppressed as profane in the previous reign. The 'saint' rode through the town on horseback, clad in armour and leading a dragon which belched flames and smoke from its nostrils. This was followed by a traditional vice, or buffoon in costume, and soldiers armed with pikes. In 1562, after another religious *volte-face* under Elizabeth, the pageant was abolished again and funds for the repair of Clopton Bridge were levied from the rates, a much less colourful process.

The Renewal of Local Government in Stratford

Although the Guilds did not fall in the reign of Henry VIII but in the one that followed, their suppression was intended. In 1545/46, Royal Commissioners visited Stratford and reported that Guild rents totalled £50 23½d and that annual outgoings were £51 19s 8¾d. The population consisted of some 1,500 'houselying people together with seven lyttle hamlets thereto belonging'; £26 6s 8d went to maintain the four chaplains; the clerk received 4s and 13.4d went to Oliver Baker, the clock mender. The Commissioners noted the free school above the Guildhall, where William Dalem's annual salary was still the £4 bequeathed by Thomas Jollyffe. The Guild possessed almshouses and every year gave 10s worth of coal and 3s 4d in cash to each of twenty-three poor brethren. There were moves to demolish the chapel that the Commissioners resisted. 'Yet it is also a thing very mete and necessary that the Gild Chapel

of Stratford stand undefaced for that it was always a chapell of ease for the seperacion of sick persons from the time of plague and standith in the face of the towne.'

The Guild was finally suppressed in 1547. Its properties were dispersed, chiefly to John Dudley, Earl of Warwick (later Duke of Northumberland), the Lord of the Manor, thus finally ending the centuries-old benign custodianship of the Bishops of Worcester. The town was left without local government or administration and, for six years, its life dissolves into a historical void. In 1553, a plea from the inhabitants that stressed the continuity of local government in Stratford gained a positive response on behalf of the dying Boy King on 7 June. The royal charter ensured that most of the old Guild property returned to the corporate hands of the townspeople. The officers and functions of the new Corporation were much the same. The Master of the Guild became the bailiff and the Proctors, the Chamberlains. This oligarchic government was to be conducted in a spirit of benevolent paternalism. The leading men of the town found themselves, by right and duty, members of the Corporation. An elaborate system of fines made it difficult to refuse service. In 1555, the school was reconstituted after the Corporation resolved to appoint 'a lawful and honest man lerned in gramr and in the lawe of god'. William Smart was paid £20 a year, 'gently dyly to employ himself, with such godly wysdom and lernynge as God hathe and shale endue hym with, to lerne and teche in the saide gramer scole such scholars and chylder as shall … cum together to lerne godly lernynge and wisdom, beying fit for the gramar scole'. Provision was made to maintain twenty-four of the aged poor in the almshouses and an overseer was appointed. A court of record was established which met fortnightly to consider small claims. The fortuitous fall of John Dudley, early in the next reign, and the reversion of his properties to the Crown, ensured that the income that had belonged to the College was given to the Corporation. In return, £30 was to be paid towards the stipends of the vicar, his assistant and the schoolmaster, and accommodation was to be provided for them.

To ensure that he retained a degree of control over the town, Dudley had reserved the right to veto the elected bailiff, and to nominate the vicar and the schoolmaster. These rights were to pass to successive Lords of the Manor and were to cause some friction in years to come.

The Rise of John Shakespeare

Around 1540, a youth left his father's farm in the village of Snitterfield and travelled the 3 miles to Stratford to take up an apprenticeship, perhaps with Alderman Thomas Dickson of the Swan Inn, whose wife came from that village. John Shakespeare served his master for seven years before paying 6s 8d to join the 'Mystery, Craft or Occupation of the Glovers, Whittawers and Collarmakers', one of the town's trade guilds. By the early 1550s, he was established in the eastern half of his now-famous house in Henley Street.

His rise was rapid. He made an excellent marriage with Mary Arden, who brought her husband considerable wealth that his business skills then expanded. This acumen had been observed by her father, Robert Arden of Wilmcote, who, having no sons, made John his effective chief heir. His will bequeathed his soul to 'Almighty God and to our Blessed Lady Saint Mary and to all the Company of Heaven'. His property was divided among his

eight daughters, but the most valuable portion went to 'my youngste daughter Marye', who inherited his property at Wilmcote called 'Asbyes', with ten marks in money and a sixth of her father's goods, which were valued at £77 11s, and included painted wall hangings, oxen, bullocks, kine, 'wayning calves', sheep, bees and poultry.

For those who prefer the national poet to have appropriate genealogy, no better forebears could be found for William Shakespeare than the Ardens, who bore the very name of the ancient Warwickshire forest that surrounded them, and whose Saxon ancestry may be traced beyond the Conquest. The family was connected with the Ardens of Park Hall, near Castle Bromwich, who were numbered with the county gentry. Robert Arden's extensive lands included part of the holdings at Snitterfield farmed by John Shakespeare's father, Richard.

Stratford's position ensured a prosperous flow of goods and people. Thirty alehouses slaked the thirst of inhabitants and travellers and over fifty malthouses supplied a wide area. Frequent fairs attracted the 'great concourse of people', observed by Leland in 1530. On market days, John Shakespeare and his fellow glovers occupied a prime site by the High Cross. 'Brasyares' and ironmongers had their stands down Bridge Street, butchers sold flesh, hides and tallow in the High Street, pewterers paid 4d a yard for their pitches in Wood Street and a 'sugerer' dispensed his commodity in Chapel Street. The butter sellers by the chapel were forbidden to light fires to soften their products; next to them were stalls for cheese, white meats, wickyarn and fruit. At the cross in the Rother Market, raw hides were laid out and saltwainers stood nearby.

This considerable trade was regulated by the Leet court at twice-yearly sessions. The magistrates heard complaints and imposed penalties. The Leet's ale tasters (John Shakespeare was appointed as one in 1556) guarded the peoples' brew against the introduction of hops and other 'subtle things'. The Leet fixed the weight of bread, checked its standard and ordained its price of a penny a loaf. In times of shortage, it was assiduous in preventing the hoarding of grain. An order of 1554 reprimanded 'persons now having barley in their houses' and ordered them to release it or face a fine of 40s.

Tudor Stratford was an Augean stable, with the stench of animal excreta mingling with the refuse of trade and markets, exacerbated by badly-paved streets and open ditches. The divide between town and countryside was narrow. Stratford was beautified by 1,000 elms within its boundaries, and the inhabitants kept pigs and other livestock in their yards. The officers of the Leet struggled to control abuses, but the persistence of their efforts implies their lack of efficacy. Butchers were the worst offenders and were frequently ordered to 'carry further of the borough at seasonal time the ridings of their beasts' bellies, garbages and beasts' pates on pain of a fine of 40/8d'. Fines were imposed on those who allowed their animals to stray on the streets, with errant ducks collecting a fine of 4d and stray dogs, 2d. Housewives did their washing at the public pump and hung it to dry on the High Cross. The town's rubbish was gathered at six huge muckheaps at its approaches. When the eye of heaven shone too hot, summer's lease brought plagues to ravage the town.

The streets around the High Cross and the Guildhall were long swept by the Widow Baker, who was provided with a shovel, broomstick and branches for her task. She was paid 6s 8d a year and had the occasional duty of helping a man named Raven sweep the bridge. Other streets were supposedly cleaned by the householders. Fines were levied to encourage compliance and it was for keeping an unauthorised muckheap outside his house that John

Shakespeare made his first inauspicious appearance in the Stratford records in April 1552, when he and his neighbours, Adrian Quiney and Henry Reynolds, were fined 12*d* at the Leet court. Three years later, he was fined for not keeping his gutter clean. Among his co-defendants was the bailiff, who was chairman of the court, so Leet justice was clearly impartial.

The fines imposed by the Leet were no stigma. Every citizen occasionally violated its regulations. For John Shakespeare they were pinpricks in a steady advance to commercial prosperity and civic dignity. In 1556, he bought his Henley Street property from his landlord. Later, he acquired the western half and the two were knocked into one. He also acquired property in Greenhill Street. By 1572, he could lay out the considerable credit of £50 to a fellow glover from Banbury. The Henley Street property fronted a busy thoroughfare and its extensive premises housed domestic and trade employees. The long backyard was essential for white tanning, which preceded the making of soft leather gloves. The weathering of hides was prohibited near the town centre. The smell was too much even for that town of many aromas. At the end of the yard, a large barn overlooking the Guild Pits, where the townsfolk obtained their gravel, was built for that purpose.

Like most Elizabethan tradesmen, John Shakespeare speculated in commodities. In 1557, he brought an action against Henry Field, a tanner of Bridge Street, for the cost of eighteen quarters of barley, probably the product of the family holdings at Wilmcote. Malting was a major trade in Stratford, so probably the crop was destined for the mash-tun. John Shakespeare was also a considerable dealer in wool. In 1599, he sued John Walford, a clothier who was twice mayor of Marlborough, for a debt of £21, outstanding on a wool contract for 30 years. When the parlour floor of the Birthplace of Shakespeare was relaid in the Regency era, woollen remnants were found embedded in the foundations.

Henley Street was a thoroughfare of many trades. Other glovers and 'whittawers' resided there and must have used the water from the stream that ran across the street and into Merepool Lane for dampening skins. The Shakespeares' immediate neighbour was William Wedgwood, a tailor of dubious reputation who was expelled from his native Warwick, after behaviour so scandalous that it even attracted the attention of the mighty Earl in his castle. The *Black Book of Warwick* recorded that

> leaving his wief he went to Stratford and divers other places and there married another wief, his first wief yet living; besides that he is a man very contentious, prowde and slanderous, oft busieing himself with naughty matters and quarrelling with his honest neighbours, which condicions forcing him to leave the place of good government first went from hence and afterward was compellid to goo from Stratford.

In 1573, John Shakespeare witnessed a land sale between Wedgwood and his other neighbour, Richard Hornby, a blacksmith whose shop was also an alehouse. William Shakespeare sued Hornby's son for a debt in 1609. In *King John* there is an apparent memory of these childhood neighbours.

> I saw a smith stand with his hammer, thus,
> The while his iron did on anvil cool,

With open mouth swallowing a tailor's news,
Who with his shears and measure in his hand,
Standing on slippers, which his nimble haste,
Had falsely thrust on contrary feet.

Others in the street included Roger Green, a miller and alehouse keeper of doubtful credentials, who was fined for selling underweight candles and brewing 'unwholsum aell'. Alderman, George Whateley, bailiff in 1564, kept a woollen-draper's shop. From his profits he endowed a school in his native Henley-in-Arden. As a Catholic sympathiser, he did much to support his brother, Sir Robert Whateley, described in a recusancy survey of 1592 as 'an old massinge' [priest] whose wiles bewildered the authorities, 'resorting often thither, but hardley to be founde'. Whateley kept bees and had 'wax, honey and other things in the apple chamber'.

Infant mortality took a predictable toll on the growing Shakespeare family. The first child, Joan, did not survive, for another child was christened with the same name in 1569. A second daughter was christened Margaret in 1562. In the following year, John and Mary Shakespeare saw her lowered into the earth at Holy Trinity. The first son, William, was brought to church for baptism on 26 April 1564; another son, Gilbert, was born in 1566. and a daughter, Anne, in 1571. She died at the age of seven and 'Mr Shaxper' paid 8*d* for the funeral pall and bell. Richard was born in 1574 and there were perhaps more miscarriages and stillbirths before Mary Shakespeare bore her last child, Edmund, in 1580. Five of her children survived to adulthood. In the year that Edmund was born, the Chapel bell tolled twelve times for Stratford children.

England's greatest genius narrowly escaped a little winding sheet in the first weeks of his life. On 11 July 1564, Oliver Gunn, an apprentice weaver, died at premises (now the Garrick Inn) in the High Street. In the burial entry, the vicar, John Bretchgirdle, wrote the ominous words, '*Hic incepit pestis*'. The plague was carried into Warwickshire by soldiers returning from the Earl of Leicester's expedition against Le Havre. Before the year was out, 238 of the town's inhabitants had died, around one in eight of the population. It was by far the worst epidemic in Stratford's history. Mary Shakespeare may have fled back to Wilmcote with her baby. Her husband remained to attend the Corporation meeting on 30 August, held in the Guild garden, rather than in the stuffy atmosphere of the Hall.

In 1558, John Shakespeare was appointed one of the four borough constables, and thus encountered many of the social problems that bedevilled Tudor England. The Elizabethan era has passed into national consciousness as one of the most triumphant in English history, and the traumas of the age are often overlooked. Economic recession was frequent, partly engendered by seemingly interminable wars. Stratford's poor were always with their Corporation, and frequent levies were imposed on the capital burgesses for their relief. Rural depopulation caused a drift into the town, which became overburdened by the influx. The Corporation made regular appeals that outlying parishes should contribute towards the poor rates. It was ordered in 1558 that 'No inhabitant ... to harbour strange beggars who if refractory are to be punished with the stocks'. In 1559, Richard Mekyns was employed at 20*s* a year, 'so long as he shall do his duties in drivinge out of beggars and vacabondes out of the towne and also shall whyppe such persons as shall be commanded hym to whyp'.

There was little room at Stratford's metaphorical inn for abandoned pregnant women. Their offspring became a charge on the borough, and the Leet developed a regular obsession that 'no inhabitant of Stratford hereafter receive any woman to be brought to bed of a child in his or their houses' on pain of a fine. Edmund Barrett of the Crown in Fore Bridge Street was fined 20s around 1558 'for evell revel keepynge in hys hous and mayntaynenge and recevenge of a strumpet woman'.

As a constable, John Shakespeare shared Dogberry's duty to 'comprehend all vagram men'. To him would have fallen the arduous task of enforcing the resolution passed in 1557, after a riot at the September fair. 'No sengle man dwellynge in Stratford ... do weyre about hym wtin the burrowe or lybertyez of Stratford eny byll, sword, wood knyf or dagger, or anie such lyke wepon under payn of ferfeyture of the same and their bodies to prison, there to remain at the Bailey's pleasure'. In 1553, Thomas Holtam was arrested for drawing his dagger 'and making a fray' on Richard Harrington, one of the constables. In the next year, Thomas Powell of Shottery was fined 3s 4d for 'revelynge as well against othere the quenes magestyez'. To maintain order, the constables were supported by a robust team of Stratfordians who could be called upon to deal with troublemakers.

In a society with inadequate means of imprisonment, penalties for wrongdoing were sharp and exemplary and imprisonment was rare. The town lock-up was used to hold prisoners until they could be brought before the magistrates. Inmates paid a gaol fee of 4d. More affluent prisoners tried to buy special privileges, for it was decreed that the officers were not 'toe presume to extorte, exact or take anie more or greater fee of anie persoune or persons upon payne of imprisonment' – and a fine of 6s 8d. The unpleasantness of the gaol is revealed by an inmate, Nicholas Rogers, an alleged housebreaker, who petitioned the bailiff that he might stand trial at the quarter sessions, protesting his innocence and stating that he was 'all most fyned for want of food and no rement to hide [his] karkas', since he was 'laden with irones'.

An elaborate system of fines existed, and cruder punishments were available for persistent wrongdoers. The pillory was repaired at a cost of 6s 8d in 1567. Where much depended on the 'bubble reputation', slanderous talk was seriously regarded. A ducking stool for scolds deterred malicious gossips. In the Southampton Leet court in 1608, it was recorded that a woman charged with slander at Stratford had been ordered to leave the town. On failing to do so, she was 'set in a cadge', with a paper detailing her offence. Economic sanctions could be taken, as with a local publican. A Corporation minute of 1575 ordered 'upon grevous complaints made to the Bayliffe and Burgesses ... that no inhabitant ... shall sell ale to George Turner or hys wyf or servauntes, or to any of hys inmates, except yt be for the provision of themselves onlie'. Many such cases went before the peculiar court, under vicarial jurisdiction. Its function of trying offenders against sexual mores gave it the nickname of the 'bawdy court'.

In 1559 and 1561, John Shakespeare assessed fines at the Leet court, signifying assent with his mark of a glover's compass. This does not imply illiteracy. A fellow alderman, Adrian Quiney, also made a mark, although he could write a fair hand. Had John Shakespeare been illiterate, the burgesses would never have made him Chamberlain in 1561 and in the two years following – the only person to be honoured with such a consecutive burden. The two Chamberlains had charge of the municipal property and presented the annual accounts. John

Shakespeare also had a gift with figures. The Corporation called him in on two subsequent occasions to rescue lesser men from the ignominy of failing to produce a coherent account.

During John Shakespeare's time as Chamberlain in January 1564, he recorded in his accounts the payment of 2s 'for defasying ymages in ye Chappell'. This item, seemingly redolent of Protestant fervour, represents something of a mystery. In fact, the Stratford burgesses were somewhat late in complying with the governmental decree to destroy Catholic vestiges in places of worship, which had been issued four years before. The compliance appeared to have been half-hearted, perhaps judiciously so in anticipation of a potential official reversion to the Old Faith. The task was performed so inadequately with whitewash that the images were revealed again some 250 years later. In any case, it would appear that not all the paintings were obliterated since, in 1635, the vicar was accused by the Corporation of defacing them.

Whatever the reason for the entry, there can be no doubt that it was the start of a fitful process that saw the progressive eradication of much of Stratford's Catholic heritage. The stained glass was removed from the chapel in January 1571, and in September the Corporation agreed that the bailiff, Adrian Quiney, should sell the velvet and damask copes and other vestments in its possession. The ascendancy of the 'Word' was underlined when a sounding board was installed in the pulpit at the Guild Chapel in 1587.

The changes had the thoroughgoing support of at least one vicar in this era. A furious Puritan survey of 186 incumbents in Warwickshire, conducted in 1586, found all but 30 of them to be wanting. One who gained a satisfactory assessment was Richard Barton of Stratford, who was described as 'a precher, learned, zealous and godlie, and fit for the ministrie. A happie age yf or Church were fraight [supplied] with many such'.

The spirit of the old Guild was reflected in the new Corporation's orders. It was decreed that 'none of the aldermen nor none of the capital burgesses, neither in the council chamber nor elsewhere, do revile each other, but brotherlike live together'. Those who drafted the orders were cautious enough to add a pecuniary inducement to fraternal accord – those disruptive of harmony were to pay 6s 8d for every default. One such contentious type was alderman William Bott, a wealthy merchant of dubious character, who lived at New Place. His son-in-law said during a Star Chamber suit of 1564 that he had been 'openly detected of divers great and notorious crimes, as namely felony, adultery, whoredom, falsehood and forging'. 'Let every man beware of him', warned another witness, 'for he is counted the craftieste merchant in all our country … and it is said that if Botte had made his righte he had been hanged long ago.' Bott, who had been accused of fraudulent conversion and forgery, was expelled from the Corporation in 1565 after speaking evil words about his colleagues. 'Ther was', he declared, 'never an honest man of the Councell or the body of the corporacyon of Stratford'. John Shakespeare was elected as an alderman in his place.

Bott's *confrere* in duplicity was Sir Lodovick Greville of Milcote. Imperious, cruel and well-connected, he achieved the capital dispatch reckoned to be Bott's desert. He was no respecter of persons, assaulting his cousin, Sir John Conway of Luddington and threatening the mighty Earl of Leicester. When his son, Edward, shot an arrow in the air that killed his elder brother, his father jested about it, telling him 'it was the best arrow he ever shot'. Lodovick coveted the land of one of his tenants, Thomas Webb, who was strangled by two servants during a visit to Mount Greville. One of them, Thomas Brock, was placed in bed,

impersonating Webb, 'dolefully groaning' and making a will in Greville's favour before feigning death – a plot worthy of the revenge tragedies of the age. With the foul deed done, the horror escalated. Brock, 'in his cups at Stratford', let slip dark hints that he had it his power to hang his master, who had him killed by the other servant, Thomas Smith. Smith was arrested and confessed all. Both were tried at Warwick, where Greville refused to plead and stood mute. According to contemporary law, it was impossible to convict, although a course of torture to any extremity was permitted and Greville was pressed to death on 14 November 1589. His estates, which would have passed to the Crown if he had confessed, were bequeathed intact to his villainous son, Edward – a courageous end to a dishonourable career that had terrorised the region.

Others found themselves in conflict with the Corporation. Robert Perrott, a cantankerous old Puritan who kept the King's Hall Tavern in the Rother Market, was bailiff in 1558, but refused subsequently to serve on the Corporation. The maintenance of the oligarchic system depended on the cooperation of all men of means. Three members of the local gentry were called in to arbitrate and the quarrel was discussed by Sir Thomas Lucy, Clement Throckmorton and Sir Henry Goodere over wine and food at the Bear, which cost the Corporation the considerable sum of 37s 8d. The burgesses must have considered themselves amply compensated when the three gentlemen suggested that Perrott, of his 'free goodwill', pay £53 6s 8d that he owed in back fines and that all should 'henceforth be Lovers and ffrendes'. Unfortunately, Perrott's goodwill did not extend to paying this enormous sum. The Corporation tried to force his hand by electing him bailiff in 1567, but he declared he would never serve again. The choice fell on John Shakespeare, who had stood unsuccessfully the year before, perhaps indulging in the ploy of associating his name with the office. Alderman Perrott bore the council no lasting animosity, endowing an annual sermon to be preached at Holy Trinity at Whitsuntide on the day that the bailiff and burgesses beat the borough bounds. After such a strenuous exercise, he thoughtfully made provision for the Corporation to 'make merye withal after the sermon is ended'.

The Corporation's annual election was held on the Wednesday before the Feast of the Nativity of the Blessed Virgin (8 September). Afterwards, the Corporation retired to the home of the new bailiff to drink wine, so the household in Henley Street must have been the scene of bustling activity.

The Friday of the following week, the Corporation held its annual 'Buck Feast' at the Bear, at the bottom of Bridge Street, or at the Swan opposite. The Bear was a substantial hostelry employing fourteen servants. It was kept by the formidable Thomas Barber, who was thrice bailiff. The feast was a substantial affair, in which the Corporation and its wives entertained local dignitaries like Sir Thomas Lucy and Sir Fulke Greville.

An account from nearby Banbury instructs that the bailiff was to be 'a lanthorn in good usage, and order as well to all the rest of his brethren as to the whole commonality'. He was to 'wel and decently behave himself in all degrees and indifferently and rightly judge and deal with all men ... according to the right of the cause and so likewise shall be comely attired in apparel.' When he was occasioned 'to go into the said town or the perambulation of the same whether on Fair days, market days or any other times and about the execution of his office, or together with his brethren touching any affairs or business of the said borough, he shall have

the Sergeant-at-Mace to be attendant upon him'. From 15 December until twenty days after Christmas, he was obliged to hang a lanthorn outside his door 'to give light in the streets'.

The Corporation surveyed its property on the Friday after Easter. The bailiff and chief alderman enjoyed the produce of the Corporation's garden, except for the offal wood, trees branches and broughes dead, withered, fallen, cutt downe or playned', which were burned on the fire at Corporation meetings.

Companies of actors are first recorded in Stratford during John Shakespeare's bailiwick. In the summer of 1569, no less a troupe than the Queen's Players was paid 9*s* for playing in the Guild Hall. Later that year, the Earl of Worcester's Men gave less satisfaction and were paid a mere shilling. It is appropriate that John Shakespeare emerges as Stratford's first-known theatrical patron, although he could not have realised the destiny of his eldest son, then aged five. Many years later, Robert Willis of Gloucester, born in the same year as William Shakespeare, wrote an account that reveals what must have happened in Stratford:

> When players of interludes come to town they first attend the mayor to inform him what nobleman's servants they are and so get a license for their public playing and if the mayor likes the actors or would show respect to their Lord and master, he appoints them to play their first play before himself and the Aldermen and common council and that is called 'The Mayor's Play' where everyone that will goes in without money, the mayor giving the players a reward as he thinks fit to show respect unto them. At such a play my father took me with him and made me sit between his legs, as he sat on one of the benches, where we saw and heard very well. The play was called 'The Cradle of Security'. The sight of it made such an impression on me that when I came to man's estate it was as fresh in my memory as if I had seen it newly acted.

As a senior alderman, John Shakespeare enjoyed the trust of his colleagues. In 1571, the Corporation resolved that Adrian Quiney and he, should 'at Hilary Term next deal in the affairs of the borough according to their discretions' and advanced him £6 to journey to London. The business was probably connected with delicate negotiations about the rights of the town. A similar trip was made by Thomas Barber and John Jefferies, the town clerk, in 1590. Leaving Stratford on 15 May, they spent 3*s* on that night's lodging, inclusive of supper and fodder for their horses. At High Wycombe the next night, the charge was 2*s* 1*d*, but at Uxbridge, they were within the inflationary radius of the capital and paid 44*d*. A fee of 20*s* was paid to a counsel, but either matter took a long time to resolve or they were enjoying the delights of the metropolis, for they were still there nine days later when they hired a boat for 8*d* and went down the Thames to Greenwich. Perhaps they were seeking the support of someone with influence at court. If so, their mission was either one of immediate success or failure for they returned rapidly to Stratford, this time staying at Aylesbury and Banbury.

A meeting nearer home took place on 4 January 1574/75 when the civic fathers conferred with their fellows of Warwick about the terms of a legacy from Thomas Oken to the poor of Stratford. They were 'well recevid', but the Stratfordians were not happy about certain restrictive clauses. Adrian Quiney declared that the conditions could be considered a slight on their integrity. The men of Warwick were annoyed. This was the first they had heard of any criticism. In any case, the conditions were not theirs, but the giver's. 'It was told to them

plainly that unles they did yeld both to the covenants & bond they should receive no money.' The Bailiff of Warwick chose his words judiciously:

> Though it be true that they be men known of good credit, honest behavior, upright dealing & such as upon their credits might be trustid in as great a matter as this... they be but men and therefore must dye ... It is not to be taken amysse that some matter be devised in writing to tye their posterytie & successors for the performance of the covenants being bothe reasonable and easy to be performid by carefull and good men whose travailes in that case being also but easy shall greatly benefyt their poore neighbors whereunto we are all bound.

The bailiff's eloquence appeased the Stratfordians. An agreement was made 'and they of Stretforde sent mery homewards'.

Stratford was fortunate in Elizabeth's reign in having public servants of high calibre. The pride in civic achievement and sound dealing is expressed in the charming epitaph in Holy Trinity of Alderman Richard Hill, who died in 1590:

> Heare borne heare lived heare died and buried heare
> Lieth Richard Hill thrise Bailiff of the Burrow
> Too matrons of good fame he married in Godes feare
> And now releast in ioi [joy] he reasts from wordlie sorrow
> A woolen draper beeing in his time
> Whose virtues live whose fame doth flourish still
> Though he disolved be to dust and lime
> A mirror he and paterne mai be made
> For such as shall succeed him in that Trade
> He did not use to sweare to glose gather faigue
> His brother to defraude in Bargaininge
> He would not strive to get excessive gaine
> In ani cloath or other kinde of tinge.
> His servant I this trueth doth testifie
> A witness that behold it with eie.

3

'Thou smilest and art still'

We ask and ask: thou smilest and art still, Out-topping knowledge.

Matthew Arnold

The frustration of delineating William Shakespeare's life is epitomised in Arnold's sonnet. Yet we know more of him than any other Elizabethan dramatist. Many of his fellows are little more than names on a playbill. Ben Jonson recorded assiduously the details of his craft, but little of his early life is known – not even the name of the woman he married, despite describing her as 'a shrew, but honest'.

By contrast, every major aspect of Shakespeare's life can be traced, but much of the information reads like programme notes, recording the author's dealings and endeavours, but telling little of his personality. Behind the stodgy, satisfied face of the bust in Holy Trinity, or the lugubrious eyes of the engraving in the First Folio, there existed the remarkable being who wrote the plays and poems. It is like finding the skeleton of a magnificent creature on a deserted beach. We can discern the bare bones, but the vital flesh that could tell us how it moved, breathed and had its being is missing. Apart from some contemporary and historical gossip, the main source of information is his works, but to construct the life and feelings of any author, particularly one of such complexity, from the internal evidence of his writings, is hazardous. Yet Stratford-upon-Avon must have contributed greatly to the formative years of the child who was father to the man Shakespeare.

His father's civic status ensured William a place at the free school over the Guildhall, which had a tendency to overflow into the chapel, necessitating occasional strictures from the Corporation to return whence it belonged. No records survive of The King's New School in this period, but its curriculum must have been as unvaried as that of other Elizabethan grammar schools. Education began at five years old. Learning was a mechanical pattern of repetition and the schoolroom echoed to chanting from the 'Absey' or ABC book, whose loss, an early play informs us, could cause a schoolboy to sigh.

'They must reade English before they can learne Latin' was the injunction of one school benefactor, and the young William's earliest literary efforts would have consisted of letters copied into a horn book. These first essays in learning would have taken place under the instruction of an under-master or his wife. The vicar, John Bretchgirdle, bequeathed in 1564, 'to the common use of the scholars of the free schole', a copy of Thomas Ellyot's Latin dictionary. If the book survived the ravages of schoolboy usage, it would have been used by the young Shakespeare. Rhetorical methods were used, hopefully not as incompetently as by Sir Hugh Evans: 'What is he, William, that doth lend articles?' 'Articles are borrowed of the pronoun and be thus declined: *singulariter, nominativo, hic, haec, hoc.*'

Sir Hugh is alluding to the prescribed exercises in William Lily's *Rudimenta Grammatices*: the obligatory means of instruction in the contemporary education system. Like all other grammar school boys, William Shakespeare would have been familiar with it. 'The relatiue agreeth with his antecedent in gendre, numbre and persone', instructed Lily, 'as *Vir sapit, qui pauca loquitor*, That manne is wyse, that speaketh fewe.' This very Latin adage is quoted by Holofernes, the pedantic schoolmaster, in *Love's Labour's Lost*.

Stratford School was an academy of distinction whose masters were men of standing, paid comparably to their fellows at Eton. William Shakespeare was too young to benefit from the learning of John Brownsward, a prominent poet in the 'Latin Empire', who left Stratford in 1567. He must have been taught by Thomas Jenkins, who arrived in 1575, and whom some have identified as the model for the Welsh schoolmaster, Sir Hugh Evans. The common Welshness does not extend beyond their surnames. Jenkins was a Londoner, educated at St John's College, Oxford. When he left Stratford in 1579, he found his own replacement in an Oxford colleague, John Cottam, who paid £6 commission to the canny Jenkins.

The most interesting of Shakespeare's likely schoolmasters was Simon Hunt, who came to the little academy in 1571. It was probably this Hunt who joined the Jesuits at Douai in 1575, although a namesake died at Stratford before 1598. He became English confessor at St Peter's, Rome, dying there in 1585. In the previous year, a request to send him into the dangerous rigours of the English mission was refused because 'Father Simon lacks sufficient learning'. Is this the source of the 'smalle Latin and less Greek' that Ben Jonson ascribed to his friend? The standard of comparison was high. Ben was tutored at Westminster by the great schoolmaster, Camden, while Hunt is being assessed as a Jesuit. Aubrey was probably nearer the mark when he said that Shakespeare 'understood Latine pretty well'. The works demonstrate classical knowledge. Two-thirds of Shakespeare's classical allusions are from his favourite book, Ovid's *Metamorphoses*. 'As the soul of Euphorbies', eulogised Francis Meres in 1598, 'was thought to live in Pythagoras, so the sweet witty soul of Ovid lives in the mellifluous and honey-tongued Shakespeare.' The fluent Latin of Stratford schoolboys is demonstrated in a letter from Richard Quiney, aged eleven, to his father and namesake, the bailiff, who was about the borough's business in London. 'I give you thanks that from the tenderest age… you have instructed me in studies of sacred doctrine, nothing could be further from my mind than mere adulation, for not one of my friends is dearer and more loving towards me than you are and I pray sincerely that my special love may remain as it is.'

It is likely that William Shakespeare's first exercises in acting would have occurred at school. There are records of plays being performed at St Paul's, Merchant Taylors, Eton and Westminster schools and it is likely that the same would have happened at Stratford. One of Shakespeare's earliest plays, *The Comedy of Errors*, is based on Plautus' *The Menaechmi*. Since no English translation appeared until 1595, it may be surmised that this was a Latin play in which William appeared while at school.

Whatever debts William Shakespeare owed to the memory of his early years, he recalled his schooldays with the lack of enthusiasm of his 'whining schoolboy, with his satchel / And shining morning face, creeping like snail / Unwillingly to school'. 'Love goes towards love', Romeo tells Juliet, 'as schoolboys from their books, But love from love, towards school with heavy looks.' Shakespeare's schoolboy eagerly awaits the moment when school breaks up and 'each hurries to his home and sporting place', or his mind wanders beyond the school door

to playing with tops, push pin, 'hide fox and all after', pursuing summer butterflies, birds-nesting, or wantonly killing flies for sport.

The Shakespeares may have travelled to see the festivities at Kenilworth in 1575 when Robert Dudley entertained the Queen to a fourteen-day extravaganza. During a water pageant on the mere below the castle walls, a huge mechanical dolphin propelled by fin-shaped oars, containing musicians and bearing the figure of Arion, singing 'a delectable ditty', skimmed across the water. 'Once I sat upon a promontory', recalls Puck. 'And heard a mermaid on a dolphin's back / Uttering such dulcet and harmonious breath / That the rude sea grew civil at her song.' Some of the cost of this progress fell on the Stratford Chamberlains, who contributed 16*s* to the 'Quenes Carryage'.

Hard Times

John Shakespeare ran into financial difficulties soon after purchasing property in Stratford in 1575. Previously a regular attendee at meetings of the Corporation, his presence is recorded only once after 1576. In 1578, he raised a loan from his brother-in-law, Edmund Lambert, offering part of his wife's inheritance, a house and 56 acres of land as surety. On the same day, alderman Roger Sadler, a High Street baker, made his will and recorded debts owed to him by John Shakespeare and Richard Hathaway, father of William's future bride. More of Mary Shakespeare's dowry was lost in 1579 when her share in two houses and 100 acres at Snitterfield was sold to her nephew for £10. The need was for ready cash to offset current debts. Impecuniosity was the likely cause of a petition by John Shakespeare to the court of the Queen's Bench in 1582, for sureties of the peace against Ralph Caudrey, Thomas Logginge and Robert Young, 'for fear of death and mutilation of his limbs'. The exaggerated phrase suggests that Alderman George Caudrey, a volatile and violent man, was not a sympathetic creditor. The matter was resolved by 5 November when both men attended the election of a new bailiff.

These difficulties confirm Nicholas Rowe's assertion that in 1709, John Shakespeare's need for William's assistance at home forced his withdrawal from school. The poet shows familiarity with the techniques of glove-making, such as stretching 'a bit of chervil ... from an inch narrow to an ell broad'. Doubtless he accompanied his father on wool-purchasing journeys through the 'high wild hills and rough uneven ways' of the Cotwolds. Two plays, *The Taming of the Shrew* and *Henry IV, Part One*, show an intimate knowledge of the region.

John Shakespeare's precarious financial position was understood by the Commissioners for recusancy in Warwickshire, who investigated those recalcitrant in church attendance. His name appears in March 1592 among a group of nine, considered to 'absent themselves for feare of processes'. Church services provided an opportunity to serve writs and William Burbage was trying to recover £7 owed from a decade before, obtaining an order for payment in the following month.

The suggestion that the list of debtors was part of an elaborate plot to protect John Shakespeare from the rigours of the laws against recusancy is unlikely. The nine were all in bad financial shape. The intriguingly-named William Fluellen and George Bardell (or Bardolf) left widows to the care of the parish. William Baynton fled to Ireland to escape his creditors. John Wheeler had his goods distrained and his son's barn was 'readi to fall for rottenness' in 1599. These were hard times in Stratford. Some 700 people, around a third of the population, were on the poor

roll. The vital wool trade had been hit hard when the Spaniards sacked Antwerp in 1576, the year in which John Shakespeare's difficulties were first manifest. His troubles look less severe in this context. Although property was mortgaged, the house in Henley Street remained. Even in his most pressing moments, he could still stand credit for others, although his judgement was not always good. In 1586, he stood bail at Coventry for Michael Pryce, a local tinker charged with a felony. The money was forfeited when the defendant failed to appear. A month earlier, he had guaranteed the debts of his unreliable farmer brother. When Henry Shakespeare defaulted, John only escaped jail through the intervention of the good alderman, Richard Hill.

Where there were militant recusants locally, the Commissioners named them, including the influential William Clopton; Mrs Frances Jeffreys, wife of the Town Clerk; Joan, wife of Alderman George Caudrey and their son, George, suspected to be 'a semynerie preeste or Jesuite'; Edward Bromley, the town carrier and William Underhill of New Place.

Several of the Catholics, regarding a peaceful existence to be worth a litany, paid lip service to conformity and attended services. In September, the Commissioners produced a second report, naming those who had conformed and lising 'sutch dangerous and seditious Papistes and Recusantes as have bene presented to us or found out by our endeavoire to (have) bene att any tyme heretofore of or in this countye … and (are) now either beyonde the seas or vagrante within this Realme'. Among them was George Caudrey, the younger.

One name on the roll was that of Richard Dibdale of Shottery, 'who hath not bene at church this yere'. His brother Robert trained for the Catholic priesthood at the Douai seminary and sent a letter from there to his family. The bearer was Thomas Cottam, a priest from Lancashire, whose brother John was appointed Stratford schoolmaster in 1579. In the letter, Dibdale told his 'right wellbeloved parents' that the 'cause of my wryting unto you ys to lett you understand that I am in healthe, commending unto you my especiall ffriend Mr Cottame, who hath bene unto me the t[w]o halfe of my life'. Neither the letter nor some small gifts were delivered. Cottam was arrested at Dover in June, 1580 and was ferociously tortured, before being hanged, drawn and quartered at Tyburn, shouting 'God bless you all' to the onlookers.

Undaunted by his friend's arrest, Robert Dibdale followed him into the hazards of the English province. He was arrested and imprisoned, but did not suffer the torture faced with such valour by many of his fellows. On 3 November 1580, William Greenway, the carrier from Bridge Street, brought a letter, a loaf, two cheeses and 5s from Dibdale's father to Newgate Prison. The prisoner was released on 30 September 1582 and fled back to France, but soon returned, establishing a reputation as an exorcist, casting out devils from a servant-girl in Hertfordshire shortly before his recapture. This time, he did not escape the fate of his friend and 'with constancy suffered martyrdom' at Tyburn on 8 October 1586.

The systematic harassment of his co-religionists produced an intense depression in a local Catholic, John Somerville of Enstone Hall, son-in-law of Edward Arden of Park Hall. On 25 October 1583, despair triumphed over reason in his troubled mind and he set off for London, announcing 'I will go up to the court and shoot the Queen with a pistol'. He was arrested near Banbury. His crazed imagination provided an opportunity to settle old scores. Sir Thomas Lucy of Charlecote, whose sympathies were entirely with the new age, arrested Edward Arden and his wife on the order of the Privy Council. Margaret Arden was spared, but her husband, a former High Sheriff of Warwickshire, was hanged, drawn and quartered. As was the custom, his

head was placed on a spike on London Bridge and perhaps gave ghoulish greeting to his young kinsman, William Shakespeare, on his arrival in London. John Somerville, who precipitated this tragedy, was found strangled in his cell. Perhaps the authorities felt that the public execution of this deranged man would reveal the sparsity of the case against Arden.

Sir Thomas Lucy prosecuted his campaign with vigour and enthusiasm. With the assiduous assistance of Thomas Wilkes, Clerk to the Privy Council, he searched a number of houses in the district with little success. Since no plot existed, there was little to find. Wilkes wrote to London in evident frustration: 'Unless you can make Somerville, Arden, Hall the priest, Somerville's wife and his sister speak directly to these things which you have discovered, it will not be possible for us here to find out more than is to be found out already, for the papists in this country greatly do work upon the advantage of clearing their houses of all shows of suspicion.'

One who apparently so acted was John Shakespeare. In 1757, an extraordinary testament – six leaves of aged parchment stitched together – was discovered in the eaves of the Birthplace by workmen employed by Thomas Hart, his sixth-generation descendent. It passed to John Payton, owner of the nearby White Lion Inn. When the scholar, Edmund Malone, heard of it in 1785, he borrowed it. By then the first sheet was lost, but John Jordan, a local wheelwright, obligingly forged a replacement. Fortunately, Malone made a copy of the manuscript, for it was subsequently lost, probably by the great critic himself. He later expressed doubts about its authenticity, but in 1966 it was exonerated when one almost identical in format was discovered.

The document is an English translation of a triumphant affirmation of the Catholic faith written by Carlo Borromeo, Archbishop of Milan.

> I John Shakespeare do protest that I will pass out of this life armed with the last sacrament of Extreme Unction, the which, if through any let or hindrance I should not be able to have, I do also for that time demand and crave the same, beseeching his Divine Majesty that He will be pleased to anoint my senses both internal and external with the sacred oil of his infinite mercy...

The 'glorious and ever Virgin Mary' and John Shakespeare's 'patroness', St Winifred (perhaps he was born on 3 November, her feast day), are invoked to intercede for him.

The testaments were brought into England with the illicit Jesuit mission of 1580, led by Edmund Campion and Robert Persons. In the following year, William Allen, head of the English College at Rheims, told Rome that 'Father Robert wants three or four thousand more of the testaments'. This shortage necessitated the painstaking business of copying the limited supply, with the supplicant entering his name on a standardised text. Both Campion and Persons were in the Midlands during 1580. 'I ride about some piece of country every day', wrote Campion. 'On horseback I meditate my sermon. When I come to the house, I polish it. Then I talk with such as come to speak with me, or hear their confessions. In the morning after Mass, I preach. They hear with exceeding greediness and very often receive the sacrament.'

In 1581, Sir William Catesby, a former high sheriff, was imprisoned for refusing to say whether Campion had stayed with him at Bushwood House, an outlying enclave of the Stratford parish, although 12 miles away at Lapworth. Perhaps John Shakespeare encountered the doomed priest, whom Elizabeth's minister, Lord Burghley had described in happier times as 'one of the diamonds of England'.

It could have been sympathy with the old faith that caused John Shakespeare to be bound over for failing to keep the peace by the court of the Queen's Bench in June, 1580. He was fined £20 for failing to appear and £20 for not bringing John Audley, a Nottingham hatmaker, into court. On the same day Audley was fined £70, that included £20 for not bringing John Shakespeare. Thomas Codey, a yeoman of Stoke-on-Trent, was fined £30, £10 as surety for John Shakespeare, while two Worcestershire farmers were each fined £10 as sureties for Audley and Codey. One hundred and forty people from all over England were dealt with in a similar way. Perhaps the authorities were reacting to the known presence of the Jesuit mission. Certainly, this would explain the link between such geographically disparate persons.

The Shakespeares may have been church papists, conforming outwardly and nursing their sympathies until the spirit of the age might change. The authorities could be surprisingly tolerant. It was even lately proposed to certain noblemen to come', wrote Father Persons, 'if it were only once a year, to church, making if they pleased a previous protestation that they come not to approve of their religion or doctrine, but only to show outward obedience to the Queen…' At Warwick it was noted that there were those 'who come to church, but not to communion at all'. Like most Englishmen in his position, John Shakespeare sought to minimise trouble. A similar attitude was taken by his fellow councillors. In this era, the Corporation was a meeting-place of differing shades of religious adherence. Friction came through personality rather than doctrine, as with Nicholas Barnhurst of Sheep Street. In 1596, he was warned for calling George Badger a 'knave and rascal', and in 1599 he was expelled for 'his great abuse offered to the whole company'.

That his fellow burgesses maintained John Shakespeare's name on their roll through his years of trouble indicates their esteem and belief in his recovery. Had they vindictively desired to persecute him they could have done so, for fines for non-attendance were high. Instead, they lightened his burden by lowering his tax assessments, a considerable gesture in an oligarchic structure where much of the financial burden fell on themselves. Finally, in 1586, the councillors replaced John Shakespeare and another impecunious alderman, adding the sad note that 'Mr Wheeler dothe desyre to be put out of the Companye and Mr Shakespeare dothe not come to the halles when they be warned nor hathe done of a longe tyme'. If they had decided after the longest period of non-attendance ever permitted, that the Shakespeare fortunes were irretrievable, they were wrong. The lost wealth was amply restored by William Shakespeare in the next decade. It was, however, not the function of a town council to assess the potential of literary genius.

To Have and to Hold

To agree with Sir Hugh Evans, 'it were a goot notion to leave our pribbles and prabbles and desire a marriage.' 27 November 1582 is the first date after William Shakespeare's baptism that can be recorded with certainty. On that day, the diocesan clerk in Worcester noted an application for a marriage licence *'inter Willelmum Shaxpere et Annam Whateley de Temple Grafton'* to secure the right to marry during the prohibited period between 2 December and 13 January. The complexity increased next day. William was joined by two men of Shottery, Fulke Sandells and John Richardson, who guaranteed a bond of £40 for the marriage of 'William Shagspere and Anne Hathaway of Stratford'.

Did William leave Anne Whateley standing at the altar? Some have thought so. The double marriage entry, William's youth (he was eighteen) and the size of the bond, imply strange goings-on. Frank Harris has suggested that Shakespeare was enamoured of the lass from Temple Graftron and intended to do the right thing by her. Meanwhile, he dabbled with Anne Hathaway and the bun was in the proverbial oven. In a bold move, he fled to Worcester to make Mistress Whateley his own, only to be thwarted by the burley husbandmen from Shottery, friends of the wronged woman's deceased father, who pledged the Bard to the shrewish Anne, who was seven years his senior. He endured her until he could stand it no longer and fled to London. Thus Anne Whateley's loss is our gain. Had he settled in solid, rural, connubial bliss, this literary genius would have flowered, unseen in a Warwickshire village.

Although Whateleys are not uncommon in South Warwickshire, no one of that name was recorded in Temple Grafton, a village 5 miles west of Stratford. William's other Anne probably never existed. Bishop Whitgift's strict ecclesiastical regime at Worcester would not have connived in youthful philandering and duplicity. The clerk must have made an error in his first entry, as he did in the same year when he wrote down the same person as 'Bradley' in one entry and 'Darby' in another. William Whateley, vicar of Crowle, had been in the consistory court that day in a wrangle over tithes. Perhaps he distracted the clerk as he was dealing with the young man from Stratford.

Still, there was plenty on William's mind as he rode out that day. Anne Hathaway was three months pregnant – a fact open to many interpretations but only one cause. Had the young man seduced the older woman during the Warwickshire summer? Opportunity for such consummation was not lacking among the woods and fields of Arden.

> Between the acres of the rye...
> With a hey and a ho and a hey nonino,
> These pretty country folk would lie...

Spinster Anne, eldest sister in a large family from her father's two marriages, might have been carried away by the young man whom John Aubrey heard was 'handsome' and 'well shap'd'. 'I would that there were no age twixt ten and twenty or that youth would sleep out the rest', observed the shepherd in *A Winter's Tale*, '...there is nothing in between but getting wenches with child, wronging the ancientry, stealing and fighting.' Yet the boot, to use an inappropriate metaphor, may have been on the other foot. James Joyce's Stephen Dedalus certainly thought so.

> ...He was chosen, it seems to me. If others have their will, Ann hath a way. By cock, she was to blame. She putteth the comether on him, sweet and twentysix. The grey-eyed goddess who bends over the boy Adonis, stooping to conquer, as prelude to the swelling act, is a bold-faced Stratford wench who tumbles in a cornfield a lover younger than herself.

Marriage and courtship customs vary according to society and age. In rural communities, couples have jumped the broomstick, considering the approbation of God and their neighbours to be sufficient. Shakespeare's aunt, Agnes Arden, was recorded as the wife of Thomas Stringer, several months before their marriage. There is a record of a couple from a nearby village exchanging vows before witnesses. 'I do confess that I am your wife and have forsaken all my friends for your sake and

I hope you will use me well.' Some went too far. A rascally carpenter, William Slatter, confessed that he 'married himself in his chamber, nobody else being by and hopeth that marriage be lawful'. He hoped vainly. His homespun liturgy was declared invalid and he underwent a church ceremony.

Common-law marriage possessed some legal standing, but children from such liaisons were barred from inheritance. Extraordinary relations were not smiled upon in the Stratford peculiar. In 1584, Harvey Fylde and Harry Russel were presented before the bawdy court for not living with their wives, and William Shepherd was accused of cohabiting with Elinor Philips while reported to have a wife. An undated entry upbraids Mr Holder, the curate at Bishopton, 'for marrying wandering persons without license or banes asking'. If William and Anne were regarded as sexual transgressors, they would have been summoned to the court, but the records for the period are lost.

The absence of John Shakespeare's name from the marriage bond does not indicate disapproval. The document would not have been issued without a declaration of parental consent. The marriage could have been a means to alleviate the monetary difficulties of the Shakespeares, the legal prose of the license masking a financial arrangement. Contracted marriages were the norm. They abound in Shakespeare's plays and the poet helped to organise a match between the daughter and the apprentice of his landlord in Cripplegate in 1604. Eight years later, 'William Shakespeare of Stratford-upon-Avon, gentleman', gave evidence on a dispute about the marriage settlement. The Stratford records contain a number of similar suits. In 1591, Henry Wagstaffe was 'attached to answer Charles Wheeler for a breach of an undertaking to give the plaintiff on his marriage with Rose Caudrey, daughter of Joan Caudrey, widow, ten bushels of rye and ten of barley, which defendant had promised the said Rose, being his kinswoman'. William Slatter claimed that George Croftes had promised him money 'whenever he should celebrate a marriage with his daughter Anne...'

The marriage of an eligible daughter against her father's wishes could cause fury. In the year of The Spanish Armada, Shakespeare's friend Richard Tyler married Susanna, eldest daughter of Richard Woodward of Shottery Manor. The bride's cantankerous old grandfather, Robert Perrott, cut her out of his will and added stern warnings to her sisters against her example. Nevertheless, the young bridegroom prospered, becoming an alderman and a churchwarden. A Corporation submission of 1612 described him as a 'man of honest conversacion and quiet and peaceable carryage amongst his neighbours and towards all people.'

The Hathaways were a family of local standing, with their prosperity seen in their considerable farmhouse. John Hathaway, an archer, probably Anne's grandfather, appeared on the muster of 1536 and later became a town constable. Anne's brother, Bartholomew, was twice churchwarden and his son, Richard, became bailiff in 1626. Anne's father left holdings of over 120 acres in 1581. To his daughter, 'Agnes' (the name was interchangeable with Anne, the 'g' being silent in the French fashion), he left 10 marks for a dowry and expressed the hope that his chief heir Bartholomew would be 'a comforte unto his Bretherene and Sisters to his powers'. Fraternal largesse was expected. With the death of her father and the growth to maturity of his many children, Anne's domestic services were less essential. It was important to find her a husband.

The links between the families endured as long as William's descent. His granddaughter left bequests to the five daughters of 'my kinsman Thomas Hathaway late of Stratford', four of whom bore the Shakespearean family names of Judith, Joan, Elizabeth and Susanna.

Anne was probably not living at home when she married. Temple Grafton is the parish mentioned in the clerk's first marriage entry and it is there that she may have been living. The vicar was Sir John Frith, an old Romish priest, who received a poor assessment in the acerbic Puritan survey of 1586, which described him with inadvertent charm as 'unsound in religion, he can neither preach nor read well; his chiefest trade is to cure hawks that are hurt or diseased for which purpose many do usually repair to him'.

If parson Frith was too busy with his hawks to do the honours, the couple need not have married in church at all. The special license enabled a valid ceremony to be conducted anywhere. One Thomas Gardner was married in the alehouse at Haselor by 'Sir Roger of Preston [-on-Stour].' Some Catholics obtained the license to give a private ceremony with secular standing, and William could likewise have been married by the old rite. The unusually large surety demanded as part of the grant of the license is explicable if it were the rite that worried the authorities.

The awaited child was christened Susanna on 26 May 1583. Twins followed. Hamnet and Judith were baptised on 2 February 1584/85. The godparents were evidently the Sadlers, a young couple who kept a baker's shop on the corner of the High Street and named a son William in 1597. Hamnet Sadler travelled frequently on business as far afield as East Anglia. He was a loved and potent husband, his neighbour, Abraham Sturley noting that 'Judith Sadler waxeth very heavy for the burden of her childing and also of the want of her husband.'

There were no more children for Anne. This could imply estrangement, but the women of her line were not distinguished by their fecundity. Perhaps there were complications undefined by Elizabethan medicine.

Whither William?

The lack of information about the seven years after the birth of the twins has enabled his biographers to wander freely. Some have noted his extensive use of legal terminology and articled him to a lawyer. The Elizabethans were keen litigants, although the Shakespeares indulged less than most. William Shakespeare, like a number of notable writers, does not appear to hold lawyers in great esteem. If he were so engaged, he did not find the experience edifying. Further speculation has put him in the military. Many Elizabethans had such an experience, if only through the type of muster organised by Falstaff. 'Care I for the limb, the hewes, the stature, bulk and big assemblage of a man? Give me the spirit Master Shallow.'

William Shakespeare's name is not among those summoned for duty during the Armada year of 1588. On 4 August, the gentlemen of Warwickshire sent their levies to the great Army assembled at Tilbury. At Stratford, the town armoury was replenished and a little band of eight recruits was sent to war. They marched off and spent some time at Warwick, where they were probably awaiting further orders. When they reached Banbury they must have heard of the Spanish fleet's dispersion for they returned to Stratford. The Chamberlains' accounts reveal the cost of this heroic action:

pd. for the soldiers coats	£8
pd. for their conduct money [travelling expenses]	4s

pd. for the entrance of their names in the captaynes rowle [the Queen's sixpence]	4s
Ther charges att Warwick	18.8d
fridaie saturdaie and sondaie morninge – ther charges	24.6d
pd. Wyll Baynton & Ryc Tyler for ther swordes and daggers	15.6d
pd. for girdles	4.6d
pd. for mending iii flaskes	6d
pd. for mendinge Robert Smythes peece [musket]	6d
for xvijli of matche [matchlock muskets]	14s
for vjli of gunpowder	9s
for carryadge of the armor to Warw	2.4d
pd. for fetchinge home a post horse from banburye	3.6d
pd. to dawkes his son for being guyde to the poste [horse]	12d
pd. to Mr alderman for a Jacke [coat of mail, with overlapping plates],	
a byll [sort of pike] & a scull [metal skull cap] to go with the cart	10s
Ther rest unpaid of the ceasures [levies] made in the wardes as per the	
Bill brought in	10.4d
pd. for flaske lethers	4s
£24 gathered £ to be gathered	

For William Baynton, one of the levy, Stratford was not to be a town fit for heroes to live in. By 1592, he had run into such debts that his name figures, with John Shakespeare's, among those who did not attend church for fear of process.

The storms that swept aside the Armada had their effects on the Avon. The floods were so high that when three men crossing Clopton Bridge reached the middle, 'they could not go forward and then returning presently, could not get back, for the water was so risen; it rose a yard every hour from eight to four...'

The most likely occupation of Shakespeare's youth is revealed by John Aubrey's assertion that he was 'in his younger yeares a schoolmaster in the country'. This statement must have some credence. Aubrey's source was the actor, Christopher Beeston, whose father was a member of Shakespeare's company. Perhaps like Simon Foreman, the astrologer, he was an under-master in a grammar school, or, like John Donne, a tutor in a noble family which provided 'a kind of liberal profession for men of good parts and gentle, but not distinguished birth'.

Most of the leading actors' companies passed through Stratford during Shakespeare's youth. The golden year was 1587 when five companies performed there, including the celebrated Queen's Players who received the highest fee ever paid. Such was the crush to see these famous actors that a bench was broken. The Stratfordians were not always spectators. In 1583, 13s 4d was paid to Davi Jones and companye for his pastyme at Whitsontyde'. David Jones was a sadler whose second wife was a cousin of Anne Hathaway. Did William Shakespeare, then aged nineteen, take part in this performance at the Corporation's annual feast? That his daughter Susanna was born in the same month makes it likely that he was in Stratford:

 at Pentecost,
 When all our pageants of delight were played,

> Our youth got me to play the woman's part,
> And I was trimmed in Madam Julia's gown;
> Which served me as fit, by all men's judgements,
> …I did play a lamentable part,
> Madam, 'twas Ariadne passioning
> For Theseus' perjury and unjust flight;
> Which I so acted with my tears,
> That my poor mistress, moved there withal
> Wept bitterly.

Aubrey gives a further hint of the poet's youthful dramatic activity. After the dubious information that young William was apprenticed to a butcher, he adds that when he killed a calf, 'he would doe it in high style and make a speech'. This curious story gains credence with the knowledge that 'killing the calfe' was a popular charade, played behind a door or curtain, in which the performer acted both the butcher and the animal.

Was William so overwhelmed by the romance of the players that he joined one of the visiting companies? Professor Mark Eccles has discovered that the Queen's Men were two actors short when they arrived at Stratford in 1587, for William Knell was killed by John Towne during a brawl at Thame. Since Towne had struck in self-defence, he was later pardoned, but, in the meantime, had his place been taken by a young man of theatrical enthusiasm from Stratford?

Whatever else William Shakespeare was doing during those lost years, he was certainly maturing his poetic skills. The fortuitous combination of environment, epoch and genius would have ensured an early blossoming of talent. In 1587, Anthony Underhill was buried in Ettington church. His family knew Shakespeare and his valedictory verses have been preserved.

> As dreams do slide and bubbles rise and fall
> As flowers do fade and flourish in an hower,
> As smoke doth rise and vapours rain shall pour
> Beyond the witt or reach of human power,
> As somers heat doth perish in the grass
> Such is our stay, so lyfe of man doth pass.

If poetry of such quality was not written by the young Shakespeare, it is clear that Warwickshire was fertile in the potential to produce a great poet.

London Road

If the most colourful legend of Shakespeare's youth is credited, his departure from Stratford was precipitate. At the end of the seventeenth century, a story emerged that he fled to London after a poaching incident to escape the wrath of Sir Thomas Lucy, whom he satirised subsequently as Justice Shallow. The fact that the story was not picked up by earlier chroniclers and the un-Shallow like character of the stern Sir Thomas argue against its validity. Perhaps the story reflects

a half-forgotten memory of a clash between the Shakespeares and the Lucys at the time of the Somerville affair. In fact, William Shakespeare was almost certainly in London by 1587.

The London road was familiar to young Stratfordians. A number became apprentices in the great city. In 1577, Roger Lock, another glover's son, began a ten-year apprenticeship to Richard Pickering, a stationer. In 1579, Richard Field, son of Henry Field, the tanner in Back Bridge Street, entered the service of Thomas Vautraullier, a Huguenot printer. After the death of his master, the young Stratfordian married either his daughter or his widow. It is not clear which. He did not forget the needs of his family in Stratford, taking on his brother, Jasper, as an apprentice after his father's death in 1592. Field printed many notable works, including Shakespeare's *Venus and Adonis*, the best-seller of the age, in 1593 and his *Rape of Lucrece* in the following year.

Stratford girls entered service in the city. In 1594, Elizabeth Trowte, sister of a local butcher, sued Elizabeth Hancocks for alleging that, after the death of her mistress in London, she stole all her clothes 'and came down to the countrye and hyd her head for the space of halfe a yeare and afterwards flourished abroad in the said clothes lyke a gentlewoman, but after that she was taken and carried to London where the same clothes were received agayne by her master without anye punishment'. Her airs and graces caught her Henry Prettie, another butcher, to whom she bore five children before she and her husband perished in the plague year of 1606.

Even more bizarre was the case of Elizabeth Evans. She left Stratford for London around 1594/95. She moved rapidly and ruthlessly to advance herself through her allure and sophistication. She entrapped Master Nixon, a silk merchant, who asked Thomas Malin, a baker, to give her lodgings on the basis that he intended to marry her, but Nixon declared that while Malin was on his travels, 'she entertained other clothiers'. Eventually, he threw her out, after which,he claimed that she lodged in a succession of places. Although clearly captivating, she was not good news to know. Marlin claimed that she received men of 'good ability' who 'shortly after became bankrupt and [of] little worth'. In March 1599, her activities were brought to the attention of the Governors of the Bridewell Hospital by Mary Holmes, who stated that she had 'sometimes served' her, but, on discovering that she was of 'ill report and an ill woman of her body', had left after about a month. She spoke of Elizabeth's relations with the brothers, John and Henry Pears, who called her 'cousin'. She had seen Elizabeth and John in bed together on two or three occasions. The lust appears to have been somewhat one-sided. She would entreat him 'to come to bed to her and hath locked him in her chamber when he hath made show to be willing to run away'. By contrast, Henry, who had vouched for her good name in some capacity, appeared obsessed with her to the point of naivety. On one occasion he knocked on the door of her bedroom while the couple were in bed together, so she 'did convey the said John into another chamber and carried his clothes after him, he rising without his clothes'.

Henry later asked Mary whether John 'had at any time lain with' Elizabeth. 'I am sorry that ever I did speak for her', he said, on hearing that he had. A warrant was issued for her arrest. After a week's search, she was charged with living with no fixed abode and living 'loosely with several men'. She was not a prostitute, as has been suggested, more like what today would be described as a gold-digger. Had she been such, she would have been charged with that offence. She was incarcerated in the Bridewell Prison while witnesses were found. Amazingly, two of them came from Stratford. Joice Cowden declared that she was born in 'Stratford uppon Hauen', where she had gone to school with Elizabeth Evans and 'knew her father, a cutler who had been executed for

'quoinge' (coining). George Pindar, whose father was probably a goldsmith in Middle Row, Bridge Street, was born in Stratford in 1566. He testified that he did not know how she maintained herself so grandly. The answer lay in the trail of bankrupts she had left behind her. Her pretention that she had a vast income of £300 per year almost gains credence in this context. She clearly had credible pretentions to gentility, adopting the surname when it suited her of two noble families associated with South Warwickshire (Dudley and Carew), doubtless claiming a family affinity. Things did not look good for her, but a surprise was still to come. A scion of yet another noble family appeared willing to acknowledge the possibility of some kind of blood relationship: 'William Howard brother to the Right Honourable ye Lord [sic] Admirall being in court did sewe for her enlargement and desired that she should be spared of her punishment for that he thought she was a kinne to him whereupon she was delivered to him the saide Sir William without any punishment.'

Sir William was the brother of the patron of the rival company to Shakespeare's own, the Admiral's Men. Elizabeth's pretentions to gentility appear to have paid off, although she was ordered to make a public confession of her faults before leaving. It is unlikely that there was any kind of sexual liaison between Sir William and the defendant. He would hardly have risked his reputation publicly and, at least theoretically, he could have laid himself open to a charge of 'incontinence'.

More respectable advancement was secured by Katherine Rogers, daughter of a High Street butcher and alderman, who married William Harvard, a wealthy Southwark brewer. Her considerable fortune from outliving three wealthy husbands enabled her son, John Harvard, to endow the famous American university that bears his name.

A popular means of travel was to accompany the carriers who made regular journeys between Stratford and London. 'If ther be any cloth for mee to bee sent downe, send it by Edward Bromley', wrote Daniel Baker to Richard Quiney, who was in London during 1598. Five days later, Quiney's wife sent him tobacco, cheeses and other articles by another carrier, William Greenway. Baker's confidence in Bromley was not to last. In 1603, he sued him for 'negligent loss ... between London and Stratford. A box containing an article called a 'starr ryall' was the missing item. In 1601, Edward Bromley sued Nicholas Jevens for 16*d* – 'the price agreed for carrying from London to Stratford of a sugar loaf, a barrel of figs, &c.'

Around 1605, John Sadler, son of the tenant of Stratford Mill, fled from an arranged marriage. 'He joined himself to the carrier and came to London, where he had never been before and sold his horse in Smithfield and having no acquaintance ... to recommend or assist him, he went from street to street and house to house, asking if they wanted an apprentice and though he met with many discouraging scorns and a thousand denials, he went on till he light upon Mr Brooksbank, a grocer in Bucklersbury.' This enterprising young man prospered, participating in the early colonisation of Virginia. His partner and brother-in-law was Richard Quiney, brother of Shakespeare's son-in-law. The two grocers did not forget Stratford. In 1632, they presented the Corporation with a mace 'to be borne before the Bailiff and Chief Alderman ... this time being for ever', which is still in use.

All these Stratfordians are eclipsed in memory by their fellow. The stage presented by David Jones and his Whitsuntide players had become too small for William Shakespeare. On an unrecorded date in the 1580s, he crossed Hugh Clopton's great bridge to start his momentous journey. Stratford was the source of his genius, but only in London could he fulfil his destiny.

4

'Exits and Entrances'

They have their exits and their entrances and one man in his time plays many parts.

As You Like It

'Fame's Immortal Book'

William Shakespeare is first recorded in London in a furious attack made on him by the playwright, Robert Greene, in 1592. By then he was an established dramatist. While his fame and fortune grew, he never lost contact with his hometown. In 1587, when he was probably already in London, he participated in an unsuccessful action against his cousin, John Lambert, for the return of his mother's Wilmcote property. As with Charles Dickens, the experience of family penury in youth had a deep effect. He developed an avid capacity for work, his output far exceeding any contemporary talent. The handsome earnings of this prolific genius were, apart from necessary professional investment, ploughed back into the Stratford area. The humiliations of the austere years were to be wiped out and the family prestige restored. Thus, John Shakespeare resurrected a twenty-year-old claim to a coat of arms, which was granted on 20 October 1596. The main device, a spear of steeled argent, was a clear pun on the family name. The motto *Non Sanz Droit* ('not without right') seems defensive and was perhaps parodied by Ben Jonson as 'Not Without Mustard'. The message is clear. This is not an award to an upstart, but to a man who had held high office, married 'a daughter and heyre of Arden' and claimed an ancestor rewarded by Henry VII. In 1602, after a personality clash, the Garter King-at-Arms, Sir William Dethick, was accused by the York Herald, Peter Brooke, of elevating base-born persons, who included John Shakespeare. A successful defence was made of the Shakespeare claim by Dethick and the Clarenceaux King at Arms, William Camden, who knew both the London and Stratford ends of William Shakespeare's life.

Subsequently, John Shakespeare applied to pair his crest with that of his wife's family. The heralds sketched the arms of the Ardens of Park Hall, but later substituted those of a junior branch of the family. The application was never pursued. The enthusiasm of the Shakespeares for the project was perhaps diminished by domestic grief. Hamnet Shakespeare, aged eleven, the only direct heir to the family name, was buried at Holy Trinity on 11 August 1596. Shakespeare's company was in Kent, but its chief dramatist was probably in Stratford, working on his adaptation of *The Troublesome Reign of King John*. Thus, he may have been in the sad group that carried the little body to the church. If any speech in his plays reflects his own feelings, it is surely that in *King John*, when the stricken Constance mourns the loss of her son:

> Grief fills the room up of my absent child,
> Lies in his bed, walks up and down with me,
> Puts on his pretty looks, repeats his words,
> Remembers me of all his gracious parts,
> Stuffs out his vacant garments with his form.
> Then I have reason to be fond of grief.

Hamnet had probably followed his father to the grammar school, where a new pedagogue had arrived in 1582 and stayed for 40 years. Alexander Aspinall, described by Shakespeare's cousin, John Greene, as 'great Philip Macedon', married in 1594 a widow, Anne Shaw. Years later, Sir Francis Fane wrote in his commonplace book, 'The gift is small / The will is all / Asheyander Asbenall. / Shaxpaire upon a peire of gloves that mas[t]er sent to his mistress'. One of Shakespeare's favourite double entendres is understood by adding 'y' to the 'will'. Gloves would have been a curious present, for the Widow Shaw's son was a glover.

It is easy to forget that Shakespeare was only thirty-two at Hamnet's death. In London he was a noted figure and the tributes flowing to him mark the start of the enduring cult of Bardolatry. To one contemporary, he was 'honey-tongued Shakespeare', while another wrote of his name being in 'Fame's immortal book'. Even more adulatory was Francis Mere's declaration that 'the Muses would speak Shakespeare's fine-filed phrase, if they could speak English.' His character was apparent from his earliest days in the city. Chettle, who published Greene's attack, apologised and declared that Shakespeare possessed 'demeanour no lesse civill than he excelent in the qualitie he professes, besides divers of worship have reported his uprightnes of dealing, which argues his honesty, and his facetious grace in writing that aprooves his art.' His conversation excited comment. 'Many were the wit-combats betwixt him and Ben Jonson', wrote Thomas Fuller, 'which two I beheld like a Spanish great Galleon and an English man of war. Master Jonson (like the former) was built far higher in learning, solid but slow in his performance. Shakespeare, with the English man of war, lesser in bulk, but light in sailing, could turn with all tides, tack about and take advantage of the winds, by the quickness of his wit and intervention.' This same Ben Jonson, never one to give praise lightly, declared, 'I loved the man this side idolatry.'

Like Joseph at the court of Pharaoh, William's success brought his brethren to his side. Gilbert became a haberdasher in St Bride's Ward, although he was often in Stratford, acting for his brother in land deals. Edmund, the youngest, became an actor of little distinction and fathered a 'base-born' son, buried at St Giles, Cripplegate, in August 1607. Four months later, Edmund Shakespeare, 'a player', was buried in the Bankside church of St Mary Ovarie with a forenoon tolling of the great bell.

Of the other siblings, his sister, Joan, married William Hart, a local hatter. Little is known of Shakespeare's brother, Richard, whose sole impact on the extant records came when he appeared with three other men before the bawdy court in 1608 on an unspecified charge. It is unlikely that he would be so little mentioned were he engaged in any trade or profession. Perhaps he was backward, living first with his parents and then his sister, helping with the simple business and household chores.

'A Praty House of Brick and Tymbre'

In 1597, Shakespeare bought New Place, 'a praty house of brick and tymbre', whose elegance had been noted by Leland, from William Underhill, a Catholic recusant. A few weeks later, this 'subtle, covetous and crafty man' was poisoned by his eldest son, Fulke, at Filongley. Although conspicuously crazy and a minor, he was executed for the murder at Warwick.

New Place was Stratford's first all-brick dwelling. It was entirely rebuilt before 1702 by another Sir Hugh Clopton. George Vertue, the engraver and antiquary, visited Stratford in 1737 and talked with Shakespeare Hart, then sixty-seven, great-grandson of the poet's sister. He remembered the house well and Vertue made a sketch from his description which shows a fine three-storey, half-timbered building, with five gables and two entrances. Through the Chapel Street entrance, 'before the House itself', there was a little grass-covered courtyard.

Shakespeare secured this fine property cheaply because it was in a state of 'great ruyne and decay and unrepayred'. Extensive work was necessary and 'Mr Shaxpere' sold the Corporation 'a lod of ston' in 1598. His concerns creep into his current play, Henry IV, Part Two, 'When we mean to build / We first survey the plot, then draw the model / And when we see the figure of the house, / Then we must rate the cost of the erection.'

The great garden of New Place was brought into order. A vehement local tradition maintained that the poet planted the mulberry tree that was cut down in 1758. Probably, like Angelo, he had a 'garden circumnured with brick, whose Western side is with a vineyard back'd', for in 1631, Sir Thomas Temple of Wolverton instructed a servant to ride to Stratford and 'desire Mr Hall Phiscon ... to suffer Harry Rose or any better in skill to gather ... 2 or 3 of the fairest of these budes or shutes of last yeares vines.'

Anne Shakespeare ran her own household for the first time at New Place. This anonymous woman emerges fleetingly in the will of Thomas Whittington, the Hathaway shepherd at Shottery, who, in 1601, left 'unto the poore people of Straford xls that is in the hand of Anne Shaxpere Wyf unto Mr William Shaxpere and is due debt to me.' Was the poet's spouse a scrounger from her brother's servants? More likely she was a trusted holder of savings.

Domestic chores would increase, although the retinue of servants living around the courtyard would diminish the burdens. Anne would be skilled in weaving and brewing. Inventories that John Shakespeare made of the goods of two deceased neighbours show that equipment for these tasks was standard in Stratford households. Ralph Shaw's home contained barrels, a sieve, a spinning wheel, four pairs of wool cards, 20 quarters of malt, pails and looms. Henry Field possessed six beer barrels, five looms, four pails, two skips, one outing vat and three malt shovels. 'The chief trade here', observed Daniel Defoe a century later, 'is in corn and malt of which last it makes in great abundance.'

Troubled Times

Stratford's economic situation deteriorated in the 1590s, a misfortune compounded by two devastating fires that wiped out much of the town. 'Those that delighted themselves in downe bedds and silken curtyenes are now glad of the shelter of a hedge', wrote an Oxford citizen in

similar circumstances. Elizabethan Stratford was an elaborate incendiary device of wattle and daub, open hearths, thatch and timber. Every burgess was obliged to keep a leather fire bucket and the Corporation provided five great hooks to pull down stricken buildings. An order of 1583 compelled householders to erect chimneys, but this did not prevent the great fires of 1594 and 1595, which caused an estimated £20,000-worth of damage. Puritan preachers made much of the fact that both broke out on Sundays. 'That which is most strange within these late years', wrote Thomas Beard in *The Theatre of God's Judgements*, 'a whole town hath bene twice burnt for the breach of the sabboth by the inhabitants.'

The Corporation was more concerned with temporal practicalities. In September 1594, eight emissaries were dispatched to raise funds for relief and rebuilding. Alderman Thomas Barber raised £21 9*d* in Worcestershire; Alderman William Parsons collected £10 11*s* 2*d* in Gloucestershire and Abraham Sturley, £4 3*s* 8*d* in 'Darby' and 55*s* 8*d* in 'Abrington'. Most successful was Richard Quiney, who raised £22 5*s* 3*d* in Northamptonshire, and with Shakespeare's friend, Hamnet Sadler, the huge sum of £75 6*s* 0*d* in Suffolk and Norfolk.

Falling economic standards and high inflation produced a rising crime rate and the declining respect for authority epitomised by Elizabeth Wheeler alias Rundles, who was brought before the bawdy court in 1595 'for continually brawling and not attending church'. Her response was graphic. 'Goodes woundes,' she exclaimed in court, 'a plague a God on you all. A fart of ons ars for you.' A terse note adds 'excommunicated'.

The rising inflation ensured that Thomas Oken's bequest of wine after the election day sermon no longer covered its costs. Rather than forego this pleasure, the Corporation decided to subsidise it from the rates. The disastrous situation was compounded by the incessant war with Spain and a succession of bad harvests, which produced grave shortages. On 3 October 1595, the Corporation forbade innkeepers from home-brewing and baking and ordered them to use the public brewers and bakers. Milk was imported from 'the villadges about us … to the relievinge of our children and others'. In 1597, a survey of barley held by the citizens was ordered as a measure against hoarding. At New Place, the Shakespeares held 18 quarters, a standard household quantity. Abraham Sturley noted 'growing malcontent' against hoarders. 'God send my Earl of Essex down to see them hanged at their own doors', he wrote vehemently; Elizabeth's ill-starred favourite was a popular figure. A petition to the Queen stressed the hardship caused by the prohibition on household malting, 'in that oure town hath no other especiall trade havinge thereby onlye tyme beyonde mans memorye lyved by exersysing the same, our houses fitted to no other uses, manye servantes amonge us hyered only to that purpose.'

Such was the depth of the depression that the Corporation placed its treasures in pawn with John Combe, a local money-lender. 'Your cousin Sir Combe holds the silver and gold plate,' wrote Sturley to Richard Quiney in 1598, 'on the advice of Daniel Baker, with whom indeed, he was very angry on thine account…' We will hear more of this Baker, who was beginning to make a speciality of unilateral decisions.

Abraham Sturley had tried to enlist the aid of the Lord of the Manor, that fratricidal heir, Sir Edward Greville. On 24 January 1596/97, he wrote to Richard Quiney: 'Theare might bi Sir Ed. some meanes made to the knightes of the Parliament for an ease and discharge of such taxes and subsides wherewith our town is like to be charged and I assure u I am in great feare and doubte bi no means able to paie. Sir Ed. Grev. is gonne to Brestowe. '

Relations between the Corporation and Greville were good at this time, exemplified in a dinner given for him at Richard Quiney's house in 1596/97. Lady Greville was entertained in 1597 and amity appeared compounded at a meeting on 3 November when Sir Edward agreed to support an application for a new charter. Sturley wrote to Quiney that Sir Edward 'saith we shall not be at any fault for money for procuring the cause, for himself will procure it and lay it down for the time'. Yet Sturley had his misgivings. In considering the financial gains to be expected from the new charter, he suggested that half should be offered to Sir Edward, 'lest he shall thinke it to good for us and procure it for himself, as he served us last time'.

The 'last time' had followed the death of the Earl of Warwick in 1590. The Corporation petitioned for the right to appoint the schoolmaster and vicar, but Greville moved faster and secured the lordship of the Manor for himself. A strong antagonism between Quiney and Greville perhaps dated from this incident. In 1592, Greville exercised his right of veto over the appointment of Quiney as bailiff. The Corporation lobbied Sir Fulke Greville at Warwick. On 5 October he wrote to his 'Cosen Greville ... If the cause of your refusal be for any wante of partes beseeking that place in the man himself, he is desirous to satisfie you in all objections'. Sir Fulke knew the volatility of his relation, for he added, 'In the meane tyme yor yeelding at this present to my request can no waie prejudice yor right and I hope yew shall have no cause to seek it violentlie of them'.

Greville conceded and relations improved, but Sturley's fears were justified. After 1598, things worsened as Greville asserted his supposed privileges with violence. He claimed the right to enclose the riverside common known as the Bancroft and sent his men there to dig ditches and build fences in January 1600/01. Quiney organised the Stratfordians to destroy the works. A legal action by Greville, in which the great jurist, Sir Edward Coke, represented the Corporation, got nowhere. Quiney was defiantly re-elected as bailiff in September. He worked assiduously against Greville's interest, visiting the Bishop of Worcester with Shakespeare's cousin, Thomas Greene, to enlist his aid in withstanding unjust inroads into the town's liberties. Greville, believing 'we shuld wynne it by the sworde', sent his rowdy followers to make trouble in Stratford taverns. 'Ther came some of them whoe beinge drunke fell to brawelinge in ther hosts howse ... and drew ther daggers uppon the hosts: at a faier tyme the Baileefs being late abroade to see the towne in order and comminge by in yt Hurley Burley came into the howse and commanded the peace to be kept butt colde nott prevayle and in hys endevor to stifle the brawle had hys heade grevously broken by one of hys (Greville's) men whom neither hym self (Greville) punished nor wolde suffer to be punished but with a shewe to turn them awaye and enterteyned agayne'. Quiney did not live out the month. On 31 May 1602, the 'Baily of Stretforde' was buried, the only one to die in office. Greville's triumph was brief. He lost his estates through speculations during the next reign and died in poverty.

During Quiney's ill-fated bailiwick he compiled a list of senior and respected citizens who could vouch for the borough's historic rights. It included the name of John Shakespeare, who, according to an anecdote of his old age, was still to be found in his glover's shop, where Thomas Plume, writing half a century later, claimed Sir John Mennis saw him 'a merry-cheeked old man – that said – Will was a good honest fellow, but that he durst have cracked a jest with him at any time'. Sir John was only two when John Shakespeare died. Perhaps the anecdote refers to an elder brother or perhaps he heard it from someone.

If Richard Quiney intended to use John Shakespeare's knowledge he was disappointed. On 8 September 1601, the old man was buried at Holy Trinity. His widow survived him by seven years.

Loving Good Friend and Countryman

In his letter telling Richard Quiney of the town's disasters, Abraham Sturley remarked that 'our countriman Mr Shakspear is willing to disburse some moneys upon some od yardelande or other att Shotterie or neare about us; he thinketh it a very fitt patterne to move him to deale in the matter of our Tithes. By the instructions u can give him thereof we think it a faire marke for him to shoot att.' Shakespeare was not moved to fire an arrow on this occasion, but later he bought land and tithes in Stratford. Quiney took advantage of this burgeoning wealth when he ran short of money during his visit to London. There was one man in the City to whom an impecunious Stratfordian could turn. He wrote 'ffrom the Bell in Carter Lane the 25 October 1598' requesting a £30 loan from 'my Loveinge good ffrend & contryman Mr Wm. Shackespere ... you shall ffrende me much in helping me out of all the debettes I owe in London I thanke god & much quiet in my mynde ... I commit thys to your care & hope of your helpe. I fear I shall nott be backe thys night ffrom the courts. Haste. The Lord be with you and with us all amen.'

Shakespeare's reputation as a man of wealth is revealed in a note written by the Revd John Ward, the vicar of Stratford after the Restoration. 'Hee spent att ye Rate of 1,000£ a year, as I have heard.' Ward's informant was Shakespeare's daughter, Judith. The sum seems absurdly high, but if it is reckoned as referring to the man's enterprises rather than his personal spending, it falls into perspective. Shakespeare was a major shareholder in his theatrical company. It is the kind of remark that an old lady might recall who had once asked her father for a new gown when he was overwhelmed by bills for costumes, wages, touring expenses and other costly items.

It is inconceivable that a man of such self-made fortune, an acquaintance and entertainer of the greatest in the land, should not be a figure of note in his own town. The Stratfordians must have been aware of the source of Shakespeare's regenerative wealth and taken a vicarious pride in their notable townsman. 'He was wont', says Aubrey, 'to go into his native country once a year.' He would visit his family, deal with his affairs and, perhaps, work on his dramatic output. Yet, despite his attachment to Stratford, he never became involved in its civic affairs. This was right and proper for a man whose working life was spent elsewhere. The great writer would not retire to the country to become embroiled in the petty affairs of a small town.

The confident face of Puritanism was encroaching on Stratford as surely as it was advancing elsewhere. When Abraham Sturley was bailiff in 1596, he paid four companies of players and 'a show of the City of Norwich', but in 1603, the Corporation, oblivious to Hamlet's strictures against the players' ill-report, banned plays and interludes from its property, 'upon payne that whatsoever of the Baylief, Alderman and Burgisses of this boroughe shall gyve on license thereunto shall forfeyte for everie offense 10s.'

The leading Puritan and architect of this ban was Daniel Baker, a high street mercer who dominated the town's councils for the next forty years. He fulfilled the cliché of his kind, combining a strict public morality with an irrepressible sensuality. A widower, he was

presented before the bawdy court in 1606 on a charge of sexual incontinence. He failed to appear, but Anne Ward admitted that 'Mr Daniel Baker is the true and undoubted father of the child with which she has been pregnant', saying that he had promised to marry her. She was ordered to make public penance in a white sheet. Baker was excommunicated for non-appearance. He appeared three weeks later and made his denials, but admitted that there was public infamy about the matter. He was ordered to 'purge' himself (make a formal confession before the minister) with six others about whom similar rumours were circulating. When he failed to do so he was pronounced guilty, but may have escaped public humiliation by paying a fine. It was probably this incident that made him an intractable opponent of the vicar, John Rogers.

One who ignored the ban on actors was Henry Walker, who as bailiff in 1608 revived the Guild Hall play. He was a friend of Shakespeare's, who was the godfather of his son, William. There were other breaches of the regulations and they were made more stringent in 1611. 'The sufferance of them is againste the orders heretofore made and againste the examples of other well governed cities and burrowes the Companie heare are contented ... that the penaltie of 10s imposed for breaking the order shall henceforth be £10 ... this to bide until the next common council and from thenceforth for ever, exepted that be their finally revoked and made void.'

The Puritans had a point. The bloody skirmish that presaged the arrival of the Queen's Players in 1587, the Tyburn mark branded on Ben Jonson's thumb after he killed a fellow actor in a duel and the violent death of Christopher Marlowe, all indicate that the epithet 'gentle' applied to Shakespeare was noteworthy because of the rarity of this quality amongst his fellows.

Adherence to the new regulations depended on the viewpoint of the bailiff. When Thomas Greene's stepson, William Chandler, held office in 1618, 3s 4d was paid 'to a company that came with a show to the town' and later 5s 'per Master bailiff's appointment to a company of Players'. As late as 1633/34, a strolling player arrested at Banbury had acted with his company at Stratford and Sir Thomas Lucy's house at Charlecote.

The poverty spiral was having its effects on Stratford. In 1601, 700 people – a third of the population – were on the poor lists. Illegitimacy, drunkenness and violence increased. The Corporation castigated the alehouse keepers for contributing 'through their unreasonable strong drink, to the increase of quarrelling and other misdemeanours in their houses and the farther and greater impoverishment of many poor men haunting the said houses when their wives and children are in extremity of begging.' In 1601, Thomas Bailes was 'slaine at the Signe of the Swan upon the sabbath day at the tyme of the sermon being there drinking...' In 1603, the Corporation prohibited inhabitants from 'tippling in alehouses unless they are labouring men partaking of drink in their dinner hour', which must have engendered initiative amongst the ingenious in evasion. The prohibition had little effect and 1609 was a notably violent year. William Robyns, a servant of Hornby the blacksmith, was killed in a quarrel over a jug of beer. Another murder took place in the low inner parlour of the Swan in Bridge Street. Lewis Gilbert, a veteran of Essex's disastrous Irish campaign, quarrelled with the host Richard Waterman, his wife and two daughters. When they attempted to eject him, he set his back against the door and resisted. 'He will spoil my father. He will murder my father', shrieked the daughters. Waterman's brother, Thomas, was sitting with Humphrey Acton by the fire in the hall. He forced open the parlour door and, seizing Gilbert by the collar, tried to throw him

out. Gilbert drew a knife and stabbed him in 'the right side by the navel, from which he died'. Gilbert, of no fixed abode or means of support, fled. The Coroner's inquest, meeting over the body of Waterman, found him guilty of wilful murder.

The crime wave kept the courts busy. Richard Barrett of Henley-in-Arden and John Whittle of Bearley were summoned in 1610 to give evidence against James Lord 'in the felonious killing of William Langford'. A capital charge was faced by William Perry in the same year, 'a person suspected of having coined gold'. James Johnson and Nicholas Worrall were 'attached to answer Thomas Townesend for having conspired with one Hugh Browne … to defraud the plaintiff of divers sums of money at play in a game of cards called Newcutt'. Richard Smyth was attached to answer Henry Collins for scandalous words uttered, viz. 'Thou art an arrant theife and wast whipped out of the countrie where thou didst dwell for stealinge sheets off a hedge'. That year, a revision of the charter extended the borough's legal jurisdiction over the church, churchyard and Old Town, 'which last locality is much infested with beggars and vagabonds'.

For a while longer, the 'spirit of brotherly love' intended to pervade the halls of the Corporation prevailed. In 1607, 5s 2d was paid 'at Mrs Queenes when Mr Rodgers and Mr Wright were made frendes'. Wright was the under-schoolmaster, just down from Oxford, whose precocious opinions must have upset the vicar. Around the same time, the Corporation wrote to Henry Yelverton, the attorney general, on behalf of 'divers poor men… much grieved and oppressed by the hard and unconscionable course taken against them by William Slatter'. Slatter, the carpenter with marital problems, was bringing actions in the Star Chamber against those too impecunious to defend themselves and was then extorting money from them in return for not proceeding. The assize Justices ordered him to desist, but he ignored this injunction and was imprisoned. On his release, he continued in his old ways, 'for he hath served poore women into the Starr Chamber for small or no causes and so terrfyed them therewith that some of them were constrayned to purloyne from their husbands to compounde with him …' The Corporation's letter was scathing. 'The sayde Slatter ys very well knowne to us to be a fellow of verry lewde behavior, a stirrer up of suites, a contentious person, a contemner of authority … He standeth indicted… for a common Barrator and reformeth not himself, but groweth worst and worst …' Yet it was difficult to take action against him because he had no fixed abode. 'Wherefore we desire that your worship will be pleased to have the compassion of the poore defendants and to take such a course that the countrye may be eased of so turbulent a fellow.'

Gunpowder, Treason and Plot

Catholic sympathisers were in a cleft stick. While their beliefs were ostensibly inviolate, the means of practising them were steadily denied and resources were drained by fines and forfeitures. Some Catholics resorted to desperate, hopeless plotting. Such desperate kicks against the pricks justified the authorities in further tightening their control. There is a tragic attraction about these Englishmen, struggling to keep alight the dwindling flame of faith amid what they regarded as a new dark age. One such was Robert Catesby, whose father lived at Bushwood House, the enclave of Old Stratford near Lapworth. He was a familiar figure to Stratfordians. 'Yff you can learne where Mr Robert Catesbie lyeth', wrote Daniel Baker to his 'Uncle Quyne' in London. 'I

pray you goe to hym and dessier hym to have a care of mee for hys Father's debt according to hys promise at Rolewright… Hee lyeth about the Strand in a back allie towards Waterside.' Catesby was six feet tall, with a noble, expressive face and strong personal magnetism. He participated in the abortive Essex rebellion of 1601. His fatal combination of charisma and naivety led him into the Gunpowder Plot of 1605, a doomed escapade nurtured in the Stratford neighbourhood. Ambrose Rookwood rented Clopton House that autumn to be near his fellow conspirators who were mainly impoverished local Catholic gentry, who included John Grant, Lord of the Manor of Northbrook near Snitterfield. The plotters whiled away their time 'ryding of great horses and hunting'. On 4 and 5 November, they attended local race meetings to be together when the news came from London. On hearing the worst they fled across country, seizing horses from Fulke Greville's stables before making a last stand at Haddington in Worcestershire. Catesby was killed by a bullet in the head. The others were executed with that horror and fortitude the age deemed necessary.

In Stratford the excitement was intense. This was as stirring as the Armada yet closer to home. The armour was again removed from its dusty repository and repaired and replenished. Musters were raised, gunpowder purchased and tactics discussed. On the night of 9 November, the Corporation drank wine at Mrs Quiney's tavern, 'when yt was said that Sir Fulke Greville's house was beseiged'. The horse-stealing incident had grown to a campaign in just three days. An expedition was launched against Clopton House. The local militia was doubtless relieved to find it unoccupied. Goods were seized, including chalices, crucifixes, surplices and other vestments. A further repercussion was a crackdown on those considered to be 'popishly affected', who fulfilled the obligation to attend church, but never received the sacrament. Amongst those so listed were the Sadlers and Susanna Shakespeare. Their names were later struck from the list, so it may be assumed that they conformed.

Sectarianism invaded the Guild Hall in 1612, when old Thomas Barber of the Bear, who had been thrice bailiff, was expelled from the aldermanic bench because his wife Joan was 'an obstinent recusant'. Unless she changed her adherence he was not to be re-elected. There were other reasons for puritanical chagrin against Barber, who was likely to have defied the ban on players.

Autumnal Years

This is the 'dark' period of Shakespeare's work, when a devastating vision of the universe produced dramas of superlative power. This vision is unlikely to have sprung from Stratford soil, except to the degree that great drama is rooted in universal experience. In his home town, William Shakespeare emerges as the man Abraham Sturley knew as interested in acquiring property. Domestic concerns played their part in his sojourns. He must have been present on the summer day in 1607 when his daughter Susanna married John Hall. Susanna, 'witty above her sex' and heiress to a fortune, was doubtless pursued by numerous suitors, each carefully vetted by the Shakespeares. Hall was a Cambridge graduate born at Carlton, Bedfordshire, in 1575, one of eleven children. He had become a doctor and taken up his practice in Stratford. Shakespeare got on well with him and, given the contemporary inheritance laws, was content

to regard him as his heir. Medical references are more closely observed in the plays after the marriage. That most fertile of minds must have been fascinated by Hall's profession. 'Elizabeth, daughter of John Hall, gentleman' was baptised on 21 February 1607/08.

Thomas Greene was living at New Place in 1609 with his wife, Lettice, and two children, aptly named William and Anne. He became town clerk in 1603 and may be the minor poet of that name who was criticised, with Shakespeare and Jonson, for failing to compose a funeral elegy to Queen Elizabeth. The accommodation provided by the Shakespeares was generously offered, for Greene wrote that he 'perceyved I might stay another year...' Much Corporation business must have been conducted from the parlour and it was presumably on Greene's behalf that a visiting preacher was entertained at New Place in 1611. He must have delivered one of the three annual endowed sermons at the Guild Chapel. The Corporation paid 20*d* for 'one quart of sack and one quart of clarett wine'. What Greene called his 'golden dayes and spirites' spent in Stratford's service, is reflected in his surviving letters, including one to John Marston, the dramatist, from his 'Lovinge ffrendes' in Stratford, but the subject is legal not literary. Another is written on behalf of the Corporation to Sir William Somerville, praying him to punish Michael Gybson of Knowle for the seduction of Dorothy Field – probably another example of public virtue coinciding with a strain on the rates!

In 1613, William Shakespeare contributed to a bill for the repair of the local highways. He had used them as much as most in Stratford, but in his autumnal years he was spending more time in the town, slowly disengaging himself from the metropolis. The hand that had written two plays a year was slowing down. *The Tempest*, written in 1611, was the last masterpiece. After that there was collaboration with the rising dramatist, John Fletcher. Probably Shakespeare worked from Stratford, sketching out plots, writing major speeches and setting scenes, while Fletcher would complete the work. On 29 June 1613, the Globe Theatre burnt down during a performance of *King Henry VIII*. Within a year, a new, more splendid building had arisen, but William Shakespeare's name was not among the shareholders. England's greatest man of the theatre had made his exit.

'The latter part of his life was spent', reported Rowe, 'as all Men of good sense will wish theirs may be, in Ease, Retirement and the Conversation of his Friends. He had the good Fortune to gather an Estate equal to his Occasion, and, in that to his Wish and is said to have spent some Years before his Death at his native Stratford.' Yet the last years were not entirely tranquil. The Shakespeares were disturbed by a distasteful episode during the summer of 1613. On 15 July, Susanna Hall brought a suit for deformation in the Diocesan court against John Lane the younger of Alveston, who had 'about five weekes past' spread a story that she had 'the runinge of the raynes' (a graphic name for gonorrhoea) and had 'bin naught' (fornicated) with Rafe Smith at John Palmer.' Robert Whatcott, probably one of the New Place servants, appeared for Mrs Hall. Lane failed to appear and was excommunicated for spreading false report. In 1619, he was presented for 'not receivinge holi communyon according to the canons' and, later that year, for drunkenness.

The incident reveals the close-knit nature of Stratford society. Ralph Smith, one of the Armada volunteers, was Hamnet Sadler's nephew. Lane's sister, Margaret, was married to Shakespeare's cousin, John Greene, the Town Clerk's brother. Lane's cousin, Thomas Nashe, married Elizabeth Hall in 1626.

'Overthrowne and Undone'

On 9 July 1614, Stratford was devastated by another fire, which destroyed fifty-four houses, 'many of them very fair … besides Barnes, stables, & other howses of Office, together also with great store of Corne, Hay, Straw, Wood & Timber therein', to the value of over £8,000. The 'Brief for the Relief of Sufferers', written in the name of King James I, makes pathetic reading:

> The force of fier was so great (the wind sitting ful upon the Towne) that it dispersed into so many places thereof, whereby the whole Towne was in very great danger to have beene utterly consumed and burnt, by reason whereof, and of two severall Fiers happening… within these twenty yeares, to the losse of Twenty Thousand Pounds more, not only our saide poore subjects who have now sustained this great losse, are utterly undone and like to perish but also the rest of the Towne is in great hazard to be overthrowne and undone, the Inhabitants there beeing no waies able to relieve their distressed neighbours in this their great want and misery. And whereas the said Towne hath been a great Market Towne whereunto great recourse of people was made … now being thus ruinated and decayed, it is in great hazard to bee utterly overthrowne, if either the resort thither may be neglected, or course of travellers diverted, which for want of a speedy reparation may be occasioned. And foreasmuch as our distressed subjects the inhabitants of the said Towne are very ready & willing to the uttermost of their powers to rectifie & new build the said Towne againe, yet finding the performance thereof far beyond their ability, they have made their humble suite unto us, that we would be pleased to provide some convenient measures that the saide Towne may be again rectified and repaired as well for the reliefe of the distressed people … as also for the restoring and continuing of the sayd market, and have humbly besought us to commend the same good & laudable deed and the charitable furtherance thereof, to the benevolence of all our loving subjects, not doubting but that all good and wel-disposed Christians will for common charity and love to their country and the rather for our Commendation hence of, be ready with all willingness to extend their charitable reliefe towards the comfort of so many distressed people…

The Corporation forbade thatching of houses and ordered existing thatch replaced by tiles and slates. The aldermen again embarked on their fundraising tours, but in 1619, a petition described Stratford as 'the anciente (but now much decayed) borough'. It was to be 200 years before this decline was reversed.

John a Combe

Further stress and controversy blew up in 1614 with a plan by a cartel of landowners to enclose the common fields at Welcombe. To the peasant freeholders, this meant destitution; to the Corporation, loss of historic rights and an increased burden of poor relief. The issue was explosive. In the spring of 1607, similar proposals had led to 'tumultuous assemblies' against

'depopulations'. Under Thomas Greene's guidance, resistance was planned. As a titheholder, William Shakespeare would be inadvertently involved.

The enclosers were men of the new age: Arthur Mainwaring, steward to the Lord Chancellor; William Combe, the High Sheriff, and his younger brother, Thomas, who had in 1598, denounced his cousins, the Sheldons, for harbouring a Catholic priest. The Combes were a *nouveau riche* family of expanding wealth. 'They say in Stratford that he cannot have less than 20,000li in his purse', wrote Leonard Digges of William Combe in 1632, 'increased by honest 8 and 10 in the hundred.'

This distaste for usury affected the posthumous reputation of the Combe brothers' Uncle John. The wealthiest man in Stratford, he lent money at interest and engaged in regular actions for its recovery. Within four years of his death in 1614, an epitaph was published 'upon John Combe of Stratford-upon-Avon, a notable Usurer, fastened upon a Tombe that he has caused to be built in his life time:

> 'Ten in the hundred must lie in his grave,
> But a hundred to ten whether God will him have?
> Who then must be interr'd in this Tombe?
> Oh (quoth the Divill) my John a Combe.'

Similar verses on an unnamed usurer had been printed previously and mock epitaphs were common. By 1634, it had been attributed to Shakespeare, Aubrey later adding the detail that it had been extemporised in a tavern. In fairness to Combe, he only charged the standard rate of interest. He left £20 to the poor of Stratford and £5 to William Shakespeare.

5

'No Peace where is no Unity'

Hence I conclude what all the World can see
There is no peace where is no Unity.

<div align="right">Anonymous verse, 1619</div>

Both sides in the enclosure controversy wooed William Shakespeare. His tithe holdings were important, but not crucial to the project. Thomas Greene was in London on 16 November 1614. 'At my cosen Shakespeare commying yesterday to towne I went to see him howe he did: he told me that they assurd him they ment to inclose no further than to gospel bushe & so upp straight (leavinge out part of the dyngles to the ffield) to the gate in Clopton hedge & take in Salisburyes peece and that they meene in April to survey the Land & and then to gyve satisfaccion & not before.' Shakespeare's view on the issue was clear. 'He and Mr Hall say they think ther will be nothing done at all', ultimately a correct opinion.

Shakespeare protected his position by agreeing compensation with Mainwaring's attorney, William Replingham, for any losses through 'inclosure or decay of tyllage' – a step taken by other titheholders including Thomas Greene and Arthur Caudrey of the Angel, who told William Combe that 'he would never consent without the Towne & that he hadd a house and other things more profitable to him than his Land was and that he rather loose his Land than loose their good willes.' The agreement was witnessed by the vicar, John Rogers, a vehement opponent of enclosure. That Shakespeare's behaviour was incontrovertible is demonstrated by the lack of any reproach from Greene, who was scathing about others, like the lawyer, Thomas Lucas, who lined his pockets from the dispute. Even Combe unctuously declared that this rascally lawyer 'could not be an honest man for he had no religion in him'.

The Corporation attempted negotiations with William Combe, sending a delegation 'to present their loves and to desire that he would be pleased to forbeare to inclose & to desire his love as they wil be redy to deserve yt'. Combe preferred the profit of enclosure to civic affection.

With the breaking of the frost on 19 December, the enclosers acted aggressively to create facts. Combe's men started to dig a lengthy trench. The Corporation wrote to Mainwaring and Shakespeare and sought the support of other landowners. 'I alsoe wrytte of myself', recorded Greene, now living at St Mary's House near Holy Trinity, 'to me cosen Shakespear the Coppyes of all oathes made then, alsoe a not[e] of the Inconvenyances wold grow by the Inclosure.'

Greene's stepson, William Chandler, and William Walford became tenants at Welcombe, so increasing the number of claimants with whom the enclosers would have to deal. When

they attempted to fill in the ditches Combe had them flung to the ground, and sat 'laughingly on his horseback & sayd they wer good football players' and 'puritan knaves and underlinges in their colour' – a reference to their acquisition of commoners' rights. Nor did he ignore bribery, offering Greene a mare worth ten pounds 'to propound a peace'.

Both sides rushed to law. On 26 January 1614/15, William Chandler wrote 'to my lovinge father Thomas Greene Esquire at his chamber in the Mydle Temple', requesting him to subpoena William Combe and his associates in the Star Chamber. On 28 March, the Corporation obtained a restraint order against enclosure at Warwick assizes, unless it could be justified in open assize. At this point Mainwaring gave up, but for Combe the matter had become a personal vendetta. He beat and imprisoned poor tenants and depopulated the village of Welcombe. He told Arthur Caudrey that 'yf he sowed the said wheat land he would eate yt upp with his sheepe.' Those attempting to fill in the illegal ditches were assaulted and told that 'in the night their corn wilbe eaten and that they will not know against whom to find remedye and tellinge others they shall be compelled and that their ould bones should be fetcht upp twice in aterm or such like speeches and by his own and others raylinge and reveilinge hath endeavoured to terrifie the petitioners and others the better to compasse such enclosure...'

A sense of civic duty prevailed. When Combe asked Alderman William Parsons why he opposed enclosure, he replied: 'We are all sworn men for the good of the borough and to preserve our inheritance. Therefore we would not have it said in the future that we were the men which gave way to the undoing and that all three fires were not so great a loss as the enclosures would be.' Parsons suffered for his probity. A week later he was beaten up by Combe's men.

On 19 April, Lawrence Wheeler and Lewis Hiccox started to plough their land within the intended enclosure. Combe merely railed at them, which encouraged them to return the next day with Mr Anthony Nashe. Nashe, who was styled a gentleman, was Shakepeare's next-door neighbour and farmed his titheholding, which implies that the action had his approval. In September, Greene made an enigmatic entry in his diary: 'Shakespeare's telling J. Greene that I was not able to beare the encloseinge of Welcombe.' Interpreted literally, this states the obvious. Perhaps Greene, without the advantage of inverted commas, was reporting the conversation verbatim.

It is unlikely that Shakespeare was so ill-informed as to imply that his cousin was unable to 'bar' the enclosure, for the forces of legality were mustering against Combe. Sir Henry Rainsford of Clifford Chambers told Greene that the Combes would never succeed and that he intended to sue William Combe for trespass and riot and to seek sureties of £40 against Thomas Combe. Peter Roswell of Welcombe, another freeholder, declared that he intended a similar course and that Sir Edward Greville 'would stick to him'.

On 1 March 1615/16, Combe had another try, his workmen digging out twenty-seven ridges. The next day, William Chandler sent his man, Michael Ward, to fill in the works. He was assaulted by Combe's men, one Stephen Sly shouting that 'if the best in Stratford were to go there to throw the ditch down he would bury his head at the bottom.'

In a petition to the assizes on 27 March 1616, the Corporation demanded that Combe, 'being of such unbridled disposition ... should be restrained.' Sir Edward Coke decided not to

punish Combe because he was the High Sheriff, but 'badd him sett his hart at rest he should never enclose nor lay downe his common arable land so long as he (Coke) served the King.' Despite such leniency, Combe considered himself ill-used and alleged that the Corporation had 'given money to work my Lord (Coke) and that was no good employment for the town's revenue.'

Combe made new proposals for enclosure, but the Corporation replied that they desired his goodwill, but they would ever oppose enclosure. On 10 April, 'Mr High Sheriff' told John Greene that he was 'out of hope now ever to enclose'.

This belated recognition did not soften Combe's belligerency. Instead, he launched a war of revenge against the Welcombe tenants. The Bailiff wrote to Combe in December that his conscience was 'blinded as yt seemeth with a desire to make your self Riche by other mens losse', so that he paid no heed to judges, 'nor the mynysters Threatnyngs against Enclosures.' A complaint to the court of Common Pleas complained that Combe had not 'laid down meres according to my Lord Hobart's order … And that he hath decayed 117 ridges of tilling and neglecting the farming thereof contrary to own word and promise made to the judge and justices at the time of their conferences.' Neglect had the same effect as enclosure. 'The grief for decaying is the destruction of our common and the decaying of the tilling is the losse of our tythes with which the poor are free.'

The bailiff brought a contempt action against Combe in 1617. The warrant was delivered by Richard Hathaway, Anne's nephew. By this time, Thomas Greene had moved to Bristol, selling St Mary's House for £640. Perhaps the absence of his old antagonist encouraged Combe, for in 1618 he brought his campaign to the borough boundary when his indefatigable workmen began to dig a ditch to enclose Butt Close, next to Clopton Bridge. The Corporation paid its own indeflectable workmen 2s 4d to fill it in.

Combe's reputation was reaching the highest councils in the land. In 1619 he received a sharp letter from the Privy Council. He must restore the enclosures and abide by judicial rulings or face the consequences. At last he became alarmed and capitulated. The decision had gone against him in every court and a contempt action was pending. The Corporation, generously and judiciously, decided to cut its losses. On payment of a £4 fine, it granted 'Mr Combe, his pardon for enclosing.'

And Death Once Dead

On 20 February 1615/16, Judith Shakespeare, aged thirty-one, and perhaps resigned to spinsterdom, was given in marriage to Thomas Quiney, four years her junior and son of that Richard who had been so assiduous in the defence of the rights of the borough. The Quiney's were vintners and the marriage may have been long intended, for in 1611, Judith had placed her mark to witness deeds for Elizabeth Quiney and her son, Adrian. In the same year, Thomas Quiney leased the tavern next door to his mother's in the High Street.

What looked to be a sound match linking two leading local families began disastrously. The bride and groom were excommunicated for marrying in the prohibited season, although this was lifted on payment of a fine. The offence was not serious and may be attributed to the

incompetence and greed of the ecclesiastical authorities. Yet Quiney had a reason to marry in haste. He was seeking to exchange premises with William Chandler, his brother-in-law, who kept The Cage (formerly the town lock-up), opposite the Market Cross. Judith's marriage portion would help finance the move, which took place in July.

There was a more serious problem. On 26 March, the consistory court heard Quiney's confession to carnal copulation (*fassus est se carnalem copulacionem habuisse*) with Margaret Wheeler, daughter of Randle Wheeler, a carrier occasionally employed by the Corporation. This unfortunate young woman had died in childbirth. A sad entry in the parish register on 15 March 1615/16 records the burial of Margaret Wheeler and her child. The court ordered Quiney to pay public penance on three consecutive Sundays, dressed in the customary white sheet: a penalty remitted on payment of what was, for this court, the considerable fine of 5*s* and the performance of private penance before the minister at Bishopton chapel. The incident did not affect Quiney's standing in the town, for he became a burgess and a constable in 1617 and was Chamberlain in 1621 and 1622. His first accounts were returned as unsatisfactory, but were later ratified. His second accounts carry his elaborate signature and a misquoted couplet from the French poet, Sainte-Gelais: *Bien heureux est celui qui devenir sage / Qui par le mal d'autrui fait son apprentissage.*

Quiney's transgressions led his father-in-law to revise his will, changing a draft that had been made in January. He must have been severely ill when he signed this document on the day before the bawdy court met at the vicarage opposite New Place. The three signatures are written with difficulty. Perhaps he was lying in bed and struggled to rise before falling back on the pillow. He knew that he was dying for he bestowed the interest on £150 on Judith if she were alive in three years, which assumed that he would not be. Her husband could not touch the capital sum unless he settled lands on her to the same value.

Clustered around the bed were the witnesses. There was Juline Shaw, a wool dealer who lived two doors away. In 1613, the Corporation, 'much approving his well-deserving in this place, for his honesty, fidelity and good opinion of him', had elected him an alderman. There was Hamnet Sadler, a life-long friend, and two men who were probably Shakespeare's servants, Robert Whatcott and John Robinson.

The will is a lawyer's draft, either by Francis Collins, Shakespeare's attorney, or his clerk. The opening statement that the signatory was 'in perfect health and memorie' is a legal convention, as is the religious declaration that follows. There are no phrases of endearment. It is 'my wife' and 'my daughter', not 'beloved wife' and 'dear daughter'.

Despite the death of Hamnet, the desire to pass the estate to a male heir remained. If not of the name, he should be of the blood. Shakespeare's property was entailed through Susanna to her eldest son. Although she had no sons, at thirty-three there was still hope. Failing this, the estate was to pass through her daughter, Elizabeth, to her sons. Only if all these contingencies failed was the estate to pass 'to the Right Heires of me the said William Shakespeare for ever.'

Judith was given an ample cash settlement – £100 for her marriage portion and £50 if she renounced her claim to a cottage in Chapel Street. Perhaps it was intended for her before her marriage was arranged. As a keepsake she received her father's 'broad silver-gilt' bowl.

Other bequests follow. Joan Hart, the poet's sister, received £20, his clothing and the life tenancy of the Henley Street house, half of which had been converted into a drover's pub, The

Swan and Maidenhead. It is curious to think of Shakespeare owning a tavern. Joan's three sons were left £20 each, although no one present could recall the name of the youngest. Elizabeth Hall received his plate, while Thomas Russell of Alderminster and Francis Collins were left £5 and 20 marks respectively, and asked to act as overseers of the will. The poor of Stratford got £10; William Walker, Shakespeare's godson, £20 in gold; Thomas Combe was bequeathed Shakespeare's sword, but his aggressive brother, William, was ignored. Some old friends were left 28s 6d each to buy memorial rings: William Reynolds, Anthony and John Nashe and 'my ffellowes John Hemynges, Richard Burbage and Henry Cundell', the only members of the theatrical profession to receive bequests. That year, Ben Jonson had become the first author to supervise a folio collection of his works. Perhaps Shakespeare cracked a few jests at Ben's expense while planning to follow suit, discussing the project with the three major shareholders in his old company, who would own the manuscripts. When he knew he was dying did he ask them to continue the task and leave the rings as a reminder of the pledge? Burbage died in 1619, but the other two completed the First Folio and in the prefatory epistle hint at Shakespeare's role in the preparations. 'It had been a thing, we confess, worthy to have wished that the author himself had liv'd to have set forth and overseen his own writings.'

Another recipient of ring money was Hamnet Sadler, whose name replaces Richard Tyler's in the second draft. Tyler too had known Shakespeare all his life, but may have been deleted because of suspicions about his character. He was one of five Stratfordians authorised to collect abroad for the victims of the great fire of 1614. An audit in the month that Shakespeare made his second will found 'every one prefferinge his own private benefittes before the general good' and 'exhibitinge to us bills of charges, excedinge theare collections.'

The most famous bequest is to Anne Shakespeare. 'Item I gyve unto my wief my second best bed with the furniture.' This has been interpreted as a posthumous slight; by implication, the best was reserved elsewhere. Yet the bed was probably the marital one, the best being reserved for guests. Others made peculiar provisions for beds. In 1609, Thomas Combe, in another will drawn up by Francis Collins, left his best bedstead to his son. Shakespeare's best bed would not pass to the dark lady or some other mysterious paramour, but to his heirs, the Halls.

The only recorded indication of the cause of Shakespeare's death is in another curious note by the Revd John Ward in 1662. 'Shakespeare, Drayton and Ben Jonson had a merry meeting and it seems drank too hard for Shakespeare died of a fever there contracted.' Since Ward's informant was Shakespeare's daughter, Judith, the statement must be taken seriously. If such revelry occurred, it could have been in London. Ben had cause to celebrate in early March when he received royal patronage, with an ample allowance of wine as part of his stipend. Perhaps Shakespeare's return was through the winds of March over roads that were a quagmire. But perhaps this is too late. Shakespeare was presumably well when he spoke to Thomas Greene in September 1615. By January when he made the first draft of his will' with all the perspicacity of pre-industrial man displayed by many of his contemporaries, he must have been aware of his approaching death. The putative meeting could have been in Stratford. Ben was a great traveller, walking as far as Scotland, while Drayton was regularly in Stratford, sojourning with his friends, the Rainsfords of Clifford Chambers.

Shakespeare's death may have been caused by his residence in an insanitary corner of a pestilent town. Along the length of Chapel Lane ran an open, festering ditch. Despite

many complaints about it, the Corporation making futile efforts to clean it up over three centuries. The issue was compounded by the pigs which the inhabitants kept in the streets. The chief offender was the vicar, John Rogers, who pleaded the necessity of poverty. In 1613, his neighbours petitioned the removal of these sanctified swine, but they crept back under his successor.

'He dyed a papist', wrote Archdeacon Richard Davies late in the seventeenth century, who, as a member of the Anglican hierarchy, was not a special pleader. Given the lack of decisive evidence it is best to be agnostic about Shakespeare's religion, but it should be noted that he allegedly died a Catholic rather than lived as one. Such returns are not without parallel. Catholic priests were still to be found in Stratford. William Reynolds, Shakespeare's recusant friend, also lived in Chapel Street and it was to his door in 1603/04 that a 'supposed seminary escaped at Stratford' was seen running, wearing green breeches, high shoes and white stockings. In August 1615, at Clifford Chambers, Reynolds married a Frenchwoman, Frances de Bois, 'of London in Philip Lane'. Perhaps the Shakespeares were present at the wedding.

On 17 April 1616, the funeral cortege of Shakespeare's brother-in-law, William Hart, the hatter, wound past New Place. The poet must have heard the great bell of the Guild Chapel tolling its melancholy tone. On 23 April, the day posterity was to deem his birthday, he died. Two days later his funeral procession departed from the courtyard of New Place, crossed the stagnant ditch and passed the gate of the school where he had studied as a boy and the Guildhall where he probably saw his first play. Holy Trinity would have been filled with the names that compose Shakespeare's Stratford: Quiney, Sadler, Greene, Hall, Reynolds, Nashe, Shaw, Walker, Hathaway (Anne's nephew, Richard Hathaway, had just been made a churchwarden) and the rest. As the minister intoned the burial service, the body was lowered into its grave at the high altar – the privilege of a tithe holder rather than a mark of esteem. Thus, the world saw the last of Shakespeare the man. The literary legend would not be confined in the Stratford earth.

'Together by the Ears'

The vicar did not receive a fee for burying the greatest figure of the age. It had been decided that such monies would go towards repairing the dilapidated chancel. Relations between the Corporation and its vicar were good at this time. That year wine was sent 'to Mr Rogers when his brother preached'. In a similar spirit, a supporting testimonial was sent in June 1617 on behalf of the lawyer, Thomas Lucas, whose devious ways had got him into trouble at Gray's Inn. Relations with the two men deteriorated soon after. The probable reason is to be found in the will of Francis Collins, made the day before his death on 26 September. He recorded that he and Rogers were trustees of a charitable legacy consisting of two houses, but that Rogers and Lucas 'did combyne themselves together and keep it from the poore most uncontionably'. Lucas had responded by suing Collins and making accusations against Thomas Greene, the Town Clerk. The Corporation banned dealings with him and he got a local dignitary, Sir Clement Throckmorton, to plead for him, somewhat equivocally. 'That which is good in Mr Lucas I wish much good to; I hope his ills the divine light will be in time making him see.'

If Lucas dropped his suit against Collins and apologised to Greene, Sir Clement hoped that the Corporation would continue to employ him. The appeal had its effect, for the reply was conciliatory. The burgesses also went out their way to cajole Rogers into better behaviour. On 30 January 1618, they gave him 'a fitt gown of good broad cloth … in hope that hee will well deserve the same hereafter. And amend his former faults and failings.'

Rogers failed to take this generous hint and gave his enemies a golden opportunity by obtaining a second benefice elsewhere. Lucas, who had made his peace with the Corporation, turned on his former confrere and advised how to dispose of him. His replacement, presented by Lord Chancellor Verulam on 6 March 1619 and endorsed by the Corporation by eighteen votes to seven, was a well-known Puritan divine, Thomas Wilson of Evesham.

Rogers, who refused to leave the vicarage, had his friends. Perhaps his easy-going ways appealed to the considerable body of citizens whose religion did not exclude cakes and ale. When Wilson arrived to conduct his first evening service on 20 May, he was met by a wild crowd armed with swords, daggers, bills, pikes and stones, screaming, 'Hang him, kill him, pull out his throat, cut off his pockie and burnt members. Let us hale him out of the church.' A way was cleared through the mob and Wilson hurried inside, the great doors slamming behind him. Some of the crowd broke in. Others battered at the doors and threw stones through the windows. The next day, Wilson was inducted into his living in the presence of the Corporation.

The most ferocious of the rioters were women. On 24 July, five of them and two men were presented before the Curate, John Owen. One of the men was Thomas Lucas, who had engaged in a fracas with a minister, Master John Bursye, 'striking and using him unreverently, calling him scurvy rascal knave'.

In September, the opposition found a cause that was cohesive for traditionalist and hooligan alike. Doubtless encouraged by the approbation given to dancing and 'such harmless recreations' by King James, the townspeople erected a maypole on the church path. It was removed by order of the bailiff, John Wilmore, who stressed that it was because it caused an obstruction, 'not for any dislike to the pole', which the townsfolk could re-erect 6 yards away. Re-erect it they did, but in the same place, to 'the great danger of raising a mutiny.'

The Corporation responded by enacting a Bill in Chancery, drawn up by Lucas, against those they regarded as the chief instigators of the disturbance, who included John Nashe (uncle of Elizabeth Hall's future husband); William Reynolds (Shakespeare's friend and, like Nashe, legatee); John Lane, gentleman (defamer of Susanna Hall); John Rogers (the quondam vicar); John Pinke (a local satirical poet); William Nixon (the corrupt apparitor of the consistory court); William Hathaway (Anne Shakespeare's half-brother); Thomas Courte, blacksmith, son of John Shakespeare's neighbour); Raphe Smith, haberdasher (with whom Susanna Hall was said to have 'bin naught') and 'divers other persons for malicious, libellous and riotous behaviour.' It is tempting to see the episode as a last flourish of the personalities of Elizabethan Stratford.

The 'libellous' offences consisted of circulating scurrilous verses. The Star Chamber proceedings reveal the literary vigour of some of Shakespeare's neighbours. *A Satyre to the Cheife rulers in the synagogue of Stratford* protests against the oligarchic control exercised by a handful of Puritans.

Stratford is a Towne that doth make a great shewe
But yet it is governed by a fewe.
O Jesus Christe of Heaven,
I thincke they are but Seaven,
Puritantes without doubt,
For you may knowe them, they are soe stout.
............
A heavy curse (o lord) upon them send
Because they have bereft us of our best friende
And in his steede here have they plast
A fellow that hath neither shame nor grace.
Yet these men are True Religious without Quirkes,
For one of the chiefest hath red far in Perkins [5] Works.
But soft my satire, be not too free,
For thou wilt make them spurn at thee,
For rubbe a horse where scabbe be thick
And thou wilt make him wince and kick.
Be sure their lawyer is of God accurst,
For he began this business first,
And with his malice and his spite
Was first that brought this 'lapse to light.

The lawyer was, of course, Thomas Lucas.

Another onslaught took the form of a letter:

Sirrah ho! The greatest news since Pentecost. Where there is report that all the old biting and young suckling Puritants of Stratford are joined with their two Justasses a piece maliciously to displace and utterly undo their Minister and to bring in his place as arrant a K------ as themselves, of purpose to assist them in their hypocracy, and now seeing they have set all the town together by the ears, which is the true effect of a Puritant, and finding their plot hath not their wished effect, it is thought that divers of them will run horn-mad: therefore I would have thee to make haste up hither.

The writer 'skibs' at one Puritan as 'too busy', another 'shows like a monster with four elbows ... because he useth in his gait or going, as some observe, to shake his elbows.' Another is 'a cobbler turned divine'. The conclusion is that 'some death-unconscionable knaves will hearken to nothing but their greedy desires. Therefore, farewell from Romany, this merry month of May; thy honest friend (if thou dost not turn Puritant). F. S.'

'Divers of them will run horn-mad ...' Shakespeare's Malvolio reflects the propensity of the Puritans to illicit sensuality. The same passions seem to have occurred closer to home than Illyria. One of them, according to a broadsheet by Joh[n] P[inke] had had carnal knowledge of 'one Margery Gunne, wife of John Gunne ... in a barley-close called The Farm'.

The Puritants are now found out, their walking late and early,
Beshrew their hearts, they spoil men's grass and do not spare the Barley.
The auntient leadinge Hipocrite, that is of all that sort,
(Some say), a sermon lately lost to await for sport;
But now 'tis meant in better sort (as some of them do say):
The cause why he neglected church was but to save his hay.
But take heed how you do him charge with doing any harm;
He'll drive the countery of him that tells him of the Farm.

The Puritan in question must have been Daniel Baker, around whom still clung the memory of the scandal of 1606.

Now it was Rogers' turn to lament, a burden assumed on his behalf by a local sonneteer of some merit.

Whoe will relieve my woe? My hearte doth burne
To see man's state, wane as the winde doth turn:
He warrs and winns and wynninge lost by strife
Warr is another death, a sure uncertayne life.
Trye then and trust, give credit by delaye.
The feyned freinds, with feyned looks betraye,
Baker had never lived to vanquish mee,
Had it not bene for Lucas trecherye.
Shall I of Chandler and busy William speake?
That bade me make a tale and it to break?
Hence I conclude, what all the world doth see –
There is noe peace where is noe unity.
Though I on earth for thee receive disgrace,
Live I in Heaven, see Jesus face to face.

The splendid introspective effect is marred by a scurrilous chorus about Wilson. 'June, July, August and September, / Although he comes he shall not mortifie one member / A very rogue he is / He cannot draw his pintle for to piss.' The reference to 'Chandler and busy William' (probably Walford, his collaborator in resistance to the Combes) is unclear. Apparently, they encouraged the vicar and then let him down. Although described as such by Combe, Chandler was no Puritan. During his bailiwick in 1618, he defied the ban on players of Baker's year.

Under a new bailiff, William Wyatt, father of one of the accused rioters, some attempt at compromise and compensation was made. It was resolved that Rogers was paid £5 to end his squat in the vicarage. The outcome of the Star Chamber proceedings is unknown, although it does not seem to have affected the later careers of the defendants. William Reynolds resisted the charges strenuously, replying to the Attorney-General that he was 'persuaded his name is inserted upon some causies mallice'. At a subsequent consistory court, the wife of Will Piggott, a maltster, was presented 'for revyling and miscalling Mr Wilson, our vicare, giving him the tytle of a knave.'

Stratford Monument

In 1634, an Army officer, Lieutenant Hammond, visited Stratford. He recorded the tradition that Shakespeare had extemporised verses on the usurer, John Combe. At the church, he admired the 'neat monument of that famous English poet, Mr William Shakespeare, who was born here.'

The monument had been in place for at least eleven years. In the prefatory poems to the First Folio of 1623, Leonard Digges, a poet with local connections, wrote,

> Shakespeare at length thy pious fellows give
> The world thy works; thy works, by which outlive
> And time dissolves thy Stratford Monument
> Here we alive shall view thee still.

According to a sonnet by William Basse, there had been a proposal to reinter the poet's remains in Westminster Abbey, but the erection of the monument must have inhibited any such move. The sculptor was Gerard Johnson, a young man of Flemish origin who worked in Southwark near the Globe Theatre. He also sculpted the tomb of John Combe. It was probably Shakespeare who commended him to the family. Presumably, the poet's London associates oversaw the creation of the monument. The epitaph is more disinterested than one composed for the family, concentrating on Shakespeare as artist, rather than as father or husband. It demonstrates a lack of knowledge of Holy Trinity and that Shakespeare was buried in a grave rather than a tomb. It would be difficult indeed to hurry past the monument at the high altar.

> Stay passenger, Why goest thou by so fast?
> Read if thou canst whom envious death has plast
> Within this tomb. Shakespeare with whome
> Quick Nature dide, whose name doth decke this Tombe
> Far more than cost. Such all yt he hath writt,
> Leaves living art but page to serve his WITT.

Shakespeare, it seems from traces of the original paint, had hazel eyes and auburn hair. The kindest view of that stodgy face is taken from a death mask. The sculptor would have required such an image. The bust was clearly a sufficient likeness to satisfy Shakespeare's family and friends. Perhaps his old company came to see it in 1622 when they attempted to play in the Guild Hall. This caused some embarrassment to the Corporation. The regulations forbade plays, yet these actors were under the patronage of the King. The Chamberlains' accounts reveal a compromise. The King's Men were paid 6s 'for not playing in the Hall.' Doubtless they got a warmer welcome at New Place.

The inscription on Shakespeare's grave has caused much speculation. 'Good friend for Jesus sake forbeare / To dig the dust enclosed heare / Bleste be the man that spares these stones, / And curst be he yt. moves my bones.'

The verse is not addressed to the passer-by. Nor is it a prophetic vision of those that would seek to exhume the Bard in the hope of proving that the works of Shakespeare are the product of another's hand. The 'good friend' is the sexton, who disinterred bones to make way for newcomers: a practice evoking Hamlet's distaste as he watched the gravediggers dig up poor Yorick's remains. 'Did these bones cost no more in the breeding than to play at loggats with 'em? Mine ache to think on't.' William Hall, who visited Stratford in 1694, declared that Shakespeare wrote the lines to frighten off ignorant clerks and sextons, adding that he 'descends to the meanest of their capacities and disrobes himself of that art which none of his contemporaries had in greater perfection.' Yet it is unlikely that Shakespeare wrote his own inscription. Few do so for obvious reasons. No matter who wrote it, the epitaph has served its purpose. Near the bust is the outline of a door which once led into the charnel house where disinterred bones were stored. Such was the fate of the mortal remains of Shakespeare's family.

Minister Wilson

As expected, Thomas Wilson proved a dedicated Puritan. He must have enjoyed a brief honeymoon of favour among his adherents, but their factiousness and his stern moral code inevitably led to friction. Although he was regarded as a fine preacher, no word of his has survived to posterity. Whether his preaching had an effect on the morals of his congregation is impossible to say, but it is possible to gain a picture of those who offended against the code through the fragmentary records of the bawdy court.

Holy Trinity was built to hold the whole of Stratford's population. Indeed, with canons demanding compulsory attendance, it had to do so. The small group of recusants continued to pay fines rather than worship against their consciences. Others were too infirm to attend. 'Neither did old Sibel Davis communicate', reported the churchwardens in 1622, 'by reason of her extreme povertie and want of clothes.'

The spectacle of virtually an entire town attending church was not always edifying. The consistory court regularly heard offences against ecclesiastical propriety. On 22 May 1622, Richard Baker, a shoemaker, was presented for 'stryking in the church in tyme of the sermon... the son of John Rogers of Shatterlie.' He claimed that the boy was playing and 'keeping a noyse' and he could not hear the preacher. He admonished the boy to desist, but he would not, so he gave him 'a little tappe upon the head.' The vicar dismissed him with the caution that 'from henceforth he stryke no more but if such offence be in church he shall complayne to the magistrate that such boys may be whipped.' It must have been a dull service that day, for Edward Rogers was also presented 'for stryking the servant of William Castle, glover, in sermon tyme.' He admitted that he 'did swing the boy by the eare because the said boy did fight and jostle with another boy and did disturbe the congregacon.'

A matter which occupied the court for five years from 1619 was the affair of William Bromley and Elinor Varney. William, born in 1580/81, was the son of Edward Bromley, the carrier. Elinor was born in 1585 and her father was registered as a pauper in 1596. In 1609, the year of his death, he sued Peter Ruswell and others, including Gilbert Shakespeare. When

Elinor served Ruswell with the writ, he 'did vyolently snatch it … and refused to redeliver it unto her and delivered his staffe he then had in his hand to a stander by who therewith did assault and beate this deponent out of the house.'

Elinor was servant to William's widowed mother, Joan Bromley. She must have been related to the Bromleys, or perhaps she assumed the status of a status of a foster-daughter, for the relationship she developed with William was deemed incestuous. On 3 February 1618/19, an 'infant of Elnor Varines de Shotery, uncrisoned, a b…' was buried. William Bromley was later presented for begetting a bastard. The verdict is lost, but it did not inhibit the relationship. In July 1621, during the triennial period when the functions of the court passed to the diocesan authorities, William was presented by the churchwardens to the Bishop of Worcester 'for Incestuousness together.' The lack of his court increased the bureaucratic duties of the vicar. He was in correspondence with John Trewman of Feckenham about Will Ball, a servant, who promised to marry Anne Deloes of that parish and then moved to Stratford, where he pledged himself to Mary Wilson, 'contrarie to all truth.'

With the reversion of the powers of the court, an Elinor Bromley was presented for fornication, so she may have assumed her lover's name. Bromley was excommunicated by the following May, when Thomas Woodward, who 'hath ben heretofore admonished to desist from the same', was presented for keeping company with him. Woodward appeared and failed to appear several times in the next few months for the same offence and for 'being in alhouses uppon the Sabaothe day in time of divine service and not coming to the church.' William and Elinor appear to have left town together by then, for neither appears in the burial register. Woodward's continued association with them must reflect sympathy or an indifference to moral sanctions.

As may be expected in the increasingly Puritan atmosphere, the most frequent charge was that of Sabbath-breaking. In March 1621, Thomas Couper was presented for 'playing at cards and soffring other in prayer tyme on ye Sabothday' and in July, Arthur Brogden and David Ainge for opening 'their shoppes and sellinge fflesh on Sabaoth dayes'. Generally, such offenders were let off with a warning on promising to reform, but in 1624, John Mase was presented for 'suffering drunkenes and fightinge with much disorder in his house on the Sabaoth day in tyme of praires.' He was obliged to confess before the magistrate, churchwardens and minister and to pay 12*d* to the poor. When he failed to pay in full, he was presented for not attending catechism and for 'a common drunkard'. He must have reformed, for in the following May, the court licensed him to practice something related to medicine, perhaps as an apothecary.

Blasphemy was considered a more serious offence. On 22 May 1624, Eleanor, wife of Thomas Silvester, was presented for 'saing that God did doate and that God knew not what he did, with manie other blasphemous speeches and cursed oathes.' This precursor of Nietzsche admitted that 'she did speak such wordes.' She was ordered to attend Holy Trinity next Sunday 'at the beginning of Morning Prayer and then to performe her penance' on pain of excommunication. This had little effect. On 16 July, she was presented again 'for blaspheaming of Godes most holy name.' She did not appear and was ordered to 'come before Mr Bailie, Mr Alderman and the minister'. Her fate is unrecorded, but the secular arm of the law was more severe than the ecclesiastic. We think of the ducking stool by the Avon.

On the same day as Eleanor Silvester's first appearance, Stephen Lea was presented for 'singing prophane and filthie songs, scoffing and deriding on ministers and the profession of religion.' On promising to reform, he was dismissed with a warning.

The ancient May Day revels were anathema to this Puritan regime. In 1621, Thomas Clarke was presented for 'playing with his tabor and pype upon the First daie of mai in evening prayer tyme at Bishopton'. Those who had rioted in 1617 were intuitively right. In 1622, a number of Mayday revellers appeared before the court. George Quiney, the Curate, presented 'Mr Birch's man for dauncing the morris in eveninge prayer tyme.' John Allen, William Plymmer and Humphrey Brown were presented for the same offence which took place 'on the feast day of Phillip and Jacob'. Allen admitted his offence and 'saith that he will never committ the lyke.' The three were ordered to perform public penance on the following Sunday. John Rickittes of Shottery, who made up the foursome in the dancing team, was excommunicated for non-appearance. Further insight into the maying festival in the village is provided by Francis Palmer, servant to John Hobbins, also of 'Shatterlie' who was presented 'for being the Maid Marrion' – presumably in the pageant of Robin Hood or Goodfellow. It was probably because of his youth that he was pardoned.

Allen was in trouble again at the next session of the court. He had failed to perform his penance and 'committed the lyke offence againe'. He was 'enioined that the next Sabaoth day presently after the reading of the gospell he confes his falt in the midle ile'. The order adds ominously 'that the congregacon may take notice of it'. In these censorious attacks, a 'Merry England' emerges that the Puritan ascendancy was seeking to extinguish. Yet its diminution would not bring renewed unity to society, for that Puritanism would prove divisive of itself.

6

'From the very Jaws of Death'

…restoring me, as it were, from the very Jaws of Death to former Health.

The Casebooks of John Hall

Sometime after the Battle of Edgehill, Dr James Cooke, a surgeon from Warwick, was posted to those remnants of the Parliamentary Army deputed to guard the bridge at Stratford. The town had its compensations. John Hall, one of the great doctors of the previous generation, had lived there. Cooke must have known him, for both men had ministered to the household of Lord Brooke in Warwick. Now he sought an introduction to his widow and was delighted to find that an Army colleague was a relative of Hall's. 'He invited me to the house of Mrs Hall, wife to the deceased, to see the Bookes left by Mr Hall. She told me, she had some Books left by one that professed Physick, with her husband, for some money. I told her if I liked them, I would give her the money again.' He noticed that two of the documents were written by Hall, 'I being acquainted with Mr Hall's hand'. Susanna disagreed. 'She denyed, I affirmed till I perceived that she began to be offended.' He agreed to reimburse what she thought she had been paid in return for the manuscripts. The mistake does not imply that Shakespeare's daughter could not read, rather that, sixty-year-old widows can be weak of sight. An illiterate would hardly dispute handwriting with a learned doctor.

Although Hall had prepared his casebooks for publication, it was fifteen years before Cooke got them into print. There were the characteristic difficulties in deciphering a doctor's idiosyncratic handwriting, but such was Hall's reputation that the task of translation from the Latin and decoding medical abbreviations was considered to be worthwhile by all whom he consulted. One of the volumes (the other was lost at some point) was published under the curious title, *Select Observations on English Bodies*. Cooke added a preface, a few cases from other famous practitioners to bring the total to 200 and a postscript explaining, 'I had almost forgot to tel ye that these Observations were chosen by Hall from all the rest of his own, which I conjectured could be no lesse than a thousand, as fittest for public view.'

A second preface eulogising Hall's contribution to contemporary practice was written by John Bird, Professor of Medicine at Cambridge University, who added that Hall intended the posthumous publication of his casebooks 'when men more willingly part with what they have.' The book was successful. Three editions were published in the next twenty years.

The book caused a stir elsewhere. Some of Hall's patients were still alive and did not welcome the intimate revelations contained in the embarrassingly explicit casebooks. 'Fluxes of the courses', 'worms', 'whites' and 'stools' – such terms must have brought a blush to many a faded cheek. In his preface to the third edition, Cooke apologised for naming names, although he had the discretion to render anonymity to a gentleman who suffered from gonorrhoea.

The casebooks tell us much of Hall the doctor and something of Hall the man. Frustratingly, the prefaces give little biographical information. It is known that his father, William Hall, an astrologer and alchemist, was keen that his brightest son should follow him in the arts which held an esteemed place in Elizabethan society, although Hall had his doubts. The father left his books on astrology and alchemy to his servant, Matthew Morris, since John would 'nothing to do with these things'.

Matthew Morris followed John Hall to Stratford. He married there in 1613 and named two of his children Susanna and John. Perhaps he fulfilled any demand for astrology and alchemy among Hall's patients. Hall's trust in his assistant was shared by his father-in-law. In 1617/18, his house in Blackfriars was conveyed to John Greene of Clement's Inn and 'Mathew Morrys' of Stratford, 'in performance of the confidence and trust reposed in them by William Shakespeare deceased.'

Around 1810, Robert Bell Wheler saw in some old papers that 'Dr Hall resided in that part of Old Town which is in the parish of Old Stratford.' James Halliwell also saw this document some time before 1864, but it is now lost. The large early Tudor house now known as Hall's Croft is one of the handful of properties that fulfils the necessary criterion.

There is no mention of Hall's Croft in his verbal will made in 1635. If the Halls did live there, they moved after Shakespeare's death, for in 1617, Thomas Greene paid a debt to 'Mr Hall at Newplace'.

Some have observed Hall in the character of Cerimon, the aristocratic doctor of *Pericles*.

> …Tis known I ever
> Have studied physic, through which secret art,
> By turning o'er authorities, I have,
> Together with my practice, made familiar
> To me and to my aid the blest infusions
> That dwell in vegetives, in metals, stones;
> And I can speak of the disturbances
> That nature works and of her cures…

Hall certainly overturned authorities. 'It seems', says Cooke, that he 'had the happiness to lead the way to that practice almost generally used by the most knowing of mixing scorbutics in most remedies; it was then, and I know for some time after, thought so strange, that it was cast as a reproach on him by those most famous in the profession.' Long before such terms were categorised, Hall realised that scurvy was a deficiency disease. His cure, a mixture of scurvy-grass, watercress, brooklime, juniper berries and wormwood, rich in vitamins, cured many sufferers. The eldest son of Mr Underhill of Loxley, aged twelve, bore the excruciating agonies which torment those with this harrowing disease. 'I found him grievously afflicted with the scurvy; on the right side he had a tumor with out discoloration, so that I judged there was a tumor of the liver. He was grown as lean as a skeleton, was melancholy, with black and crusty ulcers appearing on his legs. He had a loathing of meat, a disposition to vomit and an Eratic Fever, his urine was red, as in a burning fever, yet with out thirst or desire to drink.' That this collection of abominations was cured demonstrates Hall's intuitive brilliance.

The earliest dated observation is in 1617, the year after Shakespeare's last illness (but Hall mainly recorded his successes), when Hall treated Baron Compton (later Earl of Northampton) for toothache. When Compton became Lord President of the Council in Wales, Hall was summoned a considerable distance, to Ludlow Castle, to treat his family. On 22 March 1622, he ministered to his forty-four year-old Countess, whom he describes as 'pious, beautiful and chaste.' She was the daughter of a wealthy merchant Sir John Spencer, who opposed the match with the young Warwickshire gentleman. It was reputed that Compton carried his bride from her father's house concealed in a baker's basket, giving Shakespeare the idea for Falstaff's escapade.

The most engaging of Hall's patients was the only son of this love-match. Spencer Compton was born at the family seat of Compton Wynyates in 1601. He was a brilliant and courageous horseman. Once, when Hall went to Compton Wynyates to treat his Countess ('born of noble offspring, notably educated and of a very good disposition, very fair and beautiful'), who was suffering from severe fever and 'filthy yellow jaundice', contracted in the seventh month of her pregnancy, he was of service to her husband also. 'The Earl of Northampton, aged about 32, following his hounds in a cold and rainy day, got cold and suddenly was miserably tormented with flatuous pleurisy. He had a small cough, was restless, feverish, thirsty and the pain was stretching. I being present when he came home prescribed [a] clyster.' The effect was as expected: 'for this gave three stools and desired effect for the pain was mitigated...' For the Countess, whom Hall was not willing to purge due to her condition, a pleasant mixture was prescribed: 'the flowers of marigolds and Rosemary, Carduus Benedictus, Flowers and leaves of Melitot, boil them in a sufficient Posset, drink with a little sugar... by these she was again cured and after brought to bed with a daughter, which I saw in her arms.'

Hall treated the Countess's chambermaid, Mrs Wincol, 'aged about 48', for prolapsed haemorrhoids, which he replaced manually in a painful operation. 'The Anus was fomented as hot as could be endured. After the fundament was put up with one's finger and a sponge dipped in the decoction and wrung out, was applied thereto, on which she sat ... thus was she delivered from the aforesaid evils.'

The *Observations* contain names familiar in Shakespearean biography. The poet would have known the brilliant George Quiney, younger brother of Thomas, who became curate and assistant schoolmaster after graduating from Balliol College. In 1622, the Corporation – or Daniel Baker – attempted to replace him with its own nominee, John Trapp. Sir Edward Greville, the Lord of the Manor, appealed to the Lord Treasurer, but the action was abandoned 'uppon advice taken and the truth appearinge ... and the towne sithence hath quietlie enjoyed the same.' Quiney died of turberculosis at the age of twenty-four. 'Many things having been tried to no purpose', wrote Hall, 'peacefully he fell asleep in the Lord.'

The most interesting cases are those of Hall's wife and daughter. When Susanna suffered from colic he tried a complicated herbal cure that brought no relief, so he resorted to a traditional remedy. 'I appointed to inject a pint of sack made hot ... This presently brought forth a good deal of wind and freed her from all pain.' Elizabeth Hall, 'my only daughter', was cured of '*Tortura Oris*' (convulsions of the mouth) and a general constitutional disturbance with a fomentation of *acqua vitae* and spices. A curious note adds that 'she eats nutmegs often'. Perhaps she was addicted to this mild narcotic.

Much of Hall's ministration was to the effect of excess. The contemporary diet of huge meals and a virtual lack of fresh vegetables was formidable, but it would be a mistake to judge the general health of the population from a doctor's casebooks. Obesity had its sad side effects. 'Mrs Sheldon being corpulent, was wont to miscarry often, the second month after conception.' Hall put her on a diet and she achieved her desire. 'She … brought forth a lusty son and after that many more.'

Excess of a different kind troubled a gentleman from Northampton who suffered from gonorrhoea. Hall and Sir William Harvey, discoverer of the circulation of the blood, tried various cures, but the disease followed its course of alternating virulence and dormancy. Hall's unsuccessful formula consisted of a powder made from sarsaparilla, bark of guaicum, cinnamon, senna, dodder, hellebore root and fine sugar.

Hall's care was not restricted to the wealthy and influential. The record of one Hudson, a poor man suffering from vertigo, indicated labour amongst the needy. In 1632, the Corporation paid 4s 7d 'for a portell of sack and a portell of claret given to Thomas Lucy and Sir Robert Lee … at the Swan, when they came to confer with Mr Hall about the poor men which were arrested.'

Hall favoured the use of purgatives. There is a note of satisfaction when a treatment is successful. 'Mr Fortescue (Catholick) of Cook-hil, aged 38, (a great Drinker, of very good habit of Body, sanguine, very fat) fell into a scorbutic Dropsy by a surfeit, with difficulty of breathing, hard tumor of the Belly, Cods and Feet, wind in the sides, the yellow jaundice spread over the whole body and tumor of the Sides and Belly and by all these was much troubled.' Hall purged him every three days, took him off the beer and substituted a cold herbal drink. 'After to sweat was this prepared: Guiacum shaved … Water nine pints, boil it to the half, towards the end cast in Soldanella dried, the inner Bark of Cinnamon, Raisons unstoned … after they are boyled enough, pour them into a Glass Vessel in which there are three pints of White Wine. Of which take … in the morning … and evening, covering him well that he may sweat.' Fortescue found the diet 'trying', so Hall prescribed him a purgative consisting of jalap, cream of tartar and an electuary of tamarinds. The effect was good. 'It gave six stools … By these means in six weeks he was perfectly cured. Glory and honor to God.'

The case of Mrs Wilson, the vicar's wife, provides an example of taking the waters. 'As she thought she was tormented with the Stone, she went to Bristol and 'drank of St Vincent's Well too greedily, to the quantity of eighteen pints a day, for the expelling of the stone, so that thereby cooling her Body too much, she fell into a Palsy. She presently got herself conveyed to the Bath, where she was restored.' Returning home in rainy and tempestuous weather, 'that night she was assaulted with the Mother, with a fainting and a light Palsy on the left side.' Hall prescribed 'a powder worth Gold, which I always carry about with me.' This 'delivered her both from her fainting and trembling of her Heart, with which she had usually been troubled.'

Much of Hall's success was due to psychological insight. Dr Thornborough, the eighty-six-year-old Bishop of Worcester, 'had very unquiet Nights from salt and sharp humours, and Vapors ascending to his Head; and if he did sleep, it was with terror, which happened from the sudden slaughter in one of his Family, which did much to terrify and perplex his spirits and afflicted him grievously with melancholy.' Editha Staughton, aged seventeen, suffered

from intense hysteria and depression, 'her courses as yet not having broken forth… she was very easily angry with her nearest friends, so that she continuously cried out that her Parents would kill her.' The good doctor wisely advised that 'there should be few to trouble her.'

The casebooks give glimpses of the reaction of patients to their illnesses. Simon Underhill, aged about forty, 'troubled with extream vomiting, wind of the Stomach, difficulty of breathing, constipation of the Belly and Scurvy … said I should either cure him perfectly or cure him.' Hall achieved the former. Mrs Woodward of Avon Dassett, 'a Maid very witty and well-bred, aged 28', suffered from a chronic scurvy which led her to believe that death was imminent. 'Towards evening she expected her unwelcom Enemy with grief of Mind.' Mrs Mary Talbot, sister-in-law of the Countess of Shrewsbury, 'a Catholick, fair, was troubled with the Scurvy, with swelling of the Spleen, livid spots of the Thighs, pain of the Loins and Head, with convulsion and Palsy of the Tongue; her Pulse was small and unequal, her Urine was troubled and thick. The Countess asked me whether there was any hope of life? I answered, Yes, if she would be patient and obedient.' He forbade all drinks except his scurvy cure. 'Afterwards she began to walk, and at last was very well.'

Hall's practice covered a wide area. He was probably called in as a specialist when all else had failed and frantic messengers must have hammered on the door at New Place to summon him to distant bedsides. His dedication is demonstrated during an illness of his own.

> About the 57th year of my age, August, 1632 to September, 29, I was much debilitated with an immodest flux of the Hemorrhoids; yet daily was I constrained to go to several places to patients. By riding, a hardness being contracted, the flux was stayed for fourteen days. After I fell into a most cruel torture of my Teeth, and then into a deadly, burning fever, which then raged very much, killing almost all that it did infect.

Hall's devotion was returned by his patients. 'Noble lady', wrote Lady Eliza Tyrell to her friend Lady Temple. 'I have heard lately of your worthy knight's mischance for which I am heartily sorry. And both Mr Tyrell and myself have purposely sent to inquire of his recovery. Madam, I am very glad to hear that Mr Hall is the man of whom Sir Thomas Temple hath made choice. In regard, I know by experience that he is most excellent in that art.'

'Fair Clifford's Seat'

Over the years, Hall treated members of the Rainsford family of Clifford Chambers. Around 1633, he visited Sir Henry Rainsford's widow who he described as 'modest, pious, dedicated to sacred literature and conversant in the French language.' In view of a revelation by Cooke that Hall spoke French, it may be supposed that the doctor and his patient constituted something of a *cercle français*. The first Lady Rainsford was the daughter Sir Thomas Goodere of Polesworth, 'the good cousin and friend of Sir Philip Sidney', who lost favour during the Northern rebellion of 1570. The young Michael Drayton was a page in his household and much of his voluminous poetic output was a celebration of his master's daughter. She was the 'idea' of his sonnet sequence, 'Idea's Mirror', which was written before her marriage and published in 1619. If Thomas Fuller's

description of Drayton is credited, Sir Henry is unlikely to have regarded him as a threat to his marriage bed. 'Very temperate in life, slow in speech and inoffensive in company.' Indeed, Drayton felt that Sir Henry shared Lady Rainsford's affection for him. 'He would have sworn that to no other end / He had been born, but only for my friend.'

Following the death of Sir Henry Rainsford in 1626, his son, a second Sir Henry, became Lord of Clifford Manor. Hall visited 'Lady Rainsford, aged 27', three days after she had a baby. With his eye for an attractive woman, he describes her as 'beautiful, with a gallant structure of body.'

The second Sir Henry became MP for Andover in 1624, a seat he held until his death in 1641, when Sir Bevill Greville recorded that the 'smallpox is very common and more mortal than usuall. Fewe or none escape. Since Mr Wise his death, another good member of our House called Sir Henry Rainsford is also dead thereof and at least a dozen more...'

Sir Henry regarded the House of Commons with a degree of flippancy. In his commonplace book he noted verses 'given me of Mr St. John Hoskins composure', which included 'A Censure of a fart that was lett in the Parliament House.'

> Yet saith Mr Peake there's precedent in store,
> That his father farted here the session before.
> Then spoke Sir Thomas Challenor, I demonstrate this fart
> To bee ye voice of his belly not the thought of his heart.
> Then said Sir Hugh Byson, a dissembling speech
> Our mouth hath a privilege, but not our breach.

Drayton's visits to 'fair Clifford's seat' were not curtailed by the death of his friend. 'I am stopping at a knight's house in Gloucestershire', he wrote in 1631, 'to which place I yearly used to come in the summer to recreate myself and spend two or three months in the country.' During one of these visits, John Hall treated 'Mr Drayton, an excellent poet, labouring of a Tertian.' He prescribed syrup of violets with his Emetick infusion. 'This given wrought very well both upwards and downwards.'

Hall clearly impressed Drayton. In *Poly-Olbion*, his monumental description of the counties of England, the book on Warwickshire opens with a pious and learned doctor, skilled in herbal remedies, who is disillusioned with the ways of man. The picture neatly fits Hall.

> His happy time he spends the works of God to see,
> In those so sundry herbs which there in plenty grow.
> ...who of this world the vileness having seen,
> Retyres from it quite and with a constant mind
> Man's beastliness so loathes, that flying humane kind...
> Indifferent are to him, his hopes on God that staies...

A Broken Pledge

By 1625, Thomas Wilson, the vicar, was in conflict with Daniel Baker. Perhaps his efforts to impose a sterner moral code had conflicted with the Alderman's selectivity, for Baker's past peccadilloes would not have been forgotten. It is a measure of the hostility engendered by Wilson that his former friends attacked him for his failure to observe the High-Church Laudian canons. Like his predecessor, the vicar provided his opponents with ammunition. 'Our ... minister is desirous', the churchwardens reported to the Diocesan court. 'To make known ... [that he] doth not constantly weare his surplice and hood according to the injunction of the 58 canon.'

On 8 March 1625/26, the Corporation gave Wilson its 'Certificate under the Seale', but warned him to conform to the 'Church Cerimonyes as kneeling at the sacrament, enjoyning others thereunto, wearing the surplice, baptising with the Crosse, marryinge with the ring and all other orders of the Church.' Later that year, he was cited before the Diocesan court and the court of High Commission 'because he laboured to shake the jurisdiction of the Bishop ... and govern the people of Stratford according to his own will, as if he had been another Calvin or Bera in Geneva.' Baker's brand of Puritanism was hostile to a theocracy of divines. Yet when the bishop excommunicated Wilson, the Corporation sent a delegation to plead for him. Perhaps it was a triumph of Christian forgiveness, or they preferred the vicar to the bishop, but it is a mistake to see too many doctrinal nuances in local disputes.

Before the dispute, John Hall sold some of Shakespeare's old tithe holdings to the Corporation for £100 less than their value to enable them to increase the stipends of the vicar and schoolmaster. This they failed to do. Hall was furious and sought to prove that Daniel Baker and Francis and Anthony Smith were personally responsible for the debt of £400 due to him. He was outmanoeuvred, for an indemnification of 26 March 1626 assumed collective responsibility. Once good relations with Wilson were restored, the Corporation fulfilled its obligations, voting the vicar an additional £20 annually for his 'learned sermons'. Later that year, an old dispute resurfaced when Wilson was accused of exceeding his rights to churchyard timber. On 14 December, the annuity was withdrawn and Hall must again have been furious. A sniping battle continued until 1631, when the Corporation requested Sir Thomas Lucy and Sir Greville Verney 'to hear and to judge wherein the Bailife and Burgesses have wronged or abused Mr Wilson, oure vicare'.

There was at least one influential person who shared Wilson's distaste for the Corporation. John Hall's co-option to that body in 1632 might have been in the hope that the doctrine of collective responsibility might silence a persistent critic. The hope was mistaken. In January, 1632/33, he made 'abusive speeches againste the Bailiffe and in June 1633, he retaliated against the civic fathers with a grand gesture.

Each aisle at Holy Trinity was flanked by great box pews, the preserve of the town's notables and their households. For the poor, there were open benches in the centre aisles and galleries along the sides. Since the time of Thomas Greene, the wives of the Corporation's senior officers had used the box-pew belonging to New Place. Hall caused the erection of a new pew there for his own use. By evicting the municipal dowagers from their exalted station, he released a profound feeling of *lèse-majesté*. If Thomas Wilson turned his eloquence to the

Gospel injunction to seek the lowest place, it can only have been with a sense of irony. In the furore that followed, Hall was on strong ground, securing the support of his aged patient, Bishop Thornborough. The Corporation appealed to Canterbury, but Hall's claim was upheld by Sir Nathaniel Brent, the vicar general.

There was an echo of Hall's dispute in the church court in December. William Smythe was charged with disturbing the congregation during divine service. He replied that his behaviour was caused 'by the intrusion of Mr Richard Castle … who went about by violence to thrust… [him] out of his usual sitting place.' He boasted to the court that, unlike Castle, he had held the offices of churchwarden and alderman. '…and hath alwayes held his place among the aldermen in the said parish church … and … is above the said Castle in all taxations and payments and hath always had precendcy in the said parish church before the said Castle as his aunciente.' On 15 January 1635, John Eston 'was wished to forbeare sitting in the Burgisses seate by John Smithe' and replied, 'Who will keepe me forth?' Sir Nathaniel's report included the weary phrase, 'here are many contentious about seats in churches'.

Perhaps Hall's profession gives a further hint of the reasons for his civic disenchantment. A man used to examining the stools of the rich and powerful is unlikely to be impressed by the verbal diarrhoea of the petty bourgeoisie. That he never permitted municipal duties to interfere with his medical practice is revealed in a pleading note he received from Sidney Davenport of Bushwood House on 5 July 1633.

Good Mr Hall – I sent my boy to you this morning to carrie my water and acquainte you with what dangers and extremities I am faullen into in respect of my shortness of breath … [and] … obstructions of my liver that I cannot sleep nor take anie rest… I will not eat nor drink until I see you … Ireceived a note from you howe that you cannot be here at Bushwood with me to morrowe in respect of some private meeting at yor hall concerning the affaires of yor Towne. You saie you are warned to be there and if you are absent you are threatened to be fined. I did not expect to receive such a kind of excuse from you, considering the dangerous estate I am in, as maie appear by my water … therefore I think it is not anie Towne business that can hinder you but rather that you have prised some other patient and would put me offe with this excuse. Therefore I councell you as a friend never be bounde as long as you may be free you shall but derogat from yor studie wch deserveth the whole imployment of anie man had he 100 years to lyve longer.

A postscript adds: 'My brother Colmore's Physick is ended and all taken, he staith at home purposely to speak with you tomorrow morning for further directions.' The hypochondriac brothers had their way. Hall sent the letter to the Corporation as an explanation for his absence, but the burgesses were in no mood to be understanding with their difficult fellow and fined him for non-attendance.

The factiousness of the Corporation led to a resolution against canvassing being passed in 1633. 'The greater number of the Company have declared themselves that the course of goinge from house to house to gett the voyces or the hands of the Bayliffe, Alderman and burgesses is altogether unfitting and not hereafter in any sort to be practised.'

Hall also had family matters to trouble him. His brother-in-law, Thomas Quiney, had not done well. In 1633, his business was put into trust for his wife and sons to his kinsmen, John

Hall, Thomas Nashe and Richard Watts. Sadly, none of his sons survived to his majority. Shakespeare Quiney died in infancy; Richard and Thomas, within a few weeks of each other in 1639, probably in an epidemic.

More from the Bawdy Court

Whatever the ecclesiastical regime, the bawdy court maintained its efforts to control the town's morals. The case of Margery Warner, wife of John Warner, heard in 1624, was unusual in that she confessed her offence unilaterally – the vengeful gesture, perhaps, of a spurned lover. She 'accused herself of adulterie with Robert Wilson of the Crown' and 'now she appereth personalie and in publicke courte she confesseth herself guiltie… and uppon her oathe shee declareth that shee did two several tymes committ adulterie with the said Robert Wilson…' She was ordered to perform public penance both in the church and at the Cross on the next market day. Wilson appears to have fled the town.

A Rabelaisian note was struck in the next year. Rumours were circulating that John Hemings, the aged Beadle, had taken advantage of his access to the Guild Hall. The story reached the ears of the consistory court and so the pen of its Clerk. 'Wee present that there is a publicke fame that John Hemings alias Ames and Elizabeth Court weare in a very unseemly manner conversant alone (according to the said John Hemings his confession) in ye chamber of the towne of Stratford the dore being fast locked … when the said Elizabeth Court did provoke him the said John to Incontinency and that hee had her upon the fforme in the chamber and took up her coates and was very unmannerly with her but had not carnall knowledge of her body in regard he could not by reason of his age or inability althoughe shee consented thereunto and that he did handle her privities by her willing consent…' The passage dealing with Hemings' alleged impotence is struck out. Perhaps it was not a defence which impressed the court, any more than would at least one of his six 'honest neighbours' whom he had chosen as 'compurgers' (guarantors of the integrity of the confession), who was Thomas Woodward, a regular visitor to the court himself.

The Beadle later admitted the offence and was ordered to repair 'to the Church … uppon Sunday come senight and there to stand before the pulpitt in the middle ile … with a white sheet hanging down from his shoulders to his feate, holding a white rod in his hand and penitently to acknowledge his fault according to the forme of the schedule.' There can have been few malingerers from church that day. His cohort of the chamber, Elizabeth Court, failed to appear and was excommunicated.

The Corporation was proud of the parish's 'peculiar' status, which gave it the 'ancient privilege' of the consistory court as part of 'our liberties'. In 1625, it expelled Christopher Smith from its ranks. He had been accused of adultery in three successive hearings with three different women, but refused to accept the jurisdiction of the court. The minute reads:

> …taking into consideration, that Christopher Smith hath
> much wronged this company and disgraced them, not only
> by his heinous offence in committing adultery but also in
> that he hath refused to be censured by the judge of our

peculiar jurisdiction appealinge to the court of Worcester,

thereby weakening our liberties of this borough, as we

conceive it, contrary to his duty.

The tone implies that the burgesses were more incensed by Smith's appeal to the Bishop than his serial adultery.

The ire of the court could extend to outsiders. On 3 December 1625, Richard Hill, 'Citizen and haberdasher of London' (perhaps a grandson of his namesake, the alderman), wrote to the churchwardens acknowledging his 'ffalts comitted at Stratford uppon Avon in unlawfull frequenting and haunting of Alehouses and playeinge at unlawful games … and in giving evell words to the offices and Constables there; for all of which I am heartily sorry and promise Amendment for the tyme being to come.' Since repentance was the prime object of the court, it may be presumed that his apology was accepted.

The court records reveal Stratford's problem individuals and families. Often these were ordered to attend weekly catechism classes, presumably in the remote hope that greater knowledge of religious discipline might activate reforming instincts. The Bartlett family represented a continuing headache. On 22 May 1624, Richard and William Bartlett were presented for 'refusing to come to be cattechised'. Neither had appeared by the time the court sat, so it was ordered that they 'hereafter… doe come diligentlie to be cattechised everie Sabaoth day untill [they] can answer the minister in the principles of the Christian religion.' At this point William appeared. The Apparitor 'uppon his oathe … delivered that the said William Bartlett did when he was cited speak reproachful and revilinge words of this court, viz. "Shyte uppon the court."' He was ordered to make public confession of the offence wearing his own clothes.

The Bartletts were not strong on catechetics. On 16 July, William was cited for not answering the questions in the catechism and Richard and Stephen were excommunicated for failing to attend the classes at all. Bigger trouble was on the way for William. Five cases of slanderous abuse followed. The Churchwardens had periodic crackdowns on particular offences. Richard Wheeler was cited for calling the 'wife of Richard Brookes whore and sowlike whore with diverse other filthy speeches'. In his defence he declared that the woman 'calling him a rogue, he replyed that if he were a rogue she were a whore.' Anne Lane was presented for calling 'Katherine Trowt whore.' She admitted the offence and 'sayth moreover that William Bartlett hath publicqly confessed before witnesses that Katherine Trowt did come to bed to him.' Presumably, William had judiciously fled the precincts of the court by this time, for the Churchwardens were ordered to denounce and cite him. At the next sitting on 3 September, he denied the charge and was ordered to purge (swear an oath of denial before witnesses) himself at the next court in the presence of Katherine Trowt. This process appears to have been delayed until the following 8 June. The outcome is unclear from the fragmentary records, but it is certain that the Bartletts continued to provide the court with regular business. Their last recorded case was in 1627, when Richard was presented for 'revelling in the night and carrying himself disorderlie towards his neighbours servants calling them up at midnight to dance with him and to revell.' Little of the Puritan spirit infected the Bartletts.

The problems of what the Victorians were to call 'the submerged one-tenth led to the foundation of an institution that would endure for over 300 years. In 1625, the Justices at the quarter sessions

ordered that the poor of Stratford should build a House of Correction or workhouse 'for the punishing of those idle and lewd people who will not work within the said parish and other wandering and idle persons that resort to the said parish.' The cost of establishing the house on the corner of Henley Street and Hell Lane was to be borne by the inhabitants collectively.

John Hall was churchwarden in 1628. The bawdy court records for that year reveal another hidden current beneath the surface of Stratford society. Elizabeth or 'Goody' Bromley was presented for abusing the wife of Adrian Holder in terms redolent of the black arts. She threatened to 'overlook her and hern' (to put the evil eye on them) and exclaimed, in Shakespearean language, 'Aroint thee witch'. She told her 'to get her home', or, in an echo of the King James' version, 'a would brush the motes forth of her dirty gown.' Such spectacular invective gives further insight into the linguistic vigour of the age.

When he was churchwarden, Hall gave a carved pulpit to the church. He held the position again in 1633, presenting one man 'for loitering forth of the church in sermontime', another for sleeping in the belfry, with his hat on, upon the Sabbath'; another for 'keeping drinking in his house after evening prayer' and a fourth for being a 'common romler'. He seems to have cracked down on extreme Puritans, presenting four men for the iconoclastic gesture of 'wearing a hat in church'. Another Shakespearean echo is heard in a presentation for 'putting hands in plackets' (the opening in the front of a woman's dress), one of the peccadilloes against which Lear's fool admonishes.

'Medicus Peritissimus'

In the mid-1630s, two mighty projects were undertaken to revive Stratford's economic fortunes. The market hall was rebuilt in 1634 with the intention of increasing vital trade. At the same time, an engineer, William Sandys, was working on the ambitious project first proposed by Warwick the Kingmaker – making the Avon navigable.

Even the Corporation forgot its strife to endorse the scheme on 8 January 1635/36, 'testifyinge our approbacion, commendacion and allowance of the makinge of the River of Avon passible for bringinge of wares from sondrye places to this boroughe of Stratford'.

Yet even these great enterprises were overshadowed by the continuing conflict with the vicar. The keys of the Guild Chapel were taken away from him, probably because of dissatisfaction with the state of the building. John Hall, still seething from the swindle of the tithes, launched himself against the burgesses again. On 14 July 1634, the clerk recorded that 'Mr Hall charged some of the company to be forsworne villains'.

The acrimony extended through the vicar's household. Word reached the Corporation that his maid, Elizabeth Edwards, had been badmouthing them. When Wilson was asked to let her talk about it with the bailiff, he replied that she would not without a warrant. The bailiff sent a warrant by Tymbrill, a constable, but Wilson took it away and would not return it. When she did appear eventually, the vicar came with her to the hall, declaring that 'she was sent for as a felon and bade his mayde not to reveale who told hir certayne speeches which she spake tending to the disgrace of the companye.'

Hall and Wilson found a common cause against the Corporation in a Chancery suit in 1635, which mainly concerned Hall's lost tithe revenues. The Corporation retaliated by

expelling Hall. Since he had always been a reluctant burgess, it is unlikely that this sanction cut him to the quick.

The Corporation now petitioned for Wilson's removal, accusing him of bizarre behaviour such as wandering around the church during prayers. 'In his sermons and lectures [he] doth particularize somme of his parishioners'. It is not difficult to guess who they might have been 'and he hath profaned the chapple by sufferinge his children to playe at bale and other sports therein and his servants to hang clothes to drye in it and his pigges and poultrie to lye and feed in it and alsoe his dogge to lie in it and the pictures (presumably the wall paintings) therein to be defaced and the windows broken'. Even stranger was the vicar's behaviour during the funeral of Mrs Henry Smythe. He was not asked to give the address, so he sat on the pulpit steps to prevent Simon Trapp, the curate, from doing so.

The quarrel between Wilson and the Corporation was not doctrinal. Although he was a Puritan, so were most of his antagonists – indeed, they had been responsible for his appointment. The subtle difference between the congregational position dominant on the Corporation, and Wilson's theocratic authoritarianism, might explain some of the hostility, as indeed was the lack of division between what was Caesar's and what was God's in the running of Stratford's affairs. John Hall was not alone in his criticism. Alderman Thomas Smith pointedly gave £5 for a weekly lecture 'as long as Thomas Wilson shall continue as vicar'.

Hall appears to have shared something of the intense disillusion with authority of Shakespeare's dark period. His fight against corruption included vigorous opposition to those who purloined money intended for the poor. He paid a £10 fine early in the reign of Charles I, rather than accept a knighthood at a time when the sale of honours was a national scandal. It is apposite to recall Cerimon (*Pericles*), whose medical practice gave him 'More content in cause of true delight / Than to be thirsty after tottering honour, / Or tie my treasure up in silken bags, / To please the fool and death'.

Hall's distrust of the institutionalised man stemmed from his Christian faith. 'Thou, O Lord,' he prayed on recovery from illness, 'which hast the power of Life and Death… and drawest from the Gates of Death without art or counsel of man, but only from thy Goodness and Clemency, thou hast saved me from the bitter and deadly Symptoms of a Deadly fever, beyond the expectation of all about me, restoring me as it were from the very jaws of Death to former health'.

Whatever his own religious position, Hall was no bigot. He describes an orthodox member of the Church of England, Lady Rainsford, as 'modest, pious and kindly'. He adds 'praised be God' after curing a Catholic priest, Father Browne (perhaps in itself a risky act), but his greatest admiration of all was for the Revd John Trapp, the schoolmaster whose 'piety and learning' he considered 'second to none'. Hall treated him for a hypochondriac melancholy brought about by over-studiousness.

The Church registers record the death of 'John Hall, gent., *medicus peritissimus* (most learned physician) on 25 November 1635. There had been fever in Stratford and it is likely that he had laboured too hard and too often. His verbal will, made the day before his death, left the bulk of his property to his wife and daughter. A Bill in Chancery, filed by his widow, reveals his wealth. His goods and chattels alone were worth £1,000. He was buried close to William Shakespeare. Part of his Latin epitaph translates, 'Hall lies here who was renowned in the healing art / Awaiting the delightful joys of heaven'. Had he chosen his own memorial,

Hall might have selected the Latin inscription he wrote in his manuscript. 'He who practices medicine without just cause is as one who navigates without rudder and oars.'

Ship Money

With Hall's death, Minister Wilson lost his strongest ally. He conceded the charges against him and was suspended by the diocesan authorities for three months. Much of the parish administration devolved to the portly Mrs Wilson. On 11 May 1636, the Corporation sent Thomas Smith to enquire what arrangements she had made for her husband's absence. She said that he had asked Simon Trappe, the curate, to take over his duties, but Trappe grumbled that he had 'had nothing for his pains and therefore forebears to preach'.

The curtailing of Wilson's activities enabled the ancient Bishop Thornborough to report to Archbishop Laud in 1637 that he was 'less troubled with non-conformists since Mr Whateley of Banbury gave over his lecture at Stratford,' which was, presumably, the one endowed by Alderman Smith. Wilson retained his living until his death in 1638, after which the Corporation sought, unsuccessfully, to purchase the right to present the vicar and schoolmaster.

Times were changing fast. In 1635, the introduction of the 'Ship Money' tax by Charles I set up the events that led to civil war. On 14 June 1637, the Corporation resolved to petition the Lords 'to lessen our ship-money.' On 1 January 1638/39, it was decided that Mr 'Duppa is to goe to London to petican the Lords in behalf of the boroughe to same of ship money.' Poverty was a legitimate plea. The sum required (£30) contrasts with assessments of £160 at Birmingham and £500 at Coventry. Inflation was also taking its toll. The weekly alms payment was raised from 4d to 6d in 1623, to 8d in 1633 and 12d in 1638. The deterioration of the times (a further fire devastated the town in 1640) and the brooding air of expectation is reflected in the minutes of 26 June 1640: 'Att this hall yt is ordered that everye Ald and Burgesse shall have 2 powde of gunpowder and 2 powde of droppe shot of that wch belongs to Corporacon and shall pay for the same.' On 11 December, the Corporation demonstrated its feudal, sectarian and political allegiance by electing 'fanatic' Lord Brooke of Warwick, a vehement Parliamentarian, as its recorder.

Daniel Baker, that authoritarian old Puritan who personally epitomised the growing factiousness of forty years, did not live to see the triumph of his party. He was buried at Holy Trinity on 30 July 1641, bequeathing to the church 'there to remain for ever, my book of Mr Greenham's works for the use and benefit of such as shall be well disposed to read the same.' The book was to be fastened with a chain 'in some convenient place... for the more better and safe keeping thereof.' On 24 November, the Corporation underlined its Puritan disposition by removing decorative effects from the Guild Chapel. 'The perticon between the Chauncell and boady of the Chappell' was taken down and the walls washed with white lime. The pulpit was 'moved and convenientlye placed' in the centre aisle to stress the supremacy of the word. In 1642, Henry Twitchett, styled as 'vicar', was replaced by 'minister' Will Hawling. On 22 August, the King set his seal on the nation's divisions by raising his standard at Nottingham. The minds of the burgesses, so long obsessed with the nuances of civic dignity, would soon be concentrated on wider issues by rival armies on the very streets of Stratford.

7

'The Times hath bin Troublesome'

For watch and ward the Times hath bin Troublesome.

Jury presentment, 1646/47

The principal local antagonists at the start of the Civil War were both former patients of John Hall, Lord Brooke and Spencer Compton, Earl of Northampton. From the outset, each struck ferociously at the other. Brooke was in Stratford in July, 1642, raising over 600 men from the district, two-thirds of them armed, and the remainder, a militia for which William Combe was obliged to pay as Lord of the Manor. This considerable force reflected both the strength of Puritanism and the power of the feudal link.

The Stratfordians panicked at the sight of the armed battalions. It was rumoured that the bailiff and vicar had signed a note offering free billets to the soldiers, but they were exonerated on 3 August. 'Whereas yt. Mr Bayliffe & Mr Twitchett were accused ... that they had betrayed the Towne and that they had sett their hands to a note for builleting soldiers here, the Companie doe free and acquite them.'

The Corporation was wary enough of Compton's proximity to raise a subscription for the King's cause, donating £50. Other contributions included £5 from the vicar and £2 from Shakespeare's godson, William Walker (who was bailiff in 1649). The highest donation of £100 came from Thomas Nashe, who had married John Hall's daughter, Elizabeth, in 1626. This was impressive in view of the property, worth £255, that he had lost in the fire of 1640.

Despite their deprivations, the Stratfordians could still look generously on the plight of others. They were aware that others had contributed to their welfare in extremity. On 3 September 1642, £85 19s was collected for 'the reliefe of his maiesties distressed subjects of the Kingdom of Ireland.'

Spencer Compton was in Stratford that month. The Corporation paid 11s 2d to trumpeters 'when the Lord of Northampton lay in the Towne'. The Royalists plundered The College, home of the politically suspect William Combe. After minor rural skirmishes, Compton swept his arch-rival, Brooke, from the county and invested Warwick Castle. Brooke's position was restored by the flow of national events. That autumn the bloody and futile Battle at Edgehill ensured the district's hour at the centre of the national stage. The noise of the battle resounded round the countryside and echoed in the streets of Stratford. As far away as Alcester, the Puritan divine, Richard Baxter, preaching on the text, 'The Kingdom of Heaven suffereth violence', found his sermon punctuated by the booming of cannon.

After the battle, the retreating Parliamentary Army clogged Stratford's streets. Wagons clattered northwards, the array of weaponry and uniforms reflecting the haphazard

recruitment. Cannons were heaved out of the mud by teams of straining horses and sweating men. The groans of the wounded contributed to the confusion. Among the Army were its Puritan chaplains admired by John Trapp, the schoolmaster as 'those gallant spirits at Edgehill battle, with their reboated "Now for the fruit of prayer" and of many psalms sung by that religious armies in their several stations, whereof I have been an eyewitness … down go the anti-christians immediately by the power and prowess of the Christian armies, thus edged and encouraged by their preachers. This we have seen fulfilled.'

The Chamberlains' accounts recorded 'monyes disbursed and given unto the Parliament soldiers which weare wounded and died in the Towne after Kinton Batell', who included those who had served under Sir William Waller, 'Captain Crumell' and 'Captain Essex'.

The Battle of Stratford

Early in 1643, a troop of Royalist horse commanded by Colonel Wagstaffe occupied Stratford and recruited a number of locals. On 25 February, Lord Brooke, advancing from Warwick, resolved on an early morning surprise attack. 'Yet a countryman and friend of theirs' recorded the Parliamentary chronicler

> espying us two miles on this side, crossed the fields and gave the enemy advertisement: upon which they drew themselves under a hill, where they could view our march. We drew the greatest part of our Artillery to the Vanne, they having the greatest part of our Horse and we expediting the first charge there, but withal suspecting their weaving about, we drew up our reere, so that we stood triangle on *three hils* in full view of each other. From the *reer* division we let flie a drake, which ran through the midst of them and forced them to wheele off towards the Town and we hasted after them so fast as our Carriages and the Plowd Lands so well softened with the raine would permit us.

Faced by superior firepower, Wagstaffe retreated, leaving two dead behind. His local recruits had fled at the first sign of danger.

The Parliamentarians had not heard the last of Wagstaffe. Learning that a military council was to be held in the Town Hall, which sheltered an ammunition dump, he crept into town and laid a trail of 'powder to run along from the barrels of powder to a piece of match left at such a length as should, as they intended, just meet the powder at the time of their sitting…' The building went up, but the attack was premature.

> When they thought all had been quiet and well and the Lord Brooke and the Colonels and Captains were going to the Council, they heard a noise as if some houses had fallen down and saw the Town Hall in pieces in such a manner that it was utterly ruined, one of the townsmen slaine and four more burnt and bruised, who are very ill and this all the hurt it did. O the great cause *we* have to praise God for such deliverances as these.

The destruction of its 'very faire Hall' was a desperate blow to the Corporation. The costly building had been completed for less than a decade.

Other property was pillaged, including part of Shakespeare's Birthplace. The orphan children of Jane Hiccox (Thomas and Anne) at the Swan and Maidenhead lost silver when Lord Brooke's forces came to Stratford.

Next month, the antagonistic Warwickshire noblemen were drawn into the great siege at Lichfield with fatal consequences for both. Compton, 'most prodigal of his person to danger', perished at Hopton Heath, his end befitting the wild rider to hounds whom Dr Hall had treated a decade before. Seeking to relieve the beleaguered garrison, he routed the enemy cavalry and captured eight guns. He was slain when the enthusiasm of his pursuit caused him to outride his followers. When surrounded he refused to surrender to 'base rogues and rebels'.

Brooke was shot by one 'Dumb Doit' during an attack on the fortified Lichfield Cathedral a month later. The marksman's family was known to Shakespeare. Justice Shallow recalled 'little John Doit of Staffordshire' amongst the friends of his youth at Clement's Inn. John Trapp was left to mourn 'that thrice noble Lord Brooke, who lost his precious life at Lichfield.'

'The Queen Majestye'

In July, Stratford's bells rang as Queen Henrietta Maria arrived at the head of 2,000 foot and 1,000 horse army, with a train of artillery. She was met by Prince Rupert at the head of another force. The Queen lodged at New Place with Mrs Hall. She preferred it to the *College*, which was in the possession of the Combe family, who did not so strongly favour the King's party. In this, William Combe emerges as a typical Stratfordian. He professed to be a Royalist, but it was complained that he 'sat at home'.

More expense fell on the impecunious burgesses: £18 6s was 'disbursed and payd when the Queen Majesty laye in the towne', including £6 for six footmen and the 'cochmen and porters'. No chance was taken with the royal person: £3 was paid to the 'Bayliffe of Warwick for their fortifications', probably strong wooden barriers to exclude the over-curious or malignant.

It was probably during the Queen's visit that Susanna Hall presented Colonel Richard Greene, Chamberlain to the young Duke of York, with a copy of Henri Estienne's *Mervaylous Discourse upon the lyfe of Katherine de Medicis*. A title page inscription records the gift '*Liber R: Gracei ex dono amicae D. Susanne Hall*'. The book, printed 'At Heydelberge' in 1575, might have belonged to her father.

When the Royalists left Stratford, they carried off the diminutive schoolmaster, John Trapp, who had been outspoken in the opposing cause, subscribing £5 (two months' salary) to Parliamentary funds. He became 'one of God's poor prisoners' at Oxford, '...from which death God graciously delivered him' through a prisoner exchange. Trapp, regarded by fellow Puritans as 'a man of singular Prudence and Piety, of an acute wit, of a sound judgement and of an indefatigable spirit' became minister at Welford. 'That's the best sermon', he homilised, 'that's dig'd out of a man's own breast', but his parishioners heard little of his eloquence, for he spent 'his daily labours amongst the soldiers and in the midst of the noises of guns and drums.'

An admirer, Thomas Dugard, Rector of Barford, dedicated a poem to him.

> One of this Age's Greatest Little Men,
> Great in Good Works, witnesse his golden pen.
> His pen hath drawn his learned hand in part,
> His Holy Life proclaimes a Gracious Heart,
> Should any mee consult how hee might rise
> Unto compleatnesse, I would say,
> Trappize.

Others were probably less adulatory. Trapp inveighed energetically against theatre, masquerades and dancing.

Stratford's position between the key Parliamentary garrisons at Coventry and Gloucester ensured continued involvement on the fringes of the war. Early in 1645, a brigade of 500 Royalists rode into the town, alleged that the Stratfordians supported Parliament and demanded £800 to refrain from plunder. There were shrewd bargainers around, for they rode off after settling for £10. After this, Parliament ordered an arch of the bridge to be broken down for 'securinge the county and preventinge the incursions of the enemyes'. Stratford lacked fortifications and could be occupied with ease, but never held against a superior force. In such precarious circumstance, the Stratfordians refrained from open partisanship, each side accusing them of favouring the other.

A Journal of the Plague Year

The battalion of troubles was compounded that year by devastating plague, which may have been brought to the town by the soldiers. The community's response to this disaster is uniquely recorded in 'A Note what hath beene paid to the Infected wth the Plague and kept up for feare of further spreading, and the other charges necessary thereunto.'

The record begins on 24 May when sixteen people, mainly from the Austin and Mountford families, were registered as infected. They received subsistence grants of 7s per day. William Adams was paid 2s 'for drawing a Corps to grave' and John Granams 2s 6d 'for buryeing a corps.' He was listed as 'infected' – presumably a term denoting contact with infected persons, and paid 5d a day for his labours amongst the sick. A little village of 'pest houses' was built outside the town at a place called the Hill. The sufferers were paid their subsistence from a monthly levy of £10, raised from the borough and district. As always, the district was remiss with its payments.

Granam's wife, Mary, was in charge of the isolation colony together with Richard Rogers. The food for the sick was delivered to them and they were paid 8d a day for their efforts. In May, 10d was spent on 'a Coast [side] of Veale for Richard Rogers and Marie Granams' and 2d 'For tobacco and candles for Richard Rogers'. The healthy members of infested families were also in quarantine and worked in a nearby field. Sixpence was paid to 'George Bridges for coving of graves & for worke in the Ffield' and 4d to 'Willm. Hornbe for work in the

Ffield about Pesthouses'. George Bridges was paid for 'drawing ye Corps & making a grave for goodwife Mountford's', presumably the aged mother.

As the numbers of sick increased, the accommodation was expanded. Five men were paid 8*d* each for 'helping to sett up the Pesthouses' and £1 18*s* 5*d* for materials.

The Austin family was decimated by the plague that week.

Ffor making a grave for Austins boy	4*d*
Ffor prunes jd & raisins, jd for Austin & Granams	2*d*
Ffor more prunes, suger, cloves & cinnamon for them	4*d*
Ffor suger, candles & making a grave for Austin's wench	6*d*
Ffor a sheete to wrappe Austin's wife in	1*d*
Ffor half a strike of brans to burie the Corps	4*d*
To Alexander Hornbe wch he paid Mary Granams to bury one of Austin's children	2.6*d*

Considerable organisation was required to maintain the colony. Provisions and *ex gratia* payments were producing a considerable budget.

Ffor a legge of mutton & pitche for Rogers & Mary Granams	11*d*
Ffor drinke and milke for them	3*d*
Ffor provision for them at Cumpeares	3*d*
Ffor a calves head for Rogers & Mary Granams	6*d*
Ffor perfume & stuffe to burne in the house	6*d*
Ffor half a pound of prunes & suger for ye woman & Rogers	3*d*
To Richard Browne for caieing beer to ye Pesthouses	
To John Coxe for his paines at the Pesthouses	6*d*
To Ffrancis Smithe for Coards, pitche, & rasin for the coffins, & to burne in the house –	
To Robert Milles for two daies worke in helping up the Pesthouses & making the doores	2 –
To Taskers wife for drawing strawe for ye Pesthouses	– 4
Paid for washing Richard Rogers shirte	–3
To Goodwife Serwin for bread, butter & cheese for Rogers	–3
To Mr Harrington for aqua vitae & oyle for Mary Granams	
To Willm. Biddle for beere sent to the Company at ye Pesthouses and some to ye sicks infected folk	–2- 0
Ffor fruite & spice for Mountford's wife	– – 5
To Rich. Postons for his paines about ye sicke folke	– 1 –
To Philip Hopkins wife for bread, cheese, two great nigges [sic] & provision for ye infected at ye hill	– 1 – 9

As the infection spread, more help was required. On 11 June, payment was made to 'Goodwife Hopkins for husband & her own wages for this weeke watching, warding & tending the

people at the Hill.' William Burford was paid 4s 2d for watching & warding for 'a weeke'. Better facilities were needed and John Hobbins was paid for fetching 'stuffe from Luddington to make a cabbin for the Warders at hill.'

The plague brought one blessing. On 12 June, Fairfax's great Parliamentary Army arrived at Stratford. Normally hundreds of soldiers would have been billeted with the townsfolk, but, fearing the infection, they camped at Cross o' the Hill in the fields above the town. The next day, the bridge echoed to the sound of an Army on the march as it passed to decisive victory at Naseby.

At 'the Hill', there can have been little concern for this momentous movement of national events. The death rate was increasing with the summer heat. Coffins were ordered in bulk, but the money paid for grave-making fell, which implies that the corpses were buried in common graves.

This time it was the Mountford family which suffered most severely. George Cole, a local carpenter, was paid 9s 4d for boards, 'pitche, nailes, coard & making coffins for the infected yt died' and 'more wch hee laid out for Mountford's wife and sonne.' George Bridges was paid 6d 'for making Mountford's sonnes grave.' George Badger was paid 4d for 'making a grave for Francis Cowper's motherlawe' and 10d for 'Cook's wives grave' and helping 'to drawe the Corps.' Twopence was paid for 'sugar candie for Cook's wench.' Her family had taken their livestock with them into their horrible exile for a further 2d was paid for a 'peck of brans for their swine'. Other payments included 8d for 'a strike of Charcoale for them at Hill' and 3s 7d to 'Goodwife Hopkins for sope for them; jd for bread, meate & drinke for them wch. they had for Satirday, Sunday & Munday'.

As the summer's heat increased, so did the intensity of the infection. After 9 July, when George Bridges was paid 1s for 'making the graves & haling the coffin for Clark's wife & child', the plague could no longer be isolated, but was rife in the alleys of the town. On 2 August, 2s 6d was paid 'To the infected in sheepstreet maze.' To coax the infected into isolation it became necessary to pay them in advance: 2s 8d was donated on 9 August 'To Tasker a weeks paie beforehand to remove unto the hill.'

By Autumn the disease was on the decline. It had taken a dreadful toll. Sixty-one people had died, of whom forty-one lived in the borough. The Corporation became preoccupied with the collection of the district levies, which were predictably slow in appearing. On 24 September, 6s 4d was received from William Matthews, Constable of 'Hampton Episc. [or Lucy], a fortnight's paie[ment]…' Other places were not as forthcoming. On 22 October, George Cowper was paid 1s for going to 'Claverdon and other townes about money for the infected.' It must have been with muted joy that 2s was paid to Robert Taylor for 'pulling down the pest houses.'

Each entry in the plague book during 1645 conceals an unknown tale of suffering, but also represents a community at its best, organising itself with compassion for the general good.

'The Times hath bin Troublesome'

'For wach and ward the times hath bin troublesome', declared a jury presentment, with considerable understatement in January 1646/47. Law and order had broken down in the

countryside with a resultant effect on trade. Gangs of marauding horsemen terrorised travellers. The number of tenants in arrears had doubled to a fifth of the total. Local parishes defaulted on the Poor Rate, so increased burdens fell on the burgesses. 'Parishes and schools are polled and robbed of their maintenance as if they meant to starve us all', wrote John Trapp, who could use a pedagogue's text for man's eternal situation. 'Go to the ant, thou sluggard man', he preached from *Proverbs*. 'Man that was Captain of God's school, is now, for his truantliness, turned into the lowest form, as it were, to learn his ABC again.'

A moral and spiritual anarchy had been unleashed. On 20 March, 1645/46, Edward Welles swore before the bailiff, John Smith, gent, and the chief alderman, Thomas Horne, that, two years before at his house in Stratford, John Powse of 'Noball' [Newbold-on-Stour] had said that, 'Our Saviour CHRIST was a bastard, & our Virgin Mary a whore, & yt hee desired a bible to shewe a proofe of it, & yt our Sovaigne Lord the Kinge is both a knave & a foole, & had not so much wit as hee had'.

When Welles was asked why he did not reveal this before, 'hee saith yt hee did reveale it to some pticular men, but durst not speake it openly in regard of the times and further informeth not…' His testimony was supported by three others, including Eleanor Welles, presumably his wife, who added that she had reported the matter to Alderman Baldwin Brookes.

Powse admitted to being at Welles' house frequently at that time, but denied any recollection of the incident. The verdict of the court is lost. It would give an indication of the attitudes of the civic fathers to the religious and political issues of the day. It is noteworthy that the magistrates were keen to attack heresy and, at least nominally, defended the integrity of the monarch. In the same year, the compiler of the vestry minutes at Holy Trinity, ceased to describe the local highways as the 'King's'.

The Civil War spelt the end of the Clifford branch of the Rainsford family. Their sun continued to shine in the twilight of the first Caroline era before passing beneath the horizon forever. The third Sir Henry, eldest of the fourteen children of the second, lived up to the family motto of *Totzjours Loyall* and flung himself into the King's cause. He was a Cavalier Colonel at eighteen. When Oxford fell he was captured, but made a bold escape. To avoid the confiscation of his estates, he sold them to his former guardian, Job Dighton, lawyer to Stratford Corporation. He died a bachelor in the East Indies before the Restoration, ruined in the royal cause.

A survey of 1646 analysed the losses caused in the town by the war. The resultant claims for damages reached the huge total of £2,542, the bulk of it for quartering soldiers. A number of the 119 claims were exaggerated. The cost of plunder by Lord Brooke's forces was £135, but the report dismissed some claims as frivolus. 'It is true', stated one assessment, 'that the Mayor of Esen's coronet took an old gown to watch in, but it was redelivered.' Losses claimed at the hands of the Royalists were smaller – presumably because they were even less likely to be paid – totalling £1,412, mainly in taxes, loans and contributions. In 1649, a token £41 was laid out by the Corporation in compensation.

The coming of peace meant an upsurge in trade. With the roads relatively free of outlaws, the horse-fair of 1646 did record business with dealers coming from six counties. In more relaxed mood, the Corporation bought a china fairing for the curate's wife. Peace brought an opportunity to clear the vast backlog of civil cases. At the quarter sessions, Abraham Tibbits

was indicted for watering his hides in William Combe's fishing ground, an offence committed five years before. Similarly, William Ingram and eleven others were fined for carrying away four cartloads of Combe's soil.

On 30 April 1647, a case was heard concerning the poaching of two deer from the park of Sir Greville Verney. A man named Taylor was alleged to have had one and a 'souldier quartering with Mrs Nash', the other. Chapel Street, four years after its spectacular welcome to the Queen, had become a base for marauding soldiers.

'Our Light shall Come'

From 1646, the minister at Holy Trinity was Alexander Beane, 'a studious man and a solid preacher, who at home and abroad was highly esteemed for his judicious useful sermons. He was indeed one of the most celebrated preachers in the county.' Richard Quiney, 'grocer of London', bequeathed in 1656 to 'Master Beane, minister of God's word at Stratford-upon-Avon, forty shillings for his pains taken in preaching my funeral sermon.'

Beane was a signatory of the *Warwickshire Ministers Testimony to the Truth of Jesus Christ* and *The Solemn League and Covenant* of 1647. 'That although at present the sunne be covered and air darkened with mists risen out of the bottomlesse pit, yet ere long our light shall come and the glory of the Lord shall rise upon us.' This same fervour was encountered by the Quaker, George Fox, who, in 1648 met 'a great company of professors in Warwickshire, who were praying and expounding the scriptures in the fields'.

A delicate situation existed at the school. In January, 1649/50, the schoolmaster, John Trapp, wrote to the Corporation:

> Gentlemen all and my very good friends,
> Your ancient curtesy to me (though now for some years discontinued) as it calleth for my renewed thanks, so it give me boldnesse to remind you, that for these five years past I have received but one year's payoff that five pounds that you were pleased, fifteen yeares since to adde to my stipende…

Trapp had abandoned teaching to minister to the Parliamentary armies, but his party's ascendancy meant that he had to be handled with care. Eventually, the Corporation paid him £10 towards his losses. In 1650, he was appointed asssistant to the Commissioners for ejecting those who refused to subscribe to the covenant and substituted his son-in-law as schoolmaster with the consent of the Corporation.

Thomas Combe became Recorder of Stratford. Brother William, the former tyrant of the fields, did not fare so well. His fire was spent, wasted by advancing age and the deprivations of war. 'My uncle Combe is farr in debt', wrote George Willis in 1650 'and all the land that he hath about Stratford is sould or now upon sale.' The sad epitaph for his daughter Judith recorded by William Dugdale in Holy Trinity shows that the family had a human face. She was to have married her cousin, Richard Combe of Hemel Hempstead, 'had not death prevented it by depriving her of her life, to the extreme grief and sorrow of both their friends, but more especially of the said Richard Combe, who in testimony of his unfeigned love hath erected

this monument for perpetuating her pious memory. She took her last leave of this life on the 17 August 1649. In the arms of him who most intirely loved and was beloved of her even to the very death.'

In 1651, Stratford was near the frontline again. On 27 August, Oliver Cromwell marched his New Model Army marched through the town to rout Charles II's Scottish Army at Worcester. After the battle, the young fugitive King skirted Stratford to the north to avoid the heavily-guarded bridge, probably fording the river below the town.

Again the ratepayers bore the cost. On 2 September, it was announced that there would be a 'generall levie made for the collectinge of soo much as is charged upon this Towne by vertue of an order for provisions for Maj.-Gen. Lambert's Regiment.' On 13 September, the Corporation paid 15s for wine and tobacco 'wn. My Lord Protector was proclaimed'. Following Cromwell's suspension of Parliament, the county became a military district under CG Whalley who was noted for the suppression of alehouses and bear-baiting.

The rule of the Saints did not curtail all conviviality. 'Att this Hall', read the minutes in 1652, 'Mr John Wolmore senior is fined xxs for breaking the ancient and laudable custome of nott invitinge our wives to the feast', although it is unclear from the wording whether the burgesses were upset because he did or because he didn't. Next year, the Corporation received 'Richard Castell's bill for sacke sent to the Cheezkake feast, white wine sent to Mr Bayliffe's feast, &c...'

Efforts were made to repair the war damage. The bridge was renovated at a cost of £20 by Thomas Sargerson of Coventry in 1652. A year later, a fund was opened to rebuild the Town Hall. Meanwhile the Corporation met in the old Guild Hall. The new political *status quo* was formally acknowledged on 9 December 1653, when it was agreed that the maces be altered according to the injuncion of an Act of Parliament'. Commonwealth crowns were substituted for the royal ones. A more public symbol of the transition from monarchical to Parliamentary power was visible in the change of name of Stratford's leading inn. The Crown became The Woolsack.

The meeting of 9 December, had a more immediate matter to discuss. Another great fire had devastated the town caused by inadequately supervised malting kilns and a lack of firefighting equipment. Collections were again made towards 'the great losses' in most of the counties of England. The Corporation petitioned the 'Lord Cheefe Justice to restrain all thatched houses in our towne. Also that the buckets that remane belonging to the Company shall be made up two dozen. Also that there be some spouts provided by the Chamberlaine, and to make som fire-houkes more and mak some ladders more.' No fire was to be kept under any kiln, or any straw left in the kiln-house after 8 p.m. 'Nor any children under twelve years of age or any blinde body imployed about the keeping of fire under any kilne upon the penalty of twenty shillings.' Each Alderman and Burgess was to provide at his own expense, two leather buckets 'to keep in his house betweene this and ester next on payne of forfeiting twenty shillings.'

Once again, in the midst of their troubles, the Stratfordians remembered others. Within a year the Bailiff paid £20 3s 9d collected in the town to the Lord Mayor of London's fund 'for the distressed Protestants of the Duke of Savoy countrie', Milton's 'slaughtered saints' massacred in Piedmont.

Religious controversy continued, although it is not possible to be specific. On 12 January 1653/54, the Corporation agreed that Mr 'Wade who lately preached in the High Church,

shall be admitted again to preach in the same place upon the next Lord's day but one, or in case he shall meet with any disturbance that he cannot preach there, hee shall be permitted the use of the Chappell for that day.'

The Corporation's regular obsessions continued unabated. A meeting of 1653/54 fined Richard Castell £5 for disclosing 'the speeches of some members of some members of the Company at a common Councell'.

'Witty above her Sex'

Mrs Nash was newly widowed at the time of the poaching incident. Her husband, Thomas, died on 14 April 1647. His will shows the continuing cohesion of the Shakespeare circle. He left cash bequests 'to his mother, Mistress Hall' and to his wife's cousins, Thomas, Elizabeth and Judith Hathaway. 'To his uncle and Aunt Nash' to Richard Quiney and his wife and 'to his cousin Thomas Quiney and his wife', he left 20s each 'to buy them rings'.

In 1649, the widow Nash was wed privately at Billesley Manor to John Barnard of Abington, near Northampton. At the Restoration he was knighted for unspecified services to the Crown during the Commonwealth period.

Susanna Hall died two months after her daughter's remarriage. A charming epitaph adorns her tomb in Holy Trinity.

> Witty above her sexe, but that's not all,
> Wise to salvation was good Mistress Hall;
> Something of Shakespeare was in that, but this
> Wholly of him with whom she's now in blisse.
> Then passenger, hast ne're a teare,
> To weepe with her that wept with all?
> That wept, yet set herselfe to chere
> Them up with comforts cordiall.
> Her Love shall live, her mercy spread.
> When thou hast ne're a tear to shed.

A document of 1685 describes Thomas Quiney as having been a 'citizen and brewer of London'. Whether he abandoned his wife cannot be said. More likely he went to work with his successful elder brother, who in 1652 had assumed the sole trusteeship of his business. Presumably he was still alive on 9 February 1662, when 'Judith *uxor* (rather than vidua) Thomas Quiney' was buried at Holy Trinity. Thirty years later, a visitor was told that Shakespeare's wife and daughters 'Did earnestly Desire to be Layd in the same Grave with him', but the verse with the curse had exercised its spell.

With the death of Elizabeth, Lady Barnard, in 1670, Shakespeare's direct line came to an end. The property he had so assiduously acquired to build a dynasty was dispersed. New Place was purchased by Sir Edward Walker, the Garter King-at-Arms, while the Birthplace was confirmed in the possession of the Hart family. In 1680, died the last person who certainly

knew William Shakespeare, his godson, William Walker. Legend could now take the poet where it willed.

And legend began to do just that. The Stratfordian with the dubious distinction of being the first-known embroiderer of Shakespeare legends to suit the local topography was the aged sexton, William Castle. On the strength of his birth in Stratford two years before the poet's death, he established himself as the resident authority on the Bard, telling visitors that Shakespeare wrote the ghost scene in *Hamlet* in Holy Trinity's charnel house at night to gain the appropriate atmosphere and that he was bound 'apprentice to a butcher; but that he run from his master to London…' The sexton's insolence, negligence and avarice caused problems to his 'masters and superiors', the vestry admonishing him for taking excessive fees. He had even hired out the hearse cloth.

Restoration

A sense of unrestrained joy was apparent among Stratfordians at the return of Charles II. The Restoration of 1660 was a rare occasion when a change of government was not accepted passively, but greeted with widespread enthusiasm. The Royal Arms were restored to the bailiff's mace (the Sadler mace still carries its Commonwealth crown). Richard Phillips was paid 'for drawinge the Kinges Armes in the Chamber in the Hall' and 'for Gildinge the Crown at the Church'. To celebrate the occasion the Corporation indulged the town with a Latin gesture. 'Wyne … was put in the crose pump at the proclaiminge of the Kinge.' In 1661, a receipt was issued 'for the Voluntary Contribution of Henley St. Ward to King' – probably the first extant record of a coronation celebration.

The Restoration Parliament suppressed dissent. In 1662, the county commissioners removed three aldermen and three chief burgesses from the Corporation, although in 1665 when Richard Smart refused the oath of loyalty, he was still duly elected.

Alexander Beane did not fare so well. The vestry minutes refer to him briefly as 'vicar' before his Puritan conscience overpowered him. On St Bartholomew's Day in 1662, he was ejected from his living for failing to pledge 'unfeigned assent and consent' to the Book of Common Prayer. 'His labours in this place had been so great and successful that he could ill be spared', lamented a fellow Puritan. 'Soon after his ejectment, he preached privately and was disturbed. When endeavouring to secure himself by flight, he took a surfeit and quickly died.' Beane's resistance was courageous, for he had a wife and six children to share his penury. To its credit, the Corporation granted him a gratuity of £6 13s 4d and his arrears of salary. Surprisingly, the militant Puritan and evictor of the Civil War, John Trapp, conformed and retained his living at Weston. Perhaps the years and a desire for security had mellowed him. A curious entry in the Chamberlain's accounts in 1662 recorded the payment of £1 to 'Mr and Mrs Trappe and his sonne for preaching.'

The Puritans now found themselves in a similar plight to that which Catholics had endured for over a century. Only those with deep conviction could endure the penalties imposed for nonconformity. Prevailing attitudes are demonstrated by the visit of the Quaker, George Fox, to the area in 1673. 'At John Halford's, at Armscot in Tredington parish, where we had a large

and precious meeting in his barn, the barn, the Lord's powerful presence among us.' Fox was arrested by the magistrates, who had missed the meeting 'from their sitting too long at dinner' and was sent to Worcester jail, but no charges were preferred.

Local Nonconformity had lost its potency. In 1674, the churchwardens' response to an Episcopal survey revealed that of the 584 people living in the parish of Old Stratford, only two were 'Popish recusants or suspected to be so' and only ten were 'other dissenters which obstinately refuse or wholly absent from the communion of the Church of England.'

At the quarter sessions that year representations were made on behalf of Thomas Evetts, apprentice to William Jakeman, a Quaker tailor who had been jailed for not attending church and was 'therefore altogether uncapable of teaching his said apprentice his trade'. The court discharged Thomas from his apprenticeship and ordered Jakeman to return the boy's belongings and his 'parents and friends' to provide him with another position in the same trade 'to the end that he may serve out the residue of his time.'

A survey conducted by Lord Compton in 1676 showed that only 1.6 per cent of the townspeople were nonconformists. That a major objection of the authorities to this small band was financial is demonstrated by the presentment of Richard Bromley, Richard Hull and John Copeland in 1682, for 'not comeinge to church to heare divine service and refusinge to pay the rates levied on them for repaire of the church.'

South Warwickshire's Catholics were mainly congregated under the protection of great families like the Throckmorton's, who were regularly fined for their recusancy. The authorities demanded declarations against transubstantiation in front of the magistrates and Sir John Clopton, a local magistrate, appears to have declared against himself for refusing to deny the doctrine before returning to the bench.

'In good Order and Repaire'

The sacraments were restored at Holy Trinity and two 'gilte chalices with covers and a damaske tablecloth … a pulpit cloth and cushion, a carpit for the Comunin Table and a great cloth and a Flagon' were acquired. John Ward, a bachelor who had studied medicine at Barber Surgeons' Hall, was appointed vicar. Financial considerations forced a reduction in the stipend, although, in 1663, he was paid £3 'for his extraordinary pains as vicar, there being no assistant minister yet provided'.

Ward's approach to medicine was similar to John Hall's. He rejected bizarre cures compounded of 'the foot of a tortoise, the liver of a mole and the dung of an elephant' as 'strange and monstrous trash', favouring an analytic approach. He examined the process of breastfeeding, dissected cancerous tissues and declared vehemently against the prevalent practice of bleeding. When the plague wrought its devastation he noted that the only cure was to 'sweat twice a day and when the malignancy is collected into one bubo, the best way is to poltice and ripen it, that it may break and so dissolve it.' The pestilence brought its ravages to the nation again in 1665. The Corporation cancelled the September fair 'in respect of the plague being soe hott in London and spreadinge into many parts of the cuntry.' John Woolmer junior was ordered to send to London by the next post 'to

have it put in the news booke that thereby the cuntry may the better take notice of our resolutions therein'.

Ward noticed the effects of the climate on the health of Stratfordians. 'After a cold Winter, a cool Spring and a very hot Summer, children had the meazles extremely and men about July had agues and feavours in abundance'. A sad case gives a glimpse of the high infant mortality rate: 'A fellow that lives in Kineton had 27 children, most of them born alive, yet not one lived above a month; this man I spoke with myself'. He realised the unhealthiness of the stifling atmosphere of the contemporary bedchamber. 'Have a care in curing children, that they be not kept too hot by people lying with them: to give them breath is very good.'

Ward's clinical experience enabled him to share experience of man's ingratitude with his Saviour. 'The ten lepers praid aloud in trouble, but they being once cured, nine in ten are as mute as fishes; so itt is with physitians patients, they promise fair till they are cured, but then never so much as come back and thank you.'

The vicar's sermons struck a sure note. The confidence and calm of the notes he jotted in his commonplace book imply that, while past storms are not entirely over, more tranquil times lie ahead. 'Those mercies which we obtain by prayer, we must keep by praise', he exulted in a phrase reminiscent of George Herbert. He observed the shallowness of man's affections. 'Favourites are like dials, no longer looked upon than while the sun shines upon them.' He expressed distaste for slanderous gossip. 'The good name of a man is like a Venice glass which one drop of ink will defile.' Yet the message was one of atonement. 'He that does wrong never forgives, but he that suffers wrong may.'

Ward was clearly held in high esteem. 'Our church and churchyarde, with all the ornaments thereunto belonge are, and is, in good order and repaire', the churchwardens noted with some satisfaction at the Episcopal Visitation in 1664. 'Our minister is episcopally ordained, leagally instituted & indicted, & performeth his ministeriall office with much care and diligence, & is a person of good sober life and sivell conversation...'

He also exhibited measures of progressiveness. In 1670, one of the parish churchwardens, Thomas Baylis, died. His widow, Isabel, effectively took over his role, although she was never formally elected to the position, she presented the accounts in 1671.

Charitable provision was extended in Stratford at this time by the generosity of John Smart of Romford in Essex, who gave books and an endowment to enable for 20 poor men's children to be taught by 'some auntient woman of your Towne'. They were to take their bibles to church and 'read them at home before their Parents, at least 3 tymes in the weeke (for Parents are oftymes taken more with their childrens reading than with that they heare at Church)'.

Smart also provided that twenty 'poore men and women such as ye shall appintmant have each Sonday a Loafe of Bread if they come to Church, or bee not hindered by Sicknes or age. And that it may bee the better Bread for them I desire that when Wheat is best cheap there may bee soe much bought as may serve them for the whole yeare...'

The reason for Smart's philanthropy is unclear, since he appears to have been unfamiliar with the town. Because he lived 'out of London & know not where to send to the carriers', he requested the Corporation to appoint 'some boy in London to call for the Books and mony at my sonn's shop at the Black boy in Lombard Street at Ste Clements Lane end a woollen Draper his name Mr Joseph Smart...'

'Obedient and Loyal Subjects'

While all was well with Stratford's body ecclesiastic in the era of the Restoration, its body politic was in a state of confusion born of the financial crises of the times, which were accentuated by a steady decline in the town's economic status. Many of Stratford's domestic industries were facing increasing competition from the industrial towns to the north. Even John Shakespeare's trade of gloving was defunct. Only agricultural ancillaries like markets, malting and wool carding continued to thrive.

In 1663, the Corporation undertook measures to reduce expenditure 'in respect of the poverty of the Chamber & the improbability of being out of debt with out reducing the ordinary payments.' The town clerk's annuity was reduced from £10 to a mere £1. The 20 marks payable to the bailiff at Oken's Feast was discontinued. It was agreed to pay off arrears, but even so the mayor (the title was first used in 1665) and town clerk had to wait two years to be paid. The town's depressed state led to its being granted a general jury exemption in 1671/72.

Something of the perilous state of civic affairs is contained in a response by the schoolmaster, Josiah Simcox, to a request by an Oxford scholar for information on the foundation of the school. 'We have in the Chamber of Stratford records concerning it, but the ignorance of our Corporation renders their owne search into them insignificant, and their jealousies forbid another's search...'

A major problem for the Corporation was the compulsory renewal of the borough charter, which the impecunious government decreed in 1664. Despite the expenditure of considerable effort and money, the matter was never quite resolved. The old problem of encroachment continued. The new Lord of the Manor, Lionel, Earl of Dorset, claimed rights over the common land on the Bancroft and accused the poor inhabitants of carrying off his timber. The mayor and Justices were summoned to London to answer charges of aiding and abetting their fellow townsmen. A long wrangle ensued during which they were accused of illegal coining. This was true. Illicit invention had partially relieved the town's impecuniousness. Six lbs of halfpennies were manufactured in 1669, a practice on which the Corporation was obliged, officially, to frown. The practice was widespread. The Exchequer did not mint small change because the cost was more than its value and communities and traders issued their own. Less than a quarter of the smaller coins in circulation were genuine. In 1672, Parliament forbade further coining, but Stratford was still minting in 1676.

The first use of the word 'Mop', to describe one of the fairs occurs in the Chamberlain's accounts for 1675, when the Beadle, John Mumford, was paid 4*d* 'for cryinge the moopp' and paid for two ounces of tobacco and two doxen pipes on the same occasion. A contemporary reference shows that 'mop' was a regional word used to describe a fair at which people gathered to be hired as labourers and servants. The origin of the word is obscure, but it has been suggested that it derives from the symbols of trade worn worn by those seeking work. The Chamberlain's accounts give no indication of when this mop took place, so it cannot necessarily be identified with the October fair that still bears the name.

The Corporation participated energetically in the furore over the Titus Oates affair, even if its efforts again recall Dogberry. It was decreed that 'All persons shall watch in their own

persons and that there bee apoynted 6 persons every night to watch till they see cause to the contrary'.

The watchmen might have been employed observing the burgesses rather than in looking out for illusory Popish plotters. An order from the County Commissioners for Charitable Uses in 1682 gave the Corporation notice of an enquiry into 'the alleged misuse of Charitable funds and warning them to produce all evidences, together with accompt of the Anne Loyes money, Mr Okens money, etc…' The outcome of the investigation is unknown, but its very occurrence underlines a decline in civic status and standards. The unease expressed by the burgesses of Warwick a century before had been realised.

Yet the townspeople regarded their patriotism, if not their efficiency, as second to none, sending a Loyal Address to King Charles II on the twentieth anniversary of his Coronation.

> Dread Soveraigne.
> Wee yo: Maties most obedient and Loyall subjects looking back upon the dismall designs and bloody practizes of the late rebellious times which yet wee cannot with-out horrour and amazement reflect upon … although others have appeared before us in their Addresses of this nature, yett we declare none shall goe before us in reality and zeale to your Majesteyes service…

In 1682, the Corporation sent an address to the King 'to shew our dislike to that Assosiation drawn upp by sume of the protestinge Lords'. Yet some burgesses supported this attempt to exclude the King's Catholic brother from the succession. Next August, it was resolved to suspend three burgesses from the aldermanic bench until 'they doe acknowledge and subscribe their abhorrence to the Association formed in the Earl of Shaftesbury'. After the Rye House Conspiracy, the King was congratulated on 'his happy deliverance from that horod plot designed for the murdringe of his sacred majesty and his deere brother the Duke of Yorke'. The Corporation could not resist adding a line to this loyal address about its difficulties over its charter.

A Grand Design

In 1667, an engineer, Andrew Yarranton, began the task of repairing derelict locks on the Avon, which had fallen into disrepair during the Civil War. He developed a scheme which demonstrated the energy and invention characteristic of the pioneers of the industrial revolution. Although well before its time, it might have ensured a return of manufacturing prosperity to the depressed region.

Yarranton proposed the building of twin cities outside Stratford, one at Milcote, named New Harlam, where 10,000 inhabitants were to be employed in growing flax and manufacturing thread. The other was to be over the river at Bridgetown and called New Brunswick because a German beer called Mum was to be brewed there.

The engineer may be pictured, tramping the water meadows, measuring and calculating his grandiose plan, which he called 'the brat of my brain when I conceived it.' He envisaged that it would make Stratford 'to the West of England, Wales, Shropshire and Cheshire, as

Danzig is to Poland'. By 1674, construction had begun, but the project was wrecked by the volatile peasantry. The Privy Council received a complaint that mobs of 'the poorer sort of people' had stopped up the locks and sluices, broken into the mills and seized the corn.

Yarranton's description of the proposed spinning school is worthy of Thomas Gradgrind. Two hundred children would sit spinning on benches around a large room. In the middle would be a box 'like a pulpit' where the grand mistress would sit with a white wand in her hand. 'If she observes any of them idle, she rings a bell, by which the little cord is fixed to a box and out comes a woman. She then points to the offender and she is taken away to another room and chastised and all this is done without one word speaking. And I believe this way of ordering the young *women* in Germany is one great cause that German women have so little of the *twit twat*.'

Although his grand design was never completed, Yarranton restored the navigation, giving Stratford the appearance of a small seaport. Daniel Defoe, on a visit in 1712, noted the 'exceeding advantage' of the waterway. 'For by this river they drive a very great trade in sugar, oil, wine, tobacco, iron, lead, and … all heavy goods … and, in return, the corn, and, especially, the cheese – for Gloucester cheese is excellent in its kind, and this county drives an excellent trade in it.'

The Avon Navigation flourished throughout the eighteenth century. A local poet, the Revd Richard Jago, celebrated its economic advantages in his poem *Edge Hill*:

> On Avon's Bank, for inland commerce form'd,
> Stratford her spacious magazines unfolds,
> And hails the freighted Barge from Western Shores,
> Rich with the Tribute of a thousand Climes;
> By her, in husky Grain, or native Arts,
> Wise Industry's blest Produce well repaid.

8

'In Statu Quo'

Everything is in statu quo in our Town

Revd Joseph Greene, 1735

The Corporation sent loyal greetings on the accession of King James II in 1685. During Monmouth's abortive rebellion, Sir John Clopton raised horsemen with 'powder and bullet for four days' and a month's pay 'if there be occasion'. Action against dissenters continued during James' reign and the laws against distributing literature were rigorously enforced. In 1687, Joseph Smith, an ironmonger, was fined 1s 'for using the trade of a bookseller for space of eleven months past at Stratford.' Two years later he was charged with permitting his premises to be used as a dissenting meeting house.

In 1688, the deposition of the King passed unremarked in the Stratford minute book. Things improved for the dissenters with William III's Toleration Act of 1689 that granted certain freedoms of worship, the first small step on the road to pluralism. At the sessions that year, the houses of Joseph Smith, William Hunt, woollen-draper, and Richard Bromley were licensed as dissenting meeting places.

The bells of Holy Trinity clamoured the national pride at the victory on the Boyne in 1690 and the Corporation paid £2 15s for 'Cyder and Wine on the Kings return from Ireland.' In 1692, the vestry minute book recorded the payment of 14s 'for ringing the Victory at sea [La Hogue] and November 5th'.

Not that it required a national triumph for the Corporation to celebrate. When Thomas Willis, the schoolmaster, left in 1691, it was decided to turn his old coal house into a 'bruehouse between this and Mayday next, for the Company doth resolve to make use of it themselves'. The minute book of 1694 lists four annual feasts 'to continue until we shall order the contrary'.

A Non-Juror

It is significant that women, although denied political and many civil rights, emerge as equally culpable on recuscancy rolls. A mandate from Sir Timothy Baldwin, the diocesan vicar-general in 1694, reveals the severity of excommunication as a penalty. Elizabeth Hickocks,

Widdow of Stratford upon Avon wilfully lacking all obedience to the King and Queen's Majestys Laws Entirall is and doth stand lawfully excommunicated and so hath obstinately continued for

a long tyme ... disobediently refusing to submitt to the Governt of the Church of England as by Law it is now established and to the Magistrates and Ministers thereof. Therefore you are hereby admonished and required to eschew her ... as a person excommunicated and as a rotten member cutt off from the Church and that no person or persons within this parish or elsewhere doo give unto her entertainment in their houses, nor eat, drink, buy, sell or otherwise communicate with in publick or private but do turn her out of their houses, society and company ... untill such tyme ... of her submission and conformity to the Law...

The churchwardens were required to make 'diligent Enquiry' so that proceedings could be taken against those disregarding the order. Mrs Hickocks was possibly a non-juror – one who refused to accept the validity of William III's accession on religious grounds. If so, it would have been particularly painful for her in the next year when the Chamberlains paid 1/4d for 'cleaning the Bridge when King William and Queen Mary were coming' and the Stratfordians turned out to cheer the dual monarchs on their progress, surrounded by a great concourse of nobles.

The vicar from 1702–05 was the Revd Nicholas Brady, a chaplain to the King. It demonstrates the narrow perspectives of the time that it was said that this Irishman's 'qualifications would undoubtedly have raised him to some of the greatest dignities in the church, if the singular humanity and benevolence of his disposition would have suffered him to have run in with either prevailing party, or had he not settled in a country where he was regarded as a foreigner'. Not too much can have been seen of this amiable cleric in Stratford, for he held the plural livings of Richmond and Clapham and much of the care of the parish would have fallen on the curates. Yet Brady must have been regarded as an ornament to the town as co-author, with the Poet Laureate, Nahum Tate, of *The New Metrical Version of the Psalms,* which was commended by the King for use 'in all churches ... as they shall think fit to receive the same'. It includes such familiar hymns as 'Through all the changing scenes of life' and 'As pants the hart for cooling streams.'

The next incumbent, Richard Synge, was presented by the churchwardens in 1707 for 'neglecting to doe divine service' on the previous Sunday morning, and for 'providing no parson in his absence'. On the same day, a letter to the bishop signed with the mark of Thomas George, chapelwarden at Bishopton, accused the vicar of 'notorious and scandalous neglect' in not officiating since 15 July. He was prosecuted 'with great severity' and forced to quit the living.

A sequel to the affair emerges in a letter to the bishop from the Revd John Jeffcott, Vicar of Evesham, pleading for the borough Chamberlain, Joseph Smith. Mr Synge had promised 'to preach no more in ye church or chapel of Stratford, and therefore went on a Lord's Day in ye afternoone to Bishopton to preach there, whither abundance of people went to hear him'. It was a very hot day, the little church was packed and some of the women fainted. Smith was approached about whether glass could be removed from the chancel window 'that those within might be relieved and those without heare'. He replied that it was not his responsibility, but

desired them if they tooke any downe to take care it might not be broken, but kept safe to put up againe ... which he says was only an act of mercy and charity. If this be true, as I hope it is, I am ready to thinke it rather deserves praise than censure and therefore, most humbly pray by your

favour on his behalf yt he may not be forced to any public penance, nor troubled with further attendance. I assure you that I know him on a long and good experience to be a very pious, sober, prudent and good man, which encourages me to expect that you'l grant this request of your humble servant.

The outcome is unknown.

'The Dreadful Consequence of a Licentious Passion'

In 1714, the Corporation spent £6 10s to celebrate the proclamation of George I and sent an extravagant address to the new sovereign, expressing the hope that God would 'blast the attempts of any pretender that shall rise up against you'. Yet some of the local gentry were Jacobites: Sir William Keyte, Recorder of Stratford and owner of The College, proclaimed the Pretender at Shipston and was removed as a Commissioner of the Peace. The oaths of allegiance, supremacy and abjuration were administered at Stratford in 1723. Some 100 people signed a declaration against Popish doctrines, acknowledging,

> before God and the World that our Sovereigne Lord King George is lawfull King of this realm ... And I doe sulumnly and sincerely declare that I doe Believe in my conscience, that the person pretended to be Prince of Wales, during the life of the late King James, and since his decease, pretending to be, and taking upon himself the style & Tytle of King of England by the name of James the Third was not what he claimed.

Among the signatories was Ann, wife of Sir William Kyte, who thus doubtless greatly offended her husband. Despite their numerous children, the Keytes were incompatible, a situation compounded when the lascivious eye of Sir William alighted on Mary Johnson, one of his wife's maidservants. His suspicious wife bribed the butler to reveal all and her unrepentant husband fled with his mistress and elder children to a house at Aston Subedge. After several years of increasing penury and irascibility, he quarrelled with his mistress and children and threw them out. His fancies turned to a dairymaid, 'with no other beauty than what arrives from the bloom of youth.' Belated recognition of the harm he had done turned his mind. On a spring day in 1741, his remaining servants were alarmed to see smoke pouring from his bedroom. William Whiston, a Stratford tailor, who was delivering liveries, tried to pull him out and struggled with him, but the flames forced him to retire. All that remained of Sir William were his hip-bone and vertebrae, some keys, a gold watch and his huge debts, which obliged Lady Keyte to write a pleading letter to Mrs Welchman of the White Lion. 'I shall deem it a great kindness if you will take all opportunities to assure those I owe money to in Stratford ... that I will honourably pay what is due to them from me & pray don't let that bad woman Mrs Ward come and kant at yr. House, for she has used me very ill.' Lady Keyte would have concurred with a contemporary judgement that the tragedy was 'the dreadful consequence of a licentious passion, not checked in its infancy.'

The End of the Bawdy Court

Those of less exalted rank continued to have assistance in checking their licentious passions. During the first decades of the eighteenth century, a trickle of penitents continued to appear at public confession. Some cases evoked public sympathy. A petition from neighbours to the diocesan court in 1703 prayed for a money commutation of a public penance imposed on William Smith and Susannah Hurdis, *alias* Smith, 'their marriage having been dissolved as incestuous on the grounds that she was sister to Jane, his first wife'.

The case of Thomas Hudson, a weaver, provides the words used by the penitents. He stood through divine service clad in a white sheet on 30 March 1716, and after the Nicene creed, repeated after the Minister in, 'a distinct and audible voice',

> I Thomas Hudson do here in the presence of God and this Congregation humbly confess and acknowledge that not having the word of God before my eyes, but being seduced by the Devil and my own sinful lusts I have committed the foul sin of Adultery and have two bastard children unlawfully begotten ... Whereby I have greatly offended Almighty God, endangered my own soul and gave an evil example and scandal to all good Christians, for which offence I am heartily sorry and do humbly beg pardon of God and this congregation for the same hereby promising (God assisting me with his Grace) never to offend in the like again, but to live more chastely hereafter, asking the congregation to pray for me and with me to say, 'Our Father...'

A few weeks later, Sarah Adams made an identical confession, the minister substituting her name and offence of 'ffornication' for Hudson's on the sheet, adding that she had borne a child 'begotten on her body by William Edes the younger', a butcher who had fled before the charges were brought. Eleanor, the wife of Thomas Marshall, cordwainer, performed semi-public penance for ante-nuptial fornication and confessed 'most devoutly and solemnly'. Either the same Eleanor, or a namesake of Shottery, 'singlewoman', confessed fornication with Thomas Horsly 'and by him had a bastard child, though I wrongfully charged it upon one Thomas Green, who never had knowledge of my body.'

This ceremony of humiliation and redemption was accepted by saints and sinners alike as an act of penance in which offender and congregation participated. The last extant case was that of Ann Smith who confessed fornication in 1733. Within two decades, Stratford's first newspaper arrived on the scene. *Keating's Stratford, Shipston and Alcester Journal*, 'a good family paper', pursued the course later sanctified by overwhelming usage, providing succulent copy on rapes, murders, executions and the peccadilloes of the famous: – all lasciviously presented in a tone of unctuous condemnation. Public penance and pillory was delegated to the Fourth Estate.

Town Life

In 1724 occurred the last meeting of the court of record, which, despite collapsing in disorganisation, continued to provide a succession of stewards. After an Act of Parliament

granted overseers the authority to build workhouses and refuse relief to those unwilling to enter, a House of Correction for 'punishing and Employing the poor or other Disorderly persons belonging to this Burrough' was established in 1725 in Henley Street. In the same year, Mrs Sarah Woolmer, an alderman's wife, donated £100 to instruct six poor boys and six poor girls 'born of honest parents' to 'reade a Chapter in the Bible, distinctly say the Creed, Lord's Prayer and Ten Commandments in the vulgar tongue and be fully instructed in the Church catechisme.' They were to be known as 'Mrs Woolmer's Charity Children'.

In 1726, it was decided to give the mayor-elect 'for the time being to come a present of halfe a hogshead red wyne' in lieu of his entitlement of three-dozen bottles. He was to select his vintage and the Chamberlains would pay. The Coronation of George III was celebrated in due style in 1727 and 5s was paid to 'ye Morris dancers' on the Queen's birthday in 1732. That year Sir Hugh Clopton gave a rent of £16 from Ingon Farm to provide a blue coat biennially for the twenty-four almsmen and women, and to endow an Oak Apple Day sermon by the vicar in the Guild Chapel, for which he would receive £1, the Parish Clerk 5s and each almsperson, a shilling. The rest of the annuity was to buy straw hats and aprons for the almswomen or was to be spent in any fit manner. At its next Hall, the Corporation 'fit and properly ordered that a bole of punch be prepared this evening to drinke the good health of Sir Hugh Clopton, Knight.' In 1733, despite the Chamberlain being obliged to meet its current deficits from his own pocket, 5s was spent, with Shakespearean phraseology, on 'Cakes and Ale'. Yet in 1736, financial stringency led to the abandonment of the custom of escorting the retiring mayor home. Instead it was resolved that 'the late mayor doe make a present to the new mayor of a dozen of wine.'

There was antagonism to the Whig administration. The Corporation encouraged the county members to vote against Walpole's excise scheme in 1733. In the next year, the burgesses declined to present a loyal address on the marriage of the Princess Royal to the Prince of Orange.

A familiar dispute with the vicar re-emerged in 1735 concerning the appointment of a curate. Two senior lawyers, Sergeant Willes and Councillor Makepeace, awarded all costs against the Corporation and judged its claims to be 'illegal, Nay, Oppressive.'

'Ye Gentle Joseph'

A factor in the illegitimacy rate was the presence of two troops of dragoons stationed in the town, at least from 1713, when £1 1s 6d was paid by the Chamberlains for 'Ale the Troopers drank.' 'All things are in *statu quo* at our Town', wrote the Revd Joseph Greene to his brother in 1735, 'excepting that the Landlord and his lady at ye Crown in ye Highstreet, have battled it out to some purpose lately. I can't imagine what's the matter with the man, but to be sure he damn'd her grievously t'other day, only because he catch'd her in bed with a Trooper: one wou'd think he might put up with such trifles as those, but he swears he won't bear it, neither will he.' Another letter declares that 'we encounter as many Fools and Knaves as ever, but run some risqué of having more Whores and Bastards before ye Feast of St. Michael next; especially if our Pacifick forces alias Review-Warriors continue to quarter upon us'.

Joseph Greene was another in the line of civilised and humane clergymen who flourished at Stratford. Born at Shipston in 1712, he became curate at Preston-on-Stour in 1734, which he combined with the post of master at Stratford School. In 1736, he fell in love with Cecilia ('Tilly'), daughter of Richard Bartlett, an apothecary who was twice mayor. The courtship was opposed by Bartlett's third wife, Martha, who was desirous of cementing her alliance by providing Tilly for her own son. 'I wonder Miss' she would say to her stepdaughter, 'you'll be so much with Jo Greene' and she persuaded Bartlett to forbid the relationship. Greene passed his time composing scurrilous verses about the Bartletts and plotting his revenge, which occurred on 17 July 1737.

> I took Miss Tilly privately to my church at Preston & there I married her; the consequence you may easily guess at; Stratford bells ringing, and all ye old women in ye town hobbling up and down the streets to spread the News. Our friends laughing and rejoicing without ceasing; The father of the Bride sometimes melancholy & then raving and weeping by turns; the old Mother-in-law whisking about as if stung by a Gad-bee, with her face as red as newbrick, & fuming like an old smoakers tobacco pipe; We in ye interim wisely took occasion to keep out of these fits of various madness, & bedded together at Parson Holyoakes at Wolverton where we were to blame if we did not make one another hearty amends for being kept so long at so great a distance.

Throughout this letter to his brother Greene calls his bride 'the good ship Cecilia' and himself 'a mid siz'd privateer called ye Gentle Joseph'.

'The Strolers'

A letter of Greene's in 1734 mentions the arrival of a company of actors in Stratford. He does not record who they were, or what or where they performed, but he does not regard the event as remarkable, so such visits were not infrequent. A local poet, William Somerville, wrote *A Prologue for the Strolers at Stratford-upon-Avon*: 'We to this place where Shakespeare dwelt of old, / On foot, on horseback, or in carts have strol'd. / Be kind this night, each honest score we'l quitt / And give for sterling money, sterling wit'.

Perhaps this was written for Roger Kemble's Company. In 1740 they presented a 'Speaking Musical Pantomime', entitled *Harlequin's Invasion or Shakespeare Triumphant*, which it was reckoned would 'certainly give real pleasure to the inhabitants of this polite circle where the immortal bard first drew breath.' The dialogue was 'universally allowed to be the masterpiece of the celebrated David Garrick', then twenty-three and in the first flush of fame. This high priest of the growing cult of Bardolatry visited Stratford in 1744, with his fellow actors Denis Delane and Charles Macklin. They paid the obligatory visit to the famous mulberry tree at New Place, 'planted by Shakespeare's own hand', which Sir Hugh Clopton delighted in showing to visitors. Neither Stratford nor Garrick could know how their futures were intertwined.

The first recorded performance of the poet's work in his hometown occurred through a curious process. By 1746, natural decay and the depredations of souvenir hunters had reduced Shakespeare's bust in Holy Trinity to a lamentable state. Joseph Greene resolved to restore it

and enlisted the aid of John Ward, whose company had recently played at the Town Hall. Ward 'very genteely' offered to perform a play by Shakespeare and donate the profits to the appeal and so it was announced that the 'Warwick Company of Comedians' would act *The Merry Wives of Windsor* 'on Tuesday, next, the 9th September.'

Perhaps *Merry Wives* had been performed during Ward's season, but the play that evening was *Othello*, with Ward in the title role and 'Several Entertainments of SINGING, between the ACTS'. Greene wrote a prologue '& received greater marks of respect … than I could have presum'd to expect.' It was spoken by 'ye ingenious Mr Ward, who entered fully into my sentiments & expressed every sentence as I could wish, with ye justest Emphasis & most exact propriety, notwithstanding he had the composition but a very short time in his possession.' He considered the company 'much ye best set I have seen out of London, & in which opinion I am far from being singular. Ye characters… (except that of Brabantio) were well presented, & the whole conducted with much decorum. & in consequence, applause'.

The performance raised £17. A limner, John Hall, was engaged to repair and 'beautify' the monument. Greene had not anticipated the foibles of the woodenheaded churchwarden, John Spur, a blacksmith who refused to sign a contract with Hall, 'ridiculously vaunting that his word would go for 100 pounds'. He was finally prevailed upon to declare that when the monument was completed, he would pay the money without delay.

The restoration was meticulous. 'Care was taken', recorded Greene, '…not to add or diminish what ye work consisted of, & appeared to be, when first erected.' The restored colouring offended the taste of the age. 'Lady Caroline Petersham is not more vermillion', complained Horace Walpole on a visit in 1757.

Greene's talent for historical research enabled him to find a copy of Shakespeare's will in the diocesan records in 1747. He was depressed by his discovery, regarding the document as 'so dull and irregular, so absolutely void of ye least particle of that spirit which Animated our great Poet, that it must lessen his Character as a writer, to imagine ye least sentence of it his production.' Contemporary sensibility demanded that even the poet's last will and testament should be in blank verse.

Extant playbills show that other companies of actors played at Stratford. Charles Booth, the founder of a famous theatrical dynasty, played *Hamlet* there in 1758. The Kembles returned in 1763. No record remains of their performance, but on 12 February, 'Mary, daughter of Roger Kemble, Comedian', was baptised at Holy Trinity. They returned five years later to perform at 'The Histrionic Academy' in the Rother Market, Tate's dissected version of *King Lear*, with its happy ending. Mrs Kemble played Cordelia, Mr Charles Siddons, Albany and the thirteen-year-old Miss Sarah Kemble sang. A fortnight later, the season closed with a benefit performance of *As You Like It*. Mr Siddons played Orlando; Mrs Kemble, Celia, and Miss Kemble, Phoebe. This prodigy is better known subsequently as the wife of Mr Siddons.

'The Devil, Doubtless'

On 13 January 1743, Stratford became part of John Wesley's world parish. 'I had scarce sat down', he recorded in his journal,

before I was informed that Mrs K., a middle-aged woman of Shottery ... had been many weeks past in a way which nobody could understand; that she had sent to a minister, but almost as soon as he came began roaring in so strange a manner (her tongue at the same time hanging out of her mouth, and her face distorting into the most terrible form) that he cried out, 'It is the devil, doubtless! It is the devil', and immediately went away ... I asked What good do you think I can do? One cannot tell but Mrs K. earnestly desired you might come, if you was anywhere near, saying she had seen you in a dream, and should know you immediately: but the devil had said ... I will tear thy throat out before he comes. But afterwards she said his words were, 'If he does come, I will let thee be quiet, and thou shalt be as if nothing ails thee till he is gone away'. A very odd kind of madness this! I walked over about noon, but when I came to the house, desired all those with me to stay below ... I went straight to her room. As soon as I came to the bed-side she fixed her eyes and said, 'You are Mr Wesley. I am very well now, I thank God; nothing ails me; only I am weak.' I called them up and we began to sing ... After singing a verse or two we kneeled down in prayer. I had but just begun (my eyes being shut) when I felt as if I had been plunged into cold water, immediately there was such a roar that my voice was quite drowned, though I spoke as loud as I usually do to three of four thousand people. However I prayed on. She was then reared up in the bed, her whole body moving at once, without bending one joint or limb just as if it were one piece of stone. Immediately after it was writhed into all kinds of postures, the same horrid yell continuing still. But we left her not until all the symptoms ceased, and she was (for the present at least) rejoicing and praising God.

Later, Wesley preached at the Market Cross. 'Most of the hearers stood like posts, but some mocked, others blasphemed and a few believed.' Despite Wesley's visit and exorcism, Joseph Greene could tell his bishop in 1764 that 'about 30 years past there was a monthly meeting of the People called Quakers in the Town, but they too have wholly now quitted it, and no Dissenters of any sort remain, unless a few illiterate mechanic Methodists deserve that Appelation, who venture not however to enlist their nonsense except in some private families.'

Energy and Inertia

That Georgian necessity, a spa, known as 'Perry's Mineral Spring', was modestly established in 1744, 'at the end of a cornland' in Shottery Fields. Edward Wyles, a dragoon stationed in Stratford in Maj.-Gen. St George's Regiment, had his right leg 'full of sores and breakings out for two years' which had baffled all treatments, so he tried the mineral water. Each morning he drank up to six pints and bathed his leg in it. In a few weeks he was cured. The waters cured another dragoon of violent diarrhoea. Leonard Sherrington, Warden of the Tower of London, hearing of the water's 'great character', tried it and his persistent 'gout was cured'.

Between 1726 and 1769, the local main roads were turnpiked. The improvement was relative. 'The roads are not only very slippery, but in some places deep', wrote the Nonconformist divine, Dr Philip Doddridge from Stratford in 1743, 'and we had thirty-three gates between this and the last market town, most of them very heavy, and made fast with latches.'

Improved transport spelt disaster for the town's staple industry of malting. 'Since the roads have been made so good that Business is Cheifly Transferred to Birmingham. There was upwards of 60 Officers Formerly Employed in Town for that purpose, but now there is no more than 20.' The resultant slump led the Corporation to seek advice about establishing a permanent debt in 1744, although this was not undertaken for another thirty years.

Economic decline was paralleled in civic life. Despite fines and exhortations, many Corporation meetings were abandoned as inquorate. Even the Constables were fined in 1745 for not 'attending to proclaim the Fair'. When burgesses moved away, they could not be released from office, lest failure to replace them led to the collapse of the flimsy structure of local government. Yet Stratford was fortunate in its town clerk, Thomas Hunt, who, from his appointment in 1750, initiated virtually every positive policy pursued by the Corporation.

Corruption played its part in the system. In 1753, Mr Pixell of Worcester, a young gentleman of 'taste and good family' who was seeking a situation in the town, sought the advice of Mr John Reynolds of Wooten Wawen. He said that the only way he knew was for Mr Pixell's father to get nine or ten aldermen drunk and 'consequently they would be friends to the son'. In this Stratford was not unique, for he added that, 'This kind of proceeding prevails in England sooner than merit.'

The decay was reflected in the appearance of the town. Visitors commented on its dilapidated state. Horace Walpole, who should have appreciated a Gothic ruin, found Stratford 'the wretchedest old town that I ever saw, which I intended to find snug and pretty, and antique, not old'.

Insanitary conditions prevailed. The ditch along Chapel Lane was the receptacle for 'all manner of Filth that any person chose to put there and was very obnoxious at all Times'. The inevitable sequela was disease. The plague had exhausted its virulence, but a new scourge had emerged from the east. 'The smallpox is ruining my school as fast as it can', wrote Joseph Greene in 1747 with a heartfelt understatement. A survey in 1765 showed that 1,260 of the borough's 2,287 inhabitants had suffered the disease.

Yet some saw the town's rural virtues and were oblivious to its poverty. 'Stratford', enthused one writer, 'is most pleasantly and happily situated upon the fine navigable Avon. It is a country of beauty, plenty and cheapness and the town is very neat and is capable of accommodating a considerable number of strangers.' Alveston Field, which was some 5 miles in circumference, had been 'with great justice' styled 'The Montpelier of England' because of its fine hard gravel soil. 'But if it is condusive to health on the one hand, it is no less adapted to those rural recreations which almost all gentlemen delight in on the other; such as hunting, shooting and riding as an exercise.'

Little John Jordan

Basic education was still available to the most humble. As soon as John Jordan, the wheelwright's son, could walk, he went to school to 'a poor old woman' in Tiddington. He learned to write in a horn book. Soon after,

one Kemsley came and taught … a man whom Nature had left unfinished for he came into the world with only one hand … Being thus incapacitated from labours he was bred to letters and … being of an unfettled and whimsical Eccentric turn of mind he was weak enough to put some confidence in judicial Astrology and Occult Philosophy: in which sciences he vainly thought himself so great a proficient that he could as Shakespear says 'Conjure spirits from the vasty deep' and which experiment he had the vanity to try, but failing in the enterprise it affected his mind to such a degree that he became Melancholy, which affliction he attempted to avert with the charms of the bottle … in a short time his faculties were damaged and he grew distracted and was obliged to give up his school … Among all his fits of Paroxism he … beat many of the scholars most unmercifully.

He treated little John with the 'most tender respect'. Not surprisingly, he was soon the only pupil left. One day Kemsley declared in a flood of tears that he could teach no more, but he was sorry they must be parted. He was sent to an asylum where he was 'perfectly cured … and was for many years after a teacher at Aulcester.' Perhaps poor Kemsley exercised a formative influence over Jordan's later career as an inventor of legends.

In 1756, when he was ten, John left school. There were five younger children at home. To help support them he worked with his father as a wheelwright. Even after he was eighteen, he was obliged to work without wages to keep his siblings, 'who have since treated me with the most excessive ingratitude especially after the decease of my Father and Mother'.

'The Reverend Destroyer'

Sir Hugh Clopton was heir to the aristocratic tradition of freely opening mansions to the curious. His successor was in a different mould. The Revd Francis Gastrell, a canon residentiary of Lichfield Cathedral, acquired New Place in 1753, but felt 'no sort of pride or pleasure in this charming retirement, no consciousness of being possessed of the sacred ground which the Muses had consecrated to the memory of their favourite poet'. It is a measure of this wealthy cleric's obnoxiousness that he even stirred the Corporation from its lethargy by evicting tenants and indulging in long wrangles over his poor rates. Matters were exacerbated by the steady tramp of the visitors whom old Sir Hugh had welcomed so freely, but whose demanding presence tried the limited patience of this irascible parson. As his temper grew, he rationalised his disagreeable humour so that the celebrated mulberry tree became the focus of his disaffection. He considered it overshadowed his windows and made the house damp. In 1756, he screwed his courage to the chopping place. One John Ange did the dastardly deed by night. Next morning all that remained of the living link with Stratford's most cherished son was a pile of logs in the yard.

The people of Stratford were seized with grief and astonishment when they were informed of this sacrilegious act and nothing less than the destruction of the offender in the first transport of their rage would satisfy them. The miserable culprit was forced to skulk up and down to save himself from the Stratfordians, who as a first instalment of their terrible revenge, alleviated their fury by breaking the reverend destroyer's windows.' Amid this vehement

chaos, one man realised his hour had come. Thomas Sharpe, clockwinder and repairer to the Corporation, bought the remains of the tree and transferred them to his premises over the way. He realised that cults require relics. The mulberry wood would meet an insatiable demand. He was to create sufficient objects from the 'original' wood to consume entire groves of mulberry trees. In 1768, one Judith Brawne denied rumours that he had bought mulberry wood from her family. After he acquired a walnut tree growing in front of the Birthplace, a verse on the master and his craftsman circulated in the town. 'Gastrell the Mulberry Tree cut down / Tom Sharp he cut it up / But Gwinnett turns a Walnut Tree / Into a Mulberry Cup.'

Sharp's sales technique was cunningly simple. He nailed a piece of the real tree to his workbench and placed one hand on it while disposing of the spurious article with the other, declaring to his credulous customer: 'I do solemnly swear that I hold in my hand a portion of the tree Shakespeare himself planted.'

All was not over between Parson Gastrell and Stratford. In 1758, he petitioned to demolish three barns, but was told that he must pay full land tax. The Corporation should have known that the iconoclast was liable to act erratically when upset. When it tried to extract the full poor rate for New Place, despite Gastrell's frequent absence, he angrily declared 'that house should never be assessed again'. In 1759, he razed it to the ground and left Stratford 'amidst the rage and curses of the inhabitants'. According to one report, the populace solemnly vowed never to allow anyone of the same name to reside in Stratford again. It was fortunate that the perpetrator of the outrage was not a Smith or a Jones!

In fact little remained of Shakespeare's New Place. In 1700, Sir Hugh Clopton had completely rebuilt the house. The surly Gastrell lost a considerable investment by his eccentric action and his rage turned to self-pity. 'I shall hardly ever entertain any thought of returning', he wrote to Hunt, 'to a place where I have been so maltreated'. He gained a pyrrhic revenge on the Corporation by being in continuous arrears with his poor rates. 'This is not payd', was still being recorded against his assessment twenty years later.

Despite the loss of this attraction, the number of visitors viewing such aspects of the town as might be evocative of the 'Immortal Shakespeare' continued to increase. Stratford's most celebrated inn was the White Lion in Henley Street, which boasted a 'bill of fare equal to that of the Piazza Coffee House, Covent Garden'. The proprietor was the ebullient John Payton, who 'by a secret peculiar to publicans of making general favours appear particular ones ... brought the house into great vogue.' He did much to stimulate the nascent tourist trade, even providing that trippers' essential, an excursion. In 1762, a correspondent of the British Magazine stayed there. The 'cheerful landlord' showed him the Birthplace and was 'so complaisant' as to accompany him on a visit to two young women, 'lineal descendents of the great poet', who kept a little alehouse near Bidford. On the way, he showed him a crab tree, called 'Shakespear's Canopy', under which the young poet was said to have spent the night after a drinking contest with the local topers. When Joseph Greene heard this story of Shakespeare's imbibing, he considered it to be 'no more than the Fiction of some wag'.

A Sporting Centre

Stratford was becoming a noted racing centre. The first recorded meeting was held in 1755. A ballad recorded the hazards of the course between Bordon Hill and the river. 'Many a good 'un was down on his luck / When he first clapped his ogles on Shottery brook.'

The annual meeting in August was a 'great source of amusement to the neighbourhood and sporting world'. More reprehensible sports occurred. Joseph Greene wrote a furious letter to the Oxford Journal in 1767, which must be quoted in full for its vigour and sincerity.

The deities of Stupidity, Avarice and Cruelty, conscious of the Influence they have over that numerous and sagacious corps of this Kingdom called the Mob and how many virtues they can enumerate in the Town of Stratford in particular, have given notice they intend to hold their solemn Festival in the said Town, on ye approaching 3d day of March, commonly called Shrove Tuesday, when it is expected that there will be a temporary infraction of every social law: to make amends for which, the following Irregulations will be observed.

First, in imitation of the Ancient Heathens (an excellent pattern undoubtedly for Christians), a spacious Altar of turf will be erected within the Licensed precincts of a Mansion dedicated to Bacchus or some other inferior though equally reeling Deity; some laudable deviations will be ho*wever made from* the early items of simplicity; for instead of killing noxious animals, certain Domestick Birds called Cocks will be despoiled of the beautiful plumage which nature gave them, be obliged to mount upon the Turf almost naked (like half their spectators) and be encouraged by way of sacrifice to tear one another to pieces, to the excessive sport of the pious Devotees that surround them.

Secondly, none will be initiated or admitted to a participation of these sacred mysteries below the degree of a scoundrel, whether with or without a shirt, from the small striped ostler's waistcoat to the glittering tunic of the steady-fac'd Buck; unless he promises to swear and curse every moment, to lie, bully and over-reach as often as he has opportunity, like the rest of the infernal Associates; and in the intervals of the Solemn Rites of Sharping, Gambling and Hooking with avaricious triumph, gulph down plentiful Libations of intoxicating liquors, 'till the would be gentleman & ye chimney sweep lovingly unite in the same edifying conversation.

The letter had its effect. The mayor issued a proclamation banning cock-fighting which the town crier shouted through the streets on Shrove Tuesday morning. 'Which notice,' wrote Greene, 'however mortifying, was duly complied with; and thus for once I procur'd the poor innocent cocks a reprieve.'

'Small Beginnings'

Old controversies were stirring. In 1766, the Corporation resolved unanimously to oppose 'by all lawful means' any petition presented to Parliament for enclosing in Stratford or Bishopton. Support was enlisted and plans for resistance prepared.

Early in 1769, Stratford's shopkeepers petitioned the Secretary for War that 'the great unusual No. of Dragoons in this small borough is a most heavy oppression upon the

Inhabitants – and must infallibly reduce many of the lower victuallers to Distress and Ruin and bring their families upon the Parish, which must eventually greatly injure and oppress those who are scarcely able to bear the present heavy Load of Taxes'. The soldiers had brought smallpox, which was 'raging throughout the Town' for the first time in many years. The reason for Stratford's poverty was clear. 'There is no manufacture in this place.' The petition brought temporary relief when the dragoons were transferred to Warwick. The move was to prove fortuitous in view of the events that were to take place in the following September.

Despite the vilification Gastrell had received for knocking down a building, it was clear that unless urgent steps were taken the town's chief edifices would collapse of their own volition. The wooden bell tower at Holy Trinity was removed in 1762. The indefatigable Joseph Greene raised £250 to build the stone spire which still reigns over the church. In April 1767, the Corporation agreed to rebuild the Town Hall, which was in 'a dangerous and Ruinous State', but restricted its own contribution to £200. Since the lowest estimate was £678, William Hunt compiled a list of potential donors. A number of local worthies subscribed, but a substantial shortfall remained. A single gift of an appropriate object for the new building might stimulate largesse. In common realisation, two men decided that David Garrick, then at the height of his fame, would be the ideal benefactor. 'The Common Observation', it was said later, 'that great events have small beginnings was never more verified than in the progress of Shakespeare's Jubilee!' This beginning was no more than an empty niche above the entrance of the new Town Hall.

9

'The Lad of all Lads'

For the lad of all lads was a Warwickshire lad.

<div style="text-align: right">Jubilee Song, 1769</div>

'A Proper Letter'

On a trip to London in 1767, Francis Wheler, steward of the defunct court of record, learnt of David Garrick's adoration of anything Shakespearean and his susceptibility to grand flattery. He thought that it would be 'an ornament' to the Town Hall if Garrick could be persuaded to donate a 'Handsom present'. A means towards this might be to make the actor an honorary burgess. The Corporation agreed, so he wrote 'a proper letter', which was delivered by George Yeate, a minor poet and acquaintance of the actor. A judicious balance of boldness and deference was observed.

> It would be a reflection on the Town of Stratford to have any publick Building erected here without some Ornamental Memorial of their immortal Townsman, And the Corporation would be happy in receiving from your hands some statue Bust or Picture of him to be placed within this Building, they would be equally pleased to have some Picture of Yourself that the Memory may be perpetuated together in that town wch gave him birth & where he still lives in the mind of every inhabitant.
>
> The Corporation of Stratford ever desirous of expressing their Gratitude to all who do Honor & Justice to the Memory of Shakespeare, & highly sensible that no person in any Age hath Excelled you therein would think themselves much honoured if you would become one of their Body; Tho' this borough doth not now send members to Parliament, perhaps the Inhabitants may not be the less Virtuous and to render the Freedom of such a place the more acceptable to you the Corporation propose to send it in a Box made of that very Mulberry Tree planted by Shakespeare's own hand…

Doubtless Yeates provided an amusing account of Stratford's war with Parson Gastrell. The actor was delighted to accept this extraordinary honour. Wheler's letter was the spark that set Stratford alight. Garrick wrote on its back that it 'produc'd ye Jubilee'.

Meanwhile, John Payton of the White Lion was entertaining his friend George Alexander Stevens, the celebrated comedian. Hearing of local regrets that there was no statue of Shakespeare in the niche outside the new Town Hall, Stevens offered to approach Garrick, warning that the actor was fond of both praise and profit. While he would be flattered by

the approach, he would seek to turn it to his financial advantage. Returning to London, he visited Garrick and sent Payton a vigorous letter. 'He informed me your Recorder had been with Him & told him about the bust of Shakespeare to be in the Town Hall – Out Sir was my answer. Mr Recorder & the Corporation of Stratford want Shakespeare to be out – out I mean to Everybody's view...'

Stevens thought that Garrick would produce the required gift and suggested the lines on which Payton should write: 'Set forth his great merits, & that there is not a man of greater propriety for a Bust or Statue, say Shakespear the father of the English stage, Garrick the Restorer of Shakespear - & some other such phrases for all great men love to be praised.'

The Jubilee was afoot. If Wheler was the first to approach Garrick, it was Stevens who proposed the statue in the niche and a celebration to launch it, offering to compose an oration set to music. Given Garrick's showmanship, the extravaganza that followed was inevitable from the first.

'Warmth and Rapture'

The first priority was the preparation and exchange of all the precious gifts so lavishly promised. The elaborate flattery of Garrick produced the desired effect. He determined to present a statue and a portrait of Shakespeare, commissioning John Cheere to cast a fine lead effigy. He dabbled with Thomas Gainsborough, but was shocked by the portraitist's lack of reverence towards the Bard, so he commissioned instead a lesser but more complaisant artist, Benjamin Wilson.

The warning that Garrick would turn any situation to his advantage was soon realised. In a neat reversal of position, he revived Wheler's proposal for a portrait of himself. It would appear vain if he commissioned it, so the Corporation picked up bills from the reinstated Gainsborough and from the frame-maker, Thomas Davies of Edgbaston, who also carved the box. The borough got infinite value for its money, for Gainsborough created a happy portrait of an elegant Garrick embracing an amiable bust of Shakespeare.

The cost of relations with Garrick was soaring, but there was no going back. On 11 October 1768, '...the greatest theatrical genius of the Age ... who has done the highest Honor to the memory of the Immortal Shakespeare' was unanimously elected an honorary burgess. Garrick would have been gratified if he had known that he occasioned the first mention of William Shakespeare in the minute books.

The presentation occurred next May in London. The Freedom was accepted 'with warmth' and the box 'with rapture'. At the close of the London season, Garrick invited his audience to join him in Stratford later that year. In June, he visited the town and was received 'with public honours, bells ringing'. At a dinner at the White Lion he outlined his plans with 'much perspicacity and to ... perfect approval'. The scale of his proposal was staggering – to bring his personnel, properties and audience to an obscure little town with no theatre and scant accommodation – and all this to be achieved in ten weeks.

The first question was vital. Who was to pick up the bills? The Corporation, although spellbound by Garrick, knew that the enterprise was beyond its resources. Thus Garrick

agreed to pick up the cost, aided by local supporters. Payton would take his own gamble by organising the accommodation and catering.

The centrepiece would be a great rotunda on the Bancroft, where Garrick would deliver his *Ode Upon dedicating a Building and erecting a Statue to Shakespeare*. The leading native composer, Dr Arne, would compose some of the settings and an oratorio. A more reluctant composer was the talented Charles Dibdin, whose spendthrift ways had resulted in undue dependence on Garrick. This caused friction and after a series of quarrels he walked out.

Despite such setbacks, the number of events was escalating. Plans included civic banquets, a masked ball, a Shakespearean procession, a firework display and a horserace. The latter was the inspiration of a group of local gentlemen who gained Garrick's approval for this 'well-imagin'd thought'. The provisions to supply the anticipated 'jubelites' would have sustained an Army. Payton ordered a huge turtle and hired Gill, the celebrated chef, brother of a noted Stratford drunk, to cook it. Three hundred waiters were engaged (they alone would place a severe strain on accommodation) empty houses were leased and 1,500 beds sent up from London. Despite this, some jubelites would be pitching tents in the common fields. Extra hands were employed to complete a new turnpike between Dudley and Stratford. Hunt had promised that the town would be beautified and set a splendid example by erecting an elegant pagoda in his riverside garden. Many Stratfordians, to the regret of the antiquarians, whitewashed their houses.

At The College, Garrick's brother, George, was in charge of technical preparations. The celebrated John French from Drury Lane was painting transparencies to adorn prominent buildings, but to work he needed an ample supply of drink and George's stimulating conversation. To clear the site for the Rotunda, riverside willows were felled, revealing a charming view of the bridge. The timber was bought by Thomas Sharp, of 'mulberry-wood notoriety', who found ample use for it during the ensuing celebrations.

The papers were full of the forthcoming Jubilee. 'To such a pitch of excitation was almost every individual throughout the country raised that a literary man … observed that the people of England were always falling out of one fit of madness into another and that the passion for Mr Wilkes' politics had totally given way to Shakespeare mania.'

Not all the publicity was sympathetic. A man of Garrick's position and personality was bound to draw detractors and there were those who sensed his potential difficulties. It was equally inevitable that Stratford itself should not escape the attention of the sharp-witted. The confrontation of the corruptly sophisticate and rural naivety is a traditional element of comedy and this would be a classic encounter. The papers were full of hilarious stories allegedly emanating from Stratford and many a legend was founded before the Jubilee began. To fulfil obligatory criteria, rural officialdom must be grasping and pompous. Whatever the Corporation's claims to the latter quality, it was surely abrogated from the former by its generous support for the Jubilee. Yet in a satirical piece in the *London Chronicle*, James Solas Dodd claimed that, while staying at Stratford's principal inn, he had overheard a meeting of the Corporation. '…several songs were sung, one of which for very obvious reasons was ordered never to be performed before any company but themselves.' The alleged 'anthem' was a parody of one of Garrick's songs for *A Winter's Tale*.

Come brothers of Stratford, these flocks let us shear,
Which bright as if washed-in our Avon appear.
The cooler are they who from fleeces are free;
And who are such trimmers, such trimmers are we?
Sing Tantarara, Shear all, &c., &c..

It was announced that, to boost the local economy, Shakespeare's statue would wear a woollen nightcap and that 'the fat landlady at a noted inn fell out of a hayloft into a manger while she was practising the chamber scene in *Romeo and Juliet* with one of the candle snuffers.' A leading Stratfordian allegedly named his daughter 'Doll Tearsheet' in honour of the Bard, while the mayor was supposedly taking lessons in deportment from Mr Baddeley, 'who played the Lord Mayor of London in Richard III'. Many Stratfordians must have pondered the efficacy of this method of opening a town hall.

After feverish work, the preparations were at last completed, although hammering was heard from the Rotunda to the last. A building had been created 'to make a lover of art sigh to think how soon it would be demolished'. French's elegant transparencies were hoisted into position. At the Birthplace a huge sun rose from the clouds over the inscription, 'Here dying clouds contend with growing light.' At the Town Hall, Shakespeare rode a Pegasus, flanked by his characters and lit by scores of back-lamps. Admiring crowds gathered, although those Stratfordians whose fundamentalism was a compensation for their ignorance expressed apprehension at such idolatry, which they regarded as 'peculiarly entitled to the Vengeance of Providence'. The correspondent of the *St James Chronicle* was particularly scathing: 'The low people of Stratford-upon-Avon are without a doubt as ignorant as any in the whole island ... I talked with many, particularly the old people, and not one of them but was frightened at the Preparations ... Many of them thought that Mr G–– would raise Devils, and fly in a Chariot about the Town.' The writer's comment on the discrepancy the inhabitants and Stratford's greatest son was to be much repeated. 'Providence seems by producing Shakespeare and the rest of his Townsmen, to shew the two Extremes of Human Nature.' The man from the *Gentleman's Magazine* found the inhabitants 'pursuing their occupations in the old dog-trot way, or staring with wonderful vacancy of Phiz at the preparations, the purpose of which they had very few ideas about.' The reports alarmed Garrick, who wrote to Hunt of his concern in hearing that 'the Country People did not seem to relish our Jubilee ... I suppose this may be a joke, but after all my trouble, pains, labor & Expense for their service & the honor of ye County, I shall think it very hard, if I am not receiv'd kindly by them.' Yet there was one area where even the most ignorant of Stratfordians could exercise tolerance. 'They found our money worthy of acceptance', wrote another correspondent.

By contrast, the correspondent of the *Public Ledger* was rarely enlightened in relating Stratford's problems to its poverty. The town was 'much worse than the ruins of St Giles, with a sort of people equally needy and equally desirable of removing their necessities by honourable means'.

Stratford filled up two weeks before the Jubilee. Cooks were working day and night in every available kitchen. Sedan chairs were trundled from London and Bath. 'If a person has but money', eulogised one reporter, 'he cannot stand in need of any article that his desires may demand.' The bustle was not to everyone's taste. 'The company', reported one fastidious correspondent,

'consisted not of persons whose rank in life was likely to do honour to the Festival; on the contrary, they consisted chiefly of itinerant hairdressers and figure dancers from the Theatres.'

The priggish scribe was not long disappointed at the lack of names to drop. On 1 September, David and Eva-Maria Garrick set out, followed two days later by a great convoy of actors and musicians. The roads were congested with Jubilee traffic. 'All the inns and roads from London are filled', declared a traveller, 'as if an Army was on the march.' Some avoided the congestion by taking to the water and a little fleet floated on an Avon swollen by summer rains.

Jubilee fever touched James Boswell, newly returned from Corsica, a country in revolt against the Genoese tyranny. He was in London for a functional reason. He had contracted venereal disease and his forthcoming marriage increased the necessity for a cure. To his delight, the pox-doctor agreed that a trip would be an admirable precursor to treatment and the young writer inevitably prepared a Corsican costume for the masquerade ball.

Garrick's apprehension about his reception was unjustified. He was greeted by 'joyful demonstrations', the Corporation delivering a formal welcome at his lodgings at Hunt's house.

Those with foresight had booked accommodation and some odd households emerged. Many 'highly respectable' people lodged in the almshouses. The Duke of Dorset was with the Widow Hatton at Nash's House; the Whitmores hosted a national hero, Admiral Rodney, in Swine Street; while the Earl and Countess of Pembroke and the future Parliamentary star, Charles James Fox, boarded with Tom Sharp. The number of mulberrywood souvenirs they obtained is unrecorded.

Joseph Craddock, a friend of Garrick's, lodged at 'a clean baker's'. His family were to dine at the White Lion, but there were so many loose horses around that the ladies could not safely alight. Fortunately, the unflappable Payton appeared and led the coach round by another route. The inn was jammed with people, but he sat them in Mrs Payton's bedroom until supper was served at a table on the landing.

At the Bear, a little band settled in whose hope was to see the Jubilee founder. Most dangerous was Samuel Foote, the noted actor and satirist. The hilarity began when Charles Macklin discovered that they were lodged above the store used by the pyrotechnicist, Dominic Angelo. In mock apprehension, Foote declared that 'a new Gunpowder Plot was being hatched against them. Should they be blown up, it would give the laugh so strong on Garrick's side ... that were he to hear of it in the other world, he should be eternally unhappy.'

At the Birthplace, Mrs Hart was showing visitors 'the chair on which he used to sit when he wrote.' She soon tired of explaining her husband's descent from the poet's sister and assumed temporarily the name of Shakespeare. Her daughter of fourteen, in whom those of fertile imagination discerned a likeness to the poet, was a great attraction. In a moment of euphoria, Garrick's partner, James Lacey, announced that he would train her for the London stage. Fortunately there is no evidence that he did so.

The little town was starting to creak under the seemingly endless arrivals. Visitors were diverted to the outlying villages, but soon these too were overflowing. 'Every Inn, House or Hovel now swarms with company; and the very stables are no longer confined to the reception of Horses, or even Grooms or Postilions, the Haylofts over them being cleared for the Reception of Families of the first Credit.' Hunt had recommended a charge of a guinea a night for lodgings, but the norm soon became the minimum. One arrival reflected poetically:

'To bed I must go – for which like a ninny / I paid like my betters, no less than one guinea, / For rolling – not sleeping in linen so damp / As struck my big toe ever since with the cramp'.

It was too much for one jubelite. On 21 September, the *London Post* attributed the death of John Henry Castle, 'at his lodgings in Clopton … to his having laid in damp sheets at Stratford-upon-Avon, where he went to amuse himself at the so much talked of Jubilee.'

During Jubilee week, crowds surged through the river meadows, where Angelo, 'looking another Marlborough', strode around selling fireworks. The noise of their explosion was exacerbated by the regular thump of thirty small cannons. Showmen were exhorting the curious to inspect such sights as 'the surprising Porcupine boy with the man Tiger'. At the Masquerade warehouse in Chapel Street, ball-goers were sorting through costumes. A discreet silence was maintained about the ladies of the pavement who had followed their clients to Stratford, although one correspondent sighed over the 'wenches … there was never any Paradise so plentifully or beautifully inhabited'.

Let Beauty with the Sun Arise

Early on Jubilee morning, the Garricks awoke to a serenade led by a recalcitrant Charles Dibdin, whose defiance had evaporated in a London denuded of fashion. The harmonies of his fantastically dressed singers vied with the dawn chorus under Garrick's window.

> Let Beauty with the Sun arise,
> To Shakespeare tribute pay,
> With heavenly smiles and sparkling Eyes,
> Give Grace and Lustre to the Day.
> Each smile she gives protects his Name
> What face shall dare to frown?
> Not Envy's self can blast the Fame,
> Which Beauty deigns to crown.

Garrick was enchanted by this tribute to Eva-Maria and apologised to Dibdin for his churlishness, although the musician declared that he 'knew what credit to give to his protestations.'

The singers moved around the town, serenading society beauties at their lodgings. Stratford was waking up and the cannons on the Bancroft added to the swelling noise. Tiring of their original ditty, the singers broke into songs intended for performance later in the day. The resplendent band of the Warwickshire Militia took up the theme. The testy correspondent of *Lloyd's Evening Post*, who had considered returning to London, was overwhelmed by 'this tumult of perfect satisfaction', although his bonhomie was soon tempered by an encounter with an avaricious sedan chairman.

At eight in the morning, the Corporation, fully robed, assembled at the Guildhall to elect a new mayor and then processed to the Town Hall. It is not to be doubted that the fashionable wags greeted the appearance of the little column with every weary Stratford joke uttered in the preceding weeks.

At the Town Hall, William Hunt presented Garrick with his insignia as steward of the Jubilee: a medal and a wand of the inevitable mulberry wood. Garrick, splendid in a gold and brown suit, made a short, graceful speech before the company donned its Jubilee ribbons and devoured breakfast. The movement was then to Holy Trinity where Dr Arne was conducting his Oratorio, *Judith*. Leading singers performed the airs 'in the best style', but the choruses were sung by enthusiasts among the jubelites and were thin.

The Oratorio over, crowds inspected Shakespeare's monument, so decked with bay leaves that it 'resembled the God Pan in an old picture'. Garrick's conversation with a group of admirers was interrupted by the arrival of a weird and filthy young man, with long dank hair and wearing a scruffy grey coat. To everyone's surprise, Garrick greeted this strange creature warmly.

The newcomer was James Boswell, who had arrived at noon, having ridden postilion in a coat borrowed from a small groom. On crossing the Avon, he was overwhelmed by 'those feelings which men of enthusiasm have on seeing remarkable places'. He went on to the White Lion in the forlorn hope of finding accommodation, but that fortune that pursues the young and charming was with him. A maid directed him to Mrs Harris, an old woman who lived opposite the Birthplace, who, for a guinea a night, let him have 'a tolerable old-fashioned room with a neat, clean bed'.

Boswell was elated by the gathering in the church. 'My bosom glowed with joy when I beheld a numerous and brilliant company of nobility and gentry, the rich, the brave, the witty and the fair, assembled to pay their tribute to Shakespeare.' Although he had missed the Oratorio, he filed a fulsome review to the *Scots Magazine*, adding the pious wish that there had been prayers and a short sermon. 'It would have consecrated our Jubilee to begin it with an act of devotion.'

On greeting Garrick, Boswell slipped him a note, 'to let him know I was incognito, as I wished to appear in the Corsican dress for the first time they would know me'. When the onlookers asked the identity of the curious stranger, Garrick replied, 'A clergyman in disguise'.

Outside, a procession formed behind the singers and musicians. Niceties of rank were forgotten in the good-humoured crowd. At the Birthplace a new chorus burst forth.

> Here Nature nurs'd her darling Boy,
> From whom all care and sorrow fly,
> Whose Harp the Muses strung:
> From Heart to Heart let Joy rebound,
> Now, now we tread the enchanted Ground,
> Here Shakespeare walk'd and sung.

At four, the movement was to the Rotunda for dinner. Such was the crush that the less honest diners escaped without paying and the less honest waiters pocketed cash, leaving Payton out of pocket. Ribaldry about Stratford continued, scurrilous verses circulating about its chief magistrate.

> The mayor scarse able to keep ope his Eyes
> Peeped at the food…
> & licked his lips (to stir in vain he tryes)

> At length as sweet in sleep's soft arms he stretches
> The snoring magistrate be sh't his Breeches.

As the meal closed, Garrick's health was proposed. He replied with 'the truest liveliness and hilarity'. The reporter from the *Gentleman's Magazine,* who had enjoyed the wine, led three cheers for Garrick as the orchestra and singers appeared to perform *Shakespeare's Garland.* The soloists were the tenor, Joseph Vernon, and Mrs Sophia Baddeley, a soprano of great beauty, whose profligate ways always guaranteed interest. Scores were available, so the jubelites thundered out the choruses. After the already-obligatory *Warwickshire Lads,* Mrs Baddeley sang the Jubilee's most popular and silly lyric.

> The pride of all Nature was sweet Willy O
> The first of all the swains,
> He gladdened the plains,
> No one ever was like to Sweet Willy O.

After the concert, a group of young enthusiasts seized a mulberry wood cup that Vernon had used in a song. 'Nothing would satisfy them till it was filled with the best of wines that they might have the pleasure to drink to the memory of the Immortal Bard.' There followed the most charming scene of the Jubilee. En route for his lodgings, the cupbearer met some friends who requested the pleasure of drinking what they called 'Shakespeare's Ale' from the cup. It was filled at a nearby alehouse and passed round 'every lad and lass, as well as every Darby and Joan'. A jubelite with a good voice sang Jubilee songs and all joined in the jolly dancing.

A spirit of goodwill prevailed. As the jubelites emerged for the ball, they found that the Stratfordians had 'testified their Joy' by illuminating their windows, which 'made the Night as cheerful as the Day.'

The Rotunda had been transformed into a fairy palace, lit by a thousand lamps. The floor was soon crowded with dancers. James Boswell appeared to inspect the company 'and to be able to say I had been there'. He was so tired that he could hardly stand, so he went home to bed. 'My landlady got me warm negus and seemed to be a good motherly woman. I told her that perhaps I might retire from the world and just come to live in Stratford.'

Samuel Foote went to bed with less satisfaction. Things had gone too well, but the winds blowing up the valley of the Avon even as the jubelites danced would bring him all the disruption he desired. The Corporation took no chances with the London wags. Two men were hired to guard the statue of Shakespeare in the Rotunda. They would have heard the first patter on its roof. When Stratford woke, sheets of rain poured down, filling the gutters and the sodden meadows as the Avon rose relentlessly.

A Wet Ode

David Garrick surveyed the dreary scene from Hunt's window. On the crucial morning the one chance item, the weather, had failed him. To make matters worse, his barber, perhaps

suffering a hangover, cut his chin while shaving him. Pulling himself together, he went to the College, where 145 actors from Drury Lane mingled in confusion with the locals selected to process with them. James Lacy greeted his partner with unanswerable invective. 'Who the devil, Davy, would venture forth upon such a lowering aspect? Sir, all the ostrich feathers will be spoiled and the property will be damnified five thousand pounds!'

But if the procession were abandoned, what of the Ode, which depended on the carnival atmosphere it would engender? What of the assembled enthusiasts and carping critics, even now breakfasting in the Town Hall? Garrick took the bold and only decision. The orchestra and singers were dispatched to the Rotunda. 500 leaflets were run off announcing that the Pageant would be postponed but that the Ode would be performed.

At noon, a damp audience packed the Rotunda. Garrick was aware that a pack of literary wolves was waiting to pounce and looked nervous as he took the rostrum to waves of applause. He paused for Arne's overture, raised his voice and spoke, 'To what blessed Genius of the Isle / Shall Gratitude her Tribute pay…?'

His ascendancy was total. 'He never showed more powers', wrote James Solas Dodd. The highly critical correspondent of the *London Chronicle* acknowledged that 'after all the expense, fatigue and disappointment … we were overpaid by a single recitation of the Ode … [that] gave so perfect a satisfaction that I should not hesitate at another Stratford expedition to hear it'. With his gift for combining artistry and novelty, Garrick had devised a new dramatic form, a recitative monologue to music. His three lady singers were enclosed, so that 'their musical punctuation to Garrick's mellifluous voice came like a crash of thunder'. Frequent applause interrupted the performance. Such was its power that many considered they had heard a masterpiece, rather than the somewhat mundane composition that objective examination showed the Ode to be.

Garrick's ability to empathise with any section of his audience meant that there was even solidarity with the fight against enclosure. 'And may no sacrilegious hand, / Near Avon's banks be found / To dare to parcel out the land, / And limit Shakespeare's hallow'd ground.'

Mrs Baddeley sang the closing lines,

> Thou soft-flowing Avon by the silvery stream
> Of things more than mortal, sweet Shakespeare would dream
> The fairies by midnight dance round his green bed,
> For hallow'd the turf which pillow'd his head.

The huge doors of the Rotunda opened to reveal the Avon, anything but soft-flowing: the sort of touch for which Garrick's instinct was unerring. The audience burst into wild applause and the benches gave way in a domino effect, culminating in a door crashing down, injuring several spectators.

After the debris and the wounded were removed, Garrick recited Milton's sonnet on Shakespeare and boldly asked if anyone wished to make a contribution. The comedian Tom King emerged and launched into an extravagant parody of the critics of the Jubilee. Not surprisingly, this received a mixed response and caused some puzzlement among those not fully briefed on London life. Garrick made a mild defence, embroidered around an appeal to the ladies to protect the reputation of the Bard, and the audience spilled into the rain.

Despite Garrick's brilliance, the spirit of the Jubilee was lost. As the Avon rose, so did the exasperation of the jubelites, slowly realising that they were marooned in a ramshackle little town, 100 miles from London in depressing weather. Amid this gloom, one man's hour had come. From Samuel Foote flowed joke after joke about Garrick, the Jubilee and Stratford. This masterly humorist made an elaborate jest of the entire town, not inventing stories, but exaggerating outrageously. He claimed that he was charged nine guineas for six hours sleep, and two shillings when a local told him the time. His circle took up the theme. It was claimed that 'an eminent actor was charged a shilling every time he repaired to the *Temple of the Graces* at a particular inn and that those rated at eighteen pence… who did not live in the house' and that the chickens were only half-plucked because the cook felt that, since the jubelites were so overcharged, 'they should have their property entire'.

It was not the visiting gentry who claimed discomfort, but the London glitterati, including the fastidious press corps. At the next event, the dinner where Gill's huge turtle was eaten and claret drunk, one correspondent declared that 'we might as well have been regaled on neck of Beef and Southampton port'.

Garrick's distress about the weather was shared by Dominic Angelo. The Stratfordians had shown lively interest in his huge firework display and large crowds gathered, but the event was a damp squib. A few pieces fizzed into the night before a regretful announcement postponed the show until the following evening.

Masquerade

The Ode inspired James Boswell to write verses on the inevitable subject of Corsica. Delighted with his efforts, he rushed round to one Fulke Weale, who advertised 'printing at an hour's notice. I suppose taking it for granted that Stratford would produce a general poetic inspiration which would exert itself every hour … But Mr Angelo's fireworks had turned his head and made him idle. He preferred them to all poetical fire.' So Boswell went round to the bookseller and printer, Mr Keating, who had a lad called Shank. 'I found him a clever, active fellow and set him to work directly'.

As the waters rose, exotically-clad masqueraders struggled over the soggy Bancroft to the Rotunda. The confusion afforded fine entertainment for the locals. 'A young gentleman of London, very eminent in the musical way' fell into a ditch. He grabbed a stump and clung to it while shouting for help. A gallant masquerader who went to his aid also slipped in. Fortunately the Stratfordians suspended their hilarity long enough to effect a rescue.

The interior of the Rotunda was now surmounted by the Imperial Crown made from multi-coloured lights. The arduous passage to reach this wonder had taken its toll. 'So completely was *the wet blanket* spread over the Masqueraders, that each, taking off the mask, appeared in true English character, verily grumblers.' Garrick's friends worked hard to relieve the misery. The orchestra struck up a minuet and an Aesopian ass took the floor, 'in droll contrast' to his partner, a sultana. Many costumes from the postponed procession now appeared. Notable were three hideous witches, who, after much cackling and squealing, were revealed as the society beauties, Lady Pembroke, Mrs Bouverie and Lady Crewe. The 'astonishing contrast between

the deformity of the feigned and the beauty of the real appearance' was much remarked upon. A highly-offensive devil encountered Mr Cook, a young clergyman disguised as a sweep, who flicked his brush at him, saying that he should be used to soot. The response was a hefty thump.

A mere flood could not hinder James Boswell, who delayed his entrance to give his costume maximum effect, and then underlined his arrival by conversing with Mrs Garrick. His bizarre dress aroused as much comment as it would have on the streets of Ajaccio and he received enough attention to declare himself 'as much a favourite as I deserved'. The only disappointment was that Shank had not published his verses in time for distribution.

Outside, a Stratfordian who had made good elsewhere argued with the doorman. 'Do you know who I am?' 'Yes, I knew you when your father was refused the place of Beadle … and although you have now got some money, you must not think to domineer here.'

The man from the *Gentleman's Magazine* was unique amongst the press corps in continuing to enjoy himself, although he conceded that 'a masquerade taxes the abilities in general too high' for few of the participants sustained their roles. There were few witticisms worth recording. Best charade was the dinner, which was 'inambigu, not one thing … as it really was'. Payton's ingenious fare worked wonders for morale. After dinner, the stately minuet was abandoned for the wilder pleasures of the country dance. Yet the jollity was still forced. 'All zealous friends', said the loyal Craddock, 'endeavoured to keep up the spirit of it as long as they could.'

If revolutionary sentiment had prevailed in England rather than France, future historians would have made much of this masquerade. Languid gentry, garbed in charade costumes, revel into the night, while outside a peasant mob laugh and jeer as the angry waters rise.

As dawn broke over the lake that the Avon had become, the problem of evacuation arose. A lengthy queue waited to tentatively cross planks that had been laid across the flood to carriages standing in 2 feet of water. Braver spirits hitched up their costumes and waded grimly to shore. The surly devil attempted to exonerate his obnoxiousness by heaving a large female through the teeming waters. His previous malignity would have been better rewarded. When a gust of wind revealed breeches under her outer garments, he disgustedly dropped his burden in the flood.

A promised repetition of the Ode was out of the question and was quietly abandoned. As the jubelites returned to their damp lodgings, most shared Boswell's reflection that he was in 'a little village in wet weather, and knew not how to get away, for all the Post Chaises were bespoke'. Arrivals had been spread over several days: now all sought to leave within hours. 'We were like a crowd in a Theatre. It was impossible we could all go at a time.' Payton, at least, was happy with this captive custom.

Aftermath

For the locals, and those jubelites remaining after the first rush, one highlight remained. A huge crowd watched five horses wade relentlessly round a Shottery meadow knee-deep in water. The winner was ridden by Mr Pratt, a groom, whose horse swam home by seven lengths.

The Jubilee whimpered towards its close. Angelo exploded his last fireworks before a thin crowd. At the Town Hall a sparse ball of bitter-enders was remarkable only for Eva-Maria's

vivacious dancing. The next day the Garricks left Stratford, the receptacle of their shattered dreams, forever.

Generously, Garrick bore the full costs of the Jubilee, although he was under no legal obligation to do so. Faced with the depressing combination of debt and ribaldry, he defeated both his creditors and his critics with a masterstroke. Back at Drury Lane, a Jubilee play and pageant was a wild success, achieving a record run and amply replenishing his accounts. In *The Jubilee*, he turned on his 'fellow-burghers', lampooning them mercilessly, as a sample of dialogue reveals:

> Mary: But Ralph, have you been down to the College, where they keep all their conjurations, Hobgoblins and gunpowder plots?

> Ralph: Oh, I saw how it would be when they wouldn't let his Image alone in the Church but the show folks from Lunnonshire would paint it all over like a Popish Saint – Oh, I saw how it be ... as sure as sartain 'tis a plot among the Jews and Papishes.

Other scenes featured a fight between rival mulberry wood sellers and the injunction of Stratfordians to their women: 'Don't stir out for fear the Pagans should lay hold of you and ravish you.'

Garrick's contempt for the little town he had so happily adopted even extended to contriving a quarrel over money with the splendid Hunt. His letter brought an eloquent and dignified reply listing all the execrations Hunt had suffered.

> The Abuse of my neighbours of the lower sort for endeavouring to prevent their Exortation – the sneers of the Witty - & the Pity of the Grave & Solemn – Thanks from no Person living that I know of – This I could have laughed at, all this I, all this I cou'd have despised, & have sat down happy with a Balance so amply in my favor; for the Greatest Genius of the Age, condescended to call me his Friend – I now, alas, find Felicity vanished also & my credit side become a total Blank – Experience ... remains sagely to advise me... never to meddle with what I do not understand – nor aim at Friendship beyond the reach of my Abilities to preserve.

Hunt's difficulties increased with the return of Mr J. Fullerton of The College, who demanded compensation for damage to his property. 'What right', he fumed, 'Mr Garrick ever had to the Keys I am quite a stranger to.'

Most Stratfordians, blissfully unaware of the derision crackling around them, returned the scorn of the sophisticates with a goodwill that would have been saintly if it were not born of ignorance. Even those who had regarded Garrick as a dangerous magician now viewed him as a universal provider. The Corporation formally thanked him for 'the great Honor he hath done to this Borough in the Execution of the Office of Steward of the late Jubilee & for the great Expense and trouble he was at'. Delight was expressed with his solidarity. 'Our hearts overflowing with Gratitude, can never forget that Attention, and Regard, you have shown to our Prosperity, in so elegantly expressing your Abhorrance in your most incomparable Ode, of that cruel Design, to destroy the Beauty of this situation by inclosing our open Fields.' Thus encouraged, the Corporation held a meeting at the White Lion to oppose enclosures. The

choice of venue was ironic, since John Payton was promoting such a scheme with Thomas Mason, a local lawyer and titheholder.

On 6 September 1770, the first anniversary of the Jubilee was celebrated at Stratford 'with uncommon festivity', an annual commemoration which was abandoned after six years after a further decline in the precarious wool trade. When Hunt proposed a yearly Jubilee to Garrick, he received a caustic reply. The actor advised his 'friends' that the celebration should be on Shakespeare's Birthday, but avoided the prospect of his own presence. 'The Manner how', he declared, should be for the Stratfordians, characteristically going on to advise what to do. 'The Bells should ring & Bonfires should blaze, ye Ladies should dance and the Gentlemen be Merry & Wise … There should always be proper Songs introduced … and joined with the Hearts and Voices of all the Company…' The priority should be to decorate the town, '(ye *happiest* and why not ye *handsomest* in England) let your streets be well pav'd, & kept clean, do Something with ye delightful Meadow, allure Everybody to visit ye *holy Land*; Let it be well lighted, & clean under foot, and let it not be said… that the Town which gave Birth to the first Genius since ye Creation, is the dirty, unseemly, ill-paved, wretched-looking Town in all Britain.'

Yet nothing could temper Stratford's veneration for Garrick. The Greyhound Inn was renamed in his honour. His artistry had had its impact on the Corporation. After the mayor-making it became the custom for a number of years after the Jubilee 'to proclaim theatrically His Worship' at the Market Cross. The burgesses processed in full regalia, preceded by a band, which struck up 'Warwickshire Lads' on its return to the Town Hall. Mulberry wood objects pursued Garrick for the rest of his life as the townsfolk dreamt of the return of their Prince Charming. A typical appeal arrived in 1771 from Henry Cooper of Swine Street. 'I am a Painter, Carver and Engraver, and in short Jack of all Trades, for through the blessings of God, I never saw nothing yet but what I could do … and I should take it as a great favour if your Honour would be so good as to give me an Order.'

The extraordinary achievement of the Jubilee was not at once apparent. In the Middle Ages, pilgrims had journeyed to religious shrines. Now Garrick had given The Age of Reason its first secular saint, indubitably laying the foundations of Stratford's tourist industry, a point realised by the poet Cowper:

> For Garrick was a worshipper himself,
> He drew the liturgy and fram'd the rites
> And solemn ceremonial of the day,
> And call'd the world to worship on the banks
> Of Avon, fam'd in song.

10

'For Want of a Quorum'

No Business can be done for want of a Quorum

Corporation Minute Book, 1784

Like the Combes before them, the enclosers realised that an interest might make the burgesses more amenable to their cause. The times were with them. After hard bargaining the Corporation secured a good concession. It promoted legislation and borrowed £400 to enclose, thereby instituting its first permanent debt. In 1779, a further £200 was borrowed for enclosure at Drayton and Shottery.

The peasantry reacted in the spirited manner of its forebears. Game was killed by 'Poachers and unqualified persons'. It was announced that anyone caught poaching, or pulling down enclosure works would be prosecuted 'with the utmost vigour of the Law'. Direct action was a forlorn gesture, and Ralph Greenaway of Shottery was reported for stealing fences and doubtless the dispossessed expressed forcible views in the expanding workhouse.

The breaking-up of the ring of common land enabled the first growth in Stratford's street pattern since the Middle Ages. The thoroughfares of a small suburb off the Guild Pits were named John Street and Payton Street after their creator.

The Corporation, or Hunt, was aware of the necessity to participate in the communications revolution. In 1775, Parliamentary petitions for a cut to the projected Stourbridge Canal came to nothing, which was a serious blow. In 1777, the Grammar School contained but one pupil and Hunt could not remember more than five there in the previous twenty years. One in ten houses was empty. On Sundays, bread was distributed to the poor at church, but the charitable funds provided only 1s a week. In 1778, Thomas Sharp of mulberry wood fame was made an overseer of the poor, perhaps to remind the paupers of the virtues of self-help!

The only tenuous link with prosperity was the well-supplied and crowded weekly market. To encourage this trade, the Corporation declared the town toll-free in 1787. At the Ram and Cheese Fair on Michaelmas Day, the youths wore red waistcoats and gay bandannas and the countryfolk, elaborately embroidered smocks. Rother Street swarmed with tumblers, fire-eaters, poker-swallowers and boxers. There was a considerable hop exchange and cheese was sold in such quantities that 'upward of 200 Waggon Loads have been here at one time'.

Around this time, the Mop Fair, held during the first two weeks of October gained greater prominence in response to the pool of dispossession following enclosure. The date is significant. It came at the close of the busiest season of the farming year, harvest time, when labour was at a premium. After that labourers and servants were free to attend the hiring fairs. 'Dozens of sturdy men and buxom lasses anxious to engage themselves for twelvemonth's service' stood

'like cattle waiting to be hired by the first comer'. The women waited on the outskirts of the fair, while the men wandered around. The indenture between employer and employee was binding on both sides for a year. The 'Runaway' Mop, a smaller fair on the Friday week, gave a second chance to the dissatisfied. The gratuity, or 'fasten money' as it was known, paid once hiring had been completed was undoubtedly the origin of the 'fun' aspect of the fair.

Economic decline was paralleled by political disintegration. Around a third of Corporation meetings were abandoned as inquorate. Burgesses paid fines rather than attend. The niceties of the Test Acts were ignored. In 1772, a dissenter, William Bache, was illegally co-opted and compelled to attend a meeting, but he indignantly rejected this chance to advance his sect, protesting that he was ineligible. Involuntary election ceased in 1793 when John Cox, a mercer, refused co-option and won a High court action after his goods were distrained. In 1788, fines for non-attendance were increased. The first 'neglect' cost 5s, the second, 10s, and the third, a guinea. Burgesses had been in the habit of registering their names and then leaving, for it was prescribed that those departing early were liable to all the penalties. A copy of the minute was sent to the mayor of Jubilee year, Nathaniel Cookes, who had long absented himself.

The Corporation still possessed sufficient volition to continue its ancient jurisdictional tiffs with the vicar. In 1775, the Revd Stephen Nason gave notice to his assisting minister, the Revd James Davenport, citing 'the Many Complaints made to me against you by my Parishioners'. The burgesses were not among the complainants, for they requested the withdrawal of the notice. Davenport had secured the plural living of Weston-on-Avon so Nason disposed of him by bringing forward the sermon time at Holy Trinity. Davenport, stranded at Weston, was unable to preach and was obliged to resign. Nevertheless, the Corporation continued to pay him its share of the stipend as minister of the Guild Chapel and master of the moribund school. On Nason's death in 1787, the Corporation used its influence to secure the living for Davenport, whose brother-in-law, Thomas Ashford, was a former mayor.

Such was the ascendancy of Thomas Hunt's legal practice over the town's affairs that, on his death in 1783, a dynasty of Hunts had to be created. An acting town clerk was appointed until Charles Henry Hunt reached his majority. When C. H. Hunt resigned in 1792 he was succeeded by his brother, Thomas. In one matter at least, the Corporation demonstrated a progressive spirit, petitioning Parliament in 1788 for the abolition of the slave trade.

The Constables' Supper

One of the highlights of Stratford's official calendar was The Constables' Supper, held at The Falcon on 5 November, when punitive powers were conferred on the minor officials. It was an incentive that the money raised in fines was spent on the feast.

The first supper was in 1784 when the borough constables met together to sup on hot tripe and swig. It became an annual event. At first, the company comprised 'merely the inferior officers of the borough, such as petty-constables, aletasters, bread and butter weighers, gutter groupers, &, but the feast was noted for its conviviality and soon the higher functionaries dignified it with their presences'. Soon it was understood that although the mayor was officially elected at a hall of the Corporation, the real selection was made at the supper.

Before the constables were invested with the power to arrest rogues and vagabonds, definition was called for. The answer was any wandering beggar over seven, or those wandering abroad without a lawful 'pastport', giving no good account of themselves. There were superior varieties of vagrant, such as

> scholars and seafaring men that beg, wandering persons using unlawful games, subtle crafts, or plays, or pretending … to have skill in telling fortunes; all counterfeit Egyptians (or gypsies, not being felons), all jugglers (or sleight of hand artists, pretending to do wonders, by vertue of Hocus Pocus, the powder of Pimper le Pimp, or the like), tinkers, peddlers, petty chapmen, glassmen, &c.

The Constables were also required to 'look after' orchard robbers, 'hedgbreachers' and wood stealers; repress profane swearing and search for the horses of Popish recusants, 'above the value of £5 a piece and to seize the same for His Majesty's use'. The archaic tone of the address with its quaint definitions and virulent religious sentiments perhaps dates it back a century.

On the evening of the supper the town was 'pretty well in the hands of the mob – the authorities to show their antipathy to Popery, tacitly allowing all sorts of riotous behaviour'. Many a five-barred gate found its way onto the burning mass in the Guild Pits. Once a four-wheel wagon was dragged to the bonfire, while 'those of a better class' ran away to avoid being implicated if any offenders were brought to justice.

The injunction against travelling entertainers had been long a dead letter. At the Wheatsheaf in 1770, the sensation was Mr Hickman, who allowed anyone to load a pistol and fire it any part of his body between his thigh and his chin. After this amazing feat, he commanded a pack of cards 'to walk one by one after him till all be called for'. A further attraction was 'a most surprising English MONSTER, a Double Cow-Calf, with two bodies, two tails and but one head'.

In 1771, the Booth Company played at The Unicorn. Mr Booth played Hamlet and took the lead part of Mungo the Black in *Padlock*, 'as it was performed in London with Universal Applause'. The Kembles returned in 1774 to present *The Beggars' Opera* at the *Woolpack*, but without Mrs Siddons who had joined Garrick at Drury Lane. In 1780, the Masterman Company played its version of *King Lear and his Three Daughters*. A contemporary note was struck by a 'Petit piece (in two acts) called *American Cruelty* or *The Fate of Major Andre* (Humbly Attempted by Mr Masterman)'. This closed with a death march, but to ensure the audience departed in cheerful mood, the evening ended with a musical farce, *The Quaker*.

'Lord of the Company'

The Warwickshire Militia often held its annual manoeuvres at Stratford, once to the advantage of the actor, Joseph Munden, who found 'the temptation of visiting the Birthplace of the matchless Shakespeare … too strong for his romantic mind to withstand'. He fell in with a volunteer and learned that with great numbers assembled it would be difficult to find accommodation. His new friend suggested that he obtain a billet by presenting himself as a recruit. His companions, numbering between twenty and thirty and bearing 'an uncanny resemblance to Falstaff's ragged regiment', assembled in a rickety old tenement. 'After the cravings of nature were satisfied … our

young actor drew forth a fund of entertainment which encircled the evening and rendered him King of the Company ... heroes fresh from the barn door ... listened with pleased attention and congratulated each other on the acquisition they had gained, in a genius who would convert three months of duty into so many months of pleasantry.'

When bedtime was called, 'the mirthful crew' retired to a large Gothic apartment, where spiders' webs obliterated the light. Straw was spread on the floor and each man given a mattress and quilt. 'Full many a snore, which to nicer ears, would have murdered sleep interrupted the stillness.'

Munden woke to find the sergeant smothering each man's hair with soap studs to make his helmet fit, 'enabling each simple rustic to pass in review before his Colonel; the scarlet popinjay of a month's buffoonery.' After breakfast, the drums beat to arms and the regiment mustered. Munden, realising his tricky position, left rapidly, 'choosing to enlist under the banners of Melpomene rather than those of Mars.'

An Age of Credulity

The trickle of pilgrims filtering through the door of the Birthplace was swollen by the Jubilee. That once-fine house had descended to 'a small mean-looking edifice of wood and plaster'. The eastern half, the Swan and Maidenhead, was a favourite resort of drovers attending the cattle market. On market days, they collected in the kitchen and waited their turns to cook steaks over the kitchen fire. The backyard housed a long brewhouse, from which malty aromas mingled with the pungent smells from adjoining piggeries. In front of the house, a crude notice announced prosaicly: 'William Shakespeare was born in this house. N.B. – a horse and taxed cart to let.'

Next door, the Harts had assembled 'some antiquated lumber ... imposed upon the world as its original furniture in the period of Shakespeare.' They were quick to follow the precedent set by Thomas Sharp. Old Mr Hart sold a 'Shakespearean' manuscript for 30 guineas, his credulous benefactor keeping 'the poor, old man from want for the rest of his life'. The Harts should not be judged too harshly for taking advantage of their hereditary good fortune. Like many Stratfordians they were heavily in debt and the buyers refused to be deterred.

The premises were inspected in 1781 by the Hon. John Byng.

'How do you do, Mrs Hart? Let me see the wonders of your house.'

'Why, there, sir, is Shakespeare's old chair and I have often been bid a good sum of money for it. It has been carefully handed down by our family, but people never thought so much of it till after the Jubilee, and now see what pieces they have cut from it, as well as from the old flooring in the bedroom!'

'I bought a slice of the chair equal to the size of a tobacco stopper and I eagerly eyed the lower cross bar of the chair, curiously wrought, which Mrs Hart would not be tempted to part with.'

At the Church, Byng 'pilfer'd (in common with other collectors)', a tessellated tile from the top of Shakespeare's gravestone. Returning to the *White Lion* for dinner, he met Mrs Hart again and had 'another chaffer' for the cross bar, but in vain, but as he passed on his evening walk she accepted his offer and he proudly obtained this 'ceremonial memorial of theatrical antiquity.'

Whatever was left of the chair was sold to a Polish aristocrat, the Princess Czartoryska, for 20 guineas in 1790. Byng noticed its absence with displeasure on a return visit. 'The evening was cold and gloomy. I walked about the town in a Shakespearean reverie. At the house of his birth they would have tempted me in, but I said: "Where is his old chair that you have sold? I now enter not." My words seemed to shock them; and they have discovered that they have sold the goose which laid the golden eggs'. He reflected that had the Harts been 'makers of Italian policy', they had always kept an old chair ready to succeed the one sold, or rather kept the old one and parted with the substitute'.

The Hathaways at Shottery were equally enterprising, selling in 1793, the chair on which 'Shakespeare had sat with Anne on his knee'. In 1830, a local directory revealed that the Cottage had been provided, some years before, with several pieces of furniture, 'affirmed to have belonged to the great poet', including his 'courting chair'. 'It will be uniformly found, by those who make enquiries, without an effort of self-deception, that there is not a single article of any nature, extant, that has been proved to have belonged to Shakespeare'.

The Jubilee had awakened Stratfordians to their heritage. 'The people seem all alive to the honour of their town having produced Shakespeare', noted a visitor. 'The tailor will descend from his shopboard, or the cobbler shut up his stall and volunteer to guide you to the points connected with the history of the great poet'. An early railway guide declared, 'The most illiterate inhabitants' were so used to hearing the Bard familiarly spoken of, that many thought he lived in recent times.

The local guide, par excellence, was John Jordan, who nurtured the Shakespeare legends, producing a polished and persisting version of the Bidford drinking fable. Equally enduring was his designation of a fine old farmhouse in Wilmcote as the girlhood home of Shakespeare's mother. He was dangerous to cross. When the Harts upset him, he denigrated their famous abode and mercenary behaviour. 'Even the house that for upwards of half a century has been shown for and venerated as the place of his birth is a most flagrant and gross imposition, invented purposely with a design to extort pecuniary gratitudes from the credulous and unwary'. He selected Brook House on Waterside as a rival shrine of nativity, but even his powerful invention could not deflate the mystique of the Birthplace.

Jordan possessed poetic pretensions. He wrote a turgid narrative called *Welcombe Hills*, with some assistance from the Revd Joseph Greene, who found his style 'low and prosaic', and undertook research on behalf of Edmund Malone. He possessed the peasant instinct to provide what was required, 'discovering' poems from Shakespeare's youth in secret draws. Malone was aware of his assistant's shortcomings and expressed occasional exasperation. He too was sufficiently a child of his time to indulge in predatory vandalism, hacking John Hall's signature from the parish records and losing John Shakespeare's testament. At Holy Trinity, the poet's multi-coloured monument offended his neo-classical sensibilities. He was delighted to find that the Revd James Davenport shared his view and the bust was repainted in a dreary off-white, to suit 'the taste of the present age'. 'By – ', said Charles Lamb, 'if I had been a justice of the peace for Warwickshire, I would have clapped both commentator and sexton in the stocks, for a pair of meddling, sacrilegious varlets'. A wit was moved to verse in the visitors' book:

Stranger to whom this monument is shown
Invoke the poet's curse upon Malone;
Whose meddling zeal his barbarous taste betrays,
And daubs his tombstone as he mars his plays.

In 1793, the Harts leased their half of the Birthplace to Thomas Hornby, a butcher. His wife, Mary, soon claimed lineal descent from the Bard and assembled an impressive collection of relics, including two fine high-backed chairs ,which were said to be given Shakespeare by the Earl of Southampton, with the Earl's coronets and supporters; the little chair used by Shakespeare's son, Hamnet ... the painting said to be done by Shakespeare's nephew, William Shakespeare Hart, representing Shakespeare in the character of Petruchio; an old basket-hilted sword 'which looked as though it had lain buried for a century or two on the Field of Edge-Hill or Worcester, but which was, in fact no such thing, but the veritable sword with which Shakespeare performed in *Hamlet*... and *piece de resistance*, the very matchlock with which he shot the deer in Charlecote Park.'

Yet the highlight of a visit to the Birthplace was the 'birthroom', where the surface of the walls and ceiling was covered with the names of visitors. Those who did sign their own chose that of a celebrity. Mrs Hornby, who 'endeavoured to impose on all, was in this respect imposed by others'. Yet if this 'very decent nurse-like woman' minded, she never showed it, incorporating true and false signatures in her itinerary.

The Age of Reason was an age of credulity: the Harts, Hathaways and Hornbys merely mute, inglorious Chattertons. The Shakespeare craze led to the demand for documents connected with the Bard. Records were plundered and archives ransacked, but the results of the great quest were disappointingly thin. The search could be hampered by the local peasantry. In 1793, Samuel Ireland, a naïve London biographer, explored Stratford's outlying farms in the hope of uncovering relics. At Clopton, he encountered Mr Williams, a yeoman, who must have been alerted to droll possibilities by previous pilgrims. In response to Ireland's probing, he exclaimed dramatically: 'My God, I wish you had arrived a little sooner! Why it isn't a fortnight since I destroyed several basketfuls of letters and papers ... and as for Shakespeare, why, there were many bundles with his name upon them. Why it was in this very fireplace I made a roaring bonfire of them.' Ireland was predictably horrified. 'My God! Sir you are not aware of the loss which the whole world has sustained. Would to heaven I had arrived sooner!'

In compensation, the farmer solemnly presented him with an illuminated picture of Elizabeth of York, keeping a straight face while explaining that, being on vellum, 'it would not do to light the fire.' The joke exploded on Williams, who 'excused himself of the indiscretion' after Malone wrote a stern letter to his landlord.

Such episodes were not lost on Ireland's son, William, who produced a series of forgeries beyond the dreams of any Stratfordian. *Vortigern and Rowena*, a play he wrote on Shakespeare's behalf, was performed at Drury Lane. Malone exposed its flaws and the young man confessed. The scandal had a ripple in Stratford. A letter in Mrs Hornby's collection, 'addressed by Shakespeare from the playhouse in London to his wife', was judiciously mislaid.

Depression, Discontent and Duty

In 1791, the line of a canal to Birmingham was surveyed. Two years later, a company was floated and the enabling legislation obtained. Such was the speculative boom that £120,000 was subscribed, of which a quarter came from Stratford. The project was beset with difficulty. Ambitions were reduced in 1795 when Josiah Cloves was engaged as engineer of a branch to the Grand Union canal at Lapworth.

The foundation of a Sunday school in 1791 represents a realisation that religious instruction could teach the 'habits of cleanliness, subordination and order'. Basic literacy was a side product of the curriculum. By 1797, this attempt at mass-education had spread to seven schools, including two at Shottery.

In reaction against events in France, a local 'Church and King' mob hanged in effigy two leading radicals, Joseph Priestly and Tom Paine, in 1793. Next year, a scheme by Malone to celebrate the silver Jubilee of Garrick's Jubilee was abandoned 'in consequence of the national gloom arising from the horrors of the revolutionary war.'

One carried away by patriotic enthusiasm was Thomas Sharpe's son, John, an excellent workman in his father's trade, although regarded as very wild. Four decades after his fortuitous purchase, Sharpe was still purveying his mulberry wood articles. At least he had convinced himself. On his deathbed in 1799, he testified 'before the four Evangelists, in the presence of Almighty God' that he had only used wood from the miraculous tree. By then much of his wealth had been drained away by his son, who had enlisted on thirty-two occasions, only to be bought out each time by his doting father. Even Sharp's death did not curtail the flow of souvenirs. As late as 1812, Thomas Gibbs, the clockmaker, bought 'the remaining part of that celebrated tree' from his widow.

In 1794, a Warwickshire Regiment of Fencible Yeomanry Cavalry was raised, composed of 'respectable men of the district, whose *Amor Patriae* is above the fear of being exposed to the necessary toils of a military education.' Each man received a bounty of 5 guineas on joining, while one guinea was given for bringing in a recruit. To equip the troops, £5,000 was raised by subscription.

The local troop was commanded and equipped by Capt. James Shirley of Ettington Park. Its main function was to aid the civil authorities in quelling unrest. It was so engaged in 1795 when a riot of Irish dragoons shattered the peace.

The Fifth Regiment of Dragoons was billeted in Stratford and aroused considerable hostility that erupted with seasonal impropriety on Christmas Day. It appears that troopers were refused service in certain alehouses and a foot patrol was attacked. Either on genuine suspicion or to settle old grievances, Cpl William Ridley decided to arrest Thomas Baker, landlord of the Malt Shovel (now the Old Thatch Tavern) in the Rother Market. Troopers broke into his premises, smashed crockery and beat him severely. Passions were running high. 'By our dear Jesus and the Holy Ghost, we will massacre the first man we lay hold of', yelled the soldiers in their Irish brogues. The terrified landlady alerted the constable, William Bullard, who enlisted the aid of some townsmen. Arming themselves with staves from a woodpile, they ran into a group of dragoons in the Rother Market. Bullard shouted 'Peace', but the soldiers struck at him with their swords. At the corner of Hell Lane (now Windsor Street), he stood against a wall and defended himself against three soldiers. A townsman, Joseph Pinfield, was struck severely and

cried 'O Lord!' repeatedly as he staggered towards his house in Mere Pool Lane. The soldiers' blood was up. A local drinker, Hiron the carrier, was told that his entrails would be cut if he came near. They smashed windows and broke into houses, seized implements to act as weapons and chased after Pinfield. His wife shut the gate and begged for mercy. 'By the dear Jesus and the Holy Ghost, we will massacre him', screamed the dragoons. Forcing entry, they chased him up the yard and struck blows of such severity that Trooper James Kelley bent his sword. 'By the Holy Jesus', he exulted. 'Did you ever see my sword work so well about his head before?'

The soldiers possessed no monopoly of aggression. Trooper James Anderson staggered back to his billet at the Red Lion in the early hours, declaring erroneously that his life was ebbing away. The arrival of the dragoon officers at last brought calm. For the next two nights the Warwickshire Yeomanry and thirty specially-enrolled constables patrolled the streets before the arrival of soldiers of the King's Own Troop. On 28 December, an inquest was held at the Town Hall before John Payton, the mayor, with Joseph Pindfield, 'then and there lying dead' as the mutest of witnesses. Cpl William Ridley and Troopers James Anderson, Patrick Welsh, William Howard, James Kelley and Samuel Irwin were committed to the next assize and escorted to Warwick. Identification was made possible by Welsh and Irwin turning King's evidence. At the Lent assize, their testimony was supported by that of thirty Stratfordians. The four prisoners were convicted and were presumably executed.

Tally Ho

The patrician world surrounding Stratford was epitomised in this era by John Corbet, 'the Warwickshire Squire', master of foxhounds from 1791, who rented Clopton House for his large establishment, increased in the season by the many gentlemen who partook of his hospitality. His hounds, in the charge of the famous huntsman, Will Barrow, were kennelled in Bull Lane. Hearing of a local gentleman who disposed of his foxhounds because of his wife's nagging disapproval, Corbet declared, 'If my wife had done so I would never have kissed her again till she took off her night-cap and cried "Tally-ho".'

Once, Corbet's hounds pursued a fox for 35 miles. Of over 100 huntmen, only Corbet and five others were in at the death. This famous fox was enclosed in a glass case in the clubroom at the White Lion, whose proprietor, Bill Barke, was 'a conspicuous figure with the hounds'. Members dined on alternate Thursdays during the season, wearing their scarlet coats embroidered with the letters 'S. H.' When Corbet left in 1809, Lord Middleton took over the patronage of the hunt.

'My Dear Betsy'

A glimpse of middle-class life is revealed in the journals of Elizabeth Davenport Ashford, which possess a Janeite mixture of domesticity and sensibility. She noted recipes such as 'Peas Pudding is much better with butter boiled in it', and recorded her reading, sharing the contemporary taste for Gothic novels. In 1797, this nineteen year-old received 'amusement and instruction' from Mrs Radcliffe's *Italian, or the Confessional of the Penitents* and she found

Women as They Are, 'a novel by Mr Parsons ... very sentimental. Well worth reading.' Events in France were not ignored. She read *The History of a French Emigrant and His Family* and *The Anti-Jacobin Review*. There is a reminder of The Reign of Terror in the contribution she made to 'the Distressed Clergy' on the topic of Catholic refugees in revolutionary France.

This sheltered life was shattered by sadness. Her father, Thomas Ashford, had resigned from the Corporation because of bad health, but continued to ail. 4 On February, he suffered a paralytic stroke. Elizabeth sat with him all night. Next day, Mr Bray, the doctor, laid 'blisters' (poultices) on his head and stomach. He lingered for another week and another blister was laid on his back. On 12 February, her 'dear Father departed this life for a better'.

A period of family mourning followed, but this had finished by May when the Booth Company returned to Stratford for a two-month season. Its repertory ranged over thirty-six pieces, from cameo sketches to full-length drama. Elizabeth, an avid playgoer, saw twenty of them, although she gives no indication of where the theatre was. The most popular was Stratford's own play of *The Jubilee*, which was performed three times. Elizabeth's mother gave her a box ticket on 9 May when it was a double-bill with *The Crook'd Husband*, and she saw it again on 29 May as a double-bill with *The Way to Get Married*. Her uncle, the vicar, paid 3s for her ticket, so there was no clerical disapproval of the theatre. The next evening, a series of benefit performances began. The season closed on 4 July with performances of *Which is my Man?* or, *A Soldier for the Ladies* and *No Song, No Supper* for the benefit of Mrs Booth, and Elizabeth made her eleventh trip to the theatre.

On 12 June, Elizabeth went to an auction at The College. Edward Battersbee, the owner, could no longer afford to maintain this ancient and beautiful building in the depressed times, and demolished it while it was still 'handsome, capricious and strong.'

During 1798, Elizabeth fell in love with a young attorney, Robert Hobbes. Most middle-class marriages at Stratford occurred within the neighbourhood circle. Decorum ruled and a young lady could wait anxiously for a nervous lover to declare himself, so for several months Elizabeth had to be content with glimpses of Robert in church. Her main social indulgence was an occasional visit to the Card Assembly, where she usually lost her small stake. Her reading taste was becoming more Catholic and serious. She was devoted to Cowper's poetry and she devoured Hannah More's *Treatise on Female Education* and Isaac d'Israeli's *Curiosities of Literature*.

In the spring, Robert Hobbes began to pay tentative court, greeting her as she emerged from church. Two weeks later, she missed him at morning service, but was rewarded in the afternoon, when he escorted her part of the way home. Two days after rejecting an offer from another suitor, 'D. D.', possibly her cousin, David Davenport, she 'receiv'd some nods from R. H. as he rode up the lane with the yeomanry.' On 21 July, he stopped his horse under her window on the way to the theatre in Birmingham. Within four days, she had obtained and read the play he saw, Sheridan's *Pizarro*. Her intelligence and charm could no longer be resisted. On 13 August, she joyfully recorded: 'Mr Hobbes declared himself my lover this evening. I am the happiest of beings.' Three weeks later he obtained a partnership in his firm, so the way was clear to marry.

The couple could now walk out together. At the Ram and Cheese fair, he bought her a canary for a fairing and at the Mop they went to see the bull-roast in the Guild Pits. His sister began to call and to accompany her to the Card Assembly. Bridecakes were ordered and the marriage

settlement prepared. The ring, trousseau and household goods were bought. On New Year's Day, the lovers had the obligatory tiff and reconciliation. Robert, whose journal from 1800 takes up the story, records that they went to a Dancing Assembly at the White Lion on 13 January and lingered to 'nip' with friends until half-past three. This was something of a stag night, for two mornings later he was up at seven and off to Holy Trinity to receive the hand of 'my dear Betsy', while outside another couple waited 'to be tacked together.' After a wedding breakfast at Mrs Ashford's, they set off for Oxford, each in a sedan chair. They honeymooned in London before returning to their new house on Waterside at the end of the month. On Easter Sunday, they received the Sacrament for the first time. Elizabeth was pregnant and suffering from morning sickness. A few days later, she was bled for the first time in her life.

'Great Discontent'

Economic depression increased as the war progressed. Investment in the vital navigation project was reduced. By 1798, the canal had crept southward to Hockley Heath and there it stopped. The touchstone of the town's hopes, the canal shares, fell drastically. Robert Hobbes bought one for 40 guineas from Thomas Edkins of Welford, who had paid £100 for it five years before and was willing to forfeit £4 interest in his eagerness to shed his investment.

Stratfordians followed the news of the war with concern. Edmund Malone ended his Shakespearean enquiries to the vicar with summaries of the dispatches. Joseph Hill, the Sheep Street barber, gloomily discussed the latest French victories in his shop. In May, 1800, a public meeting sent a loyal address after the King survived an assassination attempt.

Pauper children were found places in trade and industry. Between 1794 and 1796, thirty were sent to the model cotton manufactory at Measham in Derbyshire. Some, at least, felt that they were badly treated there, or they became homesick, for they returned to their parents in Stratford, presumably walking the 100-odd miles. After Thomas Smith, a 'poor unfortunate boy' had returned to Stratford, his father, another Thomas Smith, a brickmaker, lost his temper while taking him out on a job and in 'the heat of his Anger, bruised his Arm in a dangerous Degree; which was afterwards increased by a violent Blow he unfortunately received from a brickbat thrown by his Sister'. He was returned to Measham, where, despite medical treatment, the arm continued to fester. When his father heard of his plight, he went to Measham and took him away again, announcing that he would 'himself endeavour to gain a Cure.' On his return to Stratford, the father declared that the injuries were due to 'the rigid treatment of his Masters at Measham'. At home, the condition of the arm was exacerbated by 'a bad Scrofulous Habit of Body'. After six months, the boy was sent to the General Hospital of Birmingham, where 'no Possibility could be taken, to preserve his Life, without submitting to the Amputation of his Arm'. Despite this disability, he returned to Measham soon after to renew his apprenticeship.

The case aroused strong feelings in Stratford and Mr Bolton, a churchwarden and Mr Dudley, one of the Overseers of the Poor, were sent to Measham to investigate conditions there. When they arrived at the mill, all the Stratford children were assembled in a room and asked to make their complaints. Not surprisingly, there were only a few trivial mutterings and the majority of the children expressed their great happiness. Mr Wilks, the proprietor, said

that strict attention was always paid to the children's 'Obedience in our excellent Religion' and the Sunday school was comparable to the one in Stratford.

It is impossible to discern how perceptive the two Stratfordians were in their analysis of the children's conditions. They reported that their diet was very good and their apparel clean. Their faults were corrected 'with that Mildness which is becoming Those who have the Care of Children; and they are indulged with their youthful and customary Recreations' at Whitsuntide and Christmas. Small monetary incentives were given for the children's work, which they generally spent on 'some trifling Articles of Dress; somewhat inferior to the usual Apparel worn at the Manufactury'.

The Stratford gentlemen interviewed poor Thomas in private and he speedily revealed the source of his injuries and, falling on his knees, 'supplicated the Pardon of Mr Wilks for raising so scandalous a Report …, saying the Reason he durst not declare the Truth in Stratford, was, lest his Father in the unrestrained Moments of his Anger should deprive him of Life.'

The Corporation set an example of austerity by abolishing public feasting for the duration of the war. With the chilling precedent of The Terror to concentrate minds, offenders against the civil code were treated with ferocity. On a hot summer's day in 1799, a man named Cox from Hell Lane was whipped for stealing cabbages. In October, the Corporation lamented the high price of bread and voted the almspeople another 6d a week. Both public and private violence increased through the winter. A soldier billeted in the town received 300 lashes for stealing a leg of mutton. On Boxing Day, a 'Church and King' mob stormed the little dissenting chapel at Shottery.

By spring, things were desperate. The Corporation allocated 5 guineas towards a soup kitchen. The summer brought day after day of rain and the harvest was a disaster. The price of bread soared and there were food riots in many parts of England. Robert Hobbes noted 'great discontent' amongst the poor of Stratford. On 12 September, a mob rose and plundered a broad-wheeled waggon. That night, the authorities were powerless. An uneasy peace prevailed next day, but in the evening the mob rose again in great numbers. The yeomanry cavalry cleared the streets and a day of calm followed. Four days later, the frenzied and hungry mob smashed the windows of the Guildhall, which was being used as a foodstore. On market day, the authorities tried to relive the tension by selling corn at reduced prices, but passions were too high. Blocks of butter and baskets of provisions were seized from the helpless stallholders and flung into hungry hands. That night, the remaining Guildhall windows were smashed. Three of the mob who broke into the cheese store were taken and escorted to Warwick. Rain did as much authority to clear the streets. Next day, all was quiet and Yeomanry Sgt Robert Hobbes took Betsy for a drive in their new gig. Four days later, he took her out to tea, but he was called away to a vestry meeting, which opened a subscription with a £50 grant from the Corporation.

The Corporation posted notices offering a reward to anyone providing evidence leading to the conviction of the rioters. On 9 December 1801, 20 guineas was paid to Joseph Stiles after Samuel Sambridge, a dyer of Sheep Street, was bound over at the quarter sessions with eight others in the sum of £40 to keep the peace, particularly towards John Powys of Bethnal Green, who was, perhaps, a trader whose stall had been plundered.

Robert Hobbes was concerned about his poor neighbours and did much to help them, but the middle classes were cushioned from the worst effects of the depression. His social round was unaffected by the disturbances. On 2 October, he dined at the Shakespeare and drank

lots of wine, coming home 'non se ipse'. Two weeks later he was 'very poorly and sick in the morning from eating Walnutts and high living.' At five the next morning, Betsy's contractions began. He went for John Gamble, the borough surgeon. At noon she was delivered of a 'fine, large bumping boy and had an excellent time of it'. She remained in bed for ten days. On 14 November she was churched and the baby was christened Robert.

The greatest flood ever recorded in Stratford occurred that month. The ground floors on Waterside were awash. On 18 November, the local sensation was the discovery of the body of a woman with her throat cut in the weir-break at Welford. She had been murdered by her husband, John Palmer of Snitterfield, who had hoped that the flood would carry her away. He fled but was arrested two days later, brought to Stratford and then taken to Warwick Gaol. Ten days later, his mother and his sister, Hannah, were charged as accessories.

Six weeks after the birth of their son, the Hobbes went to 'a most furious Assembly' of thirty-two couples. Robert declared himself 'wholly tired off my legs', but for Betsy there was 'not much dancing at present … poor Soul.' They got to bed at three. Robert was 'quite fagged' the next day and did not get up till 11 a.m. In the evening, the baby was inoculated against smallpox. This was a bold step, only four years after Jenner's first experiments. Understandably, Betsy was 'quite low', an apprehension which deepened two weeks later when the baby was 'exceedingly ill with the small pox which is come out very much'. Her morale rose next day when he was much better. That same month, her uncle, who had preached in support of vaccination, supped with them on oysters. Another innovation manifested itself in December when Robert paid an income tax demand for £7. This had been introduced on incomes over £60 in the previous year.

Robert was active with the bread committee through the long winter, drawing up lists of those eligible for aid, organising distributions and raising donations. On Christmas Eve, he gave sacks of potatoes to his poorer neighbours. He was a rising man, undertaking legal work for the Corporation, sitting for the local portraitist, Edward Grubb and becoming a churchwarden. The domestic routine continued. One evening the Hobbes played a card game called Chop together. Robert was busy in January bottling and racking 'madewines' and spirits from 'Harvey'. If this is the noted Bristol shipper, the order was most likely conveyed from door to door by river. Robert fasted and went to church on Ash Wednesday, but he broke his Lenten discipline by rolling back from the hostelry at eleven that evening. He found sufficient expiation, for Betsy was 'as cross as two sticks'.

Palmer and his sister were hanged at Warwick on 1 April; the mother had died in prison before she could be brought to trial. Hannah Palmer's body was sent for dissection by Robert Hobbes' friend, Gamble. The next day he saw it twice in the surgeon's garden. It is a measure of the brutality of the times that this humane man expressed no distaste or compassion at the sight of the executed woman. He was equally dispassionate two days later when he saw Palmer's corpse conveyed through Stratford on a sweltering Good Friday to be gibbeted at Cranhill Leas. At the same assize, a Stratfordian whom the local press did not even name was transported for stealing a pocket book containing money bills.

Despite such sensations, life at Stratford was generally a steady plod of familiarity. 'The town holds but one market a week', commented a visitor. 'It renders the town extremely lively when put in contrast to the apparent dullness observable on other days.'

Mock War and Peace

On 23 April 1801, Robert Hobbes bled his horse in preparation for the annual manoeuvres of the yeomanry cavalry. On 18 May, he was 'up at seven and busy soldiering'. The troop met in Banbury Lane and exercised at Clopton. Robert was quartered at the Shakespeare, but he slipped home to his own bed and Betsy. For the next three days the troop 'performed wonders'. On the second evening Robert escaped to the churchwardens' supper at the White Lion and was 'very jolly, like a true churchwarden'. On the last day, General Greenfield reviewed the regiment and Robert acted as his Orderly ('no way out of that'). That evening the sergeants dined at the expense of a delighted Lord Aylesford. Robert staggered home at two in the morning, drunk almost to oblivion for what he claimed, with true drinker's contrition, would be 'the only time'.

We follow the Hobbes through the year. Betsy was 'as ill tempered as the Devil' when Robert came home late once and 'behaved cursedly ill' on another occasion, 'being in her tantrums'. This entry is smudged, perhaps by Betsy. On 22 July, Robert attended a meeting about the plight of the poor, perhaps making plans for the winter. In the afternoon, he was 'snugly alone' with Betsy. Ten days later, they were 'snug as two G. G.'s' after supper. She was four months pregnant again.

On 3 October, news of an armistice brought scenes of heartfelt joy. At night a great illumination was made. That month, Thomas Sheldon, who had only been a burgess for two weeks, refused the mayorality and John Payton, son of 'Jubilee' Payton, was elected in his place. Afterwards the 'Jury and Officers' dined at The Windmill at his expense. Robert Hobbes stayed till 12.30 a.m. and came home sober as he did when his yeomanry captain, Evelyn Shirley, gave a dinner of 'famous venison' at the Town Hall to celebrate the peace. The party lasted till two, but Robert left early because Betsy was nearing her time. Three days later, at two in the morning, she produced 'a fine Girl'. A month later she was churched and this was the occasion for a small celebration. The couple drank a bottle of port and made merry. Robert had been excluded from Betsy's bed during her confinement, but that night he went 'to bed to wife ... comfortable as usual'. She was a sturdy nursing mother. In February, the couple danced every dance at the Assembly, returning home after four. Later that year, Robert entered one of the town's inner circles when he was received into the Third Degree of Freemasonry. Hopes of better times were compounded on 30 March 1802, with the news of the Peace Treaty of Amiens. Another great illumination was made and the streets were 'all bustle and joy'.

Peace brought renewed interest in the canal project. Shares rose to £105, but hopes proved illusory. Later that year, Robert Hobbes drafted a stern letter from the Corporation, stressing the 'propriety and absolute necessity of continuing your canal'. The town had been 'nearly ruined by the Warwick Canal having been completed ... and the Stratford left unfinished.' Its market and trade would be 'utterly sacrificed' if the Stratford Canal was not completed. Despite such exhortations, the waterway proceeded at minimal pace.

On Christmas Day, Betsy Hobbes was delivered of her annual child, a boy, described by her husband as 'a fine Xmas box'. She was up and about three days later. The ferocious winter – one of a series in the 1800s – was again causing suffering among the poor. Things got so bad that the churchwardens decided to distribute the sacrament bread and Robert Hobbes organised the handout outside The Falcon.

11

'Demand and Supply'

The price of every commodity will be determined by the demand and supply.
Warwick Advertiser, 1811

With the renewal of hostilities, a Corps of Stratford-upon-Avon Volunteer Infantry was formed, commanded by Major, the most Noble Marquis of Hertford, abruptly dismissed in the Corps records as 'non-effective'. Its strength numbered 12 officers, 9 sergeants and 240 men. Their golden hour came in 1806, when they were inspected by the figure that would give his name to an age. The volunteers were drawn up before The White Lion and received the Prince of Wales with presented arms.

Their would-be defenders were a mixed blessing to the townspeople. The effect of an annual break from families and vocations was predictable. 'The Yeomanry Cavalry came into town and behaved very ill', noted Joseph Hill in 1807. Not surprisingly, the regiment's official history tells a different story. 'The four Troops … were inspected by Colonel Corbett, who expressed himself highly satisfied and observed that he had never seen a Corps better disciplined or that made a more soldier-like appearance.'

Next year, members of the yeomanry pulled down the sign of the Swan and Maidenhead, declaring that 'as the only maidenhead left in Stratford was a wooden one, they would destroy it'.

The burden that the annual meeting of the volunteers imposed on the town is revealed in a Billet Master's report. At full complement, the 3rd Warwickshire Militia totalled 999 men, without the officers. The maximum number that could be billeted at local inns and public houses was 574, so the remainder must have been bivouacked or billeted in private homes.

The curbing of civil unrest remained a major function of the Militia. In June 1810, the Corps was ordered to march to Birmingham to quell riots. When it was 9 miles away, the countermanding order arrived, giving directions to secure billets. Next day, they marched back to Stratford. Lord Palmerston, the Secretary for War, informed the Cdr Col R. Sheldon, MP, that the men would receive 9*d* a day for two days, so a bill was presented for £62 12*s* 6*d*.

An annual notice ordered all men who had not previously trained with the militia to assemble in the Rother Market before being 'trained and exercised' for three weeks. Some passed into regular regiments and the recruiting officer made periodic visits to assist in raising men for the Permanent Additional Force, thus saving the parish financial penalties. A churchwarden and an overseer of the poor were required to attend. The paupers' rolls made good recruiting lists.

A more colourful approach was adopted by Capt. James Saunders, the local adjutant. His extravagant poster offered the 'splendid chance … of assisting the renowned and victorious general, Lord Wellington in exterminating the rapacious myrmidons of the French; or of

serving in the Artillery of the Hon'ble East India Company and at the expiration of twelve years returning to their friends Loaded with the riches of the East. Gallant hearts, men and boys, actuated by such honourable motives will meet a kindly reception.' The numbers exterminated by Stratford lads is unrecorded and none appears to have returned laden with the riches of the East. The fate of those who joined may be consigned to the anonymity the age allotted to their station.

Some recruits were of low calibre. Mr Duke of Tiddington hired John Hickman as his coachman at Warwick Mop, but he disobeyed orders and was frequently drunk on duty, purloining his master's horse to collect liquor. Robert Hobbes, the parish clerk, advised the despairing Duke that misconduct had to be proved by witnesses. At the next assize, Hickman, who had enlisted in the 14th Light Dragoons, sued unsuccessfully for breach of contract.

Crime and Punishment

Grinding poverty produced a desperate crime wave that motivated a brutal judiciary. In 1805, Henry Blun received 232 lashes at the Market Cross for stealing hay from William Bache. The unsymmetrical number implies that he collapsed and could take no more. Other traditional and exemplary punishments were used. Two stall-women, a mother and a daughter, were placed in the stocks for profane cursing and swearing and riotous behaviour in the market. The stocks were set on the ground floor of the Town Hall, where iron bars separated mockers from 'the degraded and uncomfortable offenders within'. Drunks provided most of the custom.

In 1806, the assize judge sentenced Sarah Hiron, aged twenty-six, to seven years transportation for stealing £9 5s in gold and silver from William Cook and various items of clothing from Jane Hiron (presumably a relative) at Stratford. Three local men faced capital charges during 1808 and 1809. There were humane attitudes outside the judiciary for those they had wronged pleaded for their lives. Job Edkins, aged sixteen, a postboy between Stratford and Alcester, embezzled money bills from a Bromsgrove bank. The judge told him that he had not been capitally indicted because of the leniency of his prosecutors and, in consideration of his youth, the punishment would be 'very slight indeed in proportion to his offence', sixteen months in the House of Correction. Thomas Quayle was condemned for stealing, at Stratford, a silver watch from William Tompson, but he was reprieved, possibly through Tompson's intervention. John Wesson, aged eighteen, was condemned for stealing a sheep in the parish of Old Stratford, but was reprieved through 'the humane interference of the prosecutor', Henry Robbins of Barford.

Market day was a favoured time for muggers on the Warwick Road. In December, 1811, two footpads rushed James Waring of Warwick, knocked him down, beat him severely and robbed him of 4d. Fortunately for him, they missed the £100 concealed in his coat. Another victim was Mr Green of Snitterfield. Two footpads cruelly beat him and robbed him of his loose cash, but missed £70 that was hidden in his pocket book.

There was some recognition of the economic causes of this lawlessness, although it was frequently combined with a reluctance to interfere with the *status quo*. The main newspaper circulating in Stratford, *The Warwick Advertiser*, deplored the hardships endured by 'the

labouring classes', but considered this 'trifling' compared with what they would suffer if mob-rule prevailed. 'They would empty the granaries, break open the magazines – they compel the farmer to bring his stock to market, and they would sell it at their price.' Famine would follow as stocks were exhausted. 'All the horrors which history records … would ensue; the rich would have no means of relieving the distress of the poor, for money could not procure what is not in existence.' Given contemporary economic and social thinking, the conclusion is unremarkable: 'the price of everything will be regulated by the demand and the supply'.

Slow Change

John Shakespeare's descendents symbolise the slow decline of Stratford's old families. In 1804, Thomas Hart was forced to offer the Birthplace for sale, but found no takers. While there were eager bidders for every sham relic, no one wanted to acquire the prime memorial. Perhaps its authenticity was disconcerting. There were still bidders when it was put up for auction in the following year, but in 1806, Thomas court, the landlord of The Garrick, met a distracted Mr Hart at 4 a.m. on Clopton Bridge. Perhaps he was contemplating an end to his troubles, but the outcome was happier as Court bought the building for £210. The Harts moved to Tewkesbury, but continued to visit Stratford, singing as they went the old Jubilee songs of 1769, the family's finest hour.

An echo of old strife occurred in July, 1805, when the Corporation resolved to ask the vicar to remove his pigsties from the Guild Chapel and from the yard outside the Guildhall windows. Another old controversy re-emerged next year. The Bancroft had become pitted with holes due to children and others digging peat. It was resolved to prosecute transgressors with the full vigour of the law.

In 1806, it proved so difficult to find a mayor that Joseph Walker, who had moved to Worcester, was elected. Meetings were arranged to suit his availability, which was restricted by seasonal calls on his farm. At Rogationtide, he declined the obligation to perambulate the boundaries because of his 'Barkharvest'.

The Corporation was becoming more conscious of its heritage. In 1807, two local worthies, Capt James Saunders and Robert Bell Wheler, were appointed to transcribe and classify its archives. Saunders combined a well-developed sense of rank with military earthiness. He headed a notebook with the quip: 'Where fools have scribbled, fools will scribble more, / As dogs will – where dogs have – before.'

Robert Bell Wheler was the son of Garrick's friend. In 1806, at the age of twenty-one, he published the first history of Stratford. This 'kind and amiable' lawyer filled copious notebooks with memorabilia in a minute and precise hand. Both Saunders and Wheler extensively sketched contemporary Stratford. Without them, much material would have been lost.

The Corporation was starting to take an active part in arresting Stratford's decline rather than passively accepting stagnation. The Barkes at The White Lion, successors to the Paytons, had established a considerable coaching network along the Irish mail route between London and Holyhead. The continuation of this vital trade was inhibited by the ancient bridge, which was narrow, dilapidated and 'very incommodious for the Travelling and Posting Business'. In 1805,

the Corporation agreed to petition Parliament for permission to demolish it and erect a new one. Richard Wyatt, a 'skilful architect' reported that the old bridge could be widened, but financial considerations prompted a caution increased by the reluctance of any authority to accept responsibility. In 1811, the Crown won an action at Leicester assizes, charging the Corporation with the 'non-repair of a bridge'. A further petition for demolition was prepared, but the old edifice passed precariously to the future. In 1814, it was widened and a tollhouse built.

'The sound of the coach horn and the clatter of horses' feet on the pebbled road drew the Stratfordians to their doors to watch the arrival or departure of the various stage coaches that came through the town, but such events were of too frequent occurrence to arouse more than a momentary interest.' First in view at 6 a.m. was the Regent coach from London en route for Birmingham, Wolverhampton, Shrewsbury and Holyhead. In the next three hours there followed the Union, Old Post, Ancient Britain and Mail coaches along the same route. Passengers for Warwick and Leamington changed for the Vittoria light coach, departing at 9.30 a.m. In the evening, the equivalent coaches returned, bound for the London terminus at the Bull and Mouth Inn.

The coaching heyday produced vigorous competition. In 1811, 329 Strafordians, including the mayor and vicar, pledged themselves to patronise the Leicester and Bristol Telegraph Coach and to ignore the 'very unhandsome Opposition which has lately started.'

Energy was also reviving towards the Navigation. In 1808, the Corporation subscribed £2,000 to bring the canal another mile and a half to wharves at The Navigation Inn at Wooten Wawen. An 'Assembly of Proprietors' during 1809 resolved to raise £90,000 in £30 shares to complete the project. In 1810, a cut was proposed beyond Stratford to the Berkshire and Wiltshire Canal, but nothing came of it.

A further manifestation of a rising bourgeoisie appeared in 1813 when John Whitehead, Thomas Wootton Wawen and Kelynge Greenway advertised their intention to open a bank in Stratford. Doubtless such a safe depository was made a necessity by the lawlessness of the times.

Reform was desperately needed at the ancient grammar school where, by 1808, there were no pupils, although the master continued to draw his salary! An attempt was made to revitalise this decaying institution in 1811, in the hope of 'inducing some of the more respectable inhabitants' to send their sons there. Endowments were increased so that twenty boys could be given free instruction in English and 'the learned languages'. Other courses were paid for 'according to the usual terms'. A guinea was paid to the master on admission, 2s 6d per year on fuel and pupils provided their own books. Applications were passed by the Corporation to the master, who accepted those 'duly qualified (according to long established custom) by being at the age of seven years and able to read.' Admission was restricted to inhabitants of the borough, which meant the sons of the middle class. Nine pupils in 1811 had fathers for whom the appellation 'gentleman' was sufficient. Robert Hobbes, the attorney, had two sons there, Robert, aged eleven and Charles, six. His partner, Thomas Hunt's, son was also there, as were the sons of Richard Pritchard, the surgeon; John Tasker, a prosperous grocer; William Barke, who kept The White Lion, and William Morris, a banker. After an initial rush of entries, there was a shortfall in numbers for some time.

Austin Warrilow, writing master at the grammar school, was gradually developing an independent boarding establishment at his house next to The Falcon. An account survives

for David Rice, son of the vicar of Alderminster. Six month's board, including instruction in English and writing cost 8 guineas. Each language taken cost half a guinea and David learnt Latin, Greek and French. His generous weekly personal allowance of 3s 6d was about half a farmworker's weekly wage, but there is no record of how it was spent. His seat in church cost 1s and 'Fire and Candle', 2s 6d. His book and stationary bill was itemised: 5s for a Bible; 4s for an English reader; 2s 6d for 'Jonson's Dictionary' and 2s for an 'Eton' Grammar; copy books, 4s; pens and ink, 2s 6d; a 'Blacking Ball', 9d and a further 9d for mending a box. Personal charges complete a bill for £11 15s 5d: 8d for buckles, garters and combs; 1s 4d for gloves; 1s for a haircut and 2s for servants' fees. The curriculum reflected the desire of the middle classes for a utilitarian education: land surveying; geography 'with the use of the Globes'; music, drawing and dancing.

In 1811, seven-year-old William Stanley started work as a ploughboy on 2d a day and his victuals. He was too late to benefit from the growing educational movement. Soon after, a National School was founded in Bull Lane, 'for the Education of the Poor in the Principles of the Established Church'. Two sermons were preached in Holy Trinity on its behalf in 1818, and the children sang hymns. Continuing religious factiousness emerged in 1817 when John Perry of Stratford, a printer, reported Benjamin Appleby of Stratford, also a printer, for disturbing a meeting of Protestant dissenters at Snitterfield. In 1819, Matthew Pearce opened his house in Wood Street for a Methodist Society of just six members. By 1822, the society was meeting in a barn in Meer Street.

Popular Entertainment

The deprivations of war did not curtail the range of popular entertainment. A woman was sent to the house of correction in 1808 for 'pretending to tell fortunes.' Mr Hathaway's cabinet of wax figures was better favoured when it was shown at a house leased in the High Street. 'The most interesting characters in the world' included 'the present Royal Family of England, the unfortunate Royal Family of France, and most of the foreign Emperors, Kings and illustrious personages, now living, as well as others now dead.' The highlight of a visit was a grand tableau of the funeral of Lord Nelson.

Sometimes a bizarre entertainment accompanied a travelling play. After a production of 'Tobin's admired comedy of *The Honeymoon*', at the New Theatre in Stratford in 1814, Mr V. G. Yngell displayed 'his peculiar and interesting Experiments together with the wonderful learned goldfinches, some new and popular Airs on the musical glasses, whose sounds are, of all others, the most celestial; concluding with Olympic exercises, consisting of balancing in a most astonishing manner...'

There were more brutal diversions. Cocks, a local maltmaker, fought an unnamed plumber for a purse of 5 guineas, knocking him down 118 times. Regular cockfights took place. Joseph Greene's 'reprieve for the poor birds' of sixty years before had proved only temporary. A less formal version of the 'sport' was available. Outside The Red Horse stood a muck-heap where game-cocks were penned. Boys could throw at them for a penny and all they killed, they took.

Patent Medicines

Apart from the four registered doctors whose services were costly, the main recourse for sick and hypochondriac Stratfordians was the apothecary's shop of Mr James Ward in Henley Street, where a collection of exotic mixtures guaranteed miracles to even the severest sufferer. Gentlemen of middle years could purchase such desperate remedies as 'The perfumed Palma Christi Oil of the West Indies … A Novel but certain Method of promoting the growth of Hair and a sure preventive of Baldness and Greyness'.

Many medicines were declared to be cures for a variety of complaints. Of Dr Bateman's Pectoral Drops it was claimed that 'the Public never had a more valuable Medicine presented to them, than these inestimable Drops, for certain cure in Rheumatic and Chronic Complaints, violent Colds and consequently Pains in the limbs, giving Relief in the most violent Fits of the Gout … it has been now so long established and its Virtues so well known to the public in general that it would be needless to say more in its praise'.

Buyers were warned of misguided purchases. 'Great as the good effects are from taking the True and Genuine Bateman's drops, the consequences from taking the Counterfeit Sorts, are too frequently as much the reverse, the ill effects of which have been experienced...'

Sufferers with toothache and gum boils turned to Trotter's Tincture, which was 'well known for its safety and no way prejudicial to the Enamel' or

the Oriental Dentifrice/or Asiatic Tooth Powder, its Powder, its Efficacy and Virtue being acknowledged by the most respectable medical Authorities, used by many and recommended for above 20 years. The Powder cleanses and beautifies the teeth, sweetens the breath, possesses no acid that can corrode the enamel, and puts a beautiful Polish on the teeth. From its astringency, it strengthens gums, eradicates the Scurvy (which often proves the Destruction of a whole set of teeth), preserves sound teeth from decay; secures decayed teeth from becoming worse, and fastens those which are loose. But what has enhanced it in the estimation of those who have been in the habit of using it, is, that it prevents the return of tooth ache, with which, before that period, they had been violently afflicted.

For asthma sufferers there was The Original Botanic Pill that relieved coughs by loosening the phlegm and preventing its future accumulation:

...it facilitates Expectoration, cleanses the Lungs, promotes Freedom of respiration, strengthens the Stomach, creates appetite, keeps the Bowels in a proper state, purifies the Blood and induces the most Healthy appearance.

Many by the use of this medicine have been released from a state of Lassitude and Langour and restored to Health and Vigour; and it has soothed the pains of others whom Nature has far too exhausted for the Medicine to offer a cure.

Despite John Hall's discoveries of two centuries before, the continuing prevalence and deprivations wrought by vitamin deficiency is shown in an advertisement for Dr Freeman's Gutta Salutaris.

An approved specific for the Scurvy and every foulness and Impurity of the Blood – Scorbutic Complaints are the most general malady of the British Constitution, no family is, more or less, exempt from them, and they shew themselves in a variety of ways; they produce roughness, ulceration and other diseased states of the skin, they occasion loss of appetite, weakness and dejection of the spirits, and the mass of blood being rendered foul, it is incapable of affording a healthy supply of nourishment to be properly and actively performed.

The prevalence of the disease in the winter months had been observed. 'At this period of the season', the advertisement continues, 'it is well known that the scurvy and its consequences are much to be dreaded.'

The treatment was also efficacious for 'the diseases of the Female sex, where weakness is so predominant it never fails to check the cause sooner than any other medicine.'

Unsavoury afflictions knew no class barriers, 'Ching's Patent Worm Lozenges' were patronised by such 'Honourable Ladies' as the Duchesses of Leeds and Rutland, 'who have given this Medicine to their own children and also to the Poor of their respective neighbourhoods, with unparalleled success'.

Most alarming was Ward and Perry's mixture to combat 'a Delusive Habit generally learnt at Great Schools [which] weakens and destroys the whole nervous system and in the very flower of youth brings on all the infirmities of the most languishing old age; rendering its votaries indifferent to all amusements, absent in company, dull and lifeless everywhere. These maladies are not only relieved, but ultimately cured by this excellent Medicine, which is unrivalled...' This anti-masturbatory elixir was expensive: 11s a bottle, or 33s for a 'Four in One' Family Size.

Peace at Last

The seemingly endless war ground on far away, having little immediate impact on Stratfordians, but striking into everyone's lives. Yet the end was in sight. Throughout 1812, Hill the barber recorded Napoleon's adventure in Russia, gleefully noting French defeats and keeping records of prisoners taken. A national peace petition for presentation to the House of Commons was circulating locally, which deplored 'the numerous and complicated Evils arising from the present wide-spread and long protracted war, and the growing despondency which pervades all classes of the Community' and mourned the 'multitudes of valiant men, perishing on the Field of Battle, lingering Months and Years in the gloomy Prisons of the Enemy, languishing in Hospitals, or slowly wasting by Disease in crowded camps and pestilential climates.'

Everywhere the petitioners saw the

spectacles of calamity, which necessarily accompany a state of continued war, and which are found in the deserted Cottages of Peasants and Manufacturers, in the Tears of aged Parents, 'Weeping' for their Offspring because they are not. And amidst the forlorn Widows and helpless Orphans of their slaughtered Countrymen ... while our Youth, at an Age, and in Numbers, hitherto unencamped, are balloted for Military Service, and seduced or forced away, from the useful and meritorious Employments of Husbandry and Trade, your Petitioners ... lament the

past and approaching Ruin of our once opulent Manufacturers and the Melancholy condition of our Artisans, formerly … a contented, industrious and honest Race, but now disheartened by Dreary Poverty, degraded by Galling dependence, and exposed in many quarters to temptations, by which they may be precipitated into such Acts of Violence, as would render the Forfeiture of their lives a necessary, but most deplorable measure of Public Justice…

The burden of taxes had led to exorbitant increases in the cost of food, 'diverted from circulation the current coin of the Realm' and 'introduced in its Stead, a factitious, precarious and fluctuating kind of property in Paper'. The gazettes were filled with bankruptcies, the gaols with debtors and the workhouses with paupers, 'who are compelled to flee thither as to a Place of Refuge, from Hunger and Thirst, from Cold and Nakedness and all other baleful Consequences of unexpected and involuntary Exclusion from the daily Labours which had supplied their daily Bread…'

The deprivation was selective of position and class. The Christmas assembly at The White Lion was 'fashionably attended' by over thirty-five couples who danced till dawn. 'This meeting', the *Warwick Advertiser* considered, 'is obtaining much of its former splendour, and we don't wonder at it as the form is so well calculated to exhibit the graceful movements of female elegance.' A year later, the Hunt ball was attended by 'all the nobility, elegance and fashion in the neighbourhood … The supper was served up in a very superior style, and among the decorations … was one representing "The Flight of Bonaparte across the Rhine"'.

The latter touch indicated that the war was at last drawing to a close. In April 1814, Stratford was illuminated in celebration of Napoleon's departure to Elba. With the news in June of the signing of the Peace Treaty, houses were spontaneously illuminated. Four days later, 100 gentlemen held a celebration dinner at the Town Hall and great numbers attended tea parties in the streets. At Alveston, a fine ox was given for the parish poor by John Higgins, Esq., a gesture the *Warwick Advertiser* considered 'a far more acceptable method of testifying gratitude to the Great Controller of Events, than all the pomp and parade of show, the waste and extravagance of Illuminations, or grand exhibitions.' Nearly 400 people were regaled in a specially erected booth. The band struck up with 'Oh, the roast beef of Old England' and, after grace, they sat down with (according to the reporter) 'hearts and minds blessing their benefactors'. In the evening, crowds flocked out from Stratford to join in the festivities. 'The most gratifying scene imaginable presented itself. The oldest inhabitant of the parish, having completed her ninety-second year, anxious to evince her joy, in unison with her neighbours, opened the rustic dance, in which sixty couples joined upon the green in front of the booth, under which an immense concourse of persons of all ranks were seated, giving vent to their feelings by frequent and loyal songs, and toasts accompanied by loud cheers.'

Stratford was not to be outdone by its smaller neighbour. A week of celebrations in July began with another grand illumination. The houses of Lord Middleton, Dr Davenport, Mr Hunt and Mr Hobbes were lit with 'a degree of taste and splendour never before equalled in this borough'. A 'very liberal' collection enabled a plentiful supply of beef and bread to be distributed to the poor, which were gratefully received and produced the utmost joy and satisfaction'. Those of more genteel pretensions attended a grand ball at the Town Hall.

The peace was short-lived, and the 100 days of war which followed, even shorter. The great battle that closed the Napoleonic era was marked in Stratford by two sermons; £54 was collected at the church door for the 'poor sufferers Friends at the Battle of Waterloo.' No record remains of the public festivities, although eighty-nine years later, the centenarian, William Stanley, 'well remembered the rejoicings which followed the battle... in which conflict his uncle was killed.' Two further sermons were preached on 20 August for 'the relief and benefit of the widows and orphans of the brave men killed and of the wounded sufferers in the signal victory...' The proceeds went to the formation of a benefit society in 1819, Stratford's earliest, with the prime aim of helping the veterans of the wars and their dependents. It numbered many a 'Waterloo hero – when they were all dead but one, how they carried him in triumph through the streets.'

Less auspicious was the military career of William Price, a Stratford labourer who enlisted in the 33rd Regiment of Foot in 1813. Three years later, he deserted at Sunderland. His description, sent to his hometown, shows that he was not cut out for a soldier's life. 'Height: 5'3"... Person: Stout. Head: Large. Face: Round ... Nose: Flat. Thighs: Stout. Legs: Stout. Feet: Large...' Perhaps the poor fellow was fed up with his comrades chaffing him about his singular shape.

Mrs Hornby's Waterloo

The constraints of war removed, the bicentenary of Shakespeare's death was commemorated by a breakfast, a dinner and a ball, but still no word of the poet's elevated or confused the situation.

At the Birthplace, Mary Hornby added a distinctive note to the national triumph. So absorbed in newspaper accounts of Waterloo that sleep was impossible, she utilised her insomnia to compose a poetic tragedy on this mighty theme, proudly claiming the inheritance of some of Shakespeare's genius through a literary osmosis of habitation and descent. The work was described by a sympathetic critic as 'the queerest thing imaginable' and by an unsympathetic one as 'the most execrable verses that folly ever produced'. Such was her attraction that even the Prince Regent found her irresistible. On a visit in 1815, he entered thoroughly into the spirit of the place. He signed his name on the wall and offered to buy 'Shakespeare's old sword with which he played Hamlet', asserting that he knew the family very well that gave it to Shakespeare.

When the American writer, Washington Irving, visited the Birthplace, he was delighted to note that 'Shakespeare's chair', sold by the Harts a quarter century before, had returned to its familiar chimney corner. 'It partakes something of the volatile nature of the Santa Casa of Loreto', he reflected, 'or the flying chair of the Arabian enchanter', adding good-naturedly that the he was 'always of easy faith in such matters and am willing to be deceived, where the deceit is pleasant and costs nothing.'

Mary Hornby's social success led to her downfall. Thomas Court, her landlord, died in 1817. His widow, noting the growing queue of pilgrims, doubled the annual rent to £20. The demands rose with the tide of pilgrims. Soon the rent was £40, beyond the wildest hope of touristic return.

On 20 October 1820, Mrs Hornby abandoned the fight and moved to premises across the street, taking with her the celebrated relics. Determined that her rival should not seize gratuitously what she had so painstakingly acquired, she took a brush and whitewashed over all the names on the walls. 'At one fell swoop, out went the illustrious signatures of kings, queens, princes, princesses, ambassadors, statesmen, tragedians, comedians, bishops, Lord Chancellors, lord chief justices, privy councillors, senators and famous orators; all the sweet tribe of duchesses, countesses, baronesses, honourables and dishonourables – out went they altogether with as little remorse as if death himself had been wielding the besom of destruction.

Mary Hornby, having executed this sublime execution of so many dignities, marched out with a lofty sense of the vacuum she had left behind, carrying with her the albums into the bargain. The new tenant on entering was struck with a speechless consternation! In the immortal Bard's own words, all the precious relics had 'Vanished like the fabric of a vision, / And left not a wrack behind.'

Ada Court tried threats and bribes to secure the return of the vital relics, but to no avail. The only option seemed to be to begin again with clean books and clean walls:

> as the disconsulated successor ruminated on the means – lo! a most happy and inspired idea occurred to her. Mary Hornby had been in a passion and perhaps she had forgotten to put any size into her whitewash. A brush was instantly applied to the walls – the hope became at once a certainty! Mary Hornby *had* omitted the size and by gentle and continued friction of the brush, the millions of pencilled names once more appeared in all their original clearness! The relics were at once pronounced humbug – new albums were opened and the Shakespeare show-room was restored to its ancient value.

The great entertainment in Henley Street now doubled in value. 'As these rival dowagers parted on envious terms, they were continually to be seen at their doors, abusing each other and their respective visitors, and frequently with so much acerbity as to deter the latter from entering either dwelling.' A traveller was moved to verse:

> What – Birthplace here and relics there!
> Abuse from each! Ye brawling blouses! –
> Each picks my pocket – 'tis not fair –
> A stranger's curse on both your houses!

Mrs Hornby's invective must have gained pungency when her rival's daughter was impregnated by George Skinner, the chaise driver at The White Lion. He absconded, but, like a good Stratfordian, was induced to return by the promise of living at the Birthplace after making an honest woman of Miss Court.

It was surely Mrs Court who induced William Shakespeare Hart to place an advertisement in the *Warwick Advertiser* in 1822, declaring that his family had never owned the relics. Mary Hornby was undaunted by this reductionist ploy. She persuaded Jane Iliff, 'only surviving daughter of the late Thomas Hart ... (and Aunt of William Shakespeare Hart of Tewkesbury)' to affix her mark to an advertisement in the following weeks paper, declaring that when

Thomas Hornby rented the Birthplace in 1793, he purchased all the articles which had 'from time to time immemorial, been shown as Reliques of the Great poet.' Her nephew, who was born in Tewkesbury, was then a little boy 'and never was in the house many times while my father was living … and that he cannot know anything, or but very little "traditionally", and, of course, with "no degree of certainty."' She had often heard her old grandfather and her father say that all the relics had been in the family since Shakespeare's death.

Such was the destructive rivalry between the two women that a mere street could not contain both. Mrs Hornby removed herself to premises near the Town Hall, where she exhibited her 'Collection of Reliques of William Shakespeare certified to be genuine by T. Kite and Jane Iliff, the nearest descendents of the immortal Bard.' 'Do not omit to see this museum', urged a visitor. 'Every relic will make you laugh.'

Yet Mesdames Hornby and court were making a more serious contribution than was generally realised. As the *Monthly Magazine* commented in 1818, Stratford had lost its woollen trade and 'having no manufactury would be one of the begging places of the Kingdom – but for the renown of Shakespeare, and the numerous visitors drawn to the place.'

Crime upon Crime

The long-looked-for peace did not bring prosperity. Poverty and deprivation persisted unabated, generating in their turn, a further crime wave. At the Lent assize of 1818, sixty-two felons were condemned, of whom five forgers were hanged. One who escaped death was William Salmon, indicted for possessing, at Old Stratford, £64 in forged notes. His sentence was commuted to fourteen years' transportation.

An 'Association for the Prosecution of Felons' was formed in the same year, to seek convictions through 'blood money'. By 1820, it was offering the huge reward of £30 for the conviction of those who had broken into the offices of Mr Wyatt, a local solicitor, and stolen a few obsolete and valueless banknotes.

Informers could suffer. Thomas Lench and Joseph Prince were convicted of stealing apples on the evidence provided by Joseph Calloway. On Mop night they encountered him in The Windmill and he was struck, pursued into the street and beaten violently. Lench and Price were remanded before the mayor, who refused bail and remanded them to 'the hole' until they were sent to Warwick gaol next day.

Next morning, as John Ashfield, the constable, was escorting the prisoners from the Town Hall, a friend of theirs, Thomas Palmer, struck him, demanding that they should not be handcuffed. A hostile crowd gathered and he feared that a rescue might be attempted. He boldly arrested Palmer and handed him into the custody of his brother. The mayor irenically told Palmer that an apology would secure his release, but he refused. At the county sessions, Lench and Price received a month's imprisonment, Palmer two months.

The original punishment for apple stealing must have been severe. In 1820, the magistrates ordered Samuel Edwards to pay William Evetts £1 for apples he had stolen from him. Through pride or poverty, he refused, so the Beadle was ordered to 'strip him from the middle upwards and whip him until his body be bloody.'

Court proceedings offer another glimpse of those brutalised paupers who emerge but rarely into the historical light, and then only through transgression. In 1820, Richard Smith, a labourer, was bound over for threatening to drag Mary Adams out of bed by the heels and throw her in the Avon. Two years later, he was indicted for an act of vagrancy after he went away, leaving this common-law wife and their two children to the public charge.

The severity of the penal code was an oblique incitement to violence. If wrongdoers were punished with drastic brutality for relatively trivial offences, they had little to lose be committing more heinous crimes. Such may have been the case on the foggy night of 4 November 1820 when Henry Adams (known locally as 'Black Harry'), Nathaniel Quiney and Samuel Sidney, of Waterloo Cottages on Banbury Lane, met with Thomas Heytrey of Pimlico Farm, Alveston. Their intention was to rob a farm bailiff called Parker. All four were known villains who had attacked travellers already that week. Necessity was a powerful motivator. Adams had to support a large family on 1s 9d a week. The four were well-oiled, having each drunk ten horns of ale.

At Littleham Bridge near Alveston, Adams pulled William Hiron, a local landowner, from his horse with an iron scythe tied to a pole. Quiney and Sidney hit himn with knotted sticks. The unhappy victim appealed to them not to hurt him further, begging them to take his money, together with his forgiveness of their offence. Despite the exhortations of his partners in crime, Sidney dealt him further blows to the head. The gang then decamped with their booty after Adams had dragged Mr Hirons from the middle of the road, where he was in danger of being run over.

When Mr Hirons recovered consciousness, he began to crawl on his hands and knees in the hope of reaching his home in Alveston. In his dazed condition, he mistook the direction and crept half a mile towards Wellesbourne before his strength gave out. He was found next morning in a ditch and taken to his home. He never spoke again and died three days later. Constable John Ashfield's suspicions fell on the four men, who were brought to Stratford and locked in the cellars of the Falcon, where they were given large quantities of beer. Under the stimulus, Adams began to talk. 'I never meant to murder anyone, God forbid. I only meant to get a little money to maintain my family. When my earnings were divided among them it only amounted to threepence each. I could not see my family want ... I never struck him at all.' After this, he burst into tears and said no more.

Witnesses were listening in the next room. Foolishly the men had concealed banknotes stolen from the murdered man in their homes. At the Easter assize, a chain of evidence was established, which left 'not a shadow of a doubt that the right man were doomed to suffer for the awful crime for which they were arraigned'. It took the jury only half a minute to reach their verdict. All that remained was 'the endeavour to seek penitence in this world for the hope of redemption in the next'. The ministrations of the prison chaplain brought them to 'a state of hope they never expected to experience'. On the morning of 21 April, they were taken to the prison chapel and received the sacrament. The 'deep tolling of St Mary's bell now summoned them to their ignominious end'. Adams wept bitterly. His wife had died in childbirth since his committal and the thought of leaving his six children as orphans was 'a weight too heavy for him to support'. Heytrey, whose sister had been hanged from the same scaffold the year before for the murder of her mistress, could hardly stand after he was

pinioned. After a short time in prayer, the drop fell 'and in a few minutes there was an end to their earthly suffering'.

After this 'awful and melancholy event', Stratford Corporation employed an officer 'to keep strict look out after dubious characters'. The deterrent effect was not great. Soon after the Overseers donated 5s to Private William Hughes of the 3rd Light Infantry, after he was attacked and robbed outside Stratford. Some months later, a groom was hailed by two women on the Warwick Road. They were immediately followed by two men, who knocked him off his horse with a bludgeon. They stripped him, robbed him of £12 and left him naked.

A lighter note was struck when two Herefordshire prostitutes, Mary Turner and Elizabeth Rose, were discovered *in flagrente delicto* with six local lads in a wood in Banbury Lane. The women were sent to the house of correction 'for wandering about the boro' in a riotous and indecent way'. The boys had fled 'beyond our jurisdiction' and were discharged *in absentia* with a severe reprimand.

The Canal Opened

In 1813, the canal company bought the Avon Navigation. The once-flourishing river trade was considered 'precarious' and 'attended with a Risque which may be dangerous to an individual proprietor'. After the war, trade was boosted by an increase in West Indian produce shipped from Bristol. To complete the canal, the company appointed William James of Henley-in-Arden, an architect endowed with the creative vision of the Industrial Age.

On 24 June 1816, the canal opened amid great rejoicing. The celebration was not misplaced. Soon 48,000 tons of coal was being shipped to Stratford annually, of which 18,000 were consumed there. The barges discharged their cargoes at two great basins on the Bancroft. The main return cargo was limestone, 16,000 tons of which were shipped from quarries near Wilmcote. Limekilns were established alongside the canal at Stratford. The old Bear, celebrated in Shakespeare's day, was now on the quayside, and reopened its doors as the appropriately-named Anchor.

In 1819, Thomas Lucy from Surrey was rumoured to have laid claim to the family estate at Charlecote, and bought and rebuilt the old flour mills by the church. After 1830, reputedly using the proceeds of an out-of-court settlement, shipped corn up the river in a steam vessel which puffed its way along the Avon. The new trade soon found its way into the records. In 1819, a bargee was arrested for assaulting a constable.

A Sad Ending

The story of that devoted couple, Robert and Elizabeth Hobbes, has a sad ending. In this era of enterprise and speculation, fortunes were made and as easily lost. Robert Hobbes had thrived. By 1812, he was a money-scrivener, 'receiving other men's money into his trust and custody and making merchandize thereof'. In 1816, he over-reached himself in land speculation and became indebted in the sum of £668 10s 9d to Oldaker, Tomes and

Chattaway, the Stratford bankers. A commission of bankruptcy was issued against him and he was required to 'surrender himself' to the Commissioners on three successive days. His legal partnership was dissolved and assignees were appointed from amongst his creditors to dispose of his property. As well as the family home on Waterside, there were four cottages in Chapel Lane, Thistly Meadow on the Warwick Road and a newly-erected schoolhouse in Ely Street, where Betsy was intending to open a school.

Robert's troubles came not as single spies. The assignees had permitted him to dig up his potatoes. On his way to the plot he met his friend, John Gamble, who was involved with unrecorded trouble with the Corporation. Robert told him that he disapproved of his conduct and added 'perhaps laughingly (certainly not exultingly) that the Corporation would play the Devil with him, or some other such expression.' This remark found its way back to 'those who have been indefatigable in their Exertions to defame me', who may have 'artfully' converted it into 'an expression of Triumph or Contempt against the Body Corporate.' He was in a tricky position. If his debts were called in, he could be imprisoned. In a dignified affidavit to William Chattaway, one of his assignees, he declared that Gamble would vouch for the truth of his statement, 'with his usual candour and kindness'.

This sad conflict with the Corporation he had served so well is the last we hear of Robert Hobbes. He was only forty-three and capable of the strenuous work, yet on 2 January 1817, he died from unspecified causes. He was buried at Holy Trinity five days later.

These were fractious times, for there was also unspecified trouble with the town clerk. On 5 February 1817, the Corporation decided to seek Council's advice about its powers to dismiss him, 'it being the opinion of the Corporate Body that the conduct of Mr Hunt deserves such dismissal'.

Elizabeth Hobbes faced huge problems. At thirty-nine, she was the widow of a bankrupt with eleven children to bring up. Fortunately, she possessed sympathetic friends. Her uncle, the vicar, was instrumental in the appointment of Elizabeth Ashford Hobbes, aged fifteen, as organist at Holy Trinity on a salary of £40 a year. This must have been planned before her father's death. The appointment was confirmed just eighteen days after his burial.

Either through skilful handling of her affairs or through friendly largesse, Elizabeth Hobbes was able to retain her house on Waterside. Yet income had to be generated if the family was to remain solvent. The answer was to open her projected school at home instead of in Ely Street. Ten weeks after Robert's death she advertised in the *Warwick Advertiser*:

Mrs Hobbes respectfully announces to her Friends and the Public, her intention of opening a school for Young Ladies at midsummer next, in the House where she now resides. Mrs Hobbes will engage a Teacher fully qualified for her situation, both as to acquirements and morals and she hopes that her utmost exertions for the present improvement and future happiness of her Pupils, and the support of herself and her numerous family, will meet with every encouragement from a Benevolent Public.

There were a number of small private schools at Stratford. A survey in 1818 recorded seventeen of them. Mrs Hobbes' standard boarding charge of 25 guineas per annum included tuition in English grammar and needlework. 'Parlour Boarders', who lived with the family,

paid 40 guineas. 'Day Boarders' (i.e. weekly) paid 14 guineas and 'Day Scholars', 4 guineas. It would be interesting to know who the pupils were and from whence they came, but financial considerations would ensure that they came from affluent backgrounds.

In 1819, Betsy measured the heights of her eleven children, who ranged from 2 feet 11 inches for four-year-old Harriet, to 5 feet 2¾ for eighteen-year-old Robert. Elizabeth, at seventeen, measured 5 feet and Mary, a year younger, was an inch shorter. Their diminutive size surely reflects a pattern amongst the population as a whole.

The mother fought with tenacity for her eleven children. Robert was found a position with a firm of lawyers in London. His brother, William, followed him into the profession. The six Hobbes daughters acquired the feminine accomplishments of embroidery and music, but the best long-term prospect was marriage. Not all Stratford's maidens achieved such conjunction. The assertion that the only maidenhead in town was on the pub sign of that name was belied by reality. 'Miss Whitmore', wrote a Stratfordian in 1818, 'still holds out against the sieges of those horrid creatures, men, as do our neighbours opposite and all the spinsters of the town and neighbourhood.'

The marital prospects of thirty-seven of the town's young ladies prompted a wager over dinner at the White Lion in 1820. Joseph Cresswell bet William George Morris, with Robert Hobbes Jnr, as witness, that seven would be married within five years. The stake was a dinner for the winner and four of his friends. Cresswell probably won, since four of the maidens were wed within a year, including the church organist, Elizabeth Hobbes, who improved his prospects by marrying him.

12

'Success unto Trade'

A bumper I claim, and I am not afraid
But you'll join me in drinking – success unto trade!

Shakespeare Club drinking song.

'Aye, I had a hand in that'

During the Regency era, the dramatic arts were chiefly represented in Stratford by Mrs Nunns of the Warwick Theatre, who frequently brought her company over, once with sad consequences when one of her actresses, Mrs Frimbley, hanged herself while 'lunatic'. Despite such setbacks, the company always performed to 'utmost applause'. So did the 'genius of this unrivalled band grow in the minds of its votaries', that it was resolved to build a theatre, 'that the Birthplace of the matchless poet may boast of a trophy dedicated to the memory of his immortal genius.' All that remains of Mrs Nunn's reputation is a fleeting record of local approbation, but to her must be ascribed the first inspiration for a Shakespearean Theatre at Stratford.

The suggestion that Stratford should have such a theatre was picked up by the noted comic actor, Charles Mathews. On 10 December 1820, 172 people paid 4s each to see him perform at the Town Hall. The show was called *The Trip to Paris* and he played all the parts in monologue. No record survives of his performance, although the correspondent of the *Warwick Advertiser* anticipated a 'delectable treat'. Yet the visit was historic, for next evening he convened a meeting at the same venue with Capt. Saunders in the chair. Its purpose was 'to consider the best mode of erecting, in the form of a Theatre, a National Monument to the Immortal Memory of Shakespeare'. Mathews made an eloquent speech, observing that 'it had long been a subject of regret to the Literary and Dramatic World, that a Town so distinguished as the Birthplace of Shakespeare, should not possess some token of National respect and gratitude to such an immortal genius…' He appealed to the audience to 'lend their mite were it only in the gift of 5s, as it would be the proudest boast of a person's life, so doing, to say in after times when passing by this Building, "Aye, I had a hand in that."'

He was received with loud and continuous cheering. A committee was formed with Mathews as president. In the spring, a site was selected in New Place Gardens and Mr Chantry of London appointed as architect. Fundraising was much boosted by the news from Edinburgh that Sir Walter Scott was 'making every possible exertion to promote the subscription'. Not all showed such approbation. The *Warwick Advertiser* considered that 'more moral evil than good and less pecuniary advantages [would be] derived to the inhabitants by the erection of a Theatre than of a Mausoleum.'

A Grand New Enterprise

Creative energy on a grand scale was possessed by William James, the architect who had ensured the completion of the canal. He made and lost the first fortune of the railway age. In 1820, he was worth £150,000 with an annual income of £10,000. In that year, he launched a great new enterprise to build a 'Central Junction Railway' to link Stratford's waterway system with London – and this six years before the opening of the Stockton and Darlington line. Thomas Telford was engaged as a consulting engineer and estimated that the first stage of the line to Moreton-in-Marsh would cost £45,000. George Stephenson advised James to use the revolutionary power of steam, but the uncertainties of the iron horse were mistakenly rejected in favour of the more familiar flesh-and-blood variety. Capital of £35,500 was raised with Lord Redesdale the principal backer, and an Act of Parliament was obtained. Meanwhile, William James was overwhelmed by his ill-considered speculations and was imprisoned for bankruptcy. 'His fluency of conversation I never saw equalled', declared Robert Stephenson, 'but he was no thinker at all in the practical part of the subject he had taken up.'

'My dear Robert'

From her window on Waterside, Elizabeth Hobbes could see the transformation of the Bancroft. The two large canal basins were lined by warehouses. Despite William James' bankruptcy, work on the railway continued. A graceful brick bridge was built to carry the wide-gauge tracks over the Avon in 1823. In that year, Elizabeth found places for two of her children, Thomas, aged seventeen and eleven-year-old John. She wrote to her son, Robert, in London from the Mitre Inn at Oxford.

> You will no doubt be surprised to receive a letter from me dated as above, agreeably so then I inform you that John is admitted a chorister of Magdalen College. I brought him here on Thursday. His voice was tried yesterday and his name is to be entered in the books today. I am now going to seek out Board and Lodg[ing] for him, to pay entrances to the different Masters, Fees to the Servants & purchase Cap, Gown & surplice, &c. We are much indebted to our friend the Proctor for without his weight and interest, He would not have succeeded, John's age being very much against him. I have heard of a suitable situation for Tom with the same Gentleman with whom D. Rice served his time but more of this hereafter. God bless you and believe me in great haste to remain always your affect. Mother, E.D.Hobbes. Best love to Charles. John desires his love and hopes you will call upon him when you pass through Oxford. How grateful I feel to Providence for his protection and Assistance.

Here influence is being used for a not unworthy purpose. The placing of the bright son of a genteel but impecunious widow, who was solicitous of her children's welfare.

A last glimpse of this admirable lady is afforded by the fragmentary journal she kept during 1824. The year opened on a poignant note. 'January 2nd. The anniversary of my dear Robert's death, never absent from my thoughts during the whole day.' Her life was dominated

by large washes and the routine of school life. In the summer, her married daughter resigned as organist and her mother used her influence to secure the position for her sister. Her uncle, the vicar, called to 'speak about organ, agreed to give notice in church to get Anne elected' and her mother recorded a £26 advance on the borough share of her salary. On 19 September, she was in church twice to hear Anne play. Life was not all soap and salvation, for she fitted in an occasional game of backgammon with her daughter's mother-in-law, Mrs Cresswell.

The pupils had a holiday on the mayor's Feast Day, 14 October. Robert was not practising in Stratford and it must have seemed like old times when his mother recorded his return from the festivities at the Town Hall in the early hours.

At the Runaway Mop, Mrs Hobbes hired Mary Ann Savage as cook at £8 a year – and two other domestics who had worked for her before, Sophia Plumb as housemaid and Sally Hiron as washerwoman. The difficulties associated with Mop-hiring asserted themselves. The cook and housemaid ran off early on the morning of 3 November, leaving 'nobody but Sally Hiron', She registered a complaint for breach of contract, praying that 'justice may be done'.

On 16 November, Miss Tomlinson, the teacher, took the children to a Diorama at the White Lion. Stratford was up with the times. It was only three years since Daguerre's first showing of his three-dimensional exhibit in Paris. Four days later, Mrs Hobbes went to see the celebrated comic actor, Mr Sims, perform at the Town Hall. This was her last recorded excursion. Next day, she concluded her journal with the laconic entry, 'Not so well tonight.' She wrote no more. She must have been ill through the winter and died in the spring. Her passing was noteworthy in Stratford. On 8 April 1821, James Palmer, the beadle, noted her burial in his journal. After her death, the school was closed and the house let. Her six children still at home must have gone to live with their lawyer brother or married sister.

Elizabeth Hobbes had worked hard to keep her family after the death of her beloved Robert. She would have been gratified to know that, in Stratford's terms, each achieved a fit marriage or profession.

'They won't let any of our old Things be'

Mr William Hiron, that unfortunate man murdered at Alveston, had played his part in the incipient institutional revival by voting in the first county election for forty-six years. Polling was at Warwick over three days and the public declarations of support ensured a raucous affair, although the solid Tory affiliation and comfortable means of the voters reduced the potential for corruption. Support committees for each candidate sought to get voters to the polls. 'Sir. We have sent off in all directions and hope you will have a tolerable supply today', wrote the Stratford organiser to Thomas Hunt, agent for Francis Lawley. Apathy was a problem. There is a timeless flavour to an apologetic note: '…as Mr Lawley is so far before his opponent. Mr R. hopes that his attendance is not essentially necessary.'

In the Corporation, slow revival continued. In 1821, Thomas Sheldon again refused the mayoralty. To encourage the others, he was fined £50. It was determined that £35 would be paid to 'the person who shall be elected mayor in the room of Mr Sheldon and give the rest to charity'. Two years later, the Chamberlain's annual salary was raised from £50 to £80 and the

Corporation gained the impressive services of John Gill, a Bridge Street wine merchant who, through such measures as the introduction of base auctions for leasing property, reduced debts and increased income.

Moderate increases in the town's prosperity were affecting its appearance. The derision reserved by the Georgians for non-classical architecture led to many an exterior disappearing under a false frontage. 'It was an age of Roman cement, plaster and stucco', recalled a Stratfordian later in the century. A notable landmark disappeared in 1821 with the demolition of the old Market Cross. On the Coronation day of George IV, the Corporation, attended by the public charities and preceded by a band, processed to church. Afterwards, the mayor, George Morris, laid the foundation stone of a new Market House. The alms-people and charity children were regaled to a substantial dinner. In the evening a ball was held at the Town Hall. The surplus receipts were donated to 'the Descendents of Shakespeare's sister, resident at Stratford'.

At the Constables' Supper, it became the custom to sing, 'They won't any of our old things be', 'a song written by a humoursome wag of the day, attacking those, who, under mistaken ideas of what they called "improvement", demolished, obliterated and abolished pretty well all the features which gave our town the distinctive character of the Shakespearean epoch'.

A Great Reformer

Why does an age assume certain characteristics, and what prompts change? Even before the close of the Georgian era, characteristic lethargy was giving way to the reforming energy of the Victorians. Stratford was fortunate in 1822 when, through a rare initiative by Dr Davenport, John Conolly became borough surgeon at the age of twenty-seven. This great doctor, 'being a reformer by nature and hearty liberal in politics, ardently devoted himself to the furtherance of every measure of progress'. His first great work was to establish a public dispensary, for 'the purpose of supplying the sick poor with medical advice and remedies.' A surgery and two small wards were established at the Old Bank building in Chapel Street. The scheme was intended to help those to whom a sudden illness or injury would be a disaster. Subscribers had the right of nomination, deficits being made up by appeals. The annual Dispensary Ball became a highlight of the social calendar. In the first six months, 330 patients were treated.

In August 1824, a very severe case of smallpox was diagnosed at Stratford. An immediate general vaccination was ordered, initially among those claiming parish relief, later through notices to heads of households. Conolly did not doubt that the populace would 'comply with so respectable a recommendation', but warned that anyone found wandering abroad with the disease would be prosecuted, adding that 'the punishment in some recent cases has been very severe'. His zeal for public health led him to call a public meeting next month to discuss the potential health hazards represented by lime kilns proposed on the canal wharves, and he sought advice on the issue from a specialist in Uttoxeter. His main medical interest, however, was in the field of mental health. He furthered this in 1824 by becoming the visiting physician to the private asylums of Warwickshire. That year he founded a local 'Society for Reading and Lectures' to expand educational opportunity for working people. This included a tradesmen's library and a fund for visiting lecturers.

John Conolly, a devoted churchman, was a valued diplomatist in local disputes, became an alderman in March 1825 and was elected mayor in the following October. His interest in the town continued after he was appointed the first Professor of Medical Practice at the new University of London in 1828. He held this post until 1831 when administrative difficulties led to the resignation of several professors. He went into private practice in Warwick before being appointed resident physician to the Middlesex Asylum, the largest in England, in 1839. It was here that this 'friend and guide to the crazy' achieved his greatest work. He abandoned the prevailing systems of physical restraint for the insane and pioneered the recognition of the nature of mental illness. His work and energy effected a revolution in the treatment of the mentally sick.

Christian Fervour

The new mood of activism may be ascribed in part at least to rising evangelical fervour. The movement for popular education marked a realisation that channelled literacy could have desirable social affects. In 1819, a Bible Association was formed in Stratford. 'The necessity for such an institution may be inferred from the circumstance that amongst a hundred and twenty families previously visited, not more than six copies of the scriptures were found.' Those who could not afford Bibles received subsidies. We get a first glimpse of the archetypal evangelical lady philanthropist labouring amongst the deserving poor. 'Too much praise cannot be given to those ladies who have given so much of their time and trouble to visit the poor in their respective neighbourhoods, but have enabled them to supply themselves by small weekly contributions, with copies of the Scriptures.' Within a year, the total of contributors had risen to 869, representing the majority of local householders. In 1824, the association was sufficiently affluent to donate £100 to its parent society in London.

Missionary zeal was also turning overseas, giving impetus to subsequent Imperial expansion. In 1824, a branch of the Church Missionary Society was formed, 'with every good wish and sincere desire for the conversion of the poor benighted Heathen.' The Revd Francis Fortescue Knottesford of Alveston Manor took the chair at the inaugural meeting, at which it was resolved to petition the House of Commons, demanding 'protection to Missionaries engaged in the islands and settlements of the British Empire.' In 1826, another petition for the abolition of slavery was presented.

In his religious life, Mr Fortescue Knottesford anticipated many of the practices and beliefs associated with the Tractarians. At Alveston Manor, he amassed a large library of Catholic theology, which was extended by his son. On either side of the house were glass conservatories, which he treated as cloisters, pacing around them while reciting Psalm 119. According to family tradition, he said at least the 'small hours' and perhaps the entire daily office of the breviary in Latin. Although 'the latter part of his life ran parallel to the Oxford Movement', his family recalled that 'his religious training was entirely previous to it and apart from it … he is one of the proofs that confession never really died out in the Church of England.'

Mr Knottesford also anticipated another aspect of the Oxford Movement: its immersion in social issues. He was local correspondent of the National Committee for the Abolition of Climbing Boys, the poor mites who shared the fate of Charles Kingsley's *Water Babies*. It says

little of the Stratfordians that his efforts were depressingly sterile. He arranged for a 'clever mason' he knew to be trained to sweep chimneys mechanically, in the hope of encouraging by example. The scheme was reluctantly abandoned:

> on finding the *sine qua non* generally with the inhabitants for its admission into their houses, was whether their favourite sweeper would be employed or not. At first he willingly adopted it, and spoke highly of its convenience; but time has convinced us that he is playing the same trick that so many of his fraternity have played before; in fact he serves his own purposes merely by obtaining the use of an additional boy that neither eats nor drinks, amd yet such is the prejudice of the neighbourhood that if we were to take it from him at present, he would retain all his customers.
>
> One of our first objects was to bind out his eldest boy, a poor deformed lad, an apprentice to a tailor or basket maker, but here we have been again frustrated, owing to the squabbles of the different parishes, who each deny that he belongs to them and will not admit him till that point be settled. Then will there be two more boys to get rid of.

Like many frustrated reformers, Mr Knottesford saw public legislation as the best means towards private morality. 'Our greatest hope rests on the passing of the bill to be brought forward the next session.' This splendid clergyman concludes with the hope that Stratford's parsimony was untypical of the nation. 'I sincerely hope that this will be the most discouraging report you receive from your numerous correspondents.'

Such worthy activity received little support from the vicar and his colleagues. 'When I come to consider', wrote Capt. Jenkins of Alveston, secretary of the local branch of the Church Missionary Society,

> that the Clergyman of the Parish is not inclined to favor our proceedings and the prejudice that exists with some of the principal inhabitants, I cannot but be very thankful for the success it has pleased God to give us … I have applied to one of the principal Gentlemen of the Corporation who seems to think that there can be no doubt of our obtaining the Town Hall for a meeting; to obtain a Church for a meeting would, I fear, be difficult. The Revd Mr Knottesford who resides in this Parish is the only Clergyman who belongs to our society.

The increasingly irascible Dr Davenport was in the fourth decade of his long incumbency and was maintaining his tradition of latitudinarian inactivity. His fondness for the bottle led to his nickname of 'Dive in port', while his resultant tetchiness led Capt. Sanders to fix a Shakespearean quotation upon him.

> If I can fasten but one Cup upon him
> With that which he has drunk tonight already,
> He'll be as full of quarrel and offence
> As my young mistress' dog.

This petulant cleric managed to revive a number of ancient disputes with the Corporation. On 8 October 1826, he dispatched a furious letter, declaring that he would no longer be

'deluded' with promises of an increase in his stipend. If this was 'to be delayed until you are out of debt, you all know that it may be Half a Century before it can possibly take place. I have only to add that from this day as a Corporate Body I take my leave of you for ever.' Two days later, the mayor reported that 'in consequence of an affront offered by Dr Davenport, the vicar to the Body Corporate, which when called upon by the Chamberlain to explain, he further aggravated by personal abuse of that Officer, and violent invective against the whole Corporation', he would be ordered to quit the mayor's garden next to his own, which he had been permitted to use for forty years. To underline this division between ecclesiastic and civil jurisdictions, a dividing wall was built.

Dissatisfaction with the Church of England in the town was revealed in a survey of church pews, conducted by John Conolly in 1828. Many parishioners 'expressed in the strongest terms their concern at being unable to attend Divine Service in the Church; and some of them stated that they had been housekeepers upwards of 20 years without ever having sittings and that their children were sometimes sent back from Church on this account'. Others stated that for the same reason 'they had left the Established Church altogether'.

Thus, Dissent, which for a century and a half had been a puny flower in Stratford's religious soil, began to flourish anew. Nonconformists were starting to take advantage of the Acts of Indemnity, which ended their exclusion from public office. The mayor in 1824, John Tasker, was a Dissenter. At the Mayor's Feast, Mr Jones, the curate, 'rather catechetically and without regard to time and place', upbraided him for his affiliation. With dignity he replied that he considered 'the Established Church, thro' neglect and lukewarmness in prescribed duties, to be not only the greatest dissenters themselves from what they inculcate, but by preaching it to be Orthodoxy, the cause of it in the minds of others'.

The Independent meeting in Rother Street was reviving through the inspiration of a remarkable pastor, the Revd Thomas Helmore, who was born an Anglican in 1783. In his youth, he heard the noted Independent preacher, Dr Styles, and this made such an impression on him that he was ordained to that ministry in 1813, coming to Stratford seven years later. His 'indefatigable energy' soon made its mark. In 1823, he founded a boys' school at the Rother Street Chapel under the auspices of the British and Foreign Schools Society. In 1825, a girls' school was opened. Soon there were 300 pupils in the 'British Schools', compared with 40 at the National School.

Helmore's younger son, Frederick, in a memoir written seventy-five years later, preserved an appealing picture of his father:

The active founder of the British Schools not only visited, but daily taught in them until he trained his schoolmaster, William Pardoe, to take sole charge. He drilled the boys, taught them to sing, drew and coloured maps which he mounted on frames … Then there was a band of fifes, which… [I] led at the early age of seven.

An infant school – quite a novelty in those days, if we except the good old-fashioned dames' schools – was a source of great delight to those who watched its development under the loving care of good little Mrs Corbett, directed by the indefatigable minister, who taught the tiny creatures to sing and act their school-songs and to do a variety of useful exercises which have now become familiar to educationalists.

The children sang their morning hymn before Helmore preached his fundraising sermons.

> Let grateful songs arise,
> Jehovah's name to praise;
> Who from the lofty skies
> Regards our infant lays:
> Let all rejoice to see the day,
> When children learn to read and pray.
>
> Our Sabbaths once we spent
> In folly and in sin;
> On play our minds were bent,
> And pleasure sought therein:
> But now we learn to read, and sing and pray.
>
> May those in glory shine,
> Who freely give their mite,
> To teach our youthful feet the way
> That leads to realms of endless day.

When Helmore realised that his sons possessed musical talent, he taught himself music at the age of forty so that he could teach them. Frederick's first musical memory was sitting at a table with a large music book, playing an imaginary accompaniment on a round ruler to his father and brother's struggles on their flutes. The elder brother, another Tom Helmore, possessed exceptional ability. After his return from Mill Hill School, his father put him in charge of the chapel singers. Soon there was a very fine choir and a great deal of singing was introduced into the service. At the age of ten, Frederick played the second violin part in Corelli's trios, but on the flute, with old Edmund Payne the timber merchant on first violin and Tom on the cello – the only two stringed instruments in Stratford.

> One day to my great joy my dear father presented me with the skeleton of a violin he had purchased in a sale. I ran with it down sheep-street and Edmund Payne (who seemed as delighted as myself) rigged out my instrument and lent me a bow. I took it to bed with me and next morning was up before 4 o'clock and in the loft set to work at my scales. As soon as I could play as far as 4 sharps and 4 flats in tune I got Challenor's tutor and played all through that.
>
> Before he went to bed he could play a little gavotte. He had practiced 14 hours. He practiced 'as hard as my blistered fingers would let me all through the summer vacation'. He then took lessons from Mr Gittings of Leamington, forming a class to relay what he learned to the other boys. Tom taught William Pardoe the violincello and within a year they had 'a fair orchestra, Edmund Payne, leader, my brother Holloway, and another bassoon, and old Heritage double bass...

This splendid ensemble supported a fine choir.

The eldest son's beautiful voice and Edward Adam's lovely alto especially gave sweetness and fullness to the middle parts, while the trebles, and basses were good … The four brothers Helmore formed a unique quartet of three flutes and a bassoon, for which the eldest arranged a number of pieces; the most popular of which were sequences of choice airs linked together by short interludes. Mr Rainsford, the music publisher and singer, declared twenty years after he had heard the brothers play, that it was without exception, the sweetest and most perfectly executed chamber music he had ever heard.

Frederick recalled the moral courage of his father, who 'hated cruelty above all things.' It was the custom to 'billet cocks' on Shrove Tuesday.

The dastardly game was like the modern 'Aunt Sally' only that instead of a wooden effigy of a respective relative, a live cock was tied to a post by its leg with a string, a piece of cloth being bound round the bone lest the string should break the foot off in the fluttering efforts of the unfortunate efforts of the unfortunate bird to escape the blows of the billets thrown at him. Maidenhead- lane adjoined Mr Helmore's house, and a post near his garden gate was chosen one year for this Shrovetide sport. The brave man went out among a set of villains, with a knife severed the string, and before they had time to recover from their amazement, brought in the poor bird under his arm, and fastened the garden gate. An attack was made on the garden and yard gates, and Tom, his eldest son, was sent over the fence to fetch the constables. An attempt to summon the minister for theft was made without avail and billeting cocks has never since been attempted.

Helmore faced subtler opposition when he preached against theatrical entertainments. He was subjected to stage satire, probably from Charles Mathews, but he bound the lampoon 'as a garland round his brow'.

Frederick Helmore's mother was renowned for her labours amongst the sick and needy. 'Her charming presence and sweet optimism cheered many a drooping spirit and by her careful watchfulness and wise treatment, patients of whom the doctors had despaired were nursed back to life and health.'

One incident reveals the spiritual power of Olive Helmore. There was a woman at Luddington who was blind, deaf and dumb and had lost the use of her limbs. 'The poor, helpless mortal showed evident signs of joy at the approach of Mrs Helmore. As soon as her foot touched the stair which led to her bedroom, her face lighted up, and during her visit showed kind appreciation of the kind presence of her visitor, who while she clasped the poor lifeless hand in her own gentle grasp, offered up fervent prayers for the soul of the helpless one.'

Exeunt Omnes

The theatre project ensured that Charles Mathews was seen in Stratford frequently and performed there occasionally. At one entertainment in the Town Hall, he selected the weekly market as the prosaic highlight of the town's life.

> There were pigs and donkeys, pork and veal,
> And lots of tempting mutton...
> With geese and niceties,
> To suit the greatest glutton,
> And Lord! There were such pretty girls,
> I could not get away, sirs.
> And this was all at Stratford-on-Avon,
> On a market day, Sirs.

The song is that of a travelling performer, who could adapt his material to the local topography. Such characteristic comic patter can be heard from the North-Country comedian, Woolmer, who so adapted his monologue 'Yorkshire Neddy's Ramble in search of a Wife' in February 1822.

I've travelled thro' Alveston, Clifford and Tiddington, Charlecote and Snitterfield, Newbold and Eatington ... But now I'm thinking marriage is surely a lottery. 'Yes, icod after being in so many places and not been able to get a wife was surely provoking enough, but however thinks I bad luck now, better another time, soa I set off again. Singing Ritum, titum ... I went to the Red Lion, then to the White Lion, Cross Keys, Horseshoe, Duke of Wellington, George and Dragon, Dog, Green Man, Horse and Jockey, till at last I wandered to the Thatch, but just as I was going down a Lane opposite I meets a very modest looking lass, so I goes to her and says I , 'pray my Love be so good as to tell me where I am?' 'Oh, you're quite at home, Sir' says she, 'or very near it. This is Hell Lane.' 'Dom it! I'm in for it again', says I so I turned my heel and began singing, Ritum, titum, &c.

The fullest account of a dramatic performance in this era comes from James Saunders, who recorded cryptically the shortcomings of a travelling company in 1823. The venue was the old Tythe Barn in Hell Lane, rented from Baldwin the butcher for 30s a week. The company's poor potential was further reduced by animosity between the proprietor Davenport, and Melmoth, his leading actor. Davenport was a Scot, whom Saunders considered 'utterly unfit to open his mouth before a Southern audience'. Melmoth possessed some talent, but 'lost himself by eternal drinking and smoking tobacco'. He had a violent temper and had knocked down the old actor, Macready, while playing at Bristol. At Stratford he made two malicious stage thrusts at a colleague after a minor disagreement.

Nor was the rest of the company reassuring. Mr Evans 'did not possess a single merit' and was 'old, ill-formed, insignificant and imperfect'; Mrs Gunning was 'a drunken old stager who had seen better days'; Mr Cleaver, 'a little duck-legged makeweight, without memory or any other qualification'; Mr Shearer, 'short and declamatory ... mutinous and ill-disposed, dirty in person and of bad principles'. His wife was a sad figure who had once been highly talented and 'acquired much applause both in this country and in America. In the latter she married Captain Thompson by whom she had two girls ... who have appeared in childish characters here. Her second marriage now degraded her in the eyes of her family and the consequent penury preyed on her spirits and acting.'

In such a company all were factotums. Mr Howell was 'very young and unformed, he was the professed scene painter and a very bad one – his sisters, the Misses Howell were younger

1. John Hatton de Stratford, Archbishop of Canterbury.

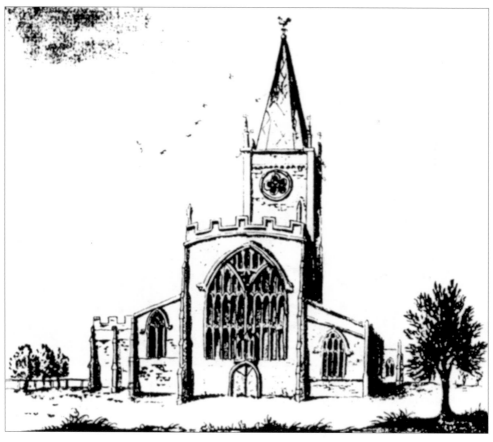

2. South-west view of Holy Trinity church (1762) showing John de Stratford's wooden spire.

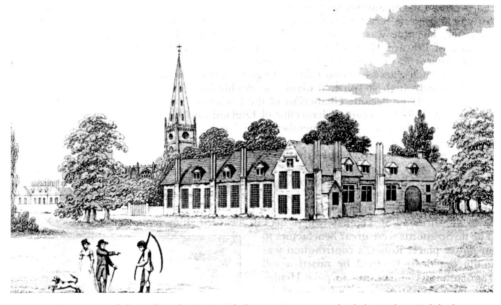

3. Engraving of the college by R. B. Wheler, *c.* 1800. It was built by Bishop Ralph de Stratford in 1353 and demolished in 1799.

Above left: 4. An 1806 watercolour reproduction of a painting of St George and the Dragon in the Guild Chapel.

Above right: 5. The Guild Chapel; an early nineteenth-century engraving.

6. The Old Market House by James Saunders, prior to its demolition in 1826. John Shakespeare would have traded here with the other glovers.

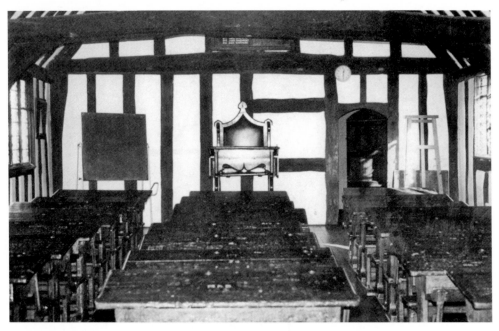

7. Big School, Stratford Grammar School, where William Shakespeare was probably educated. The desks date from the eighteenth century.

Left: 8. Bust of William Shakespeare in Holy Trinity church.

Below: 9. An early nineteenth-century engraving of Ann Hathaway's Cottage, which shows the building when it was still a working farm.

10. A sketch of the arms granted to John Shakespeare in 1596.

11. *Luxuria* or lechery, misericord at Holy Trinity church.

Above: 12. A drawing of New Place, where Shakespeare lived from 1610 to 1616, done from memory by George Vertue in 1737 after the house's demolition in 1702. This is the only known representation of the house.

Left: 13. Various signatures of William Shakespeare.

Above: 14. One of the earliest known pictures of Hall's Croft, the supposed home of John Hall.

Right: 15. Portrait of John Trapp, Stratford schoolmaster.

R.Garwood fecit

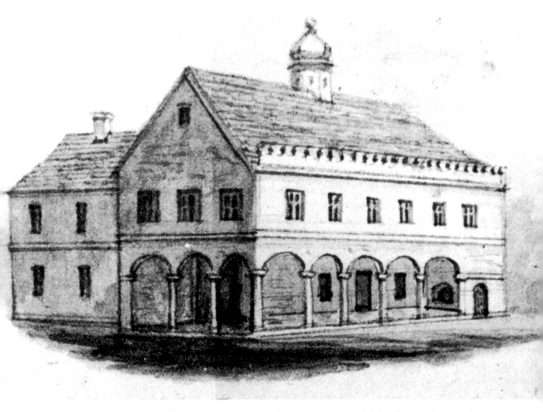

16. The old Town Hall, Stratford, as it was rebuilt after the Civil War, from a drawing by James Saunders.

17. A sailing barge on the navigable Avon, by R. B. Wheler, c. 1800.

Above left: 18. Portrait of Revd Joseph Greene.

Above right: 19. The 'Revd Destroyer', Francis Gastrell.

20. A drawing of J. T. Blight, *c.* 1860, showing the building line of Shakespeare's New Place on adjoining property.

Left: 21. Portrait of David Garrick by Thomas Gainsborough, commissioned by Stratford Corporation, 1769. It was destroyed by fire in 1946.

Below: 22. A panorama of Jubilee Stratford by James Saunders. Note the cannons in front of the Rotunda.

23. Opening of the Jubilee at the Market Cross.

24. Garrick reciting the Ode. Note the statue of Shakespeare is the wrong way round.

Left: 25. Band of the Warwickshire Militia by James Saunders.

Middle: 26. *The Mayor and all his Brethren* by James Saunders.

Below: 27. *Stratford Races* by James Saunders.

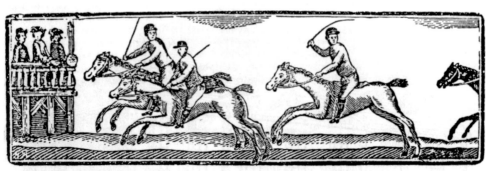

By Mr. Kemble's Company.

At the THEATRE in *Stratford-upon-Avon*,
On *This Evening* 1774,

WILL BE PRESENTED

The Beggars Opera.

Captain *Macheath*, by Mr. CHAMBERS,
Lockit, by Mr. SIDNEY,
Peachum, by Mr. JOHNSON,
Ben Budge, by Mr. MORRIS,
Jemmy Twitcher, by Mr. DONNELL,
Wat Dreary, by Mr. WHARTON,
Filch, by Mr. HINDE,
Crook-Finger'd Jack, by Mr. LEDWITH,
Drawer, by Mr. SMITH,
And *Mat o' the Mint*, by Mr. BROWN.

Polly Peachum, by Mrs. SIDNEY,
Mrs. Peachum, by Mr. KEMBLE,
Jenny Diver, by Mrs. OSBORNE,
Sukey Tawdry, by Mrs. ADAMS,
Mrs. Slammerkin, by Miss WILLIAMSON,
Mrs. Coaxer, by Mrs. SYDDALS,
Moll Brazen, by Mr. DONNELL,
And *Lucy Lockit*, by Mrs. DONNELL.

To which will be added a FARCE, call'd THE

Spirit of Contradiction.

Mr. Partlet, by Mr. SIDNEY,
Captain *Lovewell*, by Mr. HINDE,
Bat Steer, by Mr. BROWN,
Ruin, by Mr. LEDWITH,
And *Randell* (the Gardener) by Mr. DONNELL.

Mrs. Partlet, by Mrs. DONNELL,
Miss Harriet, by Mrs. SIDNEY,
And *Betty*, by Mrs. OSBORNE.

PIT 2s. GAL. 1s. *To begin exactly at Half after Six o'Clock.*

28. Playbill for the Beggars Opera, performed in Stratford in 1774 by Kemble's Company.

Above left: 29. John Jordan, the wheelwright poet.

Above right: 30. Oil painting of the Corporation Beadle, John Hickman, by Edward Grubb, *c.* 1790.

Left: 31. Mrs Elizabeth Hickman, the Corporation cook, by Edward Grubb, *c.* 1790.

Above: 32. The Warwickshire Yeomanry Cavalry, *c.* 1810. Robert Hobbes served as a sergeant in this volunteer force.

Right: 33. This is believed to be a picture of Mrs Mary Hornby, proprietress of the Birthplace.

Above left: 34. Caricature of Charles Mathews as a River God, by Landseer.

Above right: 35. Dr John Conolly, founder of the Dispensary, later 'friend and guide to the crazy'.

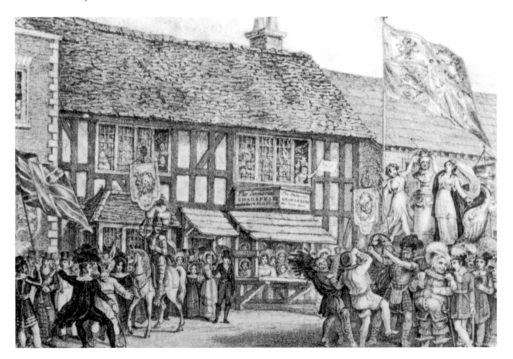

36. Shakespeare Jubilee celebrations (1830), showing the procession outside the Birthplace. The figure on horseback is Charles Kemble.

37. The barn in Windsor Street that was used as a theatre, with the old workhouse on the left. The picture is by James Saunders.

38. The Swan, *c.* 1845, showing the parish pump.

Above left: 39. Royal Shakespearean Theatre Chapel Lane, before 1862 when the cottages on the left (once a barn built by John Hall) were demolished. On demolition of the theatre, its portico was transferred to the Shakespeare Hotel, and later to the Red Horse Hotel (now Marks & Spencer).

Above right: 40: Dr Davenport, vicar of Stratford, preaching his last sermon at the age of ninety-two in 1843.

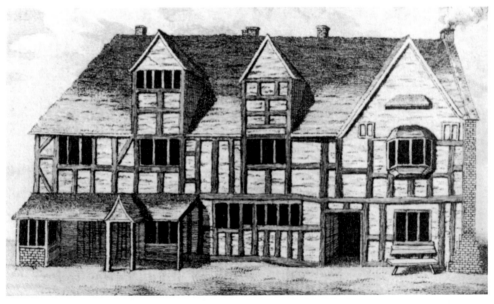

41. An engraving of Shakespeare's Birthplace (1769) by Richard Greene, based on the earliest-known picture of the building, *c.* 1762.

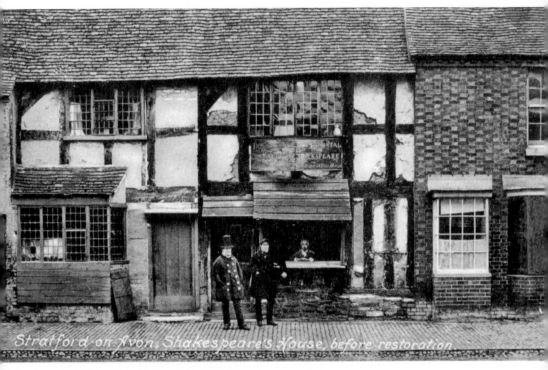

Stratford-on-Avon, Shakespeare's House, before restoration

42. Earliest-known photograph of the Birthplace, *c.* 1845. A constable of the borough force stands outside. It may be the amazing Mrs Court looking through the servery window.

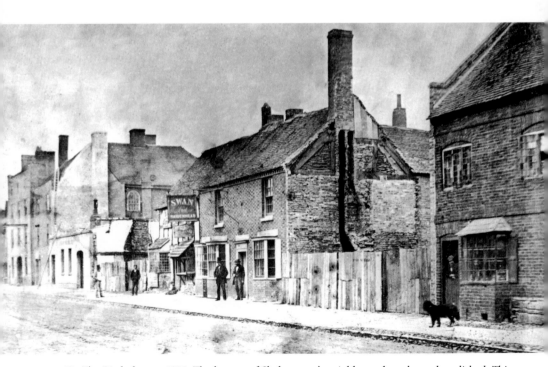

43. The Birthplace, *c.* 1850. The houses of Shakespeare's neighbours have been demolished. This gives a good view of the old drovers' public house, the Swan and Maidenhead.

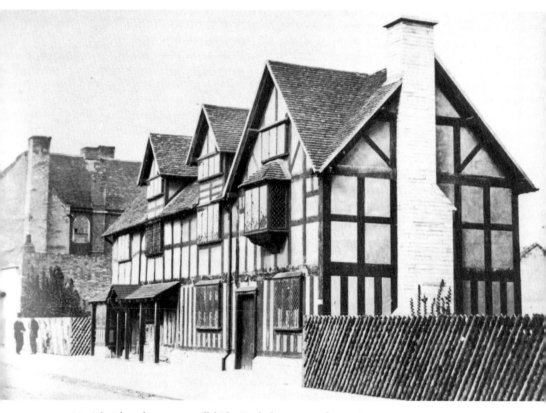

44. A 'spick and span new villa', The Birthplace restored, *c.* 1865.

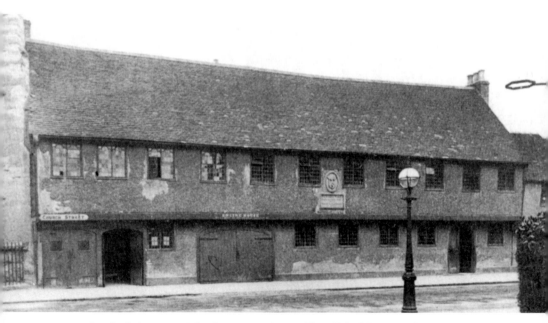

45. Stratford Grammar School, *c.* 1855. The Guild Hall had become the fire station. Note the gas lighting, which contrasts with the bracket for the old obligatory 'lanthorn' outside the former house of the town clerk, Thomas Hunt.

Above left: 46. Edward Fordham Flower, mayor of Stratford, 'looking like a Doge of Venice when a Doge was a Doge indeed'.

Above right: 47. An advertisement for 'the best beer brewed in England' by Bruce Bairnsfather.

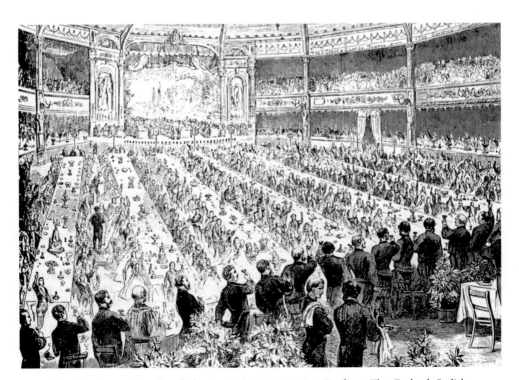

48. The banquet in the Shakespeare Commemorative Pavilion. The Earl of Carlisle proposes 'the memory of Shakespeare'.

Left: 49. Charles Edward Fordham Flower, 'the Founder' of the Shakespeare Memorial Theatre.

Below: 50. The Shakespeare Memorial Theatre, *c.* 1878. The auditorium is complete, but the water tower has not yet been built. Note the labourer in a smock and the osiers for basket-making growing in what became the theatre gardens.

Opposite: 51. Playbill for the inaugural festival at the Memorial Theatre.

LL.24/3/82

Shakespeare
MEMORIAL THEATRE,
STRATFORD-ON-AVON.

INAUGURAL FESTIVAL
ON
SHAKESPEARE'S BIRTHDAY, WEDNESDAY, APRIL 23, 1879,
AND FOLLOWING DAYS.

WEDNESDAY EVENING, APRIL 23rd,
MUCH ADO ABOUT NOTHING

On this occasion, the Council have the honour to announce that **Mrs. THEODORE MARTIN (HELEN FAUCIT)** has most kindly consented to appear.

Benedick	Mr. BARRY SULLIVAN
Don Pedro	Mr. LUIGI LABLACHE
Don John	Mr. HERBERT JENNER
Claudio	Mr. EDWARD COMPTON
Leonato	Mr. RYDER
Balthazar	Mr. W. H. CUMMINGS
	Who will Sing, "Sigh no more, Ladies."
Dogberry	Mr. W. H. STEPHENS
Verges	Mr. FRANK BARSBY
Beatrice	Mrs. THEODORE MARTIN (HELEN FAUCIT)
Hero	Miss WALLIS
Ursula	Miss HUDSPETH
Margaret	Miss GOLIEN

Previous to the Performance, A DEDICATORY ADDRESS, written by Dr. WESTLAND MARSTON, will be recited by **Miss KATE FIELD.**

THURSDAY EVENING, APRIL 24th,
HAMLET

Hamlet	Mr. BARRY SULLIVAN
Claudius	Mr. HERBERT JENNER
Polonius	Mr. W. H. STEPHENS
Laertes	Mr. EDWARD COMPTON
Horatio	Mr. LUIGI LABLACHE
Ghost	Mr. RYDER
First Gravedigger	Mr. FRANK BARSBY
Gertrude	Mrs. CHARLES CALVERT
Ophelia	Miss WALLIS
Actress	Miss EMMERSON

FRIDAY EVENING, APRIL 25th,
A CONCERT
The Music of which is associated with the Works of Shakespeare.

Madame ARABELLA GODDARD, Mrs. OSGOOD, Miss KATE FIELD, Madame ANTOINETTE STERLING, Mr. W. SHAKESPEARE, Mr. W. H. CUMMINGS, and Mr. SANTLEY. The LONDON CONCERT GLEE UNION, under the direction of Mr. FRED WALKER.

Conductor SIR JULIUS BENEDICT.

SATURDAY AFTERNOON, APRIL 26th,
HAMLET
Will be repeated.

Hamlet	Mr. BARRY SULLIVAN
Claudius	Mr. HERBERT JENNER
Polonius	Mr. W. H. STEPHENS
Laertes	Mr. EDWARD COMPTON
Horatio	Mr. LUIGI LABLACHE
Ghost	Mr. RYDER
First Gravedigger	Mr. FRANK BARSBY
Gertrude	Mrs. CHARLES CALVERT
Ophelia	Miss WALLIS
Actress	Miss EMMERSON

MONDAY AFTERNOON, APRIL 28th,
Mr. SAMUEL BRANDRAM will Recite
"THE TEMPEST."
The Songs incidental to the Play will be sung by **Miss de FONBLANQUE.**

On MONDAY EVENING, APRIL 28th, and THURSDAY EVENING, MAY 1st,
MUCH ADO ABOUT NOTHING

Benedick	Mr. BARRY SULLIVAN
Don Pedro	Mr. LUIGI LABLACHE
Don John	Mr. HERBERT JENNER
Claudio	Mr. EDWARD COMPTON
Leonato	Mr. RYDER
Balthazar	Mr. W. H. CUMMINGS
	Who will Sing, "Sigh no more, Ladies."
Dogberry	Mr. W. H. STEPHENS
Verges	Mr. FRANK BARSBY
Beatrice	Miss WALLIS
Hero	Miss EMMERSON
Ursula	Miss HUDSPETH
Margaret	Miss GOLIEN

On TUESDAY EVENING, APRIL 29th, and FRIDAY EVENING, MAY 2nd,
HAMLET

Hamlet	Mr. BARRY SULLIVAN
Claudius	Mr. HERBERT JENNER
Polonius	Mr. W. H. STEPHENS
Laertes	Mr. EDWARD COMPTON
Horatio	Mr. LUIGI LABLACHE
Ghost	Mr. RYDER
First Gravedigger	Mr. FRANK BARSBY
Gertrude	Mrs. CHARLES CALVERT
Ophelia	Miss WALLIS
Actress	Miss EMMERSON

On WEDNESDAY EVENING APRIL 30th, and SATURDAY AFTERNOON, MAY 3rd,
AS YOU LIKE IT

Jaques	Mr. BARRY SULLIVAN
Duke	Mr. ALLERTON
Banished Duke	Mr. LUIGI LABLACHE
Orlando	Mr. EDWARD COMPTON
Adam	Mr. RYDER
Touchstone	Mr. FRANK BARSBY
Amiens	Mr. W. H. CUMMINGS
	Who will Sing, "Blow, blow, thou Wintry Wind."
Rosalind	Miss WALLIS
Audry	Miss HUDSPETH
Celia	Miss EMMERSON
Phœbe	Miss GOLIEN

Return Tickets at Reduced Fares.—SPECIAL TRAINS after the Performances to Leamington Every Evening; to Birmingham on 23rd and 24th; and to Worcester on 25th and 28th, stopping at intermediate stations.

For further particulars see Official Programmes, to be had Price 6d. on application to the Festival Ticket Office, New Place, Stratford-on-Avon.

All the Evening Performances will begin at 7 o'clock; doors open at 6·15 p.m. Those in the Afternoon begin at 3 o'clock; doors open at 2·15 p.m.

PRICES OF ADMISSION (for Seats Numbered and Reserved)
WEDNESDAY, April 23rd, 20s., 10s., & 5s. THURSDAY, April 24th, 10s., 10s., 5s., & 2s. 6d. REMAINDER OF FESTIVAL, 10s., 5s., & 2s. 6d.

Remittances for Tickets can be sent by Post, addressed to Mr. H. DOWNING, New Place, Stratford-on-Avon, and the best available places will be selected by the Stewards' Committee.

Above left: 52. The American actress, Mary Anderson, whose performance as Rosalind in 1882 was the theatre's first great success.

Above right: 53. Frank Benson as Shylock. This step outside the auditorium of the theatre was much favoured for Bensonian photographs.

Left: 54. Mrs Constance Benson as Rosalind.

MEMORIAL THEATRE
STRATFORD·ON·AVON
Mr·F·R·BENSON'S·COMPANY
APRIL 20 TO MAY 2, 1903.

55. Cover of the 1903 programme for the Benson Company's season.

56. The Fairies' dance from *A Midsummer Night's Dream*. Girls rehearse in the theatre gardens. 'Hand in hand with Fairy Grace / We will sing and bless this place'. Photograph by Benjamin Stone, 1889.

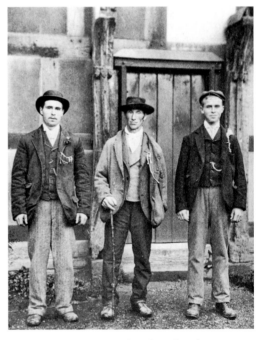

Above left: 57. An autographed postcard of Ellen Terry. 'A star danced and under that I was born.'

Above right: 58. Labourers plying for hire at the Mop (1899) by Benjamin Stone MP. Stone was one of the first men to realise the importance of photography as a social record.

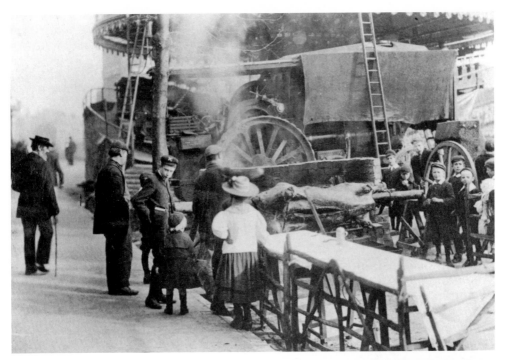

Above: 59. Ox-roasting at the Mop.

Right: 60. Women fetching water from Shottery Brook. Ann Hathaway's Cottage is in the background.

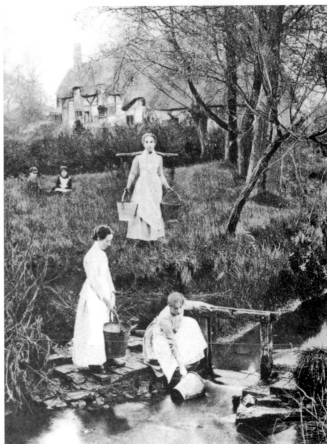

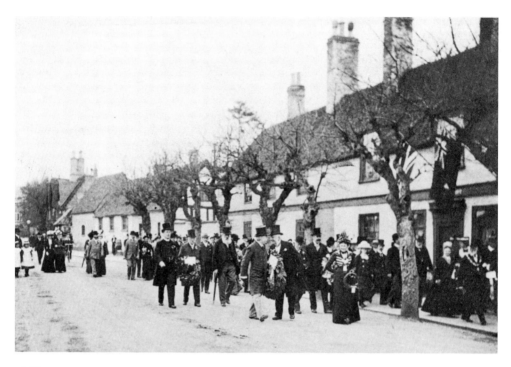

Above: 61. Birthday procession, 1900. Photograph by Benjamin Stone.

Left: 62. 'Miss Marie Corelli presents a Cup to Stratford-on-Avon Boat Club.' This is one of six scenes of Miss Corelli in Stratford produced by a local stationer. Shortly after they appeared, the entire stock was bought out, presumably by Marie, who hated pictures of herself.

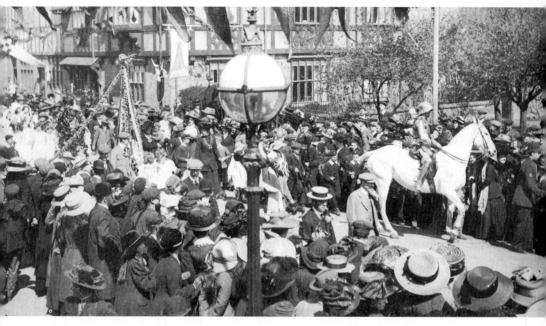

63. The May Day procession, 1911.

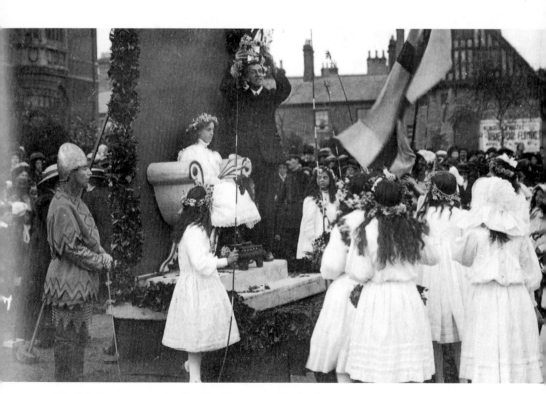

64. F. R. Benson crowning the May Queen outside the theatre.

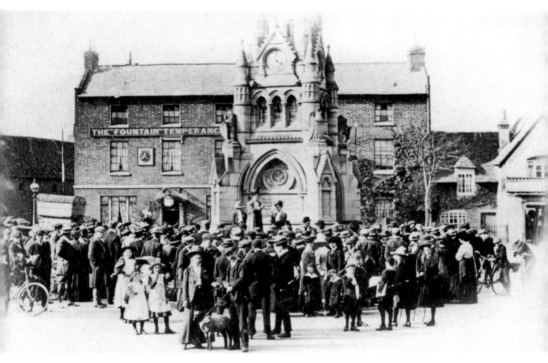

65. Women's suffrage meeting at the Fountain (1913), which ended in a riot.

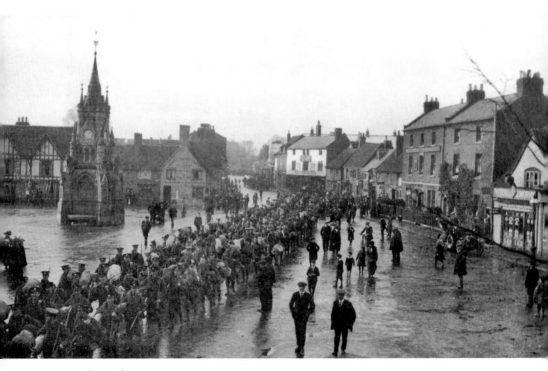

66. Marching off to war, 1914–18.

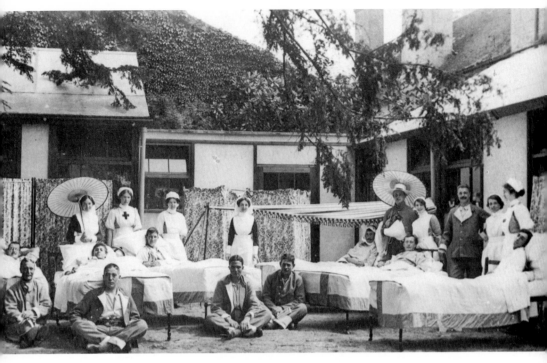

67. The convalescent hospital at Clopton House, 1914–18.

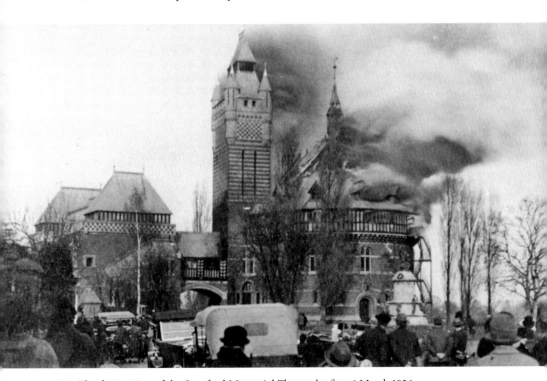

68. The destruction of the Stratford Memorial Theatre by fire, 6 March 1926.

69. The new Shakespeare Memorial Theatre.

and more unqualified with a diffidence that could not articulate beyond a whisper.' Mr Byrne, who was 'a useful actor, particularly in testy old men', was 'originally engaged as a musician, and after his performance in the act ran round and played the fiddle in the orchestra until his redemption of his stage character was necessary'. The only real talent was Mr Whyte who 'possessed a pleasing power of singing'. He appeared for a few nights before graduating to a superior company at Worcester. Davenport had hoped that Mr Rowland Green, a local hatter, would play Othello, but he declined. His talents must have been solicited in the hope of boosting the box-office.

The season was disastrous. 'Bad success soured all parties – the treasury was empty and the company separated, disgusted with each other and their want of patronage … Exeunt Omnes.'

'A Superseded Idea'

Despite the financial collapse of its architect, the Moreton 'tramway scheme' proceded apace. It opened amid great celebrations on 5 September 1826. At 10 a.m., a band set out from the wharf at Stratford, preceding a party of dignitaries in five covered carriages. They were followed down the line by the vital commodities of coal, timber and lime in twenty-one trucks. 'Universal admiration and surprise were excited and warmly expressed by the spectators on seeing three remarkably fine horses, the property of Messrs Greaves & Son, drawing a weight exceeding 15 tons, in four large coal loaded wagons, along the line, even where there was the steepest assent, without the least apparent extra-ordinary exertion.'

The *Warwick Advertiser* expressed the hope that the railway might 'prove a blessing to the poor… as affording the means of their being supplied with fuel, as well as many other necessaries of life, at a much cheaper rate than they hitherto could be afforded'.

The theme was taken up by a local poet. 'To see our iron railway we are quite content. / For what we've saved on coaling will surely pay the rent.'

Another new trade soon made its mark on the records when Thomas Lark, 'the driver of a Rail Road wagon', was charged with assaulting Joseph Hirons. The world's first recorded railway fatality occurred at Alderminster on 21 May 1830, when a child was run over.

The 16-mile track had cost the enormous sum of £80,000. In the first ten months of operation, the receipts were £2,190, rather than the annual £3,000 that was required to break even. Nevertheless, the tramway played a considerable role in the trade of the area for three decades, conveying 15,000 tons of coal annually by 1845. A branch line to Shipston was opened in 1836, but the grand design of a link to London was never fulfilled. The advent of steam soon ensured that the enterprise was 'a superseded idea'.

Crime and Incendiarism

Sentence of death was recorded twice more for crimes committed at Stratford. In 1826, James Johnson and Giles Collins were reprieved after stealing two horses. Two years later, John Windsor, William Slater and William Vale were condemned for burgling the shop of

Gibbs the watchmaker. A month later, they were conveyed aboard the hulk *Retribution*, at Sheerness, prior to transportation for life.

Stratford's proximity to the workshops of Birmingham produced a flood of counterfeit coinage. In 1826, Elizabeth Seagrave was charged with passing a dud half-crown. Crying bitterly, she threw herself on the mercy of the court, pleading for her three fatherless children. Despite this, she got twelve months hard labour. She was probably a habitual offender, for, on the same day, Ann Brotherton, who had many such convictions and who was described as going through England like a pestilence, received the same sentence. She was arrested in the Red Lion, when £4 8s 6d was found in the petticoats of the child on her knee.

On occasion, the lawlessness of the times and the driving force of poverty combined to produce a rural terrorism that struck at the wealthy and exploitative. The disaffected resorted to the incendiarism that became known as the Swing Riots, and England appeared on the brink of revolution.

The first manifestation of such incendiarism in Stratford (and one of the first in England) occurred at 11 p.m. on 8 March 1826, when two ricks were discovered ablaze in the yard of Mr Gardiner of the Red Horse. Strenuous efforts by the populace saved the nearby buildings. Next day, a rick in John Baldwin's farmhouse at Hare's Lane, Alveston, was burnt down and, three days later, a rick at Billesley Hall, 4 miles from Stratford. Public alarm was increased by anonymous letters threatening further visitations. A reward of £300 for the conviction of the 'diabolical incendiaries' was offered, but no information was forthcoming as ricks and farm buildings continued to blaze. The conspiracy was skilled and closed. On 7 December 1827, the mayor received a letter advising him that the engines should be prepared for action. The watch was alerted, but the combustibles were already in place and exploded in another rick at Baldwin's farm on New Year's Eve. When the alarm was raised, the Stratfordians 'with their usual activity on such occasions', rushed over with tarpaulins and buckets. Within minutes, over 1,000 people had congregated. When the engines arrived, a human chain passed the buckets 500 yards from the river and the fire was extinguished before it reached the farm buildings. Five days later, Mr Baldwin received a letter threatening that the 'Firelighter' would act again within four days. The *Warwick Advertiser* also received a letter, signed 'Peter Schlemil':

> There are more things in heaven and earth, Horatio,
> Than are dreamt of in your philosophy.
> Shakespeare
> Sir, - There is a man, who has actually invented a composition which will set as hard as granite; and what is most remarkable, it will ignite at the slightest contact of fire; it is capable of being formed into balls of any size, and will bear the force of a gun or cannon, to discharge it against any solid substance; and will penetrate equally the same as any other shot. I shot it against (says the inventor) a solid oak with a common fowling piece, and it has answered in every particular.

The outbreaks caused concern in Whitehall. On 14 January 1828, Lord Lansdowne, the Home Secretary, promised a royal pardon and a reward of £100 to anyone turning King's evidence. Such inducements had no effect. In May, a rick-yard in the Alcester Road was fired.

In January 1829, a £400 reward was offered after an outbreak at Binton and two weeks later 'a most alarming fire' was discovered in the stack-yard of Mr Richard Salmon at Tiddington. A horseman was dispatched to Stratford, post-horses were put to the engines and galloped over in a few minutes. The flames were uncontrollable and spread to the house and farm buildings. The desperate shouting and rushing about of several hundred people provided a 'heart-rending scene of devastation, terror and anxiety'. Several gentlemen, prepared for the chase after the Hunt ball, joined the lines of fire-fighters in their hunting pink. Some rode off on their hunters to fetch buckets and tarpaulins. Even the octogenarian Dr Davenport was seen in the line.

A police officer from Bow Street arrived in Stratford to investigate, but enjoyed no more success than the local vigilantes. Only the rising prosperity of the early 1830s brought a temporary lull to the outbreaks.

'The Milk and Water' and 'The Bran and Chaff'

The Shakespeare Club was founded at the Falcon in 1824 on the initiative of Mr Britton, a London publisher. The founder members were some fifteen Stratfordians, 'humble in rank, but enthusiastic in their admiration of the Immortal Bard.' Election to membership was by ballot with the boxes appropriately labelled 'To Be' and 'Not to Be'.

Capt. Saunders fastidiously loathed the club, regarding it as dominated by those who, 'utterly devoid of taste, liberality, and the multitudinous variety of attainments necessary to plan or conduct such an undertaking, appeared only emulous of turning the tide of Pecuniary expenditure, each into his own line of trade or influence'. The club song tended to endorse this view:

> Were the Avon's sweet Bard from the grave to arise,
> No doubt but Old Stratford he'd view with surprise:
> The Bancroft I fancy he scarcely would know,
> With its basins and wharves and black diamond show.
> A bumper I claim, and I am not afraid
> But you'll join me in drinking – Success unto Trade!

Saunders attended one of the earliest dinners of the club, 'formed to do honour as they call it, to their Immortal Bard'. At the Town Hall, 227 members and guests sat down at three – 'an unfashionable hour truly, but necessarily so to allow for the early introduction of pipes and tobacco which, they imagine (tho' the immortal Bard says nothing about it), give a great intellectuality. The system began to work in about an hour after the general muster which consisted of the parish squire – 2 bourgeois squirets – 4 Aldermen – 7 Capital Burgesses – the rest Tradesmen, players, Chelsea pensioners ... About this period the conversation became gradually metamorphosed when the whole assembly were found to consist of and call each other "gentlemen". When the mayor rose to propose the toast of St George and the King, 'Mr Vice-President began to stare – and protested that he long thought the patron saint

of England had been dead – when an Intellectual explained the toast meant his Immortal Health and the King's mortal!'

Despite this low opinion, the club organised a considerable festival in 1827. Once again it was based around the dedication of a building – the laying of the foundation stone for the new theatre.

The occasion was scrupulously modelled on Garrick's Jubilee. At dawn, the Stratfordians were aroused by bands of musicians and the firing of cannon. Despite the obligatory gloomy weather, the roads to Stratford were thronged and by 11 a.m., a vast crowd had gathered. Not all were drawn by literary enthusiasm: 'the light-fingered gentry' had mustered in force. One man lost £30, but the committee had the foresight to engage police officers from Birmingham. Ten suspicious characters were arrested soon after their arrival and the rest departed rapidly.

In the main streets, show-booths were erected. Among the attractions for non-Bardolators were the Somersetshire giantess and fairy, and Boardman, the celebrated dwarf. Crowds clustered around ballad singers, buying their eulogies of Shakespeare. 'The doleful ditty of the lame and the blind' and the shrill voices of the showmen filled the air.

The formalities began with the Shakespearean procession postponed from 1769. At New Place, Mr Bond, the actor, recited the obligatory ode, composed by Mr Searle of Covent Garden, and gave the day its purpose by laying the foundation stone of the new theatre in Chapel Lane. The procession arrived at Holy Trinity to confused expectations. An extraordinary rumour was abroad that Hamlet's gravediggers would be standing in the sanctuary resting on their spades, as if they had just completed 'their melancholy task of committing "the sweetest Bard who ever sang" to the "jaws of the ponderous and silent tomb"'. Sprites, witches and fairies would peer fearfully round the tombs, 'as if fearful of intruding into the precincts of the place occupied by the glorious musician by whose potent wand they had been called forth'. Finally, a character dressed as Hamlet would speak an oration.

Word had it that this amazing pageant had been vetoed by the irascible vicar; a putative judgement in which the local press concurred. 'It would have been a source of deep regret had the venerable and respectable character given his consent. With all our veneration for the matchless Bard of Avon, we say better had he never been born than that our altars and our temples of religion should become the scene of such profanation.' In the event, nothing more spectacular occurred than a rendering of Shakespeare's laconic epitaph by a group of amateur vocalists.

That evening, Garrick's pattern continued with a grand firework display at the White Lion. This time the weather was more auspicious and the event was highly successful. The obligatory Masquerade Ball was held in a special pavilion, which, naturally, was 'brilliantly illuminated with an immense array of variegated lamps'. Memories of 1769 kept it well away from the river. As in Garrick's year, the company was 'numerous and respectable: but few characters were taken and these but indifferently sustained.'

For members of the Shakespeare Club, the highlight of the festival was a formal dinner at the Town Hall, which was illuminated for the occasion. Speech followed speech and toast followed toast. When obvious subjects like 'The Royal Family', 'The Immortal Memory' and 'The Mayor and Corporation' were exhausted, the company raised its glasses to each other. The evening ended with an unexpected tribute to 'The Revd Mr Jones, the late Chaplain to the Corporation', which finally terminated members' ingenuity and drinking capacity. The

only jarring note was struck by the eminent radical divine, Dr Wade of Warwick, who used the occasion to attack the draconian game laws. 'Now these are strange methods of inducing the County Gentry to visit us at our next Jubilee', fumed the Tory *Warwickshire Chronicle*.

The Royal Shakespearean Theatre opened on 12 December with an address from Mr Searle and performances of *As You Like It* and *Catherine and Petruchio*. The decor and style of the building were much admired. Two years later, the theatre received the endorsement of the greatest theatrical figures of the age when Edmund Kean played Richard III and Shylock and W. C. Macready played Hamlet.

The unanimity of the Shakespeare Club was soon disturbed by a breakaway faction, known as the 'True Blues', or, more familiarly, the 'Bran and Chaff', which met at the Golden Lion and organised a rival celebration on Shakespeare's Birthday. This club's greatest asset was its permanent president, Mr Robbins of Warwick, whose qualities at the convivial table were regarded as unsurpassed. More than once, he presided for twelve hours without leaving the room.

The original club, nicknamed 'The Milk and Water', also had its characters. John Warner of Charlecote afforded much amusement to the members at their monthly meetings 'by his grotesque assumption of poetical inspiration.' This tall, gaunt man was always dressed in woollen cord breeches and blue worsted ribbon stockings. On taking his seat, he untied a handkerchief and, with an appetite reinforced by a 3-mile walk, devoured a huge snack – 'more than enough for any other four men in the room.' Once he had settled down to his pipe, the chairman would often ask him for a recitation, which 'after a little modesty on the part of the rural poet', was invariably complied with:

> Every field and pleasant lea,
> And every drooping willow tree
> Growing by a stream of water;
> And every farmer's pretty daughter,
> And the loving swain who sought her;
> Every fat cow for slaughter,
> And the farmer, lucky man, who bought her.

At one time, this noted character had 'affected the cunning man' and done good business as a diviner, but tiring of this wizardry he gave his mysterious books away. His fame, however, had spread and people continued to walk long distances to consult him about the whereabouts of their lost property.

The influence of the Shakespeare Club was recognised by Mary Hornby's daughter, Sarah Raisin, who succeeded her mother as guardian of the sacred relics and promoted her inheritance in singular style:

Mister Chareman
i make bold to sollicit the Patroney of the Shakespere Club – to my shewing the jenuine relks of the bard collected by my respekted Mother – and leave to make a nue Showband & print Cardes with your tittle. i hope gentlemen – after the Corprashen have sarvd you so kindly – you will not

thinck I am unraisonable

Your humble Sarvt

Sarah Raisin

Poor Mary Hornby, like so many purveyors of fantasy, became deluded herself and was removed to a madhouse. She died in 1829, aged sixty-three, a week after her return.

The Shakespeare clubs joined forces in 1830 for a three-day Birthday festival. The usual elements were present – dinners, a pavilion (this time in the Rother Market), illuminated buildings, a masquerade and pyrotechnics. A number of noted actors walked in the procession, including the boy-wonder of the day, Master Grossmith, 'the Reading Roscius', as Prince Arthur; young Charles Kean, son of the great Edmund, riding as St George and very fatigued by his heavy armour, and Charles Booth, who delivered an address at the Birthplace. Later Kean played Richard III with 'great energy and merit'. It was the first time that a word written by Shakespeare had featured in the celebrations. Stratford's old friend, the former Prince Regent, helped matters along by conferring the coveted title 'Royal' on the original Shakespeare Club, but the event was marred for the fastidious Saunders by the persistent failure of the Stratfordians to observe the niceties of rank. 'Three bourgeois squirets' designated themselves 'Esquires' and the theatre manager had advertised for a 'Gentleman' to build a showbooth.

Another figure who would give a name to an age visited Stratford in August, when the Duchess of Kent stayed at the Coach and Horses with her eleven year-old daughter, Princess Victoria and toured the Birthplace opposite. It had been suggested that the young princess might attend 'Avonbank', an exclusive school for young ladies with fees of £140 a year, situated at St Mary's House at the end of the church path. The school had moved to Stratford in 1824 and was run by Miss Maria Byerley and her three sisters, great-nieces of Josiah Wedgwood. Its best-known pupil was Elizabeth Stevenson (Mrs Gaskell), who despite this exclusive background became one of the acutest recorders of the social abuses of her age.

The widows Hornby and Court had realised what was now dawning on the world. The Birthplace was a gilt-edged property, said to be worth £2,000. Another glimpse of its heyday under free enterprise comes with the visit of the American humourist, Nathaniel Willis, in 1833. Lacking relics, Mrs Court had made a box of mulberry wood the pride of her collection.

I had such a time about that box, sir. Two young gemmum were here the other day – just run up, while the coach was changing to see the house. As soon as they were gone I misses the box. Off scuds my son to the Red Horse and there they sat on the top looking as innocent as maybe. 'Stop the coach', says my son. 'What do you want?' says the driver. 'My mother's mulberry box! – One of them 'ere young men's got it in his pocket.' And true enough, sir, one of 'em had the impenence to take it out of his own pocket and fling it into my son's face: and you know the coach driver never stop a minnut or he'd a smarted for it.

13

'The Interests of the People'

Let them atone for their past mistakes ... by vying with the Reformers in studying the interests of the People.

Warwick Advertiser, 1836

'Citizen of the World'

The man who was to become Stratford's most eminent Victorian first visited the town when he was nineteen, in 1825, signing Mrs Court's visitors' book as 'Citizen of the World'. Edward Fordham Flower was born in Hertfordshire in 1806, the son of Richard Flower, a radical pamphleteer, agriculturist and Unitarian, who took a gloomy view of prospects in England and, with a group of friends, founded a utopian settlement in Illinois when Edward was twelve. The boy shared the rigours of life in the wilderness, which were increased by the proximity of the Mason–Dixon line. The settlers pursued the practical implications of their radical views and participated in the 'Freedom Trail' for escaped slaves, often clashing with their southern neighbours.

Edward found much in England to attract him and decided to remain. He married Selina Graves of Barford in 1827. Soon after, he settled in Stratford, buying a house in Payton Street and going into business with James Cox as a timber merchant on the wharves behind the One Elm. He possessed great personal strength and courage. Once, he slew a bull with a pickaxe while rescuing a man from drowning.

James Cox also possessed great public spirit, energy and integrity. An Independent by denomination, his theology clashed with that of the Revd Thomas Helmore and he was expelled with eight others. They formed a Baptist congregation, for which Cox built an elegant chapel in Payton Street. In 1832, he began a 'Ragged School' in Sheep Street with forty pupils.

Edward Flower had learnt the art of brewing from his mother's family, the Fordhams, who were brewers in Hertfordshire. The government had lately reduced the duty on beer in an attempt to reduce gin drinking, so in 1831, he determined to open a brewery on a site on the Birmingham Road, for which Cox would provide the cooperage.

There was one essential ingredient that had to be found. A geologist assured Edward that there was good water there, but it was so deep that it was not worth the attempting to tap it. Undeterred, he hired a drilling team. When they got down to 700 feet, they hit solid rock and said they could go no further. When Edward asked if there was any way through, he was told the only way was by fitting a little cluster of diamonds to the drill to chip the rock away

a fraction of an inch at a time. At 750 feet, they hit water under such pressure that it shot 40 feet into the air. It was the first artesian well to be drilled in the county. The water was slightly hard, which made it ideal for brewing bitter.

Sanitation and Disease

Stratford was changing slowly. Unambitious residential suburbs were spreading along College Lane and the Warwick Road, and the rise in commercial activity which the canal had engendered spawned awful little slums between the Guild Pits and the canal. In 1830, the alley linking Bridge Street with the Guild Pits was expanded into the highway named Union Street.

In 1831, after the mayor, James Prichard, received recommendations from the Privy Council, he called a meeting to form a Board of Health. After surveying the town, the Board issued directives to abate or remove nuisances and to ventilate the cottages of the poor. Compared with the comments of the Inspector of Health two decades later, its conclusions seem complacent, but they constituted a start in clearing the filth of the centuries. Stratford was considered to be 'in a very clean and wholesome condition… the poorer part of the population, in almost all cases, enjoy ample accommodation and a free circulation of air in their dwellings.'

The Board of Health played a vital role in the cholera scare of 1832. A General Inspector of Nuisances was appointed to close cesspools, clear offal from slaughterhouses and scour open ditches and drains. Old men from the workhouse questioned travellers entering the town about possible contact with the disease. Thus, Stratford was spared from the epidemic, whereas Shottery, 'one of the dampest, dirtiest and poorest villages in Warwickshire', with a population of less than 100, suffered some 20 cases of cholera and nearly 40 of diarrhoea, resulting in 6 deaths.

Other efforts were being made to improve the lot of the poor. Thrift was encouraged by the establishment of a savings bank in Chapel Street, for those 'whose pecuniary conditions in life are narrow and humble.' The Labourers' Friends Society was founded to let allotments to the poor, 'for their moral and pecuniary benefit'. It was more important for tenants to be morally upright than green-fingered. Those culpable of drunkenness, dishonesty, or Sabbath-breaking were deprived of their gardens.

'The Strong Sense of Englishmen'

During this era of reform, the Stratfordians broke the constraints of their usual apathy. Because the ancient borough did not return members to Parliament, it was not dominated by a patrician dynasty, so the political enthusiasm of its inhabitants could be uninhibited. It was also unprecedented. In April 1831, Sir Gray Skipwith of Alveston House, the recorder of Stratford and a moderate reformer, was elected as a county member. The Stratfordians were personally and politically delighted and the Corporation asked him to give the people 'the

pleasure' of escorting him into the town. On 13 May, a huge crowd accompanied by a band greeted his carriage at the borough boundary. At the Town Hall, it took some time to obtain silence, but when all was quiet, the mayor declared the inhabitants 'fully satisfied ... that we are trusting our interests to the care of a gentleman well worthy of our entire confidence'. Sir Gray's reply was a model of moderation. 'Many excellent men', he knew admitted the need for some reform, but thought that the Bill went too far. 'They think it will make the House of Commons too democratic and thereby incur the danger of a revolution. I have no fear of that kind. I have too high an opinion of the strong sense of Englishmen.'

One who lacked this high opinion was the vicar, James Davenport, who signed a county petition against the Reform Bill, the only Stratfordian to do so. In September, a packed meeting at the Town Hall sent a petition to the Lords, who declared that 'a full, fair and free representation of the People, is not only their just right, but absolutely necessary, for the Peace and Prosperity of the Country.'

The great day of reform arrived on 9 June. In December, the borough franchise of ninety-nine electors had its first experience of local balloting, in a three-cornered contest for two seats. Committee rooms were established for the Tory candidate, Mr Evelyn Shirley, and for the Whigs, Sir Gray Skipwith and Sir George Philips. The unfranchised took a Hogarthian view of the proceedings. While there was no interference at either of the polling booths, it was popularly believed that an election represented an extension of the 5 November frivolities. On the first morning of the three-day poll, disorderly groups roamed the town. By two o'clock, the constables were powerless to disperse a huge crowd which had assembled in Ely Street. Mischief was in the air. George Cope rushed from his house in Windsor Street brandishing a poker, shouting 'Damn my eyes if I don't murder somebody with this before I have done with it.' At four o'clock, the mob, now exceeding 500 and armed with bludgeons and staves, marched to the Tory headquarters at the White Lion and smashed the windows with pitching torn from the street. The constables tried to arrest the ringleaders but were forced to retreat. Leaving the White Lion, the mob performed the same service for the George and Dragon up the street. A party of gentlemen rode to Coventry for the military, while the mob created great disturbances all over Stratford. At the Shakespeare, where the constables grouped to bar their entry, George Cope raised his poker at a special constable and threatened to split his skull. At the Bricklayers Arms, Constable John Ashfield spotted that Frederick Lewis had concealed a bludgeon under his coat. When he tried to take it from him, he was knocked to the ground. When the military arrived at 10 p.m, the Riot Act was read, several rioters taken into custody and the mob dispersed. At the quarter sessions, Lewis, Cope and nine others were gaoled for riotous behaviour.

Despite such lively scenes, Stratfordians were generally tolerant. 'In these stormy times', declared the *Warwick Advertiser*, reporting on an event at the Golden Lion,

a public dinner is not so much an ordinary matter as when the current of political affairs is flowing smoothly ... Stratford however ... boasts of the peculiar happiness – and long may it remain among the privileges of that good town – of being so little disturbed by political divisions that on all these festive occasions neighbours almost without a single exception; old and young, grave and gay, Whig and Tory, collect together, almost to a man. We observed with unspeakable

pleasure the most cordial interchange of social civilities between the most orange of the orange and the bluest of the blue.

The Tories were accommodating themselves to the reformed world. Mere resistance to change had no future. Locally, they had inveighed against the Radicals and their political unions. Now they sought to emulate them. In April 1835, the intention to form a Conservative Association in the southern division of the county was announced and succinctly defined.

> By the term Conservative is meant that rational attachment to our several Institutions, which, while it would remove all personal grievances, repair defects, and extend the means of usefulness, would, at the same time, maintain inviolate the Union of Church and State, secure to the Sovereign his just Prerogative, and to the Peers and Commons their separate independent and co-equal legislative powers.

This cry of 'The Church in Danger' reflected strong clerical backing. There were seventeen clergymen among the 'nobility, gentry and farmers' at the inaugural meeting at Warwick on 9 May, including the vicar of Stratford, Dr Davenport, now eighty-five, who seconded one of the resolutions to establish the association. The chairman, Mr Evelyn Shirley of Ettington Park, declared himself sure that everyone who had any feeling of loyalty in his heart, love to the King, attachment to the constitution and, above all, love to the Protestant Religion (of which everyone present was a member) would enrol his name. The main threat to the nation was its infiltration by Roman Catholics, particularly those of the radical, Irish variety. His remarks brought loud cheers and it was resolved to incorporate the aims of the association in a loyal address, signed by as many citizens as possible.

The radical *Warwick Advertiser* considered it unlikely that the new association would succeed, but changed its tune as the patrician power of organised Toryism manifested itself. Agents were working to secure signatories for the address. The visits of those of rank and influence were accompanied by assurances that people could 'do as they please about signing', mingled with hints that noble landlords might be offended if they refused.

Mr Shirley was returned in a subsequent Parliamentary by-election, enjoying the support of almost all the Anglican clergy, who, on the Sunday before the election, devoted 'the usual and useful length of their moral and instructive sermons for the purpose of canvassing their respective parishioners'.

The South Warwickshire Reform Association was founded in 1836, but proved ineffectual. It was to be nearly thirty years before the Tories had to defend the seat again. Yet the continuing alarm at the radical threat is amply demonstrated at a dinner held at the Shakespeare for 200 supporters. Dr Davenport, with true Tory sentiment, trusted they should be able to transmit the 'invaluable institutions' that their forefathers had established, to posterity, unimpaired and uninjured. The Revd J. Boudier, vicar of St Mary's, Warwick, was more outspoken, with a swingeing attack on Daniel O'Connell:

> Providence has permitted the ruling power to fall into the hands of persons more reckless than ever yet were known to hold the reins of Government in this country. They have thrown

themselves for support upon the Arch-agitator of our sister Isle – a man whose political principles are destructive of our glorious Constitution, and who, if he be true to his own religion, must desire to see our Protestant Establishment prostrate at the shrine of Papal idolatry and the Crown trampled in the dust. It is our duty to rouse our lay brethren to exert themselves in support of everything they have hitherto held sacred and to assist them in returning to Parliament men they know to be good and true – men who never suffer the feelings of the present day to be established in place of the venerable Institutions of our land.

He sat down to loud cheers. A local landowner, Sir John Mordaunt, closed the meeting by listing the tyrannies to which they would never submit, which included the destruction of the House of Lords, the separation of Church and State, the vote by ballot and universal suffrage.

'The Demon of Party Spirit'

By 1833, the Corporation's debt had risen to £5,500, causing conflict between the contemporary ideals of economy and progress. A recent Parliament Act enabled the provision of street lighting with the consent of two-thirds of the ratepayers. At a public meeting, the principle of economy prevailed. A poll was demanded, which revealed that, although most voters – 127 to 114 – desired public lighting, the majority was insufficient. That year the ratepayers of Old Stratford resolved to light their streets, so the fringes of the town were lit and the centre was in darkness. Nevertheless, the volition engendered by the campaign ensured that some of its supporters rapidly raised the capital to start a gas company. In September 1844, the gasworks in Chapel Lane were set in action to illuminate transparencies at the Town Hall, including one bearing Shakespeare's inscription, 'All the world will be in love with night / And pay no worship to the gaudy sun'.

The next day, the Committee dined at The Falcon. The dinner was cooked by gas and 'for cleanliness, cheapness and saving of trouble nothing could surpass it'. Soon most shops and many private houses had installed it and the new wonder had encouraged the provision of street lighting.

The oligarchies which had controlled the boroughs for centuries were terminated by the Corporation Act of 1835. At Stratford, the first chance for the 304 ratepayers in the following year to choose their own representatives resulted in the re-election of most of the old councillors, who were mainly Tories of the old school. A letter to the *Warwick Advertiser* signed 'Justice' alleged that there was great mortification in the town at the result and wondered how it had occurred. 'It has since been discovered that they left no means untried to get the burgesses to vote for their party; threats were made, promises were held out … They took advantage of the poor ignorant newly-made burgesses and defrauded them of their votes by all sorts of false pretences.'

A major grievance was that council meetings were held *in camera*. Even worse, a four-man borough police force had been established, 'to strut about the streets, insinuating that the people are becoming thieves and pickpockets … yet they know well that three years ago the people rid themselves of a night-watch, put on by the same party, which watch is not a tenth

part more odious as these Peel's police are become; and they are annoying the inhabitants with a code of by-laws, so ridiculous as to excite one universal feeling of contempt.'

There were thirty-four of these by-laws, covering over 300 subjects, many related to the Board of Health. The first thirty-three were generally ignored, especially by the councillors, 'yet our one-eyed police, acting under their directions, of course, have not been able to discover but one infringement'. It was the thirty-fourth section, forbidding the opening of shops on Sundays, which drew the outrage. It reflected both the religious concerns of the Tories and their remoteness from the lives of ordinary folk. Sunday was the only free day for working people, and the only day when many people from the district could come into town to do their shopping. Over sixty shops opened on Sunday mornings, some openly, others when the backdoor was knocked. Great resentment was caused when five shopkeepers were prosecuted. It was considered that they were being victimised for a useful and general practice. One was acquitted. Edmund Archer, the butcher, pointed out that an employer who did not pay his men until Sunday morning, was sitting on the bench. Notwithstanding, Henry Baldwin, the butcher, and Joseph Haynes Brandis, the draper, had their goods sequestered. A correspondent vented his fury in the *Warwick Advertiser*:

> They demanded a public sale of their property, but the magistrates, fearing public demonstrations, refused. A valuer was employed, when lo! and behold! they could get no person to take them at the price or any other price, so he was obliged to have them himself. George Compton refused to pay; and when they went to take out a distress, there being no goods to their taste, our liberal mayor [Mr David Rice, the surgeon] committed him to prison.' The police hired a gig at the Shakespeare Hotel (the headquarters of the Tories) to convey him to prison, but when the proprietor learnt why it was required, he ordered it to be returned. The large shopkeepers say it is no harm for them to sell at the back way; it is only those who are honest enough to open their fronts that commit sin, just as if God could not see them up their back yards! Oh! What a nation of hypocrites we are becoming! I have always understood that the Christian religion was to make us love one another – instead of which our saints are setting the people at variance … causing enmity, spite and malice throughout the town – making those who used to be the kindest friends now the greatest enemies! And what has done this? Why, trying to make all persons to think alike, and to become what is called religious, you cannot make them. You may make them hypocrites. You stated, some time ago, that the demon of party spirit had not appeared in this place. Thanks to our rulers it has recently taken deep root here.

'The demon of party spirit' was much in evidence in October 1836 when four council places (a third of the total) came up for re-election. The factions were associated with public houses: the Tories at The Falcon and the Liberals at the Golden Lion. The Liberals were first into action, having selected their candidates and completed a canvass two months before. The Tory four were supported by a handbill signed by twenty-six 'leading men', although they were so pushed for friends after the Sabbath affair that not all were voters. In an attempt to gain popularity, they dropped one of their candidates and supported the popular Liberal, Charles Lucy, canvassing for 'Mr Lucy and Party'. In a significant break with church domination of their party, they put a dissenter on their list, although they were half-hearted in their support

for him. They justified the 'foolish and vexatious by-laws' and the 'useless and odious police force' with the extraordinary claim that the Reform Act had obligated their establishment. Joseph Price was paid 6s to canvass on the Sunday before the election. Presumably, the righteousness of the cause justified the Sabbath-breaking.

A broadsheet produced by the opposition advertised 'Stratford Melodies. Being a Collection of Songs on the Contest between the shopkeepers and the Church and State Tory Council … upon the Sabbath Question.'

The tenuous position of employees under the open voting system is revealed in an affidavit from Matthew Hirons. Mr Timothy Smith, junior, the son of his employer, went to see him and said, '"Matthew, Mr Horton and me shall want your vote again this year." I said I had promised my vote to the Golden Lion Party. He said "Damn that – we must and will have it." On Saturday evening last he again tried to persuade me not to vote, saying that if I did vote, it would be the worse for me.' He voted as he intended on his way home from work. After a few minutes, the son arrived and ordered him to go to his father to be paid off. Mr Smith Snr, told him he was a great fool for voting against their instructions. At the Golden Lion, a spontaneous subscription raised a pound as a small compensation for his loss of earnings. Doubtless he found a new situation with a wealthy Liberal.

The election was a triumph for the Liberals. Charles Lucy topped the poll with 254 votes and their three other candidates, including Edward Flower, were not far behind. For the Tories it was a disaster. Their best candidate secured a mere forty-eight votes and poor William Bolton, the only councillor to seek re-election achieved an unenviable record in the borough annals by gaining just one vote – perhaps his own!

Public opinion had prevailed. At the next council meeting, it was resolved to open all meetings to the public and to take no further action on the by-laws. The correspondent of the *Warwick Advertiser* was jubilantly free with his advice to the vanquished.

> Let the Tories learn wisdom from their late defeat; and instead of trying to further incense the people of this town against their party – weak as it is in number, in influence and in wealth – let them endeavour to atone for their past misconduct and rashness, by vieing with the Reformers in studying the interest of the people at large, and not sacrifice the public good to please and promote the interest of the few; but should they let the present opportunity slip, their power is gone for ever – the people now know their strength, and never again will be Tory slaves.

The Tories took this advice and learned to look beyond the days of oligarchy. Their performance improved in the following year when five vacancies occurred. A contemporary account gives an insight into the polarised nature of local politics. There were 386 local voters; '70 were Tories, 100 Whigs, 197 working men and 19 in the middle class, who would take part with the working men.' Ten of the 16 councillors were Whigs or Tories, but there were no working men, 'so they started four on their side (for … they ought to have nine on the Council, to be fairly represented along with the others) and they elected three of them and would have elected the other if he had not exerted himself to prevent his being elected; so that this was a contest between the Whigs and the Tories against the working men; and although they made use of all their influence, still the working men beat the combined parties'.

The newly-elected reformers turned their attention to a notorious abuse – the ancient grammar school. There were seldom more than fifteen pupils, but the master was paid a handsome salary of £145 a year, which included £30 in lieu of the house, considered insufficiently grand for his habitation. It was pointed out that this sum was enough to educate gratis, nearly all the children in Stratford. After one of the martyrs of Sunday opening, Joseph Brandis, tabled a motion to examine the structure of the school, Sir Eardley Wilmott, one of the local members, raised the issue in Parliament. The result was an expansion of the curriculum to suit middle-class aspirations.

Victoria Regina

On 24 May, the Princess's birthday, the Royal Victoria Spa was opened at Bishopton, which had long been known to possess a spring whose water was 'very beneficial in various complaints'. The Pump Room was the first building in the area to be built in what became known as 'Victorian Gothic'. There would be thousands of buildings all over the world named after Victoria, but this obscure spa was probably the first.

Within a month of the spa's opening, Victoria ascended the throne. A committee was formed in Stratford to plan the local coronation celebrations. Collections were considerably boosted when the young Queen drove through the town on the way to Ragley Hall. The poor of the district were invited to apply for dinner tickets. The quantity of victuals was gargantuan: 3.304 lbs of beef; 60 legs of mutton; 620 huge loaves; 340 large plum puddings; 2,260 eggs; 2,214 quarts of best ale and 1,500 of table beer. The happy day dawned fine and clear on 26 June 1838. The town was filled with tables and decorated with flags, banners and flowers. Triumphal arches were erected in the principal streets. A band preceded a procession of the clergy and 'respectable inhabitants', followed by 1,000 children from the denominational schools, each wearing a medal and singing 'God save the Queen' as they paraded the streets, before 3,150 people sat down to dinner.

Church Rates

Holy Trinity was in another of its spells of disrepair and an appeal was launched for its restoration, which was begun in 1835. Despite the energetic efforts of Dr Conolly there was a shortfall, which placed the churchwardens in a dilemma. They were legally obliged to maintain the building in good repair, but the only way they could make up the deficit was by levying a church-rate, which would be generally unpopular. It was also an issue of principle for some. In 1837, a leaflet was circulated in the town, explaining the system of church rates and how to avoid paying them. Some 800 men and women were eligible for the rate on a collective liability of nearly £4,000. Collecting the money proved difficult. The collector had to call many times and some people locked their doors when he appeared.

Dissenters' arguments were amply aired in July, when four inhabitants were summoned for non-payment. James Cox put the basic argument when he objected to being compelled

to support a church that he did not use. He paid a voluntary contribution to his own place of worship. The members of the Church of England were wealthy enough to support their own church. Compulsory payments were contrary to all true principles of religion.

The magistrates replied that they could take no notice of these reasons. Whatever their own opinions, they were obliged to enforce the law. If Mr Cox could make any *legal* points, they would consider them, but they had no power to determine the validity of conscientious objections.

Joseph Brandis stated that, as religious objections were invalid, he would state a legal one. The rate was unequally levied. Over half the ratepayers never contributed. All the legal authorities laid down that property must be equally assessed. The Magistrates said that they had no power to decide on this objection. The inhabitants could take the issue to the Ecclesiastical court if they wished to press the issue further.

Mr Brandis replied that it was useless to urge any other reasons. They were summoned to show why they refused to pay, yet when they stated the reasons, the magistrates said that they had no power to decide upon them. What was the point of objecting? With exaggerated irony, he congratulated the churchwarden on being the first holder of the office to summon his neighbours. The churchwarden was a Tory and he did not doubt it would benefit the cause of Toryism.

The churchwarden replied with some dignity that he had been advised that, if he did not collect the rate, he would be personally liable. He was obliged to do his duty. It was immaterial to him if he gave offence. He was in a very unpleasant situation. He would be glad to be out of it and he would not care to get into it again. After a long consultation, the magistrates decided that the rate must be paid. The dissenting four declared that they would pay nothing. Eleven days later their goods were sequestrated. Memories of the Sunday-opening fiasco ensured that the property was sold in Warwick. The correspondent of the *Warwick Advertiser* was again critical of the Church Party.

> If the Tories had been wise they would have prevented this; but that is not *their* line of conduct. They will not observe the signs of the times; they imagine that, because the people once shouted 'Church and King' they would always do so; they forget that the present generation are better educated than the last… they forget that 'a well-instructed people never will be slaves', they have no idea of these things, so they oppose public opinion until it arises in its majesty and threatens to overwhelm them.

The anti-raters had a great success on 6 April 1838 when a crowded vestry meeting, at which all ratepayers were entitled to vote, met to consider a church rate. An amendment to adjourn the meeting without a rate was carried by a considerable majority. An attempt to convene a poll on the issue failed because the meeting was closed, so the rate was deferred. The issue was revived in August at what was probably the best attended vestry ever held in the parish. A rate of 2*d* in the £1 for the borough and 1*d* for the parish was moved, but the ancient vicar refused to put an amendment calling for the adjournment of the issue for one year. The only question, he said, was whether they should have a rate or not. After great confusion, a show of hands resulted in 105 votes for the rate and 103 against. The opponents demanded a poll,

which started immediately at the Town Hall and continued until two evenings later. It was conducted with great spirit and good humour, and resulted in a victory for the pro-raters by 410 votes to 310. The anti-raters were swift to deny anything other than a tactical victory for the Church Party. There was multiple voting according to rateable value and those overdue with their poor rates were prohibited from voting. In fact, 224 people had voted for the rate and 294 against. The other 582 voters were either 'afraid to vote, or their poor rates were not paid'. The correspondent of the *Warwick Advertiser* considered that, had they voted, about 500 would have been against the rate. Amongst the successful minority, 62 people, mostly living outside the borough, polled 248 votes. 'The only supporters the Church had in this contest were the interested parties, the time-servers and the slaves'.

The issue subsided with the completion of the restoration, but resurfaced during the next incumbency. John Greves, a young, radical, dissenting lawyer, denied the validity of the rate in 1844. After lengthy litigation, he obtained a protection order from process in the Birmingham Bankruptcy court. Another twenty-two people then refused payment on the grounds that he was not paying and this effectively blocked collection for four years.

The social and political divide between Church and Chapel was reflected also in educational issues. Government support for denominational education upset dissenters, who, generally lacking wealthy backers, were obliged to rely on small voluntary subscriptions. In 1845, Thomas Mason, a staunch supporter of the Church of England's National School, presented a site in Alcester Road for a new building. Another rich Anglican, William Woods Weston, donated the bulk of the costs, which made the scheme eligible for a topping-up grant from the Treasury. At the annual meeting of the British Schools, such intervention was denounced as 'unconstitutential, expensive and dangerous to liberty, to education and religion'.

Church Militant

The church rate issue was symptomatic of growing religious fervour and political awareness. A camp meeting of Primitive Methodists was held in 1832, and a stable at Shakespeare's Birthplace became the first chapel. Each June, members of this sect processed round the town, singing hymns. On Clopton Road, preachers ascended wagons and held forth before the processions returned to town.

A 'sense of duty' made the Revd Francis Fortescue Knottesford accept the living of Billesley, a hamlet of five houses and a Queen Anne church 5 miles from Stratford. Each Sunday, the family coach was brought to the front door at Alveston Manor and the whole household would embark for Matins at 11 o'clock. The parish contained the village of Wilmcote, which had been transformed into an industial community notorious for its debauched and drunken behaviour, by the exploitation of the lime pits.

Knottesford was a man of the times in that he saw the provision of a chapel-of-ease in the village as a key measure. Moral improvement was considered a prerogative towards social amelioration. St Andrew's church was the first to be built in accordance with Tractarian principles and became a focal point for those associated with the Oxford Movement. In 1847, it was the setting for the first retreat recorded in an Anglican parish.

One who was profoundly affected by the Catholic revival in the Church of England was the Revd Thomas Helmore, son of the Independent minister. Influenced by the interest in the worship of antiquity, which the Oxford Movement inspired, he joined the Church of England. His father was not distressed but told him, 'If your conscience bids you go, you will be wrong to stay'.

Thomas Helmore formed a choir of sixty members at Holy Trinity, largely from the singers at his father's meeting, who were mainly Anglicans that had joined for their love of music. Soon it was said that it was 'not excelled by the choirs of the most celebrated Cathedrals; and it is greatly to their honour, and to the honour of Stratford, that all the members ... are respectable resident tradesmen of the town and their children'. After Tom Helmore left to study for Holy Orders at Oxford, he was succeeded by Edward Adams, who conducted the choir with 'great spirit and care'.

In 1840, Thomas Helmore, newly-priested, chanted the service to commemorate the restoration of Holy Trinity. The growing reverence for church buildings and a romantic neo-medievalism was reflected in the Gothic style of the new galleries, pulpit and reading desk, which invited 'the devout attention of those who come under that sacred roof to seek instruction in the ways of piety and peace'. Helmore pursued a distinguished musical career. He founded the Motet Society, which did much to revive interest in older forms of Church music, including plainsong. His best-known setting is 'O come, O come, Emanuel'.

On 16 August 1841, Dr Davenport died at the age of ninety-two. He had been vicar of Stratford for fifty-four years, and of neighbouring Weston for sixty-seven. His career stretched back to the days of a confident Anglican ascendancy and he had striven to slow its passing. Through his very longevity he had become an institution and many must have felt that his death marked the end of an age. Virtually every inhabitant paid his respects as the cortège passed and business ceased for the day.

Religious revivalism brought a number of odd sects in its wake. One had Stratford roots. The Catholic Apostolic church numbered one Taplin among its chief adherents. This humble Stratford shoemaker nominated the twelve new apostles who would usher in the Second Coming.

A missionary for a new religious view from further afield appeared in 1843. Elder James White, a Mormon, hired Brandis's Assembly Rroom for a meeting, but only raised 2d at the collection. After this he lectured the handful ready to listen at a labourer's house in Wood Street. On a cold February day, he baptised three converts in the Avon. A curious crowd followed these frozen and sodden 'poor ducks of delusion' through the town. One developed a severe illness. Elder White was stoned by a hostile mob and escorted out of town by the police. 'Oh, *Sheam*, hide your faces in Disgrace, blush for humanity', he wrote in an outraged letter, adding justly, if idiosyncratically, 'you have brought a Disgrace on your Town and on the *Authoritys* of the same, boast no more of your liberty in *worshiping* God according to the dictates of your *Conscianc*.'

'The Bitter Pangs of Hunger'

In 1837, a trade recession combined with agricultural depression ensured the re-emergence of the wild talk and action of the 1820s. This was a situation aggravated by the Poor Law

Amendment Act of 1834, which severely curtailed outdoor relief for the able-bodied and gave the underemployed the choice between destitution and the workhouse. The need for more spacious premises thus engendered led the 'union' to move to a new site in Arden Street where those unable to support themselves lived under a regime of increasing severity. A Stratfordian signing himself 'A LOVE OF JUSTICE' wrote an open letter to local farmers in 1838, appealing to them to increase wages to a level which would keep their labourers out of the workhouse and enable them to fight 'the bitter pangs of hunger'. The first sentence reveals the religious basis of contemporary radicalism with a quotation from St James. 'Behold the hire of the labourers who have reaped your fields, which you have kept back by fraud, crieth: and the cries of them which have reaped are entered into the ears of the Lord of Sabaoth.'

A letter from an agricultural labourer to the chairman of the Stratford Union makes the same point with desperate articulacy, describing 'the prospect of our being overwhelmed in the vortex of poverty, hunger and destitution, at this inclement season of the year, in consequence of the high price of provision combined with low wages and being thrown upon our own resources by the Poor Law Amendment Act.'

> We are styled Able-Bodied Labourers, but the words are a libel upon our constitutions; if we could procure the common necessities of life the epithet would be applicable; but when hunger can only be satisfied by the indigenous roots, the body becomes unceasingly enervated by the bitter pangs of hunger – consequently, it no longer leaves us strength our labourer's servitude requires. Is nine shillings a week sufficient to maintain a labourer, his wife and three children? … it gives to each respective part of the family one penny per meal, and three pence extra in the whole. Now, Sir, let any individual go and lay out his money in the provision market, then picture to yourself, what has he gotten to sustain life. This takes the whole income! If we are to spend the whole in this luxurious manner, where is the rent to come from? Where the firing? Where the clothing? Not from the Board, I presume.

A problem created by the Act was its idiosyncratic local operation. Another correspondent to the chairman of the Union radically invoked religion.

> It behoves you to enquire minutely of each respective Guardian whether each able-bodied labourer is in constant work, and if not to render him some little assistance. His demand and right of a living out of the soil is as great as that of the most potent aristocrat in the realm. That BEING who has caused such a fecundity in the human species has likewise produced every requisite for the sustenance of the labourer, but which is unfortunately withheld by man's inhumanity to man.

Others took a more sanguine view of the plight of the poor. A characteristic Victorian institution made its first local appearance in 1837. In a lecture at the Town Hall, Mr Chapman of Birmingham explained 'the object, means and success of Temperence Societies.' 'O! my friends', he told his audience, if I could but persuade all my working friends to learn and keep sober, then I should live in hopes of seeing you better off; but as long as you swallow the intoxicating drink, so long you will be subject to poverty, and all that can be done to relieve you of your present degraded situation will be in vain.'

In 1843, the Total Abstinence Society was formed with six members. In the first year, membership rose to nearly ninety. The movement attracted by its showmanship, commemorating its first anniversary with a grand procession headed by the Rechabite Band from Redditch, followed by the banners of militant abstinence. At a mass meeting in the evening, thirty-two people took the pledge.

The *sequela* of abject impoverishment was again desperation. Incendiarists' fires smouldered anew. The most mysterious was at Radbrook House, the property of Mr Ralph Smith, in an enclave of Gloucestershire bordering Old Stratford. On the morning of 29 October 1841, a boy at work saw a man running from the yard. Soon after, a fire occurred in a cowshed, which was soon brought under control. Mr Smith and some of his neighbours galloped off in search of the suspicious character, but found no trace of him. That afternoon, a fire broke out in a barn and raged with great fury. After the bell of the Guild Chapel rang the alarm, the Stratford fire engine was heaved up the Shipston Road to play ineffectually on the flames. Hundreds poured out from Stratford to assist, or to watch the spectacle. After great destruction, the fire was suppressed. Such was the sensation that scores of people remained there all night. They were not disappointed. Next morning, another fire broke out in a calf-pen. The engines were again sent for, but no sooner was this fire extinguished than smoke was seen pouring from an oat-rick which could not be saved. That evening, a clover-rick started burning, and an hour later a large heap of straw burst into flames, destroying a nearby copse. On Saturday afternoon, the engines arrived too late to prevent the stables from being reduced to ashes. On the Sunday, an engine arrived from the Birmingham Fire Office to play on the smouldering debris. 'The highest praise' was accorded those Stratfordians who had fought each outbreak.

The episode struck great terror across the neighbourhood. The perpetrator clearly possessed good local knowledge, but it was felt that the ability to use combustibles so skilfully would be beyond the capacity of a common labourer. All the servants had been in Mr Smith's employment for lengthy periods and they were completely trusted. Mr Smith was neither a magistrate nor a guardian and was not involved in politics. Indeed he enjoyed local esteem.

The mystery deepened two weeks later. The Birmingham fire engine, which had remained in case of further outbreaks, was finally ordered home. Within hours of its departure, two ricks were destroyed. A large body of police was left to guard the farm-buildings, yet next morning, flames billowed from the house itself, which would have been burnt to the ground but for the efforts of the fire-fighters. Four servants were arrested and questioned, but were released for lack of evidence. Panic spread and it was perhaps inevitable that rumour identified Mr Smith himself as the incendiarist. The rumours were officially denied, but produced lamentable effects. Mr Smith was confined to his house at Clifford and dared not return to Radbrook. His brother at Barford was driven insane by the reports and had to be placed under constraint. The Radbrook mystery was never solved. It provided several weeks of local sensation and gave force to the argument of those who considered that when men were driven to desperation, they would seek desperate remedies.

The foundation of a public welfare system and the means to withstand the worst deprivations of poverty came with the formation of medical and benefit clubs. In 1843, a penny club was established, which provided 122 poor children with an annual 9s worth of clothing. The

Medical Club covered over 2,500 local people against the 'overwhelming embarrassments' caused by sickness. Those of better means made up the shortfall by supporting an annual charity ball, which also supported the Victoria and Becher Benefit clubs. The 'Victoria' paid a shilling benefit for each weekly halfpenny collected. The low subscription suited the lowest paid, those with large families and the elderly. Better-off workers could insure through the 'Becher', for an annuity in old age, or for death, sickness or accident. The 'Victoria' had 372 members, the 'Becher', 206. Every year, they held a full cathedral service at Holy Trinity. Then, a procession proceeded by bands and headed by the clergy and local gentry paraded through the town to a tea at the Town Hall.

'Taylor's Boot Jack'

During 1842, Stratfordians were outraged and amused by the revival of an ancient form of punishment. The magistrates sentenced a man to sit in the stocks in Bridge Street for being drunk and disorderly. When asked what he thought about it by a passer-by, he replied: 'I beamt the first man as ever were in the stocks, so I don't care a fardin about it' – a sentiment expressed by his townsman two and half centuries before in *Richard II*: 'like silly beggars, / Who, sitting in the stocks refuge their shame / That many others must sit there'. Two weeks later, three fellows suffered similarly for the same offence, which led to protests against this 'barbarous exhibition'. As a result, a concession was made to liberal opinion. When the wind was in the north, offenders were placed under the Town Hall. Next May, 'a lady' from Knowle was set in the stocks for having been, as the local expression had it, 'disguised in liquor'. A year later, a well-known character, John Cowley, endured the stocks for six hours for persistent drunkenness on the Sabbath. The propensity to tipple ran through his family. His mother and brother had 'the habit of getting more than would allow of their keeping an upright position'. He told the beaks that he could not be certain whether he would be able to resist the allure of a jug of ale in the future. His caution was justified. Six weeks later, he was sentenced to the House of Correction. His spell in what he called 'Taylor's boot-jack', after the police superintendent, had no reformatory effect. The stocks continued in sporadic use until 19 July 1865, when they claimed their last victim for the usual cause of drunkenness.

'A Most Unmanly and Unfeeling Spirit'

Despite local regression to more primitive forms of punishment, social legislation was becoming more intercessory as government was seen increasingly as a means to redress the moral balance. An Act of Parliament enabled Margaret Morris to emerge from the shadows of history and represent a Victorian type, the seduced and abandoned woman. This respectable-looking young woman was a housemaid with the Revd Mr Parker, who ran a small private school in Ely Street. She fell in love with the assistant teacher, Orlando Cooper, who also lived at the school. He paid her great attention and repeatedly promised to marry her. In what was

described as 'an unguarded moment', he took advantage of 'her attachment and confidence'. Someone told on the lovers and when Mr Parker discovered Cooper in the girl's bedroom, he dismissed them both. After Margaret revealed that she was pregnant, Cooper deserted her. Fortunately she came from a loving family and her parents stood by her. On 19 October 1844, she gave birth to a girl.

There was some redress available to Margaret. The recent Act enabled her to bring what was bluntly called a 'Bastardy' suit, which was heard on 22 November. The nature of the case and the fact that it was the first of its kind ensured that the courtroom was overflowing. Margaret's unpleasant and trying situation touched the pity of all except the defendant, who, 'as if lost to all sense of shame and decency, endeavoured, in a very improper manner, to annoy his unfortunate victim'. His conduct brought a timely rebuke from the magistrate. Cooper's lawyer attempted to denigrate Margaret's character, causing her much distress. The line of questioning appeared to have been suggested by 'a most unmanly and unfeeling spirit' on the part of her seducer, who was much amused by its effects. After a short consultation, the bench made its first maintenance order: 4s a week for the first six weeks from confinement, and 2s per week thereafter.

Despite the gallant feelings aroused by such a case, there was little practical protection for women in service. A young governess disciplined one of her charges by sending her to her room. When the parents returned, she told them what had happened. She was subjected to a volley of abuse and thrust out of the house by the master at 9.30 p.m. with no means to find lodgings. She was taken in by a lawyer, who obtained the small amount of money due to her next day. The correspondent of the *Warwick Advertiser* was disgusted by the affair. 'That a young lady, respectably, and we should not be going too far in saying, highly connected, should be driven forth, at a moment's notice, without a shelter for the night! Such cases as these, we trust, are few, for the credit-sake of masters and mistresses.'

'Happy as May Be'

The earliest descriptions of the Mop date from this era. One year tended to be much like another, with imperceptible changes occurring through fashion or improved technology. The earliest roundabouts for example, were manually propelled mainly by young lads. Later, animal labour gradually succeeded this system.

The most likely explanation for the use of the word 'Mop' comes with the first recorded reference to the tradition that those plying for hire wore the symbols of their work in their lapels – a tuft of wool for a shepherd, a knot of horsehair for a groom, a tassel of straw for a thatcher and a tuft of *mop* fabric for a maidservant. Although it has been suggested that mop was a collective name for all the emblematic tufts. Once hiring had taken place, the work symbol was replaced by a blue ribbon.

Country people appeared at the Mop in their traditional dress of smock-frocks, 'elaborately embroidered and ingeniously worked'. Thoughts of poverty and recession receded as those who had found employment found a rare opportunity for uninhibited pleasure. A correspondent to the *Warwick Advertiser* in the 1830s noted a young country lad and his

sweetheart. 'He does not mean to be stingy today – he will treat his lass and buy her a new gown into the bargain. It's a treat to see how they go rolling along, he holds up his elbow and off they go as happy as may be.'

In front of the inns there were ox and pig roasts. For many years, the expert roaster, Billy Ball, had his pitch outside the Garrick. 'Armed with knife and fork and steel, to carve roast beef for the public weal, he stands in front of the steaming carcase, fencing at the fire, radiant with the heat thereof, and brilliant in his blue attire; while his faithful help-meat takes all the money and counts out the change.'

For those who preferred daintier meals, there were stalls selling gingerbread and Banbury cakes, presided over by 'decidedly unclean and untidy persons'. Questionable looking fish was on sale at a ½*d* a slice. 'As an additional inducement to buy, on the top of each piece was a pickled onion, attractively displayed, and few persons could resist the bait…'

The players of the Jennings Theatre would parade around the town in their costumes and perform broadsword combats to attract audiences to their performances. The plays were 'naturally short and of a very sensational kind'. The Rother Market was filled with amazing shows, featuring such novelties as 'the wonderful pig, the cunning pony, the fat girl, the giant, the dwarf, serpents, crocodiles, monsters of the deep and a host of peep shows'. A correspondent to the *Warwick Advertiser* fondly recalled the ladies of 'Holloway's Acting Show' in the 1840s, with

their red cheeks and spangled dresses, and the men too in their grotesque attire. First a dance, then some fun, then a general shouting from the footlights, the clown taking his stand, whip in hand, at the top of the steps: 'Now gentlemen! Forward! Forward! Forward! Remember this is positively the last night of the sublime tragedy of *Blue Beard* in five acts, concluding with the screaming farce of *A Frog in Consumption on the top of a Hay Stack*, never before performed before a British public! Forward gentlemen! Forward!' (a crack of the whip). 'Stand away there, you little boys, let the ladies pass. If any young lady is wanting a beau, let her pull out her threepence and come to see Hollaway's show. Most select company within. We are now going to commence. Be in time! Be in time! The star actors are just going in. Forward, I say! This way to the preserved seats'. (Exit Blue Beard attended by wives, clowns, pantaloons and attendants.)

I know not how they got on with the tragedy, but should fancy that the audience wanted more of the farce, as all the players were on stage again in about twenty minutes, when the clown, Charley Marsh (then a very celebrated one), gave a speech on 'Cock Robin'.

'A Spick and Span New Villa'

A Spick and Span New Villa, standing in its own grounds.

Critic of the restored Birthplace, *c.* 1850.

Railway Mania

Less than two decades after the canal and horse-railroad had placed Stratford at the hub of a communications network, the town was again becoming a backwater. Steam was the threat. The great trunk railway lines had swept away the coaching and posting traffic. Attitudes to travel were changing rapidly. 'Nobody', it was said, 'cared to settle in a town that could not be got out of, even for a day, without considerable difficulty and inconvenience.'

Railway fever was in the air. In the closing weeks of 1845, the press was filled with flotations of railway shares. Several schemes were proposed for Stratford and the timescale for applications was short. On the last weekend in November, representatives of the companies rushed into the town to deposit notice of Parliamentary Enabling Bills with the clerk of the peace. All the post horses in the area were requisitioned, and the rattle of carriages continued into the night. During 1846, enabling legislation was obtained by the Oxford, Worcester and Wolverhampton Company for a link at Honeybourne, but progress was minimal.

Improving energy was beginning to affect other aspects of town life. After a promising start, the Royal Shakespearean Theatre had languished. With the growth of the adult education movement, it was converted in 1844 for secular enlightenment. The stage and pit were removed, the decorations obliterated and the building converted into one large hall. Only the boxes and gallery remained to show the original purpose. Classrooms and a kitchen were constructed in the basement and the building was formally reopened with a formal reading by Charles Kemble.

'The Royal Shakespearean Rooms' never had much vitality, one critic regarding it as a place where 'niggers and serenaders, itinerant lecturers and travelling showmen display themselves'. Later, the rooms housed the county court and became 'the area for forensic displays equal in grotesqueness to anything produced upon the mimic stage'.

'A Fanciful Composition'

The urge for improvement soon extended to the Birthplace. We get a last glimpse of Mrs Court maintaining its traditions when an American visitor got her to lay down a mattress, so that he

could sleep in the birth room. In 1846, she died and the property was put up for auction. Wild rumours circulated. It was said that the American showman, Phineus T. Barnum, wanted to transport it, brick by brick, to Philadelphia. As long as the Birthplace had remained a ramshackle but available shrine, concern about its status had not been profound. The moment an interloper tried to secure it, national pride was at stake. A Shakespeare's Birthplace Committee was formed in 1847, and soon enjoyed the patronage of the Queen and Prince Albert. Many and various were its fundraising activities. Jenny Lind sang and Charles Dickens organised theatricals. In Islington, Sarah Martineau, the daughter of a high-minded and philanthropic Unitarian family, and a friend, agreed that the one raising the most money would 'have the honour of sending it to Charles Dickens with a letter which we hoped would provoke a reply'. It did. Sarah's future was more closely bound with Stratford than she realised. In 1852, she married the brewery heir, Charles Flower.

The first act of the committee was to buy four cottages on the western side of the Birthplace, which gave them possession of part of John Shakespeare's old property. The sale of the rest occurred in London on 16 September 1847, amid scenes of great excitement, marred only by the temerity of a mustachioed American, who called upon the auctioneer to prove that Shakespeare had been born there. Such presumption was dismissed as an attempt to soften the market for his own bid. If so, it failed, for the house was eventually knocked down to the United Committees of Stratford and London for £3,000.

Now that possession of this considerable block of property had been achieved, the committee had to decide what to do with it. One engaging suggestion was that it should be converted into an almshouse for 'decayed dramatists of approved character'. A local architect, Alderman Edward Gibbs, was appointed and recommended that the western half of the building should house a small museum where all that could legitimately connected with Shakespeare could be collected. The former Swan and Maidenhead presented greater problems. It was resolved to restore the frontage, but no one knew how this decaying pile of bricks had appeared in Shakespeare's day. Folk-memories that a large gable had once existed were confirmed by a sketch made eight decades before. In the absence of anything better, the building was 'restored' to conform to that impression. The original massive beams interfered with the architect's 'fanciful composition', so they were pulled down. It was agreed Shakespeare's house must stand alone, so those of his neighbours were demolished. The Age decreed a picturesque garden, so down came the barns, outhouses, piggeries and brewhouse, reminders of the working life which was the property's *raison d'etre*.

The restored Birthplace was described by a critic as 'a spick and span new Villa, standing in its own grounds'. The flow of visitors was undiminished by the new order: 2,207 crossed the narrow threshold in 1851, including 444 Americans.

'About the best Beer brewed in England'

At first, Edward Flower's brewery did not thrive, paying little more than the household expenses. The Flowers often talked of emigrating and would have gone to Australia had the sale of the business paid their fares and left them with £500 when they landed. Charles

Edward Flower, born in 1830, was compelled to leave school and go into the business when he was fifteen. He began at the copper side under his father's direction, 'but as we only brewed about 82 quarters about three times a week, I had plenty of time for office work and kept the Cash and Cask books and frequently did some of the travelling.' In 1846, he was left in charge of the workforce of seven while his father was in America. The price of barley kept rising so the brewers had a meeting and agreed to raise the price of ale. 'I was very glad of the rise at the time as I knew we were losing money, but it was a very bad step and injured the trade and we soon had to come down again to the old prices.' In hot weather, the brew was in the early hours, 'for then it took longer to get through an eight quarter brewing with the old plant than it did to get through any quantity after better refrigerators were invented'.

Yet Edward Flower was a man 'gifted with the personal qualities necessary for the enterprise'. He would be cited as an exemplar of 'self-help' by its proponent, Samuel Smiles. The 'hungry forties' over, the family discovered the truth of Dr Johnson's dictum that their chosen trade could make a man as rich as Croesus. In 1852, the brewery was rebuilt on three times its former scale. Technical innovation (Flowers was the first brewery to introduce coolers) helped produce what *Punch* described as 'about the best beer brewed in England'. A dominance of the local trade was established by steady purchase, although houses like the Queen's Head, Oddfellows and Windmill long maintained their independence and home brews.

'This manly Game'

We get a first glimpse of the Victorian obsession with organised games with the formation of Stratford Cricket Club, which played twice a week during the summer of 1847 on a meadow at Shottery. The members made good progress at 'this manly game, which at this time is so popular'.

Cricket's appeal was enhanced by the quasi-religious fervour with which Englishmen invested it, enabling even sternly sabbatarian evangelicals to regard it as a worthwhile Sunday activity. Long were the hours of the worker – particularly the shop assistants, who were on duty from early in the morning till late at night – and their one day of leisure was inhibited by restriction. Some movement towards shorter working hours was tentatively commencing. The town's solicitors began closing their offices at two on Saturdays, 'to afford their clerks an opportunity for recreation and mental improvement'. This began a 'half day' movement for all workers. It was a great boon for the hard-pressed shop assistants when the town's drapers agreed to close at 7 p.m. (excepting Saturdays) during the winter months. It was generally felt that the grocers might be encouraged to follow this sound example.

'The Problems of the Centuries'

In 1897, an old man recalled the state of Stratford before its metamorphosis by Victorian energy. Its streets were

a mass of rubbish, scarcely paved even in the High Street. The scavenging in those days was done by two old men – Jim Wright who lived in Scholar's-lane, and Billy Ball, who was three parts of his time in the workhouse. One cart and one horse did the work of the whole borough. There were no underground sewers. The drains discharged at any low spot … They were left open to pollute the neighbourhood, till they were cleaned out once in two or three years.

In 1848, the borough council began to tackle the problems of the centuries. A growing concern for public health was fuelled by a national cholera epidemic. The means to improvement soon existed in the Public Health Act. There were two ways to secure its application, the petition of one tenth of the inhabitants, or a mortality rate exceeding 23 per 1,000. The energy of the borough surgeon, Dr Thomson, in compiling statistics for the period 1841–47, demonstrated that the rate exceeded this level. Jerry-built slums had grown up beyond the Guild Pits in the 1820s. If these contiguous areas outside the borough were included, as the Act demanded, the mean annual death rate reached 23.47 per 1,000, higher than almost any other similar-sized town in England.

Something had to be done. In October, a large public meeting unanimously demanded a public enquiry by the General Board of Health. The inspector appointed, George Thomas Clark, made his first visit in December. His report, published in May 1849, is a remarkable document, revealing the Augean deposits accumulated through generations of ignorance, malpractice and neglect. He had met no previous case where the 'connexion between damp and dirt, and sickness and increased expenditure has been more clearly established'.

One of 'the filthiest and least healthy quarters' was the Guild Pits. Many were the complaints about the offensive muck pits and piggeries lining its town side. Behind were badly drained, crowded courts with flooded cellars, whose privies leaked into open cesspools, into which refuse was thrown. Water poured down to flood the road and the residents complained that meat would not keep. The slums on the other side abounded in nuisances. Shakespeare Street and Victoria Terrace had the highest rate of zymotic disease in the town, clearly linked to the damp and filth abounding there.

There was no house drainage in the town and few water closets. The cesspools were emptied by purchasers of the manure, who mixed it with lime and carted it onto the land. Water was supplied by pumps and rain-butts as pump-water was considered too hard for washing. Those living near the canal used its water, which, although very dirty, was softer than that from the river, which was little used.

In wet weather, the unmetalled roads were deep in mud and scarcely passable for vehicles. Each householder paved as he chose in front of his house. Many favoured a cheap flagstone, which split easily, forming muddy puddles. Seventy pounds a year was paid to clean up after the markets, but the side streets were not cleaned at all. A small section of the streets was inadequately watered in summer. The town was badly lit. Because the gas company charged exorbitant prices, the few street lamps were lit for limited periods and gas was rare in private households. The inspector expressed his regret that the Act did not enable the Board of Health to establish its own gasworks.

Public nuisances were depressingly numerous. The seven slaughterhouses were inadequately drained and surrounded by discarded blood and offal. Eight annual fairs

polluted the streets with the excrement of a thousand livestock. The graveyards were in a terrible state. The Independents placed their dead in vaults at the chapel – 'a most injurious practice'. Most burials were in the cramped parish churchyard. The vicar considered that in a severe epidemic it would be difficult to find plots without encroaching on new graves.

The inspector's proposals were no less important for their predictability. Cattle-fairs should be held on the outskirts of the town and a cemetery established. Nuisances should be removed and a decent water supply provided – although a source was not suggested – together with proper sewers and drains. The cost of full implementation was estimated at a $9d$ to $1s$ rate to pay off capital borrowing over thirty years, which could be set against the reduction in outdoor relief resulting from the improvement in public health.

An early start was made in implementing the report. The Board of Guardians appointed an Inspector of Nuisances, John Tasker, who worked assiduously to reduce pollution. He was handicapped by his restricted powers, but it was gratifying that, since attention had been focused on matters sanitary, many nuisances had been spontaneously removed. Concern increased in September when another cholera epidemic swept the nation, producing an isolated case in Stratford. The authorities took their usual precautions, but the vicar took a more transcendental path, declaring 3 October to be a day of general humiliation and prayer. Shops closed and business ceased for the day. At a packed service in Holy Trinity, he took his text from the psalmist: 'For thou dost deliver a humble people; but the haughty eyes thou dost bring down.' Nor did the Dissenting churches allow 'this terrible affliction from the Omnipotent' to pass unregarded.

The report became a local political issue. Although Stratford was one of the first boroughs to request the application of the Act, its name was inadvertently omitted from the enabling statute, leaving any action to local initiative. There were strong differences between those who wanted full implementation and the 'Economists', who were cautious about expenditure. The parties coalesced around public houses: the Falcon Party, of which Edward Flower was a prominent member, was broadly in favour of increased spending, while the Seven Stars, popularly known as the 'Star Chamber', supported the Economists.

Some volition evaporated from the cause of sound drainage with the end of the cholera scare. On 15 November, a Day of Thanksgiving was 'religiously' observed. Places of worship were full to overflowing, all business was suspended and 'the gratitude of the public to the Almighty for the removal of the pestilence of the cholera from amongst us was shown in a most devout manner'.

Memories were short. Greater sanitary consciousness and the flow of cheaper food after the repeal of the Corn Laws led to a sharp fall in the death rate. The *Warwick Advertiser*, which, in the previous year, had been vociferous in its support for public works, implied that such a programme was now unnecessary, but swung back in favour after a torrential cloudburst proved the existing system inadequate. In Rother Street, over 3,000 gallons of water poured into the cellars of the Fleece, floating all the barrels and causing great damage.

In 1850, a local Board of Health was established, dominated by a progressive majority. After a surveyor from London was appointed in October to undertake an initial survey, the *Advertiser* changed its tune again. 'There are few persons in the town who do not cry out against the fallaciousness of this measure…' That week a group of sappers and miners began

to survey the lines of drains and sewers. They used the tower of the Guild Chapel as a vantage point, erecting a large tent on top to protect them from the weather, much to the wonder of the older inhabitants, who mused on the theme of, 'They will never let our old things be.'

In spite of sniping criticism, the Board followed an energetic path, ordering the registration of common lodging houses and slaughterhouses. Edward Gibbs, the architect of the Birthplace, was appointed as the first borough surveyor, and also as inspector of nuisances. After the borough rate rose to 1s in the £1, a member of the Board, Mr Tombs, presented it with a petition signed by 290 of the 400 ratepayers, demanding the repudiation of the Act. It was rejected by Dr Thomson, the chairman, who stated that the Board had been established at the request of the inhabitants and could not reject its own function. Charles Lucy had the last word and expressed a fine spirit of disinterested philanthropy. 'I shall participate in none of the advantages, but it will be for the benefit of the poor. I shall advocate it.' At the same meeting, the Board extended its powers to town planning, granting permission to build six cottages in College Lane after the Surveyor stated that the plans accorded with the Act.

The Economists called a public meeting on the issue a week later. This time Dr Thomson was uninhibited by the constraints of chairmanship. In recent years, 133 people had died because of the town's insanitary state. 'It appears to me that this is the light in which to look at the question before us – and as it costs a great deal of money in consequence of mortality being so high amongst a class of people who could not help themselves – are these poor creatures to be allowed to die because the remedy is attended with some expense?' The Economists had been elected on a programme of retrenchment. 'What was the first expense they incurred, an expense never before contracted – why to vote £40 towards the Hunt Ball! Who was the proposer of this outlay? Why the financial reformer, Mr Tombs.'

Dr Thomson's scathing remarks ensured that the motion was lost overwhelmingly. Opponents of the scheme maintained their campaign, but the reformers were not to be deflected. In February 1852, Edward Gibbs produced his plans for drainage works at an estimated cost of £6,528. The Board turned its energies to paving stones, selecting blue weather as the most suitable and seeking Counsel's opinion on its power to enforce adequate paving. Two months later, it was vetting plans to lay out Bull Street and College Street. The Economists were driven into a flurry of fury in the following year, when plans for water to be piped from a reservoir were drawn up to be paid for by a general rate of 9s 2d.

The last pipe of the sewage scheme was laid on 26 February 1859. It completed 6½ miles of sewers and fifty-one ventilators. Outsiders began to comment favourably on the town. The *Atheneum* reported that the streets had been made 'to gleam so bright and smell so sweet'. The writer had not wandered far. Most streets remained unpaved. The new sanitation was barely adequate. Wretched housing would remain the lot for many and there would be no cemetery for thirty years. Yet the Board's achievements were great. It had transformed Stratford in a decade, setting expectations that changed the face of local government.

'The Great Catholic Truths'

In 1848, the Revd Henry Harding, who was born at Baraset House at Alveston, became vicar. As a priest in Staffordshire, he was the first in the area 'to take up and explain the great Catholic truths which had been revived a few years before'. At Stratford he found ample scope for such revival. 'Church life was at its lowest ebb. In those days the Blessed Sacrament was celebrated only four times a year.' Almost immediately, he introduced daily services.

One problem he inherited was that of church rates, which had not been collected since Mr Greves' clever prevarication. The churchwardens took the issue to the consistory court and obtained judgement that Greves and the others were not exempt from payment. On 19 January 1849, Mr Chattaway, one of the churchwardens, called on Greves and suggested that he attend the Parish Vestry that evening. At a thinly-attended meeting, it was resolved to enforce payment and costs. Afterwards the churchwardens told Greves that they had no desire to injure him, intimating that they merely wanted him to acknowledge the validity of the rate. This he did at the next vestry, while maintaining his personal opposition to the principle. Nevertheless, Mr Lane, the legal adviser to the parish, recommended that proceedings must be taken or any future rate could be declared invalid. Given the labyrinth of ecclesiastical law, it was a mistake. Greves won an appeal in the Court of Arches on the grounds that he had never been charged with contempt. In victory, he mocked the churchwardens: 'as to enforcing this pettifogging judgment thay make so much fuss about, they cannot do it, they may just as well try to make a railway from this celebrated place to Canton, or the top of the Andes, - Really this petty, insignificant impotency of these barking poodles is to be pitied and not feared by me.' Yet the action against him, in the perverse spirit of contemporary justice, had enabled the imposition of another rate.

The next incumbent, the Revd George Granville, took a conciliatory line, expressing his own opposition to church rates, while insisting that it was the duty of the churchwardens to collect them. This satisfied the honour of all parties and the rate continued to be collected until its abolition in 1868.

The sectarian spirit was nowhere more apparent than at a public meeting in November 1850, called to protest against 'The Papal Aggression', the restoration of the Roman Catholic hierarchy by Pope Pius IX. A Loyal Address condemned the 'Bishop of Rome' and considered that his actions had been encouraged by 'the many Romish errors, both in doctrine and practice that have been lately introduced by clergymen of the Church of England'. If allowed to continue, these would be 'productive of greater dangers to our Protestant faith than any interference of the Pope of Rome'. An amendment from the Dissenters deplored any attempt to restrict religious freedom. After many speeches, accompanied by factional groans and hisses, the original motion was carried.

The Nonconformist amendment was a tactical manoeuvre, aimed at Anglican supremacy. The seconder, the Baptist Minister Mr M. T. Bumpas, expressed his own views in a sermon on 'the best means of resisting the aggressions of Romanism'. Although there was no Roman Catholic church in Stratford at this time, there must have been strong feelings on the issue in the Baptist congregation. James Cox Jnr, son of the founder of the Payton Street chapel, had been received into the Catholic Faith a year before. This genial, liberal-minded man was to do much to enhance the reputation of his church.

Such altercations obscure the fact that this was the last epoch of general religious confidence before doubt and pluralism undermined the fabric of institutionalised devotions. This world on the brink of change is revealed in the 1851 census, when the numbers attending Sunday services were uniquely recorded. The method of assessment was vague and of variable accuracy, but if the techniques of analysis employed by Horace Mann, the National Enumerator, are followed, some indication of the state of religion in contemporary Stratford is obtained.

The four Dissenting denominations in town provided seats for 1,748 worshippers in seven chapels. Of these, 948 were free sittings. The Anglicans provided 2,113 seats in three places of worship, but only 648 were free. If the highest attendance in the workhouse chapel is added, which was hardly a voluntary congregation, there were 3,861 sittings available in all the churches of the town. The population of the borough and its contiguous areas was estimated at 5,000.

Mann reckoned that, excluding those under ten, the sick and those on essential work, 70 per cent of the population could attend a place of worship on any Sunday. In Stratford, this represented 3,500 people. Adding the 1,044 Dissenters who attended chapel to the 1,926 at Anglican worship and modestly estimating 40 Roman Catholics worshipping outside the town, there were 3,010 worshippers that Sunday. Mann conjectured that half the afternoon attendees had not been present in the morning and that a third of the evening congregation had not previously attended. In Stratford, this meant that estimated Sunday churchgoers constituted some 66 per cent of the population, as against Mann's estimated national average of 58 per cent.

By modern standards the total is very high, but the returns must have shocked local churchmen. Only 43 per cent of the active population attended the established church in a town that did not possess strong traditions of Dissent, and less than 60 per cent of all worshippers were Anglicans. A third of the townspeople had not entered any church that Sunday. If allowance were made for those who had not attended that Sunday but who would on other occasions, there was still a considerable number who never, or hardly ever, attended any church. Some may have been influenced by religion as children, through denominational education or Sunday schools, but now they were as remote from ecclesiastical observance as the exotic heathen in far-off lands of whom congregations heard tell at mission services. No one looking round the streets during service-time could doubt who constituted most of the absentees, those known as 'the submerged one tenth'. A poetic wit wrote of one of Stratford's worst slums, situated off Ely Street:

> The sound of the church-going bell,
> The Russell-court folks never heard
> Never sighed at the sound of a knell,
> Or smiled when the Sabbath appeared.

When people were asked why they did not go to church, they gave several reasons: the parish church was too far away, its services were too long and the free seats no good. Whether these reasons were authentic, or whether they provided excuses for those who had no intention of attending, was never considered. Land was purchased to build a church in the Guild Pits, where the population chiefly consisted of 'that class of person whom it is eminently desirable to draw

within the fold of the Church'. The project drew the fire of the Revd Alfred Dayman. 'Heresy and sin are busy at work here, as they have been for three generations past. The parsons have lately laid the stone of an opposition temple near us, the foundation of which seems, from the muddy state of the weather, to have been as slippery as that on which their prejudices are based'.

Dayman had been an Anglican curate at Wasperton until 1849, but had been obliged to resign because of Romish tendencies in his preaching. Now he was in Stratford as its newly-appointed Roman Catholic priest. A site for a church was acquired on the Warwick Road, but costs were too high for the little congregation, and for several years it was just used as a burial ground. In 1852, 'The Firs', a mansion in Rother Street, was converted into the chapel of Notre Dame de la Salette, in 'pious association' with the Alpine shrine, where, in 1846, two peasant children saw a vision of the Virgin. 'Boldly we see before us her banner', waxed Mr Dayman, 'who, terrible as an Army in array, has alone destroyed all heresies … so we fear nothing and hope all things'.

Such language provoked its reactions. *The Times* scathingly dismissed the mission as an 'impudent imposture'. At the consecration of the church of St James, in the Guild Pits in 1855, the preacher, the Revd P. Claughton, declared that there was 'even but a few yards from where we now meet, the so-called shrine of an idolatrous, because creature worship'.

The Catholic mission was not a success. Dayman's reckless controversialism provoked disunity amongst his congregation, who resented the trouble he caused with their Protestant neighbours. After a period of ill-health, he celebrated his last Mass in August 1857, consigned all the effects of the chapel, presbytery and school (for which he had largely personally paid) to auction and left town for good.

The sale aroused great curiosity. Fascination with this mysterious foreign religion filled even the most Protestant breast. Many of the applications to view came from local clergymen and from 'the principal families and tradesmen of the town'. There were many bargains to be had at the auction. An iron tabernacle realised 2½ guineas. A life-sized statue of the Blessed Virgin, brought from Marseilles, and valued at £40, was bought for 40s. The large oil painting of the crucifixion, on panels in a gilt frame, said to be by Albrecht Durer and valued at 300 guineas, was knocked down for £14 10s. An Alexandre harmonium with twelve stops went for £17 after spirited bidding. Many beautifully carved crucifixes and statues were disposed of at well below their original price. The pulpit and hangings fetched a mere 13s. The local Catholics, abandoned by Mr Dayman, with neither priest nor chapel, invested heavily in the richly embroidered vestments, indulging in future hope.

Fierce partisanship was not restricted to the denominations. It characterised relations between the parties of the Church of England. The clergy of 'High' Holy Trinity shunned services for the evangelical Church Missionary Society at the 'Low' Guild Chapel. Low churchmen were shocked by the increasing ritualism at the parish church, which was beautified by the eminent architect, William Butterfield, in 1854. At the service of reconsecration, Sarah Flower was amazed by the changes: 'A procession of white surpliced choristers came in and took their seats each side under the tower – the pulpit having been removed to the side … Mr Twells, the sub-vicar, intoned the service and in a sermon explained the use of the alterations, saying they were as far as ever from the Romish Church'. Such modest innovations as candles, flowers and a cross were condemned by the archidiaconal visititation in 1860. Those who tried to break the droning monotony of the services met similar disapproval. The Revd Julian

Young, Vicar of Ilmington, was celebrated locally for his dramatic reading of the lessons, but Sarah Flower recorded that at Holy Trinity, 'all the people thought him quite sacrilegious to be so dramatic'.

The religiosity and order of contemporary bourgeois life is described by Alice Diehl, who, as a young girl was invited to stay with her godmother at Alveston. 'I was eager to go. My godmother, Miss Marks, was enshrined in my memory as the image of some holy, beautiful woman-saint in a niche. To be with her, to breathe the air she breathed, to hear her speak, it seemed too good to be true.'

Miss Marks lived at Alveston Cottage with Miss Holbeach, 'an upright, vigorous, handsome old lady, who wore very high caps'. The house consisted of old people. Butler, housekeeper, maid, as well as coachmen had grown grey in the service of their respected mistress. 'You and I are the only young people in the house', said Alice one day to the second housemaid as she was brushing her hair. The next day she was told 'not to talk to Ann'. The house was

all rule – rigid rule. The change from the absolute freedom allowed by my grandfather was tremendous. I was literally then, a wild weed, unkempt... At Alveston Cottage, everything moved like clockwork. The bell rang for prayers. Then came prayers. The bell rang for breakfast. Then came breakfast. Then my morning was parcelled out. So much piano practice, so much reading with my godmother, a quarter of an hour in the garden sandwiched in. Dressing for luncheon. Luncheon... at which there were consultations between the ladies as to the exact quantity I was to consume.

Alice wrote to her mother that Miss Marks was 'Betsy Trotwood ... to the life. And my mother had given permission to both ladies to read my letters before they were sent on!'

Shortly after her arrival, Alice's godmother began to give her religious instruction.

These hours in her own room, alone with her, were like fleeting visits to heaven. Seated in her chair amongst her exquisitely-arranged *impedimenta*, she spoke of God to me, with a light in her sweet, faded brown eyes which seemed to make her transparent features luminous. She spoke of law, order in life being dear to God: that we could not really love Him who loved us so dearly if we did not love what he loved. The words of such a fervent lover of God set me on fire with a longing to do right. I remember that a great revulsion of feeling ensued; instead of liking freedom and license, I conceived so intense a desire to live by rule that it has never really ceased since ... I wrote to my mother. 'When you used to call my god-mother *Saint Susanna* it was in jest, but you spoke the truth' (which letter was also inspected, as well as the 'Betsy Trotwood' one).

Such fervour linked childish pranks with Man's first disobedience.

Although I became obedient, heart and soul, to the noble woman who were trying to 'train me for God', as my godmother termed it, they tempted me more than they knew. I might walk in the kitchen garden. I might pick up windfalls in the orchard; but I must never eat of the forbidden fruit. There were raspberries in abundance, gooseberries, a most tempting bed of alpine strawberries, ripening pears and ruddy apples from the trees – but not for me! I stood that temptation. But when I was forbidden to touch a certain book which was being read aloud in the

evening – a book I longed to go on with – and was left alone in the drawing room with it in its place on the table while the old ladies were dining, I peeped – then read. Then I confessed and felt small and wretched.

Much of Alice's day was spent visiting the daughters of the local squirearchy. She conceived a 'violent admiration' for Augusta Woodmass, a girl of her own age who sat in front of her in Alveston's 'pretty, very ritualistic church.' 'She was slim, with a long graceful neck. Her round face had a warm colour on her cheeks – a colour which came and went as she spoke, when we were introduced afterwards by our elders. Quick, bright, slightly scornful dark eyes were her greatest attraction … Her father, a squire, had married the daughter of Lord Erskine and Mrs Woodmass was slowly dying of consumption'.

Alice never saw Mrs Woodmass. When she visited, Augusta presided at the table, seated opposite her father

with a dignity and self-possession strange in one so young. We became very intimate; for she was a girl who had thought, felt, read and reasoned upon what she had read as well as upon her own personal observations of men and things. I parted from her, after two months frequent companionship, with pain. We corresponded frequently afterwards. Two very touching letters I well remember. One recorded her mother's death. The other, a year later, was dated from either Torquay or Bournemouth. I knew she was ill and taken here and there according to the advice of various lung specialists, but that letter was a blow. 'I am dying', she wrote – her handwriting was still clear and firm. 'You will know that I don't mind – especially as I am allowed to receive Holy Communion. Fancy. What a privilege for anyone as young as I am!' Then, after much affectionate reference to our talks together, she ended with, 'Remember, when you hear that I am gone, I am quite happy to go.' Softened though the news was by herself in that unselfish consideration for others, which was one of the beautiful traits of a wonderful young creature, I felt her loss and missed her letters severely…

Overseas Perspectives

With the growth of Empire, Stratfordians were developing overseas perspectives. Australia was increasingly seen as a land of opportunity rather than a place of exile. As early as 1828, William Court, a relative of the Birthplace family, embarked upon this great adventure. Twenty-four years later, not realising that the Birthplace had been sold, he addressed a letter to a cousin there: 'You can tell the people of Stratford that if they wish to better their condition Australia is the place… there is not another country in the world like it. Doctors have little or nothing to do … There is plenty of employment of all sorts … and the man of fifty will do well.'

Concern for events overseas was used to raise interest in what were regarded as abuses at home. In 1850, meetings were held at the Town Hall on successive evenings on the subject of 'English and American Slavery'. The first introduced 'two men of colour'. Mr John Williams spoke of life on the cotton plantations and his escape from slavery and Mr Benjamin Benson, of the Narrangansett tribe, described the life of the American Indians, the means to evangelise

them, the destruction wrought amongst them by the 'fire waters' and the renunciation of strong drink. This last point set the scene for the theme on the following evening when members of the Stratford temperence Society spoke of 'English Slavery'.

Wild rejoicing greeted the news of victories in the Crimea, but the war also brought a sense of burden. The mayor called a meeting to support the Patriotic Fund, 'for the relief of the widows and orphans of those gallant soldiers, sailors and marines, who may fall while bravely fighting the battles of their country'. The ladies did their bit by forwarding large quantities of flannel shirts and other necessities. Dr Thomson invented a machine to lift invalids while their wounds were being dressed and their bedding changed. One was presented to Florence Nightingale's hospital at Scutari, from whence Lt William Flower, youngest son of the brewer, was invalided home after suffering severe frostbite. He later pursued a distinguished medical career, and was one of the founders of the Natural History Museum in South Kensington.

A letter received in Stratford said nothing of such horrors. 'The Russians have made several strong sorties', wrote Sgt H. Madew of the 97th Regiment, from his camp near Sebastapol in August 1855, 'but have been gallantly repulsed'. 'We are in so strong a position that no Army in the world could dislodge us; and we are creeping every day nearer and nearer to the town – we are that near we can hear the enemy conversing quite plain. Sometimes we amuse ourselves by throwing bottles loaded with powder, with a fuse inserted in the mouth, which causes great sport.' 'Our batteries', he added, 'are even now playing on the town.'

Days of humiliation and prayer marked the progress of the war. All business was suspended and services held in church and chapel, with collections for the wives of the soldiers and sailors, or 'to promote the religious welfare of our troops in the East'. In October 1857, a further Day of Humiliation remembered the victims of the Indian Mutiny.

During the 1850s, the traditional mayhem of 5 November became the occasion for patriotic fervour. In 1850, after the Papal Aggression, Pope Pius IX was burnt in effigy. In 1855, there was a grand procession, a firework display and the public burning of a 'stupendous dummy figure of the Great Russian Autocrat, Alexander the Second'. In 1857, the Indian Mutiny dominated the proceedings. A torchlight procession of boats floated down the Avon, accompanied by the town band and illuminated by coloured fires and the discharge of rockets, before a 'monster effigy of that Prince of Monsters, Nena Sahib', was burnt at the stake.

One whose service overseas was motivated by Christian dedication was the Revd Holloway Helmore, second son of the Independent minister. In 1839, aged nineteen, he was sent to Africa by the London Missionary Society. In 1857, he was feted as a hero during a brief return to Stratford, preaching to overflowing congregations at the Rother Street Chapel. At a public breakfast in his honour, he made a memorable speech. 'I know not where I am going. Having come back from the wilds of Africa, I can hardly give an opinion on such matters, but I assure my friends that when I return to Africa I will frequently look back to this pleasant meeting. I trust the recollection of it will enable me to do the work of my Redeemer with greater energy and zeal.'

He never saw Stratford again. In 1859, he was sent, at the request of Dr Livingstone, to establish a mission amongst the Makolo people on the Zambezi. His party traversed an arid and unexplored region for three desperate months. Helmore, his wife and two of their babies died, poisoned, according to one account, by the Makolo King. Their two surviving children were returned to Stratford.

Borough Police

Although dire poverty was the lot of many Stratfordians, a slow improvement in living standards was eliminating much of the sporadic lawlessness of earlier years. The last incendiarist, perhaps an arsonist rather than a rural revolutionary, was Charles Robinson. Aged twenty, he set fire to a haystack in Old Stratford in 1853. A former conviction being proved, he was sentenced to fifteen years transportation. The last local man to receive such a sentence was Joseph Randle, aged nineteen, of Billesley, who was transported for life in 1855 for raping Mary Lifley of Clifford Chambers at Stratford. Twenty years earlier, both offenders would have been hanged.

Despite the reduction in the crime rate, problems remained. Gangs of tramps walked into shops and stole goods, or threatened to break the windows unless they were given bread. The problem was increased by their clear desire to be sent to gaol, rather than the prescribed destination for vagrants, the workhouse. If sent there, they often refused to do their allotted tasks in the hope of gaining the security of a prison sentence, which, paradoxically, deterred the magistrates from giving them one. In 1853, George Breadfield, aged about sixty, was charged with begging in the streets with his wife. He said they were reduced through misfortune. He had seen better days and was not a professional beggar. He had been a ship's steward and had voyaged the world. Nevertheless, the mayor sentenced him to ten days in prison. His wife, having no home or means of support, asked to go with him. When this was refused, she thrust her fist through the window and gained her wish with six weeks hard labour.

Irish itinerants made seasonal appearances. At harvest-time in 1852, a small number employed by Mr Bruce of Tiddington slept in his hayloft. One night, one of the men asked for a light at the house, saying that his wife was ill. Soon after, he was heard at the pump. In the morning, he announced that his wife had given birth to a fine boy and he had 'well washed him'. The woman was given clothing for the child and next day was on the road with her baby in her arms, begging from passers-by.

'Gross and obnoxious acts of a gang of idle fellows' constituted a problem. They congregated on street corners, blocking the footpath and using 'gross and insolent' language, particularly offensive to ladies. After warnings from the police went unheeded, eight of them were taken to court, but the problem persisted.

Most notorious of the local rogues were the Wilkins brothers, George and William, who, between 1849 and 1860, acquired scores of convictions for poaching, drunkenness, vagrancy and other offences. In 1860, they appeared at the quarter sessions charged with larceny. The chairman said that Stratford was tired of them and imprisoned them for a year. By the standards of two decades before (or even of today), their sentences were very light. Before their appearance at the summer sessions, the Wilkins had amassed just twenty-five months imprisonment between them. Similarly, between 1850 and 1863, Philip Taylor was convicted of indecent exposure three times, indecent assault twice, assaulting his son, resisting the police and unlawful assault, yet his sentences totalled less than two years.

This more liberal approach was seen at the Michaelmas sessions in 1864, when George Haines, aged twenty-five, pleaded guilty to stealing a joint of beef. His career stretched back to less enlightened days. When 'I was only 13', he told the court, 'I was sentenced to 14 years

transportation for horse stealing at Gloucester.' He was transported to Gibraltar, but after 3½ years he was returned to England on parole. He lived at Emscote, where he joined the church choir. When work became scarce, he moved to Stratford. He was dismissed by his employer and from the choir at Charlecote church after a policemen called to ask if he was 'ticket-of-leave'. Driven to despair by police harassment, he stole the meat to feed his starving family. His story was confirmed by the Vicar of Emscote, who vouched for his good character. The deputy chairman said it was a great pity that the police had interfered and prevented him from continuing in honest employment. In consideration of the circumstances, including the fact that he had been in custody for two months, he would only sentence him to fourteen days. 'Let us hope that after his discharge he may meet with more encouragement to persevere in the better course of which he has shown himself capable and that he may no longer be unnecessarily hunted about by the police. We may reasonably call upon the Stratford Police to temper their zeal with discretion.'

In June 1856, the Revd Thomas Bumpus preached on 'the life and untimely of William Palmer', the notorious mass-murderer who had been hanged the week before at Stafford. Such mixing of sensation and morality had predictable results. The Baptist chapel was packed to overflowing and great numbers could not get in. For those who wanted a more direct experience of the supposed deterrent effects of capital punishment, public executions still took place at Warwick, although less often than before. Many Stratfordians travelled the eight miles to view these macabre spectacles, until they were abolished in 1863.

There was a growing recognition of the relationship between crime, poverty and a lack of spiritual vision. Great attention was paid by local philanthropists to the welfare of the navvies working on the drainage works. Since they were unwilling to attend church in their working clothes, the vicar held services for them in the Guild Hall. With the support of all the denominations, evening classes were established for the 'advancement, morally and spiritually of this town, but more especially of the band of navvies'. Forty adults were taught basic literacy and numeracy. At a tea party given by the Committee for the navvies and their wives at the Town Hall, the organiser, Henry Perrott, said it was his aim to start a permanent night school, where working men could receive 'such improvement, moral and spiritual, as may tend to raise their position in the social and religious scale.' The loquacious Thomas Bumpus spoke of the alienation of the working classes from the churches and proposed a strategy to overcome it.

> If we would approach the 'Sons of Toil' effectually upon religious subjects, we must let them see that we have a regard for the comforts of their everyday life … Winning them over to religious instruction will depend, not alone upon the efforts we may make for their present well-being, but upon the manner in which we approach them … There must be no patronising air, no ostentatious parade of our benevolence – no burdensome exactions of obligations and gratitude – nothing in our mode of serving them which should painfully provoke a sense of their inferiority … We must approach them in the spirit of Him, who, while he could hurl his censures at the proud and self-righteous Pharisees, with withering sincerity, was the impersonation of tenderness and compassion, and delicate condescension, when stooping to relieve the wants of the necessitous.

Bumpus moved from the particular situation of the navvies to a critique of his nation that represents the growing high-mindedness and confidence of the Victorian era.

> Such improvement of the great body of the people seems to be all that this country requires to crown her with a glory such as the world has never seen either in Pagan or Christian times. Her political constitution, though marred with the imperfections which attach to all things human, is probably the best that has ever existed; her legal tribunals are presided over by wisdom and righteousness; her seats of learning are unsurpassed; her literature is an almost boundless store of intellectual wealth; she rejoices in the possession of a pure and holy faith, and in the free utterance of all opinions; she has a Press which no home authority dares to shackle, no foreign power is able to intimidate or to bribe; her dominions are vast in all quarters of the globe; the hands of her sons are strong to labour, ingenious to invent, their hearts brave to dare; she has no fears of revolution within her shores, and can laugh at the menaces of all that look upon her from abroad with hearts full of envy and malice; and all that she wants, to make her glory and her grandeur complete, are godliness, righteousness and sobriety of life in greater measure among her people. Were these secured, then no man of intelligence, however melancholy and morbid his views, could regard her decay as possible.

15

'A New Era'

Far-seeing men are preparing for a new era in the annals of the ancient borough.

Stratford-upon-Avon Herald, 1861

'This Age of Progress'

Hopes of a local railway boom proved illusory. In 1852, the Stratford-upon-Avon Railway (SRC) was formed with capital of £100,000, but its scheme for a railway to Leamington through Charlecote collapsed through technical difficulties and the opposition of landowners. Stratford's other hope for a railway was also barren, the financial difficulties of the Oxford, Worcester and Wolverhampton Company (OW&WR) preventing the construction of a branch line. The company had taken over the horse tramway in 1847, six years later opening Stratford's first primitive passenger service in adapted trucks, which conveyed the moderately-reckless to mainline connections at Moreton. An account of this odd journey appeared in *London Society* in 1864. 'Attached to the carriage in front was a platform, on which the sagacious horse leaped to prevent being tripped up as we descended at a rattling good speed. The inspectors of the Board of Trade not having found this tramway, the occurrence, or non-occurrence, of accidents was left chiefly to the goodness of Providence.'

Down inclines, the guard applied his brake 'as lightly as he could; we all to the best of our individual capacities held on to our seats, and … thus managed to avoid being pitched off head-foremost. When the carriage came to a standstill, the horse dismounted and drew us along as before.' On approaching a tunnel, 'the driver was kind enough to suggest that such of the outside passengers as thought it likely they would have any further use for their brains, should duck their heads as low as possible, and carry their hats in their hands.'

The RSPCA took a less frivolous view of life on the tramway, bringing an action the horse contractor, Joseph Haynes, for 'cruelly ill-treating and torturing his animals.' He was fined £20.

During the fierce winter of 1855, a tram got embedded in the snow. With the canal and river frozen, Stratford's commerce was cut off. Coal was beyond the pockets of the poor and the emergency soup kitchen could hardly cope with the demand. Something had to be done. After intense lobbying, the S.R.C. was reformed to construct a 9-mile line to the Birmingham & Oxford Railway at Hatton. The great engineer, Isambard Kingdom Brunel, was engaged as adviser and the Bill was passed with the stipulation that the line should be constructed on the mixed gauge of which he was a proponent. On 12 February 1859, the chairman, David Rice, ceremonially dug the first sod. At the banquet which followed, the vicar gave the iron horse

a spiritual blessing. 'Railways', he declared, 'might justly be ranked among the most effective agencies for good enjoyed by this age of progress. I believe that no missionary effort yet made had done so much as they will accomplish for the Christianisation of the world.'

The OW&WR decided that it too had a role in this mechanical mission. By June 1859, its works from Honeybourne had reached the confluence of the Avon and Stour below Stratford and excited Stratfordians crowded the riverbanks to watch the locomotives shunting. The navvies worked at a frenetic pace and a month after the laying of the foundation stone for the bridge over the Avon, the railway was opened. A long train, drawn by two gaily decorated engines, the *William Shakespeare* and the *Ben Jonson*, conveyed three bands and a merry crowd of guests and the town turned out to cheer. Three months later, the SRC distributed hundreds of free tickets for its first train out of Stratford. One problem remained. The two branches terminated in direct line with each other half a mile apart. In 1861, rivalry was suppressed and they were joined. In the ensuing years, an elaborate system of branch lines grew to link Stratford with the world.

Now Stratfordians could take the 7.05 a.m. on the Hatton line and arrive at Paddington at 10.30 a.m. for a Third Class return fare of 8s 6d. Much of the traffic was in the other direction, however, and, while the newly-founded *Stratford-upon-Avon Herald* could make progressive remarks about new eras, not all saw the influx of day-trippers as an unmitigated blessing. The American writer, Harriet Beecher Stowe, warned that the railway might destroy Stratford's air of 'respectable, stand-still and meditative repose'. The *Herald* soon changed its tune, somewhat superciliously complaining about the 'holiday-keepers' thronging the town.

> They were not of the most refined order of beings, nor could they be accused of visiting the town of Shakespeare from any knowledge they possessed of … the associations which connect his name with this favoured town. The principal amusements of the majority … were were eating and drinking – the latter excessively in many cases – smoking, wandering through the churchyard, and taking away the flowers which decorate the tombs or stripping the chestnut trees in Bree's Lane of their splendid blossoms. Some exhibited in a limited degree a taste for fine arts, by inquiring at the shops where photographs were exhibited if 'loikenesses' were taken there. The departure scene at the railway station was anything but reassuring as regards the progress of enlightenment amongst the class who avail themselves of cheap trips at Whitsuntide. We never saw, at any of the gatherings of the rural population at our statute fairs … anything approaching the uncivilised scene.

Soon the riverside tranquillity of the Flowers at 'Avonbank' was disturbed by 'a wretched little steamer', taking trippers up and down the Avon.

The number of visitors to the Birthplace was also increasing. By 1862, some 6,000 were crossing its threshold annually. The wealth thus engendered enabled the Trust to acquire Nash's House and the site of New Place in 1864, and Anne Hathaway's Cottage in 1892.

The arrival of the railway caused property values to rise sharply and led to a demand for 'improvements', which caused the final destruction of the old Middle Row in Bridge Street in 1863, under the direction of Robert Hobbes, son of the diarist. 'If Mr Hobbes were not one of the most respected and agreeable men in Stratford', declared the outraged scholar, James

Halliwell, 'he ought, in penance, be made to stand in front of the Market House, looking at the waste he has created and have his ears well lugged for his pains.'

The End of a Dynasty

At Holy Trinity, the Kite family had held the sextonship since the Restoration, except for a brief interregnum in 1829 when Thomas Kemp was appointed, but he died two weeks later after drinking a bottle of gin, so tradition asserted itself and another Thomas Kite became Sexton. He maintained the family role of showing visitors over the church, while recounting extravagant and apocryphal stories. The aged Sir Walter Scott, Queen Adelaide, Ralph Waldo Emerson, Nathaniel Hawthorne and such noted actors as Edwin Booth, Edmund Kean and W. C. Macready were among those submitting to his singular tour. Visitors could be as odd as the Sexton. Mrs Beecher Stowe and her brother obtained special permission to receive Communion over Shakespeare's grave.

All this was highly lucrative. 'Tom's position, from the pecuniary point of view', opined Mrs Beecher Stowe, 'was more valuable than that of the vicar of the Parish.' In 1832, an anonymous letter alleged that he was negotiating to sell Shakespeare's skull to a phrenological society in London. Equally hazardous to the bones of the Bard were his dealings with Delia Bacon, an American lady of independent means who believed that the works bearing Shakespeare's name were written by her namesake. She was drawn to Stratford, said Nathaniel Hawthorne, 'by the magnetism of those rich secrets which she supposed to have been hidden by Bacon, or Raleigh, or I know not who, in Shakespeare's grave … She took a humble lodging and began to haunt the church like a ghost.'

Miss Bacon must have bribed the Sexton for the key of the church, for one night she gained entry and groped her way up the aisle to Shakespeare's grave. 'If the divine poet really wrote the inscription and cared as much for the quiet of his bones as its deprecatory earnestness would imply, it was time for those crumbling relics to bestir themselves under her sacrilegious feet.' She made no attempt to disturb them, although she satisfied herself that she could lift the tombstone. 'Had she been subject to superstitious terrors, it is impossible to conceive of a situation that could better entitle her to feel them, for, if Shakespeare's ghost would rise at any provocation, it must have been shown itself then; but it is my severe belief, that, if his figure had appeared within the scope of her dark-lantern … she would have met him fearlessly and controverted his claim to the authorship of the plays to his very face.'

Charles Flower always doubted the validity of Hawthorne's story, but what is without doubt is that Delia Bacon fell in love with Stratford and would have given anything to live there. 'She liked the old slumberous town, and awarded the only praise that ever I knew her bestow on Shakespeare … that he knew how to choose a suitable retirement for a person of shy but genial temperament.'

She gradually became a recluse, remaining in her room for days. It was only with great difficulty that her landlady, Mrs Baldwin, persuaded her to eat. When a contribution that she sent to *The Times* was returned, she tried to commit suicide, and the Baldwins had to stay with her all night. Next morning they called in the doctor. The windows were boarded up

to prevent her throwing herself out and she was watched night and day. She devised all sorts of subterfuges to deceive her custodians. Before her worst attacks, she read and recited from the Bible and engaged in edifying conversations, but afterwards she relapsed into violent and abusive language. When the Baldwins could cope no longer, she was removed to a private asylum in Henley-in-Arden. In the spring of 1858, a nephew in the US Navy came to take her back to America, where she died soon afterwards.

The end of the Kite dynasty came two years later. It was the Sexton's duty to attend services. One morning, after the sub-vicar had intoned the daily office, the congregation departed, but Thomas Kite remained in his seat. It was discovered that he was in a drunken stupor and the vicar was summoned. When he arrived, Tom was still snoring. At the next vestry, despite a petition on Kite's behalf, it was decided to dispense with this institution.

Sarah Flower

In 1853, Charles Flower attended the Birthday lunch of the Shakespeare Club, which he found 'very dull, long and stupid'. The 'Bran and Chaff' had folded up in the 1840s and the original Club met at the Golden Lion, under the presidency of the proprietor, Henry Hartley, a professional comedian.

The Flowers were great hosts, entertaining a wonderful variety of people. During 1857, they heard W. M. Thackeray lecture at Leamington. Afterwards, his agent, Mr Boddy, stayed at 'The Hill', the new family mansion on the Warwick Road. A fellow guest was Felice Orsini, the famous revolutionary, who was in England to purchase grenades. Sarah Flower found him very melancholy. One morning, he told her of his children and how sad it would be for them if he died. On a visit to the Birthplace, he expunged the name of the Emperor Napoleon III from the visitor's book and substituted his own. Later, the papers carried a story, for which Sarah supposed Mr Body responsible, that while at The Hill, he had indulged in early morning target practice. Subsequently, he made a bloody and abortive attempt to assassinate the French Emperor with the grenades and was guillotined. Sarah remembered how sorrowful he had been.

The penchant of the Flowers for interesting people and their strong Liberalism led to friendship with the rising Radical, Joseph Chamberlain. The two families acted together in a playlet, *Fair Rosamund*, which Charles had written. In 1858, the Chamberlains attended a lively Christmas party at The Hill, when eighty-six guests danced till 3 a.m. In the New Year, the families attended the infirmary ball together. At that year's Birthday luncheon, a suggestion by the comic actor, Harries Tilbury, that a grand festival be held in 1864, to celebrate the tercentenary of Shakespeare's birth, was enthusiastically received and an organising committee formed under the chairmanship of Edward Flower.

Sarah Flower's enthusiasms ranged over such causes as lunatic asylums, lifeboats and the 'underground railway' for escaped slaves from the southern states of America. Charles also busied himself, forming a local rifle corps. 'It is thought necessary to do so throughout England', wrote Sarah, 'in case of French invasion.' On 23 June 1860, the corps took part in a royal review in Hyde Park. Later that year, Charles bought 'Avonbank', a riverside property by the church. With characteristic sensibility, Sarah was thankful that their new house was

among neighbours, 'for as people grow older I am convinced they are more dependent upon cheerful society and it is wholesome to have the common friction of life.'

The rebuilding of 'Avonbank' was delayed for six years by a recession at the brewery that caused great family tension. The sons and their wives received 'a great scolding' from the father about the state of the business. Sarah thought this unfair. Charles and Edgar had been working very hard to improve things. Harder times meant the curtailment of pleasures. The sons sold their hunters and Charles gave up, 'with a great pang', a musketry training course at Hythe. The mother made everyone so anxious and depressed that Charles and Sarah agreed that he should pull out of the business as soon as he honourably could, but 'the dear father seemed so sorry that nothing was said'. Her conclusion reveals the inner resource of this fine family. 'These miserable times have been the drawbacks of a very happy life; and perhaps they have made us more particular and considerate for others. I was always so very fond of the father; he had such a fine generous spirit and was so very miserable when anything upset the harmony of the family.'

Soon after, Edward Flower retired, but the parents continued to be obsessive about the state of the business and the sons and their wives were admirably patient. One day, Mrs Flower called. Sarah was out and Charles was left 'to refute the idea that all was going wrong in the brewery and that the overdrawn account must lead to ruin'. He tried to show her 'that every year at this time there was always an overdrawn account to a large amount, but now daily money was getting paid in, and in a few months the account would all be on the other side. He told his mother what a pity it was that his father got so depressed sometimes and then overexcited with success at other times.'

Such difficulties never restricted Sarah's philanthropy. She held a party for the brewery workers' children on Boxing Day. She had begun a school on Saturday afternoons for the boys. 'I read to them and make them read to me and lend them books and from this small beginning quite a good library has arisen and every year we add to it.' This school later became a full-time infant school under the auspices of the Freemasons.

As well as recession, there were other developments to darken Victorian confidence. The rise of the critical spirit made its impact at the Flower's table when they entertained the vicar in 1861. 'The Publication of *Essays and Reviews* was now an engrossing subject – Mr Granville said one evening at dinner with us he did not like the people's minds being disturbed by such books, he had signed the petition against it, but he had never read the book!' Later they entertained the widow and sons of Professor Baden-Powell, a contributor to this milestone of Victorian religion. The youngest was the future hero of Mafeking. Half a century later, he returned to Stratford to inspect the local scout troop.

Momentous events across the Atlantic made their mark. In 1862, a ball at the Town Hall raised funds for Lancashire cotton workers made destitute by the American Civil War. Soon after, the Flowers entertained Mr Moncuse Conway, a southern abolitionist. Four years later their first guest at 'Avonbank' was Mr Lloyd Garrison, 'who had lived to see the emancipation of the slaves – the work of his life – effected'.

The year 1862 saw the closure of the Royal Shakespearean Rooms. An address expressed the hope that the management might soon reopen in a new building. This was not to be and the place was dark for five years.

A Doge Indeed

In 1863, Edward Flower became mayor for the fourth time, throwing a gargantuan banquet at the Town Hall. Plans for the tercentenary celebration were not meeting universal approval. The committee was breaking with tradition by proposing to make the event more Shakespearean than Jubilee. Many townspeople were upset that a procession was not on the official agenda. Thus an independent committee was formed to organise an alternative festival. Mr Ginnett, a circus proprietor, an old boy of the Grammar School, offered to provide any number of bipeds and quadrupeds for the occasion. The 'swells' of the official committee were not happy with this development, 'surmising that it would not greatly increase the grandeur of their ceremony'.

Others dissented for opposite reasons. William Kerr of Long Marston wrote an outraged letter to the evangelical journal, *The Revival*, declaring that the celebration would have a 'terrible influence' on the area by presenting nightly theatricals. 'I am anxious to set on foot a counteracting influence to have the gospel preached and tracts distributed.' His opinion of Stratford was not high. 'This is no party movement, but simply an evangelising in a dark and benighted and, almost, I might say, idolatrous place as it regards Shakespeare.'

The official preparations were on the grand scale. A huge pavilion, modelled on John o' Groats' house, was constructed on Charles Flower's paddock in Southern Lane. Railway sidings were built to accommodate the anticipated rush of visitors. Efforts to engage leading theatrical talents led to complications. When Charles Fecther, the French actor, was asked to play his celebrated Hamlet, there were protests that Samuel Phelps, the leading English actor, had been snubbed. Phelps said he would not come if Fecther was there and Fecther withdrew after alleging that some members of the committee had put it about that he had manipulated the choice of his Hamlet. Fortunately some other notable actors like Edward Compton agreed to appear. There were also problems with the ladies. Stella Collas, the beautiful French actress, agreed to play Juliet. The celebrated Helen Faucit, then forty-seven, was asked to appear as Rosalind, but declined because her husband, Sir Theodore Martin, wanted her to play Juliet.

The festival began with a Birthday dinner for 700 in the pavilion, at which Mr Flower presided, looking like 'a Doge of Venice when the Doge was a Doge indeed'. Its lavishness can only be described by recounting the full menu: 'roast turkeys, peafowl, roast fowls, capons, ducks, boar's head, York hams, tongues, French raised pies, mayonnaise of salmon, mayonnaise of lamb, braised lamb and beef, roast lamb, galantines of turkeys and fowls, lobsters and mayonnaise salads, dressed lobsters and crabs, potted meats, potted lamperns (sic) and lampreys, aspics of eels, soles and salmon, dessert cakes, jellies and creams, tourtes (sic), meringues and Charlotte de Russe, beehives (sic), fruit, dinner rolls, dressed potatoes, bitter ale, champagne, claret, port and sherry'.

On the Sunday, an annual Shakespeare sermon was inaugurated by Archbishop Trench of Dublin. His delivery was very bad: 'those a little way off could only catch the word – Shakespeare – which rather shocked them.'

The three-week season opened with *Romeo and Juliet*, which was much enjoyed, although Mlle Colas' performance was not highly regarded. 'She is beautiful and fascinating, but we are afraid she is not Shakespeare's Juliet', said the *Herald*, adding gallantly, 'We feel like brutes as we write it.'

Other sensibilities were prickled. When the Revd M. C. Tompson of Alderminster tried to drive his gig down Church Street, he was stopped by a police constable on traffic duty. Failing to see why his right of way should be impeded, he struck out with his whip, for which assault he was fined. More hardened lawbreakers appeared at a special court, which dealt with more than twenty pickpockets.

Charles Dickens made the journey, enjoyed himself and wrote about it in *All the Year Round*. At the Birthplace, he was disconcerted by two huge policemen blowing their noses 'like thunder in two sheets of red calico', but he found the production of *Twelfth Night* enchanting.

The alternative festival began on 2 May. Mr Ginnett had erected a huge pavilion behind the *Unicorn*, from whence the long-awaited pageant emerged and paraded the streets to great approval. The *Herald* got the right phrase: 'If it was relatively, it was not absolutely magnificent.' The next day the parade was repeated by popular demand, completing its journey at Wombwell's Menagerie in the Rother Market.

The official festival had other attractions. For the erudite, there was a lecture in German by Professor Max Muller. An exhibition of Shakespearean paintings at the Town Hall proved popular, as did a fancy dress ball in the pavilion. *The Messiah* was performed to great approval, but one intended highlight – a flight by Mr Coxwell in his famous balloon – was a fiasco. Vast crowds gathered, but the balloon failed to ascend. On enquiry, it was found that much of the gas had gone to light the pavilion. The *Herald* excruciatingly described the situation as 'gasly'.

The theatricals closed with an abridged version of *Much Ado* and the trial scene from *The Merchant*, with the popular favourite, Mrs Vezin, who was greeted with delirious applause whenever she appeared as Beatrice and Portia. At the close, there were hearty cheers for Mr Flower, which he acknowledged with a little speech.

A last event remained. The Evangelicals opposed to the festival had obtained the celebrated Baptist preacher, the Revd Charles Spurgeon, although he was unavailable until it was all over, so the visitors departed, unaware of the moral dangers which had surrounded them. The Stratfordians did not, however, escape the wrath to come. On 7 June, he addressed 2,000 people at an open-air meeting on the bowling green at the Red Horse.

Despite the success of the festival, it had lost the huge sum of £3,308 8s 3d. The deficit was borne by Edward Flower and members of the Royal Shakespearean Club. This temporarily dampened enthusiasm and the last annual meeting of the club was held in the following year. It was not until 23 April 1874, that twelve gentlemen, ten of them borough councillors, dined together at the Red Horse to revive the club tradition.

Nevertheless, the tercentenary celebrations had proved that the railway would augment local support by bringing thousands of visitors to a Shakespeare season. It was not long before the mind of Charles Flower turned towards a permanent implementation of his father's grand idea.

Despite his spectacular success, Edward Flower was relieved to retire as mayor and 'get clear of town squabbles'. He had used his casting vote to support the amalgamation of the borough police with the county force. This was long overdue. Stratford police had a strength of four in a population of 3,672. They were badly equipped and, in addition to their other duties, acted as assistant relieving officers for the casual poor. Nevertheless, local patriotism was stirred and the mayor endured a brief unpopularity.

Obscenity, Filth and Vulgarity

A number of low houses existed in Stratford and generally caused little stir. A brothel was cannily situated in Bull Street between the jurisdictions of the borough and county police. Peak trade was on Saturdays and market days. *Madame* of this unrefined establishment was Emma Day, a common whore who had walked the local streets for years, sustaining her work-shy husband, Stephen Day, with her immoral earnings. In 1858, the Days were found guilty of keeping a disorderly house, but they had the satisfaction of dropping a broad hint that the police superintendent was a not infrequent visitor to their premises! Perhaps Fanny Harris and Hannah Woodford were prostitutes at this brothel. One evening they lured John Hawkes up a court off West Street. Hoping to satisfy his predilections, he climbed into a loft where one girl blew out the candle and the other robbed him of £50.

On 15 June 1869, a commotion at The Ship beerhouse on Waterside caused Supt Rowley of the borough police to seek entry. Ann Smith, the old landlady, refused to open the door for several minutes. When he got inside he found a man in bed in one room and a woman in another, but there was female clothing scattered about the man's room. The Ship was a notorious haunt of bad characters. Many went straight there on release from Warwick gaol. It was well-situated to attract bargees and railwaymen from the wharves opposite. When Emma Bradley brought a paternity suit against Charles Beckett, it was a sufficient defence to allege that she had been seen at the The Ship.

Despite frequent exhortations to moral behaviour, a steady flow of young men made court appearances and were charged the going rate to support the infant reminders of their indiscretions, generally between 1s 6d and 2s 6d a week. Other babies were abandoned by their mothers. In the first four months of 1858, three newborn babies were found drowned in the canal. Some little bundles arrived at the workhouse where the Guardians performed the Bumble-like task of naming them. One foundling was named Mary Whitfield ('after several amusing suggestions'), having been discovered in the Whitfield hovel. More tragic was the case of a maidservant, Charlotte Sumner, who tried for murder after the severed head of her newborn baby was found in a closet. She found compassion from a jury that ignored the judge's directions and found her guilty only of concealment of birth, accepting her unlikely plea that she had severed the head while trying to cut the umbilical cord.

Venereal disease represented a grim fate for the promiscuous – the 'only inheritance' for babies born to syphilitic mothers. 'Go to Davis's in Greenhill Street', an anonymous note told the police in 1866, 'for they have poisoned a child by giving it laudanum while they go out at nights.' The baby, Harry Davis, aged about five weeks, was indeed dead, but the cause was congenital syphilis contracted from his mother, Mary Anne Davis, whose fifth child he was.

Thus Victorian morality had a rarely spoken pragmatic basis, To a local surgeon, Mr J. J. Nason, healthy development in early youth was best secured by keeping the reproductive organs in a state of quiescence.

The habit of continence, early established, will make the practice of it in after years a comparatively easy thing; whereas the early and unrestrained indulgence of the passions will bring about such

nervous irritation and constitutional unrest – not to mention great instability of purpose and diminished powers of self-control – as will lead the unhappy sufferer to seek relief in unlawful and perilous expedients, which will, like dram-drinking, not only feed the disease they were intended to remove, but also in themselves become the parent of other ills far more difficult to bear than the salutary rule of self-restraint.

'The salutary rule of self-restraint' could be enforced by more aggressive methods than persuasion. On 25 July 1867, the area around Great William Street was in a 'visible state of excitement'. A married man, who had a reputation as a 'hot gospeller' seemed to have forgotten his rigorous message and become 'unmistakably sweet' on a widow who lived nearby. Perhaps because they had suffered his moral strictures in the past, the 'virtuous indignation' of the populace was aroused. The woman was burnt in effigy 'amidst the concentrated roar of the flames and some hundreds of human voices'. The next night, the man suffered the same fate. The liaison proved costly to the unhappy couple. The man lost his job and the woman was ordered to leave her cottage where she had lived rent-free.

The Mop fairs attracted the attention of moralists. The hiring system was seen as a means to procure girls for prostitution; although there is no evidence that this occurred at Stratford, where girls plying for hire were generally accompanied by their formidable mothers. Critics of the fair claimed that, once hiring had been accomplished, the rest of the day was spent in 'immoral amusements which bring degradation upon many a young female and sorrow to many an honest parent'. Whatever else the Mop may have been, it was not a centre of fashion. The country girls flocking in wore the clothes of yesteryear, including, in 1867, 'that obsolete garment, the crinoline'.

In 1934, Mrs Ryman of 36 Clopton Road, remembered being hired at the Mop over sixty years before. After leaving school when she was eleven, she spent two years weeding gardens for 2*d* a day. At the Mop, she was engaged by the daughter of the landlord of The Swan with Two Necks in Great Brook Street, Birmingham. She travelled back on the train with her new mistress, using the 1*s* 6*d* return ticket of the girl whose place she had taken. The conditions in which she worked were 'little less than slavery'. There were no restrictions on opening hours and the pub opened at 6 a.m. for night shift workers. The little girl had to rise at 3 or 4 o'clock to scour and clean the dirty taproom and polish the tiles. After six years she left there because they refused to increase her wages and went to the Queen's Arms in Easy Row. During her whole time in Birmingham, she never missed a Stratford Mop. It was her one holiday of the year.

Later Mrs Ryman returned to Stratford and got a job at the White Swan. She recalled the hard drinking that took place at the fair. The landlord, Mr Wilkinson, brewed his own beer and reckoned to take enough money on Mop day to pay his yearly rent. 'I have seen him take the money upstairs in buckets, put it in the bed and cover the clothes over it; there was never time to count it.'

In the 1860s, a new class of Mop itinerant, the travelling photographer, became 'as plentiful as the blackberries in the Autumn'. A *Herald* reporter was amused to 'see a yokel making a present of his likeness to his cherry-cheeked companion, his head resembling a swede-turnip, with a gash for the mouth as though cut at random with a dull hatchet'. Outside one 'studio' was a *carte de visite* of the Emperor Napoleon III. The reporter wondered what

had induced 'his Imperial Majesty to honour such an establishment with a sitting. However, as the proprietor's appearance corresponded somewhat to that of a decayed prizefighter … we refrained from putting impertinent questions and passed on.'

In Wood Street, a large crowd had gathered around two men, who claimed to be miners and crouched dejectedly on the ground. A large crude oil painting showed a coal pit in which they claimed to have been injured. One man sang a mining song in a monotone, while beating time with his pick on a lump of coal. Every so often the singing would cease and his companion would hold forth in 'a whining, hypocritical tone … "Only one good leg among the two on us", he burst forth occasionally in a pathetic strain, and a most disgusting display was made of the shrivelled limbs. The bystanders' sympathy was evinced in a practical manner, for pennies fell at times nearly as thick as hailstones in a storm. In less than an hour the men's pockets were literally gorged with coppers, yet they continued to appeal to the "feeling heart" of the gullible British public with good effect'.

Such exhibitions of 'obscenity, filth and vulgarity' gave impetus to those who sought to abolish the Mop. In 1859, at a public meeting at the Town Hall, the local MP, Sir Charles Mordaunt, suggested the establishment of a 'Servants' Amelioration Society' to keep a register of employers requiring servants and servants requiring places: one of the earliest proposals for a public labour exchange. At the next Mop, a registry was established at the Corn Exchange and achieved some success, but the *Herald* considered the alternative to the hiring system to be 'fruitless journeys from farmhouse to farmhouse' and doubted the motives of those who sought to take from the poor man, 'the last remaining holiday which grasping avarice has left him'.

'It is rather a failing of some great people', declared another correspondent, 'to lecture and instruct the poor; and to go away to their luxurious and pleasurable homes, after a lengthy oration to their less-favoured brothers and sisters on the folly and even harm of such merry meetings as fairs.' The writer concluded with a verse: 'No cakes and ale for men and boys, / No bands or garlands gay; / No buns and tea for old and young / To mark the op'ning day'.

The critics had a point. The indenture system was a form of annual slavery in which the servant signed away his or her rights in the free market in return for a comparatively small fee. From time to time cases were heard at the petty sessions concerning those who had absconded. In 1861, Daniel Neal, a young lad, was hired for a stipend of £6 at the Mop by Thomas Edkins of Little Drayton to look after his horses. Within six weeks, the boy had run away, but was recaptured and brought to court in an atmosphere of mutual recrimination. Edkins said that the boy had tried to provoke him into giving him the sack. He was idle and didn't get up in the mornings. Neal replied that he had been told that he would have four horses to look after, but it had turned out to be five, that he was ordered to do domestic duties that had not been specified in the original agreement and that his meals were cold when he got them. The court ordered him to return to service for a month. If he behaved himself during that time, his master would overlook this 'step in the wrong direction'. If not, he would be punished.

The movement to abolish the Mop simply could not compete with its popular following. When Dr Collis, vicar from 1868, organised a petition for its abolition, signed by 154 people, including twenty-one clergy, the *Herald* continued its attack: 'With a marvellous obliquity of vision, they look upon the labouring man as a mere child, scatter little leaflets in his path,

adopting the idea of a pig drover, who scatters a few dry bones in the path he wishes the swine to take.' When the petition was presented to the borough council, next business was moved.

Sexual impropriety troubled Dr Collis on more occasions than Mop night. The churchyard was a favourite trysting place and there was sometimes as many as 150 young people hanging around there. This gave rise to the sort of indiscretions that a Victorian vicar was unwilling to discuss publicly, but an example was made of Phoebe Hughes, 'an intelligent looking lass', who was fined 1s with 9s 6d costs for loitering.

Love could lead to violence. In 1870, a fight took place between two aspirants 'for the smiling favours of a blooming young damsel in violent curls'. After three unequal rounds, the spectators cheered when 'O. B. gave in and P. O. B. was declared the winner'. The *Herald* reporter, who was clearly hoping to see blood flow, considered that if 'the loser estimated the prize by the amount of punishment he endured for her sake, he placed it at a very low figure'.

The Demon Drink

Another area where the hand of morality descended on the poor was drink. The code was rigid because abuse was widespread. The police court had its weekly crop of the drunk and disorderly, particularly during what was called the 'Irish Season' when casual labourers arrived for the harvest. Some amused the court, like the drunk given a discharge after claiming that he had mistaken the outside of his house in Shakespeare Street for the inside, or that regular attendee, Jack Kemp, a self-styled 'Cervantic Rabelaisian', who referred to press reports of his court appearances as his 'notices'. He was wont to address the bench in doggerel. 'This cursed spite', he once proclaimed. 'I hope I shall live to set it right.'

More frequently, the archetypal Victorian drunkard emerges, with the abject poverty and violence suffered by his family, a corollary to his condition. Two such cases, nearly thirty years apart, may represent the genre. In 1867, Sgt Cross saw William Baily, 'a small octavo specimen', of Russell Court, fighting drunk and beating his decrepit old wife. He was riled because his 'old woman's grandchildren' had lied to him. The bench jailed him for seven days and found some cash for his wife, who had suffered many years of abuse.

In 1895, John Wesson of Ely Street appeared for neglecting his wife and children. 'Were any novelist', said the *Birmingham Globe*,

> to picture a young Englishman as consuming a comfortable meal within sight of his starving wife and children, without offering them a single scrap, most readers would pronounce the incident impossible ... He used, after getting drunk, to stagger home and send out for food with the remainder of his wages. On this being placed on the table, down he sat and consumed every morsel, giving no heed to the supplications of his hungry wife and little ones for a share, however small. They were always in a state of semi-starvation, as he made a point of spending nearly all his earnings on himself. Occasionally he varied this system of torture by taking himself off and leaving the poor creatures to the tender mercies of the relieving officer ... And for all of this atrocious work, the inhuman brute received a fortnight's imprisonment!

Such cases fuelled the temperence movement. Its national power led to the introduction of licensing hours in 1872. Nightly at eleven (ten on Sundays), the pubs echoed to the new cry of 'Gentlemen out, turn out!'

Temperance meetings had to be inspirational to compete with the pubs. The Band of Hope met weekly in the Primitive Methodist schoolroom for stirring orations, or to sing campaigning songs: 'We know the cause in which we've joined / Is worthy of all zeal. / God grant that all all join our ranks / The growing fire may feel'.

Temperance audiences were regaled with horrific tales of vile deeds committed under the influence. The vicar opened meetings of the Church Temperance Society by reading such improving tales as 'Bob the Telegraph Boy'. Sometimes a reformed drunk would testify. Jack Kemp became such a one, devoting his colourful talents to temperance platforms. Sadly his reformation came too late to save him from the workhouse, but he used his fate as a salutary illustration. A 'flourishing' Junior Abstainers Union sought to avert such tragedies in the formative years. At the licensing sessions, protests were made about parents sending their children to pubs to fetch jugs of ale, which they would sip as they ran home. Publicans were condemned for giving sweets to the youngsters to encourage such errands.

At one temperance meeting, the speaker, Archdeacon Robert Wilberforce, estimated that intemperance caused nine-tenths of pauperism, crime and misery, pouring scorn on those who related social evils to bad conditions. 'Put a pig in a drawing room', he thundered, 'and see if the drawing room will convert the pig or the pig the drawing room.'

Others took a broader view. 'We must remember', wrote Henry Fisher to the *Herald*, 'that there is a very close connection between the physical and moral condition of being – between our outward circumstance and our inward character. Domestic purity, social refinement, religious sensibility, cannot flourish in foul recesses, upon which the day scarcely looks, or where the balmy life-giving air can hardly penetrate.'

Mr Fisher's outrage was prompted by a survey he had conducted of local housing conditions. He was horrified to find a family of ten living in a small dingy house with only one upper room: 'Only imagine the effect upon the morals'.

Stratford was a whited sepulchre whose attractive main streets concealed desperate poverty. 'The Birthplace of the Bard possesses outwardly much to please and delight', wrote William Greener of Rother Street to the *Birmingham Daily Gazette*, 'so clean too, so happy, apparently are the people. The happiest place in England, as frequently remarked. But alas, this is not so. It is but an outer dress. A vast amount of real misery and poverty lurk beneath.'

In 1866, this splendid man bought five cottages, which he considered unfit for stables, 'much less the houses of human beings.' They measured ten feet square with one room over the other and a wretched little outhouse. One housed seven men and women. When told to move out, 'they one and all implored my wife to use her influence with me to let them stand, for if driven from there they could not find shelter to cover their heads'.

The mayor opined that there were property owners in Stratford who were 'men of hard hearts and no consciences' – an opinion rendered less effective by the fact that the worst slums were on Corporation property. The council owned nearly all the available development land and charged a prohibitive 3 guineas for each sub-lease: money which found its way into the pocket of Henry Hunt, the town clerk, as one of the perks of his office.

Greener's scheme to develop his property as model artisan's dwellings was thus precluded by restrictive practices and he launched an attack in the columns of the *Herald*. 'The poorer classes want, and that urgently, dwellings. The Corporation have plenty of sites, money is ready to build; but no, the legal gentleman's coach stops the way. Notwithstanding the Act reforming corporations swept away all right on the part of town clerks to make out deeds with a view to prospective benefits to themselves and successors, we have an example in 1868 of the injustice practiced on the inhabitants of Stratford-on-Avon two centuries ago.' Mr Greener's campaign had its effect. The Corporation leased him land in Arden and Mansell Streets for £35 a year.

Russell Court, situated in a dark, narrow passage off Ely Street, whose defective ventilation permeated the air with the smell of burnt frying pans, was regarded as the worst slum in Stratford. Its ramshackle cottages housed appalling squalor. Some possessed only one room upstairs and the small, stuffy landing was used for sleeping. The effect of such overcrowding was frequent quarrels between neighbours. 'This classic region', wrote the *Herald*, 'hath a Vesuvionic quality: it slumbereth for a time, a thin cloud of smoke only denoting its existence, but after a while the volcano bursts forth, the "lava" – in the shape of particularly strong expletives – literally swamping all vestiges of humane and kindly feeling towards another.'

One Sunday morning, Mrs Mary Cooper went to collect milk from a neighbour, Mrs Batchelor. They chatted for a while and Mrs Caroline Boyce, who was nearby, thought that they were 'brass-nailing' her and let fly a volley of abuse. When Mrs Cooper left Mrs Batchelor's, Mrs Boyce was lying in wait for her. She pulled her hair with one hand and bashed her with the other until she was pulled away. At the police court, the neighbours turned out to testify, mainly for Mrs Cooper. Mrs Boyce was bound over for six months in sureties of £20. The magistrates instructed the police to keep a special watch on Russell Court and announced that they would, if necessary, bind over all its inhabitants to keep the peace.

Stratford's back alleys housed residual ignorance and superstition. In 1867, residents of another slum, Emms Court, off Sheep Street, believed that they had been bewitched by an elderly neighbour, Jane Ward. They had abused her for some time. John Davis, a maltster had declared frequently that he would draw her blood. One evening, while two women were haranguing the poor old woman at her door, Davis rushed at her and struck her in the face, causing a deep cut under her eye, which bled profusely. As he hit her, he shouted, 'There you old witch, I can do anything with you now.' When arrested on a charge of malicious wounding, he exclaimed, 'Serve her right. She can do no more for me now. I have drawn first blood'. A good character reference from his employer, Mr Flower, ensured that he received six months' hard labour rather than penal servitude.

16

'We are Nobodies'

It is true, we are nobodies, but we have waited 300 years for the somebodies to do something and they have not done it.

Charles Flower, Mayor of Stratford, 1879.

'Tracts and Bills galore'

After the extension of the franchise following the Second Reform Act, Lord Duncan put up at the General Election of 1865for the Liberals, favouring the abolition of church rates and a modest extension of the franchise, measures opposed by the Tories, Sir Charles Mordaunt and Mr Wise, who supported the inviolate union of Church and State.

An election was a novelty to many people who were astonished by the rushing about of placard-covered vehicles. Perhaps it was this unfamiliarity that ensured that 'scarcely a black eye was given all day'. The *Herald* had declared that the election of Lord Duncan would reflect honour upon any constituency, but the local electorate failed narrowly to so distinguish itself and the Liberals drank to 'Better luck next time' at the Red Horse while congratulating each other on having done so well. The Conservatives sat down at the Shakespeare to a 'capital dinner, served in good style by the indefatigable energy of the clever hostess and made pleasant speeches to each other upon the manner in which the day was won'. Both agents spoke highly of the way in which their opponents had conducted the canvass. Next morning, pale faces 'spoke of the excitement of the previous day, but a friendly glass pledged to neighbours soon restored the healthy tint, and gave the eye its accustomed brilliancy, and opponents of Friday jingled glasses on Saturday to the toast, "May differences of opinion never destroy friendship"'.

Edward Flower stood for the Liberals at Coventry and lost by fifty-nine votes. The family helped strenuously and in gratitude he gave Sarah £350 to furnish her new house. After 1873, he lived mainly in London. One of his great causes was the abolition of bearing reins for horses and he wrote a widely read pamphlet on it.

After Parliament had voted to extend the franchise and abolish church rates, the Tories, like true politicians, returned to the polls in 1868 to recommend what they had previously opposed. This time, Mr Wise put up with John Hardy in the Tory interest and the Liberals fielded Lord Hyde and Sir Robert Hamilton of Avon Cliffe, Alveston. It was the Irish Question, including the issue of the disestablishment of the Irish Church, that dominated the hustings.

Election morning was quiet. The polling booth was a temporary structure that had been erected in Rother Street. The only disturbance came from a few small and very dirty boys, who sported blue Liberal favours and cheered all those voting. The arrival of some grammar school boys and a few non-voting shop assistants, blazing with neckties, rosettes and ribbons in Tory orange brought 'to the assistance of the dirty little boys, a number of unwashed hobble-de-hoys and roughs of a maturer age'. The Tories were soon hooted and hustled off the streets. As each voter emerged from the booth, the teller called out who he had voted for and the roughs continued to amuse themselves by groaning and cheering according to the announcement. Anyone who interfered with them was a marked man and some people were roughly handled.

That evening, the mob, which had considerably increased in numbers and noise, paraded the streets. At the Tory committee rooms at the Shakespeare, someone rashly made a provocative gesture out of a window, which led to an assault on the building in which several windows were broken. The police, who had shown great restraint, were quickly on the spot and arrested some of the ringleaders. This time bonhomie did not prevail, the Liberals accusing their opponents of intimidating the electors. Despite winning a majority in Stratford, they lost the division. The *Herald* considered this reflected the influence of 'the old maids of Leamington, duly organised to do battle with the Pope'.

This was the last election with a carnival atmosphere. The introduction of the secret ballot in 1872 reduced the opportunity for bribery and made elections less public affairs.

Not everyone approved the reform. Years later the *Herald* published 'The Lament of an Old Voter', which revealed the attractions of the old ways for those with a vote.

> From Swan to Bear they treated me, but now to my regret
> They send me hungry, thirsty home – then how can I forget?
> They bid me seek in charge of scene the charms I used to see,
> But though the law is altered they find no change in me,
> Tis true that tracts and bills galore are now before me set,
> And lots of talk to keep me straight – but how can I forget?
> For oh! there are so many things recall the past to me;
> Plum puddings hot, prime roast beef, with plenty of grave-e,
> The rosy tint of the old pot, the jovial friends I met,
> Nay, everything I think upon – forbids that I forget.
> They tell me to be happy now, the gayest of the gay,
> But little will they think of me after polling day.

'Church Influence'

The Catholics of Stratford achieved their first great objective in 1865 when their school reopened for 'children of the town and neighbourhood, whatever their denomination', with a wider curriculum than the other denominational schools. Apart from small statutory grants, the school was dependent on voluntary aid, mainly drawn from the 2½*d* parents paid weekly.

Those who could afford more were asked to do so. In 1878, the school moved its twenty-three pupils to the premises of the old workhouse, which were 'comfortable, well-lighted and well-furnished.'

In 1866, the second great objective was achieved with the dedication of St Gregory's church by Bishop Ullathorne of Birmingham – a handsome building created largely through the philanthropy of James Cox Jnr, and designed by the firm of the distinguished architect, Edward Pugin. The bishop had had enough of idiosyncratic behaviour by local Catholics and placed the church in the charge of the Benedictine Order.

In 1870, Forster's Education Act sanctioned the building of schools out of public funds, but only in areas where existing schools were not providing enough places. Implementation of the measure was opposed fiercely by local Anglicans, whose ascendancy over Stratford's education system was threatened and by many ratepayers, who feared the expense of providing new buildings.

Some indication of the fierce denominational flavour of education is found in the logbook of the Nonconformist British School. When, in 1873, the Master, Henry Cordingley, called to ascertain why the Matthews brothers were leaving his school, the parents told him that their elder brother was attending the Church of England Night School, and he had been told that he would not be allowed to continue unless his brothers went to the National School. 'So much for Church influence', Cordingley concluded cryptically.

Cordingley had another problem. On 7 January, he had recorded that 'order in the classes under the care of the teachers is not good, although I have spoken to them about enforcing law and order several times'. These were the pupil-teachers, usually aged between thirteen and eighteen, who, under a scheme introduced in 1846, were apprenticed to the master for five years. In return for helping run the school, he taught them out of hours.

Irregular attendance was a problem in all schools. It was not made compulsory in Stratford until 1878. With many children partially employed in seasonal work or helping in family businesses, the numbers fluctuated daily.

Logbooks had to be kept by all schools in receipt of government grants and they were examined by the inspectors on their annual visits. Payments were based on pupil numbers, so all the schools were zealous in their efforts at recruitment. The pressure to achieve results made the inspector's visit an awesome affair, and an account of it always appeared in the local press.

As late as 1862, an attempt to introduce the congregational chanting of psalms at Holy Trinity had been scoffed at by a critic because of the number of illiterates in the congregation. Now literary levels were rising, but, apart from those who achieved a modest advancement through the pupil-teacher scheme, the restricted curriculum and strong stress on obedience and discipline ensured that education enabled children to fulfil their allotted roles more efficiently, rather than providing a route through the class system. Thus, the school managers saw no point in providing subjects that would not bring in any grants, and which they regarded as irrelevant to the education of working-class children. The situation persisted until 1872 when grants were first made available for passes in two additional subjects between ages nine and eleven. As a result, geography and literature were introduced into the curriculum at the National School.

Later, the grammar school would become a means for working-class children to gain an academic education, but, in 1869, it was little more than a superior elementary school. It

contained fifty-two boys, of whom five were boarders, in four classes. The average age was nine. There was only one boy over sixteen and two above fifteen. It was not until 1880 that a discretionary scholarship was used to admit a boy from a local elementary school.

In 1881, an educational census revealed that there were 1,512 children attending schools in the town, of which 248 were in private schools. There were a number of these and, if the evidence from one is anything to go by, standards were very low. Cambridge House occupied what is now Hall's Croft as a boarding school for young ladies. Details about conditions there emerge in a defended legal action against an aggrieved parent who refused to pay the fees. His daughter complained that there was no light in her bedroom and the food was coarse. For breakfast, which was served up in the schoolroom, she had thick bread with very little salt butter. There were no fires except on Sundays and bath nights. Dinner was frequently inedible. When one of the girls could not cut a baked pudding, she was told to eat it with her fingers.

Dr Collis

The best-known school in Stratford for over thirty years was Trinity College, founded by Dr Collis, the vicar, at Mason's Croft in Church Street. Before coming to Stratford, he was headmaster of Bromsgrove School. He was kind-hearted, generous and liberal-minded man, although he had a reputation for being eccentric and impulsive.

Dr Collis continued the process of 'raising' the sacramental life of the Church begun by the Revd Henry Harding. This led to controversy in an age when religion was still a topic of household discussion. His Advent sermons in 1870 were devoted to the theme of Church Order and divided opinion in the parish. It was only three decades since the latitudinarian days of Dr Davenport. The *Herald* reported that the controversy formed 'the staple conversation of the genteel dinner table; it has penetrated the murky atmosphere of the hotel smoking room; and it has reigned predominant at the scandal-provoking tea-table.' As a result, the Revd J. Scott James, the Congregational minister, launched a series of lectures attacking Ritualism, which won the approval of many Anglicans.

Dr Collis's abilities as a controversialist were not restricted to matters liturgical. Within a month of preaching his exalted view of the Church, he gained national publicity for a campaign to discourage 'funeral feasts' among the poor. The rituals of internment could cause impoverishment. The *Daily Telegraph* supported his cause: 'A vulgar, vicious idea prevails, that a certain amount of display is a token of respect to the dead, and that proper economy would indicate want of grief; and many a poor widow has been compelled to spend upon stupid, senseless trappings, fit only for savages, money that would go far to support herself and her children for months … why four horses to a hearse when two are enough? Why those hideous plumes? Why "mourning" carriages? Why scarves and hatbands? Why those theatrical supernumeraries called mutes?'

Dr Collis set out his practical schemes in a letter to *The Guardian*. To 'Christianise' and 'cheapen' funerals and 'to emancipate the poor and the respectable gentry of limited means from the miserable thraldom of public opinion under which they groan, and to abolish that stringent undertaker's ritual under which they seem powerless to shake off', the clergy of Stratford had procured a hand hearse, bier and violet pall, which could be easily managed by two bearers. These were hired out at 3s 6d, 'probably less than half the cost of the cheapest funeral.' In future, the clergy would decline to accept the

customary gifts of 'gloves, scarves, or hatbands from the friends of deceased parishioners'. They would adhere strictly to the rubric and, as there directed, meet the corpse at the entrance of the churchyard and they would never attend the costly wakes that were a feature of contemporary funerals.

> We do not wish to dictate what others shall do; but we hope gradually to modify public opinion on the matter, and to let the Church be, as she always should be, the defender of the weak against all tyrannies, including that of the funeral ritualists of the last hundred years. We do not blame undertakers as a class, many of whom are estimable men, who have, with a dogged conservation not always to be blamed, followed strictly and literally the unwritten ritual handed down from their fathers' time; but we hope to educate them and their employers in due course...
>
> Careful attention to the service itself, with the introduction of hymns, and, where desired, the celebration of Holy Communion, will, we trust, tend to make our funerals speak more of Christian hope, instead of gloomy, dreary, cheerless despair, as they do now far too much.

Letters of support came from all over the country and Dr Collis formed the 'National Burial Reform Committee', which became instrumental in the gradual change in attitudes.

The Catholic neo-medievalism of Dr Collis inspired his grand plan to reproduce at Stratford its collegiate establishment of the fifteenth century. He liked to think of himself, the priest-chaplain and the four curates as representing the old College, with its warden, sub-warden and four canons. He was thus a controversial figure at a time when 'The Protestant Religion' was a regular after-dinner toast. 'But for the ill-fated sacrilege of Henry VIII', he wrote to *The Gospeller*, and the 'culpable negligence' of those who had demolished the college in 1799, there would be ample revenues to do the work of the Church in Stratford.

Part of the scheme was Trinity College, which opened in January 1872, with twenty-two pupils. Dr Collis gathered a group of able teachers and soon boys from all over the country attended the school, which boasted nineteen admissions to the universities and scholarships to such schools as Westminster, Marlborough and Charterhouse. Emphasis was placed on the boys' backgrounds, as this attracted enrolment, although Dr Collis was not a devotee of social exclusivity. He never tired of relating how he owed his own education to the great Dr Arnold, whose custom it was at Rugby to accept one boy in ten without fees. He had instituted a similar scheme at Bromsgrove and hoped to do the same in Stratford when the endowments permitted it.

Four months later, Dr Collis, together with members of the Corporation and some young ladies, placed flowers on Shakespeare's grave on the Birthday. Although he did not repeat the ceremony, it was remembered and revived two decades later to become a cherished tradition.

Dr Collis's Catholic vision extended to a lay order doing good works. A parochial organisation for the care of the sick poor was founded in 1870 and a house acquired in West Street. A woman of 'culture, high principle and wide experience' was needed as parochial nurse. Such a person was found in Miss Emily Minet, the daughter of a Madeira wine shipper, who had trained under Florence Nightingale. Within two years, her team had paid over 2,500 visits to the homes of the poor. These were, in the words of the vicar, 'not casual, haphazard visits, aimless and resultless, far from it. Our devoted women not merely help the poor directly, but they teach them to help themselves.'

Miss Minet and her ladies organised outdoor relief for the poor. Each Christmas she appealed for money, clothing and food. On Christmas Day, 'each cottage small' boasted a portion of 'good old English roast beef'. In bad weather, casual labour, on which many poor families depended, was impossible, and a soup kitchen at the Town Hall alleviated need. Seasonal unemployment could reach 20 per cent yet, Christmas over, the needs of the poor could have low priority. The Corporation suspended the soup kitchen during a severe frost in 1871 because it interfered with arrangements for the Hunt ball.

In 1875, £3,000 was raised to start a nursing home for women and children, which did much to alleviate suffering and reduce the mortality rate. It was of great benefit during a scarletina epidemic in 1887. This was a much feared and often fatal disease. Seven years earlier, Sarah Flower had recorded the death of her little niece, Violet, from it, although she saw it as a disguised blessing. 'We never considered her like other children and probably much trouble and suffering had been saved for her poor child.'

The epidemic of 1887 began in March, when seven families were infected. By June, this had risen to nineteen, so Miss Minet opened a temporary fever hospital at Copham's Hill Farm at Bishopton. The schools closed early for the summer holidays and did not open again until mid-September. By then ninety-nine families had been infected, but, thanks to the ministrations of the nursing team, no one died.

Such was the respect for Miss Minet that a public subscription was opened for her in 1891. She died, exhausted by her efforts for the poor, a few weeks later. At her funeral, hundreds of people lined the streets. Along the route to the cemetery, there was scarcely a house without the blinds drawn. 'Her whole energies', said Dr Collis's successor, 'were devoted to the ... mitigation of the miseries of the poor.' A memorial window was erected in Holy Trinity and the Children's Recovery Hospital remained as a monument to her works of Christian charity.

All these schemes cost money and, with the abolition of church rates, there was a lot less of it around. To help plug the financial gap, Dr Collis embarked on of charging 6*d* to inspect the church. This was a controversial action. Holy Trinity was probably the only church in the land at the time with an entry fee.

Dr Collis's time as vicar was marked by an odd controversy. The Revd William Connor, the priest-chaplain at the Guild Chapel, became an adherent of Irvingism, that odd adventist sect that had some roots in Stratford. Dr Collis worked hard at diocesan level to secure his resignation, which proved a traumatic process. Connor was well-liked and those who knew little of theological niceties took the opportunity to play the traditional game of 'Bash the vicar'. Scurrilous leaflets were circulated and protest meetings held, but Dr Collis stood firm to his orthodox viewpoint.

Dr Collis's militancy was combined with a great personal charity. On the night of his death in 1879, his old dissenting antagonist, Dr James, called to pay his respects. On learning of his presence at the door, the dying vicar said, 'Give him my dearest love, and tell him I have learned to regard him as a companion in arms for Christ, and doubt not we shall meet in heaven.'

After Dr Collis's death, plans for the endowment of Trinity College failed to materialise. Without his charisma, numbers fell to sixty-five by 1893, when the school mainly prepared boys for entry to the civil service. Yet social exclusivity remained. There was 'soreness amongst boys and parents' after an astute local innkeeper got his son accepted by giving his address, without the name of his pub.

Joseph Arch

Miss Minet's stress on self-help found echoes elsewhere. Joseph Arch, 'a splendid hedger', who had been in the employ of Mr Angell James at Bridgetown, was a Primitive Methodist preacher and a brilliant platform orator. In 1872, he was instrumental in forming, at Wellesbourne, the Warwickshire Agricultural Labourers Union, the first properly-constituted trades union.

The formation of the union was followed by an extensive strike of local farm-workers and a lockout by the employers. Stratford became a rallying centre with a number of public meetings held in the Rother Market. On 11 June 1873, 2,000 people heard the Wilmcote Brass Band play before Arch proposed 'that the borough franchise should be extended to the counties'. Stratford magistrates showed some sympathy for the strikers, dismissing a case against two labourers who were charged with unlawfully absenting themselves from work after hearing that their wages were only 12s a week.

Stratford's drapers' assistants were also getting organised. In 1873, a meeting at the Town Hall demanded an early closing day and the adoption of bank holidays. The shopkeepers were agreeable, provided that all agreed to do so, but Fred Winter, an ardent Baptist and total abstainer, refused to close his shop, describing the idea as 'senseless'. There was strong public sympathy for the shop assistants. The liberal-minded Catholic timber merchant, James Cox Jnr, proposed a boycott of Winter's business. 'If the ladies will only help us, it can be done. Suppose we all determine that until the employers see things in a better light we will buy our drapery goods in other towns where they show more consideration for their assistants by closing early. After the intervention of Dr Collis, Winter agreed to close at five on Wednesdays, instead of the usual 7 p.m.

Others were achieving better results. A Saturday half-holiday was becoming general and football the passion of the masses. The first local match took place on 11 April 1873 when Stratford played Birmingham. From the time it was announced, it was the all-absorbing topic for local fans. The Stratford team, although beaten, played well.

'The once benighted Hamlet'

Complaints about the games boys played in the streets afford a glimpse of the prototypes of modern sport. 'Tip-cat' was a forerunner of baseball in which a ball was hit with a crude home-made bat, and 'bandy' was a primitive form of hockey for which any stick or broom-handle could be pressed into service.

Traditional pastimes also occurred at Shottery, that curious hamlet at the edge of the borough, whose poverty and comparative isolation ensured that it remained part of a disappearing rural England. After the Shakespeare Tavern closed, the young men of the village would often form a ring and wrestle for each other's belts. One night the police tried to break it up. Inspector James and Sergeant Glenn entered the ring and announced that wrestling for belts was forbidden. Some of the crowd formed another ring a little way away. When the inspector warned them of the consequences of persisting, William Wooten thrust his fist into his face and yelled, 'Damned if we don't wrestle for them.' Inspector James tried to arrest him, but the crowd pulled him away. Greenway, 'the crier of the belts', announced that the wrestling would continue and William

Smith and Shadrack Best threw their caps into a third ring. Despite the hostile crowd, the police officers arrested them. The mob rescued Smith, but the inspector pursued him into the village and recaptured him. 'Will you let the bugger take me?' shouted Smith to his pals. 'No! No! No!' they cried and launched a savage attack on the inspector, who held on to Smith until he was knocked unconscious. At the petty sessions, seven Shotteryites were fined 10s each and imprisoned for twenty-eight days. Shadrack Best, who had gone quietly, was bound over.

Traditional means to censure offenders against the moral code caused more problems. In 1869, after an 'indignation meeting', perhaps inspired by the one in Stratford two years before, the effigy of a married woman who had committed adultery was paraded round the village. The village constable had given permission for this rite to continue for three nights. On the third evening, around 150 people massed across the road and three men were arrested. The magistrates expressed their approbation of the moral atmosphere prevailing at Shottery, but could not overlook the offence. Fines and costs on each defendant totalled 15s 6d. An old Shotteryite wrote indignantly to the *Herald* recalling 'well and gratefully the days when a good old English gentleman' called Thomas More Esq. lived at Shottery Hall.

> He was what is called an 'eccentric'; perhaps this means Catholic as he was accustomed to go to Wootton on Saturdays to meet a priest. That don't matter; he was just, and noble and kind-hearted. He paid a labouring man a good day's wage for a good day's work. He cheerfully assisted in every case of real distress in the village, and instead of instructing the parish constable – there was no police in those days – to keep his eye upon the poor villagers, with a view to fining them and grinding them down to a state of grovelling pauperdom, he shut his eyes to any temporary obstruction of the highway and thought it unnecessary that 'every nice offence should bear its comment' by dragging each unconscious offender before the bench. In those days the quiet villagers never 'boiled over' but once a year, and that was when keeping their ancient 'wake'; and if it occasionally happened that any person found himself next morning in the Sheep Street 'lock-up', it generally turned out that the delinquent, on being released, was nearer to his own house than when taken at Shottery. It was always reckoned a quiet and tolerably moral village, considering the distance leg-weary labourers had to travel on Sundays for spiritual instruction. The villagers loved their 'squire' and were always ready to serve him to the utmost…

The implication was that it was the new owner of the hall, Admiral Douglas Curry, who had informed on the primitive ritual. If this were so, the villagers got their revenge at the next petty sessions when a number of them testified against his three sons, who were each fined £1 for breaking down a hedge.

Admiral Curry considered that the main problem for his adopted village was its lack of spiritual and educational resource. A church school was held on weekdays in the Dissenting chapel, the only available building, which was cramped and precarious of tenure, but without it, the eighty children, half of whom were under five, would be without instruction. Services were occasionally held in a tithe barn and were well attended, demonstrating in the view of the vicar, the 'universal desire' to worship. If a school and a church were provided, a curate could serve the impoverished population of around 450 and the remote outlying hamlets of Drayton and Dodwell with their 100 souls. 'A mighty interest', declared the *Herald*, 'has

sprung up recently with regard to the once benighted hamlet, formerly famous for its summer amusements of boxing and wrestling matches, and its bouts of juggling, jumping in bags, racing for gownpieces, etc…' On 2 December 1870, Shottery School was opened in a converted tithe barn. Soon afterwards, the handsome little church of St Andrew, largely endowed by the Currys, was consecrated. Yet old ways died hard. When an outbreak of typhoid occurred, medical opinion was ignored and the pump-maker, Mr Cloves's, view that 'better water could not be desired than that at Shottery', was widely quoted. 'Cloves', said the *Herald*, 'had given an opinion and Fosbrooke's degrees and the mayor's "M.B." sink into insignificance beside the livid light of the newly discovered genius of our town.'

'Everything conspired to make the Occasion Happy'

The Royal Shakespearean Rooms reopened in 1867. On Shakespeare's Birthday, the Great American Slave Troupe appeared, consisting of 'eleven Natural Talented Artistes', who had been slaves until June 1865, giving their own and only 'True Representation of Negro Life on the Plantations of America' with songs and dances, burlesques, comic dittied and banjo music, 'all given in that peculiar and mirth-provoking manner characteristic of the Negro race'.

Despite such wonders, the doors closed forever in 1872. The Shakespearean scholar, James Orchard Halliwell, had taken it into his head to honour the Bard by depriving the town of its only theatre. He desired to clear and 'restore' the Great Garden of New Place, so he bought the theatre and demolished it. In fairness, the Royal Shakespearean Theatre would probably not have survived. In 1869, the Flowers had seen a 'very badly acted' production of *The Lady of Lyons* there. 'Charles and I', wrote Sarah, 'both felt sorry that Edgar and Isabelle took Rosalie and Agnes for the first time – we should like them to have a high respect even veneration for their first play.' The entry provides an insight to the vision of Charles Flower. He desired a theatre in Stratford devoted to the works of Shakespeare and imbued the project with a moral imperative. After the losses of 1864, he cannot have conceived that such a theatre would be profitable, but he saw it as edifying the neighbourhood. He was aided by the constant support of a loving and caring wife. 'How happy we are', she had written on their sixteenth wedding anniversary.

At least things were improving in the brewery. The workforce was now 130 men and 45 clerks and travellers. It ran in families. It was very difficult to get a job there unless a member of your family was working there already. In 1865, a great new brewery was opened on the Birmingham Road. 'Many of the improvements in the manufacture of beer', wrote the *Illustrated London News*, 'which are now in use throughout the country, owe their origin to members of this firm.' By 1872, Charles Flower was worth £30,000 annually. This financial stability enabled him to proceed with his great project. He selected the 2-acre site on the Bancroft upstream from Avonbank as the ideal place for his theatre. It was where Garrick's Rotunda had once stood. The land was owned by Holy Trinity church, but on 4 April 1874, the vestry authorised its conveyance to him 'for the purpose of building a theatre'. In his turn he presented it to the newly-formed Shakespeare Memorial Association.

In 1874, the Association opened a public subscription to build a theatre complete with library, art gallery and, if possible, Charles Flower's dream of an acting school. To boost

donations, anyone subscribing £100 or more was made a governor, and, optimistically but worthily, it was announced that any surplus would be used to assist 'poor and deserving members of the acting profession'.

Charles Flower set the pattern for the appeal by giving £1,000, but the response was disappointing; only another £1,000 was raised outside Stratford. Most of the money came from the Flower family and, it may be surmised, through the freemasons of the Heart of England Lodge, to which Charles Flower belonged. In November 1875, advertisements asked for designs for the theatre. Freestanding theatres were rare and the site was magnificent. The design of Dodgshun and Unsworth of Westminster that was accepted was bold, not concealing the fly tower, but making it a conspicuous part of a building which appeared like one of Ludwig II's castles with curious turrets and gables all faintly reminiscent, in an odd Victorian way, of Shakespeare's Globe.

The official opening of the theatre came on the Birthday in 1879, an event which most of the London critics either greeted with derision or ignored. 'Can it be imagined that the poet who sought in London the sphere for his intellectual life, stands in need of a Memorial which takes the shape of an addition to the list of petty provincial theatres?' asked one journalist, although others were more sympathetic. Charles Flower replied in caustic terms. 'It is true', he said. 'We are nobodies, but we have waited three hundred years for the somebodies to do something and they have not done it.' The theatre, at least, matched the taste of the age. Oscar Wilde regarded it as 'a beautiful building, one of the loveliest erected in England for many years'.

The opening production was *Much Ado About Nothing*. Helen Faucit, now sixty-seven, was persuaded to come out of retirement to play Beatrice. Sarah Flower specially decorated her dressing room. This led to complications. Her Benedick, Barry Sullivan, demanded the same treatment or he would walk out. 'You, my dear', said Charles Flower placidly to his wife, 'must send across some silver candlesticks, vases of flowers, and a lace pincushion for Mr Sullivan'. The Flowers must have wondered what their theatre would involve. On a first night of driving rain, a capacity audience of 800 saw a performance that won general approval. 'Everything', wrote Helen Faucit, 'conspired to make the occasion happy'. It was a triumph for Charles Flower in his mayoral year.

The inaugural season saw the appearance of one of the Stratford stage's longest enduring characters. There were just two performances of *As You Like It* that year, in which Barry Sullivan played Jacques. They represented an opportunity for some Victorian realism. According to Sarah Flower, 'some of the actors went to Charlecote and asked Mr Lucy if he would let them have a deer from his park – he readily assented, and it was brought on this evening – his keepers and some dogs also appearing on the stage'.

This hapless beast became part of the Stratford tradition. It was stuffed and appeared in every production of the play for nearly forty years. When 'resting', it hung in the theatre picture gallery.

After this, various actor-managers, notably Edward Compton, who had played Claudio in that first *Much Ado* were engaged. The theatre did good business during the festivals and then was 'dark' for the rest of the year, except for the occasional visiting company. It was natural that Charles Flower's two enterprises should be interlinked. The box office was run by the cashiers from the brewery, and the scenery was stored in the bottling department. At first, there was only one permanent employee, Charles Rainbow, the custodian and a Stratfordian

who had been an inspector on the L&NWR. This experience proved useful in organising the railway excursions during the Spring Festival. Later, he was joined by his daughter, Alice, who seemed to manage everything from the box office to the bars.

The highlight of the early years came when the adulated young American actress Mary Anderson, who had spent two triumphant years on the London stage, announced her intention to make her debut as Rosalind at Stratford before returning to America. There was a scramble for tickets, despite prices being doubled. Every hotel was jammed. The performance received national critical acclaim. To commemorate the occasion, Miss Anderson commissioned two terracotta panels depicting Comedy and Tragedy, which stand above the Dress Circle entrance.

The School Board

In a reform that was long overdue, the borough boundaries were extended in 1879 to include Old Town, Shottery and Alveston. The division of the town into electoral wards diminished oligarchic power, although the public house parties, like a new one in the *One Elm*, which claimed to represent ratepayers, continued to exercise influence.

Appointing a new vicar proved a difficult process. The energy of Dr Collis had made the living less attractive to the placeseeker. His projects had added three unendowed churches to the parochial remit. The stipend was a mere £240 a year with the vicarage thrown in. Five candidates turned down the position, but in the summer of 1879, the Revd George Arbuthnot, a man of independent means, was preferred. He was a priest whose High Churchmanship and militancy made him a natural successor to Dr Collis. He was a fine and fearless preacher. Although he was accused of many things, no one ever called him dull. His style was trenchant, his grammar faultless, his reasoning cogent and his delivery polished and full of life and spirit. As an embattled and impetuous defender of what he regarded as revealed truth, he was respected and feared, but never loved. He was no stranger to controversy. In his previous incumbency at Arundel, he had had a run-in with the Catholic Duke of Norfolk over the custody of the family chapel. Among his first acts at Stratford was the restoration of the surpliced choir, the donation of the offertory to the memorial fund for the great apostle of the Oxford Movement, Edward Pusey, and the abolition of private sittings, an action he justified on grounds of social equality.

Anyone who thought that George Arbuthnot would have been mellowed after the controversy at Arundel was soon disabused. In February 1880, a young man who had sung in the choir at Holy Trinity took part in a service of song at the Baptist chapel. He received a note from the vicar telling him that if he did it again he would ask for his resignation from the choir. At evensong that week, the vicar told the congregation that he had been appointed by divine authority. 'I think this is a mistake', wrote a correspondent to the *Herald*, 'as I understand that Lord Sackville sent him, without asking the parishioners whether they liked him or not.'

Arbuthnot's campaigning talents were soon exercised in educational controversy. Enforced school attendance after 1878 placed great strain on Stratford's exclusively voluntary system. Two years later, the powers of the Education Department were stiffened to enable it to withhold grants from inadequate schools. The first casualty was Sarah Flower's little Masonic school. Her grant was withdrawn because it had a stone floor, which she believed kept the air

fresh, 'so different to the close, dirty smell that a quantity must occasion on a boarded floor'. She had the sad task of announcing the closure to the parents. 'There was much lamentation, the poor mothers begging me to go on with it – they could not pay the larger fees of the other schools and they always liked Miss Barwood. I felt sorry, for it has been a great source of pleasure and interest to me. The needlework was distributed by lottery amongst the mothers and I managed for every mother to have something to take away'.

Sarah held a party for the children on her lawn. Rita and Fordham, her niece and nephew, helped to dress the figure of Mrs Jumbo, sitting on a tea box of bran from which sweets were dispensed. Fordham gave a magic lantern show and the children sang. Sarah presented a delighted Miss Barwood with a tea set. When everybody had left, she felt sad that her 'happy little school' was no more.

Next year, the department refused further grants to the British School because of its unsatisfactory premises. A closure date was announced and, since the voluntary societies could no longer provide sufficient school places, Stratford was legally obliged to elect a School Board. The Church Party dominated the first election in 1881. Local Anglicans feared that the proposed new Board School, with its heavy government subsidy would threaten the status of their National School. The main issue in the election, however, was the fear that the provision of a Board School would be a costly burden on the rates.

As a temporary measure, the British School reopened as the Board School, but the department insisted that a new school for at least 400 children would have to be built. The Church Party countered this by offering to extend the National School, but the Department threatened to use its powers to dismiss the Board, unless it undertook to build an adequate new school. At the 5th of November Supper, Alderman Robert Gibbs proposed the toast 'Success to the Stratford School Board', although his speech made clear his social perspectives. 'If we are to have "Hewers of wood and drawers of water" it seems almost a mistake to give them a classical education, because, if we do, they think they are good for something better'.

A public meeting on the issue was held at the Town Hall. Leaflets were circulated containing spurious claims about the cost of the new building. When the blood of ratepayers is up, it is up indeed. The meeting was stormy. The few dissenting speakers were shouted down. Steam was let off, but nothing achieved against the inexorable demands of the department. The Board School was opened in 1883 in Broad Street and continues to be in use to this day.

The School Board elections presented the riotous with a new opportunity for uproarious assembly. A turbulent meeting of candidates was held at the Town Hall in March 1884. Two-thirds of the packed audience were under voting age. They were disorderly, but impartial, cheering and hissing without discrimination. When they got bored with this, they started to throw chairs about. The Church Party again won a majority, demonstrating an impressive power to turn out its vote – there was little difference between its highest and lowest candidates. The issue was polarising the town on denominational lines. The headstrong vicar even used his influence to prevent dissenting ministers visiting patients in the hospital, where he was a governor. An Anglican lady rejected the opportunity to move into lodgings on the Birmingham Road because they overlooked the Methodist church. When a Nonconformist lady engaged a maidservant from an outlying village, the family was visited by their vicar, who tried to dissuade her from taking the situation. The leading Baptist, Fred Winter, complained

that he often heard of cases of distress 'where all kinds of assistance are refused, because the parents happen to send their children to the Board School'. The lodging housekeeper, Caroline Cook, believed in keeping in with the church. 'There's no pickins from Chapel.' When the vicar asked little George Hewin why the Sunday school was so popular, his hand shot up. 'Please sir, cos of the Clothing Club!'

The advent of compulsory education brought difficulties to poor families that had trouble finding the required 2d per child per week – and most families had more than one child. 'Very few of the labouring population are in a position to pay', declared a correspondent to the *Herald* during the disastrous summer of 1888. There were cases where the weekly earnings were less than 5s. 'To ask for school fees out of that miserable sum is sheer cruelty.' Survival was an uphill task for a labourer with a family of four children on the standard wage of 13s a week. Clothing cost at least 3s 11d a week. Rent was 2s; school fees, 8d; 2cwt of coal, 1s 10d; candles, 3d; five loaves, 2s 1d; ½lb of butter, 8d; ¼lb tea, 7½d; 3lb sugar, 7½d; ½lb cheese, 4d – and the total was already 13s. Those with gardens grew vegetables and some people kept a pig, their only regular source of meat. Other items were 'pinched out'. Prudent fathers paid 6d a week into a Benefit Club. Work lost in bad weather cost a labourer an average of 6d a day. Then there was the replacement of household items and the rates. Where the money came from was a mystery, although some wives found work to enhance the family budget. Items like church collections, postage, books, newspapers, beer and tobacco passed into the realm of luxury.

In theory, help could be sought from the Guardians of the Poor, but this entailed a means test that could reduce an applicant to pauperdom. In any case, the Guardians rejected virtually every application for help with school fees, including one in 1885 from a woman whose husband had been unemployed for three weeks and who had no money and little food.

Child labour was often a necessity. The father of eleven-year-old Florence White was fined 1s after she went 'leazing'at harvest-time. Many children ran errands before school and were kept by the tradesmen until the last minute, when they rushed off dirty and tired. On Tuesdays, children were sent by their parents to queue at the soup kitchen. Father Fazakerley complained that a tenth of the pupils at the Catholic School were absent on that day. George Hewins recalled that, at the National School,

> Once you'd paid they didn't care if you didn't go in again till next Monday. If it was raining or the
> steeplechases, or peapicking, a lot of us didn't. The School Attendance Officer, he never troubled
> once your money was paid in. And plenty o' kiddies spent a penny or ha'penny of it on jibber
> and jumbles afore they got to school. They had a good swipe o' the cane: the teacher told them to
> bring another ha'penny quick! 'The older the boy the greater the ass,' he shouted.

Parents charged with the non-payment of fees often protested that their children had spent the money on the way to school.

The vicar had firm views on truancy:

> Nothing can be more distressing than to hear a parent confess that his or her children will
> not go to school, although they are regularly sent and all the persuasion in the world fails in
> inducing them to attend. Of course this is a confession that the child rules the home and not the

parent. Scores of instances are before our magistrates in the course of a year in which the pitiable spectacle is presented of children setting at defiance the authority of their parents. Kindness to such youngsters is thrown away, and if persisted in will result in their ruin. A good flogging is the best means of reaching an obstinate child.

The school-leaving age was thirteen, but those reaching the necessary standards (Standard 5) could leave before then. Most left as soon as possible. Either their earnings were needed, or they went into the world to reduce the family budget. In any case, the restricted nature of the curriculum ensured that there was little left to learn. Only two out of a sample thirty-six from the boys' intake of 1884 passed on to Standard 6, probably becoming pupil teachers. When the School of Art offered twelve reduced fee scholarships to pupils in elementary schools, there were no takers. The *Herald* fumed about lack of ambition, but lack of money was a more likely cause.

Outside the classroom, the main activity for boys of the National School was drill. They stomped around the vicar's field in companies of four, to the barked orders of a former sergeant-major, holding staves for rifles. This was regarded as important character training, 'making the lads smart at their work, as well as fine in their appearance, and it will tell on the future by making them grow up stalwart and healthy men'.

Yet schooldays could be a sojourn before the cares of the world, a time when relationships were untainted by the necessity for survival. Real affection could exist between teacher and pupils. When Miss Lydia Neall left the Girls' National School to get married, her pupils presented her with an engraved clock. Many shed floods of tears, which did not stop even when the vicar assured them that they could call on her in her new home.

The Grammar School was improving under a new headmaster, the Revd R. de Courcy Laffan, who introduced new courses and revolutionary innovations like organised games. On his appointment in 1885, the school had less than forty pupils, but on his departure to become headmaster of Cheltenham College, there were over 100.

The Choir School, so-called because the vicar subsidised the fees of the choirboys, was founded in 1881. It provided an education to fit a boy for a career in business, thus a great stress was placed on mathematics. It was located in the vicar's schoolroom at 'The Firs' and the boys played in his field when the National School boy were not drilling there. Boarders lodged with the headmaster, John Priest, at his home in Guild Street. The vicar ruthlessly expelled any choirboy guilty of what he deemed to be unseemly conduct during services. In 1890, he fell out with Priest. The schoolroom was closed and the choristers given scholarships to the Grammar School. Priest transferred his renamed 'Commercial School' to premises in Greenhill Street. The vicar's antipathy erupted at the diocesan religious examination. The Rural Dean had instructed Priest to take his boys to the National School for it. When they arrived, the door was locked. After repeated knocking, a teacher appeared at a window and refused admission. Priest demanded to see the vicar. When that formidable figure appeared, he refused entry and sent for a policeman. Mr Priest retreated, but at least had the satisfaction of reading the *Herald's* description of his adversary as 'a self-willed and intractable man'.

17

'No Hope of Escape'

There is no hope of escape for a reckless and degraded peasantry except by emigration to foreign lands.

Local clergyman, 1870.

The Door of the Workhouse

For the poor that lost the unequal struggle for survival, the door of the workhouse beckoned. A visitor in 1875 considered it as 'unlike the workhouse of 50 years ago as can be. It would literally astonish anyone not having watched the gradual but slow change.' The institution, variously known as 'The House of Rest', '50, Arden Street' and 'The Grubber', was run on strict utilitarian lines. Stringent regulations applied to everything. It was surely no coincidence that a favoured hymn for the paupers was 'Thy Will be Done'. 'People are admitted', declared the chairman of the Guardians, 'to maintain an existence, nothing more.' The inmates' dreary hours were unrelieved 'by a single ray of sunshine', actual or metaphorical. The doors were open for the old and infirm and they were urged to go into the garden, but they preferred to sit around the fireplace. Younger inmates were not allowed out, the women were regarded as 'fallen' and the officers disclaimed responsibility for overseeing them in anything other than a restrictive way.

The children suffered the same fate. There were around thirty-five of them aged between four and fourteen. They received education in four groups from the schoolmistress. The girls wore long pinafores with 'STRATFORD-UPON-AVON WORKHOUSE' emblazoned on them in big red letters. The only time they saw outside the walls of the house was when they went for a walk twice a week in a long crocodile. No toys were provided for them. When the older children sought positions in service, they were generally greatly disadvantaged by their shyness and dullness, only having known the world of the workhouse. Attempts were made, notably by the Revd George Arbuthnott, to send the children to local schools, but the argument that they would be persecuted or corrupted by the other children prevailed until 1891, when they began to trot off each morning to the National School. Sadly, they did have a hard time, with the town children shouting 'Workus brats' after them. In the same year, horizons were expanded further, with the opening of an industrial home in College Street, training girls for domestic service. From 1897, the workhouse boys were at liberty to play on the Recreation Ground and mix freely with other children. 'The change', it was felt, 'will undoubtedly do them good, besides making them happy.'

Dickensian scandals rippled periodically through the workhouse, particularly after meetings of the Board were opened to the press in 1870. In that year, Mary Berry, a young pauper mother, died

of pleurisy in dank surroundings attended only by her child. To conceal his negligence, the master omitted to register her death. The matter was raised at the Board and the master, tramp-wardsmen and surgeon resigned. The next master, Mr Bagley, left in 1876 after Miss Clarke, the schoolmistress, complained of his cruelty to the children. Two years later, she went after similar accusations were made against her. In 1890, Emma Rawlings, the pregnant wife of a farm labourer, was brought in from Hatton Rock, suffering from severe burns. Her wounds were dressed at the Recovery Hospital, but she was not admitted. There followed a further jolting ride to the workhouse, where the master turned her away because she did not have an admission order. She was then taken to the house of the Receiving Officer, who refused a note because she lived outside his district, but eventually relented. She died a few days later. There was great outrage locally. At the inquest, the jury censured the master for his 'disgraceful neglect of duty' and he was obliged to resign.

The Guardians did little about abuses until they were too conspicuous to ignore. Their visits were always pre-announced. Even when they tried to be conscientious, they got very little help from the officials. On one occasion, a government inspector upbraided them for wasting time discussing the deaths of two old men in the workhouse two months before.

Many would do anything rather than endure the workhouse, which, of course, was one of the objects of its constitution. In 1889, a Guardian, the Revd Oswald Mordaunt, successfully proposed the abolition of outdoor relief for the able-bodied, thereby reviving the notorious 'Speenhamland System' which Dickens had attacked in *Oliver Twist*. Fred Winter, the Baptist draper, made a splendid and passionate speech opposing this. It was their duty to do all they could to alleviate the sufferings of the less fortunate:

> Not to rack their brains to find new hardships to put upon them and to add to their already hard lot by telling them 'there is no relief outside the workhouse'. 'Offering the house' is a very easy, off-hand way of getting rid of a poor applicant, but think what that involves. The house must be broken up, the little furniture, which had been got together bit by bit at much sacrifice, must be sold, the children separated from their natural guardians and handed over to officials ... some gentlemen, by their actions, seemed to think there could be no love amongst the poor for their offspring, and they could be put off with anything.

Mr Winter recalled the lines of Thomas Hood. 'Rattle his bones over the stones, / He's just a pauper whom nobody owns'.

Anyone advocating such a system must have a heart of stone and, as long as he sat on that Board he would do his best to frustrate and overthrow it.

Yet Stratford seems to have treated its poor better than the neighbouring towns, despite the fact that one in twenty of the population was classified as a pauper, against one in forty at Warwick and one in fifty-eight at Solihull. Yet the town spent 4s 1¾d on each pauper, compared to 2s 8½d at Warwick and 1s 9¼d at Solihull. The *Herald* was dubious about such generosity. 'Either relief must be given with a more sparing hand', it fulminated, 'or the Stratford Union must contain a much larger number of needy persons.'

The one 'real day of happiness' came at Christmas, to which the inmates looked forward for weeks. Roast beef, plum pudding, ale, tobacco for the men and snuff for the women were in plentiful supply, and a Christmas tree was hung with presents for the children. The dining

hall, usually chillingly bare, was festooned with decorations. Such was the public interest in this annual respite for the paupers that the local press always carried an account of it.

The conviviality of the occasion was diminished in 1896, when ale was banned at the Christmas dinner, through the influence of the temperance lobby led by the vicar, who claimed that no teetotaller had ever been admitted to the Stratford Workhouse. Some inmates, through judicious exchange, had been obtaining more than their ration and their resultant boisterous behaviour had upset several of the Guardians. In compensation, the vicar provided tea and tobacco. The change did not give unqualified satisfaction. One old man, when asked for a song, replied that he could not sing on cold water. The 'beer question' was to be an annual issue at Board meetings.

Occasional social evenings broke the monotony of workhouse life. In 1892, a pauper child, 'Little Nellie Allibone', recited the long and difficult poem, 'Robert of Sicily'. Such songs as 'How did you leave the Pigs?' and 'The Farmer's Boy' appealed to the old country folk. Just before the national anthem, Mrs Frisby, an aged inmate, sang 'Far Away', which deeply moved the other old residents.

The workhouse abounded in old characters with clear memories of bygone days. Many were living history, like John Adams who enlisted in the 37th Regiment of Foot at Stratford when he was seventeen. He served all through the Indian Mutiny and entered Lucknow with the relief Army of Gen. Haveluck.

The longevity of the residents was a byword and folk pointed to the workhouse diet as demonstrating that plain fare was best for health. Doyen of them all was William Stanley, who celebrated his 100th birthday in 1904, sitting up in bed with a mug of stout in one hand and a seasoned briar in the other. Known as 'The Duke' because of his strong resemblance to the Duke of Wellington, he had followed variously the occupations of farm-labourer, tinker, sawyer and carrier. Seemingly indestructible, he died in his 102nd year.

Another resident celebrated for her longevity was Lucy Freeman. As a child, she was declared an 'imbecile' and sent to the old workhouse in Henley Street. She was wonderfully active and up to her eightieth year worked in the workhouse laundry. She loved children and it was reckoned that the number of little paupers she had nursed was in the hundreds. For months before the Mop, she saved her pennies to buy them toys. Visitors made a point of asking to see her and she rarely allowed such an occasion to pass without demonstrating a few dainty dancing steps from another era. She spent her last years in the infirmary. Her end, in 1911, at the age of ninety, was peaceful and unexpected. She was about to eat her lunch, 'when she fell back into that gentle sleep from which there is no awakening'.

The Union ministered to passing vagrants who slept on coconut-matting hammocks in the casual wards. Some were walking the country in search of work, but others were 'professional mouchers' who spent their lives in aimless travel from workhouse to workhouse. In wet weather, the wards were generally full, but numbers dwindled during hot spells, the travellers preferring to sleep in the hedgerows rather than in the close and stuffy wards. On arrival, they were searched and any money found on them was taken for Union funds. Most hid their cash and tobacco in a convenient hedgerow and collected it on their departure. They were asked their name, age and occupation, where they had spent the previous night and where they intended going on to. Seven out of eight men described themselves as labourers. The

remainder were usually looking for work and represented a wide variety of trades. Most of the women called themselves 'field women' or 'charwomen'. The questioning over, they were given 8oz of coarse bread and sent to take a bath. Contrary to popular belief, the tramps revelled in a good splash and had a strong affection for carbolic soap. Undressing was an elaborate ritual. The tramps seldom wore shirts and preferred 'toe-rags' to socks. They did not use buttons, but held their clothing together with string. By special request clothing could be 'stoved' (fumigated) overnight.

The tramps rose at an early hour and were given bread and oatmeal. They then performed an obligatory task, perhaps joining the residents in oakum-picking, sawing wood, pounding stone, or working four at a time at the pump.

The tramp wards were full of characters. Some appeared to have known better times. Once, a disguised journalist, sleeping in the Stratford Workhouse, encountered a tramp of striking individuality and intelligence, who always wore a clean collar. 'He was a man of few words, but when he did speak, the educated gentleman was at once revealed. I have no doubt that at one time he had occupied a superior position in the world. This was indicated in his mould of mind and every lineament. What tragic and unavoidable cause had brought him to this depth, I know not, but I respected his reserve as a Gentleman ought to do.'

Tramping was a way of life that lasted till death. One spring, Emma Messenger, aged sixty-seven, was found dead under a hedge on the Warwick Road. Walking with two sticks, she had taken three days to journey the 12 miles from Shipston, sleeping in hedge bottoms, with no choice but to creep on to her next destination. Whole families tramped the roads. Tiny children walked between workhouses as their parents followed the harvest seasons. It was common to see them sitting by the road, patching their shoes. In the summer of 1898, William and Mary Fisher, 'habitual tramps', left their slum lodgings in Leamington and walked their four eldest children to Stratford workhouse, where the four year-old had been born. The baby, Harriet, aged eighteen months, was pushed in a battered pram. She was ill on arrival and they asked to see a nurse. The assistant matron felt the child's pulse and said she seemed very ill, but they were told that nothing could be done until the head nurse came in later. Next morning, the family walked the 8 miles to Alcester. When they arrived at the workhouse, the baby was very ill. The nurse gave her two spoonfuls of brandy as she lay in the lap of Margaret Glover, a 'mouching' widow who had walked with the family from Stratford. She was about to give her a third when the poor child died. At the inquest, it was stated that she was emaciated, with a large sore behind her ear and an empty stomach. The verdict was that death was caused by exhaustion, caused by lack of attention and under-nourishment. The jury expressed concern about the apparent indifference to the baby's plight at Stratford Workhouse. Subsequently, the Fishers were sentenced to six months' hard labour for child neglect.

The lesson of this sad case seems to have been learned. The next year, a child who had tramped from Worcester with bad legs was sent straight to the infirmary and the case was reported to the Society for the Prevention of Cruelty to Children. In 1902, the Guardians resolved to deprive tramps of the control of children under fourteen and to send them to a certified industrial school at public expense until they were sixteen.

Travellers who could afford their modest fees, and who preferred greater freedom, used common lodging houses. If a policeman met 'a superior sort o' travelling man looking for a

bed he might direct them to Caroline Cook's on Waterside.' Rougher customers were pointed over the bridge to Mr Hoare's, behind The Shoulder of Mutton. It was what was known locally as a 'padding ken'. George Hewins remembered characters like Sam the Pig Poker. '"Sam, Sam, dirty old man", we hollered after him "Washed 'is face, in the frying pan"'...

He used to chase us with his frying pan! He was a beggar, pea-picker, scrap iron, rags, bones, anything. Tramps in those days had to earn a living. One of them had a Russian bear, twice as tall as me, a great fat thing. We kept back when we saw that bear! He came every year to Stratford – they knowed places where they'd done well – and slept at the *Shoulder of Mutton*, in the stable. He was a regular Russian tramp, with baggy trousers and ribbons hanging down. He'd got no musical instrument, just talked to the bear in his way and it danced! Then he went round with his hat for money. The bear grunted and pulled on its chain and we ran off. We'd heard tell that that bear ate a little girl called Laura Edkins once upon a time.

Hoare's was a riotous house. After the police broke up a drunken brawl there, cries of 'Murder' were heard next morning. Mr Hoare was beating up his wife. Four inmates later appeared in court. When Hoare was called, he was too drunk to testify. Mrs Hoare appeared with two black eyes and said firmly, 'I shall not prosecute, gentlemen. No one saw him assault me, so you cannot do anything.'

Complaints were frequent about 'lazy and dirty-looking fellows' prowling the streets, begging for 'a bit o' bread', in cringing tones. They were especially offensive to women, sometimes threatening violence and usually calling when the men were out. Once, when police Supt Simmonds answered his door while off-duty, Samuel Bond, a professional beggar, handed him a fake subscription list. The vicar was down for 2s 6d, but his name was misspelt. 'You have come to the wrong door', said Simmonds, and escorted him to the police station.

Others used the subtler and safer approach of the Royal Mail. Stratfordians would receive pleading missives from such unfortunates as José, the Spanish prisoner, jailed unjustly for bankruptcy and needing financial help to recover 1,200,000 francs, deposited at a French railway station. The proceeds would, of course, be shared with anyone aiding him.

Then there were the local 'slaves of the lamposts', who gathered at Bridgefoot and offended ladies with their foul language. Yet even the poorest possessed the consolations afforded by man's best friend. 'Persons who have to struggle for a livelihood', observed the *Herald*, 'as well as the idle and dissolute, all keep a cur of some sort.' The streets swarmed with mongrels of 'every degree of ugliness and filthiness. From the costly carpets and fancy goods exhibited at the draper's shop door, down to the humble hamper of celery at the greengrocer's, nothing escapes their indelicate attention.'

Yet there was an alternative to pauperdom. 'There is no hope of escape', wrote a local parson, 'for a reckless and degraded peasantry except by emigration to foreign lands or manufacturing districts, which will take away the strong, the healthy and the brave and leave us the cripple, the drunkard and the beggar.' Societies to encourage emigration wrote to the *Herald*. The Agent for the Government of Tasmania lectured on 'this charming colony and the opening it presents for intending Emigrants'. During the agricultural slump of the 1870s,

the Warwickshire Union of Agricultural Labourers encouraged its members to emigrate to places as distant as Brazil, Canada and Queensland. The Board of Guardians started to send paupers overseas, in 1870 providing £6 for Ben.Whiston to go to Canada. There was self-interest in the decision. He had been sent to Warwick Gaol for misbehaviour in the workhouse. Canada was a popular destination and workhouse children were sent there to farm colonies. The fate of those placed nearer home roused concern. The *Herald* expressed grave doubts about sending boys to join the deep-sea fishing fleet. 'If the Guardians of the Stratford Union have any regard for the future comfort and well-being of the lads committed to their charge they will not apprentice them to Grimsby fishermen. It would be a great deal more merciful to keep them in the workhouse for life.' The sentiment was not endorsed by some of the lads at Grimsby. 'I am not apprenticed now', wrote Joseph Dyde from the Fisherlad's Institute, 'for my master failed and gave me my papers. I am earning 12s a week in a trawler. All the lads from the Union are getting on very well. H. Burden was down at Iceland seventeen weeks last year, and was frozen in the ice six weeks. Frank Pratt is out of his time, and has gone down to Scotland for eight weeks and I am tired of fishing. Me and Burden are going to Hull to engage ourselves on a steamship, about 2,963 tons, as engineers' stewards, and are going to America.'

The urge to spread over the globe led to rare adventures. After The Swan was demolished, John Williams, the landlord, became a Major in the U.S. Army, serving in India. William Monk was sergeant-major in Garibaldi's British Legion, marching under a 'hot broiling sun and nothing to eat ... and water could not be obtained for love or money.' Others took the 'Queen's Shilling'. Pte George Turvey of Russell Court served on the expedition to relieve Gordon at Khartoum. The Mop was a fruitful place for the recruiting sergeant. In his gaily-bedecked cap, he mingled with those plying for hire in search of impetuous youths.

A Quiet Thoroughfare

Despite the altercations of the desperate, to the casual visitor, Stratford was a sleepy place. For the townsman of moderate outlook and respectable habits, life was uneventful. Where some saw teeming alleys and dire poverty, others observed picturesque streets. For the editor of the *Herald* in 1868, the greatest hazards were those dangerous innovations, bicycles and velocipedes, which added to the existing perils of perambulators.

Miss F. D. Rowley, daughter of the police superintendent, remembered Sheep Street in the 1870s as a quiet thoroughfare, except on market days, when farmers used the stables behind the Shakespeare. Breeders, notably Mr Wynn of Ryon Hill, used the streets to show their horses. It was a great delight for little Miss Rowley to 'watch the beautiful creatures charging along the roadway, while their red-faced, shiny pated owner, with coat tails flying, vigorously rattled his whip stock inside his top hat to make them show off their paces as he raced up and down the streets after them.' This picturesque old custom was, astonishingly, curtailed by prudery. In 1892, George Rathbone, a groom in the employ of Mr J. Charles of Wellesbourne, was summoned for exposing a stallion to show in the High Street. Supt Simmons stated that he had received several complaints about such 'indecent exhibitions', although he conceded

that it had long been the practice. Although the case was dismissed, costs were awarded against the defendant, which effectively ended the practice.

Miss Rowley recalled that the streets were metalled with stone sand.

It had a lovely ochre tint and the deflected light from it on a sunny day had a wonderful effect on the appearance of the old houses. But oh, the clouds of dust that settled on a windy one! The tarmac stopped all that, but it also brought an end to the little colony of swallows who made their houses in the arched window heads of the old Town Hall, sometimes 2 or 3 nests in each window.

Often when the road was dry and dusty in the early Spring, Harris the day man (a kindly soul and very fond of animals) would come round to say 'swallows have come sir, and the road is dry, shall I throw some water down?' – and then passers-by had the unusual sight of a policeman swilling the roadway with water to provide 'mud-pies' for the swallows!

On Sunday mornings the smell of sweet, newly-made bread from old Mr Tustain's spotless little shop pervaded the street. In the evening, tradesmen took their horses and ponies for 'a freshener' in the cool of the flowing river… what a flurry of hooves and splashing of waterdrops as the lads and men whistling and shouting took them scampering up Southern Lane to their well-earned rest in the quiet fields.

Sheep Street had its characters, like 'Old Nance', whose 'honesty, sobriety and good name never seemed in question', yet who was an 'absolutely perfect example of the good-humoured slattern. 'To see her racing for a ring-side seat at anything promising entertainment – (weddings, funerals, elections – anything which drew a crowd was all 'fish to her net') – was a sight to behold. She wore a marvellous bonnet with roses and feathers on top and long strings flying behind her, but how on earth she kept the thing on her head, perched as it was, nearly on the back of it, was a mystery!'

There were great survivors like 'the well-known driver of the 'Shakespeare Bus', John Walker, a tall sturdy-looking elderly man with bowed shoulders. 'With his russet face and grizzled hair and side whiskers, and, in his cut-away coat, breeches and low-crowned bowler hat, he was a typical figure of the … coaching period.'

Most houses had privies up the yard. In poorer localities these were frequently shared with the neighbours and they could be 'three headers' at which the users sat side-by-side. The night soil would be emptied into a bucket known as a 'midden'. Each night it was placed outside the front door. People coming home late had to be careful they didn't knock them over. In the early hours, the 'midnight milkman' would come round the town in his cart and empty them. His load was either dumped on the land as a fertiliser, or less ecologically, into the River Avon at the Wash down Southern Lane.

Home Rule

A Nonconformist Association was formed in 1885. At its inaugural meeting, the chairman, Alderman Newton, said that probably every member was prepared to work for the Liberal Party.

The Revd George Arbuthnot resisted the converse identification of the Church with the Tories, declining an invitation to speak at the annual dinner of the Conservative Working Men's Club. 'I consider that a clergyman's presence at a political meeting is a great mistake. I am quite certain that those who take an active part in politics greatly diminish their influence with their people.'

The vicar's fears were not shared by the priest-chaplain, the Revd Frank Smith, a low-church Irish Tory, who attended the dinner instead. His speech caused great offence, the *Herald* declaring that the toast of 'Church and State' always provided the opportunity for 'some enthusiastic churchman to have a go at his dissenting fellow countrymen'.

The election of 1885 was the first in which rural labourers were enfranchised. Together with boundary changes, this gave the Liberals their best hope for years. The opening shot of the campaign came when a Mr Walter upset the local Tories by advising voters to wear Tory colours, ride to the poll in Tory carriages and then vote Liberal! In return, the Liberals accused the ladies of the Primrose League of canvassing poor voters with extravagant promises.

The Liberals possessed an attractive candidate in Lord William Compton of Compton Wynyates. A radical philanthropist, he had assisted at London's first welfare settlement at Toynbee Hall. During the election, the Tories claimed that his support for free education meant that he was a communist, but the combination of patrician aristocrat and enfranchised labourer proved irresistible. Lord William's eve-of-poll meeting was the largest political gathering ever seen in Stratford. At the declaration, a large excited crowd heard that he had won the seat by 4,639 votes to 3,738. Sarah Flower, who had worked hard for the Liberals, thought how happy he and his young wife looked as they stood on the steps of the Town Hall.

The reforming hopes and fears engendered by Gladstone's Third Ministry emerged at a meeting of the Church Defence Movement, which opposed disestablishment, a month after the election. A few weeks later, Lord William upbraided republican elements within the Liberal Association. The great question was whether the Irish Home Rule Bill would bring down the Government. The crisis emerged in the Liberal Association during May 1886. Most of the leading members opposed the Bill, including the president, Mr R. N. Phillips, the philanthropic owner of Welcombe House, a Lancashire industrialist who was a founder of the Anti-Corn Law League; his son-in-law, Sir George Trevelyan, the president of the Board of Trade, and the Earl of Camperdown, who as Lord Duncan had fought the seat for the Liberals in 1865. Public feeling, observed the *Herald*, had rarely run so high. A week later it reported the Government's defeat and dissolution. Lord William Compton had voted with his leader.

It was inevitable that the Flowers would split with their party over the Irish issue. They were closely associated with the leader of the Liberal Unionists, Joseph Chamberlain. John Bright, the great Liberal statesman, who also split with Gladstone, was a frequent guest at 'Avonbank'. His daughter was married to a stepson of Dr Collis. 'He loves to sit in the Palm House with a cigar and a cup of coffee', wrote Sarah Flower, 'to be surrounded by us all and to go on talking and it is delightful to listen to him.'

Another factor in the Flowers' disillusion was the increasing identification of the Liberals with religious nonconformity and, with it, the Temperance Movement, but they felt no personal animosity to Lord William Compton. Edgar described him from a Unionist platform as 'a man who, above all others, has a high motive of duty, one who has so unselfishly worked

in the slums of the East End of London and elsewhere for the improvement and alleviation of suffering among his poorer neighbours.' The Conservative, Frederick Townsend of Honnington Hall, was less inspiring. He was introduced at a Tory meeting as 'no orator, but one of those great and worthy and silent workers.' Lord William fought hard to keep the seat, facing the major issue head on. 'You have to decide', he told the electors, 'whether we shall grant Self Government to Ireland with proper safeguards, or whether we shall continue to misgovern that country, with the help of Coercive and Repressive Measures.' His campaign had its lighter moments. This attractive man sang very well and enlivened meetings with his rendition of 'Upon the Danube River'. When the delighted audience called for an encore, he responded with 'The Midshipmite', before leading them in the national anthem and cheers for the 'Grand Old Man'. Yet the forces against him were too great, Townsend gaining the verdict by 469 votes. Prolonged cheering and groans greeted the announcement at the Town Hall.

The Liberals soon found Lord William a safe seat at Barnsley. On the deaths of his elder brother and father in rapid succession, he went into the Lords as Marquis of Northampton and held Cabinet office in several Liberal administrations. He continued his interest in Stratford, where he often appeared on public platforms supporting liberal causes.

The vicar fought a good election campaign, taking advantage of the interest aroused to expound what Church and State should be doing. 'It is all very well,' he declared, 'to take an interest in the labourer at election time when his vote is required, but Christ's law requires an interest at all times.' There were cottages in Stratford that were 'a disgrace to the civilisation of this nineteenth century'. A severe winter had revealed the wretchedness in which many of their poor neighbours lived. They had done well to institute soup kitchens and other relieving agencies, but were these just palliatives? The answer was less radical than the analysis. Shut some of the public houses and start a crusade against drink and immorality.

Perhaps George Arbuthnot received criticism for this analysis, or perhaps he thought more deeply on the subject. A few months later he returned to the theme. The soup kitchen was indeed a palliative, but what was the solution? 'The proper remedy is to increase the wages, not to dole out charity in Winter. Do not ask the employer to give charity to men willing to work instead of a fair wage. Do not tempt a man to sooth his conscience by subscribing a few shillings when he ought to be spending some pounds. Such "relief", so called, cannot succeed in the long run. As well try to turn our river aside with a few barrow loads of earth.'

The vicar's social programme was now well considered. Why not use the money subscribed for the soup kitchen to provide work? The streets needed cleaning, a recreation ground was to be laid out, why not put the men to work on these at once? Instead of giving away bread and soup to paupers, why not prevent people reaching that stage by subsidising the price of their bread? 'The payment of a sum of money – be it ever so small – saves the loss of self-respect, which so many unconsciously suffer by accepting year after year a dole of charity … My heart bleeds at this season', he added with undoubted sincerity, 'for the wants of many of my *people*.'

Blood and Fire

During the Home Rule election, the attention of Stratfordians was diverted by a new phenomenon. A contingent of Salvationists arrived to commence an onslaught against 'sin and the devil'. They made a big impact. The Clerk of the magistrates' court interrupted proceedings to complain about being woken up at 5 a.m. by lusty hymn singing. Whoever this was, was freelance, for the Salvation Army denied that it had authorised anyone to hold services in Stratford, but the enthusiasts were mere presages of the real thing. In September an official group arrived. The *Herald* was hostile. 'To see half-a-dozen slatternly girls, with perhaps a similar number of unkempt boys, trying to preserve military order, and hear them howling questionable hymns during their progress through the streets, gives rise to feelings the reverse of favourable to their proceedings.'

Yet despite, or perhaps because of, such publicity, the army was attracting crowds of two to three hundred to its Sunday meetings in the Rother Market. Complaints rolled in about its street corner meetings. 'I live in close proximity to the Parish Church', wrote one aggrieved citizen, 'and acting on an old adage, "the nearer to church the further from God", I suppose the "Army" consider the inhabitants of this particular quarter fit subjects.' Among the renditions in the half-hour serenade to tambourine accompaniment was 'You won't be right until you're saved', 'Mary Ann' and a song to the tune of 'Annie Lisle': 'Death is coming, surely coming, / And the Judgement Day, / Hasten sinner to your Saviour, / Seek the narrow way'.

An Army orator declared West Street the most spiritually destitute in Stratford. 'The result of this destitution', declared a resident, 'is that the band blares under our windows and the "soldiers" make the air hideous for about an hour on Sunday morning.'

The Army was undaunted by such criticism. In October 1887, Emma Booth, daughter of the renowned 'General', visited Stratford. Sunday started with 'knee drill' and meetings were held all day. Next evening, she presented the local corps with its 'Blood and Fire' banner, while a band of singers yelled a Salvationist ditty to a tambourine accompaniment. By 1890, sufficient interest had been raised in the Army for a railway excursion to be laid on for Mrs Booth's 'Promoted to Glory' service. In 1906, the great 'General' himself paid a visit. The *Herald*'s response demonstrated the respect that the sect had gained. 'Here is a man who has done more for the relief and raising of the submerged tenth than any man in England... The Salvationists are not numerous in Stratford. Their ways have not won over many converts, but the enthusiasm of the few enlisted under their banners affords a lesson which might be useful to other denominations.' The 'General' paid another visit in 1911 at the age of eighty-two.

There was one in Stratford whose enthusiasm matched that of the Salvationists. Inevitably the vicar weighed forth on the Army. Parishioners should not admit Salvationists to their homes. Courteously but firmly, they should refuse to buy *War Cry* and they never should be lured into argument. A Birmingham paper found it difficult to detect much charity in this approach, but it was rather that George Arbuthnot was uncompromising about what he saw as truth. On the Board of Guardians, he collaborated freely on common causes, notably with the Catholic priest, Father O'Brien, in efforts to get the children boarded out. When this was rejected, he said he would boycott meetings until a more humane approach was adopted. He could be equally aggressive with his fellow-churchmen. When the reactionary cleric, the Revd Oswald Mordaunt, declaimed on the virtues of thrift for the poor, he asked cryptically, 'Who

can be thrifty on ten shillings a week?' He had the sense and courage to see that there was no future for a church rooted in past privilege. In a sermon on 'Liberty, Equality and Fraternity', he attacked those who regarded the secret ballot as 'unmanly and un-English', commenting that such epithets usually came from those 'who would like to control the consciences and votes of those over whom they suppose they have control or influence!' Yet his pronouncements could border on absurdity. 'One of our greatest national sins', he told the congregation at Holy Trinity, 'is the sin of drunkenness; it is possible, to my mind, probable, that the influenza is sent to us as a punishment for it.' It was small wonder that Henry Labouchere, MP, editor of the radical journal, *Truth*, stated that he probably received 'a hundred complaints against the vicar of Stratford to one against any other cleric'. The churchwardens of Holy Trinity would earn his deep gratitude if they organised 'a Society for the Suppression of the Vicar'.

George Arbuthnot's great cause, for which his fervour bordered on the fanatic, was temperence. He saw his work as divided between the Church of England Temperance Society ('which worked on individuals and devoted itself ... to the promotion of the spiritual life') and the Temperance League, which he founded with ministers of other denominations to campaign for laws restricting the sale of drink and whose local objective was clear. There were 'too many public houses in Stratford-upon-Avon'. The programme was to campaign for local options on licensing, with no compensation for the publican if his license was not renewed. As a result, the licensed victuallers of Stratford formed an association in 1891 and announced that they would campaign against any Parliamentary candidate who stood against their interests.

Another area for denominational cooperation was 'the great work of moral purification'. Its vehicle was the local branch of the Vigilance Association, formed for 'the repression of vice and public immorality'. At the inaugural meeting, the treasurer, Mr Milton Chesterton, urged young men not to listen to listen to indecent conversation, whether in the workshop, the office, or in their daily lives. For once the vicar waxed mellow, making favourable comparisons of moral standards in Stratford and Birmingham. The Congregational minister, the Revd James Pugh, was unable to concur. Perhaps he was referring to the prostitutes who still frequented the town. The centre of vice had shifted to Meer Street, where there were several houses of 'ill-fame'. One was kept by Sarah Adams, a woman in her twenties. It had transpired that her 'husband', John Timms, was already married and he was imprisoned for bigamy. The couple continued to live together after his release. It was when he was in hospital for a spell that the house became a brothel. During Christmas week in 1891, the police noted the names of visitors to the premises. When proceedings were brought, the superintendent requested the bench's discretion about the list of clients. Many were in 'respectable positions' and several were married. Sarah Adams expressed her regret and said it would never have happened had 'the master' been at home. When the mayor suggested that there were other brothels in Meer Street, the superintendent said it was difficult to prove. In his youth, George Hewins used to visit a pretty whore called Poll there with his pals. Once when they hammered on the door she shouted, 'You'll 'ave to wait! I got somebody's give me sixpence – and you lads come 'ere wi' cocks like men for twopence!'

Yet sexual ignorance was still the prerogative of many. Annie Woodall, a maidservant in College Street, woke a fellow servant early one morning to tell her that she had had an awful fright. She had given birth to a baby that was found to be dead. She had fainted and not regained consciousness until after the birth. When asked why she did not call for help, she

replied that she had no idea of her condition. The child appeared weak, but there were no external marks of injury. The inquest attributed the death to lack of attention at birth.

According to contemporary norms, childlessness could be a reproach to married women. Peter Silver's grandmother told him that after she had been married and hadn't become pregnant she would cry herself to sleep with the shame of it. Her prayers were answered for she subsequently had eight children.

With the Swallows

'With the swallows', wrote a Stratfordian in the 1890s, 'come our American visitors. They are now to be seen, with Baedeker in hand, making notes and sometimes taking "snap shots" of the buildings.' The ever-improving transatlantic crossing was contributing to the American way of tourism. 'Although there visits are generally marked by express speed, they manage to leave some cash behind.'

The most distinguished visitor was the least inspiring. The Flowers were hosts to President Ulysses S. Grant and his wife in 1877. The famous general was 'very uninterested in everything he saw', in contrast to his former protagonist, the Confederate leader, Jefferson Davies, who showed great enthusiasm. The writer, Oliver Wendell Holmes, expected Shakespeare's image to be ever before local youngsters and was disappointed when he asked some boys fishing in the Avon about the poet. 'Boys turn around and look up with plentiful lack of intelligence in their countenances. "Don't you know who he was?" Boys look at each other, but confess ignorance. Let us try the universal stimulant of the human faculties. "Here are some pennies for the boy who will tell me what Mr Shakespeare was." The biggest boy finds his tongue at last! "He was a writer – he wrote plays." That was as much as I could get out of the youngling.'

Others had the opposite criticism. As the number of tourists increased so did the mercenary interest of the local lads. Visitors were accosted by urchins clamouring, 'Tell you all about Shakespeare for a penny.' An American journal, *Youth's Companion*, caught the rhythm of local speech.

'William Shykespeare, the gryte poet'. they are almost humming in chorus, 'was born at Stratford-on-Avon in 1564 – the 'ouse in which he dwelt may still be seen – 'is father in the gryte poet's boyhood was 'igh Bailiff of the plyce – one who shakes a spear is the meaning of 'is nyme' and so on, in an even monotone, undisturbed and tranquil, almost like a distant sound of bees.

That is about all the stranger can understand. The rest is lost in faint, incoherent mumblings, only an occasional word being at all intelligible. The boys do not look at anyone in particular. One gazes vacantly across the street, another at his shoes, still another at the sky, but all unite in telling the one weird tale. For it, of course, they expect to be tipped.

If the visitor ventured a question, the monologue stopped in full flow and started again at the beginning. 'There is never a laugh in its delivery, not even a smile. It is just a self-imposed duty – a ceremony bequeathed by one generation of Stratford boys to the next.' Visitors to Anne Hathaway's Cottage were not overlooked. There were a number of children from Shottery School who seemed always to be there, trying to get visitors to buy wildflowers they had picked.

As always, the Stratfordians could be as put upon as they put upon others. In 1887, to commemorate the Queen's Golden Jubilee, a wealthy Philadelphian, George W. Childs, presented a clock tower, the American Fountain, which stands in Rother Street. Soon after its unveiling by the celebrated actor, Henry Irving, a charming young man presented himself in the town, claiming to be Mr Child's nephew, sent to inspect his uncle's gift. He was entertained royally and relieved several local worthies of substantial 'loans' before departing. The young man, Ernest Rolfe, was caught after trying a similar trick on Joseph Chamberlain. He had made a habit of this sort of thing and got ten years' imprisonment.

The vicar upset those Americans who could not understand his devotion to Holy Trinity as a living church rather than as a museum of Shakespeareana. The *New York Tribune* was particularly scathing. 'Mr Arbuthnot is fond of ecclesiastical processions; he likes to array himself in full canonicals and walk up and down. Other people do not care as much for this imposing pageant as they do for the relics of the Bard. Who is this arrogant cleric, that he may please his taste for ridiculous high-church ceremonials, to enrage the feelings of intellectual people throughout the world.'

The vicar was used to being the subject of ferocious letters signed with names like 'ANTI-RITUALIST' or 'ENGLISH PROTESTANT', but he had the last word on this one, deciding to add a religious dimension to the cult of Shakespeare. Mrs de Courcy Laffan, a minor romantic novelist who was the wife of the headmaster of the Grammar School, had revived Dr Collis's pleasing ceremony of senior boys laying flowers on Shakespeare's tomb on the Birthday. In 1899, the vicar invited 'great and small' to do the same and stood on the chancel steps to receive them with a prayer.

'Science wins New Victories'

The progress that brought the growing number of visitors was affecting Stratfordians. In 1885, the Flowers installed electricity at 'Avonbank'. Five years later, Charles Flower, sitting in his Palm House, spoke into a phonograph with Sir Arthur Hodgson of Clopton House. Isabella, his niece, sang, but this was less satisfactory and 'her voice was not immortalised'. Even quack medicine was becoming technological. In 1888, a Mr Retallick demonstrated his 'curative electrical appliances' at premises rented in Ely Street. Imposing testimonials were advertised to support the 'greatest remedy of the age'. Such was the demand that he extended his stay. Mr Days, a guard on the E&WJR, may represent the grateful sufferers.

> I don't know how to thank you sufficiently for the marked benefit I have received from your electric belt, as for years I have suffered from Lumbago and Indigestion, which your band has taken away; neither am I now troubled with the wind, which previous to wearing your curative band was most unpleasant. Increased strength and energy has returned to me, and the pain and weakness gone. I shall do my best to add to the fame of your wonderful appliances which have done me more good than anything and everything I have tried.

Innovation was escalating. In 1896, audiences in the Town Hall heard lectures on 'the Rontgen or "X" rays, which have recently created such a stir in scientific and medical circles'. Dr Lupton, the Medical Officer of Health, had proposed that the Hospital Governors should

provide such an apparatus. The proceeds of the lectures were to be used in equipping a room for this purpose. 'The truth of the famous remark made to Horatio', remarked the *Herald* sagely, 'becomes clearer every year as science wins more victories.' That same year the extraordinary sound of two motorcars was heard a quarter mile away. When they parked, they were surrounded by inquisitive crowds, who were repelled by the stink of oil, but impressed by their steering and speed – anything up to 20 mph. Many were sceptical. Motor cars might have their uses, but they would have to be improved drastically if they were to replace the horse 'to any extent for pleasure'.

Such doubters were confounded three years later when twenty vehicles from the London Automobile Club passed through. Their ugliness, lack of comfort and smell were remarked upon, but their 'oscillating properties' were considered 'fearful and wonderful'. One driver claimed to have covered 2 miles in as many minutes. To curb such excesses, the county council imposed a speed limit of 12 mph, but the reckless ignored such petty restrictions, cornering at 20 mph and terrifying the horses. Those predicting dire consequences nodded sagely in 1899 when the county's first fatal motor crash occurred at Edge Hill, but the internal combustion engine was not to be denied. Soon, forty cars an hour were passing down the Birmingham Road and roadside trees and gardens were white with dust. Concern was expressed about motorists who hired cars in Coventry and Birmingham and drove to Stratford, imbibing freely en route.

The early days of the motor industry were very much a homespun business. The proprietors of Stratford's first garage, Messrs Guyver, built their first motorcycle in 1899 in their workshop in what was later the lounge of the White Swan. Fitted with a Motor Manufacturing Co. engine, it was called 'The Bard of Avon'. The first Stratfordian to own a motor car was Dr Lupton, who, ever at the forefront of progress, bought a Benz 'Ideal' in May 1899. In the following month, he told the *Motor Car Journal* that he found much more enjoyment in doing his rounds and was much less fatigued at the end of them than he had when his mode of transport was a horse and dog cart. 'I can lean back comfortably in my seat and become quite rested. I can get over the ground and up the hills – and there are some very stiff hills around Stratford – in half the time that a horse would take to do the same distance, and I feel all the time that I have no tired horse to consider and that the machine is equal to any demand that I may make upon it.'

Years later, those who recalled Dr Lupton's motor car recollected that he spent an inordinate amount of time on the ground underneath it. Yet the horseless carriage was becoming a public utility. There were complaints about the Stratford and Shipston steam omnibus blocking Clopton Bridge. By 1903, a network of motorbus services connected Stratford with the surrounding villages. Even the nursery was being transformed. At Christmas, the shops were full of ingenious clockwork toys beyond the dreams of a child of the previous generation, when people would have paid just to see them. The year 1896 brought another wonder. A charity show at the Town Hall demonstrated

The marvellous KINEMATOGRAPH PICTURES
Or
ANIMATED PHOTOGRAPHS
As produced in London at various places of Entertainment.
The Sensation of the Day! Every incident is depicted on the screen, in all its detail, with
absolute fidelity.

No one was impressed. The frames slipped and many were defective. For 'life absolutely reproduced', Stratfordians waited a year for Fred Ginnett's Circus to show the Fitzsimmons and Corbett fight for the world heavyweight crown, the Queen's Jubilee procession and other 'up-to-date' scenes. Soon Chipperfields were filming local scenes to show to packed houses at the Mop. In 1903, the Birthday procession from the previous April was shown and an excited audience identified its fellow townsfolk. The *Herald* wisely realised that technical innovation was not an unmixed blessing. It was not pleasant to 'contemplate the dropping of explosives among a sleeping Army in the field, and it is to be hoped that the Powers will agree among themselves that such a way of destroying life shall be prohibited in civilised warfare in the same way that red hot shot and explosive bullets have been abandoned.'

18

'No Thieves and No Burglars'

There are no thieves and no burglars… I think we might fairly consider ourselves in the position of being well managed.

<div align="right">Mr C. Holton, 1897</div>

'Send me a fast bowler to play Laertes' (legendary telegram sent by F. R. Benson to his agent)

In the year that Charles Flower opened his theatre, Francis Robert Benson won the Oxford University mile. All sport he loved, but his greatest passion was the theatre. After graduation, he joined Henry Irving's Lyceum Co. and then, to extend his range, acted with a touring company. When it went broke, he raised the money to take it over and the Benson Co. was born. Those he engaged frequently shared his fanaticism for sport and his ability to mould a team, both theatrical and sporting, made him a great actor-manager. As an actor and aesthete of upper-class background, he helped make the theatre respectable. Dorothy Green, who joined the company in 1901, recalled its 'unique position in the provinces.' 'It was very much like a public school; we were all loyal and enthusiastic supporters of its reputation. Inspired by Mr and Mrs Benson, the company was the servant of our beloved theatre, and of the public. There was no tiresome preaching, but it was understood that we should behave as became members of a great profession.'

No one was better suited than Frank Benson for the rather uncommercial theatre at Stratford, born of a private enthusiasm he was to share. He formed a desire to act there and, in the spring of 1885, arranged for Charles and Sarah Flower to see his company perform at Leamington Spa.

The night was a disaster. The play was *Macbeth*, notoriously the stage's unluckiest – and with good reason, since it contains such potential for accidents. Scenery fell down and the cauldron attached itself to one of the witches and moved around the stage. If it's possible to be drunk in any part in Shakespeare, the role of the porter is the most likely, but it did not help when George Weir, who was playing the role in a state of advanced inebriation, said, 'The damned cat's mewed three times', rather than 'Three times the brindle cat hath mewed'. When Benson, as Macbeth, said 'When my drink is ready, strike upon the bell', one of the stagehands mistook the signal and brought the curtain down in mid-soliloquy. When it was raised again, Macbeth was at the back of the stage, swearing into the wings. When Benson looked up into the box where the Flowers were supposed to be sitting, he was horrified to discover that they'd left. He still had sufficient nerve to invite himself to Sunday lunch at Avonbank. The

combination of his charm, and the fact that the Flowers had undoubtedly seen 'the nucleus of good shows', ensured that the Company was engaged to play the following season, which was then only a week long. Years later, Benson's wife, Constance, recalled sitting by Anne Hathaway's Cottage, 'little more than boy and girl ... planning our lives and our work, in which Stratford, we hoped would play a big part.'

On the following Easter Monday, 'F. R. B.' opened the first of his forty Stratford seasons as Hamlet. The evening was a great success and favourable comparisons were made with Irving, but it was his Birthday performance as Richard III which most intrigued. 'Infinitely more subtle and kingly', felt one critic, 'than Barry Sullivan's.' The enchantment was reciprocated. Benson wrote to his fiancée, enthusing about the town and the Flowers, who conducted their theatre with 'personal love and reverence.' By the standards of the day, the scenery was simple and the stagehands were all locals on a week's secondment. Stratfordians also performed as 'supers', playing walk-on parts. Whenever they appeared on stage, their friends in the gallery shouted their names.

Next year, the Bensonians returned. The noted comic actor, George Weir, was not happy with his padding and played a somewhat depressive Falstaff in the *Merry Wives*. The irrepressible Benson played Dr Caius, merely, thought his wife, to participate in the comic sword fight. The audience loved it, shaking off their 'customary frigidity' and applauding wildly.

In the season of 1888, Mrs Benson made her Stratford debut. A painstaking but not brilliant actress, her Juliet was not a great success, but her Titania was. In a very Bensonian *Dream*, fifty tiny local children scattered over the stage as fairies with little wings fluttering on their backs. A fight was staged between a spider and a wasp, and Benson, as Oberon, descended to bribe an Indian boy with bull's eyes.

After that, Stratford had a two-year break from Benson. Charles Flower was keen to bring a scholarly approach to the theatre and explore the range of the Shakespearean canon, so Oswald Tearle revived *Henry VI, Part I*. Benson pursued this pioneering approach on his return, when the obscure *Timon of Athens* was chosen for the Birthday production. Constance was not pleased, preferring to dance in the masque in Act 1 than to play a speaking part. She remembered throwing off her exotic costume and spending a pleasant hour on the river. Her view that 'no one could possibly be interested in Timon' was generally shared by the audience.

Ten days later, the man of whom Benson always spoke reverentially as 'The Founder' died after collapsing at a meeting of the newly-formed county council. Some months previously, he and Sarah had chosen the plot in the cemetery where he was laid. Like Wren, his monument is seen in what he created. His brother Edgar became chairman of the Theatre Governors, but decisions were often taken by Sarah.

When the Bensonians returned for the season of 1893, their leader was suffering from typhoid, which had been misdiagnosed as influenza. He was rushed to bed in a delirium and remained there for several weeks. Lyall Swete learned what he could of Petruchio for the Birthday production and improvised the rest. A young and very large Australian, Oscar Asche, later to be famous in musical comedy, made his debut that season. It was said that Benson was impressed when he told him that he had come over with the Australian cricket team. He had, but on the same boat!

It had been intended that the Birthday production should be *Coriolanus*, but this had been rendered impossible by Benson's illness. The governors were loath to let a year go by without

introducing a new play, so it was arranged that the company should return in August. The weather was glorious. Many rehearsals were in the theatre grounds, or in the garden of the Black Swan, from that summer on, always the Dirty Duck. The townspeople gave the actors a magnificent welcome and Constance reflected that there was 'no other theatre in the world where it was possible to work in such perfect conditions'.

Memory was to exaggerate the extent of Bensonian athletic activity at Stratford. So busy were they rehearsing for the cramped season, that they had little time for diversions. Occasionally, they would squeeze in a game of hockey against local opposition, with Benson on the right wing and the enormous bulk of Oscar Asche filling the goal.

In 1894, the new play was *Henry IV, Part Two*. Benson stocked Shallow's farm with live and cacophonous sheep, fowl and pigeons. The most remarkable performance was from Constance as Doll Tearsheet. Many people tried to dissuade her from playing such a role, but she had her own reasons. 'I had watched a living "Doll Tearsheet" in Manchester, and was most anxious to turn my copy to account. The Press were good enough to say many complimentary things of my performance, but several clergymen preached against me ... though not one of them owned to having come more than once to the performance. Nowadays no one would be shocked', she recalled thirty years later, but then 'it was thought highly immoral to "make vice attractive"'.

Here is the essence of Victorian morality – that a sense of retributive justice should manifest itself. We should not judge too sardonically. The effects of vice and other social abuses were probably clearer to a caring clergyman than a theatre audience. The Bensonians themselves had a prim sense of Victorian values, bowdlerising their way through Shakespeare's works. Even the 'motions' in the *Merry Wives*, 'he gives me the lotions and the motions', became the 'potions'.

In 1895, it was time for another change, and a future theatrical knight, Philip Ben Greet, presented a season, introducing to Stratford Frank Rodney, who for a few brief springs was a festival favourite. This was the Bensonians' last break from Stratford for twenty years. By the late 1890s, scores of people were travelling up from London for the season, necessitating a ballot for tickets. In 1898, the season was extended to two weeks. That year, Benson mounted the most extravagant of his productions, *Antony and Cleopatra*, with himself and Constance in the title roles. Since it was too elaborate to tour, most of the huge outlay was non-returnable. Halliwell Hobbes made his festival debut as Varrius. He was a Stratfordian, a great-grandson of that Robert and Betsy who had been such avid playgoers a century before. Next season, another monumental drama was staged, *Hamlet* in its entirety, played at a snail's pace over an afternoon and evening. That year, Benson was a phenomenon of energy, playing nine other parts, including Henry V, Richard III, Macbeth, Richard II, Malvolio and Orlando. His unflagging enthusiasm and genteel spirit of adventure suited Stratford well, although there were already complaints that Stratfordians did not attend festivals as assiduously as they might. If upbraided with this, there was a ready reply. With the exception of the revival play, they had seen the Bensonian repertory over and over again, with the same actors filling the parts and Benson in most, if not all, of the title roles. In 1919, a lady claimed that she had seen *As You Like It* no less than twenty-seven times. Her memory had not failed her. There were twenty-six festival productions of the play between 1875 and 1919 and Mary Anderson's gala performance of 1878 provided the twenty-seventh. Curiously, the Bensonians did not put on the play till 1894, but after that, sixteen out of next eighteen productions until 1915 were by Benson. Between 1894 and 1910,

Benson played Orlando opposite Constance's Rosalind ten times. In 1911, he played it opposite Violet Farebrother, before switching to Jacques in the last three performances until 1915.

The criticism was inapplicable in 1900, when Benson, busy in London after a disastrous fire destroyed most of the company's properties, sent down a scratch company led by John Coleman, an old actor from an earlier age. Despite the misgivings of Sarah Flower, a bizarre, bowdlerised version of *Pericles* was presented, which lived long in memory as the worst production ever seen at Straford.

Even less could the criticism be applied to the festival of 1901. After a first week of six revived comedies (four of them Shakespearean), the company embarked on a long-remembered 'Week of Kings', when eight of Shakespeare's history plays – half of them new to the repertory – were presented in sequence. A different play could be seen every evening for a fortnight. Constance recalled the hectic schedule:

Most of the Company had four or five parts to study, and with the entire day given up to rehearsing and the night to acting, and constant matinees, there was little leisure for study. The agony of nervousness we all went through that week beggars description. When there was a short period of 'rest' between rehearsal and the night's performance, many of the Company were to be seen lying in boats among the rushes, trying to memorise their parts. Some would roam the fields, declaiming to the startled sheep. You seldom met a member of the Company … who was not carrying a Shakespeare.

One delighted by the theatre, 'made, not to make money, but pleasure', was W. B. Yeats, who eulogised that the Bensons spoke verse, 'not indeed perfectly, but less imperfectly than any other players upon our stage.'

The festival of 1902 brought one of the theatre's great moments. The doyenne of the stage, Ellen Terry, came to play Queen Katherine in *Henry VIII*, fulfilling a promise that she had made twenty years before – that she would act under Benson's management. 'Those of us who can look over the vista of the years and note the swell of the enthusiasm which greets our Shakespeare festival', wrote a local theatre buff, 'will find it hard to recall one in which enthusiasm has been so wide and deep and real.' When Miss Terry entered, she received a prolonged standing ovation, but it was not she who was best remembered on that amazing evening. It was public knowledge that Frank Rodney, one of those fine middle-part actors who are the mainstay of any classical company, had cancer of the tongue. The shocked Benson, knowing he would never act again even if he survived an operation the following week, offered him any part in the repertory and he chose Buckingham in this play. A deathly hush descended as he spoke his final, terrible, majestic lines in Act 2.

All good people
Pray for me! I must now forsake ye; the last hour
Of my life has come upon me. Farewell;
And when you would say something that is sad,
Speak of how I fell. I have done and God forgive me!

At the end of the scene, the audience shouted for him, but he did not return. He had taken his exit from the stage and, a few weeks later, from life. The Bensonians gave a fine processional cross in his memory to Holy Trinity, which is still carried in services.

Benson also brought drama from the beginning of life to this production. Always a stickler for accurate effects, he engaged a baby from Waterside to play the tiny Princess Elizabeth. The infant screamed the house down and had to be taken off. Despite taking third place on the evening, Ellen Terry was enchanted by Stratford and made a graceful little speech at the final curtain: 'This really is a beautiful little theatre and you must all be proud and happy that you have built it with the splendid motive of honouring Shakespeare in his own town. It really is the nearest approach to a national theatre in England.' Charles Flower's vision, scorned by the sophisticate a quarter-century before, had become part of the theatrical firmament.

'Discontent is your Duty'

New ideas were under discussion. The Methodist minister, the Revd J. J. Ellis, declared himself a socialist. His ideology was a curious mixture of the homespun and the theoretical. Society was 'founded on clothes'. Socialism would abolish fustian, corduroy and moleskin and dress the people in broadcloth – it was widely believed that fabrics other than wool were bad for the skin. Equality would ensue through a moderate programme based on manhood suffrage; free, compulsory non-sectarian education (the old Nonconformist cry); adequate housing and worker shareholding. The railways might be nationalised with adequate compensation. Land nationalisation was also desirable, based on the slogan, 'The land for the people, the people for the land.' Industrial disputes would be settled by arbitration. The keystone to the vision was settlements like Toynbee Hall, in 'the midst of the swarming lives of the human workers, and the gradual evolution of the people through the influence of moral education into a Christian brotherhood'.

Attempts were made to work out the practicalities of such idealism. In 1896, a Co-operative Society was started in Stratford and a movement was set afoot to found a free library. Fervent voices were emerging. The *Herald*, which had once dubbed Joseph Arch 'the Warwickshire agitator', came to regard him as a quaint, homely, respectable figure, whose trades unionism was of the 'jog-trot, solid, respectable order'. The 'Red Van' of the English Land Restoration League travelled the area, proclaiming the area, proclaiming the 'abolition of landlordism.' Local idealists like the Quaker auctioneer, H. P. Bullard and Bolton King, a Liberal activist who had organised an unsuccessful farm-workers' co-operative, orated from its platform, as well as more militant outsiders like Dr Edward Aveling and his common-law wife, Eleanor, daughter of Karl Marx. Aveling was a familiar figure in Stratford, writing a column of London tittle-tattle for the *Herald* under a pseudonym, and reviewing the festival season for the national press. 'Discontent is your duty', Mrs Aveling told her audiences. 'The workers of England are poor not because they are idle, but because they are robbed.'

The appearance of Eleanor Marx Aveling on campaigning platforms betokens the stirring of activity among another aspirant group. In 1887, at a meeting in the Town Hall, the Revd De Coucy Laffan proposed the extension of the franchise to duly qualified women. He was

supported by Charles Flower, who suggested petitioning the local MP. The audience was 'large and influential' and, not surprisingly, consisted chiefly of ladies.

'Ladies' were still accorded a special role in the scheme of things. Their behaviour was expected to be decorous. In 1890, Mrs de Courcy Laffan wrote an anonymous complaint to the *Evesham Journal*. She expressed shock that during a play that had been produced to raise funds for the clothing club, one of the ladies had gracefully drooped her head on a man's shoulder. 'No doubt', she remonstrated unctuously, 'those who selected this piece for a charity were guided by the old Jesuit maxim that the end justifies the means. Yet it is impossible not to regret seeing such a questionable matter set before the public under the direct patronage of the clergy.' She was reaping the whirlwind! Not only was the clergyman in question the explosive vicar, the lady was his cousin! George Arbuthnot fired off a furious letter, which provoked a reply from Mr Laffan, breaking his wife's incognito. The vicar's response illustrates the attitude of the genteel classes to the fairer sex. 'I find then, my opponent is a lady, and I can only take my hat off and stand aside. I do not fight with women, nor will I notice anything which Mrs Laffan may choose to write against me, if she will append her name to it. As long as women write as women they have the privilege of attacking men without producing a reply.'

Life was not simple for those caught in the crossfire of such disputes. Before he knew her identity, the vicar had sounded off a few choice remarks about the anonymous writer in the parish magazine. As a result, Mr Laffan obliged the printer, John Morgan, to withdraw his sons from the grammar school. He had little choice but to send them to the Commercial School of Mr Priest, the vicar's sworn enemy, so he lost the contract to print the magazine.

Ironically, Mrs Laffan soon repaired her breach with the vicar. Two years later, she told a meeting at the Town Hall that he supported the vote for women qualified by property. In 1893, a real advance was made when women became eligible to become Guardians of the Poor. Mrs Rachel Lowe, a widow from Ettington, was elected in April and proved an energetic and humane guardian.

There was modest progress for women elsewhere. Lady cyclists pedalled energetically through the countryside and fashion reflected this activism. The 'New She' was fetchingly dressed in gaiters, knickerbockers, surtout and hat. New expressions horrified traditionalists. 'A few words of slang from a pretty woman's lips', fumed a columnist in the *Herald*, 'tend to obscure her charm and to cause a refined woman's lips to curl with contempt. Such is the vulgar abuse of the word "awful". "Thanks awfully", "an awful nice man".' The new slang made its appearance at the theatre. A dancer arriving half an hour late for rehearsal pouted coquettishly when upbraided. 'And was ums angry with its Popsy Wopsy den?'

But it was the growing possibilities of employment that was doing most to expand female perspectives. It was becoming difficult to find servants. The long-resisted aim of those who wanted to abolish Mop-hiring was being achieved by the simple lack of servants to hire. Many women were finding jobs in public services like the General Post Office and the demand for shorthand typists always exceeded the supply. The rise of a new middle class was reflected in the ribbon developments creeping out of Stratford. Many were acquiring servants for the first time and older wealth considered that this constituted a problem. 'The *quid quo pro* principle is so much lost sight of by the mistress that the obligation which should be mutual is one-sided, hence, 'our servant' quickly degenerates into a "slavey" ... She received neither

common courtesy nor consideration from her "missus", has a time of it also with the children who know no better … and soon she looks about for relief or freedom from an intolerable strain, often as it happens to fall from the frying pan into the fire.'

Vulgar women caused other outrages. In 1897, a nurse, Elizabeth Brandish, faced committal proceedings on a charge of murdering her illegitimate baby. A large crowd, consisting mainly of well-dressed women, gathered outside the Town Hall. When the doors opened, they were allowed in first, and chattered and laughed as if they were going to an entertainment rather than a grim judicial procedure. Since there were few men present, the order to remove hats was greeted with sustained giggling. There was a happier ending to this sad case. At the assizes, Nurse Brandish was acquitted after a juror, George Enston, a local Guardian of the Poor who was opposed to capital punishment, persistently blocked the guilty verdict.

Stratford's first divorce occurred in 1897. When Henry Edwards, a billposter who was town crier, came home after three months in hospital, he discovered that Ethel, his wife of four years had been drinking a lot, and that William Smart, a local butcher, had paid her regular visits. The neighbours had carefully monitored the affair. In the divorce court, three of them testified that they had seen two figures silhouetted on the bedroom blinds and that Smart had left the next morning.

The servant problem was exacerbated during the celebrations of the Queen's Diamond Jubilee during the summer of 1897. The *Herald* warned that those girls who had saved a little money, or who had a good home to go to, would cease working until the national festivities were over. At Stratford, the celebrations included a Shakespearean procession, a water pageant, races and tea for 2,000 children, illuminations and a performance at the theatre of 'that screaming farce', *My Turn Next*.

From his pulpit, the vicar gave thanks for the peace and prosperity the reign had brought, but even on occasions of national rejoicing he could not resist controversy. The Church, he declared, had also prospered during Victoria's reign, 'but I cannot admit that its wonderful progress has been so much due to the influence of Her Majesty, who has failed to grasp the true meaning of the Catholic faith.' The resultant storm was predictable and perhaps calculated. One correspondent was grieved that 'even upon so graceful and patriotic occasion … your vicar could not repress his aggressive and defiant spirit'. Another regretted that Stratford was the 'only place in the Empire where a growl was heard on the day of the Queen's Jubilee'. The vicar considered that such criticism was the inevitable lot of those who did their duty as social reformers who were in contact with 'abuses which some persons preferred remaining in ignorance of'.

Despite such altercations, assessments of the reign were glowing. 'The duties of the Bench', opined its chairman, John Smallwood, 'are light and becoming lighter. People are becoming better and I think the schoolmaster has not been abroad to no purpose.' At the 5th of November Supper, Mr C. Holton made favourable contrasts with the Stratford of his youth. 'It says something for the improvement in morals of the town that it is only necessary to pull down your blinds to shut up shop. There are no thieves and no burglars. The town could bear comparison with any town of its size. It is well lighted; it has a good trade, for I hardly ever see a shop to let, and it is impossible to get good houses. I think we might fairly consider ourselves to be in the happy position of being well managed.'

Big Shows

The Mop was more than a 'day' to Stratfordians. As the *Herald* pointed out, it was also a 'date', a kind of solstice in the town's year. Things happened 'before the Mop' and 'after the Mop' – 'Our Bertie will be six on the first Friday after the Mop' – 'I shall go to Birmingham some time before the Mop' – 'Here 10s; mind you pay me back before Mop Day.'

A few days before the Mop, what the show people referred to as their 'sleeping-waggons' tethered their horses and took their berths in the streets around the fair. They stretched from one end of Arden Street to the other and they would stay there for a day or two afterwards. Some brought chickens to scratch about in the road – or a goat to provide them with milk. They would get their water from local houses and gave the children free rides in return.

Despite the feeling that one year's Mop was much like any other, subtle change reflected innovation. By the 1890s, improved transport was bringing 'big shows' – and 3,000 visitors – to the fair. The waxworks were gradually melting away, living prodigies received scant support and the barrel organ, with 'its sonorous and musical tones', was becoming a rarity. Each year there were less draught horses as steam and electric motors were taking over from manual and animal power. 'It was a sight', recalled Arthur Locke, 'to see the engine drivers and their mates polishing the brass rods up like gold.' Strickland's famous galloping horses (always known in Stratford as the 'Jinny' horses) that stood at the top of Bridge Street were being put in the shade by enormous chanticleers. The 'ping' of the shooting galleries was incessant, while Wilson's big wheel reigned over all. Boxing booths appeared, offering a pound to anyone who could last five rounds with their champion. George Hewins recalled seeing a local labourer knock the fairground man out 'in one'. Stalls selling 'penny squibs' – waterfilled tubes – became popular among the young men, who used them to squirt lasses on the roundabouts. Another innovation came in 1908: 'Houp-la ... red hot from the White City', where the Olympic Games had taken place earlier that year. It was noted that 'despite the delightful simplicity of the notice that "all you ring you have", the odds were not in favour of the purchaser of the rings'.

The most popular attraction was the switchback railway. Even clergymen were seen on its 'giddy whirl', although the vicar was unflagging in his condemnation. In a sermon preached from Jeremiah 22.1, he attacked the heavy drinking which occurred on Mop day and regretted that 'many think indecency a 'subject of merriment and laugh at an indecent picture or a dirty exhibition'. The issue for all decent Christian people was,

How can this be avoided? Fathers and older brothers, you don't want your daughters and sisters to see sights which should make honest girls blush! I ask you then, in whatever rank of life you are, to say boldly and insistently, 'it shall not be'. Go and see for yourself, especially after nightfall, and if there is an indecent picture, just smash it, or, if a low fellow makes a coarse remark, just silence him: forcibly: knock him down if necessary. You may be technically breaking the law, but public opinion will be on your side... Sin winked at, even if not indulged in, is bound sooner or later to bring its punishment, and the state of Jerusalem at the present day, and the condition of the Jewish nation, are startling examples for us that the prophetic warning of Jeremiah has indeed been fulfilled.

The *Herald* regarded this as 'distinctly bad advice. The person acting upon it might soon have discovered that he had caught a Tartar and his personal appearance might have undergone considerable transformation'. Others felt that the vicar was contradicting his latest progressive campaign to abolish corporal punishment in elementary schools. Ursula Bloom recalled that the kind of show which upset the vicar was in great demand:

> On the morning of the great day itself, the Mop was open to the elite, and the Mayor and Corporation went round to have a look at the peep shows and see that they were quite respectable … Of course they were for the Corporation; nice little views of Cheddar Gorge and sunset at the seaside, the plough on the hill and the simple village maiden doing her knitting. But the moment they had been passed as okay, they changed the pictures and there they were with buxom blowsy belles with practically nothing on them at all.
>
> The mayor and Corporation were followed by an enormous crowd who … waited till they had done their stuff, then in they nipped. The men who ran the peep shows were very quick to change their menu if they saw worthy burghers without their wives, but stayed pure as the driven snow for those who looked as if purity was their maxim.

The vicar's condemnation of drunkenness at the Mop did not go unheeded. The *Herald* regarded 'the dazed and drunken condition of many young girls' as its saddest aspect. Supporters of the temperance movement were usually to the fore, with Mrs Arbuthnot 'displaying an earnestness and vigour which soon became contagious…' Members of the Nonconformist 'Women's Total Abstinence Union' toured the showmen's caravans before the Mop and issued invitations to a tea party, which generally over 100 people, mostly men, attended. After tea, a musical programme was followed by 'a short earnest address' from a local minister.

It was not just 'What the Butler saw' and the heavy drinking which concerned local moralists. At the turn of the century, a new sort of confidence trickster appeared. The popular illustrator, Phil May, once started to sketch a clever gentleman who appeared to be wrapping up sovereigns and half-crowns and selling them for two shillings. The 'sharp' saw what he was doing. 'If that there celebrited portrit painter with the tight breeches on will 'and up the picter to the equal celebrited benefactor to 'oomanity wot is giving away quids for coppers will reward 'im accordingly.' Phil, with a twinkle in his eye, handed up the drawing. The conjuror was delighted, pinning it to his cart. He screwed up three sovereigns, three half-sovereigns and several half-crowns in a piece of paper and handed it to the artist. 'You'll be president of the bloomin' Ryal Academy some dye, young man', he promised. 'Here catch!' 'A bargain's a bargain', said Phil. When he opened the packet and found two pennies and a halfpenny, he declared it the most entertaining commission he had ever had.

'What creates wonder in these supposed enlightened times,' declared the *Herald*, 'is the number of people who come into town to be deliberately swindled. Would anyone have supposed that such idiots could have been in existence as to imagine that a man they had never seen before would on an instant become so generously disposed as to make them a present of seven half-crowns for a single coin of that value? And yet one simpleton allowed himself to be fleeced of every coin he had … Cannot the police protect such people from their own foolishness?'

Confidence tricksters featured on the sideshows, often relying on humour to achieve their objectives. 'Come an' see me bare cock an' arse', George Hewins recalled one fellow shouting. 'We fell for it – everybody did! Inside he'd got a mare, a donkey and an old cockerel! Folks came out: "We've been had!" But they soon fell a-laughing too!'

In the days before the general availability of medical services, patent cures and treatments abounded 'painless extraction' was advertised for those with bad teeth and so skilful were these homespun dentists that no pain was felt by those undergoing the treatment.

It was not until the 1860s that freak shows ceased to be a feature of the Mop. They displayed such items as the cow with two heads, the malformed lamb, the fat lady, the thin man, the lion-faced lady, whose mother was reputed to have been frightened by lions when she was pregnant, and 'the smallest mare and foal in the world alive'. In 1908, the Westwood family from New Zealand caused a sensation. 'The son is 12 and weighs over 22 stone and is 5ft 7ins, while his sister Ruby is no believer in Anti-Fat.'

In 1902, a writer for the London *Morning Leader* caught what must have been among the last of the 'serving wenches' to ply for hire. They were standing

in a row, like ninepins ready to be knocked down. These maids – what few there were – were coy. Their Sunday skirts were hoisted to the disclosure of striped petticoats of gorgeous hues. They carried their characters in their grubby hands. They could milk, churn, cook, wash – goodness knows what else; and here they stood at the 'Statty Fair' in a sort of twentieth century slave market. Now and again a portly dame would come along, puffing like a steam engine, with a basket on one arm, a bulging umbrella under the other, an apple face, a tinkle of beads in a fierce bonnet and a most impressive show of white stocking. 'Are you fer 'ire, me gal?' 'Yessum' – and a bobbing curtsey. Then there would be a kitchen floor conversation, and a few preliminary digs with the umbrella, just as you see at a cattle market at Christmas time and a good many 'yessums' and a few 'No mums'. But business is bad and by lunchtime the waiting wenches had had enough of it. 'Come on Jinny, let's have a goo at the round-a-bouts' cried one of the blithesome slaves. Who could resist such a temptation, when the steam organ was playing the sad part of the 'Ora pro Nobis?' So Jinny and the rest of the white slaves clambered on the backs of ostriches, giraffes, horses and camels.

By 1908, the hiring of maidservants had ceased. The *Herald* declared that 'for domestic service, Mary has too great an idea of her own importance and her presence at the Mop is in pursuit of enjoyment, not work'.

The practice lasted a few more years, however. Young farmworkers 'with straw-coloured hair', continued to stand 'with their backs against the market cross and grinned sheepishly as they were chaffed by the sightseers. The farmers questioned them. 'Now, Jack, d'ye keep off the drink, my lad? Have yo got a character better than your face, young fellow?'

'The old custom suits me well enough', said one farmer. 'I have got many a proper lad who is none the worse because he grins like a calf-head. I have promised him £17 for the year, with all found – food and board.'

Shortly before the opening injunction from the mayor was fulfilled (that the Mop should close at midnight), it became the custom to play hymns on the roundabout organs. Arthur Locke could never hear these lovely old tunes in church without being reminded of the fair.

People were always amazed by the rapidity of the Mop's departure, struck by skilled hands. Ursula Bloom considered that the streets of Stratford were filthier on the morning after the Mop than on any other day of the year, 'even though the booth renters were supposed to clear up after themselves. The big shows were good at this, for the men worked all night, and they would be packed and away by eleven the next morning. They never left so much as a wisp of paper behind them, but the small men were different.'

Roasts

'What gives the "Mop" its exceptional position?' asked the *Herald* just before the First World War. 'Undoubtedly the ox-roasting which takes place in the public streets. This is a spectacle that cannot be witnessed anywhere else; the people flock to Stratford to feast their eyes upon the impaled and revolving carcasses and later to sample their quality.' The record was achieved in 1909 when no less than eight oxen and twelve pigs were spitted.

The roasts were associated with particular inns. It was a tradition at the Seven Stars that the first roast had taken place there in 1790. Stratford roasters were nationally celebrated, travelling the length of the kingdom. Each Mop day, George Luckett, self-proclaimed champion roaster of the world, turned his spit outside the Horse and Jockey in Wood Street. He had roasted for the Marquis of Bute and Lord Derby. His claim to ascendancy was challenged by other famous roasters like 'Panham' Worrell, who set his pitch at the Garrick, and 'Judy' Hewins, who roasted at the Prince of Wales in Rother Street for more than half a century. Mop days in his company were a delight to his grandson, George Hewins, who stuffed his pockets with stale crusts and caught the dripping and ate it while he was carving. Other roasts were at the White Swan, Plymouth Arms, Queen's Head and Unicorn.

'The old town just roared with fun', noted the correspondent of the *Morning Leader*.

Roared for a full mile, amid booths and butchery, sausages, kerosene, cheap Jacks, rifle-shots, confetti, the strenuous harmony of steam organs, clashing cymbals and jangling bells. And over all these there hung a sweet savour – the smell of wood fires burning terribly in the middle of the quaint old streets, and the giant oxen roasting whole in the crackle of the blaze. Think of it! Multiply the appetising aroma of one rumpsteak sizzling at the grill by 5,920 and you will have an idea what Stratford smelt like yesterday. After all the ox is the thing at Stratford fair, with a savory of pig. It may be Mr Shakespeare for 364 days a year, but on the 365th it is another glorious old English institution – Roast Beef and Bacon. Yesterday eight oxen and twelve pigs were sacrificed to make a glorious holiday; and by sunset nothing was left of 5,920 pounds weight beyond eight pairs of charred horns and twenty bleached skeletons.

The bounty continued next day when people took their quart basins round to the pubs and paid a mere twopence for pure beef or pork dripping.

Sequah

Other, more transitory, shows occurred. In the summer of 1890, Sequah, the 'Indian medicine-man', was engaged in promoting his curative remedies, Sequah Oil and Prairie Flower. He paraded the streets in an exotic gilt carriage, with a band playing on the roof. His assistants were dressed as American frontiersmen. The first evening only a small crowd gathered in the field behind the Unicorn to see his curative miracles, but as word got about, the audience increased nightly. He commenced by extracting teeth free of charge. So skilled was he that the sufferers were often unaware that the teeth had gone. He then made a 'temperate little speech' about the diseases that he specialised in curing and the nature of his medicines. The first customer worked at the gasworks. George Clarke, aged fifty-seven, of 53 Shakespeare Street, had suffered from chronic rheumatism for twenty years and had to crawl upstairs on his hands and knees. He was accompanied into Sequah's caravan by several witnesses. Lying on a couch, he had Sequah Oil rubbed vigourously over his knees and thighs. After ten minutes, he could bend his legs freely. Sequah told him that he could be cured permanently if he used the oil regularly. Soon, to the delight of the crowd, he was dancing a jig to the music of the band.

Next evening, a larger crowd saw James Norris, a retired blacksmith from Birmingham Road, who had suffered from rheumatism for fourteen years. He could only walk with a stick. After ten minutes of rubbing, he went through the same routine as Mr Clarke, leaving his stick with Sequah as a memento. For the next three evenings, the scepticism of the spectators gave way to confidence. Around thirty people had their teeth pulled and those who had been cured of rheumatics testified to the efficacy of the remedy. Old Mr Norris had walked the 10 miles to Wellesbourne and back.

The most remarkable cure was on the last night. William Unitt, aged seventeen, of New Street, had suffered from chronic rheumatism since he was two and was wheeled to see Sequah in his Bath chair. On the couch he suffered excruciating pain, but after being rubbed with the oil for twenty-five minutes, he dragged his father round in a chair to loud applause. Many expressed scepticism about the cures, but could provide no explanation. Sequah's system was certainly lucrative. His annual profits were nearly £45,000.

Most spectacular of the exotic visitors was Lord George Sanger's Circus, 'the oldest, richest, largest and most sumptuous establishment in the World', whose huge tent was erected in a field off Cherry Street. 'Idiasa, the Queen of the Eastern Star! The beautiful woman of Egypt!' was followed by equestrian displays, animal acts, acrobats and trapeze artists. The grande finale often struck a topical note. On one occasion the war in the Sudan, in which 250 horses, a battery of camels with huge cannons firing on their backs and the field artillery appeared simultaneously in the arena. The Mahdist Army was represented by 500 locals. In 1901, after a rebellion in China, the 'latest and greatest novelty' was 'Real Chinese Boxers', who had been at the siege of the British Legation in Peking. One year, a football match was staged, with a massive cup for the prize, between the captain of Stratford Rovers FC and Sanger's 'centre-forward elephant'.

The School Board

After the first School Board election, the denominations, realising there was little gain in such raucous affairs, established a *modus vivendi* in which the Church of England filled four of the seven seats; the Nonconformists, two, and the Roman Catholics, one. The arrangement was uneasy. The Nonconformists suspected that the Anglicans and Catholics were in league to keep the Board School underfunded. The inevitable conflict came in 1896 when, under the leadership of the vicar, the Anglican majority refused to endorse the appointment of a Unitarian, Miss Gold, as a teacher. A national storm of protest ensued. 'The Board', said the *Herald*, 'had made itself notorious from Land's End to John o' Groats'. Joseph Chamberlain expressed sorrow that such bigotry still existed and a stormy protest meeting was held in Stratford Town Hall.

The Anglican party was undaunted by the storm, passing a resolution that the Apostle's Creed should be taught at the Board School to those children whose parents did not object. Who these were was to be ascertained by asking the children. 'Among people who are not priest-ridden', wrote a protester, 'to ask babies whether they or their parents object to the Apostles' Creed is sheer imbecility.' To Nonconformists this was an objectionable form of denominational teaching in a school maintained out of the rates. Even so, they considered it in their interest to maintain the pact at the next School Board election in 1899, fearing that their representation might be obliterated.

Mr Francis Talbot, a Unitarian, was not bound by any such caution and his nomination ensured a contest. Electors had seven votes to distribute amongst the eight candidates. Excitement was increased by the fact that public personalities not usually associated with elections were standing, like the controversial vicar and Father Thomas, the Catholic priest. The degree of decline of institutional religion was an uncertain factor. 'A vast body of voters go to neither Church nor chapel', wrote the *Herald*, 'and care nothing for religious shibboleths. It is these people who will decide the election.'

Numerous canvassers pounded the doorsteps. The Anglican clergy, unlike their Nonconformist counterparts, campaigned hard. On polling day, it was soon apparent that there would be a high turnout. All parties, except Mr Talbot's, had tellers on the doors of the polling-stations and carriages ferried voters to the polls. Father Thomas was expected to do well. Most of his little flock would give him all seven of their votes and he could expect to pick up Anglican votes for not being a Nonconformist and vice-versa.

A large crowd waited outside the Town Hall to hear the declaration. Huge cheers greeted the news that John Smallwood, a prominent Nonconformist, had topped the poll. Father Thomas was runner-up with 1,447 votes. The biggest cheer of the evening came for Francis Talbot's 1,289 votes. The vicar's name, twenty votes behind in fifth place, provoked loud hooting mingled with cheers, which was repeated for the other three candidates, including Mr Ashton who, with 710 votes, failed to get elected. When Mr Smallwood tried to say a few words, the cheering crowd surged forward and the candidates fled for home. The crowd continued its frivolities by kicking a policeman unconscious before dispersing.

There were agonised post-mortems in church circles. The vicar had instructed his supporters to plump for him, rather than distributing their votes, so it was clear that he had

few friends outside the inner circle of churchmanship. The regular cry of defeated candidates was raised – that scores of people had failed to deliver the votes they had promised. The *Herald* was not surprised.

> An elector is in this position. If he will not promise a vote the canvasser naturally assumes that he intends to support the opposition party. This suspicion finds its way to the committee room and if he be a poor man the order goes forth that he must in future be struck off the charity list; or if the elector be in a good position, patronage from his business must be withdrawn … to prevent this kind of intimidation being exerted canvassing should be an offence, disqualifying the candidate resorting to it. The ballot, of course, secures secrecy, but a sort of delusion is kept up that the way in which a burgess casts his vote can, in some occult manner, be ascertained. This is intended to frighten nervous people.

Non-Churchmen were elated. The Revd J. J. Pugh, the former Methodist minister, wrote to congratulate 'the lovers of civil and religious liberty on the splendid position achieved at this poll. All parties are now represented as in justice should be the case in a community holding diverse opinions. The day of "family government" is over. No clerical corner or party preserve should be in possession in Stratford again.'

In fact, the Anglicans maintained control of the School Board through their alliance with Father Thomas. Yet Mr Pugh was basically right. The election reflected the decline of Anglican hegemony over social policy. Doubtless the vicar would have gone down with all guns firing, but the necessity t o do so was removed in 1902, when the powers of the Board were transferred to the county council. Despite appearing to coincide with their aims, this move was opposed by Nonconformists, for it enabled denominational schools to receive subsidies from the rates. A passive resistance movement developed which had its effects in Stratford. In 1904, nine men were summoned for non-payment of rates, including H. H. Bullard, the auctioneer and Fred Winter, the draper. In court, J. E. Asquith of Rother Street declared that they objected to a portion of the 'so-called poor rate', and had deducted a penny in the pound from their payments. There should be no taxation without representation and no doctrinal tests should be applied to those whose wages were paid by the state. It was decided to sequester the goods of the resisters to the value of the debt. There would have been more of them, but a number had had the sum owing paid off by 'friends, so-called'. Two weeks later, goods to the value of £4 18s 9d were auctioned amidst great hilarity. Mr A. Baily, the auctioneer, himself a Nonconformist, could not resist making a little speech. He thought that the passive resisters had gone too far, but they had a right to please themselves. The proceedings finished with the hymn, 'Dare to be a Daniel' Honour was satisfied and the denominational issue gradually faded.

A Grande Dame

In 1890, the popular novelist Marie Corelli, on a visit to Stratford, made the obligatory call at *Avonbank*. The Revd Frank Smith, the priest-chaplain, was one of her multitudes of admirers and recommended her novel *Ardath* to the Flowers. Sarah found it most

disagreeable and wondered why people did not protest about the harm such books could do, especially to the young.

Nine years later, the unwitting recipient of this criticism rented Hall's Croft and came to live in Stratford. She was at the peak of her popularity. Her melodramatic romances, like *Barabas* and *The Sorrows of Satan,* often on sentimentalised and heretical religious themes, sold phenomenally. She certainly aroused curiosity, eschewing photographs in an image of herself equitable with one of her romantic heroines. The material was unpromising. She was in her mid-forties, short and plump, but she hinted that she was thirty and dressed as if she was sixteen. She was the illegitimate daughter of Charles Mackay, a journalist and writer of popular songs, who had brought her up. Her real name was Minnie Mackay, but her exotic pseudonym was part of the process of romanticising her origins, a task in which she was assisted by her life-long companion and admirer, Bertha Vyver, daughter of a Belgian aristocrat, who she claimed to have met at her convent school in France.

Miss Corelli's residence in Stratford got off to an unfortunate start. Opposite Hall's Croft was the private girls' school run by the formidable Mrs Cameron Stuart. All day, Old Town resonated with the lasses' chatter and the flat tinkle of piano practice. Marie sent over a curt note requesting silence, as she was working on *Boy,* her latest masterpiece. Mrs Cameron Stuart's rejoinder was correct but negative, and a furious Marie rented *Avoncroft* further down the street, where in June she played the *grande dame* in Stratford for the first time. The celebrated French actress, Sarah Bernhardt, came to the theatre to play her famed version of Hamlet in French prose, supported by the Benson Company speaking in English. It sold out weeks before the performance amid great excitement. Stratford's newest resident was well to the fore amid the crowds assembled at the station to greet her. The fulsome description in the *Herald* was the first of many which would eventually rebound on the authoress. 'Miss Corelli was charmingly attired in cream lisse, trimmed with Venetian guipire lace and wore a gold and white toque trimmed with black tips and osprey.' When the special train arrived, she stepped forward and greeted Madame Bernhardt in French, handing her a magnificent bouquet, tied with the tri-coloured ribbons of the two nations. Years later, 'the Divine Sarah' recalled this pilgrimage as one of her 'heart's memories'.

Marie's desire for social ascendancy in Stratford was temporarily sealed a week later when she gave a garden party for the Whitefriars Club, a literary circle of which Winston Churchill was chairman and Sir Henry Irving a member. To impress the town with such connections, she invited appropriate locals. On her own terms, her generosity could be great. During her first Christmas in Stratford, she entertained the children from the Catholic School around a huge Christmas tree and 500 'ragged and hungry' Birmingham youngsters fed with 'the most evident gusto' at her expense. Later she took 250 Board School children on a railway excursion to Ragley and she freely presented trophies to the town's clubs and societies. As President of the Choral Society, she secured the great contralto, Clara Butt, to sing at its annual concert. Small wonder that, at the theatre, bouquets were thrust into her chubby hands and the house rose to cheer her. The triumph represented a lull before the storm.

19

War on All Fronts

At 29 Windsor Street lived James Barnhurst, who, as a sergeant in the Warwickshire Regiment, had fought in the disastrous defeat at Majuba Hill in the first Boer War. He had spent twelve days in captivity before being repatriated. His war might have been another forgotten colonial episode, but the discovery of gold in the Transvaal ensured an influx of fortune hunters, including a number of Stratfordians. A further war appeared inevitable and was much in the air in the autumn of 1899. On 1 October, the vicar courageously inveighed against the government's aggressive policies towards the Boer republics. Two weeks later, war was declared and he changed his tune. It was now everyone's duty to rally round the flag. On a visit to the National School, he asked the girls about the meaning of words like 'Patriotism' and 'Britannia' and was readily answered. They were faced, he said, with a sad and possibly long war, and young and old must take every opportunity to express their patriotism and their readiness, if necessary, to fight and die for their country. The 240 girls then sang 'God Save the Queen' and 'Rule Britannia' before a like performance occurred for the 260 boys. At the Mayor's Ball, the centrepiece of the dinner was a boar's head, inscribed 'Straight from Majuba'. It was too soon for the war to feature in the waxworks at the Mop, where the main exhibit was still of poor Captain Dreyfus. A correspondent to the *Herald* expressed the national feeling. 'The Boers may be brutal to coloured people … and a real dirty lot … but they know how to fight, and we respect them on the battlefield.' The patriotic surge was reflected at the font. Baptismal names suggested by the war included such future embarrassments as 'Dundonald', 'Roberts', 'Colenso' and 'Redvers'. Others felt unease. Many Liberals opposed the war. The Bullard brothers, antique dealers and auctioneers, were outspoken in condemning its injustice, a stand that was to cost them dearly.

In November, the first fourteen local reservists were called up. Employers held 'smokers' at which patriotic songs were sung and each conscript was presented with a pipe and tobacco pouch. A crowd of 2,000 saw them off at the station, shouting 'Good old Warwicks', 'Give it to 'em boys' and 'Don't forget old Kruger', while weeping women said farewell to husbands and sons. Pte Frank Huckfield proudly displayed the medal he had won at the Battle of Omdurman in the previous year.

Several employers announced that they would keep jobs open for men who had been called up and pay their wives 5s a week in their absence. Not all dependents were so fortunate. One soldier had been sending his grandmother a small allowance, but after he embarked for the Cape, she had just 1s left after paying her weekly rent. The mayor and the vicar had started a fund to relieve the families of conscripts. The old lady was visited by a clergyman who told her she was ineligible for help as the soldier was not her son. Her case was taken up by a neighbour, Joseph Wyatt. 'Having known the lad since he could walk, I can say that he

is equal to a son in every respect. She brought him up, fed, clothed and sheltered him, and I know her one great grief is this, that she thinks she will never see him again.'

The war was the last in which censorship was slack, and increased literacy and improved communications ensured a regular flow of information. After a series of British disasters, Pte Wilfred Rickatson of Broad Street wrote that he would not go through the Battle of Modder River again for £1,000.

> We had to lie flat on our bellies for thirteen hours, and the least move you ran the risk of getting shot. If a dust storm had not come on when it did we should have had to retire, and God knows what would have happened then, but we got safely over the river and the Boers fled like a swarm of bees … Believe me, although we are on the scene of the operations, you people in England know more of what is going on than we do, as we have the order to take a certain position no matter what it may cost, and no matter how many lives are lost, it has to be done. If they think you are hanging back you get court-marshalled for cowardice … I would not like you to hear that I was a coward before the enemy. I think there are only two other Stratford chaps in our battalion … one named Basket and the other Morris.

Pte R. Turvey was with the 2nd Royal Warwicks who were attempting to relieve Ladysmith.

> I am in the best of health, but only a little wild to get at the Boers, for we had a go at them last Wednesday and made terrible havoc among them. We charged and charged them with the bayonets till hardly one was left, and those that were, were taken prisoners. You ought to see a field after the fight. It would make your blood run cold. Next morning our bayonets were rusty with blood. We are only waiting for them again, as we are now always ready for them. They are good targets in the open, but they take a lot of getting at in the hills. However, when they are out they know what they will get from us, and off they go and we after them. My heart ached for some of them, especially when it was for me to stab one, but it is either you or him, and you have to take a true aim. But it is our duty, and when we have been at it a bit it seems like sport. We have only got one blanket to sleep on and one or two hard biscuits and a bit of bully beef, and we wash and bathe in the same water. Isn't it lovely?

Drummer E. J. Dimock of Scholar's Lane was among those shut up in Ladysmith, where there was 'a terrible lot of sickness and deaths were more frequent than we cared for'.

At the outbreak of war, C. A. Savage, son of the secretary of the Birthplace Trust, was working in the Transvaal with his brother. They slipped out and from Durban he wrote a view of events that found frequent echoes away from the front. 'If there is any spur wanted to urge on the young men of Stratford to become volunteers, surely it is enough to think that someday the call may sound and they may have the honour of fighting under the Union Jack for the honour and glory of our Queen and Country.'

On 31 January, the Warwickshire Company of Imperial Yeomanry embarked for the Cape. The Stratford-on-Avon troop was commanded by Lt Richard Fordham Flower. The youngest member to be called to the colours was Robert Lidzy, aged fourteen. He had left the National School just a few weeks before and got a job in the cellars at Messrs R.M. Bird, the wine merchants.

Fred Winter, the High Street draper, sought to turn the departure to commercial advantage, appealing to 'the Ladies of Warwickshire for contributions of knitted socks, nitted helments, For Night Wear, comforters, &c ... Special samples of these goods are now being shown (or will be sent on approval)...'

Apprehension lessened when the news of the surrender of the Boer commander, Gen. Cronje, was received on 28 February. It seemed that the war would soon be over. Two days later, news of the relief of Ladysmith brought unbounded joy. The bells rang, flags were hoisted, schoolchildren marched through the streets wearing red, white and blue ribbons, while 'those of a riper age testified to their patriotism and love for the old country by their eagerness to impart the news to all with whom they came into contact'. The *Herald* magnanimously declared Cronje 'a valiant and accomplished foe, and now that he has surrendered in the presence of overwhelming odds, the last thing that the British people will be disposed to do is to crow over him in his downfall!'

Not everybody shared such generous feelings. That night a mob gathered outside the Conservative Club in Rother Street before parading round the town, bawling patriotic ditties. Joseph Wyatt, who had taken up the grandmother's case was rumoured to be a pro-Boer. The window of his upholstery shop at 38 Sheep Street was splintered by a heavy stone and coal was thrown through his bedroom window. His door was kicked and hammered, the bell rung violently and cries of 'Turn him out' and 'Come out, Wyatt' were bellowed before the mob moved on to the antique shop of the 'conchy' Bullard brothers in Chapel Street, where hisses and groans were given. Malicious rumours had been circulating that the Bullards hoped that the British Army would be annihilated and that they had flown a Boer flag, which had been removed on police advice. In fact, they were conscientious objectors on the basis of their Christian faith.

The mob, now some 200 strong, battered down the side door. When the Bullards and their young lodger sought to defend the property, they were met by a hail of missiles. They appealed to a police constable standing nearby, but he refused assistance, so the three, with great bravado, drove the rioters out. Several of the crowd were hurt in the melee, one quite severely. After a semblance of order was restored, Mr W. P. Bullard, with amazing sangfroid, started to explain his views to the crowd. Surprisingly, he got a hearing, until someone shouted, 'Don't listen to his soft soap' and a stone from nearby roadworks was hurled through his shop window. Shortly after midnight, the mob moved on to the houses of other alleged 'pro-Boers'. The *Herald* reported that,

Remarkable fairy tales (rather ugly ones) had been circulated with regard to Mr Flint and the windows of his residence were smashed in. One or two of his sons were said to be helping the Boers and Mr Flint was represented to have openly expressed the wish that the Republics would be successful. As a matter of fact Mr Flint had a son in Johannesburg, but he took no part in the war ... Mr Flint has never taken part in politics, has the greatest respect for Her Majesty, abhors the republican spirit and utterly repudiates the odious insinuations that have been levelled against him.

It was common knowledge that the mob would rendezvous outside the Conservative Club again next evening. The police should have taken decisive action, but did little. The superior courage of the Bullards in dispersing the mob rankled the malignant. Reinforced by local roughs, the crowd went straight to Chapel Street, where a mere half dozen policemen waited.

Such a feeble force was no deterrent. The gas lamp opposite the shop was extinguished and all the front windows were smashed to loud cheers. The sleeping Bullard children were endangered by falling glass and stones. Furniture was dragged into the street and set alight. The bomBardment continued for over two hours. Henry Bullard locked himself in the kitchen and read to his daughters.

A bystander, Mr T. R. Elleker, was surprised that none of the crowd seemed to be the worse for drink. He discovered later that the pubs were very quiet that night. Around midnight, Cllr E. Deer managed to quieten the mob by calling for three cheers for the Queen and the soldiers at the front, before persuading them to disperse. Part of the crowd, however, smashed into Bullards' workshop on the Banbury Road and their auction rooms in Guild Street.

The next day, Bullard's shop was boarded up like 'a miniature Ladysmith'. That evening several thousand onlookers turned out hoping to see more fun. Some rushes were made at 'the kopjes of the pro-Boers', but the 500 rioters were easily contained by the scores of police that had been drafted in. The disappointed mob marched towards Tiddington, where a prominent resident had come under its suspicion. They were met by policemen with drawn truncheons and fled back to Stratford. Numerous names were taken during the evening and after four men were arrested – two described as 'ringleaders' – the town was quiet. Two weeks later, the news of the fall of Bloemfontein brought a noisy crowd onto the streets, but no damage was done. That week the news came that the Stratford Yeomanry had been ordered to the front.

Henry Bullard announced his intention to seek compensation under the Riot (Damages) Act. Many people communicated their sympathy, but most did so secretly for fear of reprisals. Edward Fox, the son of a local printer, wrote an arrogant letter to the *Herald*, which implied that he had been a ringleader in the riots and concluded pompously that England was 'too free for those who are not loyal to her'. Mr Wyatt wrote a scathing reply:

> My ideas of patriotism are something higher and nobler than terrifying helpless women and young children and coming to demonstrate and destroy in the darkness when the chances of detection would be materially decreased...
>
> Patriotism to my mind consists in deeds not words, and as Mr Fox and his sympathisers seem so brimful of it there is a splendid opportunity for them to show it by joining some branch of the military service, and so taking the risks of their ideal ... instead of enjoying the luxury of a feather bed and home comforts while others do the hard and dangerous work, and they the talking and shouting.

The ripples caused by the riots went a long way. 'Who would think?' asked the *New York Herald*, 'that dear sleepy old Stratford-on-Avon could get so excited as to break windows and smash warehouses?' The Home Secretary was questioned in Parliament about Mr Bullard's claim that respectable Stratfordians had orchestrated the riots. Enquiries were promised. The theme was taken up in one of the vicar's most splendid sermons. Preaching from Galatians: 'The fruit of the spirit is love, joy, peace', he conveyed his outrage in a few succinct phrases.

> I for one rather admire a man who is not afraid to give expression to views when he knows they are unpopular ... I am annoyed at the indifference with which many regard what has occurred ... It has been publicly stated that men occupying good positions in the town were in the crowd encouraging

them to violence ... The Home Secretary should be invited to send down a commission to take evidence on oath ... If Stratford with its population of 8,000 can produce an uncontrollable mob of 500, what could London, what could Birmingham do if they were similarly stirred?

When the four who had been arrested appeared in court, one was re-categorised as 'drunk and disorderly'. A more prominent individual was imprisoned for a month at the quarter sessions and a subscription was opened for him in the town. George Hewins' friends, Charlie Jones and Billy Palmer, got the same sentence and were described in the *Herald* as 'two half-drunken creatures'.

The vicar was the only one who stuck up for them ... Everybody else jumped on the bandwagon – even Parliament! Parliament called Charlie a '*dangerous ring-leader* oo no doubt incited the crowd!' – afore he'd been tried! That was what shocked me. And they said that the other ringleaders was being brought to justice! The vicar answered back, he weren't frit: 'They been left to bear their punishment alone, four men out of a mob o' five hundred!' My opinion of old Arbuthnot shot up. Black George weren't the only name he was called in Stratford – but this time he was right! They hadn't been responsible. I knowed that, I'd seen. That the true ringleaders 'ave escaped punishment there is not a shadow of a doubt. They are a different class o' folks to the two half-drunken creatures oo was creatin a disturbance Sat'day evening. But they 'ave been conveniently overlooked – their cloth 'as saved em.

Henry Bullard succeeded in his claim for compensation, the court ruling that the mayor had failed in his duty to read the Riot Act and call out the military. A further consolation was that, as a result of the publicity ensuing from the riots, his shop gained royal patronage! Princess Mary, the future Queen, an avid collector of antiques, came down to pay him a visit.

Further trouble was averted on the night Stratford heard of the relief of Mafeking. A torchlight procession and a firework display were organised. A year later a hero of the siege arrived with Wombwell's Menagerie. 'General Snyman, The Wonderful Mafeking Bell-Ringing Ape. This intelligent ape was trained by one of Baden-Powell's troopers to ring the town bell directly the Boers commenced firing, thereby warning the inhabitants to seek the bomb-proof shelters.'

In South Africa, the Stratford Yeomanry was faring badly. 'I have not undressed', wrote a trooper, 'except to bathe, since we left Warwick. We have not had anybody die yet, but some have been very bad. The water is as thick and red as a sheep dip, but we have it boiled first ... I went to town yesterday and bought jam, cheese, matches, &c. but could not get drunk, as the hotel is kicked inside out and all the stuff gone.' A few days later, the troop received its baptism of fire. While taking an important position, the company commander, Maj. Orr-Ewing MP and a trooper were killed and six soldiers wounded. Yet deaths on the battlefield were few compared with fatalities from enteric fever. At Bloemfontein, Private Wynne of the 2nd Warwicks got weary of conveying corpses for burial and obtained a transfer to the rest camp where 'light fatigue is done until you are fit for duty ... The nights are very cold at this time of year. I think I caught cold at Springfields, where we stayed for a fortnight, and where it rained for the whole time. We had one blanket, no canvas, and woke up in the morning sometimes in several inches of water. I would not tell you this', he concluded ironically, 'only I see by the papers how well Tommy is treated'.

War weariness was setting in. 'I wish to goodness it was all over', wrote Sergeant Charles Luckett of Wood Street, serving with the 5th Dragoons. 'Everyone here is heartily sick of what we are doing. It seems rot. We must have nearly 6 to 1 against the Boers now, and they keep going on, dropping down our people, and killing and taking lots of prisoners, and then getting off again. I am well, but getting a bit war-sick.' Drummer E. J. Dimock described the horror of the hit-and-run raids. 'I saw the effects of one of the Boer shells. It took one man's left breast off, a hind leg of a horse, then burst in the ground, and struck one man on the head and took a piece off his heel. It then hit another man on the head, and broke a pony's legs, so that it had to be shot.'

The flow of disillusion from the front led to protests by the local magnate, the Marquis of Hertford. 'Many of the men fighting our battles', replied the *Herald*, 'are now in rags and tatters, covered with vermin, are without boots and have scarcely the common necessities of life; one can quite understand that the rank and file might imagine that they were not sharing equally in the comforts sent from England for their special benefit. Starving men are always suspicious.'

The Stratford Yeomanry was in trouble again. In July, Lt Flower fell mortally wounded at Hammond's Kraal. A trooper recounted his last moments.

Just before they moved him from the place where he had been shot, he shook hands with us all round, wished us all goodbye and said: 'I did my duty, didn't I now? Tell my mother how I died.' With that he ordered us to leave him and proceed with the Wilts Infantry to the firing line again. Lieutenant Flower was put in an ambulance, but before he could be got to the temporary hospital he died. You cannot crack him up too much; he was so faithful to his men. He always got us food and bread, and if any of the men wanted money at any time he had only to ask for some ... We buried him under a large tree at midnight, and many were the tears that were shed. The grave was covered with stones and has been fenced round and a nice cross erected by Sergeant-Major Smart. The grave has been photographed and we all hope to get a copy.

Stratford mourned another death in January. Almost everyone heard of the Queen's passing, soon after the news arrived at the telegraph office. Her reign was so long and her image so stamped on the age that most people felt a sense of personal loss. Once again, Fred Winter did not miss a trick. 'I am fully prepared with a large stock of new mourning clothes' he advertised.

After Victoria's death, interest in the far-off, and seemingly interminable, war waned. In February, a further contingent of the Stratford yeomanry embarked. It included Edward Fox, perhaps called to action by disparaging remarks about his role in the riots. He proved a point by his absence, for violence flared again that summer, during a by-election caused by the death of Col. Victor Milward MP. The Liberals had wisely decided not to test local passions during the general election in 1900, but now they had little choice. Their candidate was the radical idealist, Bolton King. A favourite pupil of Dean Jowett's at Balliol, his enduring object was 'to carry the principles of Christianity into political and social life.' In ordinary times he would have been a splendid choice, but these were not ordinary times. His adoption meeting at the Corn Exchange was turned into a farce by the same well-dressed camaraderie that had orchestrated the riots. Speeches were interrupted by the inebriated rendering of patriotic songs, chairs were overturned and fighting broke out. When it appeared that the mob might storm the platform, most of those sitting there fled to an anteroom. At his adoption meeting next evening, the Tory candidate, Philip Foster of

Ingon Grange, appealed for tolerance. He had previously fought a Liberal stronghold in the North. 'They helped me in every possible way and treated me fairly and I do not want it to be said, now the boot is on the other leg, that here, where we have, or hope to have, a Conservative majority, that the fight had not been fairly conducted. I ask you to give my opponents a fair hearing.'

This generous appeal went unheeded. Two more Liberal meetings at the Corn Exchange were broken up. For their eve-of-poll rally, the seats were arranged to reduce confrontation and forty stewards imported from Studley. The first speaker, a Welsh MP, William Jones, was soon interrupted by shouts of 'Get your hair cut', 'You're no Englishman' and 'Go home'. 'Noise', he retorted, 'is one of the Tory arguments, but I do not reason with beer, I reason with men.' Fighting broke out in several parts of the room and a number of people were badly knocked about. One speaker, Mr A. M. Scott, foolishly tangled with the mob and was dragged into the street, knocked down and trampled in the gutter. He received a severe gash under his eye and fainted when helped into a shop. The police arrested a man who had kicked him, but also took Mr Scott's name as it was alleged he had struck the first blow.

Outside, a large excited crowd assembled. When Mr and Mrs Bolton King arrived, the struggle was so fierce that they were not noticed until they mounted the platform. The police ejected a number of brawlers, but the Liberals complained that these included the stewards who were trying to keep order. When Mr Jones threatened to report the matter to the Home Secretary, Supt Lambourne replied that the police had no power to interfere unless there was a breach of the peace. This was the cue for Mr Scott to reappear, with his face streaming with blood and mud covering his clothes, demanding if his condition was not sufficient evidence. When he tried to speak, he was greeted with shouts of 'Traitor'. 'I am no traitor', he retorted. 'The traitors are the men who sent our soldiers to one of the greatest campaigns in which England has ever been engaged without first providing them with the proper means of defending themselves.' Mr Bolton King tried to address a few words to the orderly part of the audience, but he was scarcely audible. The last speaker, Miss Marshall of the Women's Liberal League, at least got a good-humoured response. She had hardly begun when the crowd struck up with the popular song of the day, 'I'll be your Sweetheart'. Mrs Bolton King got a less genteel response. As she left the hall, course expressions were flung at her. Given the prevailing hysteria and largely Tory, non-resident 'out-vote', her husband probably did better than expected, losing by 2,977 votes to 4,755. During the election, it was learned that he beat his wife; farmed 2,000 acres, but employed no local labour; and that anyone voting Liberal would have to pay 1s towards his election expenses. For the second time in a year, questions were asked in Parliament about disturbances in Stratford.

In South Africa, the yeomanry was involved in the internment of the Boer population in a bid to end the guerrilla war, impounding livestock, burning down farmhouses and removing women and children to special camps. Trooper Hancox Bullock of Warwick Road thought these distasteful tasks to be, on balance, preferable to allowing them to starve on the veldt. The soldiers, he revealed, had only received £3 of their pay in five months – and prices were four times higher than at home. The Boers could still hit quickly and viciously. In one attack, trooper Hancox was hit by a bullet and fell, his horse on top of him. As he lay semi-conscious, the Boers took his rifle, bandolier, tobacco and a letter. One was about to shoot him, but was prevented by a comrade. Curiously, his letter was forwarded to his sister at Wilmcote by a released British prisoner, with a note that it had been taken from the body of an English soldier.

Corp. Edward Fox was discovering the reality of war. After he was captured with seven other troopers, the Boers took their rifles, bandoliers and valuables, leaving them to stagger back to base, clutching the tops of their breeches. After a spell in hospital, he was discharged and sent home.

Grenadier Guardsman, W. Gardner of 1 Banbury Road, wrote that his company had been in three or four engagements a day for the past week. During the fighting on the previous Sunday, he had thought of home at dinnertime, 'as we had not had anything to eat for 24 hours. Still, you have to keep your eyes open for food, and put something in your pocket.' They had been viciously ambushed. 'It was the nearest to death that I have ever been in my life. I saw my mates being shot down around me, and could not make out why they did not finish me.' A Boer galloped up to him, put a pistol to his head and shouted to him to surrender. His personal possessions were taken, including his belt. The Boers told him that, if he had been a colonial, they would have shot him, but they spared him because he was forced to come. 'If ever I reach home no war will get me to this country again. We have lost, through fighting and sickness, 50 already out of 140 … You are not safe 10 yards from camp … and if you go up into the hills you get shot at in all directions. But they are bad shots at the best of times.'

Yet the war was dragging towards its close. In June 1902, news of peace brought great rejoicing in Stratford. Signals were fired on the railway and flags hung from every window. Drapers displayed red, white and blue material and nearly everyone wore patriotic colours. Over the next few months – and largely unheralded in contrast to the fervour that had seen them off – the soldiers returned.

The *Herald* was statesmanlike in its assessment of the war. 'Every generation seems to be in need of a reminder of the horrors of the battlefield. The Englishmen who were witnesses of the Crimean campaign, and who remembered the suffering and taxation which it involved had a genuine and heartfelt abhorrence of war. It is probable that, while the generations now living survive, England will not easily tred the path which may lead to bloodshed and carnage.' More prophetically, the paper had, at the turn of the century, predicted that 'complications may arise, sooner or later, between Britain and Germany'.

The Stratford mob, which had enjoyed the war, had another flourish to offer. Eight weeks after the peace, John Kensit, the militant anti-ritualist, arrived in Stratford with his team of preachers, doubtless attracted by the scathing national press the vicar inspired. Stratford did not take kindly to this. It was all very well for townsfolk to criticise George Arbuthnot, but motivated outsiders were another matter. Hostile demonstrations erupted during a meeting at the Fountain, although it was noted that the crowd did not consist of 'conspicuous attenders at any particular place of worship'. That evening, over 2,000 people gathered ominously outside Kensit's meeting at the Corn Exchange and imprisoned those within until 1 a.m.

'The Real and Living Hummer'

In 1901, Marie Corelli moved to 'Mason Croft', a Georgian mansion in Church Street which she refurbished in idiosyncratic style. Her celebrity attracted crowds to the pavement opposite. While publicly deprecating such attention, she tacitly encouraged it by her flamboyance. On Shakespeare's Birthday, she produced an enormous wreath, gathered in Dante's garden in

Florence. She and Bertha were pulled around Stratford in a miniature chaise by two Shetland ponies named Puck and Ariel. Cabdrivers pointed out her house as Stratford's prime attraction. Even the Americans, as *Punch* wittily observed, were diverted.

> The Yankee streaming to the Shrine
> Of our Immortal Mummer,
> Forgets the dead and doubtful 'Swan'
> And concentrates his worship on
> The real and living Hummer.

Marie's interest in Stratford led to a genuine desire for its conservation. Many of her instincts were sound, but her efforts were often marred by egocentricity and tactlessness. Nevertheless, her first campaign was a great success. When Sir Theodore Martin proposed to erect a large memorial to his wife, Helen Faucit, opposite Shakespeare's monument in Holy Trinity, Marie wrote a letter of protest to the *Morning Post*, which engendered considerable support, but her triumph was due to assiduous research. When Sir Arthur Hodgson, the high steward of the borough, applied for a faculty to remove two monuments to make room for the memorial, she secured the opposition of the descendents of those commemorated, so Sir Theodore had to be content with donating a handsome stone pulpit.

After a brief and cautious honeymoon, relations between Stratford and Marie were starting to sour. She was soon at war with Dr and Mrs Earnshaw Hewer, her next-door neighbours, accusing them of spying on her over the fence. On the other side, the boys of Trinity College kicked balls and threw missiles into her garden, despite the efforts of Mr Beckwith, the harassed headmaster, to restrain them: the greater Marie's fury, the more provocative the boys. According to Ursula Bloom, a boy named Skinner nearly blew himself up while attempting to bomBard Miss Corelli's new winter garden with a starting cannon bought at Mr Sleath's shop in the High Street.

Storm clouds were gathering elsewhere. Marie's relations with the Bensons were soon delicate. She was irritated when refused entry to a dress rehearsal, upset when they pleaded pressure of work and turned down an invitation to lunch and mortified when Mrs Benson's messenger delivered the note at the tradesmen's entrance. During Benson's absence from the festival of 1900, she vented her feelings in reviews for the London papers, praising copiously John Coleman's ludicrous *Pericles* and pouring her wrath on some of the other actors, one of whom, Corbett Thalborg, brought a successful libel action against her.

In the summer of 1901, Marie entered the parade of decorated boats that closed the annual regatta. A punt was elaborately decked out as a basket of flowers, glee singers were hired and she and Bertha donned their most colourful apparel. As they were preparing for their triumph, news arrived that Oscar Asche, holidaying in Stratford, had entered an exotic float, with his glamorous wife, Lily Brayton, basking as Cleopatra on a tiger-skin, hauled by a chorus of Hebrew slaves. The infuriated Marie could not bear to be runner-up and sent a curt note to the committee that her entry was for display only. Ironically her effort was thought the best, but she blamed the Boat Club for what she considered to be a humiliation, 'forgetting' an offer to present a Coronation Cup and mischievously citing an alleged conversation with Sir Arthur Hodgson. 'Too good for the likes of them, my dear lady. Too good for them.'

Among the children that Marie took on her float was Ursula Bloom, aged six, who was also to be a prolific novelist. She was the daughter of the Revd Harvey Bloom, a scholarly eccentric who was Rector of nearby Whitchurch. Marie was charmed by this bright, pretty girl and liked her to play in her garden, dedicating a children's book she wrote, *Christmas Greeting*, 'to my little-child friend, Ursula Bloom.' The dénouement came one day when the little girl asked her if she had been divorced. Marie's fury knew no bounds. She surmised, possibly correctly, that the child was repeating a discussion between the parents. Ordering her carriage, she drove to the Rectory, and, with the parents absent, questioned the servants in front of the child. Despite this, Harvey Bloom tried to be conciliatory, but Marie's blood was up and her resolve to make a foe of this clever clergyman was as determined as it was unwise.

Marie's desire to 'lovingly and sacredly guard every old building and the form of all Stratford's old streets' led to her greatest trouble in the town. If she could have had her way, every building would have been in the style of 'the Master's day'. In this she found common cause in contemporary taste. Even the new Boat Club was mock-Tudor. In 1902, she paid to restore the 'Tudor House' in the High Street to what was deemed its original appearance. That year the mayor, Archibald Flower, presented three dilapidated cottages in Henley Street to the town as a site for a long-awaited free library. The American philanthropist, Andrew Carnegie, agreed to put up the money, but Marie declared herself aghast and carried opposition to the press. These, she declared fancifully, were cottages that Shakespeare had loved as a boy. She enlisted celebrities like Ellen Terry and the poetess Alice Meynell to her cause and interpreted a polite reply from a secretary to represent the King's support. She established a private press on which she published a journal, the *Avon Star*, to launch wild attacks on those supporting the scheme and reflected her artistic prejudices, even making snide remarks about the humble origins of Ben Jonson, whose *Every Man in His Humour* was a festival production that year.

Stratford was furious. Marie Corelli became the subject of lampoons, although a contribution called 'The Avon Stir' showed a sneaking admiration for her ability to upset the local establishment:

> Miss Corelli had a notion,
> That she'd cause a great commotion,
> In Stratford by the Avon's gentle flow,
> So she launched a shilling number,
> And the tradesmen woke from slumber,
> And she prodded up the Corporation slow.
> Now the town is by the ears,
> Pa is cross and Ma's in tears,
> For 'twas a nasty thing to do,
> And the language, well 'tis shocking
> Of those she's been a mocking
> But we wish she'd tell us something really new.

A wag suggested that the postmen in Henley Street should dress as beefeaters in deference to Miss Corelli's sensibilities. Andrew Carnegie was less subtle. Although he regarded the

Birthplace as 'more sacred than the Holy Sepulchre', he swore that even if the cottages were as old as Jesus Christ they would come down. The age of the cottages was taken up by Marie's new adversary, Harvey Bloom, who produced a counterblast by publishing *The Errors of the Avon Star*. Two of the cottages had been rebuilt within living memory, although he conceded that the third was Elizabethan. Miss Corelli was no friend of old buildings. She had vandalised 'Mason's Croft' by building a winter garden that looked like a Strand teashop. Even more humiliating was his defence of Ben. Jonson. Of whom can he have been thinking when he declared that the poet's birth in lawful wedlock was 'at least as respectable as many a birth in higher walks of life'?

Another of Marie's eruptions was on the way. It came on 12 June 1903, when the editor of the *Herald*, George Boyden, incautiously published a letter from Fred Winter revealing that before any idea of the library was mooted, she had asked him to find out the price of the properties in Henley Street, in order, he implied, to donate them herself. The price was too high, 'but, it would have been a "Corelli" instead of a "Carnegie" library.'

Marie Corelli's lawyers issued writs for libel against Winter and Boyden (although Boyden's was withdrawn). The case was heard in a Birmingham court with a gallery packed with Stratfordians. Marie's appearance in the witness box in one of her most flamboyant costumes so flustered her counsel, that he asked her, to the delight of the gallery, whether she had lived in Stratford for forty-three years – and this to a woman who hinted that she was no more than thirty! When George Boyden was called, Marie's counsel asked him to explain the flattering paragraphs which regularly appeared about her in the *Herald*. His answer was devastating. She wrote them herself!

The jury's verdict was for Marie, but damages were a mere farthing, 'the smallest coin of the realm', with costs against the respective parties. Stratford was immediately inundated with farthings. The doorsteps of Miss Corelli and Mr Winter were covered in them and Marie had a huge cardboard one glued to her door. Fred. Winter started a 'farthing fund' for local charities. In a gesture of reconciliation, Marie sent £11 worth, but sadly the gift was returned because she would only release the letters that showed her in a good light, rather than the whole correspondence on the issue.

There is no doubt that, although Marie could behave absurdly in her dealings with the Stratfordians, many of them were as difficult as she. Joseph Skipsey, 'the Pitman Poet', at that time quite a noted figure, said that the only unhappy time of his life was spent as custodian of the Birthplace and that Stratford was no place for a poet of 'refined and sensitive nature.' As it happened, Marie gained the last laugh. It was discovered that the cottages had once belonged to Thomas Quiney and that an obscure by-law forbade the destruction of any property that had been owned by Shakespeare's family. Threat of further legal action caused a sensible compromise and the library was established in the heavily restored cottages, blending unobtrusively into the hotchpotch of Henley Street.

Marie, still smarting from imagined slights from the Bensons, patronised Mrs Sinclair's company, popularly known as 'The Blood Tub', the last of the itinerant troupes that had been coming to Stratford for centuries and which were disappearing under the onslaught of the picture-palaces. Each summer, their tent was erected for a six-week season in the field down Cherry Street. The Misses Corelli and Vyver sat grandly and incongruously in a specially-constructed box, which had, unbeknown to them, been reinforced with orange boxes to support their weight. The theatrical delights presented included *The Pirates of the Savannah*

or *The Tiger-slayer of Mexico*, with its 'famous duel of four with revolvers and guns in the true American fashion'; *East Lynne*, described by Ursula Bloom as 'eternally a winner'; the 'wildly -exciting' *Under Two Flags* with 'The Marseillaise', played on a cornet by Master Sinclair; and *Maria Marten* or *Murder in the Red Barn*, advertised as 'Not for Children', which ensured 'a satisfactorily large audience who were privately hoping for something dirty'. As an added attraction, locals were employed as 'supers', and plays were adapted so that they bore such titles as *The Lily of Stratford*.

Sir Henry Irving agreed to play Shylock at the festival of 1905, but by April, he was terminally ill and withdrew. Marie's tastelessness reached new depths as she seized the chance to hit back at the local establishment. In a review she wrote that Irving 'was not to be blamed for putting a wide distance between himself and the historic building on the banks of the Avon'. That summer, she imported a Venetian gondola, complete with gondolier. The latter was not a success. In the low parlour of the *Dirty Duck*, he developed a taste for Flower's Ale and was merry at the helm once too often. He was replaced by a more phlegmatic local who must have felt uncomfortable in his Venetian costume as he paddled Marie and Bertha down the Avon. This gondola was to be remembered in Stratford long after Marie's other exploits were forgotten. In 1907, she achieved a great social coup by persuading a reluctant Mark Twain to visit her. The great and aged writer was whisked about to her greater glory and later confided that he had found her 'an offensive sham'.

Over the fence, another of Marie's wars continued. Trinity College had become the Army School, with the main objective of preparing boys for the military academies. This change of purpose did not improve relations. In 1908 she struck, purchasing the paddock behind Mason's Croft where the boys played games. Although the lease had five years to run and she gave blithe assurances that she would not interfere, life under such a landlady would be intolerable. Land was purchased in Maidenhead and the school moved out.

Stratford's fury was boundless. The school was a good source of trade. Marie's windows were broken as the boys took their leave, and the townspeople were generally glad for any hurt that was done to this harridan in their midst. Marie, at least, kept her cool. She had accounted for one vexatious neighbour, but who could say that there would not be another? She moved swiftly and bought Trinity College from its trustees. They were pleased enough to sell to finance their new venture.

Eloquence and Zeal

On 2 July 1904, Stratford's other great controversialist held a garden party to celebrate the twenty-fifth anniversary of his incumbency. George Arbuthnot's iconoclasm extended to the occasion. Rather than a closed, self-congratulatory event, anyone on the parish was invited to apply for a ticket. Thus, 1,200 people of all denominations mingled happily together. A wave of affection for this somewhat unlovable man swept the town. His achievements were remembered, his zeal for education and temperance and his creation of a comprehensive parochial organisation. During his incumbency, 4,486 people had been baptised, 2,731 buried and 962 couples married, so there were few in the twin parishes who had not encountered him. His fear of no one and his attempt, however idiosyncratic, to propound a social gospel,

made him a formidable opponent. After a vagrant was arrested for sleeping in a warm brick kiln on the Birmingham Road, the vicar announced that, if men were to be prosecuted for such trivialities, he would test the law by sleeping rough. The resultant alarm on the bench made such action unnecessary.

Like Mr Gladstone, who he saw as the personal exemplar of the Christian social ethic, the vicar never allowed appearances to inhibit his duty. The tongues wagged after he befriended a nineteen-year-old orphan girl and found her a position at Mr Parkhouse's drapery in Bridge Street. One strand of gossip said that she was his daughter, another that she was his mistress. Few gave a verdict to Christian altruism. When the putative scandal reached his ears, he acted decisively, and announced that he would make a statement on the issue at Evensong. That night, the church was packed. From the pulpit, the vicar challenged anyone who wanted to know the truth to come to the vestry afterwards. Needless to say no one came.

Arbuthnot's eloquence and zeal would have graced the episcopal bench, but his lack of tact and outspokenness mitigated against any such preferment. In 1908, he made his sole hierarchical advance when he was appointed Archdeacon of Coventry, which ensured that his connection with Stratford would not be severed. His farewell sermon listed his achievements: daily celebration of Holy Communion, a fortnightly choral Eucharist, free sittings and the growth of the National School. He concluded on a characteristically controversial note with a swingeing attack on the Low Churchmanship prevailing at the Guild Chapel. He may or may not have realised that he was reviving a friction that was almost as old as Stratford itself, which was nearing resolution – not by an admission of the vicar's plea for full jurisdiction, but through a growing indifference to such questions. Increased leisure was bringing the cry that more and more people did not go to church, but spent their Sundays in recreation. The churches were becoming places of elderly females. The recreation ground and cheap railway excursions were replacing the vicar's sharp moral imperatives as a means of Sabbath edification. No cleric after George Arbuthnot established his dominance over Stratford's faith and morals.

Matters Politic

After the disastrous 'Khaki Election' of 1902, the Liberals began a rapid revival. In June 1905, the Women's Liberal Association's rally at Welcombe, the home of Sir George Trevelyan MP, opened with a strident song: 'Liberals all now call to action, / Rise to fight the Tory faction! / their ranks now spread distraction, / Scatter all their bands'.

Next month their Parliamentary star, Winston Churchill, received a rousing reception from a packed Corn Exchange. The *Herald* did not find him 'an inspiring speaker, but his manner is good, and when he wants to drive home a point he is particularly incisive and bitterly sarcastic.'

The election came in the following January. The amiable Tory, Philip Foster, sought re-election, while the Liberals, pondering who would go down well in a Conservative area, chose Captain Kincaid-Smith, who had participated in the Jamieson raid and been decorated during the Boer War.

National politics reached a rare peak of interest that month: a mood thoroughly reflected in Stratford. Kincaid-Smith canvassed assiduously and generally found a good response, but not

from George Hewins, the bricklayer who heard him declare, to great applause, that only those who worked regularly should not get relief during economic depression. He was stunned.

> Any fool knowed that in the building trade you was never in regular work! None of us was idle – you couldn't afford to be! – it all depended on the weather and if you could find a gaffer to take you on. A gaffer might have forty blokes working for him one week, cos it suited him, three or four the next. How could you save?
>
> That's what we should a-been doing, Foster, the Conservative bloke said, – saving! I went to hear him speak too. If we'd been thrifty, he said, saved for a rainy day, we'd a-been alright! Some folks was cheering, waving their hats in the air! Well, I got the last laugh. It happened a gang o' pickpockets from Birmingham came to town that day, and those as was well dressed they stripped them of everything of value: watches, pocket handkerchiefs, money! There was some long faces after the speechifying at those meetings.

Polling day saw a high turnout. George got strict instructions from his wife. "'They got the money, the jobs. You put your cross in the right place", she said, "and keep that on", meaning my rosette. I'd been switching from the yellow to the blue and back again, according I couldn't make up my mind.'

That evening hundreds assembled in the rain in the High Street, where Mr Eccles used a magic lantern to project the results onto a screen outside his electrical shop as they were received by telephone. The Liberal landslide and the defeat of the Prime Minister, A. J. Balfour, were greeted with huge cheers. Excitement increased as rumours spread that the local result was close. Indeed it was! Deafening cheers greeted the announcement that Kincaid-Smith had triumphed by 148 votes. The new member proved a dubious asset to the Liberals. In his first six months in Parliament he opposed vital party policies, while developing an idiosyncratic programme of his own called 'Universal Military Training'. Lloyd George described him as 'one of the freaks of the last election… more Tory than the leader of the Opposition'. In the constituency he was admired by some Tories who thought him a better member than Philip Foster, but the Liberal Committee resolved to send him a strong protest with a warning that the membership would be canvassed for its views. At a consequent emergency meeting it was resolved that the Executive should find 'a fit Liberal candidate'. Kincaid-Smith, who was present, announced that he would try to elicit the views of the electorate. He was as good as his word, visiting 1,500 households. He did not reveal his conclusions immediately, but it was clear that this principled eccentric felt that he had a mandate to act. In the Commons he brought forward his National Training Bill under the ten minute rule. One clause proposed exemption for 'habitual drunkards, persons of weak intellect and members of both Houses of Parliament.' According to *Punch*, 'a roar of cheers and laughter greeted this happy grouping.'

In 1907, the Stratford branch of the Women's Suffrage Society was formed with four members. Within a year there were over fifty. Some women proposed to raise the issue at the AGM of the Conservative Association, but did not do so after it was hinted that it would be discussed. It wasn't and it was predicted that Philip Foster might face suffragist heckling at his next meeting. The local branch represented feminine gentility, holding drawing-room meetings and numbering Lady Trevelyan and the vicar's wife among its adherents. The members impressed

by their lucid arguments and careful aspirates. Although they did not support the violence of the suffragettes, they confessed to admiring their courage. Men and reporters were barred from their meetings, but the *Herald* infiltrated a correspondent, presumably a woman, into a rally at the Town Hall. She was suitably eulogistic. 'Surely there were among those present those who were entitled to the franchise, and who could exercise it with greater safety and discretion, than nine-tenths of the present electorate. Women's enfranchisement must come, and the ladies of Stratford are helping it on at a pace mere man can little dream of.'

Within a week of a public meeting at the Fountain, a 'Socialist and Ethical Society' was formed in Stratford. In 1908 local branches of the Independent Labour Party and various trades unions chose Mr Kenneth Holden of Stratford as their Parliamentary candidate. The new party had a rough birth. Often its chief detractors were those it sought to emancipate. One public meeting at the Fountain made Mr J. C. Huckvale – not himself a Socialist – ashamed of some of his townsmen. 'The senseless and witless exclamations of the half-drunken and thriftless part of the crowd, together with the sheer inability to frame the semblance of an intelligent question, would have disgraced a horde of primitive savages.'

The Liberal Government was bringing in fundamental reforms. On 1 January 1909, the lives of the elderly were transformed by the introduction of Old Age Pensions. On the great day, expectant queues formed long before the Post Office opened. It was estimated that the measure would reduce the permanent population of the workhouse by two-thirds and that a projected review of the Poor Law would do the rest.

April brought the amazing news that Kincaid-Smith had resigned his seat and intended to fight a by-election to test opinion on his Bill. Such a contest would clearly attract protagonists of the issues of the day. First in the field was Stuart Gray, notorious to many for his inflammatory speeches as leader of the hunger marches for the right to work. He offered himself first to the Liberals as their candidate, but they referred him to the Socialists, who in the event did not contest the seat. He withdrew to the Fountain, where he drew large and frequently tempestuous crowds with his fiery oratory. The Liberals eventually selected a distinguished candidate in the Hon. Joseph Martin, known as 'Fighting Joe from Manitoba', a former Prime Minister of British Columbia, who later sat for St Pancras East. He was candid about his lack of knowledge of the British political scene. 'That's what I am going to Parliament to find out', he would reply disarmingly to awkward questioners.

Others took advantage of the by-election. The Free Trade Union and the Suffragists opened campaign offices. The ladies did much to enliven the otherwise predictable proceedings, holding by far the liveliest meetings when Mrs Pankhurst spoke in the afternoon to women only and in the evening to an open assembly. A joke was circulating that there were two performances that night, one at the Theatre, the other at the Corn Exchange and both were called 'Much Ado about Nothing'. Mrs Pankhurst bristled. 'Let them see what that nothing is. In the play the nothing about which there is much ado is a woman's honour and reputation, and the much ado at this meeting is connected with a struggle for women's rights and liberties.'

The result of the by-election, given the government's unpopularity and the circumstance of the contest, was a foregone conclusion. That amiable Parliamentary mute, Philip Foster, swept back with a huge majority. Poor Kincaid-Smith polled a mere 479 votes, but perhaps felt his point had been made when war broke out five years later.

Despite the magnitude of their defeat, the Liberals were not deflated. This was another of those rare periods of electric political interest. Their years in the local political wilderness had conditioned them to defeat, making them more interested in issues than power. They adopted a local squire, Oscar Bowen, to fight Foster in the general election of January 1910. Reform was still in the air. At the largest Liberal meeting since 1886, a packed audience sang defiance of the landed interest. 'The Land! The Land! 'Twas God gave the Land, / The Land! The Land! The Land on which we stand! / Why should we be beggars with our ballots in our hand? / God gave the land to the People.'

On election day, ladies flourished petitions for women's suffrage outside polling stations. Foster was again returned in a record poll with a large majority. A second general election in December produced an almost identical result. The Liberals fielded a blind candidate, Mr Walker King, 'a gentleman honourable in every fibre' and were not disheartened by another defeat. Out-voting was to be abolished and the rising generation could be enthused. A local branch of the National League of Young Liberals was formed with a membership of sixty young men, but no young women. Its meetings were highly earnest, discussing issues like 'Electoral Reform', 'Payment of MPs', 'Naval Expenditure' and 'The Insurance Bill'.

Like most MPs, Philip Foster was a gentleman of independent means, regarding his service as a duty endowed by his position. When payment of members was introduced, he announced that he would retire at the next election, having strong objections to being 'a paid representative'. The Tories chose Mr Ludford Docker of Alveston Leys as his prospective successor. He had captained Warwickshire at cricket and played for England in Australia. The Liberals selected Mr John Pascoe as their candidate, and Stratford looked set for another exciting contest in 1915.

The borough council had settled into another period of lethargy. Most local elections were uncontested and complaints about the townspeople's apathy were frequent. A brief controversy in 1910 revived memories of stormier days. The son of Thomas Lunn, the town clerk, was appointed as his successor without the post being advertised. Indeed it transpired that every town clerk had been appointed in this way since 1818. 'A pretty hole-in-corner job', fumed the popular magazine, *John Bull*, and in Stratford a protest meeting was held. Elsewhere there was slow progress. Stratford's first six council dwellings were occupied before Christmas in 1910.

The cause of women's suffrage was gaining ground. Locally it was the Suffragists, with their reasoned arguments, who made an impact, rather than the dreaded Suffragettes, who believed in direct action. They were very persuasive. In the autumn of 1909, a theatrical group sponsored by the National Union of Women's Suffrage Societies, presented two playlets, *A Woman's Influence* and *How the Vote was Won*, to a large and appreciative audience at the Corn Exchange. Edith Craig, the daughter of Ellen Terry, played Mary Bull, a Lancashire lass, quietly but effectively demonstrating the social handicaps inflicted on women. 'The words put into her mouth were words of wisdom', said the *Herald*, always sympathetic to this cause.

In 1911 the Stratford Conservative Women's Suffrage Association was formed. Its members included Lady Willoughby de Broke, wife of the most effectively reactionary peer in Britain. Others actively opposed the movement. In 1912, the local branch of the National League for Opposing Women's Suffrage held a public meeting in the Corn Exchange, with

Lady Fairfax-Lucy in the chair. A clash in the old Stratford tradition came on 16 July 1913. Fifty-six suffragists, marching to London, were welcomed by local supporters. They laid a wreath on Shakespeare's grave before holding a public meeting at the Fountain. After the first speaker, Miss Hanbury, had welcomed the 'jolly sporting' ladies, unruly spirits in the crowd began a barrage of continuous heckling. The mob surged towards the platform and several ladies were jostled. Arrests were made, but the cacophony was irrepressible. The crowd was clearly organised to prevent the speeches and the meeting was abandoned, but from another platform the formidable Mrs Despard, a sister of Sir John French, awed the remnant of the crowd into silence.

Archdeacon Arbuthnot took up his pen to express his shame and regret that his old parish had disgraced itself 'by the violence shown by some contemptible rascals to ladies, who, whether we agree with their views or not, are peaceable citizens and entitled to that free speech, which, within the rights of the law, is the birthright of every Briton.'

The 'Suffragist Riot' was the last flourish of the Stratford mob. A year later events would engage some at least on a more deadly business than shouting down a few women.

Sporting Prowess

In the pre-war years, young Stratfordians achieved exceptional sporting success on land and water. The rowing eight won trophies at many regattas, including Henley; the cricket XI was formidable and the rugby team won the Midlands Cup at Leicester. Patrick Thompson of Greenhill Street stroked the eight and played in the XV. Wing three-quarter was Norman Kinman, son of the High Street fishmonger and poulterer. He was widely regarded as the finest sportsman that Stratford had ever produced – and this at a time when memory could reach back to the very start of organised games in the town. He was endowed with a magnificent physique, a fine turn of speed and a matchless courage. There was no outdoor sport at which he did not excel. As a boy at the Commercial School, his skill at soccer had gained the interest of a leading league club, but he preferred the less potentially lucrative game of rugby, 'Stratford's premier sport'. His magnificent defensive play had played a decisive part in the magnificent victory at Leicester. He won a place in the Midlands Counties team that won a heroic victory against Middlesex on Stratford's home ground at Pearcecroft. His type was that of the taciturn sportsman. 'Plain and blunt, modest and retiring, for anything in the nature of a show of fuss was anathema to Norman.'

The Grammar School contributed fine sportsmen to the town's teams. Head boy in 1913 was Gordon Barber, the eldest son of the Congregational minister. He was an excellent wicket-keeper, Captain of the XV and secretary of the debating society. As a lay preacher he won 'great acceptance' in the village chapels. He was looking forward to taking up a place to read history at Birmingham University.

20

'The Sleeping Soul of England'

It is your privilege and ours … to help revive the sleeping soul of England.

F. R. Benson, 1908

Indian Summer

Despite the lengthening shadows that darkened the Edwardian era, the image of the age is of an Indian summer. In Stratford, this was due at least partially to the Bensonians. The company had become an institution and there was even an Old Bensonian Association. On May Day 1905, like a gathering of former pupils, they remembered old comrades with the first of a group of stained-glass windows on the staircase in the theatre lobby. Four dead actors were commemorated, including Frank Rodney.

Yet this very institutionalism was causing muted but mounting criticism. The sameness of the productions and the domination of them by the Bensons were disillusioning a new generation of theatregoers, although the multitudes who loved the company remained forever faithful. F. R. B. was aware of this feeling and went some way to meet it. Leading actors were engaged, some as guest artists, with the Benson Company, others bringing their own productions. Thus began a 'star' system that lasted over half a century. First to come was the matinee idol, Louis Waller, who played Othello in 1907 and returned as Henry V next year, when Constance Collier acted Juliet and Helen Haye, Mistress Page.

As Benson's dominance diminished, so the Stratfordians' affection increased. Each April, crowds gathered at the station to welcome the company. The approaches were decorated with flags and banners. One hung across the road bore the appropriate Shakespearean motto: 'To meet you on your way and welcome you'. The railway company placed fog detonators on the line, which exploded as the train approached. Constance Benson was shocked when one of the porters said to her, 'We have a lot to thank you and Mr Benson for, you are making Stratford another Blackpool.'

The involvement of the Stratfordians could be highly participatory. Each season, the 'supers' were recruited to play the walk-on roles. The myriads of fairies who were paid 1s a night to appear in *The Dream* were taught to dance by Leah Hanman, whose ethereal Puck was regarded by Stratford playgoers as supreme. Many of the girls were recruited from the Alcester Road School by the secretary of the Birthplace Trust, Frederick Wellstood.

Another custom was added to the Birthday celebrations in 1907, when the King donated a Union Jack to be unfurled at the opening. In the following year it was joined by the flags of the

nations, 'to signify the universality of Shakespeare's genius' and after the Austro-Hungarian ambassador unfurled the flag of the dual empire in 1910, it became customary to invite the representatives of the nations to do the same.

The growth of the festival led Benson towards a quasi-mystical view of Stratford. His romantic spirit and his contact with the Irish revival caused him to consider it the town's destiny to become 'a Temple of the Anglo-Celtic race'. His closing speech to the adoring audience at the 1908 festival expressed the theme. 'It is your privilege and ours in this building to help reawaken the sleeping soul of England.'

That year on the Bancroft, Benson inaugurated a day of 'Old English Sports and Games'. Children danced round the maypole, skipped, sweated at the tug-of-war and a May-Queen of dark eyes and raven locks was crowned. Later, the adults did their bit with 'catch as catch can' and 'pick a back' wrestling, the greasy pole climbed for a leg of mutton, fencing, stick fighting and Morris dancing. On the river there was 'dongola' racing and tilting in boats, while an Elizabethan state barge, full of glee singers, rowed up and down.

In 1909, the Old Bensonian, Matheson Lang, brought his Lyceum Company in *Hamlet*. Constance Collier played Portia and Johnstone Forbes-Robertson presented *The Passing of the Third Floor Back*, preceded by an extract from *Henry VIII*, in which the great actor-manager played Buckingham. The year 1910 promised the grandest festival yet, lasting four weeks. There were two Hamlets. John Martin Harvey's was given the edge over the production that brought Sir Herbert Beerbohm Tree and Marie Lohr. Constance Benson met Tree at the station and he looked with great interest at the Birthday decorations before asking, 'Is all this kind thought for me?' Past favourites performed scenes from Shakespeare's comedies at an Old Bensonian matinee. The audience was enraptured, calling the Bensons to the curtain before every scene. Ellen Terry retruned to play Portia, with her husband, the American actor, James Carew, thirty years her junior, as Shylock. She was sixty-three, short-sighted and weak on memory, but the audience was determined that the occasion should be an overwhelming success. That night the news arrived that the King had died, and the festival was abandoned, providing a golden opportunity to revive it in the summer, an idea given greater poignancy by the fact that Benson was due to emulate Garrick by becoming a Freeman of Stratford. As part of his plan for cultural revival, he had organised a competition to find a new play set in a period before 1800. The winner, probably chosen because it employed the scores of children that Benson liked to swarm through his *Dream*, was *The Piper*, a verse drama of Hamelin by Josephine Preston Peabody. It was decided to premier it at the summer festival, which now became an annual fixture.

When Benson received his Freedom on 25 July, he quoted lines from *The Piper*. 'This day you have constituted me your knight, your friend, your serving man. I hope I may be spared to owe you still my life and service.' He and Constance were drawn through the streets in a decorated carriage, as the Stratfordians bombarded them with flowers.

The Piper was not a success and lost money when it transferred to London. Never a sound administrator, Benson's resources were running low. The theatre governors helped with grants and loans, but it was never enough. To ensure the company's survival, a syndicate, the Stratford-upon-Avon Players, was formed. Benson was paid a generous salary, but one of the provisos was that Constance should no longer pick her parts, but be replaced in certain roles by younger actresses.

The old order, including Constance, survived the spring festival of 1911. Fred Terry, forgetful of his lines but dominant of his part, played Benedick to the Beatrice of his wife, Julia Neilson. Lewis Waller came as Romeo, and Oscar Asche played an Othello of primitive passion. Benson was showing great talent as an impresario. The National Theatre Society of Dublin, a manifestation of the Celtic revival he so admired, brought three controversial new plays: *Kathleen ni Houlihan* by W. B. Yeats, *The Rising of the Moon* by Lady Gregory and *The Playboy of the Western World* by J. M. Synge. It was the latter that drew the fire – its presentation in Dublin had led to riots. 'Blasphemous', 'indecent', 'reeking of the pothouse', 'impious' and 'disgraceful' were some of the epithets hurled by the departing audience. One man declared he would have given £20 not to have seen it. The critic of the *Manchester Guardian* had a more balanced view.

> It does not seem to some of the worshippers at Shakespeare's shrine … that Synge's play is not the only one that reeks of the pothouse, and that if by some operation the cataract of literary respectability which blinds them could be removed, *Henry IV* and *The Merry Wives of Windsor* and a crowd of scenes and figures in other plays would appear so 'impious', 'indecent' and 'disgraceful' that, without doubt, they would willingly incur a much larger forfeit of £20 to be spared the pain of seeing them. Antiquity gilds the disreputable; the rags and tatters and profane speech of common humanity become amiable if it is long enough dead.

The Bensons continued their own version of revivalist folk art in the May Day celebrations, subconscious compensation, perhaps, for the loss of power in the theatre. For Constance, even this ostensibly harmless activity had its tensions, as she became reluctantly embroiled in disputes about the correct style of Morris dancing – 'stiff' or 'loose' knee. Some mocked such attempts to revive 'the true spirit of Merrie England', but despite, or perhaps, because of the disputes, the Stratfordians loved it. For the first time, a part of the season was truly theirs.

The May Day of 1912 was the most elaborate yet. Scores of children were decked out in smocks and print gowns from the Bensonian wardrobe. The procession was led by a white knight on a white horse. He was followed by a maypole. Each flowered ribbon was clutched by a girl in white and it was escorted by six girls in smocks from Shottery School. Behind came the fantastic figure of Jack-i'-the-Green, a man enclosed in an elaborate frame of evergreens, leading the Stratford schoolchildren, girls first, in white dresses and bonnets. At the Birthplace, the procession halted while the children sang and danced. Next came six sweeps with a master sweep, a hobbyhorse, a clown, a fiddler and the children of Ilmington. The May Queen was preceded by six maids with peeled wands, four maids with candles and escorted by four maids of honour. She was riding on a decorated cart pulled by four white oxen from a Shottery farm. Concern had been expressed about how these beasts would take to the hard streets and cheering crowds, but they were led by their carters in smocks and 'treated it calmly', in Ursula Bloom's words, 'as being a lot of silly nonsense'. There was more to come, Robin Hood and Maid Marian with six foresters, another clown and a fiddler, Barford School with another maypole and Binton School with a tableau on weaving. In front of the theatre, Benson crowned the May Queen. A photograph caught the moment. Benson raises the crown as if he were playing Prince Hal. The little Queen looks blandly bemused

by the whole odd show. The maids of honour gather round, one with an expression that says 'my turn next'. After the crowning, the schools demonstrated the results of weeks of careful rehearsal, performing their elaborate and stately dances.

The Ilmington Morris Men represented a rare tradition. It was a village where the morris dance had never died. They also represented another authentic rural tradition. Under the leadership of the local jack-of-all-trades, Sam Bennet, who had a reputation for being 'okkard', they refused to dance without remuneration.

A few days after the extravagant happiness of May Day, Archie Flower had the painful task of telling Constance that her future role was to be different. Through pain or tact she did not return that summer and her parts were played by Dorothy Green. Musical director of the company during 1912 and 1913 was Dr Ralph Vaughan Williams, who wrestled with Benson's musical philistinism, set his famous arrangement of 'Greensleeves' for a production of the *Dream*, lectured on folk song and received an inscribed baton from admiring playgoers.

The Benson legend was irrepressible amid the audience it had created. In the spring of 1913, Constance returned by popular demand to play Doll, the Shrew and Lady Anne. She was met at the station with bouquets and when she screeched her first off-stage words as Doll Tearsheet, the audience erupted in cheers. That year saw the Stratford's debut of a great actress. Edith Evans played Cressida with William Poel's English Stage Society. She made her last appearance under the direction of Peter Hall nearly sixty years later. Another friend of fame made his debut that summer, Basil Rathbone, straight from Repton and looking a 'glorious Apollo'. In September, the company toured America for nine months to mixed receptions from audiences to whom the Benson mystique did not create an advance atmosphere of success. Constance, elated by her Stratford reception, who was over-demanding, did not go and escaped a savaging from the Chicago critics. Patrick Kirwan, Benson's stand-in for the festival of 1914, made little impact, but was not entirely to blame. Oscar Asche withdrew after an accident and Sir Herbert Beerbohm Tree forgot to appear. The *Herald*, getting daring as the Victorian age receded, likened one production to 'an Orgie in Babylon with its clothes on'.

Trit, Trit, Trot

Customs are often noted as they wane. Benson's 'Merrie England' revivalism led to an interest in recording what was disappearing forever. A very old lady recalled that, in the 1820s, dancers competed for ribbons. At the end of the day there was a ribbon dance for all the winners. Susan Rice, from an old Stratford family, remembered that, fifty years before, any boy arriving at the Grammar School on Oak Apple Day without a sprig of oak in his cap would be buffeted by the other boys to cries of 'Ship-shap, ship-shap, no oak in your cap'. Even stranger was the custom recalled by the librarian Salt Brassington. On May Day, the sweeps paraded the streets, singing, capering and making discordant noises to attract attention. One was decked in traditional foliage as 'Jack in the Green'. Another, dressed as a clown, collected coppers in a long ladle thrust at passers-by. Formal dances occurred at set points. In the May Day rituals, the sweep possessed a special and forgotten significance and his character was often represented in the children's dances.

One of the last repositories of the declining folk-culture was the playground. May Day songs were particularly well preserved in the Stratford area, partly as a legacy of poverty. They represented a legitimised opportunity for children to beg. A 'Maybrush' of hawthorn was cut from the hedgerow and ribbons, brightly-coloured rags and flowers were tied to its branches. The children dressed up in whatever finery and garlands they could obtain. One held the Maybrush and the others danced round it, chanting the May Day song. Each parish had its own version, which was passed down from child to child. The one most sung at Stratford went:

> Dance around the Maypole,
> Trit, trit, trot,
> See what a Maypole
> We have got.
>
> Fine and gay,
> Skip away,
> Happy as the new Mayday.
> For God save the King!
>
> Garlands above.
> Garlands below,
> See what a Maypole
> We can show,
> Fine and gay,
> Skip away,
> Happy as the new Mayday.
> For God save the King!
>
> Our box it shall stand
> At the shade of your hand,
> Whatever you choose to bestow.
> Gentlemen and ladies
> Don't turn away,
> On the first day of May!

Other cruder rituals went unrecorded. Trades had vulgar initiation ceremonies. Young Bob Jones was sent off by his mother to his first day as an apprentice railway clerk with instructions to take care of his best suit. When he arrived at work, his new colleagues seized him, removed his knickerbockers and smothered his private parts in axle grease. The fury of his mother on his sorry return was considerable.

Yet traditions were being forgotten as technical innovation stretched horizons. In July 1912, Stratfordians were thrilled with the first sight of an aeroplane over the town. A great cheer went up as it appeared over Bordon Hill, circled and landed on the recreation ground. The pilot, Monsieur Salmet of the *Daily Mail* Flying Corps, then flew over the hospital so that the

nurses and patients could see his wonder. Before departing he gave a breathtaking exhibition, diving, flying between trees and skimming the river like a bird.

The steps of the May dancers faltered further that October with the opening of the Picture House in Greenhill Street. Here was a place of dreams with which the working men's club found it difficult to compete. Despite splendid facilities attendance was poor. 'The young men', said the *Herald*, 'have succumbed to the temptations of the picture palace, and the click of the billiard ball, the ping of the bullet, is rarely heard on the club premises.'

The Great War

The *Herald*, which a few years earlier had expressed its admiration for the Kaiser, had become convinced that England's chief potential enemy lay across the German ocean. In 1913, it noted that pessimists considered war with Germany to be inevitable. Yet, in July 1914, it relegated the news of the assassination of the Austrian Archduke below such items as 'The Search for Fertilisers' and 'Municipal Apathy'. Summer wound its usual way. The regulars at the One Elm organised an outing to Blackpool. At the Hereford Regatta, the Stratford eight won the West of England Challenge Vase. The GWR announced August bank holiday excursions to south coast resorts and, nearer home, to the Kineton Horse Show and a river trip to Cleeve Prior, which included tea.

Amid this tranquillity, war clouds were gathering. The *Herald* took more seriously the Austrian bomBardment of Belgrade. To match the hour, the Picture House showed *The Hundred Days*, culminating in a spectacular portrayal of the Battle of Waterloo. In the dying days of peace, Kathleen Hudson, aged nineteen, the daughter of a local printer, was married at Holy Trinity to Charles Stoehr, a twenty-seven year-old officer in the Royal Engineers. The bridegroom was stationed in Aden, so the wedding was timed for his extended furlough.

On 31 July, a reception was held in the theatre gardens for the returning Bensonians. F. R. B., back with his own company again – the syndicate having been dissolved – made a balanced speech, recalling that from the same pen that wrote, 'Come the three corners of the world in arms, / And we shall shock them. Nought shall make us rue, / If England to itself do rest but true' had also come 'One touch of nature makes the whole world kin.' He concluded amidst applause that the one thought should not preclude the other in the trials that were to come. On 4 August, war was declared and there was a special performance of *Henry V* – 'Now all the youth of England are on fire' – with Basil Rathbone as the Dauphin. After curtain-fall, the company drilled on stage with halberds and spears.

Charles Stoehr received his recall to the colours while on his honeymoon. He returned to Aden, where his bride joined him at the first opportunity.

Already food shortages were apparent, popularly blamed on hoarding by unscrupulous middlemen. Some feared that a prolonged war would produce near-starvation. Despite such fears, an intense patriotic surge swept the area. A recruiting station in Sheep Street was swamped with volunteers. In proportion to its size, Stratford was contributing more men to the war effort than any other town in the County. A Roll of Honour of local recruits was displayed from the Town Hall. A new company of Territorial Rifles had temporary headquarters lent

by the vicar in the parish parlour. First commander was the twenty-six-year-old Major Bruce Bairnsfather of Bishopton, a noted local artist who would devise a prime image of the War with his cartoon character, 'Old Bill' of 'If you knows a better hole you go to it' fame.

Roger Noakes, the High Street grocer, who was a server at Holy Trinity, was so keen to enlist that he cycled over 100 miles in an attempt to join the Cycle Corps. His gallant effort was unsuccessful, but in October he cast in his lot with the Royal Warwicks.

Stratford's fine generation of sportsmen was among the first to the colours. Patrick Thompson joined the Royal Engineers. Norman Kinman had been in Australia, but returned shortly before war broke out. He enlisted in the Warwickshire Company of the Royal Horse Artillery before the end of August, and enjoyed what the *Herald* described as 'the privilege' of going to France with the first Territorial Battery. He was in time to participate in the first British action of the war – the retreat from Mons.

In the expectation of rapid victory, many were rejected as not fit, who would later be conscripted. Edgar Cranmer, aged twenty-three, of Shottery, had been a scholarship boy at the Grammar School and gone on to qualify as a Post Office clerk. This involved the vital military skill of telegraphy. He could transmit and receive Morse at an impressive speed, but he was turned down because he had suffered from appendicitis – then a serious ailment – before the war.

Two others who were turned down were John Bone and Charles Guise. Bone was a twenty-five-year-old assistant at Noaks and Crofts, the High Street grocers. He was just 4 feet 11 inches in height and weighed 6 stone 10lbs, just 26 lbs heavier than an infantryman's equipment. Guise, a printer with Edward Fox, was just 4 feet 9 inches tall.

The mayor, Cllr Fred Winter, in sentencing a drunk to a month's imprisonment, told him that all Englishmen should be keeping the peace. The Picture House screened the latest news and appeals to 'The Common Cause'. 'Eat no eggs in Easter Week', suggested the *Herald*, 'but give them to the wounded.' The Town Hall became a hospital with forty beds filled by wounded Belgian soldiers. The *Herald* was reduced to six pages, an indignity that may have influenced its view that economics precluded a lengthy war – it was later reduced to four. Some considered that the war would be over by Christmas and the troops home in the spring. Political differences were put aside, the Tory and Liberal Parliamentary candidates addressing a mass meeting at the Fountain.

In September, the Warwickshire Yeomanry was mobilised. Robert Lidzy, now aged thirty and living at 3 Percy Street, was called up again. After the Boer War, he had returned to Messrs R. M. Bird and had risen to the position of head cellarman. He was 'a big, fine built man' who was captain of the fire brigade and a Baptist layman. His wife and nine-year-old daughter, a pupil at the National School, were among the crowds at the station to see the troops off, en route to Egypt before taking part in the Gallipoli landings. Florrie Lidzy was to remember what a sad day it was for her mother.

On 7 October, Sergeant J. H. Savage of 24 Henley Street, a regular in the South Wales Borderers, was struck by shrapnel at the Battle of the Aisne. He was brought home and died in Bournbrook Military Hospital, the first Stratfordian to die in the First World War.

As yet, life in Stratford was not greatly affected by the war. The Mop took place as usual, with five oxen and seven pigs on the spits. The excursion trains arrived as normal, but collections were made for the War Relief Fund, and the 'Aunt Sally' stalls offered the chance to pitch at the Kaiser and his high command.

In December, the recruiting office, desperate for men, announced that the minimum height had been reduced to five feet. Attention turned to the 100 'unwilling and selfish' young men who had not volunteered. One big strong fellow of around twenty-six caused derision when asked 'Why not enlist?' by replying 'Mother won't let me.' The father of four youths sent them off to London to escape the recruiting officer. The *Herald* suggested that taxpayers should 'give these enlistable men no peace until they do their duty. Failing that they should give the Government no rest until the order is issued for conscription.'

George Hewins had been a bandsman in the 2nd Volunteer Battalion of the Royal Warwicks. When the volunteers were replaced by the territorials, he had decided not to join, but had been persuaded to sign a paper declaring, 'If my country needs me, I'll oblige.' At Christmas, he was called up into the 7th Warwickshire Infantry, despite being a married man of thirty-five with seven children. There were some thirty Stratfordians in his platoon. After a brief spell of training in Essex, they got their marching orders for France and a week's home leave. When the time came to embark, his wife said, 'I wish you weren't going', and gave him two bottles of rhubarb wine from the *Oddfellows* and a photograph of his family. 'Even then I'd no thoughts of *not* going back. There was a chap in Stratford who'd knocked a saucepan o' water over him and scalded both his feet. He said: I'll suffer the agony! They found another chap hiding in a bunker on the golf course. But *I* hadn't seen, you see, I didn't know. If you'd asked me why I was going to fight I'd have said: "To save the country". If the Germans had won we would be slaves!'

A more immediate reminder of the war came when the 2nd Hampshire Regiment was stationed in the town for some weeks, and established its headquarters in the Methodist Chapel. It must have been at this time that Pte Bartholomew Mullins met Lucy Conway. Her husband, Frederick, the proud possessor of medals from the Sudan and Afghan Wars, had left her to go to Canada eighteen months previously. On the outbreak of war, he joined the Canadian Field Artillery. His military experience ensured that he was at once promoted to sergeant.

Pte Frederick Hayter was billeted with Agnes Emms, who ran a tea shop at 12 Sheep Street with her sister, Theresa. On 3 February at Holy Trinity, Pte John Scammell, who was billeted at 2 Alcester Road, married Daisy Harris, his sweetheart from Eastleigh. There were to be many marriages like this; a brief period of intense intimacy before the bridegroom was plucked away amidst the uncertainty whether he would ever return. A few days later, the regiment held a church parade at Holy Trinity. Next month they marched off to war. Agnes Emms waved a sad goodbye to Pte Hayter. They had fallen in love and her sister had been walking out with another soldier from the Regiment, Percy Horwood. Next month, they were horrified to hear that the Hampshires had suffered a disaster in the Gallipoli landings. Only 150 had survived unscathed from a roll of 1,050. Fred and Percy had both been wounded and eventually they were transferred to military hospitals in Britain. On 20 November, they married their sister sweethearts in a double wedding at Holy Trinity.

The Hampshires had won a place in the hearts of Stratfordians. In April 1916, a memorial service at Holy Trinity commemorated the many members of the regiment who had fallen. Afterwards, the mayor, Archie Flower, entertained the survivors who had attended the service to lunch.

F. R. B. was back in the spring of 1915 with a much depleted company. Age had prevented him from enlisting despite several attempts, but at least he could boost morale as Henry V.

Oscar Ashe played Shylock and Genevieve Ward, Queen Margaret, to stalls filled with the convalescing soldiers. The flags were absent on the Birthday. A ceremony intended to preach the unity of the nations was inappropriate. They reappeared in 1918, but the German, Austro-Hungarian, Turkish and Bulgarian flags were absent.

More and more wounded were returning from 'the inferno on the continent'. Marie Corelli generously offered Trinity College, which had stood empty for ten years, as a hospital, but through the largesse of the owner, the Revd Francis Hodgson, Clopton House was placed at the disposal of the military authorities and a hospital, 'perfect in every essential', erected in the grounds. The patriotic fervour of the Hon. Mrs Hodgson matched her husband's, and she undertook the administration of the establishment. The first convoy of the wounded arrived on 31 May 1915, and the last on 28 March 1919. In all, 2,452 invalids were treated there.

The Warwickshire Yeomanry was suffering at Gallipoli. It was alleged that the Turks had poisoned the waterholes as they retreated. Men and horses had to be held back at gunpoint, so mad were they for a drink. On 21 August, Cpl Robert Lidzy fell in a 'magnificent charge', probably a euphemism for a suicidal infantry assault on machine guns. Constance Lidzy was the first woman in Stratford to receive the dreaded telegram '…regret to say your husband was killed…' Florrie had just won a scholarship to Warwick High School for Girls. Now, her teacher, Miss Viveash, told her mother that she wouldn't be able to afford to send her.

The spectacle of men who had lost limbs at the front was becoming sadly familiar, as was the sight of 'the boys in blue' – wounded soldiers in convalescent uniform. German prisoners from the camp at Drayton were another familiar sight. Many of them worked on local farms. Occasionally, a military funeral provided an unwanted reminder of the war. Casualties from the Western Front were shipped to hospitals at home. Sgt Frederick Conway of the Canadian Field Artillery had been in the thick of the fighting, but did not escape unscathed. He was sent to a base hospital in Liverpool and then to Lincoln Military Hospital where he died of nephritis on 3 March 1916. He was buried in Stratford cemetery with full military honours in the presence of his widow, who probably hadn't seen him for three years.

The Mop of 1915 was a shadow of its former glory. Lack of fodder meant that the menageries were 'being driven from the road'. Only two beasts were roasted and there were no incoming excursion trains, but thousands thronged the town, glad of the temporary illusion of relief from the war, although the recruiting sergeant mingling with the crowds served as a reminder.

The Mop continued throughout the war, but had to close at 6.30 p.m. It was a reflection of the growing gloom that few thought that it could ever recover its former jollity, but would reflect a post-war world of sombre austerity. To their credit, the members of the Women's Temperance League kept in touch with the showmen who had been called up, and sent them parcels while they were on active service.

In the dark days of December 1915, the P&O liner SS *Persia* 'fell victim to the fiendish activities of a German submarine'. Amongst the 350 'precious souls which were summoned to the Great Audit' was Mrs Kathleen Stoehr. She had returned to England in the summer and was now on her way to rejoin her husband in Aden.

Early in 1916 came the Zeppelin scare. The news that enemy airships had raided unspecified locations in the Midlands was sufficient to send Stratfordians into a panic. Many took cover in cellars and shelters on hearing the news that Zeppelins had crossed the East coast. The

anti-German propaganda that had prevailed for two years bore inadvertent fruit. Saturated with stories of Hunnish atrocities against cultural institutions, Stratfordians believed their town would be a prime target. Word of this penetrated to Berlin where the press waxed indignant at the suggestion, declaring that Germans so venerated Shakespeare that they would do nothing to violate the sanctity of his Birthplace. This 'touch of nature' was not reciprocated in Stratford. At the town council on 8 February 1916, the mayor, Archie Flower, said that their priceless historic buildings were sufficient reasons for Germany to pick out Stratford. 'We also have our due compliment of women and children and that is another reason for Germany coming against us.' Blackout orders were introduced. 'Until the war is over', said the *New York Evening Mail*, 'Stratfordians shall go to bed with the chickens or spend their evenings in darkness.' Offenders against the Lighting Orders were fined, including a clergyman, the shopkeeper Frank Organ and the owner of Hall's Croft. In fact, the town had to wait for another war for its first sight of enemy aircraft.

The proximity of the Western Front meant that soldiers could return on all-too-brief leave. Frances Holtom remembered how rough her dad's uniform was when she snuggled up to him – 'even his shirt'. Marriages occurred in these few snatched hours. On 28 April 1916, Bdr Norman Kinman married a Stratford girl, Kathleen Adams, at Fenny Stratford. His company must have been temporarily stationed there before its return to France. The couple cannot have seen much of each other in the previous months. Norman had been in the Army for nearly two years and before that he had been in Australia. For some, it was a final farewell. Sgt Brebner, a regular soldier in the Royal Field Artillery, spent a few days at his home in Ely Street with his wife and three children in June 1917. He was killed in action on 3 August.

The uncertainty of survival led to an intense need for physical relationships, and matches that might not have taken place in peacetime. Richard Kane, a twenty-two year-old captain in the Royal Field Artillery from South Ascot in Berkshire, was a patient in Clopton War Hospital. Gwendolen Webb, who was thirteen years his senior, was probably one of his nurses. The couple were married by special license at Holy Trinity early in 1916 by the Revd Francis Hodgson, with the bridegroom's mother as a witness. In 1918, a convalescent at Stratford's other military hospital, the Whytegate, Pte Reginald Dewing of the Royal Irish Rifles married Flossie Gibbs. She also may have been one of his nurses for she came from Norfolk. The couple were only twenty-one, but she was already a widow.

The Borough War Tribunal

From July 1915, all men and women between sixteen and sixty-five were obliged to register for potential call-up. The advent of universal conscription on 1 March 1916 meant that those who had been rejected in 1914 faced a renewed call to arms. Edgar Cranmer was summoned to a medical at the regimental headquarters of the Royal Warwicks at Budbrook Barracks and was passed B1. The Post Office had the right to demand that any of its telegraphists who were called up should serve in the signals section of the Royal Engineers, so Edgar was transferred to the special training section at Worcester.

The Act brought into being the Borough War Tribunal. It consisted of town councillors, a representative of the trades council and a retired officer representing the military. Its function

was to hear appeals from those who claimed exemption through conscientious objection, because they were in a reserved occupation, or because of 'special financial, business or business obligations'. These had to be registered within three weeks of the receipt of call-up papers. There is no doubt that the Tribunal tried hard to be fair, but its prime task was to send men to the Army, so it was impossible to be sympathetic or unbiased in too many cases. Because this was the first time that conscription had been introduced, conscientious objection to war became an issue for the first time. On 24 February 1916, Henry 'Bob' Bullard, the auctioneer who had defied the Boer War rioters, claimed absolute exemption on grounds of his religious beliefs. Had he been a Quaker, this might well have been granted, but he was a Congregationalist, which was not a denomination that upheld pacifism, so the Tribunal did not question him on his personal beliefs, but granted him non-combatant status, which meant that he was forced into the Army, in where he fared badly. He was court-marshalled and twice sentenced to imprisonment in Wormwood Scrubs. The conscientious objectors, who were relatively few in number, were something of an embarrassment to the Government, which appointed the Pelham Committee to place them appropriately. On 10 August, Bullard applied to be re-referred to the Borough Tribunal, but the Army, probably exasperated with him, had already done so.

Later, a similar response was given to a baker's assistant, Charles Handy, who told the tribunal that going to war would be 'opposed to the example of Jesus Christ'. The only other applicant to claim full exemption, John Ready, described as a 'village evangelist and colporteur', was granted it, but at forty, he was already over the eligible age.

Bob Bullard had little choice to base his claim for exemption on his beliefs. Had he sought it on the grounds of his trade he may well have succeeded. Another auctioneer, Robert Garrett, was deemed to be doing work of national importance, but had Bullard failed in his argument, he would have had no choice but to serve.

Generally, the response to those who claimed exemption on non-conscientious grounds was the same. A short period of grace was given to arrange alternatives in their place of employment: a woman, a boy, or a discharged soldier. Albert Pearce, the Wood Street confectioner, was given a respite to sort out his business affairs, but that night, in the back bar of *The Windmill*, a woman gave him the white feather of cowardice. He promptly enlisted in the Durham Light Infantry, temporarily billeted in Stratford, en route for Salonika. Such was the need for manpower that he was embarked immediately and was not issued with a uniform until he got to Marseilles.

White feathers were the least of their worries for many who had once been keen to go. The tales of horror from the Western Front had diminished their patriotic fervour and now they appealed against conscription. Both John Bone and Charles Guise, the diminutive grocer's assistant and printer, appeared before the tribunal. Bone had been given a B2 fitness assessment at Budbrooke, but was granted exemption on the grounds of his size. The mayor could not resist the comment that had he been passed A1, he would have been 'just the man for one of the tanks'. The new fighting vehicle had first seen action only five days before. The increasing pressure for manpower was reflected two months later when Guise was given merely a two month exemption, despite being two inches shorter than Bone.

The call-up brought genuine difficulties for the self-employed. Fred Chivers, aged thirty-six, of 2 Garden Row, Scholar's Lane, was a builder and carpenter with a business at

Broom to which he travelled on his motor bike. Although he employed eight men, seven were over military age and the eighth was exempted. He had no partners and no one who could run the business in his absence. The Tribunal granted him exemption till the end of the year.

The Tribunal did not look kindly on those who claimed they had already 'done their bit'. Arthur Wright, a bricklayer's labourer of 53 Birmingham Road, stated that his four brothers had all served in the Army and one had died at the Battle of Loos. His widowed mother was unable to work and could not manage on the remittances they sent her. Mr Talbot, the military representative, responded that Mr Wright was an old soldier who had fought in the Boer War. He would be a very suitable man for the Army. Similarly, Fred Amphlett, aged thirty-seven, the Snitterfield postman who lived in Great William Street, said he had an invalid father and was the only son at home. He had two brothers serving in France. The Tribunal considered that, with the allowances he could claim, there would be no hardship for the father.

A judgement of Solomon was required in the case of the Eborall brothers, William and Frank. They ran the Oddfellow's Arms, the last home-brew pub in Stratford. Frank had appealed against conscription, but on 16 May 1917, he told the Tribunal he would withdraw his appeal and go if his brother was excused, but William Eborall said that 'as he was single, he thought he should go and his brother stay at home'. A member of the Tribunal, Cllr E. W. Everard, missed the point entirely. 'It is refreshing to see two young men willing to serve. Can't you both go?' It was essential that one brother remain to do the brewing and run the pub, was the reply. Archie Flower looked benignly upon this minor rival establishment to his brewery, and Frank Eborall was granted exemption as long as his brother remained in the Army.

At the same hearing, Amos Unitt applied for temporary exemption on domestic grounds and was granted three months grace. He was the twenty-eight-year-old manager of Lennard's the boot-makers, and lived with his wife over the shop in the High Street. He was a teacher in the Wesleyan Sunday School, and an 'acceptable' local preacher who sang in the choir.

Women's Work

The emancipation of women was becoming a necessity as more and more jobs were propelled into the female domain by the acute labour shortages. Over a third of the 160 male workforce at the brewery was in the forces. Twenty women had replaced them.

Changed attitudes were having their effects in the social arena. Before the war, mixed swimming was discouraged at the town council's bathing place up the river. Now Cllr Edward Fox noted that, it had become prevalent, but was pleased to note that 'there were no unseemly sights'.

For the first time, women could join a branch of the services other than nursing. Eleanor Melville, the vicar's wife, formed a local branch of the Women's Volunteer Reserve. When Sarah Bull, aged twenty-six, married Driver William Wright who lived on the Birmingham Road, on 18 October 1918, she became an unwitting first in the parish records. Rather than 'spinster' or 'widow', as women had always been described, she was entered as a 'Foreman Cook with the Women's Royal Army Corps' (WAAC). After Margery Eliot of 4 Chapel Street joined the newly formed WAAC, she spent 'a fortnight in England 'training', but her 'chief occupation was being vaccinated and inoculated for overseas work'. After the war, the Revd

Francis Hodgson expressed gratitude to 'the sons of the Empire' who 'had proven themselves magnificent men'. Such attitudes were not shared by Margery's family and friends, who expressed concern that she would have 'to work alongside native troops'. She was able to reassure them on this point. 'This is so in some of our work, but as all native troops work under the eagle eyes of white NCOs and officers I can say from my own experience that no harm or unpleasantness is even possible.'

Before her husband's death, Constance Lidzy had never worked and her war widow's pension was only 29s 10d a week, so she was obliged to take menial cleaning jobs to pay the rent and support her daughter. On two mornings a week, she worked for sixpence an hour at a house called 'The Myrtles' in Rother Street. There were a lot of patterned tiles so 'it was all scrubbing and cleaning'. When that was finished there was an 'awful lot' of polishing. Her hours were eight till noon, but she was so conscientious that she was often going at 7 a.m. and not finishing till one o'clock.

On the other three days, she went to a big house in Rowley Crescent, the home of a Birmingham dentist. She worked from 8 a.m. till 5 p.m., doing so much scrubbing and cleaning that her hands became chapped and painful and she was obliged to bandage them at night. Fortunately, the household possessed a 'very good, old-fashioned cook'. When Constance got to work, there was always a little bit of breakfast for her, and at 11 o'clock she'd make her sit down for a quarter of an hour with a piece of cake and a cup of cocoa. At one o'clock, she made her sit down again, saying 'No, you don't, you have an hour for your dinner'. Before she left there would be a cup of tea and a piece of cake.

The censors had learnt their lesson from the Boer War. News from the front was generalised and sparse. The letters recounting the circumstances of deaths, sent by comrades to grieving relatives, had a sameness. All died instantly and without pain. Acts of gallantry the censor did allow past. On 6 July 1917, Sgt Norman Kinman was awarded the Military Medal. At Arras on 9 April, under heavy fire and without any regard to his own safety, he had continued to serve his gun, although the next gun had received a direct hit, killing ten and wounding five. On 10 August, his battery was under heavy shellfire on the canal bank at Boesinghe. Two guns were put out of action and a third set alight. The ammunition started to explode. Sgt Kinman and two other soldiers worked for 20 minutes under continuous shellfire, with the ammunition continuing to explode, to extinguish the fires. He was awarded a bar to his Military Medal. On 28 September, the *Herald* reported that he had played in a football match behind the lines, as the pivot of his section in a two-goal victory. In October, his old team mate, Lt Patrick Thompson, was awarded the Military Cross, for his 'devotion to duty in taping out a jumping-off line for an infantry attack under exceptionally difficult and dangerous circumstances'.

Bitter Years

A release for Stratfordians from the horrors of war was provided with characteristic theatricality by the knighting of Frank Benson by the King in the Royal Box at Drury Lane. The news was announced to a delighted festival audience at the Memorial Theatre and cheers resounded throughout the house. Next day, cheering crowds waited at the station and sheaves

of lilies were presented to Lady Benson and a chaplet of bays to Sir Frank, before members of the company drew them to the theatre in an open landau.

After Ben Greet brought the depleted Old Vic Company in the summer of 1916, there were no more festivals for the duration of the war. Even Benson deserted Stratford. He and Constance ran a canteen for wounded soldiers in France, although he made a brief return to address a packed 'patriotic meeting' at the theatre on the Birthday in 1918. It is indicative of the times that he shared the stage with a Miss Peers, the travelling inspector for the Food Production Department.

The desperate need for manpower was reflected in the increasing intransigence of the Tribunal. The deal made with William Eborall was now forgotten as he received his call-up papers again. As he remarked to the tribunal, 'The Army had rather placed him in the cart.' His appeal was heard on 26 July. This time the tribunal could only offer him two months' exemption.

In October, Arthur Fletcher, a twenty-one-year-old plumber and painter, was passed fit for general service, but he appealed on the apparently reasonable grounds that he only had one eye! One of the panel members, Mr R. G. Savage, thought it 'a scandalous thing to pass a man under such conditions.' 'You make too much of this one-eye business,' retorted Mr Talbot. 'I have practically had the use of only one eye since I was twelve.' Mr Savage asked him if he had ever been in the Army. 'No,' he replied, 'but I have been in the Volunteers.' Exemption was refused.

In 1917, the Food Hoarding Act had made it illegal to hold any more provisions than would be required for normal household use. In the case of sugar, this was defined as ½lb per head, per week. Thus for the period between 5 September and 15 November, Marie Corelli, with a household of seven, was entitled to 32lbs, but was holding 183lbs. Someone tipped off the police and PCs Walton and Hawke of the Stratford force went round to see her. 'I am a patriot,' she told them, 'and would not think of hoarding. I think you police are overstepping your duty to visit my house.' She added the astonishing information that 'Lloyd George will be resigning tomorrow and there will be a revolution in England in less than a week.' This wild prophecy caused great hilarity when it was read out in the police court on 2 January. Marie, it transpired, had been ordering sugar from Lipton's in London as well as buying it locally. On her behalf, Bertha Vyver stated that the sugar was not for personal use, but was for food production – to make jam from the large quantities of fruit in the garden. The plea was rejected and Marie was fined £50 with 20 guineas of costs. This was somewhat unfair, since a similar plea had been accepted on other occasions, but perhaps she could not hope for much sympathy from a bench on which sat her old antagonists, George Boyden and Fred Winter.

Early in 1917, Lennards Ltd asked for a further exemption for their manager, Amos Unitt, but were refused. He joined the Royal Warwicks in February 1917, and embarked for France in December. The company let his wife continue to live over the shop in the High Street. On 1 February, Fred Chivers gained a further exemption for two months, but he was not called up to the 1st Royal Warwicks till July 1917.

Shortages were compounded by one of the coldest winters on record in 1917. The way through the fields to Shottery was so deep in snow that travellers could not trace the road.

Many were the sad reflections on the emptiness of Stratford during the last two bitter years of the war. The town was devoid of men under forty and the lengthening casualty lists – something that even the rigorous censorship could not suppress – recorded those who would not return. On 7 April 1917, Lt Patrick Thompson was killed in action. Out of the 'splendid'

eight who had triumphed at Hereford in 1914, only one survived. Sixty-one members of the Boat Club served in the forces and nineteen did not return.

There was no street in Stratford that was not mourning the death of its young men. The three sons of the Beesley family of 44 Great William Street all joined the colours. Henry, aged twenty, was killed by a German sniper at dusk on 23 May 1916. Albert, aged nineteen, was posted missing eight weeks later. Arthur, aged eighteen, was serving in the Worcester Cycling Corps and survived the war. James and Elizabeth Berry of Swan's Nest Cottage also lost two sons. James, aged twenty-seven, was killed in September 1918. Poor Harold, aged nineteen, was appointed valet to the vicar in his role as the Revd Lt-Col Melville of the Warwickshire Horse Artillery, but he got no further than Worcester, where he died of illness in 1915.

Whereas in the last six months of 1914, only one serving soldier got married at Holy Trinity, during 1917/18, the total numbered forty. Some of the twenty-eight bridegrooms who were not recorded as serving in the forces may already have been discharged, others were in the process of call-up and a number in reserved occupations – two farmers, a railway fireman and a signalman, an engineer, a dental surgeon and, somewhat surprisingly, a dockyard riveter and a stevedore.

Soldiers from afar made their mark in the registers. In 1916, Sgt Frank Cobb of the 110th Canadian Battalion married Iva Symington of 31 High Street. In 1917, seventy-seven Australian convalescents arrived in town. Within weeks, four had married local girls.

Edgar Cranmer had joined the Bantam Division, comprised of soldiers who had been originally considered too small for service, in France in 1917. In November, he contracted trench fever and was hospitalised. W hen he recovered he was sent up to the 2nd Army Observation Group. Positioned immediately behind the lines, it was a wireless station that monitored German signals.

 Sgt Norman Kinman had become something of a legend in Stratford. 'Although many times in the thick of the fighting with the battery, he enjoyed a remarkable immunity from the Hun shell and shrapnel', but on 30 November his battery suffered further heavy shelling. He was busy digging them out when the Germans sent over some gas shells, and the next thing he knew was when he woke up in hospital in Rouen. By January, he was back in Stratford. He must have made some recovery from his injuries, for, in that month, his wife, Kitty, fell pregnant. He set up home with her in a house owned by her sister's in-laws at 77 Clopton Road, In February, he received his medical discharge from the Army and found a position as a commercial clerk at the brewery.

Mr Hawkes, the policeman, now promoted to sergeant, was having a good war. In February 1918, at 6.20 a.m., he invited a young man he encountered in Chapel Street to identify himself. He immediately confessed that he was an escaped German prisoner called Bernhard Hardt, who was trying to make his way to the coast in the hope of boarding a Dutch ship. Flushed with this success, he challenged another young man while he was on duty at the Market Cross five months later. He turned out to be a deserter from the South Staffordshire Regiment called Alfred Richards.

The great German offensive in the spring of 1918 brought renewed fears of defeat. On the day of the onslaught, Edgar Cranmer was due to go on leave, but the British lines were swept aside and the observation group were obliged to smash down their huts and cut down the wireless masts before fleeing. On another part of the front, Pte Fred Chivers worked his gun alone for several hours after the other seven members of his gun crew were killed or wounded.

He was awarded the Military Medal.

Amos Unitt was posted as missing. When his wife enquired about his whereabouts, the War Office held out the hope that he had been taken prisoner. He had been 'slightly wounded, as far as can be ascertained, and was last seen together with numerous other comrades.' While this was initially reassuring, her anxiety must have increased as no confirmation came from Germany through the Red Cross.

All activity was now subordinate to the national emergency. Virtually all the iron railings in town went into the melting pot, including those in front of Marie Corelli's house. The rails and sleepers on the old tramway went the same way. An urgent message came down to the tribunal that all grade 1 and 2 men were required. On 10 April, it heard twenty-one cases, which were mainly reviews of previous exemptions, 'with a result favourable to the National Service department'. A branch of the 'National Kitchen' was opened in Stratford in May. It provided cheap and nutritious meals. On its first day, it served 633 portions.

On 10 August, a recruiting rally was held for the Women's Auxiliary Army Corps. A contingent of girls from Budbrooke Barracks 'who had answered the call' were joined by Mrs Melville's Women's Volunteer Reserve to march through the town. The women were desperately needed. On 16 August, the *Herald* announced that the upper age limit for conscription had been increased to fifty.

Ada Chivers did not like her daughter, Dorothy, playing in the street, so she found the resource from her limited budget to pay for dancing lessons with Leah Hanman, the old Bensonian actress who had established a dance school at the bottom of Bridge Street. In September, she received a letter from the captain of the Number 1 Casualty Clearing Station. Fred had been dangerously wounded in the neck. A letter followed from her husband, from mumber 16 general hospital at Le Treport, saying that he felt a little better. On 18 September, she was told that she could go and see him, which was a rare occurrence, probably achieved through the good offices of the Salvation Army whose barracks were near her house. She packed hastily and left the same evening in the red dress she was wearing. Except for the occasional holiday, she'd never been out of Stratford and she'd never been on the sea before, which was very rough. She arrived at the hospital late on Thursday night, only to learn that her husband had died earlier in the day. Two days later, she attended his funeral in the red dress – the only one she had with her – and was always distressed that she had not worn black.

After his undignified retreat, Edgar Cranmer was relieved to be seconded to the wireless section of the Army GHQ, partly located in railway carriages at Bertincourt. His transmitter was powered by the engine of a lorry. Each morning at 6 a.m., the driver switched it on, and the clerk on duty exchanged signals with the different sections of the front line to check the code, which was changed every day.

After the German offensive was stemmed, the British counter-offensive began with a series of spectacular victories and GHQ moved forward to Ghoury for about five weeks. The wireless operators were sending out messages every night, abandoning the use of code as they told the 'the troops how many prisoners we had captured, how many guns and all the rest of it. Then we moved from Ghoury to Verticorn, still doing it. Well, we knew Gerry had had it.'

A muted optimism began to prevail. People were looking beyond the war. Local discussions were taking place about the desirability of ending the workhouse system once peace was

declared. The transatlantic reinforcements, whose advent was tipping the balance in favour of the Allies, were greeted with wild enthusiasm. In September, sixty officers and men of the American Air Force were entertained in the town. Teams from two of the flying squadrons – the Red Sox and the White Sox – played a baseball game on the cricket ground. Marie Corelli entertained a group of American officers at a weekend gathering at Mason's Croft. She was so touched by their enthusiasm for the beauties of Stratford that she offered Trinity College, free of rent, as a hostel – 'The American Inn'. Forty bedrooms would be available to officers from all the Allied armies, but Americans would take precedence. The American YMCA agreed to put up the considerable sum required to convert the building and agreed to run it. Marie was waxing mellow, for she even offered 'a further privilege in the free use of the extensive paddock'!

In October, a scourge that was to prove even deadlier than the war arrived. The worldwide epidemic of 'Spanish flu' (a name emanating from its supposed place of origin) had made a minor appearance in May and June, and now returned. It would carry away 228,900 people in Britain alone. It was made all the more fearsome by the fact that the young were the most vulnerable: 45 per cent of its victims were under thirty-five. Others succumbed to sheer exhaustion. The son of the Congregational minister, 2nd Lt Gordon Barber, had joined the Worcestershire Regiment in 1916. After eight days and night in the open without sleep in the last British offensive, he succumbed to broncopneumonia and died in hospital at Rouen. He was posthumously awarded the MC. The Stratford games-player may be recognised in the description of him by his Colonel: 'An officer whose sole object was to win for his side.'

Stratford was not spared the epidemic. The prolonged wartime shortages ensured that people's ability to cope with infection was much reduced. Winter was coming on and there was a deficiency of fuel and of warm clothing. Spirits were much in demand to allay the effects of the disease, but such was their scarcity that doctors were driven to issuing certificates to retailers directing them to supply small quantities to applicants. In the great majority of cases these were not honoured, 'not because of an unwillingness or a fear of breaking the law, but because the purveyors had no stocks in hand'. The *Herald* blamed the Food Department 'for not liberating the large stock reported to be in bond'.

The Medical Officer of Health could do little but publish obvious advice. 'If every person who is suffering from influenza or catarrh recognised that he is a likely source of infection to others, that some of the persons infected by him may die as a result of this infection, and took all possible precautions, the present disability and mortality from catarrhal epidemics would be materially reduced.'

Crowds of sufferers overwhelmed the doctors' surgeries. Entire households were affected and unable to obtain any assistance. In the last week of October, funerals reached record levels. At the workhouse, nine deaths occurred in a month. At the worst extreme, two or three members of a family were lying dead at the same time. Norman Kinman was among those prostrated by the disease. Kitty gave birth to a son on 27 October, but died the following day. Norman fought hard against the malady, but his constitution had been badly undermined by his privations and the shock of his bereavement. He died on 5 November. The baby was taken in by Kitty's sister, Mrs Ernest Horton. On 6 December he was christened Paul Norman Kinman. The war had been tough on the family. One of Norman's brothers had lost a leg.

The last wartime Mop was a month before the Armistice. The new atmosphere of hope

brought large numbers of people, many from the surrounding villages, determined to enjoy the shows and stalls, which the *Herald* described as 'meagre and dowdy'. A couple of roundabouts constituted the sole amusement for children and the fair proprietors had 'caught the infection of putting up prices and charged double for whatever they retailed'. There were no 'sacrificial beasts or pigs' since meat was rationed, and no pubs opened, so it was not possible 'to obtain the wherewithal for making merry'. The subsequent Runaway Mop was 'a very poor affair, just a few swing boats and ordinary booths'. Wounded soldiers worked energetically to relieve people of their coppers to create a mile of pennies for charity.

The last meeting of the Tribunal took place on 23 October 1918, when two exemptions were granted for forty-six-year-olds until 1 April. The imminence of the end of the war may have made this a rare jocular gesture from the panel.

Yet the war effort continued. Stratford claimed to have contributed more per head to the National War Savings Fund than any other borough in the country. On 4 November, a captured German howitzer and 'that greater destructive agent, the ponderous tank' (built in Birmingham and probably intended to trundle its way to the Western Front) were placed at the top of Bridge Street. From this platform, appeals were made for contributions to the War Loan.

On 22 October 1918, Edgar Cranmer was on duty at the wireless control centre. At 6 a.m., the driver started the engine of his lorry and sat down beside him. Edgar called up the cavalry corps and was about to call up another division when he realised that the German headquarters at Spa was offering him a message. He did not understand German, but 'of course, it was all in Morse so it didn't matter two hoots what language it was in.' 'Here, Germany calling,' he told the driver. 'Go and fetch Sergeant.'

'What's Cranny had in his cocoa this morning?' was the sergeant's response when the driver woke him up, but he realised the importance of the situation and went straight over to the wireless station where Edgar was still receiving the message, which neither of them understood. The sergeant took it to the train, which was just round the corner, and found the intelligence officer. He read it and said 'Well, Sergeant, in a few words, it's Gerry asking for an armistice!'

It was decided that the message must be communicated to Marshall Foch, 'the head of the whole caboodle', as Edgar put it, at his headquarters in the Vosges Mountains, but their transmitter did not have sufficient power to reach him. Instead, a message was sent to the Eiffel Tower in Paris for retransmission. The reply came back via the same route that the marshall wanted to contact the British commander, Sir Douglas Haig.

Next day, Edgar recorded in his diary that the two generals arrived in separate cars. During the subsequent negotiations with the Germans, he remained on duty to maintain contact with Spa. After the Armistice was signed on 11 November, the wireless operators were instructed to have a bath and a change of clothes, and to re-equip anything they wanted at the station in preparation to move up to Spa to take over the German wireless systems.

'That is All'

In Stratford, the first intimation of the good tidings was the hooting of train whistles just before 11 a.m. Within minutes, flags were flying all over town. That afternoon, the mayor, the

Corporation and a large number of wounded soldiers processed to a service of thanksgiving at Holy Trinity. Hundreds were unable to gain admittance and stood in the porch or avenues. Elation at the victory was muted by reflection on the scores of fallen, which the *Herald* had poignantly recorded throughout the war. The vicar, the Revd Canon Melville, caught the sombre note in a short address.

> What for four long weary years we have struggled for has been achieved. That is all. We have prayed, worked, denied ourselves, fought and some have paid the extreme sacrifice. Many have given their all freely in the cause of truth, honour, and liberty. So we shall sing our *Te Deum* of thankfulness, go back to our little world, think it over and wonder what is coming. We are paying our vows; we are mindful of the death of those who have saved us. Let us see to it that it be not said of us, 'These people honoured me with their lips, but their hearts were far from me.'

The sad news of the death of the last Stratfordian to fall in action, Pte Frederick Boyne of the 2nd–8th Worcestershire Regiment, came almost simultaneously with the news of the Armistice. He lived in Greenhill Street and had embarked across the Channel as recently as Easter Monday. Before he was conscripted, he had worked in the bottling department at the brewery.

With the ending of the war, censorship was relaxed and the *Herald* was able to report that the super dreadnaught, HMS *Audacious*, had sunk after striking a mine off the Irish coast on 27 October 1914. It handled the announcement with a touch of irony. 'Now that hostilities have ceased the Admiralty lets the world know (or rather that part of it that had not discovered the secret for themselves) that the war had only been in progress for ten weeks when we lost one of the finest ships of our Navy'.

In an effort to raise the spirits of the Stratfordians 'to a pitch of exuberance' to celebrate the news of victory, a torchlight procession was held on 16 November. Although some people put out bunting, the sombre mood continued. The *Herald* was not surprised that, after the protracted four-year struggle, the town had no heart for excessive rejoicing. 'It remembers the fallen, those who have made the supreme sacrifice; the maimed and suffering; the widows and orphans; the parents left without well-loved sons.'

The trickle of men returning from the battlefront began, each one scarred by the bitter experience. News of fresh tragedies prevented any feeling of jubilation. On 13 December, the *Herald* carried the sad news of the death, at the age of twenty-five, of Gunner William Turvey of 41 Ely Street. He had joined the colours in 1914 and went to France in the same year. He had come through severe fighting at Mons, Loos and Ypres without a scratch. Now, on his way home, he had succumbed to the epidemic and died of bronchial pneumonia at Boulogne-sur-Mer.

Edgar Cranmer and the wireless crew got to Spa on 17 December. The place was crawling with British officers. As he came out of a photographic shop where he had been getting some film developed, two officers in the Military Police passed him. One turned round. 'Cranmer!' He looked at him and replied: 'Hello, Duncan.' 'Don't you reckon to salute officers?' 'I'm fed up to the teeth with saluting', he replied. 'There are a lot more soldiers than officers', he was told, with the implication that saluting was an unequal two-way process. The officer was Maj. Duncan Bairnsfather of Bishopton, younger brother of the cartoonist who was as fed up with the war as he was.

21

'These Swelling Local Dogberrys'

Words fail to describe what will be the verdict of the world on these swelling local Dogberrys.

The Globe

Aftermath

On 13 December 1918, Marie Corelli's 'American Inn' opened, too late to receive combatants, but with the U.S. Army still in full force in Europe. Marie herself had supervised the arrangements. At the opening ceremony, the American Gen. Biddle demonstrated that he had learnt in a few minutes what many Stratfordians had failed to grasp in two decades – that flattery was the key to Marie's heart. 'They felt', he said, 'that one of the greatest pleasures American officers could have in coming there would be to see Miss Corelli.'

The *Herald*, which in recent years cannot have featured on Marie's list of friends, was delighted by this development, seeing it as contributing to the economic regeneration of the town. Once peace came, large numbers of the Americans serving on the continent would visit England before returning home, and Stratford was sure to receive their attention. Nevertheless, the American Inn was a short-lived facility. Lack of funds forced its closure in April.

Anti-German feeling and rhetoric continued to prevail, which, given the scale of the slaughter that had occurred, was understandable. The most outspoken statements tended to come from older non-combatants and could border on absurdity. At a mass meeting at the theatre to commemorate the Armistice, the mayor, Archie Flower, referred to the ex-Kaiser as a 'blasphemous felon'. The phrase was taken up by Alderman Edward Fox. He had visited a church at Upper Dovercourt, near Harwich and was shocked to find that it contained a stained-glass window that had been presented by the German Emperor. He demanded that the vicar and churchwardens expel this 'vain-glorious memorial of a debased and treacherous foe'. The vicar replied that Mr Fox had 'a confused idea' of the King's English. 'One cannot solemnly inform a window that it is "expelled with ignominy" or otherwise. If E. Fox will pay for a fresh window, I think facilities will be afforded him to heave a brick through the offending glass. This is, perhaps, a more effective way than "killing the Kaiser with his mouth."'

The anti-German sentiments even had their effects on small children. Paul Morgan remembered suffering 'from an ingrained terror of "Huns" due to the propaganda of the day'. On a journey on GWR in 1919 when he was four, the knowledge that there were two coaches of German POWs attached to the train kept him terrified for the entire trip.

The flags of the defeated Central Powers were excluded from the Birthday celebrations until 1927. Another emblem was added to the list of *refusés,* with the exclusion of the Soviet

flag after the Bolshevik Revolution. The hammer and sickle was flown for the first time in 1926, but, because of local protests over its presence, the mast bore no shield to indicate its nationality. Since the other sixty-two masts all bore one, this made it the most conspicuous flag in town. Next year, it was dropped again altogether.

As the first peacetime Christmas approached, the shortages eased slightly, but not to the general benefit. 'Fruit can actually be seen and tasted this year', the *Herald* noted with great satisfaction, but, although the food shops 'certainly seemed replete with everything essential to the Christmas table', prices had soared to place the goods 'utterly beyond the purses of ordinary people.' The New Year was rung in by the full peal at Holy Trinity, a sound that the townspeople had not heard for two years.

Demob

Demobilisation was proving exceedingly slow. Among the first to return to Stratford was a group who had been POWs in Germany. A subscription was raised and each man was presented with a silver-mounted pipe and fifty cigarettes at a 'sumptuous' dinner held at the Shakespeare. Among the party was Sgt George Tadman, aged thirty-six, of the 3rd Battalion of the Sussex Regiment, who had been captured during the retreat from Mons. His sweetheart, Amelia Lee, aged thirty-eight, of 7 Guild Street, had waited for him and they were married at Holy Trinity on 22 February.

It was not until June 1919 that the wife of Amos Unitt was finally notified of his death, which was 'supposed to have taken place in the fierce fighting of March of last year'.

A number of war widows married returning soldiers soon after the war. Among them was Lucy Conway, who wed Bartholomew Mullins, once of the Hampshire Regiment, then working as a packer in Stratford, at Holy Trinity on 30 August 1919.

Moves were afoot to commemorate those who had made the 'supreme sacrifice'. The first memorial in Stratford was unveiled at the Scouts' Hall on 25 January 1919. A Roll of Honour commemorated 120 members of the 1st Stratford Troop who had served in the war, of whom sixteen had fallen. If the recorded dead were proportionate to the survivors, some 1,800 local men had served in the war. The population recorded in the 1911 census was 8,532. Something under half would have been males. Excluding those too young and too old, those with disabilities and those in reserved occupations, it is clear that virtually every eligible man had served. The War Tribunal had done its job with great efficiency.

In the post-war years' trips to the battlefields were frequent. The Stratford branch of the British Legion was formed in 1922. It was inspected by the Prince of Wales on a flying visit to Stratford a year later. In 1928, the veterans went on a pilgrimage to France and Belgium. Despite the solemnity of the occasion, a 'holiday atmosphere' prevailed, doubtless in part born of a sense of euphoria at survival, to which the sampling of a few Belgian beers must also have contributed.

At Ypres, the party joined with other old soldiers to march past the Prince of Wales at the huge war memorial at the Menin Gate. When their banner appeared, the crowd shouted 'Good old Stratford' and 'Good old Bill – where have you put him?' (a reference to Bruce Bairnsfather's comic creation) and 'What price Flower's Ale?'

Exit Benson

In the early days of the peace, it was felt imperative to revive the festival in the following April. As the *Herald* put it, 'If nothing had been attempted there would have been general disappointment. People were weary of the War – weary of the peace negotiations dragging themselves so languidly along – and they wanted something that would take them out of the morbid state into which they were rapidly drifting. It was felt that amusement was the best cure to effect this object'.

On 23 December, Frank Benson made a flying visit to Stratford to discuss plans. In early February, the Memorial Governors announced that there would be a festival and that it would be conducted 'as of yore' by Sir Frank Benson. He faced huge difficulties. Many Bensonians had signed up in the early days of the war. Many had not yet been demobbed. Others would never return. As late as 7 March, he still could not determine which plays his limited resource of actors would enable him to present. In the event, a scratch cast presented an abridged season.

The chairman of the governors, Archie Flower, realised that the war had changed so much that the style of the Bensons had run its course. That summer, the thirty-year-old director and designer, W. Bridges-Adams, presented his first season, employing many Old Bensonians. For the first time, the Shakespeare Memorial Theatre had a company of its own.

Murray Carrington had played Romeo in 1914 and Basil Rathbone in 1915. Now, the drama critic of the *Herald* was moved to contemplation as he watched the company rehearse. 'Surely that is not the same slim youth rehearsing Romeo, not changed at all, yet in between the Festivals he has been a Captain and won the military cross. Is that Murray striding across the boards, hardly changed, perhaps a little older? Absurd Majors are old and peppery, or were before the great upheaval. Captains, Lieutenants, Sergeants, and humble privates back here once more at the shrine of the Stratford Mummers again.'

'The Supreme Sacrifice'

At the town council meeting on 7 April 1919, the mayor invited suggestions for a permanent reminder of the war and the lives that had been sacrificed. Among ideas forthcoming were a boulevard on the Warwick Road, a new bridge, public baths, a promenade along the river and an endowment fund for the hospital. The District Labour Council proposed building 'war memorial houses' for disabled soldiers, or for the aged parents of the fallen. Mr H .C. Lacey said that he was more concerned with 'the flesh and blood of those who had made the supreme sacrifice – the fatherless children'. Their families had lost their breadwinner and the people of Stratford were now the guardians of these little ones. He wanted to see a trust fund established, 'to give them a fair chance when they were launched out into life'.

These suggestions were all rejected on the grounds that they were projects that should be paid for from the rates. A proposal from Cllr Winter won the day, a memorial on an island site at the top of Bridge Street. He estimated it would cost no more than £600. His suggestion of a statue of a British Tommy was later changed to a cross of Hornton Stone, quarried locally and designed by the local architect Guy Pemberton.

By February 1921, fine memorials had been erected in all the neighbouring villages, but there was no sign of one in Stratford. The reason for the delay was an argument about whether the names of the fallen should be placed on the memorial, or on the walls of the council chamber. When it was pointed out that most people seeing them would be those before the magistrate's court, the issue was resolved in favour of the memorial.

Canon Melville was active in the cause of commemorating the dead, commissioning designs for a memorial screen and reredos at Holy Trinity. The names of the fallen would be engraved on copper plates 'as a perpetual reminder of their sacrifice for the Empire'. Those who had lost relatives in the war were asked to send in their names, rank and regiment. Yet his frequent financial appeals to his parishioners were disappointingly unproductive. By March, 1920, a month before the dedication, only £200 of the £420 costs had been subscribed. The Canon's wealthy wife must have made up the shortfall. The memorial to 237 men who had fallen was dedicated after the Shakespeare sermon on 24 April.

Three old soldiers finally unveiled the war memorial on 17 February 1922. It was a dignified ceremony, attended by those who had lost loved ones who were dressed in mourning clothes. While most of the names on the memorial were genuine Stratfordians, the fact that their presence depended on the response of friends and relatives, led to some curious anomalies. Whereas Sgt James Brebner of Russell Cottages' name does not appear, that of Pte Walter Garner of the Queen's Royal West Surrey Regiment features on both the memorial screen and the war memorial. He was born in Chile, lived in South Kensington, enlisted in Wood Green and has no discernable link with Stratford.

The war memorial was not to remain at the top of Bridge Street for long. In 1926, a lorry ran out of control and toppled it, and it was decided to move it to the Bancroft Gardens.

'The Worn Out Symbols of War'

It was easier to honour dead heroes than live ones. By 31 March 1919, only 291 Stratfordians had been demobbed, but complaints were rising that the streets were filled 'with youngsters who seem more disposed to obstruct our pavements and indulge in horse play than do any work that will help the general well-being'. It was supposed that the services would 'first liberate' those who had employment, but the experience in Stratford was that 'the more useful are kept behind to do work which is not only humiliating, but which needs no sort of technical skill or ability'.

A correspondent to the *Herald*, signing himself 'A discharged soldier' tried to explain the 'Unemployment Mystery'. Like 'a great many other Government schemes', it had been badly handled. Each discharged serviceman was entitled to a weekly allowance of 29s whether he was married or single. The result was that the bachelor had no incentive to work and was tempted 'to take a holiday, while the married man who had the responsibility of a home found it difficult to live on the government allowance and thought it unfair that he was getting so little'. If the recipient found work, he was liable to lose all or part of his allowance. The writer knew of three discharged soldiers who had been offered work by a builder. When they asked what the local rate was, they were told it was 27s a week. 'Can you wonder, then,' the correspondent concluded, 'that employers cannot get men?'

In response to such criticisms, the Army announced that it was prepared to discharge all men with a job to go to, but an extraordinary piece of bureaucracy complicated the situation. The job had to be the same one that the soldier was doing when he enlisted. Winter's toy factory had closed during the war and the job of William Clarke, the manager, had ceased to exist. Fred Winter appears to have been reluctant to apply for his return, which left him stymied. 'I am down in the Army records as "Toy Manufacturer" and as far as I can see, must be applied for as such', he wrote to his old boss from the camp at Autigny in December 1918. If the directors made an application for him, he could get a rapid release. 'I hope they will see my point and do so, the question of my resuming my position as Managing Director does not interfere with the application'. 'During the twelve years I was in your employ', he added plaintively, 'I don't think we ever had a cross word.' His plea had its effect. 'I have just received yours of January 1st' he wrote on 5 January 1919, 'and thank both you and the company for making application for me.' His release came in the nick of time. 'The men out here are very restless', he wrote two weeks later, 'and there has [sic] been several riots at the base.'

Another former employee who was less fortunate was a soldier called McCullough, who wrote from the General Reinforcement Camp at Boulogne-sur-Mer on 3 April 1919. 'I will admit I have been a very scilly [sic] fellow and caused my poor father and mother and sisters a lot of troubles.' As did Adam, McCullough blamed his bad behaviour on a woman, but this was now remedied. 'But dear sir my wife is now gone and I do not mind what salary I get so I can get a start and you can rely I will work hard.' This plea produced a curt response. 'Mr Winter has no vacancy for Mr McCullough and any reference from him would not do Mr McCullough any good.'

It was difficult for civilians to realise that many who had served in the war were permanently scarred by the experience. George Hewins had got a job as a night watchman at the military hospital at Clopton House, where the last contingent of wounded was received on 28 March 1919. He was given a wooden sentry box and told to demand the password from convalescents who were returning from an evening in town. 'In that coffin up Clopton Lane I started to have dreams. I fancied I was still in the trenches, with the rats running all over: swarms o' rats with yella eyes and big fat bellies. You could a-told me it was only the branches of a tree a-squeaking and a-scratching across the top o' the box – it wouldn't a-made no difference. I used to get off the seat and crouch underneath it, eyes shut, hands over my eyes.' When the Medical Board discovered that George was earning 25s a week, £1 was docked off his pension.

George Holtom suffered from lumbago as a result of his time in the trenches. His wife would cover his back with brown paper, he would bend over the table, and she would iron it to relieve the pain. One of the four sons of Alderman Fox was crippled with rheumatics. William Jones died in 1926. It was considered that his premature end had been brought about by the privations he had suffered as a Turkish prisoner-of-war. He left a wife and three children.

The shell-shocked were a familiar sight around Stratford for the next half century. Men like 'Larley' Dale and 'Colonel' Franklin were cruelly teased by children who knew or cared nothing of what they had been through.

The return of the 'heroes' brought another scourge from afar. In May, the Warwickshire county council advertised free treatment for 'all persons who are suffering from diseases such as Syphilis or Gonorrhoea at special treatment centres'. Strict privacy would be observed and no hospital ticket was necessary. The affliction was clearly a speciality of quack medicine, for

it was pointed out that the Venereal Diseases Act of 1917 made it 'illegal for anyone, other than a duly qualified medical practitioner, for reward, either direct or indirect, to treat any person for Venereal Disease, or prescribe any remedy for such disease, or give advice in connection with the treatment thereof'.

A positive result of the return of the young men was the revival of organised games. The Golf Club was the first back, but since fewer of its members had fought in the war than those in sporting clubs for younger men, this was hardly surprising. The suspension of activity had taken its toll. The cricket ground and pavilion were much neglected and it would take a considerable sum to restore them, but it was not too late to organise a crash programme of winter games. The draw was made for the Stratford Football Cup, with the first round played on Easter Saturday. The first rugby match took place two days later.

The tank and gun that had arrived in the last days of the war were becoming victims of changing attitudes. Once, they had represented patriotic fervour and the will to win at all costs. Now the *Herald* dismissed the tank as 'the battered, dirty, disreputable piece of ordnance now disfiguring the top of Bridge-street'.

The fact was that people were still war-weary. 'What need we,' asked the *Herald*, 'of an object of this kind to daily remind us of a costly war, involving the destruction of thousands of precious lives and the mutilation of some of our finest specimens of humanity?'

These 'worn-out symbols of war' were now used by small boys who became as grubby as the tank itself as they climbed all over it. The town council was at a loss to know what to do with its trophies. In May, it was proposed that a base for the tank should be built at the junction of the Warwick Road and Guild Street. In the meantime, it was moved to the Bancroft Gardens and the gun to the Fountain. The *Herald* suggested that the tank be used to level 'some of the squalid houses condemned by the Medical Officer of Health, and then send it to some engineering works to be consigned to the melting pot'. Failing this, it should be placed at 'the rear of the adjacent fellmongery. The pungent odours would not in the least affect it and it would be in the company of other tanks'.

The Peace Treaty with Germany was signed on 28 June. At closing time that night, the fate of the gun was sealed. A large band of young men, many recently demobbed, who had imbibed freely, sallied forth and made for the Fountain. They broke the chain holding the gun and dragged it towards the river. On the way, they were joined by hundreds of other 'exuberant spirits'. A police sergeant on the waterside made a futile attempt to stop the procession. The gun was pushed into the river at the Wash in Southern Lane, but the water was not deep enough to cover it. As it was being dragged out part of the wall of a landing stage was knocked down, but, not daunted, the mob hurtled the gun towards Clopton Bridge. After Herculean efforts, 'the huge mass of wood and iron' was pushed over the parapet into the river. The bridge was damaged, but this was of no matter to the boisterous crowd. In this 'humiliating position', the gun collected many more sightseers than it had in Rother Street. 'The only thing to be done', suggested the *Herald*, 'is to rescue it from its present position, and, to prevent further indignity, a free gift should be made of it to one of our local ironfounders'.

A potentially more sinister demonstration occurred next evening, when some young men decided to visit a farmer who was employing a few German prisoners-of-war, but a considerable force of police was waiting and 'nothing unseemly occurred'.

On 18 July, the Peace Treaty was celebrated in appropriate fashion. Six hundred 'gallant fellows, the pick of the town, swung off in procession' to the cricket ground. With prophetic discernment, one person at least was uneasy about the turn of events. A correspondent to the *Herald* signing himself 'H. J. A.' expressed a concern that would be heard with increasing frequency over the next two decades. 'A very large part of the civil population of Germany does not now believe that Germany is beaten, for the simple reason that they see no evidence of the fact ... I may claim victory but Germany does not admit defeat.'

The captain of the Boat Club, Eddie Thompson, the only member of the eight to survive the war, expressed a similar view. 'I am not so optimistic', he declared at the unveiling of the Boat Club memorial, 'as to believe that the late war is the end of wars'.

Despite such ultimately justified pessimism, an attempt to build a new world order was reflected in Stratford at the close of 1919. The bellicose Edward Fox was an unlikely League of Nations man, but, as mayor, he fulfilled his duty by presiding at the inaugural branch of the local association.

'For the Working Classes'

Although small-scale ribbon development had occurred in the Victorian era, Stratford was still largely contained within its medieval boundaries. That was about to alter forever. The first agent of change was the town council. Lloyd George's famous injunction 'to make Britain a fit country land fit for heroes to live in' was having its effects. Local councils were obliged to provide an adequate public housing stock. In Stratford there was very little, so in May 1919 the town council sought to borrow £2,000 to purchase a 14-acre field from a farm belonging to the Marquis of Hertford on the Evesham Road, to build a housing estate 'for the working classes'. In the following week, the borough surveyor was instructed to submit a preliminary design for the erection of 100 houses on the Birmingham Road.

The problem of providing work for the war veterans remained. In 1920, the county council established a centre on a 117-acre site at Shottery, which possessed excellent farm buildings. Its purpose was 'to give a thoroughly sound training in agriculture, market gardening, poultry-keeping and dairy work to those disabled men who were qualified in the eyes of the committee to earn a living on the land'. Twenty-five men would be housed in Army huts and it was hoped to expand the number to fifty. A principal was appointed and a lecture series planned.

The centre did not thrive. 117 acres was hardly sufficient to support twenty-five men, let alone fifty. By February 1921, the county council was already making moves to close it. The *Herald* waxed angry at such egregious blundering. 'The ex-serviceman is being so scandalously treated ... that something should be done to save him from a condition bordering on starvation.'

The town council was also getting into employment creation. As early as 1911, it had advertised a parcel of land for sale on the Birmingham Road. There were no takers, so the plot was turned into allotments. Now a bid from a manufacturer of aluminium castings, Messrs N. C. Joseph of Birmingham was accepted by seven votes to six. The response was predictable and ill considered. 'Do the members really know what a casting foundry really

means?' furiously demanded a local architect, Guy Pemberton, who proceeded to answer his own question. 'A row of short furnace stacks, belching forth sulphurous and deadly fumes, poisoning the air for vegetable growth. The site lies west of the town, so that the prevailing wind will waft this gently over everything and all of us.'

Next in line were the sixty allotment holders, who quite rightly pointed out that they had cultivated their plots 'at great expense and labour' for seven years. The row went national as a great many angry letters appeared in the press. *The Globe* pilloried the seven councillors. 'Words fail to describe what will be the verdict of the world on these swelling local Dogberrys.'

'An influential meeting' declared that the council's action in accepting the bid had been precipitate. 'We contemplate with dismay', declared a letter signed by sixteen leading inhabitants, including the vicar, the secretary of the Birthplace Trust and the headmaster of the Grammar School, 'the certain destruction of the character which our historic town and neighbourhood possesses'.

Inevitably, Marie Corelli entered the fray with a letter to the *Morning Post*. As well as the aluminium works, she had picked up a proposal to build a 'chemical manure' factory at 'dear little Shottery'. Between the two 'stenches' there would be poor health for local children.

The furore galvanised Mr N. C. Joseph into action. He had read the views of his opponents 'with some amusement, and, latterly, with much amazement'. They were aluminium workers, not aluminium manufacturers. It was as absurd to suggest that they made their own metal as it was to expect the grocer to make his own tea. In a letter to the *Herald* he was scathing about the ignorance of 'Art Gallery keepers and magazine writers, however eminent', and suggested that they should hesitate in future before venturing outside their own specialities. 'Even at the large extracting works', he explained, 'from which we buy our aluminium there are no blast furnaces or smelting processes, as aluminium is not obtained from an ore like most metals, but is electro-chemically reduced from common clay'. There would be no smuts or smoke. The power would be electric or gas taken from the local supply. Only ten allotment holders would be dispossessed and these would be fully compensated. They would be very pleased to show any ratepayer round their Birmingham plant. Seventy-five per cent of the male workers there were ex-servicemen. They would seek the same in Stratford, which would 'enable them not only to work, but to live under healthy and desirable surroundings'.

The letter changed the climate of opinion. The Birmingham Road was hardly a garden suburb. As well as the brewery and Kendall's chemical factory, there were the gasworks, Birch's Skin Yard and the claypit at Epsley's Brickworks where there was blasting every day. A railway siding ran across the road from the goods yard and trucks shunted backwards and forwards across it. Reginald Carter of Shottery Hall, one of the signatories of the letter, declared that he would be satisfied if Mr Joseph's assurances were made legally 'binding for ever'. At a crowded meeting at the Town Hall, Sir Frank Benson, who had travelled from London to speak against the proposal, was shouted down. This was just a month after a fervent audience had cheered him at the theatre, and a motion in favour of the factory was overwhelmingly carried.

Those opposed to the factory had not exhausted their options. The plot in question belonged to the College Estate, one of the borough charities, so now the chairman of the Birthplace trustees, Sir Sidney Lee, appealed to the charity commission. An enquiry was held in Stratford in October, but proved so drawn out that the hearing did not even get to the

opposition's case. Mr G. C. Wallace, the assistant commissioner, announced that it would be postponed for a week, which caused consternation to the scheme's supporters, who felt that delay might jeopardise the project. The fears were ungrounded. Before the end of the month, the commissioners announced that they would not be justified in refusing to approve the sale.

'As things now stand', Sir Sidney told the *Daily Chronicle*, 'it looks as though the factory will be built in spite of world-wide antagonism to the scheme.' He was pained that the Stratfordians had ignored this universal opinion and perversely continued to support the factory. There was one last hope. A proposal was being considered by a number of well-known Parliamentarians to promote a Bill in the House of Commons. If passed, it 'would have the effect of saving Stratford, and other places of like historic interest, from disfiguration by industrial concerns'.

With the collapse of the environmental case, Sir Frank Benson sought to establish a new line of attack. 'If you have this factory you will have others, and there will be the same problems that other great towns have failed to solve.' This was undoubtedly correct, but it would be some time before light industry on any scale came to Stratford. In the meantime, the opponents of the factory provided no alternative proposals as to how to employ the hundreds of returned servicemen. Ironically, when the factory did open, there was insufficient local, skilled labour to take advantage of the opportunities, and the principal hands had to be brought in daily from Birmingham. For the locals, it tended to provide more piecework than permanent jobs.

One positive effect of the factory issue was that the borough council determined to take up the option of controlling its statutory planning powers. Its first act was to commission a report on the future development of the town from Patrick Abercrombie, the Professor of Civics at Leeds University, and his brother Lascelles, a noted poet, playwright and essayist.

The report is noteworthy for its common sense and foresight, putting forward sensible suggestions for preserving the historical and aesthetic associations that had made Stratford famous while providing for its natural and legitimate expansion. It placed great stress on the necessity to preserve the factors that had made the town a balanced community as the centre of a rural area, perceiving the importance of not marginalising the markets that had been its original *raison d'etre*. Had its suggestions been observed more fully over the years, there is no doubt that the town would be a better place.

Ribbon Development

Despite the passion expended on the factory issue, the major threat to the historic character of Stratford was not light industry, but ribbon development. The proposed factory would be situated opposite the large estate that the council was planning on a green-field site. Already speculators were buying up land along the roads into the town. The outlying villages and hamlets, which had retained their own character for centuries, were becoming suburbs. In the very week in which Benson spoke, an enclosure of rich old turf land known as the Leys, situated on the side of the road then known as Skinner's Lane, which led from Shottery to the Evesham Road 'and having a valuable building frontage', was auctioned to a builder, Mr A. H. Pearce, for £975.

Naturally, the developers were not happy with the name Skinner's Lane and proposed that it be changed to Hathaway Lane. This was carried after a last-ditch stand by those who resisted the

anaesthetising of names rooted in local history. The same had happened with Shottery Road, which many older people still referred to by its old name of Burial Lane. The name 'Cottage Lane' was coined to describe what had been known merely as 'Shottery'. The Barracks became a bijou 'Hathaway Hamlet'. Burmans had farmed in the village in the days of Anne Hathaway, but now the name of their old property was changed to 'Hathaway Farm'.

The process had begun even before the end of the war. The pressure for speculative building land and the high cost of maintenance was breaking up the ring of estates that surrounded Stratford. 'An important element of country life is disappearing', noted the *Herald*, 'and its members going into smaller houses which can be run without the present heavy expense.' On 28 October 1918, the Shottery Manor estate was put up for sale. It included 'a field of old turf, with a frontage to the Alcester Road', which was suitable for market-gardening or building land. Part of this site was to benefit local girls, who had had to travel to Warwick and elsewhere for secondary education. In 1931, it was acquired to build a girls' school.

Two years later, the Avon Cliffe estate at Alveston came on the market and was split up for speculative building along the Tiddington Road. The new physical reality was recognised in 1924 when the parish of Alveston was incorporated into the borough, doubling its size.

In the post-war era, the old shopkeeping families started to move out of their flats above the shop and into more salubrious accommodation. George Ballance, the grocer, and George Boyden, the proprietor of the *Herald*, went to Rowley Crescent, the Winter family to Loxley and Nancy Justins of the Shakespeare to a nice house on the Maidenhead Road. The moves increased the petty snobberies and distinctions between 'trade' and 'artisan' classes that had long pervaded local society. Freemasonry continued to play an important role in its hierarchy. F. C. Wellstood, the Birthplace secretary; Salt Brassington, the theatre librarian; Fred Winter, the draper; George Lea, the butcher; Kibler Morgan, the estate agent and J. H. Rowe, who farmed at Bridgetown and owned the Racecourse, were all members of the Swan of Avon Lodge, of which George Boyden, of the *Herald*, was a founder-member.

Poorer people were moving from the town's old alleys to the new estates. This demographic shift was recognised by Flower's Brewery, which closed the Lord Nelson on Great William Street in 1930 to transfer its license to the Salmon Tail on the Evesham Road, in close proximity to the Bordon Place estate. Another council estate was built in 1936 on the evocatively-named Swin(e)cotes up the Alcester Road.

The growing pressure of traffic meant that plans for a new bridge, replacing the beautiful Tramway Bridge, were drawn up. As a preliminary, two ancient cottages were demolished at Bridgetown, despite protests. Fortunately for Stratford, the county council abandoned the bridge scheme in 1930, on grounds of cost. The site of the cottages became a garage.

'Our Day has passed'

The theatre was progressing under the tutelage of Bridges-Adams. His penchant for presenting the plays of Shakespeare in full had led to his acquiring the nickname of 'Unabridges Adams'. The 1921 summer season of seven weeks was the longest on record. He was not beyond the odd Bensonian gimmick. In 1920, the distinguished Dutch tragedian, Louis Bouwmeester,

played Shylock in his own language, with the rest of the cast speaking English. In 1921, there was an extraordinary all-women performance of *Henry V*.

In April 1922, the choristers of All Saint's, Margaret Street, London, laid a wreath on Shakespeare's grave, watched a rehearsal of *Othello* and in the afternoon performed *The Taming of the Shrew* in the theatre. One boy in particular caught the eye in the anonymous cast. 'There can be nothing but praise for the acting of Katherina', wrote the *Herald*. Ellen Terry attended the performance and noted in her diary that she had only seen the part done better by Ada Rehan. The boy's name was Laurence Olivier.

In the summer of 1925, Sir Frank Benson returned to see Dame Ellen Terry silently unveil a window in the theatre gallery to the Bensonians who had been lost in the war. The principal figure of St George bears the features of Benson's son, Eric, who had been killed on the Somme. Three months later, Sir Johnstone Forbes-Robertson unveiled the 'Players Memorial' in Holy Trinity, with an inscription by Rudyard Kipling: 'We counterfeited once for your disport / Men's joy and sorrow; but our day has passed. / We pray your pardon all where we fell short, / Seeing we were your servants to this last'.

At Christmas in 1923, Marie Corelli, with characteristic generosity, sent a plump chicken to each of the tenants of the almshouses. She died on the following Easter Monday. Her literary star had waned, but her exploits would ensure that she was long remembered in Stratford. The *Herald* eulogised about its old antagonist. 'That Miss Corelli succeeded in making the town a prettier place than she entered must be generally admitted.'

Bertha Vyver lived on at 'Mason's Croft' until her death in 1939. Marie had intended that the house should then pass to the ownership of a trust 'for the benefit of distinguished persons visiting Stratford-upon-Avon from far countries'. It was, perhaps, the recollection of uneasy relations with the Bensons that led her to add that anyone connected with the stage was 'particularly excluded' and, it almost goes without saying that anyone connected with Stratford was 'specifically debarred from the management of the Trust'. 'Never let Mason Croft fall into the hands of the borough Council', a further clause added. But, even in death, her schemes went awry. The will was declared invalid and her property sold. Today, 'Mason's Croft' is part of the postgraduate English school of Birmingham University, which might have pleased Marie until she fell out with the professors!

Mr Gisborne's Bonfire

Early in 1919, the Stratford Fire Brigade acquired its first motor fire engine. On 24 January, it was put through its paces at a public demonstration on the Bancroft Gardens. Onlookers were 'favourably impressed' as it played on the Memorial Theatre and threw a jet of water 120 feet up the tower.

With what proved to be fortunate timing, the Picture House shut for refurbishment in 1923. It reopened in June 1924 as a palace of delights, with exotic murals of ladies in gondolas amidst romantic nights in Venice. A feature of the auditorium was a 'fine, new roomy stage ... the capital lighting effects leave nothing to be desired'. The cinema could now present live shows. In September, Harold Montague and his troupe of vagabonds appeared for a week.

On 5 March 1926, the stage was turned into a boxing ring, which led to protests from the Free Church council.

The guest-of-honour at the Birthday lunch in 1925 was George Bernard Shaw. In scintillating and impish form, he told his delighted audience that the Memorial Theatre was an 'admirable building, adapted for every conceivable purpose than that of a theatre ... You must have a new theatre, a new front to the house and a new stage. This will require a great deal of money and if there are any stray millionaires among the audience, I invite them frankly to give all they can to this worthy object. After all, there is no place in the world where one gets the same sensation from the plays of Shakespeare.'

That summer, the curtain rang down on the festival as Randle Ayrton, as Leontes, spoke the last Shakespearean words heard on the stage of the old Memorial Theatre: 'Lead us from hence, where we may leisurely / Each one demand, and answer to his part / Perform'd in this wide gap of time, since first / We were dissever'd: hastily lead away.'

An American visitor was shocked to note that neither the Memorial Theatre nor its art gallery was equipped with automatic sprinklers. 'Sooner or later the inevitable must happen', was his comment.

The 'inevitable' happened next year when the builders and decorators began to prepare the theatre for the spring festival. Someone may have dropped a cigarette butt in the backstage stores. Saturday 26 March was a blustery day. At around 11 a.m., little Eileen White, aged eight, was sent round the corner from her home in Sheep Street by her mother to run some errands for an old lady who lived on Waterside. 'There's an awful lot of smoke in the street', she told her when she arrived. 'Oh, it's alright', replied the old lady. 'It's Mr Gisborne's bonfire.' It never occurred to her that the gardener on the Bancroft Gardens was unlikely to light a bonfire in springtime.

Late that morning, a workman brought Alice Rainbow, the manageress, the startling news that a fire was raging on the stage behind the safety curtain. She went into the theatre and found it full of smoke. Her reaction was undoubtedly that of many people under the same circumstances. To try to curb the fire she opened all the doors. This had the opposite effect and created a blazing inferno. By lunchtime, smoke was pouring from the roof of the theatre. Fire brigades were summoned from miles around. The Warwick engine was still horse-drawn and the horses were covered in foam as they came galloping down the Warwick Road. The pumps were drawing water from the river and the hoses played on the flames, but it was a hopeless cause as the wind fanned the fire to greater intensity.

Although the auditorium was engulfed, the wind was blowing the flames away from the theatre gallery, so a human chain was formed, to carry the pictures over the road to the lecture room. Great crowds gathered to see the spectacle. They were not disappointed. The intense heat caused the tiles to fly off the roof and into the river. The gallery was preserved intact, but the auditorium was gutted. On the Sunday morning it was still smouldering. George Bernard Shaw was moved to send a telegram of congratulations that the old, restricted building had been destroyed.

The festival was due to open in six weeks and the implication to all in Stratford was clear. 'No Festival, no visitors!' Next morning, Archie and Spencer Flower, the controlling shareholders in the picture house, went there with Bridges Adams in the pouring rain. With their umbrellas they traced in the mud a plan to enlarge the building to provide it with space for dressing rooms and storage. It came as no surprise when, on that Sunday morning, Alderman J. H.

Rowe, the chairman of the Picture House Co., announced that it would be offered for the festival. Always known as 'Squeaker' because of his high-pitched voice, he had the reputation of being 'a randy old blinder'. Archie Flower and Bridges Adams made a rapid decision. The festival would take place in the cinema, which actually had a greater seating capacity than the old theatre. At a public meeting at the Town Hall, over £1,000 was subscribed towards the alterations. Five weeks of feverish toil followed. A stage and dressing rooms were built and the scenery and costumes that had been destroyed in the fire were replaced. Miraculously, the event opened on the advertised date, 12 April, with Randle Ayrton as Falstaff. The gallery, in the surviving section of the old theatre, was reopened in May, with re-hung pictures.

As if things were not desperate enough, the situation was compounded in May by the short-lived General Strike, although this did not have a huge direct effect in Stratford, it closed the railways, which brought the vital visitors. Despite this, the company pulled through with audiences that were diminished, but adequate. 'The Festival has survived the fire and the strike', declared Bridges Adams on the last night. 'Nothing in the world can destroy it.'

The Jam Factory

For five years, the festival was housed in the Picture House. There were proposals that the new theatre should be built on the site of the Union Club in Chapel Lane, but it was decided to build it on an extended site next to the old theatre entrance and gallery. The tramway site, part intended for a new bridge over the Avon, was acquired and part-swapped with the town council in exchange for the new site on the Bancroft. A competition was announced for a new theatre with architects from the United Kingdom, Canada and the United States invited to compete. 'As far as humanly possible', declared the briefing, 'the new theatre must be adequate to the presentation of Shakespeare in any fashion that later generations may approve'. Seventy-four schemes were submitted with the anonymity of the practice guaranteed. In July 1927, a shortlist of six – three British and three American – were invited to submit further designs by November. Three of the proposals were on very similar lines to the eventual winner, but two of the American designs were Gothic creations even more fantastical than the old theatre.

Yet even strenuous fundraising efforts could not raise all the required funds. George Bernard Shaw quipped that Archie Flower had adopted rather an expensive orphan in William Shakespeare.

In an attempt to raise the considerable shortfall, Archie and his wife toured America. They had been given lists of people who might be helpful to their cause. One by one they made these contacts and got nowhere. 'Florence, we're going home. We've failed', said Archie. 'But there's one more man on the list that we haven't tried.' 'It's no good', he said. 'He'll be just like the others. I'm not going to talk to him.' 'Well, I will', she replied. 'Florence, you can't do that. You haven't been introduced.' She ignored both the convention and her husband and rang the man up, a total stranger. She explained who she was and invited herself to luncheon with him. Intrigued by this very forward Englishwoman, he agreed. She was determinedly persuasive and he turned out to be the right man. 'I can't do anything for you', he told her, 'but I'll tell you who can.' He gave her a new list that completely transformed their mission, and they raised

two thirds of the funds for the new theatre in the U.S.A. John D. Rockefeller Jr alone gave the enormous sum of £50,000. The Theatre Fund now stood at £250,000. On 2 November 1927, the *Daily Telegraph* announced that the project was assured.

Late in 1927, it was announced that the only woman who had submitted a design, Elizabeth Gilbert Scott, was the unanimous choice of the judging panel. She was a member of a famous architectural dynasty, but, at twenty-nine, her portfolio of previous work was slim. Yet the *Herald* was surely right when it described the decision as 'one of the first signal successes ever obtained by a woman in the realm of architecture'.

The press was almost unanimous in its praise for the design. Even George Bernard Shaw was, at least for a while, happy with it. 'Miss Scott's plan is the only one that shows any theatrical sense', he told the governors' meeting in seconding Archie Flower's proposal that the scheme be adopted, although he later changed his tune and said it looked like a fort on the Nile. Stratfordians were equally inventive, calling the building 'a water tank', 'a factory' and 'a blot on the landscape'. The first recorded instance of its lasting soubriquet came even before the opening, when a child at the Alcester Road School declared that she was sure it would be 'much more beautiful than a jam factory'.

The Festival Company embarked on its second great North American tour in recognition of the largesse that had been provided. In Hollywood, they were entertained by the most famous Englishman of his day, Charlie Chaplin.

In 1927, Bridges Adams was thrilled to receive a letter from the Master of the King's Musick, Sir Edward Elgar, who had already composed on Shakespearean themes, expressing a desire to compose incidental music for productions at Stratford. In the next year, he leased Tiddington House for eighteen months before moving to Worcester. There was even talk of him composing an overture to his symphonic work *Falstaff* to be performed at the theatre's opening.

On 8 February 1929, the first piles were driven of the new theatre. On the same day, demolition of the Gothic tower of the old theatre, a familiar Stratford landmark for half a century, began. On 2 July, the foundation stone was laid by Lord Amphlet, the Grand Master of the United Grand Lodge of England. As in 1877, hundreds of masons paraded in the apron, collar and gauntlet of their order. The triumph was compounded in the New Year's Honours List with the award of a knighthood to Archie Flower. Two months later, he received what Stratford might have deemed a greater honour when he was made the third Freeman of the borough in the town's history. The scroll was presented to him by the mayor, Nancye Justins, in an oaken casket in the shape of the new theatre.

The future of the shell of the old theatre was in some doubt. The governors offered to give it to the town council to build a conference hall on the site. This was regarded as a much-needed facility, but it would cost an estimated £20,000, so after careful consideration, the council declined the offer. In the end, the governors decided to use the old walls to build their own conference hall, so most of the old theatre survived.

Two years later, Sir Frank Benson proposed the toast to the 'Immortal Memory' at the Birthday luncheon. Time had done nothing to diminish his whimsical loquaciousness as he spoke of 'the gospel of peace which the great song-maker rhymed years ago in this little centre of yeoman England.' The audience looked anxiously at their watches. Mr Baldwin, the Prime

Minister, was due to speak before the Prince of Wales arrived by aeroplane to open the new theatre. Schedules were narrowly kept.

In honour of the occasion, the last remnants of the fellmongers and the coal wharves on the Bancroft, relics of Stratford's first industrial area, had been swept away. The Prince opened the great door of the new theatre with a golden key presented to him by Elizabeth Scott. Once the audience was in its seats, Lady Keeble, who as Lillah Macarthy had played in the controversial *Playboy of the Western World* at the old theatre in 1911, appeared before the drop curtain to speak the special ode written by the Poet Laureate, John Masefield, who was in the audience: 'Beside this House there is a blackened shell, / The Theatre that Flower built of old, / Lest English love of Shakespeare should go grow cold'. The final lines represented a wish that all the hopes engendered by the occasion might be fulfilled:

> And may this House be famous, may it be
> The home of lovely players: and a stage
> Schooling young poets to a fruitful age.
> We but begin, our story is not told:
> Friends, may this day begin an age of gold,
> England again a star among the sea,
> That beauty hers that is her heritage.

The curtain rose on Randle Ayrton, who had spoken the last lines in both the old Memorial Theatre and at the Picture House, to speak the first Shakespearean lines in the new theatre, in the title role in *Henry IV, Part One*: 'So shaken as we are, so wan with care.' The lines set the scene for the rest of the afternoon. It was generally considered 'probably the dullest performance ...[of the play] ever given in Stratford-upon-Avon'. The opening was just in time. Within a month, the river had risen by 18 feet to its second highest recorded level.

For many, the real opening came with an Old Bensonian matinee at Whitsuntide, at which Sir Frank made his last Stratford appearance in the *Merchant of Venice* in a cast that included the noted Old Bensonians Lilian Braithwaite, O. B. Clarence, Robert Donat, Leah Hanman, Cedric Hardwicke and Sir Nigel Playfair. At the close, the audience rose to cheer as Bridges-Adams advanced from the wings to lay a laurel chaplet simply inscribed 'Pa' at Benson's feet.

The new theatre was a huge success. The production of *The Merchant of Venice* by Theodore Komisarjevsky broke all records with an attendance of 1,279, including 120 standing at the back of the stalls. The overall profit for the season was £4,000. The cost of building the new theatre and converting the shell of the old one into a conference hall totalled £193,480. The appeal had produced a surplus of £117,000 that was placed in an endowment fund.

Stratford became a place of pilgrimage for such distinguished literati as Rudyard Kipling, John Galsworthy and John Drinkwater. Celebrity concerts by the likes of Count John McCormack and Madame Tetrazzini helped make the new theatre a cultural powerhouse. Such was the demand for tickets that in 1933, it was decided to combine the spring and summer festivals into a seamless twenty-one-week season.

In 1936, a record 193,362 people attended the theatre and 41,300 people paid 1s to tour the building. Such was the demand for the cheaper seats that the capacity of the gallery was

extended to hold 450 instead of 300. In 1937, the season was extended to twenty-six weeks, making it the world's longest-running dramatic festival.

Despite such public approbation, there was muted criticism of the theatre, particularly from those who had to play in it. Balliol Holloway complained about the 'immense distance' between the stage and the front row of the stalls, which completely destroyed all contact between actor and audience. 'Actors', he stated, 'had been heard to say that it was like acting on the beach at Dover with the audience in Calais'. To such criticism, Elizabeth Scott responded that her intention had been to enable the producer to incorporate a platform stage.

The most vociferous critic of all was Sir Edward Elgar, who, without warning, telephoned Sir Archibald Flower on 15 February 1932 to announce that he intended to travel over to Stratford that very morning to view the theatre, and that he would be arriving at 11.30 a.m. Sir Archie arrived at the appointed time to find that Elgar had already been there ten minutes and 'went right off the deep end, saying that the building was so unspeakably ugly and wrong that he would have nothing to do with it'. Sir Archie offered to take him on a tour of the building, but later confided that he had 'dreaded having to take him through the entrance hall … for fear he should faint'.

Next day Elgar sent a furious letter to Bridges-Adams. Nothing had ever given him greater pain, but he was withdrawing 'from all connection with Stratford-upon-Avon'. 'I had looked forward to devote the closing years of my life to music for Shakespeare … but I cannot face the possibility of daily contact – even for what might be a short time – with that distressing, vulgar and abominable building. I may have led a deplorably bad life but I can conceive no crime that deserves the punishment inflicted on poor Stratford and by that awful female.'

Yet things might not have been as simple as they seem. There would be those who would speculate that Elgar, at the age of seventy-four, had doubts about his powers to deliver the promised incidental music and was using his distaste for the building as a pretext to withdraw from the project.

'The Uncrowned King'

In the aftermath of both world wars, the Royal Family achieved an almost God-like status as the sacred symbol of the nation. The Prince of Wales was the most admired man of his age and when he paid a brief visit of fifty minutes to Stratford in 1923, he was enthusiastically acclaimed by thousands of inhabitants and those who had flocked in from the villages.

The Silver Jubilee of King George V was celebrated with due pomp. Early in 1936 came the famous message on the wireless: 'The King's life is moving peacefully to its close.' The news spread rapidly and the streets of Stratford were practically deserted as people dispersed to their houses to listen to subsequent bulletins. Here and there, small groups could be seen anxiously discussing his fight for life. In the clubs and pubs 'laughing tongues were stilled, and games were brought to a rapid conclusion'.

With the accession of Edward VIII, thoughts turned to his coronation. On 16 October, 200 people attended a public meeting to discuss suggestions for the celebrations. It was proposed that a park be created at Bridgefoot to commemorate the occasion. N. C. Joseph

Ltd announced its intention to present medals bearing the King's head and the borough coat-of-arms to all the local schoolchildren.

It was not to be. On 1 December, Stratfordians heard the news that the King wanted to marry Mrs Simpson, and shared 'the prayers of the countless millions who acknowledge Edward VIII as their temporal Lord'. Ten days later, came the news that the King was preparing to abdicate and that there would be a special announcement during the day. Once again, people took to their wirelesses to await the 'painful experience'. In every office and factory a telephone call reporting the decision was expected at any moment. At four o'clock the streets were deserted. When the news came, it spread through 'every nook and corner of the town' and for the rest of the day the dramatic events were the sole topic of conversation. The mayor, Cllr E. P. Ray, pronounced that Edward would be known in history as 'The Uncrowned King' and that his work as Prince of Wales would long be remembered.

Edward VIII's brother, the Duke of York, was proclaimed as King George VI at the Market Cross on the following Sunday. Special services were held in the local churches that must have revealed to some the decline in the moral prerogatives of the Church of England. The general reaction from the pulpit was one of sympathy for the ex-King's position, and prayers for his future. It is difficult to imagine that the Revd George Arbuthnot would ever have tacitly condoned such dereliction of duty and adultery in high places, although the mayor did express the hope that the nation would welcome the new King and Queen 'as examples of the family life which is one of the nation's ideals'.

The celebrations intended for Edward VIII's coronation were simply transferred to that of his brother, who was crowned on 12 May 1937. The major feature in Stratford was a giant facsimile of St Edward's crown, constructed by the Corporation work-staff and erected on the road island at the top of Bridge Street.

'They won't let any of our old Things be'

The internal combustion engine was bringing 'visiting hordes from every corner of the globe' to destroy the delicate balance of the little town and take Stratfordians to work in the nearly cities. Rows of 'semis' were spreading out along the main roads. On 15 March 1929, the mayor cut the first sod of the new council estate up the Birmingham Road, which was appropriately named after her – Justins Avenue.

Only in one area was the urban sprawl prevented. After the death of Sir George Trevelyan in 1928, his son and heir, Robert, sold the 4,000-acre Welcombe Estate to a speculator. The land along the Warwick Road was split into lots and labelled 'choice building land', while the woodland was described as 'convenient parcels.' Soon 'oak-trees, gate-posts and boards blossomed with notices of a sale to take place on 22 November.'

While most of the other housing developments aroused, if anything, muted protests, the prospect of what *The Observer* described as 'the most English road in England' disappearing under bricks and mortar caused a national furore. 'The axe threatens the woodland where Shakespeare walked', fumed the *Manchester Guardian* fancifully, 'and villadom prepares to occupy the spinneys where he saw 'Puck's impish face peeping from behind oak and ash'.

The town council sought advice on its powers and was informed that they were merely limited to the capacity to restrict the development to five houses per acre. The day was saved by Archie Flower, who bought the Welcombe Estate and put an injunction on future building development. He sold the mansion on to the LMS Railway, which opened it as a luxury hotel in 1931. This apparently selfless gesture was not without its critics. Some questioned his motives since the development would have bordered his own residence at The Hill. Others said, somewhat churlishly, that, rather than selling the mansion on, he should have donated it to the National Trust.

The Shakespeare Birthplace Trust acquired another property in 1930 with the purchase of Mary Arden's House at Wilmcote. It was presented as such until 2001 when, as a result of a bold initiative by the Trust director, Roger Pringle, it was discovered that a neighbouring farmhouse was the genuine property. Fortunately it was already in the possession of the Trust.

The Birthday was becoming more an international than a local institution, attended by more and more representatives of the nations. In 1931, ex-Crown Prince Ruprecht of Bavaria paid a private visit to Stratford. He had been a leading German general in the war, but he was shown around the town with great courtesy. In the evening, he was entertained at The Hill by Archie Flower, who had mellowed beyond his previous anti-German rhetoric.

The respite from animosity was brief. Ruprecht's visit occurred in the midst of the Great Depression. Although Stratford, with its lack of industry, was spared its deepest anguishes, it encroached on its doorstep. In 1929, the mayor, Nancye Justins, had appealed for relief parcels to send to out-of-work miners. A month later, seventy hunger marchers from Lancashire arrived in Stratford on the way to make their protest in London and were accommodated in the Poor Law Institution.

The same depression was precipitating the Nazis to power in Germany. After 1933, the presence of the swastika at the Birthday celebrations presaged another war. On 15 April 1934, a rabbi from Birmingham, Dr A. Cohen, spoke to the local religious meeting known as the Brotherhood on the persecution of the Jews in Germany. Next month, a meeting of the blackshirts of the British Union of Fascists at the Hippodrome in Wood Street ended in a riot. It was addressed by A. K. Chesterton, who had written theatrical criticism for the *Herald* over the years.

In 1931, the Birthplace Trust's receipts were down by 30 per cent On 10 September, members of the local teachers' association gathered round a solitary wireless set to learn their fate in the Chancellor of the Exchequer's proposed salary cuts. Everyone present anticipated that there would be a last-minute reduction in the proposed cut of 15 per cent, but not only were their hopes dashed, but it was announced that the tax threshold would also be lowered. This represented a further 7.5 per cent reduction in their salaries. The meeting resolved to draft a letter of protest to their MP, Captain Anthony Eden, which got a polite reply, but had little effect. Three months later, the town council resolved against making salary cuts for its staff.

The hunger marchers became a familiar sight. On 21 October 1932, 208 marchers arrived. The local GP, Dr Murray, treated fifty of them for blistered feet. They spent the night at the Poor Law Institution and the standard tramp's breakfast of tea, bread and margarine was laid out for them in the sale yard of Walker, Barnard & Sons. They made a vigorous protest against this frugal fare, angrily demanding meat. When there was no response, they started smashing things and were rounded up by the police.

22

'Not a Sight or Sound to be Forgotten'

Stratford-upon-Avon Herald, 1942

War Clouds

War clouds were again gathering. In 1937, the secretary of the local branch of the League of Nations Union, Mr R. Cross, sensed the gloom caused by 'the seemingly inevitable catastrophe'. The nation was beginning to be placed on a war footing. Members of the Surveyor's staff undertook training in Rural District Council Yard in Tyler Street, disposing of a 'bomb' that was thrown off an adjoining roof. Ten public air-raid shelters were soon under construction around the town. Those who wished to build their own shelters were advised that designs were available at the Town Hall. Shops selling provisions were advised to issue their customers with no more than their usual requirements and arrangements for issuing ration cards should the need arise were announced. Families willing to accommodate evacuee children were recruited.

The newly formed corps of air raid wardens was making a long round of visits to measure people for gas masks. It was announced that warnings of an imminent air raid would be given by a warbling signal from the fire alarm that lasted two minutes and a series of blasts on the brewery hooter. On hearing these signals, people were advised to go indoors until the 'All Clear' sounded. The *Herald* conceded that the prospect of Stratford suffering an air raid was extremely remote, 'but the need for being prepared for the worst is obvious'.

On the afternoon of 28 September 1938, news came that the Prime Minister was to meet the leaders of Germany, France and Italy in an eleventh-hour attempt to avert war. Immediately, the strain was relaxed and hopes ran high. The news of the Munich Agreement brought a rapturous response and a service of thanksgiving was held at Holy Trinity. With the temporary lessening of tension, the preparations for war were neglected. The trenches that had been so hurriedly dug were filled in, or became waterlogged.

Whatever the rights or wrongs of the Munich Agreement, it undoubtedly gave the nation time to prepare for war. The local yeomanry cavalry, in theory an armoured car unit, received thirty-one new recruits and by May were at war strength. 'What they lacked in experience of warfare they made up for in enthusiasm.' On 10 March, the mayor appealed for assistance in forming a local Territorial unit of infantry. 'D' Company of the 7th Battalion of the

Warwickshire Regiment was inaugurated on 3 May, and more than 100 volunteers enrolled at the hippodrome. The new company soon acquired the nickname of 'Waldron's Warriers'.

An Auxiliary Fire Service was formed, based at the fire station in Guild Street. It was singularly ill-equipped. When war broke out the volunteers possessed only a tin helmet and an axe each. They had no fire engines, only some old cars. To supplement their transport, a well-wisher presented them with a big old car which they nick-named 'The Flying Bedstead'.

With German annexation of the remnants of Czechoslovakia, Anthony Eden saw his stance against Munich exonerated. 'Out of all this week's tragic events', he told a meeting at Alveston House on 22 March, 'I think there is one gain. We all have no more comfortable illusions... Some of us have been called harsh names – even warmongers – during the past year because we were unable to accept these optimistic forecasts. Henceforth I hope we shall all realise what confronts us...'

War fears increased dramatically. Messrs N. C. Joseph Ltd erected nine air-raid shelters to accommodate all 450 of their employees in the fields next to the factory. The long function room at the Unicorn was stacked high with boxes as a team of volunteers worked to provide gas masks for the whole of South Warwickshire. To relieve the monotony, the local electrical suppliers, Messrs Hanson, provided a radio.

The world crisis was affecting the Shakespeare industry. The number of visitors to the Birthplace was down by 11,000. The destruction of so many nations by Axis aggression presented the Birthday Celebrations Committee with several dilemmas. The Austrian flag had been withdrawn following the Anschluss with Germany in the previous year and the Ethiopian flag disappeared after that nation's conquest by Italy. With war seemingly inevitable, it was decided to retain the flags of Albania (another of Mussolini's conquests) and Czechoslovakia. The resolution of the Civil War in Spain ensured that the Duke of Alba, the accredited representative of the new regime, presented the committee with a new flag, but the thorny question of which nations to invite to the Birthday Luncheon was partially resolved when only the Ambassador for Peru accepted the invitation to appear.

By May, 500 beds had been provided at the Stratford Hospital, of which 400 were intended for war casualties. It was announced that huts, each taking 150 beds, would be erected in the grounds. An emergency rations store was established at the GWR goods yard.

In June, conscription was inaugurated locally, when 127 men in the 20–21 age group were ordered to report at the Birmingham Road Employment Exchange to register for military training. Three days later, the nintey recruits of the newly-formed Territorial Company drilled for the first time on the quadrangle at the Grammar School.

War

In 1914, life had gone on as normal while the world slid almost absent-mindedly into disaster. By August, 1939, the question was not one of 'If?' but 'When?' By the last week of the month, as the Polish crisis moved inevitably forward, the prospect of war had become the sole topic of conversation. Yet morale was high. When the theatre orchestra struck up the national

anthem before the performance of *Much Ado about Nothing*, on 31 August, the audience rose as one to sing it with great fervour.

The telephone services at the General Hospital were staffed twenty-four hours a day after 23 August. The ARP control centre was to be permanently manned for the next five years. The air-raid shelters in Arden Street were completed in reinforced concrete, and other trenches were being dug in various parts of the town. In the sand-pits on the Banbury Road, the Corporation workmen, assisted by a squad of King Edward's School boys and other volunteers, were filling sandbags to place around public buildings. The perennial problem of hoarding arose again with heavy purchases of food, especially sugar and tinned goods.

On 31 August, Miss Haydon, the matron of the nursing home in Rother Street, received an order to turn it into a home for expectant mothers who were to be evacuated from Birmingham next day. With members of her staff, she immediately got busy. Arrangements were made to transfer existing patients to establishments in Birmingham and Walsall. No one appears to have commented on the fact that these were precisely the areas from which the evacuees would arrive. A voluntary worker agreed to convey the children.

Within half an hour of the receipt of the order, men were working on gas and electricity supplies. The hard work of setting up beds and removing furniture and lumber was undertaken by a squad of policemen. Activity was also frenetic at the Public Assistance Institution (the workhouse), where the number of hospital beds was increased from 187 to 300.

The next day, all railway excursions from Stratford were cancelled because 750 evacuee children were expected to arrive from the poorest areas of Birmingham, accompanied by their teachers. In the event, only 420 turned up. Many 'Brummies' had clearly adopted a 'wait and see' policy in relation to the war.

The mayoress, Mrs F. N. Waldron, greeted the evacuee children at the station. Many of them chatted happily with her, their faces wreathed in smiles, but some of the smaller ones looked bewildered and a few sobbed bitterly and were comforted by elder sisters and friends. Toddlers struggled under the weight of suitcases, haversacks, innumerable paper bags and most prominent of all, gas masks. Some of the suitcases were as big as the children themselves and it seemed highly improbable that they would reach their destinations.

The Catholic children were escorted to St Gregory's School in Henley Street and the rest to the Alcester Road School. At the schools, each child was given rations for two days, which included sweetened and unsweetened condensed milk and tins of corned beef. They were then distributed to families that had offered them board. This represented something of a culture clash. Some of the children had never slept in beds before, and quite a few had never eaten a boiled egg and did not know how to tackle one. It was even reported that some youngsters had to learn the nature of stinging nettles from personal experience.

Next day, 600 expectant mothers and their children were due to arrive, but only 90 women and 100 children turned up and were sent in the first instance to three maternity homes that were still being prepared. For one woman her arrival was just in time. Stratford's first evacuee baby, a boy, was born that night at the newly-converted maternity home in Rother Street. The conditions were somewhat makeshift. The conversion work wasn't completed until the following Tuesday. A lady doctor was appointed to take charge of the maternity cases and she was soon engaged on her ante-natal work with the hall and gardens full of expectant mothers.

On 1 September, the day that Germany invaded Poland, reservists were called up. The young brewer, Dennis Flower, was drafted into the Royal Corps of Signals. At the annual meeting of the governors of the theatre, he had succeeded his father, who had died earlier that year, as a member of the Executive Council.

The 114 members of the local territorials were called up as a company. They were enhanced by an intake of six officers from other units to give a nucleus of administration. While the changed nature of war meant that there was not the same drive for volunteers as in 1914, many were forthcoming. Age was not a barrier to those with specialist skills. Lt-Col. J. M. Crawford of Shottery Road had retired from the Royal Army Medical Corps. Now he volunteered to rejoin the service and was seconded to the Merchant Marine.

Despite the comparative lack of need for mass manpower, something of the hysteria of the First World War persisted. When somebody asked Ted Eborall, the landlord of the Garrick, why he wasn't in the Army like everybody else, he joined up, despite really being too old for automatic service.

As war approached, people clustered around their radios to listen to every news bulletin. Rumours were circulating that, once it broke out, Parliament would be evacuated from London and convene in the Conference Hall. The rumours were exacerbated when a large number of extra phone lines were installed at the theatre. The validity of the rumour appeared to be confirmed when the Government requisitioned most of the town's hotel and boarding house accommodation in an apparent prelude to a departmental evacuation. The only hotels to remain as a public facilities were the Swan's Nest and the William and Mary in Old Town.

In the event, most of the hotels were taken over by the services. The Falcon and the Shakespeare provided accommodation for the RAF's no. 9 Initial Training Wing, and the Boat Club was sequestrated as a recreation facility. A hostel was opened on the Clopton Road for the 'Land Girls' of the WLA. The Canadian Salvation Army established itself at the Alveston Manor to run a forces club. During the course of the war, 20,700 Canadian servicemen and women would stay there.

On 3 September, Britain and France declared war on Germany. The 1939 festival still had two weeks to run, but all theatres and cinemas were ordered to close immediately. The cinema reopened within a fortnight and was packed out every evening. The closure cost the Theatre £4,500 in lost revenue, partly because the governors honourably decided to pay the actors their wages in spite of their not being able to perform.

The initial stages of the war were not proving particularly hazardous for the heroes of 'Waldron's Warriers', who had been mobilised on 1 September. Each day they would march through the town to have lunch at the Old Red Lion. On their route, marches somebody would be sent on ahead to a pub to order fifty pints of beer, which would be lined up on the counter on their arrival.

The town council's first act of war was to appoint a food control committee. Of its fifteen members, five represented retail traders and ten consumers, but only two were women. The borough treasures like the Gainsborough portraits of Shakespeare and Garrick, the maces and the charter, were removed from the Town Hall and deposited at the Flower residence at Ilmington Manor.

Shortly before 8 o'clock on Wednesday, 6 September, the air-raid sirens sounded in earnest for the first time. The reaction disappointed those responsible for the painstaking ARP exercises. These had taken place at night. No one appears to have prepared the populace for the more likely event of a daytime raid. The reaction was extremely casual. Many Stratfordians simply went outside and looked up into the air to ascertain what was going on. Even before the 'All Clear' had sounded, many people were going about their business as usual. A better example was set at N. C. Joseph's, where the alarm came between two shifts. Nevertheless, the entire workforce was accommodated in the nearby air-raid shelters. The situation was not helped by the fact that the sirens were not heard in many areas of the town, although, strangely, they were heard as far away as Wilmcote.

Even the progress of the war excited little interest. After the momentous events of early September, when people had crowded around their wireless sets to listen to the latest bulletins, most people had returned as nearly as possible to normal living. An estimated 700 Stratfordians were serving in the forces, of which at least thirty were in the Royal Navy. Their progress did not arouse the interest in the *Herald* that it had in the previous war, although censorship would have something to do with that. Nor did events closer to home arouse much interest. Late in 1939, a significant event in the history of Stratford's educational system passed almost unnoticed. The new secondary school up the Alcester Road opened with segregated girls' and boys' divisions.

The lighting regulations were another cause for concern. Many people simply ignored them. On 6 September, officers visited the most obvious offenders and warned that proceedings would be taken against them if they persisted. The Chief Constable said that such people could be aiding enemy aircraft and endangering their lives and those of many others. Examples were made *pour encourager les autres*. Miss Hilda Copsey, the manageress of a shop in Henley Street, was fined 5s for failing to screen lights at the premises on an October evening.

Yet in this period of 'phoney war', there were simply no enemy aircraft about so it was difficult to take the regulations seriously – a point of view shared by many of the evacuee women who could not bear the loneliness of life 'in the country' and returned home.

In fact, the regulations were a greater danger to life and limb than the Luftwaffe. Many of the mishaps were caused by the blackouts. On 7 October, a motorcyclist was killed when he collided with a stationary van on the Banbury Road. The Coroner was in little doubt that the accident had been caused by the reduced lighting.

On the evening of 25 October, an RAF officer's car broke down outside the Red Lion at Bridgefoot. James Moore, a night watchman at the nearby telephone exchange, was passing by on his way to work and helped to give him a push. A passing car hit him from behind and he was pinned between the two vehicles, later dying in hospital.

The idyll of 'D' Company ceased some three weeks into the war. The 7th Battalion, with its companies from Stratford, Warwick, Leamington and Coventry, was sent to Swindon for its main training. The Battalion eventually embarked for France on 16 January.

During 1939, twenty-eight people were prosecuted for drunkenness, a big increase on previous years. The mayor suggested that, since only eight of them were Stratfordians, it seemed to indicate that the evacuees were responsible for the rise. In fact, most of those remaining were women and children, and only six of the drunks were women. A more likely

cause was the men in uniform who were crowding the streets. Col. N. C. Joseph, home for weekend leave from his unit in the North of England, was disturbed by the numbers aimlessly wandering about or hanging around on street corners.

The reality of war hit home a little more on 15 September, the date on which it was announced that petrol rationing would be introduced. Long lines of cars besieged garages, eager to fill up. For some reason the rationing was postponed for a week when the queues duly reappeared.

On 6 October, a weekly dance-entertainment club opened in the Conference Hall. It was intended, in the words of the mayor, Cllr T. N. Waldron, 'to banish those black-out blues'. Beatrice Morgan, a self-confessed 'naughty girl', was a regular attendee with her friend. 'It cost a shilling to go in … My mother and Dorothy's mother let us go if each of us went to each other's homes in turn to stay the night because we had to go home together – at least they thought we went home together!'

Three days later, the theatre reopened with Ian Hay's comedy *Little Ladyship*. Circumstances were somewhat different from just five weeks before. No member of the audience was admitted without a gas mask, which had to be kept on the lap throughout the performance. If an air raid warning was given, the theatre manager would inform the audience immediately. 'In this event, keep calm', they were instructed, with admirable sangfroid. 'The show will go on.' Somewhat surprisingly, the authorities considered that the audience would be safer in the theatre than in the street. If anyone wished to leave, they were ordered to do so quietly.

Despite the appearance of Phyllis Neilson-Terry, an old Stratford favourite, in *The Corn is Green*, the short season of touring plays was not a success. Much of the theatre's support came from outside Stratford, and petrol rationing restricted access. On 3 November, it was announced that the theatre was closing again. Under such circumstances, the decision by the theatre governors to stage a festival in 1940 was particularly courageous.

The Mop occurred as usual on 12 October, but it was a shadow of its former self, taking place on the Bridgefoot car park. There were no roasts. The fair had to close at dusk and 'all instruments capable of making a noise' were banned. The fact was that, with the petrol restrictions, the call-up of many of their men and the commandeering of many of their vehicles for the war effort, the showmen were hard pushed to put on any kind of fair.

In 1941, the authorities conceded that the Mop could keep going till 10.30 p.m. in the large cattle shed, but the lack of manpower ensured that this was the last one until the end of the war. In order to maintain continuity and not lose their historic rights, the showmen ensured that, on each 12 October, a solitary roundabout would appear. On 20 October, the order came through to suspend local government elections, so Stratford was to be stuck with its council 'for the duration'.

The New Year brought news of the death, on the last day of 1939, of Stratford's freeman, Sir Frank Benson, at the age of eighty. At a memorial service in Holy Trinity, Randle Ayrton quoted the toast at the annual Bensonian dinner: 'To the health of those that are present and to the memory of those that are away.' It was hoped that Benson's ashes might be scattered in Stratford, but Constance, perhaps mindful of his treatment in 1919, decreed it should be over his beloved Sussex Downs.

The town council appointed a committee to consider a public memorial to Stratford's favourite son, but despite the enthusiasm of its members it was clearly not the hour for it. F.

R. B. was finally commemorated in Stratford on Shakespeare's Birthday in 1950, when the last of the memorial windows was unveiled to him by the Old Bensonians, Dorothy Green and Baliol Holloway.

The rigid censorship even extended to the weather. It was forbidden to publish any account of it until two weeks had passed, presumably to prevent the Luftwaffe gaining knowledge of flying conditions. Doubtless they had other sources of information of the British climate than the *Stratford-upon-Avon Herald*. German airmen must have been aware that mid-January brought the coldest weather for nearly half a century, with skaters enjoying themselves on the frozen Avon.

The theatre reopened on 22 February, when the legendary Irish tenor, Count John McCormick, came out of retirement to give a recital 'to help the common cause of freedom'. His accompanist was Gerald Moore. Soon after, the 1940 Festival Company went into rehearsal in London. The Old Bensonian favourite, Baliol Holloway, was to play Shylock.

The festival opened on the Birthday with *Measure for Measure*. There were no flags or representatives of the nations and no official luncheon. A much shorter procession than usual wound its way to the church with its floral tributes.

The government was bringing in limited conscription, calling up some young men and requiring others to register. This time, the tribunal for those seeking deferment was based in Birmingham. It was almost inevitable that a member of the Bullard family would be summoned. Henry 'Bob' Bullard, of 7 Henley Street, arrived at the court on 24 April. He was the son of the man who had defied the Boer War rioters and refused conscription in the Great War. Although the moral integrity of the family is admirable, the Bullards were certainly imbued with a strong measure of contrariness. It had been suggested to the father that he declare himself a Quaker to escape the rigours of the First World War tribunals. This he had refused to do, but he became a Quaker when the war was over. Bob Bullard had registered as a conscientious objector earlier in the year, but had not revealed that he was a Quaker, which would have given him automatic exemption. 'I am not prepared to answer', he replied when he was asked what he did for a living. 'My conscience has no connection with my occupation.' The tribunal only wanted to know this so that it could find an alternative to military service.

The Tribunal showed a greater breadth of sympathy than its predecessor of 1916. Judge Longton said they were satisfied that Bullard had a conscientious objection. He would therefore be given two months to find work of national importance. That his objection extended to doing anything towards the war effort was overlooked. Inevitably he was summoned again. On 24 July, the tribunal ordered him to be removed from the register of conscientious objectors and placed on the one of men called up for non-combatant duties. On 23 November, he failed to answer a summons to attend a medical examination. He failed to appear and was fined £5 or twenty-one days in prison. He failed to pay and was sent to Hm Prison, Winson Green prison on 12 February.

As in the First World War, women took over the work of men who were called up. At the Cannery, most of the work was done by girls with no previous experience of factory work. During the course of the war they dispatched 40 million cans of fruit, vegetables, soups and jams to the forces, and through the Red Cross, to British POWs. Drawing on the vast supply of displaced people, each summer the cannery organised camps to pick and prepare fruit.

At the town's two railway stations, there were women in the offices, women porters and even women in the loco maintenance sheds. Several of the drivers and garage hands at Stratford Blue Motors were called up on the outbreak of war. In July 1940, the company appointed its first bus conductress, Mrs Malpass of Bordon Place, who was still zipping up and down the gangways at the end of the war.

Dunkirk

The war turned serious in June 1940 with the German blitzkrieg in France, which resulted in the epic evacuation of the British Army. In its wake, rumour abounded. The more exotic a rumour was, the more likely it was to be believed. The rigid censorship, with its denial of basic information to the public, must have contributed to this.

A letter to the *Herald*, signed 'A GUNNER', said that, on two days running in the previous week, his family had heard conflicting rumours of his whereabouts and existence. In the course of the war, he had not yet been out of England, or even seen an enemy plane, but that had not prevented people from reporting to his mother that he had been wounded. 'In these times it is a pity that the gossips cannot find a better outlet for their energies. Those left at home by men and women in the forces have sufficient worry and anxiety without these disciples of Lord Haw Haw adding to their cares.' The latter reference was to a rumour that the Nazi broadcaster had threatened that Clopton Bridge would be blown up.

The most extravagant gossip concerned the fifth columnist scare. After Dunkirk, the authorities rounded up suspected collaborators and Nazi sympathisers. The *Herald* professed itself astonished at the number of fifth-columnists 'popular imagination' had arrested in the district who included retired police officers, business men and even housewives. The fact that the subjects of the gossip continued to appear in public did not deter 'the chatterbugs from finding new victims to take the place of those whose incarceration has been visibly disproved'.

The addition of Italy to Britain's list of enemies meant that anyone with a swarthy complexion was liable to be labelled Italian. The mayor made an appeal to people not to repeat rumours or distort facts. He had good cause for concern. At the next meeting of the town council, he rose to refute a 'ridiculous and malicious' rumour that he was a German! 'I cannot speak German. Neither have I any friends in Germany.' Councillors would best serve the town by reporting anyone they heard repeating this lie, but the *Herald* considered that the mayor had brought the rumours on himself by his close-cropped haircut. 'Long before the war… visitors to the town have in all innocence jumped to the wrong conclusion through precisely this reason.' Such rumours were fuelled by the fact that a number of those posted-missing were turning up as POWs. One such was Dennis Flower. On 13 August, his mother heard the good news that he was a German prisoner from the Red Cross in Geneva. That night she received a telegram from a Swiss friend. 'Dennis prisoner: safe: sends love: letter follows.'

Following the collapse of France, the Government decided to move people from the south and east coasts. People were simply given train tickets and billeting certificates for towns where they claimed to have friends or relations. Many came to Stratford and begged

Mr J. H. Davies, the Billeting Officer to find them accommodation. There was a fair amount available because many of the evacuees from Birmingham had returned home during the Phoney War.

When the kindly Mr Davies interviewed an evacuee, he would try to visualise the homes they had left and tried to find them a billet that would suit them, although he confessed that he sometimes made mistakes.

The fear of imminent invasion was real. As a result of a clarion call broadcast by Anthony Eden, now the Secretary for War, on 14 May, the Local Defence Volunteers (LDV) was formed. Its nickname of the 'Look, Duck and Vanish' was short-lived. The body was renamed the Home Guard by Winston Churchill, and the local volunteers became 'C' Company of the 4th Battalion Royal Warwickshire Regiment. There was a rush to join what the Herald encouragingly described as 'a suicide squad … ready to fight in the fields and in the streets with whatever weapons came to hand'. In all, 2,000 men volunteered, of whom 1,800 were accepted. The later epithet 'Dad's Army' was not inappropriate. Charles Taylor from Tiddington, who had just turned eighteen, was atypical. Many volunteers were veterans of the Great War, including Edgar Cranmer, who joined at the inception at the age of forty-eight. An even more remarkable recruit was seventy-one-year-old William Bawcutt of 3 Evenlode Close, who had seen service in the Matabele Campaign and the Boer War.

'C' Company had its headquarters in the police station. Its initial armament to combat a panzer invasion was 20 rifles and 270 rounds of ammunition. Later, the volunteers acquired a naval gun. It was mounted on a makeshift carriage and fired six-inch armour-piercing shells.

Once again, the church bells were silenced, but this time it was because their ringing would announce the arrival of the Germans. A brief exception occurred when one bell was tolled three times during the induction of the new vicar, Canon Noël Prentice.

. Obstructions were placed in any field that was deemed a likely landing spot for an ambitious Luftwaffe pilot. The Grammar School playing fields positively bristled with them, while suitable steps were taken by the town council to render the recreation ground unattractive to any airman seeking a clandestine landing ground.

The scare led to the removal of road signs and other indicators of whereabouts. This caused more inconvenience to the native population than any assistance it could have rendered to invading paratroopers. Nor was the job done with any great logic or efficiency. The word 'Alveston' was removed from the sign at the Alveston Manor Estate, but retained on the one for the Alveston Manor Hotel. The proprietors of the Bridgetown filling station had to remove the offending name that was retained on the Bridgetown Stores over the road.

The 'fifth-column' scare led to the establishment of road blocks at strategic locations like Clopton Bridge, the gasworks and the pumping stations. At the Evesham Road level crossing, armed with just one bayonet between them, the volunteers stopped everybody and asked for their identity cards. When one driver tried to dodge up Shottery Road, Pte "Doc" Phipps stuck the bayonet into his wheel and out got a tall Italian who explained that he was in the band at the theatre. As he knew they were looking for fifth columnists, he didn't fancy his chances of escaping arrest as a categorisable 'enemy alien'.

Another duty of 'C' Company was guarding of the German officers' POW camp that had been established on the racecourse. In the early days the inmates were mainly captured

U-boat crews who invested a lot of energy on escape attempts. Later, it mainly housed Italians who had been captured in the desert.

The biggest scare came when the news came that the Germans had made an airborne landing on the airfield at Snitterfield. There was no panic. Three platoons moved off within twenty-five minutes of the first alert. Calm prevailed up to the very moment when the Home Guard was preparing to attack the airfield. The alarm turned out to be a 'try-out' to test their efficiency and response capacity.

In the aftermath of Dunkirk, Stratford became the centre of a makeshift 'International Brigade' of the remnants of armies that had escaped from Hitler – Czechs and Poles and Free French.

Aerodromes for the defence of the great industrial centres were being constructed at a frenetic pace in a ring around the town – at Long Marston, Wellesbourne, Snitterfield and Atherstone. To do the work, the contractors brought labourers from Ireland. In the evenings they came into Stratford to spend their money. With all the allied soldiers doing the same thing, the place acquired the atmosphere of a frontier town.

Pots and Pans

With the fall of France, the Axis powers controlled nearly half the world's supply of bauxite, the raw material from which aluminium is made. Members of the public were asked to hand in all aluminium artefacts, so that they could be transformed into aeroplanes to beat Hitler. In Stratford, the collection was undertaken by the Women's Voluntary Service. In the first twenty-four hours, thousands of articles were received at their HQ in Henley Street. Volunteers were busy packing them into sacks and boxes, ready for transport to the factories.

The collection included pots and pans, coffee pots and percolators, egg poachers, hot-water bottles, jugs, a vacuum cleaner, eggcups, teapots, electric torches, frying pans, colanders, shoetrees, thermos flasks, moulds, knitting needles and a clock. A piece from the first Zeppelin to be shot down over England arrived. The owner had decided that this was no time for souvenirs.

Even children played their part with exemplary personal sacrifice, handing in dolls' tea sets made of aluminium, although how many of these it would take to build one Spitfire was not revealed. Not everyone maintained his resolve. One small boy brought in his treasured mug, but, at the moment of handover, he burst into tears and took it away again.

Whatever ironwork that had not been requisitioned in the Great War was now seconded. Surprisingly, there were still as many as 1,400 sets of railings that could be earmarked for appropriation. The selection was arbitrary. The only grounds for appeal were on artistic or historic interest. Even this was not a guaranteed defence. There were complaints when the Georgian railings, complete with their lamp brackets, at 7 and 8 Rother Street, were whisked off.

The truth of Churchill's prediction in his famous broadcast 'The Battle of France is over: the Battle of Britain is about to begin' was soon realised, as German air raids intensified across the Midlands. People learned to distinguish between the sound of RAF planes and the higher pitched noise of German ones. As anxiety increased, fines for infringing the blackout regulations were increased to 10s.

Sightings were frequent. Emma Hewins, the caretaker's wife at the Church of England

School, was out feeding her chickens while the children were playing in the next-door playground when a German plane flew over. 'I never seen a sight like it! 'E waved! To the kiddies – and me! The cheeky devil! The cheeky bugger! 'E 'ad the nerve to wave!' 'But she was laughing as she remembered it', her daughter recalled.

The bombing of London in August brought many more people to Stratford. As the indiscriminate bombing of British cities increased, evacuees arrived in numbers beyond the town's capacity to absorb. The situation was exacerbated by the large amount of accommodation still being held by the Government. An appeal for the rooms to be released was rejected. In October, the first stages of the plans to evacuate the Civil Service were put in hand when it was decided to transfer the Treasury Office to the Welcombe Hotel.

The Blitz

On 14 November, a night of brilliant moonlight, came the devastating German raid that destroyed much of Coventry. The flames of the burning city could be seen from Stratford. At eight o'clock that evening, the local fire brigade was sent over to help, but when they got there, the bombing had burst many of the hydrants and there was no water.

The Stratford Auxiliary Fire Brigade went off to Coventry to do its bit, but since it still only possessed axes and tin hats, it concentrated on evacuating people and rescuing others from the rubble. An agonising moment came when its main means of transport, 'the Flying Bedstead', was lost to enemy action. Fortunately no one was near it at the time. Other volunteers went to Coventry on special trains, to pick up wounded and traumatised people and bring them back to Stratford Hospital.

None of the volunteers was hurt in the hazardous operation, but in the words of Beatrice Morgan, whose husband was an auxiliary firemen, they were as 'black as coal, as if they had been dumped in the river and put up a chimney. Almost speechless, they were. They came home and couldn't speak.' Two of the men suffered breakdowns from what they had gone through that night.

The bombing of Coventry was a traumatic experience for Stratford people and not just because of their geographic proximity. Many people had relations who had gone to the city to work. A trickle of refugees from the bombing began to arrive at Stratford, although the numbers were not as great as expected. Some had been sent out of the way of the relief work, some had hitched a lift over; some had come by bus, train or car. Most of them had tried to get digs and had gone to the police for help.

The ladies of the British Legion, and the local relieving officer, borrowed palliasses and blankets, prepared tea and sandwiches and stoked the fires at a temporary hostel that had been established at the Grammar School. A mother and father and their eleven children were given a dormitory to themselves. One young lad was so exhausted that he went to sleep standing up and soon fell over, but he was quickly rolled up in a blanket near the fire. A honeymoon couple had to share a room with several others, but they were discreetly placed in a corner. A soldier who had been immobilising time bombs sat near the radiator. He was taking his family, who had been made homeless by the bombing, to stay with relations. Two

tiny tots who had been dubbed 'the babes in the wood' were sleeping in an improvised cot in an upturned table.

Three of the helpers sat up all night in case they were needed. Morning brought a light breakfast, the filling of babies' bottles – and departure. Some wanted to pay for their primitive accommodation. A Scotsman who had slept on the floor positively insisted on contributing to the funds. In the cold light of day, many who had fled their homes now resolved to return. 'Please can you tell me when there's a bus back to Coventry?' was a common question.

The billeting officer fixed up those who were genuinely homeless. The family with eleven children proved something of a conundrum and were shared out between six different houses. Eventually a cottage was found for them in Wellesbourne.

As a result of the influx, the basis for deciding the number of people a house should accommodate was changed from one person per room, to three per two rooms, with children under ten counting as half a person. In early December, Mr Davies, the billeting officer, estimated that there were around 4,000 evacuees in Stratford, of whom some 500 were official. In addition there were 103 unaccompanied children, who included 54 deaf and dumb children who had been billeted in the Youth Hostel at Shottery. 'We have been able to carry on without using compulsory powers', announced the amiable Mr Davies with justifiable pride.

The maternity home on Rother Street continued to receive pregnant ladies from the blitzed cities. Sixteen-year-old Susan Buggins was moved by their desperation. 'Poor haggard ladies came from Coventry, Birmingham, London, Liverpool – anywhere else that was bombed, and they came there for a four week's rest to have their babies, and, oh, dear, the poor things. Their faces were so drawn with pregnancy and fear and lack of food and comfort.'

Stratford's firemen were stretched to the limit during the Blitz, going into action as far afield as Coventry, Birmingham, Swansea, Cardiff, Bristol, Avonmouth, Bath, Exeter, Nuneaton and London. In addition, they were called out to around 100 plane crashes, saving several lives.

The town's greatest moment of airborne danger came on the morning of 13 September 1941 when a plane of the Fleet Air Arm flew low over the town. Its course was followed by hundreds of people. Leading Aircraftsman Sidney Hines was walking down Grove Road and watched its progress. 'It made a number of steep bank turns and side slips, losing quite a bit of height in this way. The pilot came down rather low in one of these banks and the plane seemed to straighten out, lift a little and then crashed.' It hit the air-raid shelter on the road island at Evesham Place. Fortunately it was unoccupied since it was only just after 10 a.m. The plane burst into flames and clouds of black smoke rolled over the town. Sidney Hines ran to the spot but was driven back by the fierce heat. The two-man crew, both aged twenty, were killed on impact.

Despite the destruction wrought on the neighbouring industrial centres, Stratford remained relatively unscathed by the bombing. The alert sounded ninety-seven times and a total of nine high explosive devices, an oil bomb and some 100 incendiaries fell on the town, all on the outlying areas as German bombers ditched their cargoes rather than face the flak over Birmingham and Coventry. Apart from broken windows and tiles, no damage was done by this mini-Blitz, but it had its farcical moments. When bombs fell in the area of the Maidenhead Road, a warden found freshly-turned earth and diagnosed an unexploded bomb. The occupants of nearby houses were evacuated and the area roped off. At dawn, the

owner returned from a night in an air-raid shelter. 'Unexploded bomb, my foot!' he exclaimed. 'That's where I dug up an apple tree yesterday.'

The Wheels of Industry

On 14 July 1940 at 1.40 p.m., a German reconnaissance plane took photographs of Stratford from a great height. When these were examined by military intelligence, everything that appeared to be a military objective was marked and numbered. The Clopton tramway and railway bridges across the Avon were marked as potential targets, as was the gasworks. A section of the railway was shown as a marshalling yard and a building on the Banbury Road was described as a food depot. Most disturbingly, the Alcester Road School was reckoned to be a military camp and barracks.

The photograph did not give the full picture. Had the *Abwehr* possessed more knowledge of what went on, it might have taken Stratford more seriously. Even before the war, the town had become a light engineering centre of some significance, supplying nearby industrial centres like Birmingham and Coventry. These workshops were rapidly put onto war work and, in many cases, what they doing was so vital to the war effort that had the Germans known about it, they would certainly have attempted to drop a few well-placed bombs on the town.

In the well-equipped workshops of Wright Engineering in Mulberry Street, delicate work proceeded for the Ministry of Aircraft Production. Round the corner in Arden Street, Messrs Balls Brothers (Engineers) Ltd were making fabric for barrage balloons and parachutes. In peacetime, the foundry at the Royal Label Factory in College Lane produced road signs for the world. Now it was turned to the production of sand castings for the Admiralty, the Ministry of Aircraft Production and the Ministry of Supply. During the course of the war, no less than 19 million holes were drilled at the foundry. No discrepancy in the stated quantities of weekly dispatches was ever reported by the recipients.

The Aluminium Service Co. in Windsor Street was producing die castings for use in aircraft carburettors, tank parts and gear-box castings. Messrs Howard Clayton-Wright of Tiddington Road was awarded defence contracts of considerable magnitude and secrecy during the course of the war. Products were sent as far afield as Russia and Burma.

Another Stratford company vital to the war effort was Messrs T. N. Waldron Ltd of Great William Street, whose owner was mayor at the outbreak of the war. The firm did work for the Admiralty of such importance and secrecy, that its nature could not even be revealed at the end of the war.

The works staff of the Wildmoor Engineering Co. of Guild Street included a 'bright and breezy lad' of seventy-one, who assisted in the assembly of 635 new throttle parts for four-engined bombers. Ingram's Garage on the Birmingham Road was no less active, manufacturing over a million Sten gun parts.

The German Blitz on manufacturing industry had been anticipated. In June 1940, the Coventry Repetition Co., which specialised in the mass production of chains, was relocated behind Guyver's Garage in Rother Street. Skilled operatives were moved to Stratford to train eighty-five unskilled workers that were required to maintain production schedules.

Mr R. Rotherham, the manager, reckoned that most of the trainees proved more than equal to the job, considering that women proved to be just as good as men in many aspects of the work.

Following the Blitz on Coventry, Messrs Alvis Ltd, the noted motor manufacturers, dispersed the section of its aircraft division that repaired the power plants on Miles Master trainers to Bird's Garage on the Birmingham Road. Later, the engines of large numbers of Wellington and Lancaster bombers were repaired there. The Hippodrome in Wood Street was taken over for storage. As demand became greater, the ministry approved extensions to the floor space in the factory to six times its original size. The building was equipped with a canteen and a sports and social club. The bulk of the 200-strong labour force, which included seventy women, was made up of Stratfordians, who were trained by Alvis's highly skilled operatives.

Another Coventry firm, Messrs John Harris Ltd, took over the Warwickshire County Garage on Waterside, which was used for screwing ground-thread taps for aeroplanes and naval craft. To keep the machinery fully occupied, the staff worked double shifts and at the peak of production were turning out 17,000 taps per week.

The machine-tool company, Messrs R. O. Gray, moved its combination lathes and heavy milling machines from North-West London to part of the old cattle market site at Bridge Foot. The move was undertaken with astonishing swiftness and Mr Gray expressed his gratitude to the town council for its cooperation. At the new plant, propeller hubs were manufactured for Spitfire and Hurricane fighters and engine and gearbox parts for tank engines were produced.

Disaster and Triumph

Japan's entry into the war in December 1941 was heralded by the sinking of the battleships *Prince of Wales* and *Repulse* off the coast of Malaya. This presaged the biggest debacle in British military history, the fall of Singapore in February 1942. A number of Stratfordians were taken prisoner. The family of Gunner Alfred Tutt of 31 Ely Street, heard that he was in Japanese hands in October 1942. For others, the anxious wait to hear the fate of their loved ones was even more prolonged. In July 1943, the vintner Chris Rookes received a postcard from his brother dated 20 June 1942, covered in Japanese markings. It bore the laconic message, 'I am quite well. Best wishes – Wilfred.' In August, the parents of Gunner John Seeney at 11 John Street also received a card which belied the deprivations he was undoubtedly suffering, but what else could he put? 'I am quite well and getting plenty of food. Hope to see you again soon.'

After this, the postcards trickled in, all with similar laconic and optimistic messages. Gunner Tutt's parents got another card in December 1943, saying that he was in good health and working for pay. Fred Scruby's card arrived at his parents' home at 9 Holtom Street early in 1944, saying that he was in a POW camp in Java and quite well. Trooper Ronald Morris, of the Royal Armoured Corps, had joined the Army before the war. He had been evacuated from Dunkirk and captured when Singapore fell. In July 1944, his mother, at 63 West Street, received a card saying that he too was well and working for pay. Only the war's end would fully reveal the cynical motives behind these cards and the desperate deprivations suffered by the prisoners of the Japanese.

On 13 November 1942, the bells of Holy Trinity sounded out in a manner reminiscent of the seventeenth century, for the victory of El Alamein, a major point in the turning of the war's

tide. In the subsequent advance, the 8th Armoured Division had overrun the supply lines of the retreating Germans. 'At the moment', wrote Corporal Aubrey Jaggard, 'I am smoking a Jerry cigarette, of which I have several boxes, having just finished a dinner of Jerry bread, coffee and jam. They have tins labelled "Marmelade", and when you open them there is a red liquid inside, which is because they use beetroot instead of oranges, I believe.' The German bread was beautifully 'done up in airtight packages, 3" thick', but it was made of rye and tasted like 'very stale Hovis'.

The Show Goes On

At the theatre, audiences increased as the summer of 1940 progressed. Although 80,000 people attended the twenty-week season, the inevitable loss of £5,500 was borne by the extensive reserves. To offset this, the company agreed to take a cut in salary for the 1941 season. No sooner had the curtain come down, than the company embarked on a tour with Entertainments National Service Association (ENSA), performing condensed versions of *Twelfth Night* and *Merry Wives*.

Another great actor appeared at the theatre in late November. Alec Guinness made his sole appearance there in *Thunder Rock* by Robert Ardley. At the close of the Friday performance, he appeared before the curtain to apologise to the audience. They had been unable to do justice to the play because of the noise from the gallery. The cup of fine acting overflowed that winter. The Old Bensonian and Oscar winner, Robert Donat, appeared in *The Devil's Disciple*, with Roger Livesey, Rosamund John and the future company director Milton Rosmer in the supporting cast.

The Birthday celebrations of 1941 followed the restricted form of the previous year, except that the mayor symbolically unfurled the Union Jack at the top of Bridge Street. That afternoon, the mayor and mayoress held a reception in the Town Hall, and the guests were addressed by Margaretta Scott, who was playing Beatrice that evening, and T. C. Kemp, the drama critic of the *Birmingham Post*.

Despite the difficulties with transport, audiences were making their way to Stratford again and the twenty-two-week festival season of 1941 was attended by 140,700 people, a huge increase on the previous year. Takings totalled £20,000 and to their great delight, the members of the company had their salaries made up.

So many talented actors were serving in the forces that casting was again a problem. The veteran Bensonian, Baliol Holloway played Henry V in 1943. 'But he doesn't look 60, you know', said the festival director, Milton Rosmer. As T. C. Kemp expressed it, 'The young actor who should have played Henry was flying, sailing or marching elsewhere on Britain's wartime business. Yet the breach was filled at Stratford.' Holloway's experience made up for his lack of youth and he created a splendid Henry.

A note of cautious optimism about the progress of the war was beginning to permeate conversation. On the Birthday in 1942, the fourteen flags of the Allied nations were unfurled in Bridge Street. It was something of a dampener that six were still occupied by the Nazis, but a source of great satisfaction was derived from the Stars and Stripes fluttering in the breeze. The pleasure was not entirely strategic. An influx of American sightseers was

anticipated – all in uniform! A hospitality committee was formed to greet them. The hope was fulfilled on 30 August when over 100 officers and men of the US Army visited the town. In November, a *Herald* reporter was amazed to see 'forty-five American Negroes' sitting on the riverbank singing *Way Down upon the Swanee River*. 'Not a sight or a sound to be forgotten.'

The Treasury Solicitor's Office was obliged to vacate the *White Swan* for the *Welcombe* because the American Red Cross was taking it over as a rehabilitation centre for wounded officers.

As the fear of invasion receded, thoughts turned to the post-war world. In February 1943, the mayor called a meeting to discuss the Beveridge Report, which was to lead to the foundation of the National Health Service.

The relaxation of the invasion scare was symbolised by the announcement in June 1943 that church bells could be rung again. Nevertheless, the Home Guard, by now an efficient fighting force, remained on full alert. Hundreds of men in Stratford were happy to spend their spare time crawling through undergrowth to surprise farmhouses where 'paratroopers' had landed, or in setting up road blocks, often to the annoyance of the populace.

Shortages

The Nazi occupation of most of Europe led to grave shortages of many commodities. Food items unknown before the war appeared. 'All sorts of funny fish were on display in Mr Kinman's shop, including whale meat and snook.' Inevitably, the shortages led to queues. This harmless activity earned the ire of the chairman of the local women's council, Mrs S. Nichols. 'During the hours spent in queues, women, many of them from blitzed areas, talked, stories go round, often exaggerated, and people imagine all sorts of things might happen.' Mrs T. N.Waldron said the queues were for such 'luxuries' as cigarettes, cakes and tomatoes. Her butcher assured her that boys queued for such items as sausages and took them back to their roads to resell them, with a mark up for their time and effort. The shopkeepers contributed to the problem by posting such notices as 'Tomatoes will be served at 3.30 this afternoon.' Miss Hastings said that one local shop had ingeniously got round this by exhibiting a notice saying that the first six people in any queue would not be served. Several ladies said that people should grow more of their own food.

A riposte came in the form of a letter to the *Herald* from Mrs Margaret Jones, an inveterate queuer, who pointed out that they had no fruit for their children and that their husbands were out from early morning till late at night. 'We have to pack lunches for them.' As for growing their own food, did the ladies of the women's council realise that many people in Stratford were evacuees and had no gardens?

In the same issue, James Barnard from Manchester, a regular festival-goer since 1921, brought forth another grievance – profiteering. His lameness meant that he had to be driven about a good deal. A local taxi-driver who he had often employed, told him that he had increased his charges threefold. 'I told him that this was extortionate and that I would stay indoors, or limp my way along rather than pay his demands. Fortunately I obtained a much fairer and better deal elsewhere...'

The longest queues were for cigarettes and tobacco, and it was anticipated that the shortage was likely to become more acute. Even when the smoker got his packet of fags, he could still be in trouble because of a shortage of matches. When a man walked into a tobacconist and asked for six boxes, the assistant gaped at him in sheer incredulity.

Even beer was in short supply. There were complaints that many publicans shut the front door and admitted their chosen regulars round the back, or that they simply served their beer until it ran out and then shut up. In 1941, Flower's introduced a rationing scheme and asked their tenants to reserve a proportion of their beer for each period of opening. Like most other employers, the brewery faced a problem of labour shortages. With so many men called up, women and older men could not always plug the skills gap. To partly solve this problem, the Brewery hired maltsters from the Guinness brewery in neutral Dublin. A large caravan was equipped with bunks for their accommodation and parked in Justin's Avenue. The Irishmen proved good workers and kept the vital supplies flowing.

The problem was not just lack of raw materials or the shortage of labour. With beer, as with everything else, priority was given to the war effort. By the end of the war, Flower's Brewery was supplying more than 150 British and American service camps and depots, 40 aerodromes, 50 canteens at munitions factories, 20 Home Guard and National Fire Service canteens, as well as Government construction camps and searchlight and anti-aircraft stations. During the last two years of the war, regular supplies of malt were dispatched to the Middle East for brewing purposes and monthly rations of bottled beer were sent off to the fighting forces on many battlefronts. It was small wonder that ale was in short supply in the pubs.

The boys of King Edward's School also had their problems. It was impossible to obtain rugby boots or shirts in the school colours. An appeal went out to old boys in October 1941 to look in their bottom draws and send whatever they found to the school.

Inevitably there was a thriving black market. In its very nature this was undercover, surreptitious and little spoken-of. The *Herald* did reveal, however, that much of it was supplied by gangs who stole goods in transit.

A wartime institution, a British Government restaurant, with accommodation for 130 diners, opened in the Corn Exchange on 12 November 1941. It provided a three-course meal and a cup of tea for 1s 3d, but it was no gourmet's paradise. It was only open between noon and 2 p.m. and there was no lingering over the coffee. Patrons served themselves at a cafeteria and were expected to take no longer than quarter of an hour to eat their meal and depart. Nevertheless, it sold out on the first day it opened, doing more than 500 covers. Later, it served suppers at a mere 8d.

The theme of 'Dig for Victory' was taken up in no uncertain terms. Sheep reappeared on the recreation ground and part of the rugby ground at Pearcecroft was ploughed up. The humble pet rabbit was transformed into a food item, kept by many people in cages in the back yard. A Domestic Livestock Club was formed to encourage sound rabbit and poultry breeding, and a show drew ninety entries in 1942.

No better example could be set than that of the boys of the Senior School in Alcester Road, whose playing field was converted into a market garden. Tons of fresh produce flowed from it, including a number of varieties that would then have been regarded as exotic. In 1942, the boys produced 6 cwts of beet; 1½ cwt of carrots; 1¾ cwts of parsnips; 2 cwts of turnips; 2 cwt of kohl rabi; ¾ cwt of kale; 200 head of broccoli; 1¼ cwts of purple sprouting; ½ cwt of white sprouting;

80 cabbages; 100 savoy cabbages; 3 cwt of Brussels sprouts; 200 lettuces; 1½ cwts of peas; 60 lbs of runner beans; 20 lbs of broad beans; 3 quarts of haricot beans; 200 cucumbers; 6 cwts of ripe tomatoes; 2 cwts of green tomatoes; ½ cwt of endives; 40 lbs of salsify; 2 cwts of rhubarb and over eight tons of potatoes. In addition, a dozen apple and 23 plum trees were planted.

Sometimes a returning soldier brought goodies from places where rationing was unknown. When L-Cpl C. Horace Davies came home after ten years in India in 1944, he brought supplies of tea and oranges.

The acute shortage of new vehicles meant that whatever was available was cannibalised for spare parts. At Archer's, the agricultural machinery makers on the Birmingham Road, repair work became an urgent part of the firm's activities. It was with some pride that the workers always reckoned to have the vehicles completed in time for the harvest. Prisoners of war provided a useful source of agricultural labour under terms permitted in the Geneva Convention. Mary Hewins loved to see them go by. 'Oh and they were handsome, a lot of the German prisoners, fair hair, bright cheeks, only young chaps ... They used to wave to me and all, as they went up the Alcester Road in lorries back to their camp. They waved and laughed. I think they were happy to be caught.'

Bob Bullard

With so many men in uniform, the uglier aspects of the Great War manifested themselves. A wife, her husband and a young friend walking down Wood Street were sneered at and called 'scum' for not being in the war. The boy was under age, but his three brothers and his father were in the forces. The husband had been all through the last war and was doing essential war work for eleven hours a day and getting less than £5 a week for it. All three were evacuees who had been bombed out of their homes. They had slept for three months in a shelter before coming to Stratford.

One who bore such disapprobation like a battle honour was Bob Bullard, who had no intention of 'finding work of national importance'. He regarded such a move as contributing to the war effort that he strenuously opposed. On 11 November 1941, he was again notified to report for medical examination. Again he failed to do so and was later sentenced to another nine months in prison for failing to obey the court order. On 3 November 1942, he was again summoned to undertake agricultural work. 'I do not think it ought to be necessary to tell you', he replied, 'I shall not be there on Monday.' After this the Tribunal gave up on him. Instead, he was summoned to appear before Stratford magistrates. On 16 December, he got a sympathetic hearing, although the powers of the beaks were strictly circumscribed. Local solicitor, Stanley Warden, appearing for the Ministry of Labour, said that it was an unpleasant duty to prosecute a fellow townsman. A moral debate of high quality and mutual respect followed, with Bullard rehearsing classic pacifist arguments. 'To my mind', he told the court, 'there is no difference between doing work which I am ordered to do for the more efficient prosecution of the war and going into the Army.'

When the chairman of the bench, Cllr Trevor Matthews, asked him what work he was doing, he replied that he was helping his father in the fruit and vegetable trade. 'You don't

mind helping in your father's trade, but not in anybody else's business?' Bullard replied that he was doing that before the war and because the state declared war, it did not therefore become war work.

'You see a difference', said Cllr Matthews, 'between growing veg and selling them. You are prepared to benefit by the sacrifices other people are making, but are not prepared to contribute in any way.'

'If I were prepared to help the war effort I would join up.'

'You are helping the war effort. The only way not to help the war effort is to stay in bed. Is your attitude that you are willing to work for your present firm in distributing food for the nation, but you are not willing to assist in the production of food?'

'I will admit it is a very thin point.'

'And you would rather go to prison than solve that small point? If everybody carried out your line of argument we should all be in prison.'

'There would not be a war then, would there?'

'Is there the slightest chance that you are prepared to change your present attitude?'

'I do not think so.'

'The bench wants to be helpful if it can. Instead of acting as a neutral and helping neither side you are definitely helping the enemy.'

'I do not want to help the Germans.'

'But you are taking up the labour and time of other people…'

'I am not doing it just to save my own skin…'

'No, I don't think you are.'

Cllr Matthews had probed, but not entirely demolished, Bullard's case. The court had little choice but to sentence him to a further three months in prison. When Bob was released from Stafford Gaol, he found that the majority of people in Stratford crossed the road to avoid speaking to him. A quarter of a century after the end of the war, there were still people who snubbed him.

23

'These short-sighted Men and their Kidney'

Andrew Faulds, 1957

Moral Values

The perceived decline in moral values brought about by the war was revealed at a meeting of the Diocesan Council for Moral Welfare held at the Town Hall on 18 May 1943. It was addressed by Miss Steele, an army welfare officer, who expressed great concern about the rise in marital infidelity. Many homes had been broken up. There had been a great increase in the number of children born out of wedlock and to married people who had separated from their spouses. Many of those involved were quite young and they should be regarded as casualties of the war. A major problem was that adolescent girls could dress attractively to look like older women and could be picked up by men from the military camps quite easily. They were completely irresponsible and difficult to reason with. There had been nothing in their education to enable them to handle such situations.

There had been a great increase in the incidence of venereal disease. Some people said that this was nothing to do with morals, but that it was purely a health matter. Miss Steele was in no doubt as to her own views on the issue. 'Are we going to accept that? Is it sufficient to combat venereal disease merely by use of prophylactics or to deal with the unmarried mother merely by encouraging contraceptives?'

A practical demonstration of the scale of the problem came in July 1944 when the Ministry of Health approved the adaptation of the little-used first aid post in the Poor Law Institution, into a VD clinic at a cost of £360. Although it was known that the new miracle drug of penicillin could be used in the treatment and cure of sexually transmitted diseases, its virtual non-availability meant that ineffective traditional methods were used which did little to stem the epidemic.

Two cases illustrating Miss Steele's concerns came to court soon after her talk. In November 1939, a twenty-year-old factory girl, Margarita Fisher, met Ronald Jacques, a twenty-five-year-old private in the Northumberland Fusiliers, who was stationed locally. He told her he was single and a romance developed. In February 1940, he was posted elsewhere, but they continued to correspond. In December 1940, he came in uniform to her mother's house at 4

Park Road and told her he was being discharged from the Army. He obtained work locally. On 26 September 1942, they went through a form of marriage at St James' church and lived together at her mother's house until he was arrested on a charge of desertion. There was more to follow. On 1 June 1943, in the borough police court, he pleaded guilty to bigamy. Elizabeth Jacques, his real wife, who was four years his senior, told the court that she had married him on 19 March 1932. Three months later she had given birth to a son. Her husband was only seventeen when they married, but the relationship had never been happy due to his philandering. They had lived together until September 1939, when he had joined the Army. She had last seen him when he had a three-day leave in December 1940. A month later, he was posted as a deserter and her allowance was stopped.

The prisoner asked her from the dock if she intended divorcing him, but Mr L. C. Haynes, said that had nothing to do with the case. A month later, Miss Fisher told the assize court at Warwick that she wanted to continue living with him. Passing a sentence of six months imprisonment, the commissioner, Sir Walter Monkton KC, declared that 'bigamy is prevalent and serious'.

In 1940, seventeen-year-old Edith Ingram of 9 Swincotes had started to go out with Staff Sgt Josef Schneller of the Czech Army, who was stationed locally. Before the war he had been a medical student, but now he hoped to stay on in the Army after the war. After three years courtship, the couple wanted to get married. When her parents refused their consent, Edith applied to the magistrates for permission to marry Josef. The case was heard on 15 June 1943. Edith's father told the court that he and his wife had refused consent because their daughter was too young to marry and did not know her own mind. They had nothing against Josef, but he would want to go back to his own country after the war and they would lose touch with their daughter. If the couple were prepared to wait to the New Year and were then of the same mind, he would willingly consent to the marriage.

The mayor, Cllr Roderick Baker, said that the bench could quite understand the parents' apprehension about their daughter marrying a foreigner, but this was not a matter for magistrates to consider. There was no reason why they should refuse the daughter's application and they hoped that the young couple would be happy and that the parents would forgive and forget and take them back into the home. This hope was not fulfilled immediately. Two months later, the couple were married at St James church, Alveston, but the parents do not seem to have been present.

Edith's case is interesting for a number of reasons. The magistrates clearly considered that it better for the young couple to marry rather than to cohabit, as they might well have done if permission had been refused. It is also noteworthy from Mr Ingram's evidence that, by the middle of 1943, there was a general assumption that the war would be won, rather than the previous vague hope that it might be.

The social disorientation produced by the war led people into odd situations. In January 1945, a fifteen-year-old local girl, who is kept anonymous by subsequent events, met Alexander Innes, a thirty year-old Glaswegian at a dance. He was a soldier in the Royal Engineers, stationed at Long Marston. He came from 'a good family' and had been a solicitor's clerk, a probationer constable and, until joining the forces, a commercial traveller. The couple started to go out together. She took him home to meet her parents and the family assumed that he

was single. He stayed at her house quite frequently when he had weekend leave. One night at the pictures, the girl told him she would be sixteen in the following September. He told her she looked older. That April, she told him she loved him while they were walking one evening in a meadow by the river, and they had sexual intercourse for the first time.

When Innes was demobbed in January 1946, he stayed at the girl's home for a fortnight and asked the mother if he could marry her. She told him that her daughter was too young, but spoke to the father, who would not hear of it. Perhaps in the hope that the issue would go away, they did agree to an engagement. Innes returned to Stratford at the beginning of March and the parents agreed that he could take her to Glasgow to meet his parents, but in fact they went to Aberdeen. Soon after their return, he took her away again. As they were preparing to leave she saw his Army pay book and realised that he was married with a child. Nevertheless, she went with him and the couple lived together as man and wife in Leeds. The parents heard nothing from them for some time, until they received a telegram from their daughter that read, 'Returning home this weekend. Don't worry'. When she did not appear, her two brothers went up to Glasgow to try and trace her. They made enquiries with the police, who revealed that they had detained Innes on a charge of underage sex when he made a return visit to Glasgow. In July, at Stratford magistrates' court, Innes claimed that he was unaware that the girl was underage. He was committed to the Warwick assizes. Earlier that day, the girl, who was now sixteen, had appeared before the juvenile court as being in need of care and protection. A supervision order was made for a year. It was the first time the parents had seen her since March.

At the assizes in November 1946, Innes' council told the court that this was one of those cases that arose from 'war conditions'. There was no doubt that they would marry if it were possible. This did not prevent his client from being sentenced to eight months' imprisonment. Mr Justice Singleton said he thought it would be a good thing if the accused kept away from the girl for some time.

'Salute the Italian Airman Week'

The surrender of Italy in 1943, and her transition from enemy to ally, posed a dilemma. What should happen to the thousands of prisoners that had been taken? The solurion was that they be redefined as 'co-operators' with considerable freedom. Richard Reid of Beechwood House on the Alcester Road was not happy with this. Whenever he walked through Stratford he saw 'our gallant soldiers' who had been wounded while fighting 'to rid the world of Hitler and his Nazi thugs, and make it a world fit for all to live in'. 'They try to enjoy themselves on 10/- a week, and I'm sure they would (as the English Tommy puts up with lots of things) if they did not see, breathing the Stratford air, those Italians who were killing and wounding their fellow troops only a few months ago.'

The Italians were allowed to do almost anything they pleased. They could go to the pictures and the theatre and go boating. Bombed-out Londoners were given second place when it came to housing and they had special coaches reserved for them on some trains. Worst of all, he saw 'English girls fraternising with these sleek-haired Romeos'. 'Any day now I expect

a "Salute the Italian Airman Week" in aid of those gallant airmen who sent a special request to Hitler asking him to permit them to take part in the bombing of London. The sooner a few divisions of these co-operators are sent to fight against the ideals they not so loyally tried to defend, the happier the English people will be.'

The Picture House was crowded with Italians. There would be hundreds of them in the queue, which snaked all the way down Greenhill Street, past the Green Dragon and into Arden Street. Most of them didn't possess sufficient English to follow the films, but they went anyway. German POWs remained in custody, but those deemed 'anti-Nazi' – sixty in all – were housed separately at Ettington Park.

Second Front

Recognition of the major contribution being made by the Russians towards the defeat of Hitler came in November 1944 when the employees of Messrs N. C. Joseph raised £150, which was matched by the directors, to endow two beds in the hospital at Stalingrad. A Stratford branch of the Communist Party made its sole appearance in the local press on 17 September 1943 when the *Herald* reported that it had passed an inevitable resolution calling for a second front against the Germans.

After D-Day, the fear of air raids on the Midlands was all but over, and a 'dim out' of lights was introduced in place of the 'black-out'. On 15 November, the Civil Defence Control Centre was stood down from the continuous vigil it had maintained since 24 August 1939. The Home Guard was disbanded, but the enthusiastic volunteers of the 4th Warwickshire Battalion were rewarded with a final parade and march-past where the Rt Hon Anthony Eden MP took the salute.

Anxiety about the potential fate of the prisoners still in the hands of the Germans and Japanese led to the formation of a self-help group in Stratford, the POW Relatives Association.

Peace at Least

Even before the war was over, the town council was considering ways to deal with social problems amidst the austerity to come. In February 1945, it ordered fifty of the temporary factory-built homes that were to be universally known as prefabs and selected a site off the Clopton Road. German POWs were used to erect them.

Lt Dennis Flower, released from his POW camp, was on a plane flying home on 7 May when he heard the official announcement that the war in Europe was over. News of the German surrender came to Stratford at 9 p.m. that evening. Within an hour, the streets were transformed. The flags, banners, streamers and bunting that had greeted the Coronation reappeared and the flags of the four main Allied powers – the United Kingdom, USA, USSR and China – flew in Bridge Street. Two days later, street parties took place in many parts of the town. To celebrate the peace, Flower's brewed a special victory ale called 'Stingo'.

Despite the genuine and joyful spontaneity of the VE Day celebrations, there were bitter complaints from the townspeople at the failure of the town council to organise any kind of

event to mark the great occasion. There was no excuse. It had been apparent for weeks that the war was drawing to its close.

News of the end of the Second World War came at midnight on 13 August with the Japanese surrender. On hearing the joyful tidings, people gathered at the Fountain outside the American Red Cross Club in the White Swan. Some had dressed, but some appeared in their pyjamas and dressing gowns. Somebody started a bonfire in the street. A dash of petrol every now and then sent the flames soaring high. Fireworks thrown into the embers exploded intermittently, hurling clouds of sparks into the sky. A piano appeared and set the crowds singing. It was soon joined by an accordion and a big bass drum. American Army lorries gave joyrides to all and sundry. With blaring horns they roared through the streets and into the countryside beyond, making sleep impossible for those who had not joined the celebrations. Half of the Festival Company formed one contingent.

Next evening, the town council, conscious of the criticism of its inertia at the time of the VE celebrations, organised a dance in Bridge Street. At the outset, only half a dozen couples took the floor, but the Palais Glide soon set hundreds of feet in motion. At 8.30 p.m., the mayor, Cllr Roderick Baker, spoke to the crowd through a microphone and called for three cheers for all who had served the nation so well during the long years of war. Half an hour later, the large crowd fell silent as the King's broadcast to the nation was relayed. At the end, three hearty cheers were given for His Majesty. The joy and thankfulness at final victory was heartfelt. The next day, street parties were thrown in many parts of the town and in the evening there was again dancing in Bridge Street.

At the Mayor's Church Parade, to give thanks for the peace on the following Sunday, the sword-of-honour was carried by Warrant Officer, Roy Salmon. His release from his POW camp on 16 April was three years to the day since his capture.

On 28 January 1946, the first of a series of 'Welcome Home' parties was held at the Town Hall for returning servicemen and women. It consisted of a 'substantial' meal and a 'first-class' concert party. The cost was born out of the rates. The progress of demobilisation was slow. The final party was not held until May 1948.

Austerity

Following the first municipal elections for seven years, Stratford went along with the national tide by electing its first Labour mayor, a railway porter, Cllr H. V. 'Tom' White. Hopes that the end of the war would see the relaxation of austerity were soon thwarted. Indeed the case was the reverse. Bread rationing had never been introduced during the war, although supplies were restricted, but on 20 July 1946 people received coupons to collect their loaves.

The town council's efforts in the housing sphere were substantial. Despite their nominal independence, the councillors were overwhelmingly Conservative. Yet, in the post-war era, municipal endeavour was the order of the hour. Tenders were accepted to build 32 council houses and 100 prefabs at Tiddington, along with 148 houses on the Clopton Estate. 100 of these would be prefabs, along with another 50 prefabs at Swincotes. The inhabitants decided that the keys of the first council house to be completed for seven years would be handed

to Mr R. H. Simmonds BEM, who until he was demobbed a few weeks before had been a Quartermaster Sergeant with the Warwickshire Yeomanry. 'If there is any certainty with regard to materials', predicted the Chairman of the Housing Committee, Ald. J. H. Knight, 'there is no doubt that by the end of 1947, we should have completed at least 200 houses.'

The situation was not helped by the fact that the Government was still holding over 500 bedrooms in the town. It was not until November 1946 that, the first of the leading hotels requisitioned for war service, was returned to civilian use. The *Falcon* was bought by the wine merchant Chris Rookes. When he took it over there was 'not a stick of furniture and the building was in a state to which only care-free service units could reduce it.'

On 4 October 1946, Stratford returned to the political map, following the recommendation that the constituency should be restored. Anthony Eden, the sitting member, opted for the Warwick and Leamington end of the divided division. As its prospective candidate, the newly-reconstituted Stratford Divisional Conservative Association selected John Profumo, a wealthy Old Harrovian who had been elected as MP for Kettering at a by-election in 1940. His then-role as 'baby of the House' (he was just twenty-five years old) attracted the derision of Lord Haw Haw. He had served with distinction on the Headquarters staff of the Eighth Army in Italy, attaining the rank of Brigadier. He lost Kettering in the Labour landslide of 1945, but won Stratford with a comfortable majority at the general election in 1950.

The borough council lost its greatest treasure that year. Fire raged through the upper floor of the Town Hall – ironically on the night of 5 November. The roof collapsed and Gainsborough's portrait of David Garrick was reduced to a cinder. A half-size copy of the painting was bought, and 40 guineas invested in a portrait of Garrick playing Richard III by Nathaniel Dance. When the vendor, who was a descendent of the great actor's nephew, learned the destination of the picture, she remitted the fee. On the face of it, the council had done well out of its investment. They received £25,000 from the insurers as compensation for an original payment of 60 guineas. Now they got a replacement by a notable artist, without charge. Yet such sums are spurious. Not only would the picture now be worth millions, a link with one of the town's greatest hours was lost forever.

Despite the ending of the war, things were getting little better. Indeed, people might be forgiven for wondering what difference the peace had made. The winter of 1947 was one of the worst on record. In January and February there was frost every night for six weeks, and in early March, the worst blizzard in memory isolated Stratford. The inevitable sequel was floods, which brought the river to the bottom of Sheep Street. A return to wartime conditions followed. Production in local factories largely ceased. Once again, a blackout descended on the town and many homes were without coal.

At the height of the war, Albert Pearce recalled the gingerbreads, brandy snaps and the striped peppermint sticks that were always known in Stratford as 'Mop Rock'. 'Still most of these things will return in the Mops of the future, when the Second World War will be almost a memory, and the huge carcasses of beef will revolve before the great open fire, the "Hot Dogs" will again be sizzling in the pans and the pies will contain real pork and the children will be able to buy "Mop Rock" without coupons, The "Fun of the Fair" will be with us again.'

Yet rationing continued well into the post-war era. Indeed such was the austerity of the times that the meat ration was actually reduced in 1951. Its final abolition on 5 July 1954 must

have led to hopes of the return of the Mop roasts – as Mr Pearce had prophesied. A beast was duly roasted outside the Red Horse that year, and in the following five years the custom was restored in the Rother Market as a charitable fundraiser, but then the custom died. The main reason for the loss of this old tradition may well have been the decline in the number of roasters during the sixteen years of austerity. In 1955, it was reckoned that there were only two ox roasters worth their salt in the kingdom. In 1956, one of them, George Tyler, 'Britain's champion ox-roaster', appeared at a charity roast in Rother Street for the Catholic Church.

Austerity had become part of people's lives, a habit that was hard to get out of. When in 1953, white bread returned to a number of Stratford shops after an absence of eleven years, most customers were content to stick with the wartime 'national bread', which was made from 80 per cent extraction flour and sold at a subsidised price. Many mothers believed, probably rightly, that national bread was more nutritious for their young families. In the words of one shop assistant, 'Of course a lot of people think that sixpence is much too dear for a small loaf. Others say they have got used to national bread and can't be bothered to change, and some say they can't tell the difference.'

A further indication of a return to pre-war norms came on 20 November 1953 when a dozen Stilton cheeses appeared at an auction. Bob Garrett, the auctioneer, reckoned that the last consignment to pass through his hands had been in 1939. A cheese borer, unused for fourteen years was restored to duty and the samplers declared the cheeses to be ripe.

With the relaxation of wartime price maintenance and the soaring cost of raw materials, inflation became a factor in the public and domestic economies. In April 1951, the local bus company, the 'Stratford Blue', applied to the licensing authorities for permission to increase fares. This was the first time that such a step had been taken in the firm's twenty-four-year history. The rise was not difficult to justify. Recent price rises had affected every aspect of the company's operation. Even so, the increase was modest. The minimum single fare of 1*d* was to rise by a halfpenny.

Despite such deprivations, or perhaps because of them, the post-war era saw a boom in public entertainment. A record 290,000 people attended the seven-month theatre season in 1948. Such was the demand that it became necessary to institute a ballot for tickets. The theatre achieved a remarkable 99 per cent capacity during the 1949 season.

By the early 1950s, most households were in possession of a motor car, however humble. This universal access to instant transport had its effect on the railway system. First to go were the passenger services on the old SMJ line to Blisworth. The last train left at 6.40 p.m. on 5 April 1952, carrying an official party, including the mayor, who went only as far as the first stop at Ettington.

The rising prosperity was benefiting the newly elected Tory government, which claimed the credit for the slow growth in living standards. Jack Profumo's star was rising with his party. Those in the know saw him as destined for higher things. Soon after the Tory victory in 1951, he was appointed as Parliamentary Under-Secretary to the Air Ministry. One of his functions was to see the new young Queen off on her frequent tours overseas. In 1960, he was made Privy Councillor and, soon after, War Minister, at the age of forty-five.

John Profumo's charm and panache had made him the subject of adulation by the Tory ladies of South Warwickshire. There must have been a number of disappointed maidens in the area when he married the noted and beautiful actress, Valerie Hobson, in January 1955.

She was thirty-six and playing in the West End production of *The King and I*, but retired from the theatre soon after her wedding. It was her second marriage, his first. In 1959, a *Herald* reporter visited the Profumo's London home: a Nash terrace house in Regent's Park. The couple lived in this idyllic place with Valerie's sons from her first marriage, aged fourteen and seven, the couple's own son, David, aged three, Jack's butler and his wife's old dresser.

'Flower's Greatest Success Story'

At Flower's Brewery, the ceremony of 'trussing' was briefly revived on 2 November 1953 when Ronald Huckvale became the first apprentice cooper since George Smith (by now the foreman) forty-five years before to experience the 'trussing' ceremony. The affair was well-planned, for not only did Ron's parents turn up by invitation, but also the directors and officials of the brewery along a reporter and photographer from the *Herald*. In a short speech, Col Fordham Flower expressed his pleasure at the perpetuation of the ancient craft of coopering in the machine age. The Chief Cooper, Mr A. F. CobBard, explained that barrels had been hand-made with almost no changes in tools or materials for hundreds of years. The large barrel, known as a ponto, that Ron had made would last for thirty or more years.

In fact, the writing was on the wall. In the next month it was announced that 'exploratory talks' had begun with the Luton brewers, J. W. Green Ltd, towards 'a possible … fusion of their respective interests'. The merger took place in the following February and created one of the largest brewing combines in the country. Green's possessed some 1,100 tied houses, while Flower's had a considerable holding in the Midlands. The new company had net tangible assets of £7 million.

There was clearly concern about the fate of the old brewery, for the directors put out a statement that there was no question of Flower & Sons Ltd going out of business, or closing their brewery. Indeed, the directors of Flower's somewhat disingenuously claimed that the takeover was in their direction, for the title of the enlarged group was changed to Flowers Brewers Ltd. Col Flower emphasised that the Stratford Brewery would continue to operate as a separate unit, with its own board, within the framework of the group.

In 1954, David Comyn, the head brewer, played a major role in what was described as 'Flower's greatest success story'. He was conscious that the brewery supplied small clubs that did not open every night and found it difficult to keep their draught beers drinkable, so he devised Keg Bitter, which was delivered in pre-sealed aluminium containers and served through an electric tap, with extraneous carbon dioxide forcing the beer into the glass. This standardised product needed a minimum of cellar care and naturally became a panacea for lazy publicans. It snowballed after other breweries jumped on the bandwagon. By the 1970s, the words 'keg beer' had become synonymous with an inferior product and there was a massive consumer revolt against it, but by then Flower's Brewery was no more.

In 1959, the brewery's maltings were closed after 128 years. It was explained that patterns of production had changed, so ended what had once been the town's main industry. Nevertheless, the brewery was booming, and it was decided to expand capacity, particularly of the Keg Bitter. Soon, fifty barrels an hour were being produced.

The apparently inexorable trend towards larger units ensured a further 'merger' between Flower's and Whitbread's that was announced on 27 April 1962. The new £49 million group would own 3,250 pubs. Dennis Flower, the managing director of the local company, assured his 550 employees that the move would give added security to their jobs, and that Flower's famous name would remain on their pubs. 'I was able to tell them that the business will carry on as if we had continued on our own. Whitbread's policy has always been to leave local units intact and the future should be even more secure.' The directors' apparent faith in this message was demonstrated three years later, by the decision to move the offices from the old site in Brewery Street to a new block on the Birmingham Road, which opened on 3 March 1966. Sir Fordham Flower described it as 'one of the most exciting days in the history of the firm'. On 9 July, this man who had dedicated his life to the brewery and the theatre died, while waiting for a flight home after presenting theatre awards in New York. Had he lived, he might have saved Stratford's brewery, but the inexorable movement towards bigger units would have almost certainly defeated him.

Early in 1967, a spate of rumours and speculation hit Stratford. So persistent were the whispers that the brewery was to close and that the new office building had been sold, that notices were posted to alleviate the fears of the employees. 'There is no truth in the rumours', declared Dennis Flower, who had taken over as MD of the joint Whitbread-Flowers company. 'We are trying to get together from an administrative point-of-view with West Country Breweries at Cheltenham. We have joined our managed houses departments, for instance – but our pubs are still ours and their pubs are still theirs. That does not mean there may not be changes in the near future', he added darkly. 'Changes are always possible – but there are no specific plans for Stratford.'

An anonymous spokesman at Whitbread's headquarters in London was more forthcoming. 'It is terribly difficult to say at any time that a brewery will not close down. As the form of the group changes, so does its policies.'

Few workers at the brewery believed Mr Flower's pronouncements. Over the next few weeks, the offices slowly emptied as key personnel moved from Stratford to Cheltenham. In July, the Board of Whitbread Flowers announced that the brewery would close a month after Christmas; 350 jobs would go. Many of the workers were middle-aged men who had worked for Flower's since leaving school.

When asked whether the decision might be reversed as a result of pressure from any quarter, Mr Flower replied that it was irrevocable. The brewery brewed its last pint at the end of January 1969, breaking a 138 year-old tradition. By then, the workforce was reduced to a mere nintey. The last day of employment on 13 February, a day on which there was little else for the workers to do but get drunk. Despite a pledge that a small number of office workers would be retained at Stratford, the last twenty-five departed eight days later. On 14 July, the abandoned brewery caught fire, and flames 50 feet high shot from its roof. On 17 October, the brewery offices were sold to a London property company for £350,000. The brewery was demolished in 1972 and the site became an industrial estate.

With the brewery's demise went one of Stratford's main industries, part of that heritage of local initiative that had given the town its character. All that remains today is a logo on a beer brewed elsewhere, and the concrete slabs that cover the artesian wells of the vanished tower brewery.

'You have got to play your hunches'

The theatre season of 1955 was made remarkable by the appearance of the first couple of the stage. Lawrence Olivier would make his first appearance at Stratford since he played Katrina in the old theatre in 1922. He would appear as Malvolio, Macbeth and Titus Andronicus: Vivien Leigh as Viola, Lady Macbeth and Lavinia. The booking office was overwhelmed and thousands were disappointed.

'The Oliviers have added lustre to Stratford', wrote the *Herald* at the end of the season, but the stardust was not over. A touring company which had been spreading the theatre's name far and wide returned to the theatre for a short season. Its repertory included John Gielgud's Lear and Peggy Ashcroft's Beatrice.

The following season was the longest yet (thirty-five weeks), and the fifty-year-old Peggy Ashcroft returned to play Rosalind opposite the Orlando of Richard Johnson, twenty-two years her junior. Glen Byam Shaw, the theatre director, demonstrated another stroke of panache. He invited the legendary baritone, Paul Robeson, to play the part of Gower in *Pericles*. He was unable to do so and the part was played by Edric Connor, the West Indian singer. A twenty-six-year-old Cambridge graduate, Peter Hall, made his debut at Stratford, directing a somewhat pedestrian version of *Love's Labours Lost*.

Glen Byam Shaw announced that he would retire at the end of the season in 1959 – the Theatre's 100th, but not its 100th anniversary, as in the Bensonian days there had often been two seasons a year. Peter Hall, at that time married to the French actress, Lesley Caron, would be appointed in his place. The season was star studded. Paul Robeson would definitely play Othello, with Sam Wannamaker, the future creator of the reconstructed Globe Theatre, as Iago. Tyrone Guthrie, who had recently inaugurated the Shakespeare Festival at Stratford's namesake in Ontario directed an *All's Well*, in which a future star, Diana Rigg, appeared. Charles Laughton played Bottom opposite Vanessa Redgrave's Titania and also appeared as Lear. Highlight of the season was the fifty-year-old Laurence Olivier's Coriolanus. His was the most spectacular death scene ever seen at Stratford, falling backwards off a cliff to be held by the ankles by the attacking Volscians as a panic-stricken audience to its feet. The strain would have been great on the muscles of a younger man. The part was eventually taken over with equal aplomb by the understudy, another actor of great energy, Albert Finney.

Within days of Peter Hall taking over the reins in November, a series of initiatives that would set the pattern for the future were announced. A London base would be established at the Aldwych Theatre. The Arts Theatre in the West End was added to the portfolio as a centre for experimental theatre. The stage at Stratford would be extended to give the actors closer contact with the audience, and a revolve became a feature. There would be greater emphasis on the spoken word. The gifte, local singing teacher, Mrs Denne Gilkes, was appointed as voice coach. A theme would run through each season. In 1960, six comedies would be presented. The stars still had their place. Peggy Ashcroft would play Katrina opposite Peter O'Toole's Petruchio and Dorothy Tutin would appear as Portia, Cressida and Viola.

During the season, the theatre orchestra was replaced by a wind band, which shocked traditionalists by playing what appeared to be a 'syncopated' arrangement of the National Anthem (it was explained that it was one of the earliest known versions). To create a

permanent company, sixteen actors and actresses were given three-year contracts. It was announced that the company would commission new works and, in 1961, *The Devils*, by John Whiting, became its first-ever world premiere. 'In the world of the theatre', Peter Hall explained, 'you have got to play your hunches.' The hunch was paying off. A Royal Charter heralded the birth of the Royal Shakespeare Company.

One of the theatre's great moments came in 1964. *The Wars of the Roses* presented the entire sweep of Shakespearean history from *Richard II* to *Richard III*. It featured a remarkable *tour de force* from Peggy Ashcroft as Margaret of Anjou, in which she moved from a young princess to an embittered dowager over three plays. On occasions, it was possible to see all three on one day, starting with a morning performance. The season saw new attendance records, with an average house of an amazing 99 per cent.

Peter Hall stepped down as the artistic director in 1968. He was replaced by another product of the Marlowe Society, Trevor Nunn, who at twenty-eight was only slightly older than was his predecessor when he was first appointed.

The retreat from empire by the European powers and the creation of new nations was having its effect on the Birthday celebrations. In 1968, no less than 130 national flags were unfurled.

Conservation

At the AGM of the Shakespeare Birthplace Trust in 1956, Professor Allardyce Nicoll of the Shakespeare Institute expressed his concern at the way Stratford was developing. 'I feel that we are becoming worse off because of what has happened in Stratford during recent years. Old buildings have been displaced by modern buildings which are out of character in the town.'

Such a case was the medieval dovecote at Shottery Manor. In 1953, the county council had bought the manor from Col. Flower as a site for a girls' grammar school. There was a grammar stream among the girls at the Hugh Clopton School, but it was decided that there should be a separate facility for them. In 1957, the developers proposed to demolish the dovecote because it interfered with their plans. Fortunately, the public got wind of it and strong protests led by the newly-knighted Sir Fordham Flower led to the building's preservation.

A major problem for those who sought to preserve the old buildings and character of the town was the attitude of some members of the borough council. In the view of Alderman Trevor Matthews, the town existed by its trade. 'We must have modern efficiency – and most of those buildings are not efficient.' Such a view led to the demolition of the Corn Exchange in 1957, despite fierce opposition from several councillors who felt that insufficient consideration was being given to the matter.

The actor, Andrew Faulds, got involved in a major conservation battle in the same year. He had first come to Stratford as an actor in 1944 and married a local girl, Bunty Whitfield. He had found fame by playing Jet Morgan in the cult radio serial, *Journey into Space*. When he heard of a proposal to demolish two council-owned cottages at 9 and 10 Church Street to make way for an extension to the National Farmers Union building, he reacted with a furious letter to the *Herald*. The houses dated from the seventeenth century and were in good

condition. He knew that because his in-laws had lived in one of them, and he had stayed there frequently. He treated Alderman Matthews' comment that they must think of the town's prosperity with appropriate contempt.

> This is just what these short-sighted men and their kidney fail to do. The town's prosperity stems from the fortuitous fact that William Shakespeare was born here and his plays are performed here. If you 'create a different atmosphere' in the sense they mean, you'll destroy the period feel and damage its buildings and heritage. We have their improvements with us – the Waterside lavatories, the Buttercup Café and soon the projected N.F.U. 'Mutual' wing in Chapel Street.

A similar sentiment was voiced by Reginald Hawkes, who had led the protests against the demolition of the old building on the Banbury Road thirty years before. 'One awaits with mounting anguish', he wrote, 'wondering what will be brought to light in the way of desecration.' Faulds lost this campaign, but it clearly had its effects on the town council. In 1962, it voted to reprieve two Tudor cottages in Sheep Street from demolition.

Yet the council was not the only threat to the town's buildings. By 1966, the steady and increasing flow of traffic in Guild Street had made St James' church in danger of collapse and the building had to be demolished.

In 1957, the process of infilling the fields between the ribbon developments of the interwar era began, when 46 acres of Bridgetown Farm between the Shipston and Banbury Roads was sold by Ald. J. H. Rowe for £25,000, to Dare (Stratford) Ltd, to build 276 houses. The Bridgetown Estate was the first of the anonymous developments that sprang up between every main road into town – bar the Warwick Road that Sir Archibald Flower had ensured was protected. Even the beauty of the Welcombe Hills were threatened by the break-up of the neighbouring Clopton estate after the death of the last individual owner, Lady Utica Beecham, first wife of Sir Thomas, who never acknowledged the divorce. Now, the semis crept across the Welcombe fields where Stratfordians had once fought the encroachment of enclosers. The members of twentieth-century planning committees proved a lesser body of men.

The Canal Restored

In 1957, a Stratford Canal Society was formed with a view to restoring the waterway, a manifestation of a growing movement to preserve industrial archaeology and find new uses for it. It took members of the society six weekends to pilot a canoe along the beautiful course of the canal. It had not been used for commercial traffic since the early 1930s, and the last pleasure boat was seen on it in 1948.

The society was formed just in time. In July 1957, Cllr Cyril Kemp presented a petition to the borough council signed by forty-six people living near the canal, complaining that the stench was detrimental to their health. It was especially bad when the water was disturbed, even by rain. In February 1958, the council agreed to support an application to the Ministry of Transport, by the county council, for a warrant authorising the closure of navigation rights on the canal. Five months later, it supported an application for total closure. It was unclear

who should pay the hefty bill for the process of abandoning the canal, but it was thought that at least part of it might fall on the borough council.

The response of the society to these moves was to organise a 3-mile trip along the waterway with dozens of small craft. No one could now say that the canal wasn't used. On 29 May 1959, the minister rejected the application because it hadn't been proven that the canal had been disused for navigation within the meaning of 'the Act for at least three years'.

Events took a dramatic turn when the National Trust announced that it was interested in taking over the waterway. It must have seemed like a godsend to the councillors, although the Trust was canny enough to add that it was only prepared to do so if no financial responsibility was involved. The deep interest that the project was arousing was demonstrated when a public meeting about the project at the Town Hall was attended by 400 people, who were told that the cost of restoring the southern section of the canal would be around £20,000, of which £1,000 had been raised already. The cost of closure would have been £119,000.

Members of the Canal Society were already engaged on the task of towpath clearance. On 14 October, the National Trust came to an agreement with the Ministry of Transport to take over the canal. An architect with Coventry Corporation, David Hutchings, was appointed as manager. In the following year, forty soldiers from the Port Maintenance Troop, a specialist unit of the Royal Engineers, helped to clear the canal. Progress was rapid and it was hoped that the project would be completed in time for the quatercentenary of Shakespeare's birth in 1964.

It almost goes without saying that the borough council did its best to forestall such a hope, proving difficult about allowing access to the river across the Bancroft. The excellent Sir Fordham Flower was moved to wonder why the council should be so stuffy: 'Boats are gay, colourful and elegant things.'

Once the route into the river had been settled, 5,000 tons of mud and rubble had to be cleared from the Basin. In the process, the towpath under the road bridge, which had long been buried, was rediscovered. The installation of the final lock gate at One Elm Bridge was completed by inmates from Winson Green Prison on 10 January 1964. In the next month, the war hero and local solicitor, Jack Tompkins, took his *Laughing Water II* along the length of the canal, the first boat to navigate it for thirty-five years.

On 11 July 1964, the Queen Mother opened the restored canal. David Hutchings was amazed that the councillors, who had been the most determined opponents of the project, now pressed for inclusion in the line-up to meet the royal lady. Six days later, at the annual dinner of the Inland Waterways Association, Sir Fordham Flower called for the restoration of the Upper Avon for navigation.

Save our River

By the 1950s, the condition of the River Avon was a cause for concern. The River Sherbourne, which flowed through Coventry, was an open sewer. That 'so-called river' flowed into the Sowe, which it killed stone dead, and the Sowe then flowed into the Avon.

In 1957, the town council decided to close the Bathing Place on health grounds. The same motive led the secretary of the Swimming Club, Miss Lillian Booker, to write to the town

clerk to inform him that, due to the state of the river, it was impossible to hold the annual long-distance race.

That summer, James Johnson, MP for Rugby, asked questions in Parliament about the state of the river. The replies from the Prime Minister were unconvincing, laying responsibility for putting matters right on the Severn River Board, despite the body stating categorically that it could do nothing for at least ten years. 'By that time', commented the *Herald*, 'the Avon will be completely silted up with sewage, sludge and the trickle of water flowing through Stratford will most certainly keep tourists away.'

In fact, with voluntary efforts concentrating on the canal restoration, not a lot was done until 1966, when Sir Fordham's call was heeded in the formation of the Upper Avon Navigation Trust, with David Hutchings its Project Manager. To restore the nine locks that would make the river navigable again to the sea, £150,000 would have to be raised. The job was duly done and, on 1 June 1974, the Queen Mother returned to Stratford to open the restored Upper Avon Navigation.

As one form of transport was being revived – if only for leisure activities – another was under threat. In 1966, the Sunday train service was withdrawn from Stratford. Fourteen months later, it was announced that the Stratford–Gloucester line would close, making the town the terminus of a branch line. In June 1968, the Minister of Transport consented to the closure of the Stratford–Henley–Birmingham line. With road congestion increasing year by year, this was an absurdity. Early in 1969, the borough council complained to the Ombudsman about the projected closure, and later threatened legal action if it happened.

Teds

The first of the post-war youth cults manifested itself in Stratford in 1957. 'Teddy Boys' were so-named because of their adoption of the supposed dress of the Edwardian age, although it is doubtful whether the gentlemen of that epoch wore fluorescent socks and crepe soles and sported 'DA' (supposedly short for 'Duck's Arse') hairstyles.

On Whit Monday in 1957, around forty 'Teds' broke up a folk dancing display on the Bancroft. Later, they were refused admission to a dance hall and walked in a body to the station. Some returned to the town and split up, visiting various pubs. Sgt Greathead and PC Harrison of the local force were on patrol when they heard the sound of breaking glass. A menu-holder outside a restaurant had been smashed. Two men, who were said to be leaders of the gang, David Lawson of Longbridge and Ronald Harford of Beoley Castle, were standing nearby. When they tried to arrest them, Lawson tried to lash out with a heavy belt and Harford reached for a knuckleduster in his pocket. When Lawson was searched, a razor blade was found in his pocket. They told PC Harrison that they carried the weapons to protect themselves, but in court they denied saying this. They were each fined £20 with 10s costs.

Worse was to follow when 200 drink-crazed screaming Teddy boys and girls from Birmingham were waiting for 12.10 a.m. train home at midnight on Mop night. The train arrived ten minutes early, but they would not board it and went on the rampage. Some

threw bottles, others danced in drunken abandon. They scrambled onto trolleys and were dragged round and round. Two boys picked up a seat and pounded it against the platform until the iron back was smashed. Plants were pulled out of the flowerbeds and thrown across the platform, and two windows in a stationary train were shattered.

Mr W. Bright, the stationmaster, tried to remonstrate with the hooligans and narrowly escaped being hit on the head with a bottle. The train did not pull out until 12.45, only to stop a few yards down the line when the communication cord was pulled. By that time, the train was in complete darkness. All the light bulbs had been smashed. While the train was waiting, several youths were kicked out of it by their 'friends'.

'I have never seen anything like it in my experience on the railways', said Mr Bright. 'A dozen policemen would not have been able to control them.'

The police met the train when it eventually reached Birmingham one and half hours late, and took a number of names. The communications cord had been pulled several times, more than sixty windows had been smashed, compartments had been torn apart and seats slashed with knives. All eleven coaches had to be taken out of service.

In the following July, Cpl George Mainprize was waiting in uniform at the bus station when he was accosted by Trevor Brown, a twenty-year-old Teddy boy from Welford Pastures. 'I'll bet you are a bastard', he said threateningly. The corporal made no reply. 'I was in the Army, all corporals are bastards', Brown continued. Mainprize still made no reply. Brown smashed his fist into his face several times and then made off. He was apprehended and fined £25 with £4 3s costs.

Successive youth cults proved a continuing irritation, particularly on bank holidays. Mods and Rockers fought it out on the Bancroft from the early 1960s, and were still going strong as late as 1983. In the early 1970s, the Skinheads arrived on the scene. In 1972, six youths faced charges ranging from theft to assault. They had anticipated trouble at the Mop with a group they referred to as 'grebos'. The night before, they had stolen three mallets from a local youth club and hidden them on the Bancroft. After retrieving them on Mop night, they saw two youths in leather jackets and chased them over Clopton Bridge. David Tilley, a labourer, aged eighteen, of Bordon Place, hit David Hopkins of Mickleton on the head with a mallet. The force was such that he was still in hospital four months later. His skull had been fractured in two places. He was suffering from a speech defect and his injuries necessitated the removal of a piece of his skull. At the crown court, one defendant was discharged, four were sent to Borstal and Tilley was imprisoned for three years.

The Profumo Affair

Andrew Faulds had been converted to political activism by the American singer Paul Robeson, who told him that views without commitment were valueless. He joined the local Labour Party and stood for the Alveston Ward at the town council elections in 1960. His address was characteristically forthright. 'It's time some of the fogeys retired', he wrote, 'for they are plainly competent no longer.' He failed to get elected, but he doubled the size of the poll. He was clearly a star campaigner. In the following year, he became chairman of the local Labour Party and, in 1962, its Parliamentary candidate.

The winter of 1963 was one of the coldest on record. The Avon froze and pretty well the whole of Stratford ventured onto the ice on the last weekend in January. The Profumos did not miss this photo opportunity, and the *Herald* had a picture of John pulling the beautiful Valerie on a sledge across the ice by the theatre. However, things were not as cosy as they seemed. Although nothing was known of it in Stratford, informed circles were agog with the gossip that Jack Profumo had been having an affair with a high-class call-girl, Christine Keeler. It would emerge that she was also having a liaison with the Russian naval attaché, Eugene Ivanov, which made the War Minister's position highly vulnerable. The press could not reveal the story, but they hinted of what they knew. The *Daily Mail* famously published separate pictures of the minister and the lass adjacent to each other. On 3 March, the Labour MP, George Wigg, used Parliamentary privilege to raise the matter in the House.

Profumo denied the rumours in an interview with the Prime Minister, Harold MacMillan, who accepted his word as 'an officer and a gentleman'. A few weeks later, he made a personal statement to the House of Commons in which he admitted that he knew Keeler, but denied there was any impropriety in the relationship.

The die was cast. While the British media were inhibited about the story, the continental press was less restrained. On 6 April, the Italian magazine *Tempo Illustrato* suggested that Profumo had been, or may have been, in an improper relationship.

Profumo had reached a point of no return. He had little choice but to back up his Commons statement by seeking injunctions and costs against the British distributors of the magazine. On 10 April, his lawyer, Mark Littman QC, told the high court that the magazine had repeated a rumour that his client had in some way been involved in Miss Keeler's failure to appear in a case at the central criminal court, where she had been bound over to give evidence. The distributors offered an unqualified apology which had its effect. That week, the German magazine, *Neue Illustrierte,* reported that its British wholesalers had refused to distribute its Easter issue because of a report and pictures of John Profumo and Christine Keeler. It was also announced that Mr Profumo had begun a libel action against *Paris Match*.

Back in Stratford, the political enthusiasm that characterised the 1960s was manifesting itself in the liveliest local elections for years, with contests in all four wards and an unprecedented near 50 per cent poll. A Young Liberal, Judith Oliver, succeeded where Andrew Faulds had failed and won Alveston ward from the mayor elect, Sam Tomlinson-Jones. Perhaps conscious of the impending sensation, Liberal headquarters replaced its Parliamentary candidate for Stratford (who resigned on grounds of 'ill-health') with a thirty-three-year-old former president of the Cambridge Union, Derick Mirfin, who was able and sincere, but lacked Andrew Faulds' charisma.

John Profumo had little choice but to continue to brazen out his lie. On his last visit to the constituency as its MP, he and a happy-looking Valerie were pictured singing a duet at a Tory meeting. On 4 June, Alf Bond, the Tory agent, was engaged in sending out invitations to a Conservative rally, which was to be addressed by the MP. It was not to be. Next day, the story broke and he resigned. He said that he had lied to protect his wife and family, 'who were equally misled, as were my professional advisers'. 'I cannot tell you of my deep remorse for the embarrassment I have caused you', he wrote to the Prime Minister, 'to my colleagues in the Government, to my constituents and to the party which I have served for the past 25 years.'

An even more terrible task for Profumo was to tell his wife that the rumours were true, that he had lied and that his career was in shreds. She loyally resolved to stick by him and, to escape the attention of the press, the couple simply disappeared. A nationwide search ensued. A suspicion that they were somewhere in the constituency turned out to be true when they returned to their London home on 18 June. They had been staying at Radway with prominent Tory supporters, Air Commodore and Mrs Victor Willis. Mr Profumo was interviewed by Scotland Yard officers about the role in the affair of the society osteopath, Dr Stephen Ward, who was subsequently found guilty of living off immoral earnings and committed suicide. Profumo was charged with no offence, although in the light of the Jeffrey Archer case some forty years later, he had been conspicuously guilty of perjury in the high court.

The Profumo affair was a watershed in British politics. It undermined people's trust in politicians and brought widespread scepticism about their motives. As the *Birmingham Post* put it, he had debased the currency of the Parliamentary personal statement and lowered the quality of English public life. 'Anything that leads to the spreading of cynicism about public affairs constitutes a deep injury to the whole nation.' This was true, but Jack Profumo was to rehabilitate himself in the best possible way. In 1975, he was awarded the CBE for his work with the poor, at the East End settlement of Toynbee Hall.

The Stratford By-Election

John Profumo's resignation meant that there would be a Parliamentary by-election in the Stratford constituency. 'I want it to be a clean, straight fight on policies' declared Andrew Faulds in an instant response to news of the MP's resignation. This was not only courteous, but possibly expedient, since rumour did not leave his own sexual reputation entirely untarnished. During the campaign, he would have the advantage of high public profile, which would be increased by his appearance as Carver Doone in a forthcoming television serialisation of *Lorna Doone*.

The forthcoming by-election was bound to attract a lot of interest – and the attention of fringe candidates. First in the field was a Worcestershire farmer, Miles Blair, who would fight on a platform of solidarity ('through thick and thin with kith and kin') with the white Rhodesians. Another potential candidate was Herbert Stratton, an inmate of Hull Prison. He was eligible to stand because his sentence was for a misdemeanour, not a felony. The papers were sent to him, but the prison authorities made it clear that he would not be released in order to obtain the necessary ten signatures of local electors on his nomination form. His mother expressed relief when he decided not to proceed. She told the press that she did not believe her son was 'bad enough' to want to be a politician.

One who created more than fleeting attention was the twenty-two-year-old rock singer David 'Screaming Lord' Sutch, who stood as the 'National Teenage Candidate' and dressed throughout the campaign in top hat and tails. His slogan was 'Vote for the Ghoul. He's no Fool', which proved correct, since he enjoyed the rare, if not unique, privilege for a politician of seeing most of his promises come to pass, including voting at eighteen, all-day opening for pubs, the legalising of commercial radio, the abolition of dog licences and a National Lottery.

Naturally, there were many applications from those wishing to become the Tory candidate for this safe seat. To many people's surprise, the choice fell on Angus Maude. An able journalist, he had quit Britain to become the editor of the *Sydney Morning Herald*, making some acid remarks about the state of the nation as he did so. He had recently lost the safe seat of South Dorset, to Labour in a by-election, albeit in extraordinary circumstances, with the former MP backing an Independent candidate against him. He was a worthy, but not particularly attractive figure, which may have commended him to the local association, which was still shell-shocked from the loss of John Profumo.

Derick Mirfin made an early gaffe in calling for the by-election to be held as soon as possible. The Profumo Affair was becoming a running story, with new revelations and speculations coming every day, so it was in the Tory interest to get things over with. The longer it took, however, the better it would be for the Liberals. Not only could they benefit from the rising surge of scandal, they could build up their organisation, which was non-existent in many parts of the constituency. The grateful Tories moved the writ for 15 August. This was not good news for the town clerk, Mr D. M. Bamforth, who had gone off for a fortnight's holiday in Devon with his family and had to return to organise the poll.

The campaign attracted huge national coverage and, although intense, was not devoid of humour. When Andrew Faulds described Lord Sutch as a product of the Tory education system, Angus Maude retorted that his formative years had been spent under Labour.

The Tory eve-of-poll meeting was a stormy affair, with the colonial secretary, Ian Macleod, facing severe heckling from members of the League of Empire Loyalists, who had gathered in force. At one point, Randolph Churchill, who was covering the by-election as a journalist, bullishly demanded that the Public Order Act be invoked to enable the stewards to forcibly eject the hecklers. The mild-mannered chairman, Dennis Flower, wisely saw the implications of such a suggestion and politely ignored it.

Hundreds of people gathered outside the Town Hall on 16 August to hear the declaration. The Profumo Affair had had its effect. The Tory majority was cut by 75 per cent to 3, 470 on a 69 per cent poll. Angus Maude was to prove an effective, hardworking MP, but he was never loved by the Tory faithful as Profumo had been. Andrew Faulds' campaigning skills had been noted by the Labour hierarchy and he became the MP for Smethwick (later Warley East) in 1966, after the seat had been lost to a Tory campaign that was alleged to be racist two years before.

As for 'Screaming Lord' Sutch, he had got the campaigning bug. He founded the 'Monster Raving Looney Party' and was an inveterate candidate in virtually every by-election that occurred until his sad suicide in 1999.

EPILOGUE
Everything's The Same

Everything's the same as in another town.

Charles Taylor

Changing Norms

Changing moral norms were reflected in the establishment of a family planning clinic in the town in 1960, although it did not advertise its existence until eight years later. Increasing marital breakdown was reflected in the establishment, in 1966, of a Stratford Club for the Divorced and Separated.

In 1968, Mrs Kathleen Cox, aged thirty-four, of Shipston, achieved a first she could have done without when she became Stratford's first breathalyser case. She was banned for a year and fined £50, after pleading guilty to driving with excess alcohol and without lights on the Shipston Road.

In the same year, the county council proposed to institute a comprehensive system in Stratford by amalgamating the Girls' Grammar School with the High School, and making King Edward's School a sixth form college. The proposal was resisted strenuously, particularly by King Edward School which, with plentiful endowments, was in a position to go independent. The scheme was dropped a few months later.

One of the most bizarre incidents in Stratford's contemporary history occurred in 1970. Alan Jacques of 16 Mount Crescent, a twenty-one year-old builders' labourer, went with his blond girlfriend, Jenny Evans, to a pub, where they spent the evening arguing. She told him that she didn't want to see him anymore. He then went off to a garage at Bridgefoot and obtained a container of petrol, telling the attendant that his car had run dry. He then proceeded to set fire to Anne Hathaway's Cottage, causing at least £25,000 worth of damage. When he received a four-year sentence for arson at the Crown Court, Jenny was weeping in the gallery.

Drugs such as LSD, Mandrax and barbiturates were freely circulating in Stratford by 1993, according to a report by the Principal Probation Officer. The police had reported only three cases of possession of cannabis in 1971, but in the following year, this had risen to eighteen.

The tradition of the Birthday – that all nations were welcomed irrespective of their regimes – came under threat in 1972, when a group of actors from the RSC chose to demonstrate against the dictatorship of the colonels at the unfurling of the Greek flag. Things came to a head again in 1988, when the company boycotted the annual mayoral reception for

the RSC. Stratford District Council, to which responsibility for organising the celebrations had devolved, bowed in to the incipient threat of violence and announced that no diplomatic reps would be invited in 1989. The Birthday looked to be in jeopardy. Since then, the flags of the nations have crept back – but only of those that possess a Shakespeare Festival of some kind.

Even Stratford's oldest continuing tradition – Shakespeare's Birthday – has latterly come under threat. In 2012, the organising committee, consisting of various interested local bodies, announced that there would be no procession or formal lunch that year, on grounds of previous losses. Instead, it was suggested that people organise their own lunches in various restaurants around the town. Rumours circulated as to whether the rug had been pulled on the occasion, but all was not lost. The town council stepped into the breach to organise the procession, while a local industrialist, Tony Bird, took on organising the luncheon, describing the plan to replace the event with a series of privately-organised lunches as 'ludicrous'. He considered the Birthday Luncheon to be one of the most important, if not the most important, Shakespearean event for the town where his birthday is celebrated on the international stage'. In the event, he found the response of the various organisations involved to be disappointing, so he did not repeat the venture in 2013. He felt that it would be an outrage if the 450th anniversary of Shakespeare's birth was not appropriately commemorated in 2014, so the event returned to its marquee by the river. The future of the occasion remains in doubt, however.

The shift of population out of the town centre, and changing social habits, continued to wreak destruction on Stratford's pubs. In 1959, the Great Western Arms was demolished to make way for a National Westminster Bank. In 1962, the Talbot on Bull Street became a private house, and the licenses of the Coach and Horses (opposite the Birthplace) and the old brewery tap (the Sir John Falstaff) were transferred to the short-lived Three Witches, on the Swinecotes Estate up the Alcester Road, and the Yard of Ale on Justin's Avenue. The Globe closed in 1973. The Red Horse, where Prince Rupert had lodged in 1643 and Garrick and Macklin stayed on their visit in 1744, and which Washington Irving immortalised in his Sketchbook after his visit in 1815, became a Marks and Spence'rs. The Horse and Jockey briefly became the Butt of Malmsey before closing to become part of a shopping precinct. The Plymouth Arms, so-named because the Countess of Plymouth had owned it in 1842, became a remaindered bookstore. The Mason's Arms in Sanctus Street closed.

Other pubs lost their old, evocative names. The Anchor, whose name recalled the old canal trade, was renamed The Encore. The Unicorn became the Pen and Parchment and the Green Dragon, the Bar M, full of noisy discos. The One Elm, which remembered the boundary tree that had once stood on the end of the Guild Pits, struck a brief topical note in the 1980s as The Recession, before becoming the Bar Humbug and then, thankfully, reverting to its original name in 2003.

Most amazing of all was the fate of the Phoenix, a run-down old pub on Guild Street. Since the 1890s it had been run by Flower's Brewery, which paid £273 4*d* a year in rent to a local solicitor. The last-known owner, Septimus Sutton Lane, a surgeon, had died in an earthquake in Peru in 1851. He had had three sons. One was known to have had a daughter, but a search of the Peruvian records had proved fruitless.

As a result of nationwide publicity, two people came forward to claim ownership of the pub – and £4,000 in accumulated back rent. Timothy Hicks of Holland Park submitted the

will of his great-great grandfather, another surgeon called Septimus Sutton Lowe, who had died in Yorkshire in 1894. Mrs Betty Castle of Dorking submitted a portrait of her 'Uncle' Thomas Lowe, who had died about 150 years before in Stratford. She thought that his family had intermarried with another local family, the Boltons, one of whose children had become the owner of the Shakespeare Hotel.

On 7 November 1972, the high court rejected claims by the attorney general, Sir Peter Rawlinson, that the Phoenix belonged to the Crown, but, in March, the appeal court sent it back to the high court. 'It may well be', commented Lord Justice Russell, 'that Mr Justice Goulding will decide in the end that it appears sufficiently to him that the Crown is entitled to the land and will order a sale.'

Neither claimant was accepted, so the property indeed passed to the Crown. It was eventually auctioned to become the first bistro in the Slug and Lettuce chain, but more recently has reverted to become the Hole in the Wall, which was the nickname of the Gloucester Arms next door, which had closed in 1978.

Even the Picture House went in 1983. The advent of television had made it increasingly non-viable. Developers acting on behalf of Tesco, the supermarket chain, applied for permission to demolish the building and the neighbouring cottages and build a supermarket. This was granted *provided* that a new multi-screen cinema was built on the site. In 1983, they withdrew from the scheme in the hopes of gaining a larger site on the Birmingham Road. Eventually Safeways took over the site, but did not offer to provide a cinema. It was pointed out that the closure of the cinema would mean the loss of sixteen jobs, but a supermarket would provide up to 150. Despite a petition to retain the cinema signed by 1,109 people, the cinema closed on 1 June. The last picture to be shown was *Gandhi*, starring the Oscar-winning RSC actor Ben Kingsley.

Eventually both chains opened superstores in Stratford: Tesco on the old brickworks site up the Birmingham Road and Safeway behind the station off the Alcester Road. Stratford was left without a cinema for a number of years, but due to the sterling efforts of Cyril Bennis, a local councillor and future mayor, the necessary funding was gained to convert Guyver's old garage in Windsor Street.

As local shops serving the community have been replaced by those serving the tourist trade (Pargetter's bakery became a Macdonald's as early as 1983 and out-of-town shopping has become an increasing trend), the town has become excessively dependent on its visitors and is now a less appealing place to live. The old ties with the neighbouring rural community have been weakened. In the 1990s, the cattle market, part of the town's original *raison d'etre*, shut down. The demands of tourism as against those of conservation of the local community have become out of kilter. The vulnerability of places that are over-dependent on tourism has been seen in towns and cities around the world.

Following the Redcliffe Maud Report, a Stratford district council was elected on 7 June 1973. For the twenty-eight members of the borough council, a shadow life of nine months began as many of its powers were transferred to the new body. The aldermanic system was abolished and the aldermen were allocated to the wards in which they had originally been elected. On 1 April 1974 (some doubtless saw the date as appropriate), the Stratford-upon-Avon Town Council was inaugurated. The town was reduced to the status of a parish, although the mayor

and all his trappings would blend with other traditions to give an air of continuity.

In 1986, a new theatre-in-the-round, the Swan, was established in the shell of the old auditorium. A new phase of controversy was initiated by proposals to demolish Elizabeth Gilbert Scott's Theatre in its entirety and build a 'theatre village' on the site. Many Stratfordians were outraged at the prospect of the destruction of a building they had grown to love and a 'Save our Jam Factory' campaign was launched. This was successful, but there was determination for change. The architects, Rab and Denise Bennetts redesigned the building, ostensibly in an attempt to marry the outstanding features of Elizabeth Scott's original with sensitivity to the demands of the modern stage. The verdict is awaited, but surely no one can condone the completely anachronous tower that has been erected beside the building. How long will it be before the 'Jam Factory' becomes known as 'Stalag Luft III'?

Those who asserted that Stratford would never again be other than a safe Tory seat were in for a surprise in 1992, when the sitting member, Alan Howarth, crossed the floor of the House to join the Labour Party, for whom he continued to represent the constituency, until the election of 1997, when he decamped to a safe Labour seat in South Wales.

The old Stratford theme continues: 'They won't let any of our old things be'. As Charles Taylor, a Chindit veteran from Tiddington, put it. 'No matter where you go in the country, everything's the same as in another town, the shops are the same. Nothing is different. Things to do are not different, are they? They are the same everywhere more or less, so you don't have to make your own fun. Fun is made for you, more or less.'

Select Bibliography

It would have been prohibitive of space and time to have documented every reference in the book. Some are mentioned in the footnotes, some in the text. At the end of each reference, a note indicates the chapters to which the material most appertains. Material of general interest does not carry such a reference. Some books that might particularly interest the reader who wants to learn about the history of Stratford are marked with a *.

Manuscripts

Borough of Stratford, *Accounts of the Chamberlains*, Birthplace Library.
--, *Bridge Book of the Corporation*, Birthplace Library.
--, *Council Books of the Corporation*, Birthplace Library.
Daniel, George, *The Jubilee*, scrapbook in the British Museum, 8.
Flower, C. E., *Scrapbooks in the Birthplace Library*, 17–19.
Flower, Sarah, *Aunt Sarah's Diary*, beginning with her copy of the early reminiscences of C. E. Flower, Birthplace Library, 13–18.
Hill, Joseph, *Joseph Hill, His Book*, Birthplace Library, 10–12.
Hobbes, Robert and Elizabeth (*née* Ashford), *Diaries and Papers*, Birthplace Library, 10–12.
Hunt, William, *The Hunt and Garrick Correspondence*, Birthplace Library, 9.
Miscellaneous Documents, Borough Records in the Birthplace Library, 16 vols. (listed in Halliwell [-Philips]'s *Calendar.*)
Morgan, John, manuscript reminiscences in the Birthplace Library, 17–19.
Rowley, Miss F. D., *Stratford-upon-Avon in the Seventies*, typescript reminiscences in the Birthplace Library, 17.
Saunders, James, *An Account of the Stratford Jubilee*, Birthplace Library, 9.
--, *Jubilee Correspondence*, 9.
--, *Stratford Races and the Theatre*, Birthplace Library, 8–12.
Stratford-upon-Avon parish records, comprising the parish registers, documents concerning charities and other miscellaneous papers.
Wheler, Robert Bell, *An Account of the Jubilee at Stratford-upon-Avon*, Birthplace Library, 9.
Wheler, Robert Bell, *Collections on the Stratford Jubilee*, Birthplace Library, 9.
--, *Wheler Papers*, Birthplace Library

Newspapers

The Stratford-upon-Avon Chronicle, 1861–1886, 14–16.
The Stratford-upon-Avon Herald, 1860–1969, 11–23.
The Warwick Advertiser, 1806–1860, 11–14.
The Warwickshire Chronicle, 1826–1835, 12–14.

Printed Works

Adderley, H. A., *A History of the Warwichshire Yeomanry Cavalry* (Warwick: W. H. Smith & Son, 1912), 10–11.

Arbuthnott, G. (ed.), *Vestry Minute Book, Stratford-upon-Avon, 1617–1699* (Bedford Press, 1890), 5–8.

Barber, Alexander, *A Church of the Ejectment, Stratford-upon-Avon* (Stratford-upon-Avon, 1912), 10–11.

Bearman, Robert, *Education in Stratford-upon-Avon* (Shakespeare's Birthplace Trust, 1976), 10–14.

Bearman, Robert, *Stratford-upon-Avon As It Was* (Nelson: Hendon Publishing Co., 1978), 16–23.

Bearman, Robert (ed.), *The History of an English Borough: Stratford-upon-Avon, 1196–1896*, (Sutton Publishing, 1997). *

Benson, Constance, *Mainly Players* (London: Thornton Butterworth), 1926, 18–21.

Benson, Frank, *My Memoirs*, (London: Ernest Bain, 1930), 18–21.

Bisset, James, *Bisset's (Anticipated) Joys of the Jubilee, at Stratford-upon-Avon* (Leamington, 1827).

Bloom, J. Harvey, *Shakespeare's Church* (T. Fisher Unwin, 1902).

––, (ed), *The Gild Register, Stratford-upon-Avon* (Chichester Phillimore, 1907), 1.

Bloom, the Revd J. H., *Topographical Notes*, reprinted from the *Stratford-upon-Avon Herald*, 1903, 1.

Bloom, Ursula, *Rosemary for Stratford-upon-Avon* (London: Robert Hale, 1966), 19–20.

Boswell, James, *Boswell in Search of a Wife*, eds., Frank Brady and Frederick A. Pottle, (London, 1957), 9.

Brinkworth, E. R. C., *Shakespeare and the Bawdy Court at Stratford*, Chichester: Phillimore, 1972), 3–6.

Brown, Ivor and George Feardon, *Amazing Monument: A Short History of the Shakespeare Industry* (London, 1939).

Chambers, E. K., *William Shakespeare, A Study of Facts and Problems*, 2 vols., Oxford: Oxford University Press, 1930), 3–6.

Concise Account of Garrick's Jubilee … and of the Commemorative Festivals in 1827 and 1830, 9–13.

Cradock, Joseph, *Literary and Miscellaneous Memoirs*, 4 vols. (London, 1830), 9.

Deelman, Christian, *The Great Shakespeare Jubilee* (Michael Joseph, 1964), 9.*

Dodd, James Solas, *Essays and Poems* (Corke, 1770), 9.

Eccles, Mark, *Shakespeare in Warwickshire* (The University of Wisconsin Press, 1963), 2–6.*

England, Martha Windurn, *Garrick and Stratford* (New York, 1962), 9.

Fairfax-Lucy, Alice, *Charlecote and the Lucys* (Oxford: Oxford University Press, 1958), 3.

Fogg, Nicholas, *Hidden Shakespeare* (Stroud: Amberley Publishing, 2012), 2–6.

Fogg, Nicholas, *Stratford: A Town at War* (Stroud: Sutton Publishing, 2008), 20–22.*

Foulkes, Richard, *The Shakespeare Tercentenary of 1864* (London: The Society for Theatre Research, 1984).

Forest, H. E., *The Old Houses of Stratford-upon-Avon* (London: Methuen & Co., 1925).

Fox, Levi (ed.), *The Correspondence of the Revd. Joseph Greene, Parson, Schoolmaster and Antiquary*, (HMSO, London, 1965), 8–10.

Hadfield, C. and Norris, J., *Waterways to Stratford* (David and Charles, 1962), 12–17

Halliwell, J.O., *A Descriptive Calendar of the Ancient Manuscripts and Records in the Possession of the Corporation of Stratford-upon-Avon* (1863).

Halliwell, J. O., *An Historical Account of the New Place, Stratford-upon-Avon*, 1864.

Hewins, Angela, *The Dillen, Memoirs of a Man of Stratford-upon-Avon* (London: Elm Tree Books, 1981), 18–21.*

Hewins, Angela, *Mary after the Queen* (Oxford: Oxford University Press, 1985), 20–22.

Ingleby, C. M., *Shakespeare and the Enclosure of the Common Fields at Welcombe* (1865) 4, 5.

Irving, Washington, 'Stratford' in Richard Savage and Salt Brassington (eds.), *The Sketch Book* (Shakespeare Quiney Press, 1900), 11.

Jarvis, J. A., *Correct Detail of the Ceremonies attending the Shakespearean Gala at Stratford-upon-Avon, 1827; Together with some Account of Garrick's Jubilee, 1769* (Stratford, 1769), 9–12.

Joseph, Harriet, *Shakespeare's Son-in-Law, John Hall, Man and Physician* (Hamden Conn., 1964), 6.

Kemp, Thomas (ed.), *The Black Book of Warwick* (Warwick: Henry C. Cooke & Son, 1898), 2.

Lane, Joan, *John Hall and his Patients*, (Shakespeare Birthplace Trust, 1996), 6.*

Malone, Edmund, *Original Letters ... to John Jordan, the Poet*: ed. J. O. Halliwell, (London, 1861), 10.

Masters, Brian, *Now Barabbas was a Rotter, the Story of Marie Corelli* (London: Hamish Hamilton, 1978), 19, 20.*

Mordaunt, C. and W. R. Vernrey, *Annals of the Warwickshire Hunt* (Marston and Co., 1896), 10.

Mullen, Michael, *Theatre at Stratford-upon-Avon*, 2 vols (Greenfield Press, 1980).

Savage, Richard and Elgar Fripp (ed), *Minutes and Accounts of the Corporation of Stratford-upon-Avon, Vols I–X, Publications of the Dugdale Society*, 1921–30, 2–6.

Schoenbaum. S., *William Shakespeare, A Documentary Life* (Oxford: The Clarendon Press, 1976), 2–6.*

Simpson, Frank, *New Place: the only Representation of Shakespeare's House, from an Unpublished Manuscript*, Shakespeare Survey 5 (Cambridge, 1952), 8.

Terry, Ellen and Christopher St John, *Ellen Terry's Memoirs* (London: Ernest Benn, 1933), 19–20.

Trewin, J. C., *Benson and the Bensonians*, (London: Barrie and Rockliff, 1960), 18–21.*

Wellstood, F. C., *Shakespeare Club Papers* (Stratford-upon-Avon, 1920), 12–14.

Wellstood, F. C., *Stratford-upon-Avon Papers*, reproduced from *The Straford-upon-Avon Herald* 1915–21.

Wheler, Robert Bell, *History and Antiquities of Stratford-upon-Avon* (Stratford, 1806).